PHOTOGRAPHY
THE WHOLE STORY

General Editor
Juliet Hacking

Foreword by
David Campany

PHOTOGRAPHY
THE WHOLE STORY

Thames & Hudson

First published in the United Kingdom in 2012 by
Thames & Hudson Ltd, 181A High Holborn,
London WC1V 7QX

© 2012 Quintessence

This book was designed and produced by
Quintessence
230 City Road
London EC1V 2TT

Project Editor	Fiona Plowman
Editors	Robert Dimery, Becky Gee, Carol King
Designer	Nicole Kuderer
Picture Manager	Helena Baser
Picture Researchers	Jo Walton, Julia Harris-Voss
Production Manager	Anna Pauletti
Editorial Director	Jane Laing
Publisher	Mark Fletcher

British Library Cataloguing-in-Publication Data
A catalogue record for this book is available from
the British Library

ISBN 978-0-500-29045-3

Printed in China

To find out about all our publications, please visit **www.thamesandhudson.com**.
There you can subscribe to our e-newsletter, browse or download our current
catalogue, and buy any titles that are in print.

CONTENTS

FOREWORD

Strictly speaking, the whole story of photography would be an account of every photograph ever taken and every response to it, from that tentative handful first made in the 1830s to the thirty billion or so now snapped annually around the world. Impossible. Choices have to be made. In fact, the process of shaping a story of photography is not unlike taking photographs. It is an art or science of abbreviation. It involves judgement, selection, framing, editing, assessment and reassessment.

Photography has had more lives than a lucky cat, each with its own convoluted story. It has had many deaths, too. For over a century, the medium's demise has been announced regularly. The first challenger was cinema and then came television, the electronic image and most recently the internet. Yet photography has been nothing if not resilient and adaptable. Its essence does not reside in any particular technology or in any particular social function. Indeed, the argument still rages as to whether there is an essence at all, or just a loose and shifting affiliation of characteristics.

Photography was well established before anyone even tried to tell its story. It was only its centenary in the 1930s that prompted the first attempt. For much of its existence it symbolized a moving present, the medium best able to picture a fast-changing world. The relentless onwards drive seemed to cut it off from its own past. Photography had given rise to whole new fields of experience, entering every institution of modern life. Journalism, ethnography, architecture, advertising, fashion, topography, medicine, education, tourism, history, law, politics, design and, of course, art. It was becoming the pre-eminent modern art. It was also transforming the other arts by redefining realism and establishing itself as the reproductive medium through which all art would be known beyond the museum. Even in the 1930s, an overview of photography was a Sisyphean task. Combined together with a mix of connoisseurship and science, those early attempts at a history established a familiar roll call of great names and watershed moments of technical innovation.

Since then photography's story has become even more complex and plural. Nevertheless, the fascination with it has not gone away. Indeed, for every voice claiming that photography is responsible for obliterating history in a blizzard of disposable 'nowness', there are those who see clearly the links between what photography is today and what it has been.

Over the last few decades photography has become a much more reflective medium, aware of its history and able to draw upon it with maturity. As a result the continuities are as striking as the ruptures. This book captures the widespread revival of interest in photography's past—not as a set of dead facts but as a way of understanding where we are in the present day.

No doubt the internet has had much to do with this revival. Firstly, the experience of looking at immaterial screen images has made us acutely aware of the physical and material properties that shaped photography for much of its life. Not just prints, but books, magazines, newspapers, albums and archives (none of which have yet vanished into the electronic ether). Secondly, the internet has allowed us to grasp the tensions between local histories of photography and the uneven globalization of visual culture. Thirdly, it has made photography's past more available to us and in greater richness than ever before. So many of the challenges, issues and interests we think of as uniquely our own have been encountered by photographers and audiences in the past.

For example, the perplexing tension between the photograph as record and expression has animated every stage of its development as art. Its legal and factual status is as unavoidable and contested today as it was when William Henry Fox Talbot so prophetically described it as 'evidence of a novel kind'. The narrative properties of the still image engaged photography's pioneers just as much as the most contemporary image makers working in art or advertising. The relationship between the single image and the many was also explored by those pioneers in their books and early photo-essays, while today we know a photograph is both a unique image and part of a larger body of work. The photography of people, places and objects remains central and always will: portrait, landscape and still life photography persist not as an upholding of traditional genres, but as flexible pictorial forms. Then there are the deep connections between the colonial impulse that spread photography so rapidly around the world in the 19th century and new global culture emanating from the centres of image production.

Photography appeals because it is both a subject and a passport. To be interested in it allows one to feel grounded while venturing into all those aspects of the past and present it has touched and transformed.

DAVID CAMPANY
WRITER, CURATOR, BROADCASTER AND PHOTOGRAPHER

INTRODUCTION

Why are photographic images so compelling? The fact that many of us now take pictures on a weekly, even daily, basis has not served to diminish the magic either of personal snapshots or the works to be found in the gallery, museum or book. The pictures placed in an album or posted on social networking sites can make us laugh out loud. When we encounter stunning images from the history of photography, such as the early 20th-century photographs of Antarctica by Herbert Ponting (1870–1935), we are captivated. Ponting's images from the British Antarctic Expedition of 1910 to 1913 make the remote past thrillingly present. Yet these images are not simply historical documents: it is clear that even in such forbidding conditions the photographer was determined to sacrifice nothing of aesthetic effect. Photography belongs both to the realms of reality and imagination: although it sometimes favours one over the other, it never quite relinquishes its hold on either.

When it was announced to the world in January 1839 that it was possible to capture the image seen in a camera obscura (a drawing aid that projected what the artist saw on to a surface from which he or she could copy their subject), it seemed that there were no limits to human ingenuity. Daguerreotypy—developed in France by Louis-Jacques-Mandé Daguerre (1787–1851)—resulted in a highly detailed image on a small metal plate, as if a small mirror had been held up to nature. The January announcement of the daguerreotype was promptly followed by news of another photographic process developed in England by William (known as Henry) Fox Talbot (1800–77). Talbot's process, which he called 'photogenic drawing', resulted in a negative image on paper that had the warmth and burr of graphic art.

▼ A study of the Castle Berg, with dog sledge, in Antarctica by Herbert Ponting (1911). Ponting taught photography to members of the expedition to discover the South Pole in 1911 to 1912. Their undeveloped negatives were found in the tent in which Captain Scott, Edward Wilson and Henry Bowers perished on their return journey, having discovered the Norwegian flag at the pole.

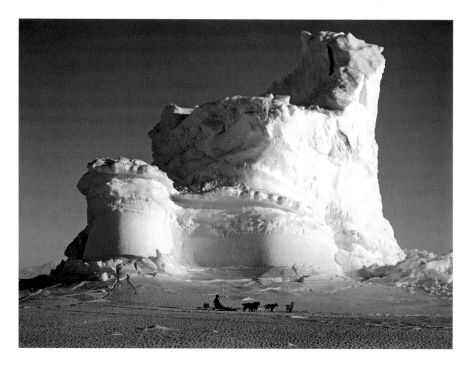

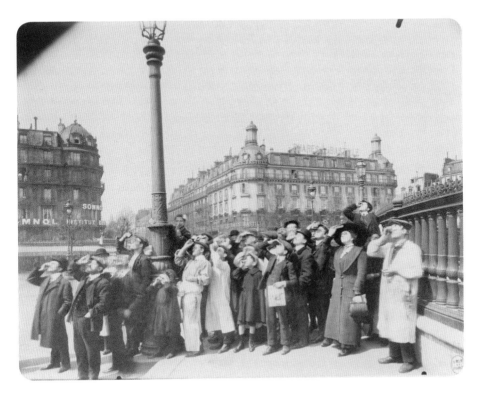

Whereas a daguerreotype was a unique object (there was no negative), a photogenic drawing could be used to make multiple positive prints. Ever since these beginnings, photography has oscillated between uniqueness and multiplicity. Today a unique or limited edition photographic print by a celebrated artist can sell for more than a million dollars and, at the same time, digital photography—with its seemingly endless replication—plays a fundamental role in global communication.

Photography: The Whole Story chronicles the history of extraordinary pictures made by photographic means. There are many thousands of important art photographs in public and private collections worldwide and yet the majority were not made with the art exhibition in mind. Some were intended as demonstrations of what the new medium could do; others began life as documents, records or illustrations; only later were they seen as art objects. Some photographs, such as the study by Eugène Atget (1852–1927) of Parisians viewing an eclipse, find the surreal in the real. Others, including Self-portrait as a Drowned Man (1840; see p.21) by Hippolyte Bayard (1807–77), play with photography's ability to make fiction appear as fact. As the majority of great photographic images have been accepted as art objects retrospectively, their story cannot be told by reference to movements, schools and coteries. This book is structured, therefore, around a variety of key developments, groupings, subjects and themes. Individual works of remarkable power, whether made as documents or art, are featured throughout.

▲ Eugène Atget's photograph of Parisians viewing an eclipse (1912) was used by Man Ray for the cover of the journal La Révolution surréaliste in June 1926. Atget, who according to Man Ray conceived of his photographs as 'simply documents I make', refused to be credited.

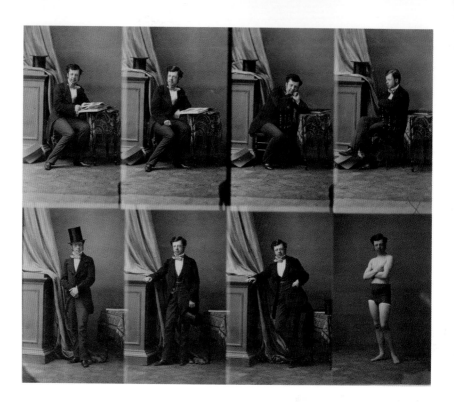

▲ The *carte de visite* allowed for up to eight miniature portraits to be printed on the same negative. Printed in multiples, they could then be given to family, friends and acquaintances. This example from 1858 by André-Adolphe-Eugène Disdéri (1819–89) shows Prince Lobkowitz in a variety of poses, including one in unconventional attire.

From the invention of photography in 1839, the question of the medium's identity and status was debated not by reference to its technological origins but by its relationship to the arts. Few denied that photography was an ingenious invention of the modern age but many saw it as a threat to the traditional values associated with fine art. In a society symbolically divided between 'gentlemen' (those who exercised their intellect and imagination) and 'operators' (manual workers who did unthinking, mechanical work), a machine that made pictures was a challenge to the existing social order.

In the 1850s, daguerreotypy and calotypy (the name that Talbot gave to his process after important refinements in 1841) both gave way to wet-collodion photography, a process based on the use of glass negatives for the production of paper images. The resulting images were generally printed on paper coated with albumen (egg white) and are characterized by crisp detail, a chocolate-brown tonality and a shiny surface. The practice of photography, both amateur and commercial, experienced a massive boom in the mid 1850s. The practice of photography on paper had been freed from licencing restrictions and two new formats were about to become very popular. The stereograph (two images of the same subject taken slightly apart and pasted side by side on a piece of card) presents a three-dimensional image when looked at in a special viewer; subjects were sometimes educational, but often were designed simply for visual effect, or even titillation. The *carte de visite*, also known as the album or card portrait, was a full-length portrait the size of a calling (business) card, and emphasized the dress rather than the features of the sitter.

The popularization of photography in the mid 19th century led to a shift in attitudes towards the medium. The practice of calotypy in the 1840s and 1850s in Britain and France had seen an extraordinarily high degree of technical and aesthetic experimentation and achievement. In the face of the rapid commercialization and popularization of photography in the 1850s and 1860s, the idea that photography could be art—and that photographers (drawn from

the lower social ranks) could be artists—appeared preposterous to some. In 1857 the art critic and historian Elizabeth Eastlake expressed the view that photography should be celebrated, but only if it did not evince pretensions beyond dealing with 'facts'. A few years later the French poet and critic Charles Baudelaire denounced commercial photography as art's 'most mortal enemy'. The influential art critic John Ruskin, who had marvelled at the fidelity to nature of daguerreotypy when using it as a visual aid in Venice in the mid 1840s, later said of photography that it 'has nothing to do with art. . .and will never supersede it'.

In the 1860s the majority of commercial photographers considered technical qualities, such as sharpness of visual information and immaculate print quality, as the means to demonstrate the superiority of their photographic images. This technical conception of excellence meant that, for the would-be professional photographer, photography was an art of the real. A few notable individuals rejected this orthodoxy and regarded photography as a means to create complex weavings of ideality and reality. The most well-known of these amateurs was a woman: Julia Margaret Cameron (1815–79). Cameron took up photography in her late forties and throughout the next decade created a large body of work solely for aesthetic reasons. She used differential focus, costume box clothes and occasional props to create soft-edged, warm-toned portraits and figure studies, the latter inspired by biblical, literary or allegorical subjects. Cameron's belief that it was she who was making an art of photography was so audacious, and her idiosyncratic practice such an affront to the modest aspirations

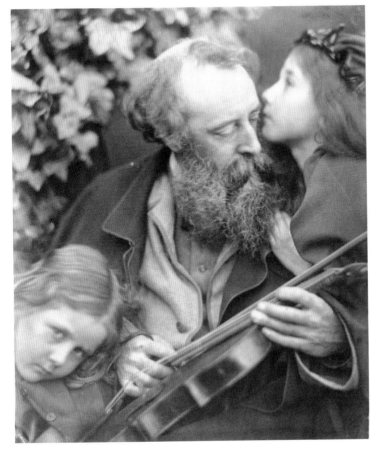

◄ The artist George Frederic Watts, together with two of Julia Margaret Cameron's favourite child models— Elizabeth and Kate Keown—personify creative inspiration in *The Whisper of the Muse* (1865).

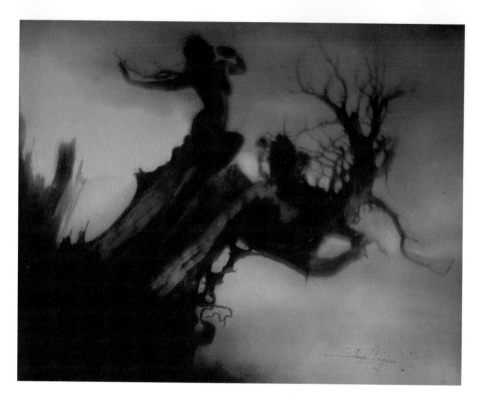

▲ Picturing the human figure in the landscape was a distinctive feature of Anne Brigman's work. Brigman, who was based in California, did not use professional models but instead would spend the summer camping in the Sierra Nevada with her friends and sisters, posing them in the rugged landscape to create dramatic compositions, such as *The Wind Harp* (1912).

of the works shown at photographic society exhibitions, that she was characterized by the photographic community as a hapless female eccentric who could not use her equipment properly.

It was not until the end of the 19th century, however, that subjectivity in photography gained a broader cultural legitimacy. Central to the international movement known as 'Pictorialism', the exponents of which promoted photography as an expressive medium, were photographers who had 'succeeded' from established photographic societies and the technical accomplishments they valued. Pictorialist photography is characterized by techniques and effects borrowed from the graphic arts. Although a Pictorialist image generally came from a sharply defined negative image, the often extensive darkroom manipulations involved in transforming the image away from this hard-edged reality meant that each print could be claimed as unique. The resultant images, often printed in a vibrant hue and appearing soft, hazy and dreamlike, were meant to provoke aesthetic rather than literal responses. Many Pictorialist compositions invoked the high art seriousness of contemporary Symbolism, as seen in the photograph *The Wind Harp* (1912) by Anne Brigman (1869–1950).

The figure most closely associated with the promotion of art photography at this time was Alfred Stieglitz (1864–1946), a New Yorker with close connections to Europe. Having turned his back on the Camera Club of New York and founded the Photo-Secession, Stieglitz went on to preside over the journal *Camera Work*, a showcase for the best photographic art then being made internationally, including his own. Stieglitz and *Camera Work* played as important a role in the move away from Pictorialism as they had done in its promotion. As early as 1904 the critic Sadakichi Hartmann, writing in *Camera Work*, used the phrase 'straight photography' as a foil to the soft-edged aesthetic of Pictorialism. Stieglitz's *The Steerage* (1907; see p.182), which appeared in *Camera Work* in 1911, is often hailed as the first modern

photograph. It was not until the final issue of the journal appeared in 1917, however, that a straight aesthetic for photography was fully realized. The issue was dedicated to works by Paul Strand (1890–1976) and included his now iconic *Wall Street* (1915; see p.179), which fused bold pictorial geometry with a modern life subject.

The idea that photography could have an aesthetic of its own and that it was grounded in qualities singular to the medium was hugely compelling for US art photographers, many of whom renounced Pictorialism. Edward Weston (1886–1958) came to espouse the idea that the creative work of photography was no longer to be conducted in the darkroom but in the photographer's 'pre-visualization' of the subject and in its composition before exposing the negative in the camera. In 1932 a group dedicated to the promotion of straight photography, known as Group f/64, was formed in California with Weston and Ansel Adams (1902–84) among its members. Weston, with his near-abstract still lifes and nudes, and Adams, with his lyrical landscape photography, went on to dominate photographic art-making in the United States for decades.

In Europe, World War I had a profound effect on the making of art. Disaffected artists sought to develop modes of pictorial expression that could express the crisis of faith in traditional values that had been brought about by the conflict. The first non-figurative photographs, invoking time, space and other abstract concepts, were made during the war and this spirit of radical innovation informed avant-garde art-making in the 1920s and beyond. As a modern technology with demotic connotations, photography was perfectly placed to take a central role in avant-garde art. The medium— now generally taking the form of silver-based prints with a 'black-and-white' appearance—was used by the Dadaists in Germany for works of biting social critique; by Constructivists in the Soviet Union to forge new pictorial modes for a new society; by Surrealists such as Man Ray (1890–76) in Paris in their visual jests and explorations of the subconscious; and internationally by modernists to celebrate new forms of art and design. Photography lent

▼ Man Ray's photograph *Larmes* (popularly known as *Glass Tears*) from the early 1930s is often linked to the breakdown of his relationship with Lee Miller (1907–77), the US model turned photographer. The image, which plays on the nature of reality, is also—with its fake tears and perfect mascara—suggestive of insincerity.

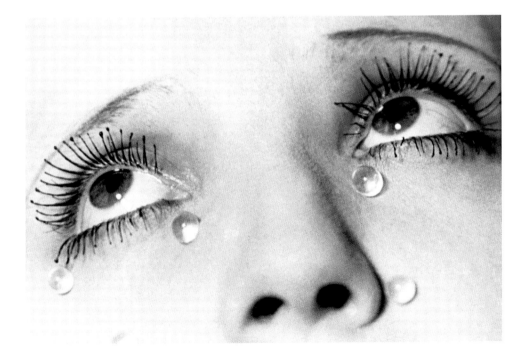

itself to these widely different aesthetic agendas because of its hold on actuality. As a modern technology, photography celebrated the modern and the material. As a mechanistic recording device, photography lent the imaginative or irrational the weight of objective fact. In countries as ideologically opposed as Soviet Russia and the United States, a small but influential number of avant-garde practitioners came to see photography as the ideal visual medium for the modern era.

Photography may have been widely used by avant-garde artists but this does not mean that they always recognized its equality with the other arts. This was in part because of its commercialization in the form of celebrity portraiture, advertising and fashion. This anxiety over photography's status was shared by biographers, art historians and curators who glossed over the commercial elements of photographers' careers in order to secure their recognition as artists. Today it is well-known that the major photographers among the Parisian avant-garde of the 1920s—Man Ray, André Kertész (1894–1985) and Brassaï (1899–1984)—all worked on commission. Man Ray, born Emmanuel Radnitzky in Philadephia, moved to Paris in 1921 and distinguished himself as an iconoclastic innovator in painting, sculpture, film and photography. Nowadays, we do not regard his creativity as compromised by his editorial or fashion photography (see p.261). Sometimes, as in the case of his celebrated image *Black and White* (see p.224), the commission acted as a spur to the creativity.

Another important development that had its roots in France during the interwar years is humanist photography. Closely linked to the rise of photographically illustrated popular journals such as *Life* magazine, this type of photography pictured subjects of human interest. The best-known photographer working in a humanist vein was Henri Cartier-Bresson (1908–2004), whose photo-reportage images from around the world were also published in a series of influential photobooks. Executed in a realist idiom, Cartier-Bresson's oeuvre owed as much to Surrealism as to straight photography but this was obscured in the later 20th century by photography's place within the modernist orthodoxy.

The Museum of Modern Art in New York (MoMA) was the ideological home of modernism—the dominant avant-garde aesthetic of the mid century that embraced art, design and architecture. MoMA held an important survey of photography in 1937 and eventually opened its department of photography in 1940, yet photography's status as an art form was still not secure. It was John Szarkowski (1925–2007), who became curator of photographs at MoMA in 1962, who was most effective in assimilating photography to modernism. According to Szarkowski, legitimate photography was 'straight', democratic in its subject matter and had a strong formal component. Photographs were not works of the imagination but fragments of actuality pictorially organized to reflect a strong personal vision.

According to the scholar Douglas Crimp, 'if photography was invented in 1839, it was only discovered in the 1960s and 1970s—photography, that is, as an essence, photography itself'. Crimp, and others in his circle, critiqued the loss of understanding that was being effected by the transfer of photographs from the drawers of the archive to the walls of the art museum. Inevitably, this critical interest in photography, together with texts such as Pierre Bourdieu's *Un art moyen* (1965), Susan Sontag's *On Photography* (1977) and Roland Barthes's *Camera Lucida* (1979), served to further elevate photography in terms of its cultural status. Barthes's text—a highly poignant account of his search for a 'true' image of his mother—is perhaps the most influential example of the attempt to define photography in essentialist terms. In his book, Barthes formulated the idea of the 'punctum', the detail within a photograph that

pricks the viewer with a woundlike sensation. Like modernist accounts of photography, *Camera Lucida* suggested that photography had a unique nature that made it distinct from all other visual media.

A competing conceptualization of photography claims that it has no innate characteristics. Its identity is, it is argued, dependent upon the roles and applications ascribed to it. This theorization of photography belongs to the critique of modernism that is known as postmodernism. The desire to once again see art as socially and politically engaged, rather than belonging to a realm of creative purity, led scholars back to the writings of Walter Benjamin, the critic and philosopher who was associated with the Frankfurt School in the 1930s. In claiming that a photographic copy destroyed the 'aura' of an original work of art, and that it was possible for the masses to enjoy art through this simulacrum, photography symbolized for Benjamin the possibility of a divestment of cultural, and ultimately political, power from the National Socialists. In the 1980s, left-wing theorists began to reconceptualize the medium's history in terms of how photography has been implicated in the exercise of power. The notion of photographic objectivity was further undermined by the writings of those scholars and intellectuals, most notably Jean Baudrillard, who challenged the idea of a pre-existent reality that is merely captured or reflected by visual media. According to Baudrillard, imagery is the reality through which we come to know the world.

In the 1970s, photographic art was identified with iconic images from the 19th century and the early 20th century. Today it is identified with works made in the last thirty-five or so years. At the time of writing, the world record for a photograph sold at auction is US$4.3 million—for *The Rhine II* (1999) by Andreas Gursky (b.1955). A mere twelve years ago, when we entered the 21st century, the world record was US$860,000—for *The Great Wave, Sète* by Gustave Le Gray (1820–84; see p.98). The massive increase in the value of photographs is often cited as proof that photography has finally been accepted as art. You will see from the essays included in this book that this is not the first time, however, that photography has been identified as an art form. What does distinguish the present day from the past is that information, in whatever form, is now rarely conveyed without still or moving pictures: photography, in its digital form, is as much a modern wonder as was the daguerreotype in 1839.

▼ Andreas Gursky is one of the best-known contemporary artists working with lens-based media. This photograph of the Rhine from 1999 was taken with a medium-format camera. The resulting image was scanned into a computer and digitally reworked by Gursky, who was able to create the picture he wanted by discarding elements from the original scene—such as the buildings on the far side of the river—that he found distracting.

THE BIRTH OF PHOTOGRAPHY (p.18)

Boulevard du Temple, Paris | Lo

DAG

DAGUERREOTY

THE BRITISH CALOTYPE (p.42)

1 | 1826 TO 1855

THE

STILL LIFE (p.62)

EGY

PHO

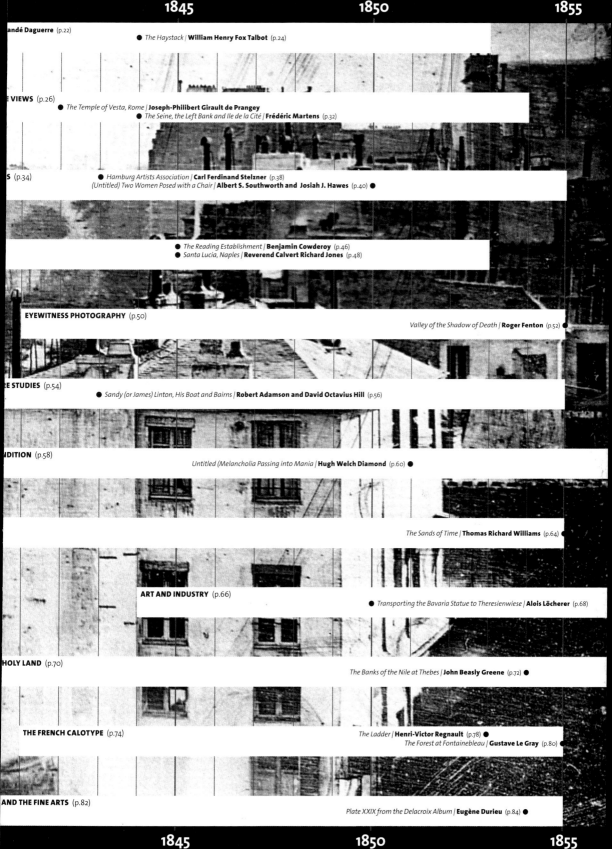

THE BIRTH OF PHOTOGRAPHY

The blurred and grainy image above represents a landmark in the history of photography. Taken by the French inventor Joseph Nicéphore Niépce (1765–1833) in 1826–27, *View from the Window at Le Gras* is the earliest surviving photograph, although it was largely unknown at the time. It was not until 1839 that photography was dramatically unveiled to the world. Many of its key elements had, in fact, been known for some time. By the 4th century BC, Aristotle knew about the principle of the camera obscura: light passing from an external source into a darkened room, through a pinhole or other small aperture, forms an inverted image of the outside scene on a surface such as a wall or screen. By the mid 16th century, lenses had replaced inefficient pinholes, creating more sharply focused images. In the 17th century, the camera obscura was combined with tents or sedan chairs, for greater portability, and later reduced to the size of a tabletop box. During the 18th century, artists were regularly using the instrument to project an image from life that they could then copy.

The key element necessary for photography to evolve was a substance sensitive to light. The effects of light on physical objects were well known—the ability of sunlight to tan skin, for example—and alchemists had identified many substances that reacted to light, usually by darkening. In 1777, Carl Wilhelm

KEY EVENTS

1826–27	1835	1837	1838	1839	1839
Joseph Nicéphore Niépce takes what is regarded as the earliest known photograph— a view from his window at Saint-Loup-de-Varennes.	William Henry Fox Talbot photographs the library window at his home, Lacock Abbey. In doing so, he creates what is now the oldest surviving negative.	Louis-Jacques-Mandé Daguerre produces *L'atelier de l'artiste*, the first 'daguerreotype' to be exposed, developed and fixed successfully.	Daguerre attempts to sell his process (along with Niépce's 'héliographie') by subscription, but fails.	The invention of the daguerreotype is made public in January, although details only emerge in August. Talbot reveals his 'photogenic drawings'.	Sir John Herschel reveals that hyposulphite of soda (sodium thiosulfate) can permanently 'fix' a photographic image.

Scheele used light to freeze a stencil's image in a solution in a flask. Scottish chemist Elizabeth Fulhame explored many ideas, the most intriguing of which was to form images of rivers photographically in light-sensitive salts of gold on a cloth map. Although none of her productions is known to have survived, her monograph *An Essay on Combustion, with a View to a New Art of Dying and Painting* (1794) was the first explicit publication of a photographic process.

Around this time, Thomas Wedgwood (1771–1805) began using light-sensitive salts of silver on paper and leather. Unable to pass sufficient light through a camera lens, he turned to 'photograms', created by placing objects directly on to light-sensitive surfaces. Publishing an outline of Wedgwood's results in 1802, Humphry Davy noted: 'Nothing but a method of preventing the unshaded parts of the delineation from being coloured by exposure to the day is wanting, to render the process as useful as it is elegant.' Wedgwood had conceived of the idea of photography and had created images, but could not preserve them.

Two separate paths subsequently emerged that would dictate the future course of photography. In *c.* 1816, Niépce, motivated by his interest in the art of lithography, made his first experiments with the camera obscura. Abandoning the salts of silver, he turned to bitumen: a 'resist' (protective coating) for printing plates that hardened in light. By *c.* 1826–27 he had succeeded, creating *View from the Window at Le Gras* on a pewter plate. In 1829, he entered into partnership with Parisian showman Louis-Jacques-Mandé Daguerre (1787–1851), who had been attempting to devise a method of taking photographs for a long time, without success. Niépce died in 1833, his process of 'héliographie' (drawing with the sun) still unknown to the public.

Just months after Niépce died, and totally unaware of his efforts, the Englishman William Henry Fox Talbot (1800–77) embarked on his own photographic quest. In October 1833, Talbot visited Italy with several family members. In their leisure time, they sketched the local scenery—all except Talbot, an accomplished scientist and linguist but a terrible draughtsman. For help, he turned initially to the camera lucida: a portable invention that used a prism on the end of a stem to project an image on to a surface, but, unlike the camera obscura, without the need for a strong light source. When the artist's eye was positioned over the prism, it became possible to superimpose the image on to that of the drawing surface below, allowing the artist to make a tracing of it. The device proved hard to master, however. Talbot was reminded of the camera obscura; in spring 1834, at his home, Lacock Abbey, in Wiltshire— and then quite unacquainted with Wedgwood's efforts—he employed silver compounds on paper. Unlike Wedgwood, Talbot found a 'fixer', a way to stabilize the image, and an example of the sort of photogenic drawing he was able to produce is *Byronia dioca—the English Wild Vine* (right). He then turned his attention to his many and various scientific and political concerns without making his invention public.

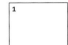

1 *View from the Window at Le Gras* (1826–27)
Joseph Nicéphore Niépce • heliograph
6 ⅝ x 7 ⅞ in. | 16.5 x 20 cm
Harry Ransom Center, University of Texas at Austin, USA

2 *Byronia dioca—the English Wild Vine* (*c.* 1839)
William Henry Fox Talbot
photogenic drawing
8 ⅞ x 7 ¼ in. | 22.5 x 18.5 cm
National Media Museum, Bradford, UK

1841	1841	1843	1844	1851	1853
Having discovered the idea of a latent image (an invisible image that can be developed into a negative) in 1840, Talbot patents his calotype process.	The Royal Academy of Science in Brussels displays the earliest stereographs—images that, through a special viewer, create the illusion of depth.	Anna Atkins publishes a limited edition of *British Algae: Cyanotype Impressions*, the first published book to be illustrated with photographs.	The first instalments of Talbot's *The Pencil of Nature* bring photography to the attention of a wider public.	Frederick Scott Archer reveals the 'wet-collodion' process: a sheet of glass is coated with silver salts and collodion to create a glass negative.	The Photographic Society of London (later the Royal Photographic Society) is founded.

In the meantime, Daguerre made an incredible breakthrough when he discovered that iodized silver plates could be developed with mercury, producing direct positives, as seen in *L'atelier de l'artiste* (above). In 1838, he exhibited examples such as *Boulevard du Temple, Paris* (see p.22) and tried to sell his process by subscription, without success. In January 1839, François Arago, of the Académie des Sciences, announced Daguerre's invention, along with the intention of the French government to purchase the rights to it for the world. Although his approach had been quite independent, and radically different to Daguerre's, Talbot was forced into the position of declaring his own discovery.

Many other claimants for the art stepped forward, too. Hippolyte Bayard (1807–77), a French civil servant, independently invented a process that combined Daguerre's direct positive with Talbot's use of paper. His *Self-portrait as a Drowned Man* (opposite below) expresses his frustration at having been pushed aside in the public mind. Daguerre never made another significant contribution to photography, but within two years others had made the daguerreotype more sensitive with bromine and protected it through gilding. In late 1840, Talbot made a great advance, discovering the latent image and the amplifying power of development. Exposure times for paper negatives dropped from tens of minutes to just seconds, and publication of his calotype process in 1841 provided the first really practical negative/positive photography.

A high level of detail was the daguerreotype's greatest asset, emphasized by scrutiny under a magnifier. The smooth surface of the metal plate helped, because no fibres disrupted the image as they could with paper, and each daguerreotype was an original image made directly in the camera, with only the limitations of the lens mediating the view. However, this uniqueness was also the daguerreotype's greatest drawback. Although it was possible to make daguerreotype copies of original daguerreotypes, silvered copper sheets bearing images were totally impractical for widespread distribution. Imagine a book illustrated with pages of solid metal.

It took an early female member of the Botanical Society of London, Anna Atkins (1799–1871), to embark on the first photographically illustrated book. She had previously executed fine watercolours illustrating her father's scientific

3 *L'atelier de l'artiste* (1837)
Louis-Jacques-Mandé Daguerre
daguerreotype
6 ¼ x 8 ¼ in. | 16 x 21 cm
Société Française de Photographie,
Paris, France

4 *Dictyota dichotoma, in the
young state; & in fruit* (1843)
Anna Atkins • cyanotype
New York Public Library,
New York, USA

5 *Self-portrait as a Drowned Man* (1840)
Hippolyte Bayard • direct paper positive
10 ⅛ x 8 ½ in. | 25.5 x 21.5 cm
Société Française de Photographie,
Paris, France

works and recognized their ability to bring collections to a wider audience. In 1842, her friend Sir John Herschel (1792–1871) had invented the cyanotype, a photographic negative on paper based on the salts of iron rather than silver. Unsuitable for camera exposures, it excelled at producing very stable, finely detailed photograms, although its rich blue colour was inherent. Starting in 1843 and continuing for a decade, Atkins employed flattened dried algae effectively as negatives, positioning them on sheets of sensitive paper in the sun. In this way, she produced thousands of prints for editions of her *British Algae: Cyanotype Impressions* (1843–53). Bound initially into parts, later into larger volumes, plates such as *Dictyota dichotoma, in the young state; & in fruit* (right) vividly demonstrated the precision of photographic book reproductions.

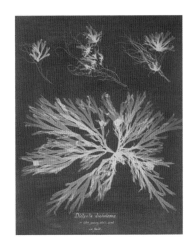

Bringing photography to the pages of books had always been Talbot's goal. In June 1844, he began issuing the first commercially distributed, photographically illustrated book: *The Pencil of Nature*. He envisioned a wide range of uses for photography and *The Pencil of Nature* was intended to demonstrate that range. His former valet and assistant, Nicolaas Henneman (1813–98), moved to Reading in 1843 to set up one of the first photographic laboratories. Without the means to convert photographs into printer's ink, *The Pencil of Nature* was illustrated with original photographic prints glued to its pages. Henneman used a range of Talbot's calotype negatives to make editions of prints. Issued as a part book, each fascicle of *The Pencil of Nature* contained several photographic prints, accompanied by Talbot's text, including plates such as *The Haystack* (1844; see p.24). Unfortunately, scaling a personal art up to industrial dimensions revealed its inherent weaknesses. Silver prints could never be as permanent as time-tested printer's ink. As the plates in *The Pencil of Nature* began to fade, either from internal faults or through exposure to pollution, the dream of publishing original photographic prints faded too. Talbot turned his attention to photogravure. Not long after his lifetime, photographs printed in ink would become the universal mode of conveying visual information. **LJS**

Boulevard du Temple, Paris 1838
LOUIS-JACQUES-MANDÉ DAGUERRE 1787 – 1851

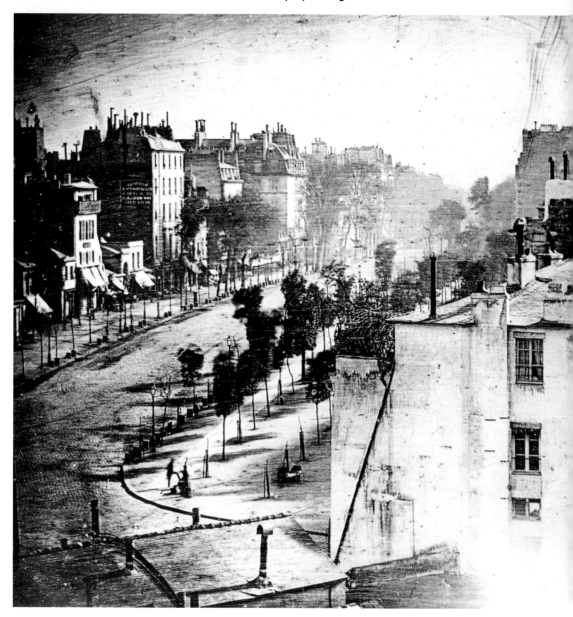

1 CAMERA POSITION
Using these three tall buildings, which are still standing, it is possible to pinpoint Daguerre's camera position. As human beings, vehicles and animals moved too quickly to be captured—because of the long exposure times needed—early daguerreotypes tend to feature architecture only.

2 HIGH DETAIL
From the exposed timbers to the roof tiles, the clarity of Daguerre's image was unprecedented. Samuel Morse marvelled in a letter to his brother: 'The exquisite minuteness of the delineation cannot be conceived. No painting or engraving ever approached it.'

After years of experimenting, in 1837 Louis-Jacques-Mandé Daguerre finally managed to permanently fix the images seen in the camera obscura. His first successes were still lifes. Soon, however, he would move out of the studio and go beyond mere renderings of architecture towards recording life itself. Some time between 24 April and 4 May 1838, Daguerre mounted his camera in an upper window of his residence at 5 rue des Marais, right behind his Diorama (a specially adapted theatre of his own devising, in which spectators could view a changing series of painted scenes), and took the first photograph known to include human beings. Carts, horses and people were swirling around the busy boulevard that morning, but the long exposure time and their haste to get somewhere condemned them to the status of ghosts. It would appear, however, that one man's concern with the appearance of his boots made him and his shoeblack stay in one place long enough to make history.

This is one of the images that Daguerre proudly displayed early in 1839 to inventor Samuel Morse and others. After his disclosure of the details of the process in August 1839, Daguerre presented this image to the king of Bavaria, who exhibited it publicly in Munich in October of that year. This plate survived the devastating World War II bombing of the city's museum, in which it then hung, only to be scoured nearly bare in a misguided attempt at cleaning it in c. 1960. Fortunately, the photographic curator and historian Beaumont Newhall had commissioned a high-quality negative of the image to make a print for his pioneering exhibition at New York's Museum of Modern Art in 1937. In 1979, Peter Dost and Bernd Renard were able to use this reproduction to create the facsimile daguerreotype, and now this image hangs once again in Munich.

The frequent printings of this daguerreotype in books and journals all have their root in Newhall's negative. Ironically, given Daguerre and William Henry Fox Talbot's rival claims to be the inventor of photography, it was Talbot's negative/positive process that preserved Daguerre's legacy. **LJS**

Modern daguerreotype
5 ⅞ x 7 ¼ in. | 15 x 18.5 cm
Bayerisches Nationalmuseum, Munich, Germany

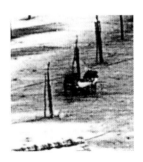

3 FIGURES ON BENCH
Some viewers of this image may see five or even six people. Perhaps there is a couple seated on the bench? Or a man reading a newspaper? Other viewers may believe that they can see a boy peering back at Daguerre from a window in the white house in the foreground of the image.

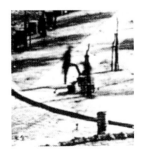

4 MAN AND SHOESHINE
The man having his boots blacked is the most prominent feature of this daguerreotype; he holds his foot steady while his torso sways slightly. The energetic polisher, possibly a boy, is less defined. It is possible that Daguerre paid or otherwise encouraged them to hold the pose.

The Haystack 1844
WILLIAM HENRY FOX TALBOT 1800 – 77

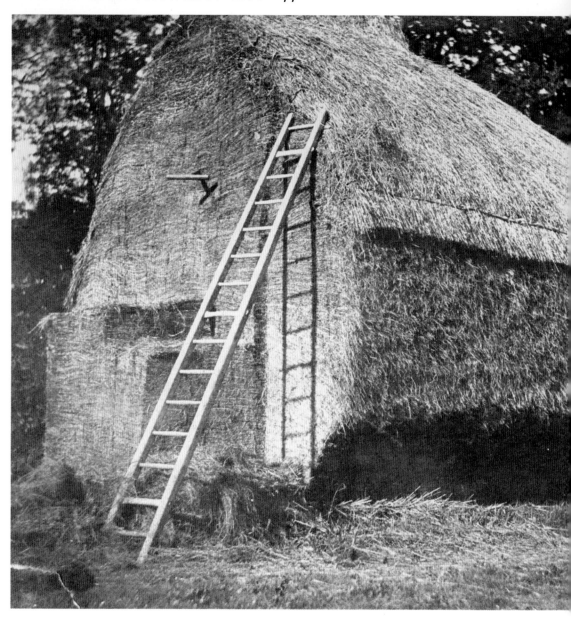

1 KNIFE
The knife used to cut the bales was usually stored by plunging it into the hay, so this feature is authentic. Here, it acts like a sundial, providing the viewer with a sense of time and also a sense of foreboding that the elegant structure before the viewer will soon be cut apart.

2 LEAVES
The green light from the leaves did not affect photographic materials in this period, so foliage usually appeared too dark. Talbot took advantage of this, allowing background trees to appear darker than they normally would, making a greater contrast with the lighter tone of the hay.

Salted paper print from a paper negative
6 ⅜ x 8 ¼ in. | 16 x 21 cm
National Media Museum, Bradford, UK

✵ NAVIGATOR

William Henry Fox Talbot included this image in his pioneering book *The Pencil of Nature*, which appeared in six instalments from 1844 to 1846. In the text, he observed that photography would 'enable us to introduce into our pictures a multitude of minute details which add to the truth and reality of the representation, but which no artist would take the trouble to copy faithfully from nature.' Indeed, with its sharp definition, contrasting areas of light and shade and strong geometrical shapes— the roundness of the haystack, the squared-off blocks of bales to the left, the pale ladder with its dark shadow set against a patch of sunlight—the image provided ample evidence of photography's possibilities. So novel was the technology that Talbot added a note to the reader, emphasizing that the plates had been created purely by light (he called them 'sun pictures'), without artistic intervention. Time and light are the essential elements of any photograph, but especially so here. The *Athenaeum* observed that Talbot's photograph '[enables] us to hand down to future ages a picture of the sunshine of yesterday'. **LJS**

⏱ PHOTOGRAPHER PROFILE

1800–32
Having studied at Harrow and Cambridge, in 1821 William Henry Fox Talbot began publishing papers in mathematics and later in the physical sciences. In 1827, he moved into Lacock Abbey, Wiltshire and became a member of the first Reform Parliament in 1832.

1833–39
He conceived of the idea of photography during a trip to Italy. In spring 1834, he achieved his first results on paper and in summer 1835 he first used a camera to create images. Prompted by news of the invention of the daguerreotype, Talbot made public his photogenic drawing process in 1839.

1840–77
In September 1840, Talbot started to utilize a developer for his calotype negative process, which became the essential basis for all photography. Having spent thousands of pounds researching the process, he patented the calotype in 1841. By 1845, however, he had temporarily withdrawn from all photographic activity. Talbot's interests in other fields, especially Assyrian cuneiform, made him better known in intellectual circles than photographic ones. In 1852, he succeeded in marrying photography with printer's ink, producing permanent prints in a standard printing press. The perfection of photogravure occupied him until his death in 1877.

3 TEXTURE AND TONE
The bright sunlight picks out the straw in the haystack, conveying something of its prickly texture. The strong light also creates a varied tonal palette across the image, ranging from the sunlit top of the stack to deep shadow underneath, which helps to delineate its bulky form.

4 LADDER
This is an 'authentic' image taken from life, but some advance observation and planning went into its creation. The ladder had to be at a very precise angle to cast its shadow vertically. The time of day would have been critical—the light conditions in this scene would have lasted only minutes.

DAGUERREOTYPE VIEWS

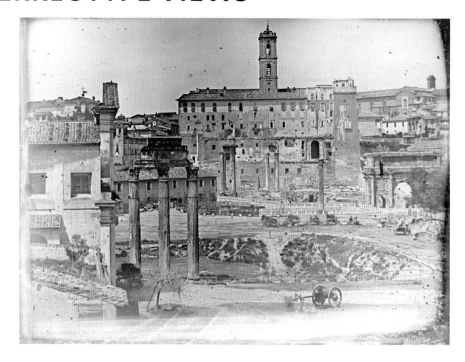

At dawn on 20 August 1839, the day after François Arago's revelations about the working methods of the daguerreotype, the chemist Marc Antoine Auguste Gaudin (1804–80) set out to experiment with the radical new process, clutching a camera consisting of an ordinary lens secured in a cardboard box. 'After having iodized the plate,' he later reported, 'I put it in my box which I pointed out of my window, and bravely waited out the fifteen minutes that the exposure required. . . . I had a Prussian blue sky, houses black as ink, but the window frame was perfect!' To skilled hands, so simple was the daguerreotype that a primitive but thrilling result could be accomplished on the first attempt.

Paris was a natural location for pioneers, but budding daguerreotypists were inspired to travel farther afield. The prospect was compelling, both as a challenge and as a commercial opportunity—especially to the optician Noël Paymal Lerebours (1807–73). Printsellers had already proven that there was a market for a visual travelogue of the Grand Tour. In some cases, these prints were mementos for those who had actually taken a tour, but more often they served the needs of armchair adventurers. A month after the daguerreotype process was announced, Lerebours was commissioning artists to fan out over the world to make daguerreotypes of classical antiquity and modern wonders

KEY EVENTS

1841	1841	1842	1843	1844	1845
John Lloyd Stephens (1805–52) and Frederick Catherwood (1799–1854) daguerreotype Mayan ruins in the Yucatán peninsula, Mexico.	Using bromine acceleration, Marc Antoine Gaudin takes daguerreotypes of Paris with a short enough exposure to record people and traffic.	Joseph-Philibert Girault de Prangey sets off on a three-year tour of Italy, Greece, Egypt, Syria and Palestine, making more than 800 daguerreotypes.	The French customs official Jules Itier travels to China on a diplomatic mission and makes daguerreotypes of Canton and Macao.	Franziska Möllinger (1817–80) produces daguerreotypes of the mountainous scenery of Switzerland. They are published as lithographs.	William (1807–74) and Frederick Langenheim (1809–79) make five daguerreotype panoramas of Niagara Falls. They are framed and given to Daguerre.

alike. By December 1839, his shop was selling individual daguerreotypes of Corsica and Italy. Soon, views would be pouring in from all over the world, from Niagara Falls, Algeria, Moscow, Greece, Spain, Egypt and Palestine.

As each daguerreotype was a direct positive image taken in the camera, it retained the glorious detail and subtle tones that an original could possess. However, lacking a negative from which reproductions could be taken, every daguerreotype was also condemned to be the sole issue of that image. Lerebours knew that his stock of originals would always be limited, so he turned to a range of reproductive processes to translate these unique plates into printer's ink. Starting in 1840, he began issuing *Daguerreian Travels, Representing the Most Remarkable Views and Monuments in the World.* Each of the prints within these volumes had a veracity based on an original daguerreotype plate, but each was wholly or largely engraved by hand.

The practice of buying daguerreotype views that Lerebours pioneered was soon copied. In 1840, Englishman Alexander John Ellis (1814–90) conceived of a plan for a book to be titled 'Italy Daguerreotyped'. Before he started taking his own views, he purchased finished plates from local practitioners, including Lorenzo Suscipj (Suscipi; 1802–55), one example of which is *Rome, Forum from the West Side of the Arch of Titus* (opposite). Ellis's book never materialized, but the 159 daguerreotype views that he collected form an important archive today.

When John Ruskin was in Italy writing *The Stones of Venice* (1851–53), he discovered the documentary value of daguerreotype views, such as *Venice, St Mark's* (below). They provided him with sketches of undoubted clarity and

1 *Rome, Forum from the West Side of the Arch of Titus* (1840)
Lorenzo Suscipj • daguerreotype
6 x 8 ¼ in. | 15.5 x 21 cm
National Media Museum, Bradford, UK

2 *Venice, St Mark's* (1845)
Photographer unknown • daguerreotype
2 ¾ x 3 ¾ in. | 7 x 9.5 cm
Ken and Jenny Jacobson Collection, London, UK

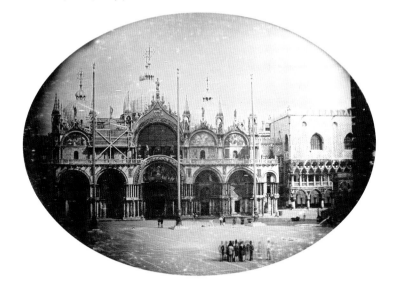

1845–46	1848	1850	1851	1853	1854
Entrepreneurial photographer and publisher John Plumbe (1809–57) makes a daguerreotype of the Capitol Building in Washington, DC.	Charles Fontayne (1814–1901) and William S. Porter (1822–89) produce a huge daguerreotype panorama of Cincinnati, USA.	Robert H. Vance (1825–76) of San Francisco takes more than 300 daguerreotypes of California scenery.	John A. Whipple daguerreotypes the moon through a telescope at Harvard University. It is displayed at the Great Exhibition in London.	Eliphalet M. Brown, Jr (1816–86) accompanies the Perry Expedition to Japan. Woodcuts from his daguerreotypes survive, but not the originals.	William and Frederick Langenheim, based in Philadelphia, make a series of eight daguerreotypes tracking the progress of a solar eclipse.

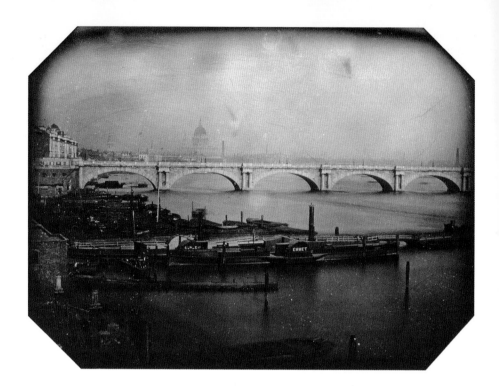

3 *Waterloo Bridge on The Thames,*
London (1851)
Jean-Baptiste-Louis Gros • daguerreotype
6 x 7 ⅞ in. | 15 x 20 cm
Bibliothèque Nationale de France,
Paris, France

4 *The Moon* (1851)
John Adams Whipple and William
Cranch Bond • daguerreotype
2 ¾ x 2 ⅛ in. | 7 x 5.5 cm
National Media Museum, Bradford, UK

5 *Tourists Viewing Niagara Falls*
from Prospect Point (c. 1855)
Platt D. Babbitt • daguerreotype with
applied colour
5 ⅜ x 7 ½ in. | 13.5 x 19 cm (full plate)
George Eastman House, Rochester,
New York, USA

honesty, ones that he could refer to time and again to confirm specific points and even to make fresh observations. Although he was later to take up the art himself (at least by directing an assistant), some of Ruskin's first uses of the medium resulted from acquiring existing daguerreian views. He recalled purchasing such daguerreotypes, including the view of St Mark's in Venice: 'I have been lucky enough to get from a poor Frenchm[an] here. . .some most beautiful though small daguerreotypes of the palaces I have been trying to draw—and certainly daguerreotypes taken by this vivid sunlight are glorious things.' Ruskin had undoubtedly seen other daguerreotypes before this, and his comment that these were 'small' was probably based on the fact that the majority of the early daguerreotype views were 'whole plate' in size, echoing the plates supplied with the camera authorized by Louis-Jacques-Mandé Daguerre (1787–1851), roughly 6 ½ x 8 ½ inches (18 x 24 cm). However, for Ruskin's purposes, the quarter-plate size of this view was perfectly adequate. There are interesting parallels between Ruskin and Joseph-Philibert Girault de Prangey (1804–92), whose *The Temple of Vesta, Rome* (1842; see p.30) provided both documentation and the basis for later illustration. Ruskin found the rectangular format of his quarter plates to be ideal, but de Prangey was more inventive, splitting the whole plate in a way to encompass a wider sweep of detail.

The panoramic view presented a challenge to the daguerreotype. The split plates of de Prangey still had their optical limitations because the inescapable laws of physics came into play. *The Seine, the Left Bank and the Ile de la Cité* (c. 1844; see p.32), photographed by Frédéric Martens (1806–85), addresses this problem by curving the metal daguerreotype plate to match the curvature of the lens. The silvered copper plate could then be flattened for viewing.

In 1851, the same year that Daguerre died, the Great Exhibition was held in London. The French diplomat Jean-Baptiste-Louis Gros (1793–1870), fresh from negotiating a peaceful resolution between Greece and Britain, attended the exhibition and daguerreotyped the Crystal Palace. It was probably during this trip that he also daguerreotyped *Waterloo Bridge on The Thames, London* (above).

Gros is likely to have positioned his camera on the terrace of the Adelphi, an 18th-century building, looking eastwards towards St Paul's Cathedral. It is an eerily empty scene. Evidently no one had reason to stay still long enough to be recorded during the lengthy exposure. The badges on two small paddle-steamers, the *Curlew* and the *Emmet*, prove that the image is not laterally reversed.

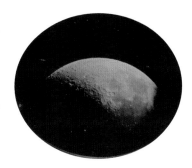

The Great Exhibition of 1851 displayed many marvels from throughout the world—and, in at least one case, from beyond. Since 1848, John Adams Whipple (1822–91) had been collaborating with astronomer William Cranch Bond to attempt to daguerreotype the moon (right) with the telescope at Harvard University. In 1851, adjusting for the difference between actinic focus (the point at which actinic rays—generally associated with ultraviolet light—are focused by a lens) and visual focus, he succeeded, making a number of highly detailed images. Each daguerreotype was unique, but the moon itself was relatively unchanging, so repeated exposures led to a number of virtually identical views. One, displayed in the Great Exhibition, secured him a prize medal from jurists who recognized that his image marked a new era in astronomical investigation. Whipple also sent two daguerreotypes of the moon to the British astronomer and photographic pioneer Sir John Herschel (1792–1871).

Although a daguerreotype of the moon was startling to the visitors at the Great Exhibition, at least it was a photograph of a subject that everyone had seen. Very few privileged individuals could travel to see the wonders of the world at the time. Prints and engravings were available, but the armchair traveller had to overcome a suspicion that the unfamiliar sights were products more of the artist's imagination than of the real world. In 1853, Platt D. Babbitt (1822–72) was granted a monopoly concession to establish a daguerreotype studio on the US side of Niagara Falls. Most of the crowds who gathered on Prospect Point to see Horseshoe Falls had probably not noticed his pavilion and were unaware that their visit was about to be immortalized with the majestic falls in the background (below).

The announcement of the daguerreotype in 1839 captivated the public's imagination about the new art and paved the way for a photographic exploration of the world. Portraits were often personal, but views of the world naturally cultivated a wider audience. It would take paper to carry what were essentially private photographs into the public sphere, but for the first fifteen years of the art, the daguerreian view dominated. **LJS**

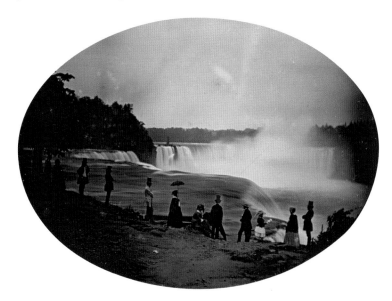

The Temple of Vesta, Rome 1842
JOSEPH-PHILIBERT GIRAULT DE PRANGEY 1804 – 92

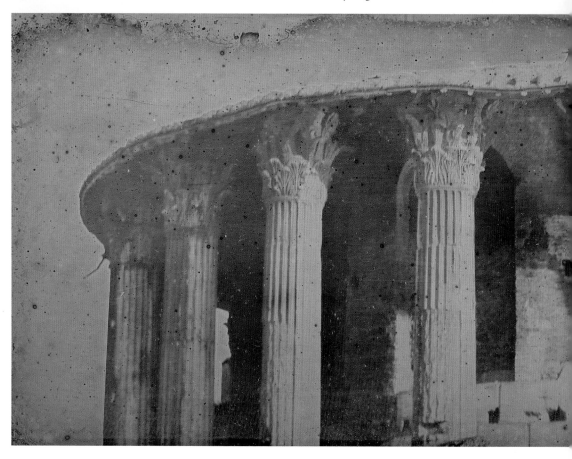

Daguerreotype
3 ⅝ x 9 ⅜ in. | 9 x 24 cm
J. Paul Getty Museum, Los Angeles, USA

One of Rome's oldest surviving buildings, the structure known (wrongly) as the Temple of Vesta was small enough to be photographed easily and was isolated sufficiently within its environs to allow a comfortable position for the camera. The circular shape of the temple lent itself well to the view of a lens, and the various angles of the columns guaranteed that the light articulated them in an interesting way. Joseph-Philibert Girault de Prangey's view differs radically from the usual photographic approach to the subject at the time because he split his daguerreotype plate in half horizontally—giving a panoramic effect, and focusing on the upper third of the building. It is the angle that the viewer would have seen if standing close and looking up at the temple details.

The Temple of Vesta formed an essential part of any artist's portfolio. Early photographers of the city celebrated the temple's distinctive circular layout, often counterbalancing it with the nearby rectangular Temple of Portunus. It was natural that de Prangey and his contemporaries assumed from its circular pattern that this was a temple to the vestal virgins, but they were mistaken—that temple is one of the ruins in the Foro Romano. Today, the building shown here is simply called the 'Round Temple'; it is thought to have been built in tribute to Hercules Victor, a demigod of commerce and conflict. Only hinted at in this framing is the central core of the temple, the *peripeteros*, which incorporated the *cella*, an inner room housing the statue to the god. **LJS**

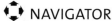

NAVIGATOR

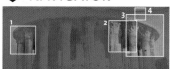

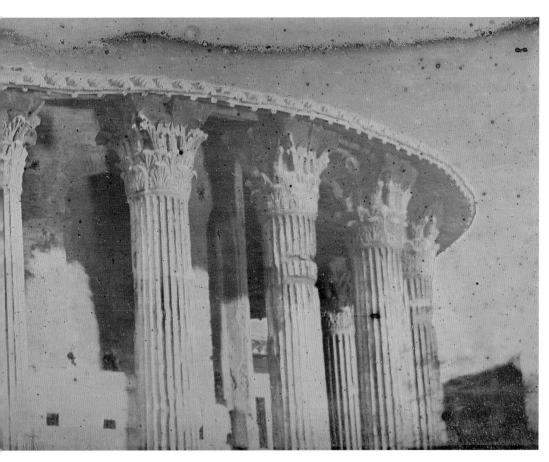

1 FRINGING ON COLUMN

Some physicalities of a plate serve to reinforce the artist's vision, intentionally or not. The white fringing seen especially on the left column is an edge effect caused by the contrasting light. The blue in the sky matches our idea of reality, although it is simply the effect of overexposure of this area.

2 LIGHT AND SHADOW

The artist carefully considered the time of day, waiting for just the right angle of the sun to define the columns against the shade of the roof. The temple's architecture is also well suited to photography, presenting a ringed procession of textured columns, each catching a slightly different angle of light.

3 CURVE OF ROOFTOP

The curve of the temple's circular roof line sweeps across the photograph. By tilting up his lens slightly, de Prangey removed background detail. In so doing, he highlighted the architectural detail of the building, in particular the circular rooftop and the elegant Corinthian capitals.

4 COATING LINE

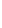

The uneven coating line at the top is a reminder that every daguerreotype plate was the result of intensive handling by a skilled operator. Each plate had to be polished and sensitized in the field and then promptly developed over mercury fumes. Each, therefore, has a distinct 'signature'.

The Seine, the Left Bank and the Ile de la Cité *c.* 1844

FRÉDÉRIC MARTENS 1806 – 85

Panoramic daguerreotype
4 ⅛ x 14 ¾ in. | 10.5 x 37.5 cm
George Eastman House, Rochester,
New York, USA

This sweeping view of Paris by Frédéric Martens is the first true photographic panorama. Perched on top of one of the pavilions of the Palais du Louvre, Martens placed the Passerelle des Arts—leading to the Institut de France—at the centre of his work, as if inviting the viewer to take this pedestrian bridge right into the scene. On the right is the Ile de la Cité.

The picture provides a fabulously detailed rendering, but represents a somewhat disconcerting view of Paris because it is laterally reversed—an outcome of the direct positive daguerreotype process. For Martens, a steel-plate engraver, this was a familiar way to see a panoramic view of a city—one he had drawn many times before the invention of photography. Daguerreotypes of landscapes and architectural views could be re-reversed by means of a prism.

The front of Notre-Dame de Paris is covered in scaffolding, a detail that provides a clue when dating the plate. Eugène Viollet-le-Duc's controversial restoration of the cathedral started in 1845. The scaffolding may have been erected in preparation for the renovation, in 1844, or may be evidence of actual work in 1845. This rare image demonstrated one of Martens's daguerreian camera inventions, for which he would receive a patent in 1845. A clockwork mechanism swept the lens through an arc of 150 degrees, 'drawing' the picture across a metal plate that was curved, so that it would maintain the same distance from the lens at all times. This avoided the distortion that occurred when using a wide-angle lens, where the distance from the lens to the plate in the centre was far less than on the edges. It mirrors the way that our eyes work as we pivot our head to take in an expansive scene. Familiar in its creation of apparent perspective, this approach would become common practice later in the 19th century, especially when used to photograph large groups of people. **LJS**

⚽ NAVIGATOR

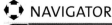

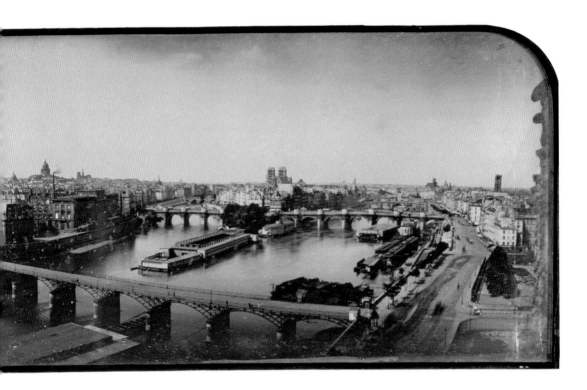

1 ROUNDED UPPER CORNERS
Sometimes photographers rounded the top corners of their prints to disguise the light fall-off at the edge of their lens, but this was not a problem with Martens's revolving lens. Here, the corners are a visual conceit, a framing device also used by Martens in his hand-drawn panoramas of cities.

2 BLURRED SEINE
Time is an element in all photographs, whether perceived or not. Although the image is very sharp, the length of the exposure time required by the plate was sufficient to blur any people or vehicles in the scene. Recently dredged and deepened by locks, the Seine is shown flowing at a leisurely pace through Paris. Martens must have prized the gentle blur that this introduced in the surface of the water—the reflections are softened and made more pictorial.

3 BELCHING SMOKESTACK
A belching smokestack nearly obscures the elegant Pantheon. In *The Pencil of Nature* (1844–46), William Henry Fox Talbot (1800–77) observed: 'The instrument chronicles whatever it sees, and certainly would delineate a chimney-pot...with the same impartiality as it would the Apollo of Belvedere.'

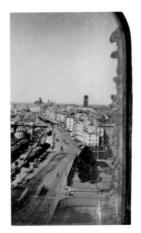

4 ARCHITECTURAL FRAME
One of the joys of photography is the accidental recording of details probably not even noticed by the photographer, and certainly not intended to be part of the final picture. The far right edge of the daguerreotype is framed by a decorative piece of the Louvre's architecture. In a hand-drawn rendition, Martens might have chosen to omit this detail, but in photography it became a physical limit that helped to define the composition of his picture.

DAGUERREOTYPE PORTRAITS

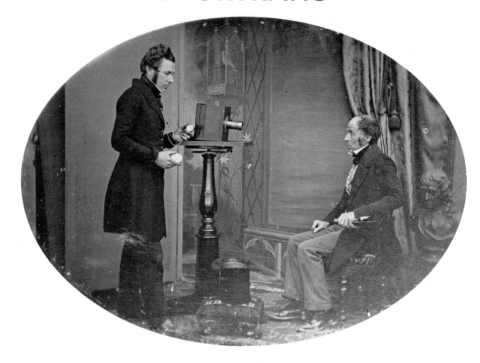

In the image above, taken in *c.* 1842 it is thought by Jabez Hogg (1817–99), the maker demonstrates the process of taking a daguerreian portrait, with himself as the photographer. The sitter is believed to be William S. Johnson, the father of John Johnson, a partner in New York's first daguerreian studio. Just a few years earlier, the prospect of daguerreotype portraits had been deemed impossible. In August 1839, speaking on behalf of Louis-Jacques-Mandé Daguerre (1787–1851) before a specially convened joint meeting of the Académie des Beaux-Arts and the Académie des Sciences, François Arago revealed the working details of the daguerreotype. Enthusiastically outlining all the applications that were anticipated, ranging from still lifes to archaeology, he still felt compelled to voice the regret that the new art 'could never be used to make portraits'. Arago was reflecting Daguerre's belief that long exposure times and the consequent forced immobility of the subject would preclude this application. Within months of Arago's statement, however, eager amateurs had disproved it.

In November 1839, an early daguerreotype manual from French publishers Lerebours carried the intimidating suggestion that 'to make a portrait, it is necessary to have recourse to a bright light. . .one can only succeed well by exposing the person to the sun in the open air, with reflections from white

KEY EVENTS

1838	1839	1839	1839	1840	1840
Daguerre makes the first photograph to include people, seen as partial silhouettes in a Paris street, in *Boulevard du Temple, Paris* (see p.22).	On 19 August, details of the daguerreotype process are explained to members of the Académie des Sciences and the Académie des Beaux-Arts jointly.	Robert Cornelius takes a daguerreotype self-portrait. It is the earliest surviving US daguerreotype and one of the earliest photographic portraits.	On 23 November, François Gourand lands in New York with daguerreotypes from Europe. A show of thirty plates is greeted with ecstatic reviews.	Cornelius and partner Dr Paul Beck Goddard open a daguerreotype studio in Philadelphia.	In England J. F. Goddard uses iodine to shorten exposure times for daguerreotypes. US chemist Dr Paul Beck Goddard (no relation) makes the same link.

34 THE EXPERIMENTAL PERIOD 1826–55

draperies'. In spring or summer 1840, the American Dr John William Draper (1811–82) persuaded his white-powdered sister Dorothy to remain still and open-eyed in bright sunlight for sixty-five seconds while he photographed her. He sent the resulting daguerreotype to the pre-eminent British scientist Sir John Herschel (1792–1871), receiving back the compliment that it was 'by far the most satisfactory portrait which I have yet seen'. By the end of 1840, experimental daguerreotype portraits were not infrequent and the stage for commercialization had been set. With the notable exception of the Edinburgh partnership of David Octavius Hill (1802–70) and Robert Adamson (1821–48), very little portraiture was achieved in paper photography during the 1840s and early 1850s. The daguerreotype had the field to itself.

Daguerre had good personal reasons for his pessimism about portraiture, because the solutions to the problem were beyond the limits of his expertise. He had disclosed all that he knew in August 1839 and the best that he could manage was an exposure time of five to ten minutes. The camera that Daguerre promoted was outfitted with a Chevalier lens of competent but traditional design; it was relatively inefficient, with a maximum aperture near f16. Of the various optical solutions proposed, the suggestion made in 1840 by Joseph Petzval—a professor of mathematics at the University of Vienna—proved the most practical. He turned to sophisticated computations in order to create a radically new design. The result, marketed specifically for daguerreotype portraiture, had an aperture of f3.6, letting in nearly eight times more light than Chevalier's. The image was very sharp in the middle, at the expense of a fall-off of light and definition around the periphery. In landscapes, this could be a problem, but for portraiture it often proved to be an advantage, emphasizing the face while gently suppressing the background.

The second crucial technical contribution to making portraiture practical was an advance in the sensitivity of the process itself. In December 1840, John Frederick Goddard published his breakthrough technique of adding bromine to the iodine used to sensitize the daguerreotype plate. Based on these two contributions, exposure times dropped to about a minute and continued to shorten as refinements were made.

Given the unexplored complexities of the process at first, it is not surprising that many of the earliest daguerreian portraitists were primarily inventors or potential suppliers to the trade. The Philadelphia chemist Robert Cornelius (1809–93) succeeded in making daguerreotypes in 1839 and established the first studio in that city. When he set up his *Self-portrait with Laboratory Instruments* (right), it was a demonstration not only of his technical prowess, but also of his confidence that the new art could supply the basis for illustration (it was used as the basis for a woodcut in a textbook).

By the mid 1840s, the technical problems had been solved and anyone who was adept with their hands and sharp with their eye could set up as a

1 *An Operator for Richard Beard* (*c.* 1842)
Attributed to Jabez Hogg • daguerreotype
3 ¼ x 4 ¼ in. | 8.5 x 11 cm
National Media Museum, Bradford, UK

2 *Self-portrait with Laboratory Instruments* (1843)
Robert Cornelius • daguerreotype
3 ¼ x 3 in. | 8.5 x 7.5 cm
George Eastman House, Rochester, New York, USA

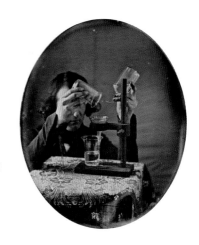

1840–41	1841	1843	1850	1851	1855
Various optical solutions to long exposure times are proposed, including improved lenses and Alexander Wolcott's mirror camera.	Richard Beard opens Europe's first commercial photographic studio in London.	The Brussels police is the first to start collecting daguerreian mug shots.	With daguerreotypes still enjoying a healthy popularity, New York alone boasts around seventy daguerreotype portrait studios.	The United States dominates the awards for daguerreotypes at the Great Exhibition, London. Portraits by Mathew Brady (*c.* 1823–96) win first prize.	US daguerreian studios, which held out longer than their European counterparts, begin to convert to photography on paper.

3 *Louis Dodier as a Prisoner* (1847)
Louis Adolphe Humbert de Molard
daguerreotype
4 ½ x 6 ⅛ in. | 11.5 x 15.5 cm
Musée d'Orsay, Paris, France

4 *Jaswant Rao Ponwar, Raja of Dhar*
(early 1850s)
Photographer unknown • daguerreotype
7 x 5 ⅛ in. | 18 x 13 cm
British Library, London, UK

daguerreotype portrait artist. Americans took to daguerreotype portraiture more avidly than anyone else—far more daguerreotype portraits were created in the United States than the rest of the world combined, a phenomenon that has never been adequately explained. There was certainly a huge potential market in a new and relatively poor country to secure inexpensive portraits, and the economic turmoil in the 1840s lured entrepreneurs into starting new types of business. The Boston firm Southworth & Hawes represented the highest reaches of the art. Their portrait of c. 1850, known as *Two Women Posed with a Chair* (see p.40), combined technical proficiency with high artistic talent and set a standard that the numerous itinerant daguerreotypists could not hope to match.

In London, Richard Beard (1801–85), a coal merchant and entrepreneur, bought the patent rights to make daguerreotypes in England directly from Daguerre and established Europe's first public photographic studio in March 1841. Beard's patent rights were contested immediately, however, then rightfully ignored (as the French government had offered the process free to the world).

A group portrait of Der Hamburger Künstlerverein (Hamburg Artists Association, 1843; see p.38) taken by Carl Ferdinand Stelzner (1805–94) demonstrates that daguerreian expertise existed in Germany, although the daguerreian community there was fractured because of the complex nature of the German confederation. The other large market for daguerreian portraits was Paris. There were fewer daguerreotypists in Paris than in smaller US cities, but between 1848 and 1856, which marked both the peak and the waning years of the daguerreotype, the number of commercial studios in Paris tripled to nearly 150. Many French amateur daguerreotypists employed the process primarily for artistic reasons. Louis Adolphe Humbert de Molard (1800–74) was highly skilled with his hands (he had taken over his uncle's museum of botanically exact wax flowers). When he married a miniaturist and lithographer, he further sharpened his attention to artistic detail, just in time for the advent of the daguerreotype. His *Louis Dodier as a Prisoner* (above) was made at the peak of his interest in detail and transcends the limitations of the metal plate. The medium was a conscious choice because, like many of his colleagues, he was already experimenting with paper photography and was to become a founding member of the Société Française de Photographie.

One of the peculiarities of daguerreotype portraiture is that a high proportion of the surviving images was taken by people who will probably never be identified. For some practitioners, the portraits were simply a sideline to another business. Other daguerreotypists were clearly accomplished studio artists whose names perhaps became lost when the protective case for the daguerreotype was changed. The portrait of *Jaswant Rao Ponwar, Raja of Dhar* (below) was taken either in a studio or in a studiolike setting. The lighting brings out all the gilded features that were so important to establishing the sitter's station in life. The fixed stare is not so much rigid as imperious. Perhaps in this instance the name of the photographer was not considered to be of any importance, for the raja cultivated his own image long before sitting in front of the lens.

Referred to at the time as a 'mirror with a memory', the daguerreotype portrait was so uncannily accurate that in literature the term 'daguerreotype' became a synonym for truth. In *The Pencil of Nature* (1844–46), William Henry Fox Talbot (1800–77) wished that photographic portraits rather than paintings of past nobility had existed, for 'such a record of their ancestors' would have been invaluable to history and 'how small a portion of their family picture galleries can they really rely with confidence!' The greatest strength of the daguerreotype portrait is its ability to convey to viewers today the sense of a real individual from history. **LJS**

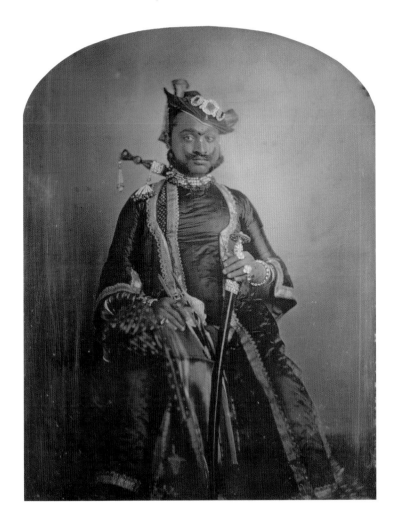

Hamburg Artists Association 1843

CARL FERDINAND STELZNER 1805 – 94

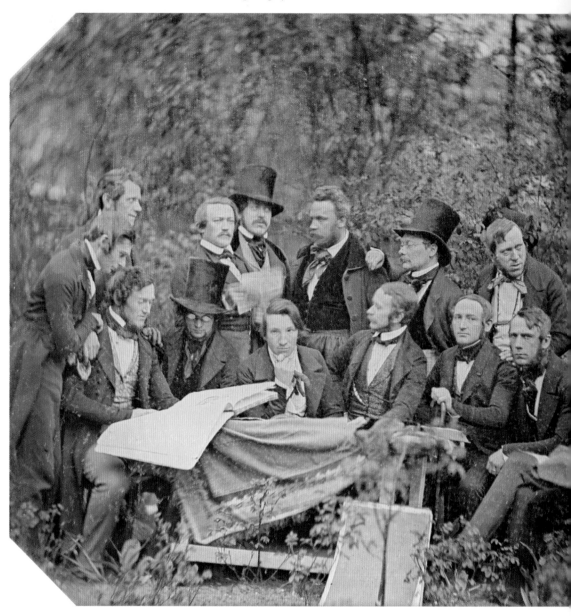

1 DYNAMIC BLURRING
The blurs at the upper edges of the image are a complex of coma (a lens distortion reducing points of light to tapering, cometlike shapes), barrel distortion of the lens (making images swell) and a curved field. They add a subtle but insistent liveliness, providing a dynamic frame for the main subject.

2 MAN HOLDING DOCUMENT
Although this gentleman was able to hold his pose, the document he is holding is blurred, testifying to the long exposure time needed. Perhaps a breeze shook the paper. The slightly 'smudged' features of other members of the group indicate that they made small movements.

*Der Hamburger Künstlerverein im
Sommerlokal auf der Caffamacherreihe*
Daguerreotype
4 ¾ x 5 ¾ in. | 12 x 14.5 cm
Museum für Kunst und Gewerbe,
Hamburg, Germany

 NAVIGATOR

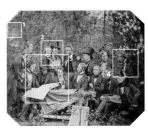

In 1840, Günther Gensler made a famous painting representing half a dozen members of the Hamburg Artists Association at one of their meetings, and perhaps the exhibition of this painting provided the inspiration for Carl Ferdinand Stelzner's evocative image. In 1843, outdoors in the garden of their restaurant, he took several group daguerreotypes, one reportedly showing thirty members. This one, showing half that number, is the sole survivor. Every individual in the photograph had to take up a braced position in order to minimize movement, without blocking another's face. Stelzner was almost certainly using an early Petzval portrait lens, designed to cover the small angle typical for portrait subjects. When forced to cover a larger plate than was intended, however, the edges distorted, resulting in the striking patterns at the top of the image.

Stelzner's connection with the group in 1843 cannot be confirmed, but by 1850, he was number twenty-seven on their membership list. It is possible that the group portraits of 1843 were his eloquent demonstration of suitability for membership. Only David Octavius Hill and Robert Adamson, working with the calotype process in Scotland, had attempted such ambitious group posings up to this point. Formed in 1832, the Hamburg Artists Association would become a major force in rebuilding the city of Hamburg after it was devasted in the Great Fire of 1842. The organization became the centre of Hamburg cultural life, sponsoring biannual exhibitions, raising monuments, donating artworks for the public good and holding debates on artistic matters. **LJS**

PHOTOGRAPHER PROFILE

1805–42
Born in Germany in 1805, Carl Ferdinand Stelzner was trained and raised by a step-father who was a painter of miniatures and who instructed Stelzner in the art. In 1837, having made two trips to Paris for further study, in 1829 and 1831–34, Stelzner opened a painting studio for miniature portraits in Hamburg. In 1839, he returned to Paris once more to learn the new art of photography directly from Daguerre. Three years later, he entered into a short-lived daguerreian studio partnership with Hermann Biow (1804–50).

1843–53
Stelzner returned to his own studio to become one of Germany's finest portrait daguerreotypists. His wife, Anna, hand-coloured some of his daguerreotypes and copied others as miniature paintings.

1854–94
In 1854, Stelzner turned to photography on paper, but largely with the help of assistants because incipient blindness was increasingly encroaching on his vision. Forced to abandon photography by 1862, he remained an active voice in Hamburg's artistic community until his death in 1894.

3 MEN WITH PORTFOLIO
One way to freeze subjects in a 'natural' pose was to give them something to do. In this case, Stelzner had them examine a portfolio of artistic works. Nonetheless the simple wooden sawhorse, hastily topped with a blanket to provide a makeshift table, asserts the artificial nature of the composition.

4 FIGURE FAR RIGHT
The artist at the right seems to be rushing into the scene, part way through the exposure— hence the blurred head. Comparison with photographs of Stelzner suggests that this figure may be the photographer himself, joining the group as soon as the lens cap was removed for exposure.

Untitled (Two Women Posed with a Chair) *c.* 1850

ALBERT S. SOUTHWORTH 1811 – 94 JOSIAH J. HAWES 1808 – 1901

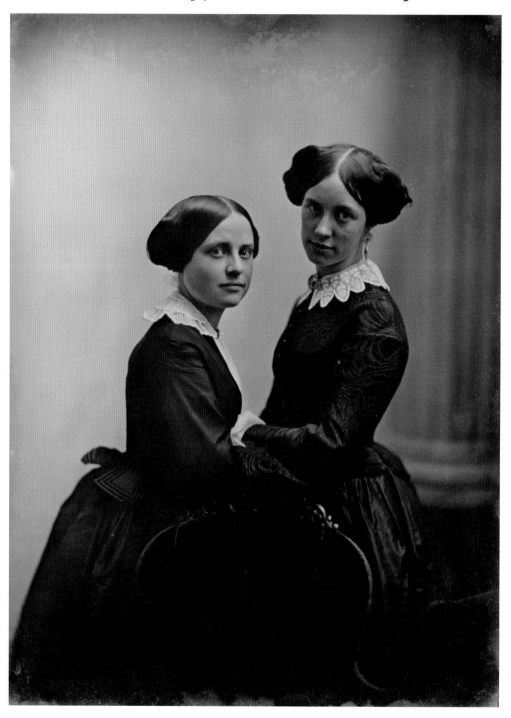

Daguerreotype
7 x 5 ½ in. | 18 x 14 cm
Amon Carter Museum,
Fort Worth, Texas, USA

This double portrait is testament to the pictorial subtlety and richness made possible by the daguerreotype. The careful lighting brings out a broad range of tones, from the dark chair to the gradation of shadow on the sitters' faces. The image boasts remarkable detail, notably in the lace collars and the swirled patterning in the dress of the woman on the right. Set against a soft, pale background, the outlines of the two sitters emerge sharp and strong, their dark figures having great immediacy. They appear to be ladies of wealth, and the portrait is formal, but the expressions are unposed and natural.

Southworth & Hawes sustained an unsurpassed standard in daguerreotype portraiture. The studio's style was distinctive—technically above reproach, but harmonious and avoiding the coldness of too-perfect technique. Josiah Hawes had built his reputation as an itinerant portrait painter by harnessing light and shade so effectively that his clients were flattered by what they saw. Albert Southworth was an affable showman who had an inescapable drive to better himself. The duo were dedicated to quality, promoting their business as 'Artists' Daguerreotype Rooms', although this perhaps explains the financial distress that they faced regularly. Many of the clients that they photographed in their Boston studio were pillars of society. In 1855, one advert for their company noted that of the daguerreotypes in their gallery: 'Some of the very best are pictures of young ladies from Maine.' **LJS**

👁 FOCAL POINTS

1 LIGHT ON FACE
The light on this sitter's face is mellow but yields great definition. Southworth and Hawes installed a huge overhead skylight in their spacious studio. Instead of working from a fixed position, as the sun tracked through the day they could pose their sitters in the most flattering light.

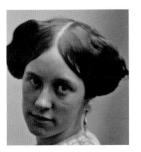

2 HAIRSTYLES
One sitter presents a three-quarter profile; the other tilts her head forward. The centre parting with hair tied into a chignon had been common at the start of daguerreotypy. But the 1850s brought an evolution of that style, with the sides waved or puffed dramatically over the ears.

3 WAIST AREA
This is one of three known plates taken at this sitting. The other two are close variants, although framed more tightly— from the waist up—visually driving the sitters more apart than together. In this more generous cropping, the women emerge almost sculpturally from the base of their dresses.

4 COLUMN
The barest hint of a fluted column adds depth to the composition. It was a prominent prop—often presented in sharp focus in many of Southworth & Hawes's studio portraits, particularly in those of larger groups, where its presence was almost inevitable.

⏱ PHOTOGRAPHERS PROFILE

1808–43
Born in Massachusetts in 1808, Josiah Johnson Hawes trained as a carpenter and from 1829 worked as an itinerant portrait painter. Albert Sands Southworth was born in Vermont in 1811; he taught for a period, then set up a drugstore in Massachusetts in 1839. In 1840, he attended lectures on the daguerreotype, then opened a studio with an old classmate, Joseph Pennell, a former assistant to Samuel Morse. In 1841, they moved to Boston. Meanwhile, Hawes had become an itinerant daguerreotypist. In 1843, Pennell left and Hawes replaced him.

1844–1901
The new partners produced high-quality portraits. Gold rush fever seduced Southworth and he left for California in 1849. Hawes operated alone until Southworth returned in 1851. By 1854, the silvered copper sheets of the daguerreotype were becoming obsolete and the duo turned to wet collodion on glass negatives to make albumen prints. The firm collapsed in 1862. Southworth returned to the family farm, practised some photography and became a handwriting expert, dying in 1894. Hawes maintained a photographic studio until his death in 1901.

THE BRITISH CALOTYPE

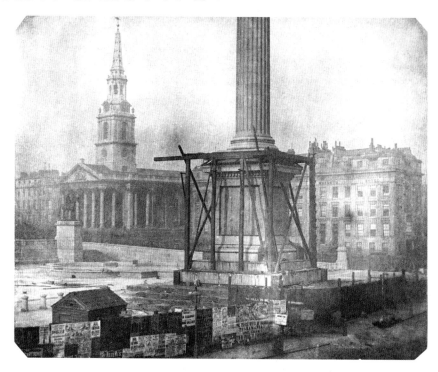

When William Henry Fox Talbot (1800–77) first conceived of the idea of photography in 1833, he was embarking on a personal quest. It is perhaps fitting, then, that the paper negative process of Talbot's invention was to flourish more strongly in the realm of personal expression than through commercial exploitation. Talbot's negatives allowed for the production of multiple identical prints, but even more fundamentally important was the fact that his photographs were on paper, a medium that was versatile, relatively inexpensive and capable of rendering images beautifully.

His photogenic drawing process captured images on paper, but its limitations—particularly the reliance on long exposure times—were all too clear. When he discovered the latent image in September 1840, however, and published his calotype negative process in 1841, Talbot effectively offered amateurs and professionals a practical alternative to the daguerreotype. The calotype's patent almost certainly contributed to its slow adoption by professionals, but it affected amateurs much less than is commonly assumed, and some of the most endearing images in the first decades of photography were calotypes by dedicated individuals seeking avenues of self-expression.

KEY EVENTS

1839	1841	1841	1843	1843	1844
In the same year that Talbot makes public his paper-based process, Sir John Herschel (1792–1871) makes experimental negatives on glass.	Henry Collen (1797–1879), a London-based portrait miniaturist, is the first person to receive a licence to practise calotypy commercially.	Talbot publishes the working details of his 'calotype' process. Loyal friends wish to call it the 'Talbotype'.	Robert Adamson opens his studio in Edinburgh, soon to be joined by David Octavius Hill.	Nicolaas Henneman opens his business in Reading, intending to publish photographic prints and to promote the work of other photographers.	George Smith Cundell (1798–1882) publishes *On the Practice of the Calotype Process in Photography*, the first clear instruction on the process available.

Talbot's more mature work, such as *Nelson's Column under Construction* (opposite), taken in April 1844, led the way. It is a complex and sophisticated image with implications extending well beyond its literal truthfulness. Implicit in Talbot's interpretation was his concern with the rapidly deteriorating social and economic situation then spreading throughout Europe. Instead of photographing the top of the column, soon to receive its statue, he concentrated on the area around the base, the first open public space in central London and a cause of concern as a possible stage for rioting. The circular fountains were designed not as amenities, but rather as a means of enforcing crowd control. Images on a daguerreotype's metal plate had a sharpness that bordered on artificiality, whereas the paper of the calotype broadened the rendition while still retaining sufficient clarity to enable viewers to read the printed matter so liberally mounted around the 'Post No Bills' notice. The various railway timetables and theatre announcements make it possible to date this image within a few days, a reminder of Talbot's fascination with the idea that the photograph could record more than the artist perceived at the time.

With Talbot's blessing, the young Robert Adamson (1821–48) set up a studio in Edinburgh in the same year that Nicolaas Henneman (1813–98)— Talbot's longtime assistant—set up his own, in the form of the Reading Establishment. Adamson's initial plans are not clear, and likely were a mystery to him as well. From the scale of his operation and his initial work, it seems likely that a conventional portrait studio was his goal. However, just weeks after he set up this new and unproven operation, an enormous rift tore apart the Scottish church. Hundreds of ministers left their living in an act of conscience and David Octavius Hill (1802–70), an Edinburgh artist, wanted to record the event in a massive group portrait. Facing the reality that they would soon scatter, he took scientist Sir David Brewster's advice to enquire about Adamson's new venture. Hill initially saw the calotypes Adamson produced as sketches for his eventual painting, but they soon took on a life of their own. In the short period of their partnership, Adamson and Hill produced some 3,000 negatives—predominantly portraits, but also of both the natural and the built environment. *Sophia Finlay and Harriet Farnie* (right) represents a paradox. Hill & Adamson was a commercial studio, but one strongly influenced by Hill's connections within the world of art. It is impossible to view their photographs as products of enterprise; they are the reflections of deep personal visions. The works are also a reminder of the balance of science and art inherent in photography, a balance sometimes interpreted as tension, but a productive one nonetheless. Without question, Adamson's technical skill was vital to the operation. Equally, Hill's social and artistic connections were essential. But neither man succeeded without the other. Prone to ill health, Adamson tragically died after just four years of the partnership and Hill never again took a memorable photograph.

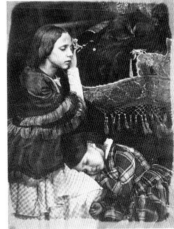

1 *Nelson's Column under Construction* (1844)
William Henry Fox Talbot
salted paper print from a paper negative
8 ⅞ x 7 ½ in. | 22.5 x 19 cm
National Media Museum, Bradford, UK

2 *Sophia Finlay and Harriet Farnie*
(1843–47)
Robert Adamson and David Octavius Hill
salted paper print from a paper negative
7 ⅞ x 5 ⅜ in. | 20 x 13.5 cm
National Galleries of Scotland,
Edinburgh, UK

1844–47	1846	1848	1850	1852	1853
The partnership of Hill & Adamson produces thousands of calotype negatives, the most significant body of this art outside Talbot's own productions.	Christopher Talbot, cousin to the inventor, and Calvert Jones meet Rev. George Bridges (1788–1863) in Malta. Jones instructs Bridges in the art of calotypy.	Robert Adamson dies, ending the most successful commercial calotype operation. Nicolaas Henneman relocates to London and diversifies.	Gustave Le Gray publishes details of the waxed-paper negative process. This affects British practice and arouses French interest in paper negatives.	The Society of Arts in London holds the first major photographic exhibition. Of the works, 460 are from paper negatives, 300 from glass negatives.	Mary, Countess of Rosse takes up calotype. She is one of a small but significant number of amateur female photographers at this time.

At first, the art of calotypy had spread through Talbot's immediate circle, including his Welsh cousin 'Kit', Christopher Rice Mansel Talbot, and Kit's close friend and travelling companion the Reverend Calvert Richard Jones (1804–77). Jones brought an established artistic style to calotypy, executing very similar scenes in silvered paper to those that he had long been creating in watercolour. He contributed a high degree of enthusiasm to the practice of calotype photography, including innovations such as his joined panorama *Santa Lucia, Naples* (1845; see p.48). Jones commercialized the calotype to the extent that he sold negatives to Talbot, but never compromised what he would have pictured by choice for himself. Benjamin Brecknell Turner (1815–94) is most remembered today for bringing a vision to rural landscapes echoing that of his namesake, artist J. M. W. Turner, after Talbot had abandoned the art. His best photographs include *Hawkhurst Church, Kent (A Photographic Truth)* (above), the composition and title of which plays upon the tension between reality and representation.

The staged panorama of *The Reading Establishment* (c. 1845; see p.46), attributed to Benjamin Cowderoy (1812–1904), embodied everything that Talbot had hoped for the art. It showed calotypy expanded to an industrial scale, a facility capable of producing masses of prints for public consumption and using photography as a means of making factual recordings. It is also a vivid demonstration of Talbot's reach exceeding his grasp. His vision for photography was entirely valid because every activity pictured within this set piece would become commonplace in the future. However, very little of this would occur within the useful economic lifespan of the calotype, and much would be left to its direct descendants.

The calotype carried on successfully in Britain well into the 1850s. Thomas Sutton (1819–75) reflected one aspect of the art. An indifferent daguerreotypist in the 1840s, he met with a number of influential photographers in the early 1850s and switched to the calotype. In 1855, he went into partnership with Louis Désiré Blanquart-Evrard (1802–72). They combined their skills to establish a photographic printing establishment in Jersey, which had as its patron the royal consort Prince Albert, himself an enthusiastic collector of photographs.

Few of these amateurs approached the achievements of the Englishman Roger Fenton (1819–69). Setting aside his law practice, he moved to Paris to study painting, and in October 1851 encountered Gustave Le Gray (1820–84), the inventor of the waxed-paper process. Seeing several hundred negatives, Fenton observed, 'The wax process by which these pictures were produced [seemed] to have superseded in practical employment all the other kinds of prepared paper.' Back in London, Fenton made the acquaintance of the engineer Charles Blacker Vignoles, who had secured a contract to build a daring suspension bridge at Kiev, across the River Dnieper. Vignoles hired Fenton to photograph the progress of the construction and Fenton arrived in Moscow at the beginning of September 1852, a stopover on his way to Kiev. From one of the upper windows of the Ivan the Great Bell Tower, the tallest structure in the Kremlin, Fenton had a commanding view over the oldest and most important church in Moscow, the 15th-century Cathedral of the Assumption, with the smaller domes of the Church of the Deposition of the Robe beyond. *Moscow, Domes of the Churches of the Kremlin* (below) amply repaid the effort of hauling his large-format camera gear up the winding stairs, because the waxed-paper negative brought out the best of the fantastical structure of the building. The domes expressed a joy that transcended their religious purpose. The waxed paper retained enough detail to asset an undisputed authenticity, but still broadened the scene to abstract its essential elements. Within the year, Fenton and Vignoles were the founding force behind the Photographic Society of London (later the Royal Photographic Society) and Fenton turned away from the calotype in favour of wet collodion on glass. In other hands, however, the calotype was just reaching its peak and continued to be a force during the 1850s.

David Octavius Hill explained the lure of the calotype most clearly. Guiding a new collector in how to evaluate photographs, he observed that 'the rough surface and unequal texture throughout of the paper is the main cause of the calotype failing in details, before the process of daguerreotypy—and this is the very life of it. They look like the imperfect work of man—and not the much diminished perfect work of God.' He concluded, 'I think you will find that the calotypes, like fine pictures, will be always giving out new lights of themselves.' **LJS**

3 *Hawkhurst Church, Kent (A Photographic Truth)* (c. 1852)
Benjamin Brecknell Turner
albumen print from a paper negative
10 ¼ x 14 ⅛ in. | 26 x 36 cm
Victoria and Albert Museum, London, UK

4 *Moscow, Domes of the Churches of the Kremlin* (1852)
Roger Fenton
salted paper print from a paper negative
7 ⅛ x 8 ⅜ in. | 18 x 21 cm
Metropolitan Museum of Art, New York, USA

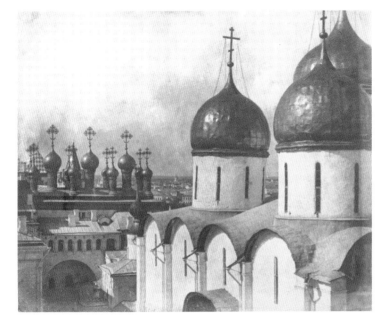

The Reading Establishment *c.* 1845
ATTRIBUTED TO BENJAMIN COWDEROY 1812 – 1904

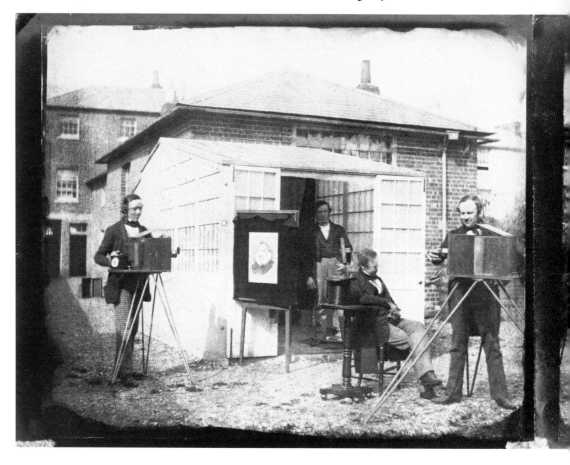

Salted paper prints from paper negatives
7 ¼ x 8 ¾ in. | 18.5 x 22.5 cm (each)
Metropolitan Museum of Modern Art,
New York, USA

NAVIGATOR

William Henry Fox Talbot's longtime valet, the Dutch-born Nicolaas Henneman, had worked beside his master in photographic experiments from the start. With many photographic successes behind him, he shared Talbot's confidence in the merits of negative/positive photography, and in late 1843 left his sinecure to set up the world's first photographic production facility in Reading, on the railway halfway between London and Lacock Abbey. Although he styled himself 'Mr N. Henneman, Calotypist', his operation became known as the Reading Establishment. It was always his business, never Talbot's, but his former employer kept it busy with work orders and other forms of support. Even so, by 1845, financial difficulties were swamping the operation, and Talbot brought in Benjamin Cowderoy, a Reading land agent and man of science, to promote the business.

This *tableau vivant* is one of his efforts. It shows an idealized operation, with the sun shining cooperatively on numerous simultaneous photographic activities. When Talbot and Henneman were working at Lacock Abbey, with ample water and fuel and no commercial pressures, their prints were beautiful. Henneman attempted to scale up the new art to a level of industrial production beyond the technology's limits, however, and the quality and permanence of the prints suffered. He abandoned Reading about a year after this confident picture was staged, relocating to London where the markets were more concentrated. **LJS**

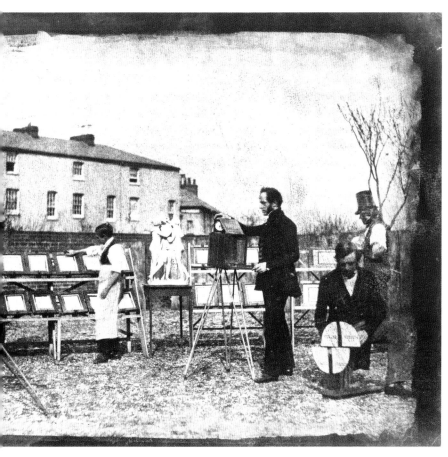

1 MAN ON FAR LEFT

This figure is Henneman. He envisioned his studio handling a range of tasks, including copying art works—in this case, a print from William Stirling's collection. Henneman later made prints for the first photographically illustrated art book—Stirling's *Annals of the Artists of Spain* (1848).

2 MAN LEFT OF CENTRE

This is now accepted to be Talbot himself (a modern statue in Chippenham is based on this photograph). He is operating a sliding-box wooden camera (which had to be larger in size than the final print). His subject would have had to have stayed as still as possible for perhaps a minute in bright sunlight.

3 BOY MAKING PRINTS

Sandwiched under glass in a frame, each print was made one at a time by exposing it to sunlight under its negative. The boy would try to keep as many frames as possible exposing, each holding a negative. A negative might yield twenty prints on a bright day, but far fewer in overcast conditions.

4 CIRCULAR DEVICE

This is a form of Antoine Claudet's focimeter. The wavelengths of light that affected early photographic materials were different from those that stimulated the eye. This device measured the difference between human and 'actinic' vision; a compensation could then be made in the focus.

Santa Lucia, Naples 1845
REVEREND CALVERT RICHARD JONES 1804 – 77

1 WASHING ON LINE
Some artists would have felt
that the drying laundry added
a picturesque element; others
would have considered it
undignified and left it out.
As a photographer, Jones
had no choice but to include
it; however, he has skilfully
incorporated it to balance
the awnings and windows.

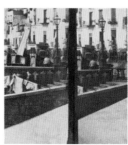

2 SEA WALL
Jones used the strong angle of
the newly refurbished sea wall
to draw the eye into the picture.
The camera was hard to align
when rotated, so he allowed
some overlap to insure against
a void. The slightly different
angle from rotating the camera
meant that the parts would not
join perfectly.

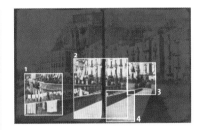

Reverend Calvert Richard Jones pioneered 'joiners'—composite panoramic prints made from multiple negatives. Recognizing a long visual tradition in hand-drawn art, he argued that this format was the most natural way to depict landscapes and urban scenes. Usually employing two negatives, although sometimes three or four, Jones used both vertical and horizontal formats. His photographic practice stemmed from his strongly held belief that the field of vision provided by an ordinary lens was too limited. In his article 'On a Binocular Camera,' for *Journal of the Photographic Society of London* (1853), he compared the effect to viewing a scene with only one eye and proposed a special camera with two lenses to provide a panoramic view. By the era of the European Grand Tour, Santa Lucia—a major waterfront area since Naples was founded in the 6th century BC—had been converted into one of the most fashionable areas of the city. James Duffield Harding, the drawing master to both John Ruskin and Calvert Jones, issued a steel engraving of this scene in 1832, anchoring the horizon with the Castel dell'Ovo and stressing the maritime connections. By contrast, in both content and form, Jones reflected the emerging modernization of the area. He moved in more tightly, allowing the ancient Monte Echia to loom overhead. Harding regarded his former student's panoramas with 'astonishment', exclaiming, 'the satisfaction to the eye, in a pictorial point of view, is hardly to be imagined'. **LJS**

Salted paper prints from paper negatives
8 ¾ x 6 ⅝ in. | 22 x 17 cm (each)
Metropolitan Museum of Art, New York, USA

3 STREET AREA
Many photographs of this period appear to record unpeopled scenes because required exposure times were long enough to blur any moving people. Jones accepted more than most the presence of ghost figures, suggesting a population without rendering specific details.

4 INSCRIPTION '43. STA LUCIA'
Jones inscribed his paper negatives in pencil, usually as soon as he took them. He also maintained detailed lists of his negatives, but sometimes changed or duplicated his numbering system. Here, the left-hand negative, no. 42, is next to the right-hand negative, no. 43.

EYEWITNESS PHOTOGRAPHY

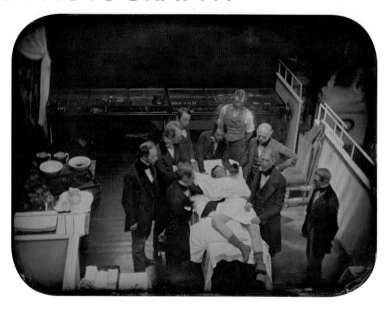

Since every photograph is inextricably linked to an exact place and a particular moment, chance has always been an invaluable ally of the medium. In May 1842, a five-day fire gutted the city of Hamburg. *The Illustrated London News* was assembling its first edition and would soon use photography as the basis for many of its woodcuts. To depict this tragedy, however, its artist rushed to the British Museum and copied an old print of Hamburg, adding flames to the evocative but fanciful rendition. Its editors were probably unaware of a daguerreian studio very near the scene of the conflagration that had been opened in 1841 by Hermann Biow (c. 1803–50). As a Jew, Biow was excluded from working in Hamburg—then part of the German Federation—and had to locate his studio in Altona, just across the River Elba. This gave him an ideal vantage point for making more than forty daguerreotypes of the ruins of Hamburg after the Great Fire, although only three have survived.

The Boston partnership of Southworth & Hawes documented early surgery under anaesthesia at Massachusetts General Hospital (above). A surgeon had asked a dentist to administer ether to a patient before the removal of a tumour. Southworth & Hawes had not been on hand for the pioneering operation itself (Josiah J. Hawes (1808–1901) reportedly shrank from the sight of blood), so a re-enactment was staged soon after. This was the first of many times in which the 'eyewitness' photograph was a simulacrum, one of the best known being *Old Glory Goes Up on Mt Suribachi, Iwo Jima* (1945) by Joe Rosenthal (1911–2006).

KEY EVENTS

1842	1842	1842	1846	1848	1848
Hermann Biow daguerreotypes the Great Fire of Hamburg.	*Daguerreian Travels*, with images based on daguerreotypes of well-known locations, suggests the actuality of photographs is much prized.	*The Illustrated London News* is first published. It is soon followed by similar weeklies in France and Germany.	The United States declares war on Mexico. Around fifty anonymous daguerreotypes of the ensuing conflict survive.	In June Eugène Thibault (a. 1840–70) daguerreotypes rue Saint-Maur-Popincourt before and after a night of civil unrest.	Widespread unrest in Europe and the growing market for news woodcuts create a demand for photographic documentation.

Widespread political unrest and social upheaval convulsed most of Europe in 1848. General Lamoricière's troops launched a devastating attack on insurgents in Paris on 26 June, during which thousands of people died. An amateur photographer, most likely a local resident from a relatively safe vantage point, executed 'before' and 'after' views of the barricades erected in rue Saint-Maur-Popincourt. Woodcuts patterned after them were printed by the newspaper *L'Illustration*, crediting the artist as Thibault. Another remarkable daguerreian document was taken earlier that year. William Edward Kilburn (1818–91), an established professional in London, was on hand to record *View of the Great Chartist Meeting on Kennington Common* (below) on 10 April 1848. The crowd had formed to deliver a petition from the first working-class labour movement, but the government countered by deploying 100,000 special constables to control the feared violence. Some official reports denied that the event ever took place; others described the size of the crowd as a handful. Kilburn's silver plate testifies to an orderly and massive turnout. In complete contrast, *Valley of the Shadow of Death* (1855; see p.52) by Roger Fenton (1819–69) depicts an unpeopled, alien landscape. Taken during the Crimean War, its barren coldness is so powerful that it burns into the viewer's memory in a way no action picture could. **LJS**

1 *Use of Ether for Anaesthesia* (1847)
Albert S. Southworth and
Josiah J. Hawes • daguerreotype
5 ¾ x 7 ⅞ in. | 14.5 x 20 cm
J. Paul Getty Museum, Los Angeles, USA

2 *View of the Great Chartist Meeting
on Kennington Common* (1848)
William Edward Kilburn • daguerreotype
4 ¼ x 5 ¾ in. | 10.5 x 14.5 cm
Royal Collection, Windsor Castle, UK

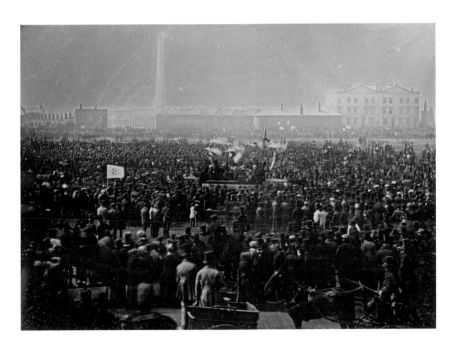

1849	1853	1853	1853	1854	1854–55
Daguerreotypes are used to document the California Gold Rush.	Emperor Nicholas I of Russia monitors the erection of a suspension bridge in Kiev by consulting daguerreotypes made on a daily basis.	Opposite his studio at Niagara Falls, Platt D. Babbitt (1822–72) records a boater clinging to a log for eighteen hours before being swept over.	On 5 July, George Barnard (1819–1902) daguerreotypes burning grain elevators in Oswego, New York.	Queen Victoria is photographed with her entourage opening the new Crystal Palace at Sydenham, London.	Photographers including Carol Szathmari (1812–87), Roger Fenton and Léon Méhédin (1828–1905) photograph the conflict in the Crimea.

Valley of the Shadow of Death 1855
ROGER FENTON 1819 – 69

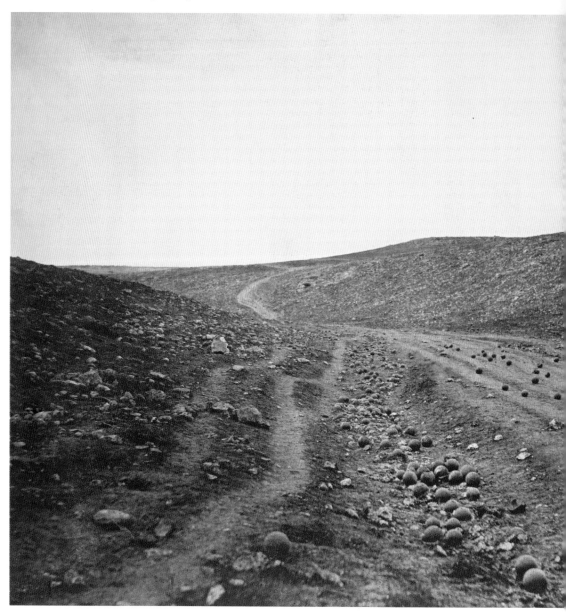

1 HORIZON AND SKY
The severely delineated horizon line was one of Fenton's visual trademarks. All photographic materials during this period were overly sensitive to blue light, leaving the sky a featureless blank white, which in this case served to emphasize the starkness of the scene.

2 WANDERING LINE
Fenton was an expert landscape photographer before the Crimean War, and a wandering line leading the viewer's eye through the photograph was one of his signature techniques. Its meandering form encourages the viewer to examine every detail along its course.

The most notorious of many blunders during the Crimean War, the ill-fated Charge of the Light Brigade in 1854 inspired an epic poem by Alfred Lord Tennyson. Half a year later, during the same campaign, but in an entirely different valley, Roger Fenton drew on Tennyson's work for this singular photograph. Fenton discovered these Russian cannonballs in a ravine, where 'the sight passed all imagination—round shot & shell lay in a stream at the bottom of the hollow all the way down you could not walk without treading upon them'. Returning on 24 April 1855, his chosen 'best view' unfortunately proved to be directly in the line of fire. A cannonball rolling up to his feet persuaded him to move elsewhere, but in an hour and a half he managed two good photographs, 'returning back in triumph with our trophies'. The other negative shows the same scene, but with the cannonballs in the surrounding terrain, clear of the road. This has led to some speculation that Fenton moved the balls into a more dramatic and artistic arrangement (a practice later common in US Civil War photographs), although it defies the imagination that he would have attempted this dangerous task while under fire, or that the British army would have taken kindly to his planting impediments in the roadway. Whether or not Fenton used artistic licence, as Tennyson had used poetic licence, the image is compelling. One London reviewer exclaimed, 'Here is the Valley of the Shadow of Death. . .rough with shot, and bare, stony, and blasted as an accursed and unholy place.'

Fenton's cumbersome wet-collodion glass negatives had to be prepared in the dark shortly prior to the exposure and developed immediately afterwards, before the ether and alcohol dried out. A portable darkroom was a necessity to work in the Crimean battlefields, so Fenton adapted a wine merchant's old delivery van. His driver and assistant was Marcus Sparling (1822–70), the son of an Irish organ builder and an expert rifleman discharged from the 4th Light Dragoons.

In the brilliant light of the Crimea, Fenton found that adequate exposures usually ranged from three to twenty seconds. However, the sun brought along heat as well as light, and 'as soon as the door was closed to commence the preparation of a plate, perspiration started from every pore'. The swarms of flies were an additional menace, especially with the sticky wet collodion. 'This is the studio of battle,' declared *The Illustrated London News*. **LJS**

Salted paper print from a wet-collodion negative
10 ⅞ x 13 ¾ in. | 27.5 x 35 cm
J. Paul Getty Museum, Los Angeles, USA

3 ABSENCE OF BODIES
It may seem unusual for a war photograph not to feature soldiers. In fact, Fenton avoided showing dead, injured or maimed bodies. He was sent to the Crimea as a war photographer to counter anti-war reporting in *The Times* and public perception of an unpopular war.

4 DANGER
Although the cannonballs littering the landscape were generally not explosive, they were still an obstacle to travel, hazardous to horses and wagons—especially when they came to rest in roadways. Army crews had to clear them, and often the collected balls were shot back at the enemy.

FIGURE STUDIES

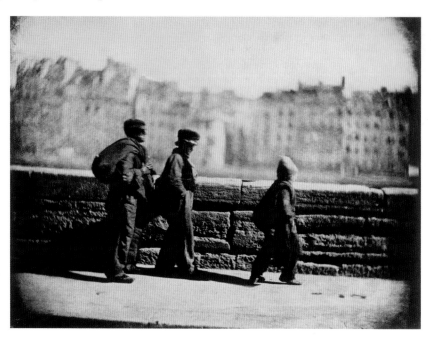

T he rise of commercial portrait studios in the 1840s influenced the general understanding of photography as an invaluable record of personal likeness and identity. Ostensibly, every photograph of a figure was a declarative portrait, because the camera registered a specific individual automatically, and not a symbol for an entire class. However, amateurs, artists and scientists using the new medium sought to adapt the camera to previous representational conventions that treated men and women of the lower classes, as well as those of non-Western descent, as anonymous figures.

Working with the challenge of long exposure times, artistic photographers endeavoured to represent manual labour as a series of momentary gestures and actions, which their models had to re-enact before the lens. French aristocrat and amateur photographer Louis Adolphe Humbert de Molard (1800–74) directed farmhands at his Argentelles property to pose in *tableau vivant* formations, depicting card players lost in concentration or butchers dressing a slaughtered pig. In Paris, painter and photographer Charles Nègre (1820–80) took the pursuit of instantaneity further in *Chimney Sweeps Walking* (above). The youngest sweep appears frozen mid-step; in fact, the model balanced on his toe under the photographer's direction. While Nègre chose a modern approach to representing street life in motion, other contemporaries were

KEY EVENTS

1842	1844	1845	1850	1850	1851
Louis-Auguste Bisson (1814–76) produces daguerreotypes of natives of the Canary Islands.	David Octavius Hill and Robert Adamson advertise the projected volume *The Fishermen and Women of the Firth of Forth*.	Etienne-Reynaud-Augustin Serres makes a case for photography's value to ethnographic study to the French Académie des Sciences.	At his Argentelles home, Louis Adolphe Humbert de Molard poses his family and staff in genre scenes for daguerreotypes.	Louis Agassiz hires photographer J. T. Zealy to make ethnographic studies of African-born slaves in Columbia, South Carolina.	Frenchman Louis Désiré Blanquart-Evrard (1802–72) begins to publish albums containing genre scenes and figure studies.

content to pose figures in a studio environment. Featured in artificial settings, street musicians, gypsies, 'Oriental' concubines and other peripheral types that populated Western fantasies took shape as photographic commodities.

In effect, figure studies furnished ideas for the artistic imagination as well as cultural stereotypes for a burgeoning mass culture. Impressed by its visual exactitude, early proponents of Louis-Jacques-Mandé Daguerre's (1787–1851) method framed the invention as a superlative tool to aid scientific study. Among them was a professor and member of the Académie des Sciences in Paris, Etienne-Reynaud-Augustin Serres, who promoted the daguerreotype as a tool for anthropological research. He envisioned a visual archive of humanity classified by race, and starting in 1845, Serres commissioned photographers such as Henri Jacquart (1809–c. 73) to photograph ethnic types. Jacquart took portraits of members of the Algerian cavalry invited to Paris in 1851, including Mohamed ben Saïd (right). The sitter's intense gaze pierces through whatever scientific imperative lay behind the image, and the treatment of Jacquart's colonial sitters, each of whom was reimbursed for their likeness, was an unusual exception. Louis Agassiz, a Swiss naturalist working as a professor at Harvard University, was decidedly more ideological in his photographic classification of race and hired daguerreotypist J. T. Zealy (1812–93) in Columbia, South Carolina to photograph naked enslaved men and women representative of an array of West African tribes. Agassiz wanted the photographs to support his theory of polygenesis, which considered each race to constitute a separate species.

Eager practitioners in the United States deftly navigated between art, science and showmanship, and the most inexperienced fancied themselves 'destined to make a figure, or figures in the world' without much consideration for likeness, as daguerreotypist John H. Fitzgibbon (1816–82) groused in an article in 1851. At his Saint Louis portrait studio, Fitzgibbon applied his practical experience to record the chiselled features of a Kansas tribe chief named Kno-Shr (opposite below). Although it was produced like any other portrait at the time, this rare document of an unassimilated Native American recalls the paintings of George Catlin and his travelling Indian Gallery, which introduced white audiences to the disappearing tribes of the American West.

Classification was less a concern for amateurs and commercial photographers using calotypes in France and Britain, for whom photography's aesthetic potential resided in its proximity to everyday life. Using the coarse fibres of the paper photograph, and the tendency to mass light and shadow in artful ways, calotypists often staged genre scenes before the lens that resemble 17th-century Dutch paintings in spirit, including those by the inventor William Henry Fox Talbot (1800–77) and the ambitious Scottish collaborators David Octavius Hill (1802–70) and Robert Adamson (1821–48), such as *Sandy (or James) Linton, his Boat and Bairns* (c. 1843–46; see p.56). **JWL**

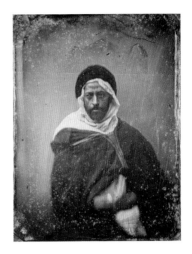

1 *Chimney Sweeps Walking* (c. 1851)
Charles Nègre • albumen print from a waxed-paper negative
6 ¼ x 8 ½ in. | 16 x 21.5 cm
Musée Carnavalet, Paris, France

2 *Mohamed ben Saïd* (1851)
Henri Jacquart • daguerreotype
5 ⅛ x 4 in. | 13 x 10 cm
Musée du quai Branly, Paris, France

3 *Kno-Shr, Kansas Chief* (1853)
John H. Fitzgibbon • daguerreotype with applied colour
7 x 5 ⅞ in. | 18 x 15 cm
Metropolitan Museum of Art, New York, USA

1851	1852	1853	1854	1855	1855
Henry Mayhew's *London Labour and the London Poor* includes illustrations based on daguerreotypes by Richard Beard (1801–85).	Italian Giacomo Caneva (1813–65) produces studies of Italianate models in traditional and religious dress.	Using wet collodion on glass negatives, André-Adolphe-Eugène Disdéri (1819–89) produces images of street types in Nîmes, France.	*The Photographic and Fine Art Journal* (1851–60) publishes an article by John H. Fitzgibbon on 'Daguerreotyping in the Backwoods'.	Narayen Dajee (c. 1830–75) exhibits his albumen prints of agricultural labourers from Gujarat to the Photographic Society of Bombay in India.	Hungarian Carol Szathmari (1812–87) shows figure studies of Romanians in folk costumes at Paris's Exposition Universelle.

Sandy (or James) Linton, his Boat and Bairns *c. 1843 – 46*

DAVID OCTAVIUS HILL 1802 – 70 ROBERT ADAMSON 1821 – 48

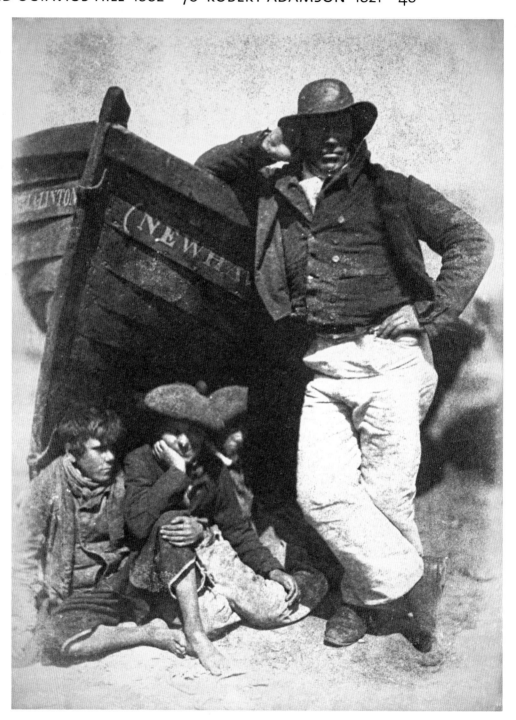

Salted paper print from a paper negative
7 ⅝ x 5 ⅝ in. | 19.5 x 14 cm
National Galleries of Scotland,
Edinburgh, UK

In 1843 David Octavius Hill and Robert Adamson entered into partnership 'to apply the calotype to many other general purposes of a very popular kind and especially to the execution of large pictures representing different bodies and classes of individuals'. Over the next few years, they embarked on a major study of the inhabitants of the fishing village of Newhaven, just north of Edinburgh. With Hill supplying intention and Adamson the technical execution, they explored photography's access to modernity and social reality that painting lacked, in effect pioneering social documentary. The 150 photographs under the projected title *The Fishermen and Women of the Firth of Forth* show posed arrangements of the town's women in traditional dress, and its hardworking fishermen, whose livelihood was frequently under threat of danger. *Sandy (or James) Linton, his Boat and Bairns* represents the depth of their accomplishment. It is one of several compositions featuring the same figures and setting, and the work's symbolic arrangement and dramatic use of light attest to the makers' aspirations to achieve rich social description and touch upon larger artistic themes. The fisherman Linton leans against his boat, providing shelter to his sons, the town's next generation. The image communicates a moment from everyday life and the theme of the paternal legacy of work passed from father to sons. Newhaven's economic and social model was perceived to be under threat from modern industrial society, a force signalled by new technologies such as photography. **JWL**

◉ FOCAL POINTS

1 LANGUAGE
The words 'Newhaven' and 'Linton' can be read on the boat's bow, partially obscured by the figures. The prominence of the words lends language an objectlike existence, alongside the locally crafted boat and the villagers' bodies, which Hill and Adamson sought in their social documentary approach.

2 DYNAMIC POSE
Hill and Adamson directed their subjects in dynamic arrays even when limited by a short-focus lens that required close-knit arrangements. They worked with models to perform a variety of poses, in search of a natural attitude, such as the one communicated by Linton's relaxed tilt.

3 TEXTURE
Hill felt paper photography's challenges informed its formal strengths, writing in 1849: 'The rough surface and unequal texture throughout of the paper is the main cause of the calotype failing in details. . .and this is the very life of it. They look like the imperfect work of a man, not. . .of God.'

4 MASSING OF LIGHT
Light is used to frame the Newhaven figures into distinct spaces, such as the quiet children resting in the shadow of Linton and his boat. Hill's eye for chiaroscuro, Adamson's technical proficiency and the chemical printing made their grasp of form unequalled in photography's first decade.

⏱ PHOTOGRAPHERS PROFILE

1802–43
Ill health prevented Robert Adamson from pursuing a career as an engineer. A friend of William Henry Fox Talbot, Sir David Brewster, mentored him in photography. Adamson opened a calotype studio in Edinburgh, where he met painter and lithographer David Octavius Hill in 1843. They formed a partnership and produced photographic studies as an aid to Hill's painting commemorating the foundation of the Free Church of Scotland.

1844–47
Hill and Adamson took more than 3,000 photographs. In 1844, they advertised six intended volumes on facets of Scottish life, including *The Fishermen and Women of the Firth of Forth*. Optician Thomas Davidson devised a camera with a mirrored lens able to take large negatives for the project.

1848–70
Adamson died in 1848. Hill formed a new partnership in c. 1860 with studio photographer Alexander MacGlashan (d.1877), but the collaboration was short lived because MacGlashan's technique could not translate Hill's artistic ideas well enough.

THE HUMAN CONDITION

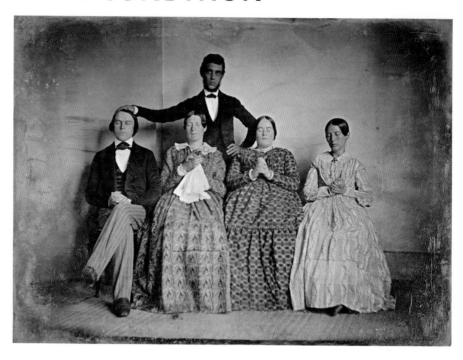

When in 1857 the wife of the president of the Photographic Society of Great Britain, art critic Lady Elizabeth Eastlake, described the camera as 'an unreasoning machine', whose 'business is to give evidence of facts', she was voicing a growing belief. Many viewed the photograph not simply as telling the truth but being part of it too: a physical trace of actuality. Scientists also looked to photography as an instrument that could provide reliable, empirical records. The study of human psyche was one of the first subjects for which scientists sought the aid of the camera. This might seem peculiar given that photographs record surface detail. However, at the time, it was thought that a person's character, indeed their soul, could be read from their body. The notion took various guises: physiognomy looked to the features of the face, phrenology studied the shape and structure of the skull, and pathognomy scrutinized emotional expression and gesture. The earliest known clinical photographs are attributed to the physiognomy advocate Hugh Welch Diamond (1808–86). While working at the Surrey County Lunatic Asylum, he began taking portraits of his female wards (c. 1851; see p.60). In 1856 he gave a paper at the Royal Society of Medicine proposing the use of photography in treating the insane as a record to aid diagnosis.

KEY EVENTS

1839	1847	1847	1851	1851	1852–56
On 8 April Hugh Welch Diamond buys some photographic paper. The next day he makes his first photogenic drawing.	Scottish doctor James Young Simpson discovers the anaesthetic properties of chloroform, bringing an end to the use of hypnosis in operations.	Southworth & Hawes photograph a re-enactment of the first operation carried out under anaesthetic (ether).	Daguerreotypist Félix-Jacques Antoine Moulin (1802–75) is arrested for the possession of 'obscene subjects' (photographic pornography).	US companies advertise tombstone daguerreotypes: 'Your duty to your beloved. . . remains unfulfilled without. . .one of these beautiful cases.'	Physician Duchenne du Boulogne makes photographic studies of human subjects having their facial muscles stimulated by an electric current.

Photography was used occasionally to document scientific demonstrations and experiments. The daguerreotype *Hypnotism* (opposite) by Boston scientist John Adams Whipple (1822–91) presents a strange scene in which a man stands behind four seated subjects. He stares directly at the camera. His patients, with hands clasped and eyes closed, appear hypnotized. Hypnosis, although nowadays associated with quacks and conjurors, was then accepted in medical circles as a cure for various ailments and as an anaesthetic. However, the arrangement of the people within this image suggests something other than hypnosis. The practitioner's palm touches the male sitter's head and he is linked elbow to elbow with the three women. This line of contact indicates that the operator is in fact practising mesmerism, which was becoming increasingly popular during this period of the 19th century. Mesmerists believed that a magnetic force or fluid flowed from them to their subjects and, through it, they could control minds and bodies.

Postmortem photography was also a widespread practice in the 19th century. The composition in the daguerreotype by Alphonse Le Blondel (1814–75) of a father and his dead child (below) hints at an afterlife. Whereas the watchful father sits in shadow, the dead child is cast in ethereal light surrounded by folds of drapery that guide the eye heavenwards. On the back of this daguerreotype, a label advertises 'Portraits after death, death masks'. Such images offered the parents of the dead child a physical trace of the child's actual self and a talisman with which to mourn them. **JMH**

1 *Hypnotism* (c. 1845)
John Adams Whipple • daguerreotype
5 ¼ x 7 ¼ in. | 13.5 x 18.5 cm
Metropolitan Museum of Art,
New York, USA

2 *Postmortem* (c. 1850)
Alphonse Le Blondel • daguerreotype
3 ½ x 4 ⅝ in. | 9 x 12 cm
Metropolitan Museum of Art,
New York, USA

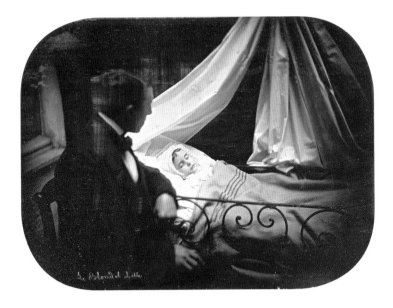

1853	1853	1854	1854	1855	1857
The *Encyclopedia Britannica* records how in places where notions of physiognomy have become 'an epidemic', 'people went masked through the streets'.	Hugh Welch Diamond becomes the secretary to the Photographic Society of London and editor of its journal in the year of its foundation.	The first exhibition of the Photographic Society of London opens. It includes Diamond's portraits of the insane.	A cashier accused of stealing from the Banque Rothschild in Paris is later arrested in the United States on the basis of a photograph.	French critic Ernest Lacan notes how mug shots mean criminals will forever be 'recognized by this accusatory image'.	Lady Elizabeth Eastlake calls photography 'a household want' in her treatise on photography in the British *Quarterly Review*.

Untitled (Melancholia Passing into Mania) c. 1851
HUGH WELCH DIAMOND 1808 – 86

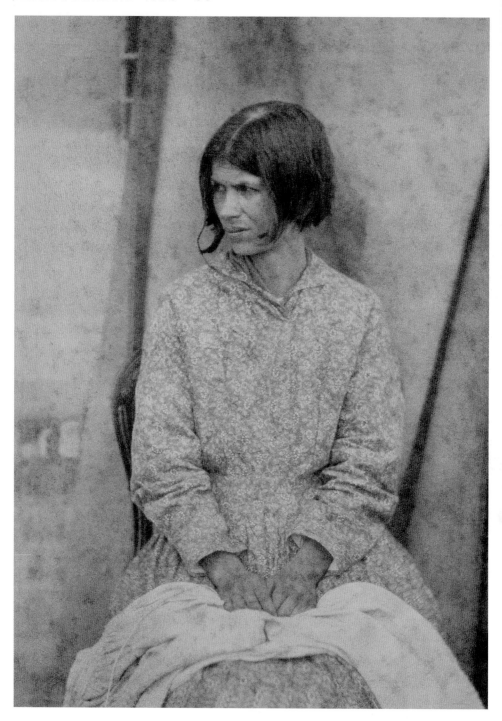

Albumen print from a wet collodion on glass negative
5 ⅜ x 3 ¾ in. | 13.5 x 9.5 cm
Royal Photographic Society Collection,
National Media Museum, Bradford, UK

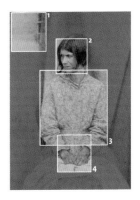

This portrait is one of at least fifty-five images that Hugh Welch Diamond took of his female patients while he was resident superintendent at the Surrey County Lunatic Asylum. In his address to the Royal Society of Medicine in 1856 he argued that photographs like this could help diagnose and treat the subject. He gave a professor of medicine at the University of London, John Conolly, permission to use many of the images; they were the basis for the lithographic illustrations to Conolly's essay series 'The Physiognomy of Insanity' (1858).

This portrait appears as *No. 4—Melancholia Passing into Mania*. Despite Conolly's use of the photographs as scientific illustrations, it is unlikely that Diamond viewed them simply as clinical documents. As a founding member and secretary to the Photographic Society of London, Diamond moved in artistic photographic circles and was known for his photographic still lifes. The lighting and screened backdrop depicted hint at creative sensibilities. In other portraits from the series, Diamond even exhibits a tendency to theatricality by allowing sitters to hold props associated with their affliction. One lady appears with garlands in her hair as if she saw herself as William Shakespeare's Ophelia. In another, the patient wears a crucifix and appears as if lit by a celestial shaft of light. Diamond submitted some of these photographs to exhibitions, including the first public exhibition devoted to photographs held at the Royal Society of Arts in 1852. **JMH**

FOCAL POINTS

1 WINDOW
A window on the outside of a building peeping out from behind the drapes is discernible in the upper left corner of the image. In order to get a good exposure, Diamond would still have required plenty of light. It is highly likely this portrait was taken in a sunlit outdoor spot.

2 FROWN
Conolly assesses the patient's frown in his essay as exhibiting the first hints of excitement in her melancholic or depressed state 'as if the patient was now beginning to understand some plot and to discern some enemies'. It is equally possible that she was simply squinting against the bright sunlight.

3 DRESS
The patient wears a simple, clean dress. Conolly records that before she was admitted: 'She gained a small livelihood by the occupation of a sorter and folder of paper, and lived but poorly.' He lists the benefits of admission to an asylum: 'To be well clothed, to have a comfortable bed and sufficient good food every day.'

4 HANDS
Diamond used the newly invented wet-collodion process. The technique had detail to rival the daguerreotype and could reduce exposure time from minutes to seconds. However, the subject would still need to sit still to prevent blurring. She may be holding her hands to still them.

PHOTOGRAPHER PROFILE

1808–47
Hugh Welch Diamond was born in Goudhurst, Kent, England. From 1824 he studied medicine at the Royal College of Surgeons, moving to St Bartholomew's Hospital in 1828.

1848–51
Diamond was appointed resident superintendent of the female department of Surrey County Lunatic Asylum, where he looked after more than 400 women. He started to write articles for *Notes & Queries* in 1849.

1852–57
In 1853 he was made a member of London's Photographic Society. He was elected secretary of the society and editor of *The Photographic Journal* that same year. In 1856 he gave a paper to the Royal Society of Medicine on the functions of photography in the treatment of the mentally ill.

1858–86
Diamond's series *Portraits of the Insane* was published with John Conolly's essays. He moved to Twickenham, Surrey and opened a private asylum. He resigned from the Photographic Society in 1869, and rarely made photographs thereafter.

STILL LIFE

In painting, the term 'still life' signifies a clearly defined genre: images of grouped items whose functions range from the purely decorative to profound meditations on the nature of existence and mortality. The still life in early photography, however, is not so easy to define. Many early photographers imitated the traditions of still life painting—arranging fruits, game and other objects to produce pictures reminiscent of the Dutch origins of the painted still life—but as photography's role expanded, so did the elements that constituted a photographic still life. As a result, the term 'still life' could justifiably be applied to a wide variety of photographic practices, including inventories of items, arranged images of plaster casts and studies of single objects, as well as more traditional still life images.

Exposure times were measured in hours for the earliest photographs and minutes for several years after, so in order for anything to impress itself on a photographic surface, it had to remain immobile for the duration. Inanimate

KEY EVENTS

1827	1836	1839	1839–40	c. 1842	1844
Set Table by Joseph Nicéphore Niépce (1765–1833) is one of the world's first photographs and the first photographic still life.	Achille Collas invents a machine to produce smaller versions of sculptures. Such reproductions appear in early still life photographs.	Daguerre's process is officially announced and the inventor distributes his still lifes to notables such as King Ludwig I of Bavaria.	US inventor Samuel Morse, who visited Daguerre at his studio in Paris in spring 1839, and William Draper create a still life daguerreotype.	Armand-Pierre Séguier (1803-76), the French inventor of a portable bellows camera, makes a still life daguerreotype featuring plaster busts.	William Henry Fox Talbot begins issuing his *The Pencil of Nature*, which includes the still life *Fruit Piece*.

objects made for cooperative subjects. This practical concern accounts for the popularity of the still life among the photography's inventors; many of them experimented with the genre, including Louis-Jacques-Mandé Daguerre (1787–1851), William Henry Fox Talbot (1800–77) and Hippolyte Bayard (1807–87). Daguerre's still life from 1837 presents an array of sculptures, a wicker-covered jug and a framed picture, all carefully arranged on or near a windowsill thought to be in his studio.

Following on from Daguerre's study, many French photographers, including Bayard and Hippolyte Fizeau (1819–96), composed complex images packed with plaster casts and other artifacts arranged against a textile backdrop. These strange compositions not only demonstrate photography's ability to render textures and surfaces, but also embody eclectic visions of artistic taste, hidden narratives about contemporary life and meditations upon the nature of reproduction. Talbot made at least forty-seven different negatives of his plaster bust of Patroclus as well as more elaborate arrangements of sculptures on shelves. He also made several different still lifes of items, including glass, silver and china. In his publication *The Pencil of Nature* (1844–46), Talbot concluded that such inventory pictures would be of use as evidence of ownership, should a thief ever steal the items.

By the 1850s the notion of photography as a fine art had gathered steam. Defendants who adopted and imitated the traditional artistic genres of landscape, portraiture and still life found that still life offered the greatest possibility because it gave the photographer agency over the subject. As opposed to landscape—and to some degree portraiture—still life was a matter of composition, not just selection. It also allowed the photographer a chance to apply the objective process of photography to the world of symbolism and metaphor, as evident in the stereographic image *The Sands of Time* (c. 1855; see p.64) by Thomas Richard Williams (1824–71).

The First of September (opposite) by William Lake Price (1810–96) is an early example of art photography's institutional success. The bold, graphic image of two dead grouse—a nod to the Dutch still life theme of the fleeting nature of life—is also a contemporary document of the autumnal hunting season. When it was displayed at the third annual exhibition of the Photographic Society of London in 1856, it caught the attention of the director of the South Kensington (now Victoria and Albert) Museum, Sir Henry Cole, who purchased it as he began the museum's collection of photography. *Fantaisies* (right) by Henri Le Secq (1818–82) is a fitting frontispiece for his suite of still lifes because it introduces Le Secq's unique take on the nature of photography. He arranged a photographic lens, standing on its end, and a corked bottle standing ready to replenish the two glasses, half-filled with wine. He suggests that if photography gives the viewer reality then it is an intoxicating one, a world of fantasy in which the familiar becomes strange in front of the inquisitive eye of the camera. **RL**

1844	1845	c. 1850	1851	1852	1855
Léon Foucault makes a still life daguerreotype of a bunch of grapes, seen as the test of an artist's ability to achieve pictorial unity through light and shadow.	Hippolyte Bayard creates photographs of complex and sometimes curious arrangements of sculptures.	Louis Jules Duboscq-Soleil (1817–86) makes a still life daguerreotype featuring a miniature human skeleton, human skull, crucifix and hourglass.	The Great Exhibition opens in London. More than 150 photographs of the displays are produced to illustrate the *Reports of the Juries*.	The Photographic Institution is founded in London. It sells art photographs of all genres, including still lifes.	Roger Fenton (1819–69), who would later become a master of still life photography, works for the British Museum photographing sculptures and objects.

The Sands of Time *c.* 1855

THOMAS RICHARD WILLIAMS 1824 – 71

Stereoscopic daguerreotype
3 ⅛ x 6 ¾ in. | 8 x 17 cm
Royal Photographic Society Collection,
National Media Museum, Bradford, UK

Although Thomas Richard Willliams's early beginnings in photography were firmly embedded in studio portraiture—at which he enjoyed great success—his reputation was largely established through other kinds of photographic practice, including still life. *The Sands of Time* is his photographic twist on the centuries-old practice of painted allegory. Every element within the frame was chosen to craft a symbolic admonition: make good use of your time, for it is finite and marches inexorably forward. The sombre interior setting, suggestive of a well-used study, seems to have been abandoned recently, perhaps for good, by a diligent scholar. The candle, burnt down to its base, and the spectacles resting on an ancient tome serve as evidence of the industriousness and elderly nature of the absent academic, who must have been working late into the night.

Williams drew upon painterly conventions for this image, but photographers often upended artistic traditions even as they tried to imitate them. He has transformed a theme usually reserved for fine art institutions or the refined studies of the aristocracy into an effective parlour amusement available to a much wider segment of the population. Stereographic images appeared as a single three-dimensional image when seen through a hand-held or freestanding viewing device. Such a phenomenon must have rendered the sense of melancholy even more palpable, drawing the viewer into the scene and implicating them in the tableau's cautionary tale. **RL**

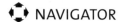 NAVIGATOR

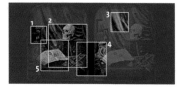

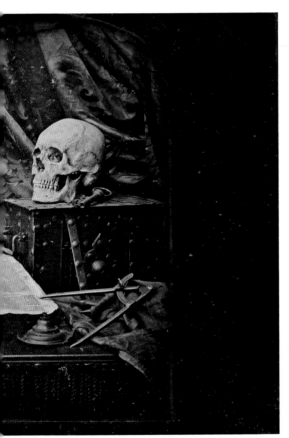

FOCAL POINTS

1 HOURGLASS
The shifting sands of the hourglass embody life's finite nature. In painting, an hourglass often represents death. It was also found in depictions of alchemists' laboratories, a fitting parallel for this allegory since early photographic chemistry, like alchemy, mystified many.

2 SKULL AND COMPASS
By itself, the skull is a memento mori—a reminder of death—but in the symbolism of the allegorical tradition, the meaning of elements changes depending upon what appears with them. Paired with a compass, the skull is a symbol of melancholy. The compass by itself represents maturity.

3 DRAPERY
Williams has packed his picture with a variety of textures, including wood, bone and fabric. The heavy patterned textile backdrop provides a sense of refinement and a malleable setting upon which he could vertically stagger the other elements and hide any unsightly supports.

PHOTOGRAPHER PROFILE

1824–46
Thomas Richard Williams was born in Blackfriars, London. By the early 1840s he was working for Antoine Claudet (1797–1867), one of the first photographers to produce stereographic daguerreotypes in England.

1847–53
Williams married Elizabeth Gorfin, with whom he had twelve children, in 1847. He may have worked for Richard Beard (1801–85) during this time; the evidence is inconclusive. When the Great Exhibition opened in London in 1851, Williams produced stereographic daguerreotypes of the interior of the Crystal Palace. Shortly after, he opened his first studio, in Lambeth, London.

1854–60
He moved his studio to Regent Street. Williams produced three series of stereographic albumen prints in 1856. The same year he was commissioned to photograph Princess Victoria.

1861–71
Williams was elected to the council of the Photographic Society of London. In the late 1860s, ailing, he took on a partner, William Mayland (a.1850–c. 80), to continue the business.

4 STEREO VISION
Stereographs were made with dual-lens cameras. The two lenses were spaced the same as the distance between a pair of human eyes, so the two images are almost but not quite identical. Williams stages this scene for maximum 3-D effect, with the compass point jutting into the foreground.

5 BOOK AND SPECTACLES
The book is the source of learned wisdom, but wisdom cannot defeat time and the spectacles suggest that the scholar's senses are in decline. Their lenses magnify the words on the page, drawing attention to the binocular nature of sight that the stereographic process attempted to imitate.

ART AND INDUSTRY

The world fairs of the mid 19th century were spectacular events that provided the public with some of the earliest opportunities to see photographic images. The first such occasion was the Great Exhibition of the Works of Industry of All Nations, held in London's Hyde Park from 1 May to 15 October 1851. Under the direction of Prince Albert, the aim was to present each country's industrial, technological and artistic achievements in an effort to promote goodwill and trade. Joseph Paxton designed the lacy, cast iron and glass building, which astonished all with its translucency and grace, and quickly became known as the Crystal Palace. With 17,000 exhibits from ninety-four nations, the fair was a defining moment for industry, science, art and culture, and an extraordinary achievement for Britain. It attracted more than six million visitors and was an enormous success.

The Great Exhibition was influential in many ways, but it had particular significance photographically. Scattered throughout the displays were approximately 770 calotypes and daguerreotypes, demonstrating that the medium was enormously important. Of the nine nations that submitted photographic work, three—England, France and the United States—were best represented. The French images on paper attracted the greatest attention for their expressive delicacy and subtlety. US daguerreotypes were also praised for their fineness.

Some of the most important early British photographers brought their cameras to the exhibition. William Henry Fox Talbot (1800–77) photographed the hall, as did Benjamin Brecknell Turner (1815–94), the gentleman

KEY EVENTS

1844	1850	1850	1851	1851	1852
All the photographs exhibited at the Exposition des Produits de l'Art et de l'Industrie in Paris are daguerreotypes.	Louis Désiré Blanquart-Evrard, who in 1847 had published the first calotype process in France, introduces prints on paper coated with albumen.	The *Bavaria* statue is erected at Munich's Oktoberfest. Its installation (1850; see p.68) is photographed by Alois Löcherer (1815–62).	US photographer Mathew Brady (c. 1823–96) is awarded a medal by the Great Exhibition jurors for his daguerreotypes.	Blanquart-Evrard sets up his photo-printing firm near Lille, France, and begins to mass-produce positives for book illustration.	The first exhibition devoted solely to photographic images is held at the Society of Arts in London. No daguerreotypes are shown.

photographer best known for his rural and architectural subjects. Turner captured the marvellous grandeur of the structure (opposite above)—as well as a beautiful elm tree that the builders had left standing—just before the building was dismantled in 1852. The four-volume *Reports by the Juries* of the exhibition were issued to dignitaries of all the nations that participated. The reports included 155 original photographic images by Hugh Owen (1808–97) and Claude-Marie Ferrier (1811–89) that conveyed the excitement and the optimism surrounding the event.

The success of the Great Exhibition led to the creation of the South Kensington Museum (later renamed the Victoria and Albert Museum) in 1852. Its director Henry Cole not only collected photographs for his new institution, but also employed the medium for documentary purposes. He hired Charles Thurston Thompson (1816–68) to record a Venetian mirror (right) in conjunction with an exhibition of decorative furniture held at Gore House in 1853. Taking the mirror into the garden and including himself and his camera in its reflection, Thompson made an engaging image that celebrated not only the elaborate gilded frame, but also his new role as art photographer.

An influential model for the establishment of the new London museum was the Minutoli Institute in Liegnitz, Silesia (now Legnica, Poland). Prussian art collector Alexander von Minutoli created the institute to promote appreciation of the decorative arts. In 1853 he commissioned Ludwig Belitski (c. 1830–1902) to make photographic reproductions of his collection. The results, published in seven folio-sized albums, earned the photographer international fame. Belitski's photograph *Venetian Vases and Glasses* (opposite below) was taken in strong sunlight, creating an almost X-ray-like effect that highlights the delicate decorative detail of the glassware.

The following years saw a broad diversification of applications for photography as a result of the introduction of the waxed-paper negative by Gustave Le Gray (1820–84), the wet-collodion on glass technique by Frederick Scott Archer (1813–57) and a method for printing large numbers of images from negatives by Louis Désiré Blanquart-Evrard (1802–72). These technical developments were central to the presentations of the medium at the next world fair, the Paris Exposition Universelle. Hosted by Napoleon III and held on the Champs-Elysées from 15 May to 15 November in 1855, it attempted to surpass London's Great Exhibition. Besides portraiture, still life and landscapes, a variety of images produced for scientific, industrial, artistic and commercial reasons was shown at the Palais de l'Industrie. These included documentary photographs from the Mission Héliographique, floral studies for wallpaper and textile design by Adolphe Braun (1812–77) and renderings of Sèvres porcelains by Louis-Rémy Robert (1810–82). At the exposition, proponents of photography were also beginning to speak out in favour of the artistry that enabled the best camera images to excel. **AEH**

1 *Crystal Palace Transept, Hyde Park* (c. 1852)
Benjamin Brecknell Turner • salted paper print from a waxed-paper negative
10 ⅜ x 15 ½ in. | 26.5 x 39.5 cm
Victoria and Albert Museum, London, UK

2 *Venetian Mirror* (1853)
Charles Thurston Thompson
albumen print from a wet collodion on glass negative
9 x 6 ½ in. | 23 x 16.5 cm
Victoria and Albert Museum, London, UK

3 *Venetian Vases and Glasses* (c. 1855)
Ludwig Belitski • salted paper print from glass negative
9 x 7 ⅛ in. | 23 x 18 cm
Victoria and Albert Museum, London, UK

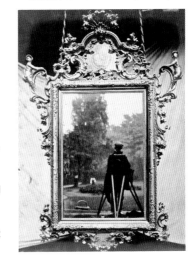

1852	1854	1854	1855	1855	1856
William Henry Fox Talbot patents a prototype of photoengraving.	The reconstructed Crystal Palace, an expanded version of the original structure, opens in Sydenham in south London.	André-Adolphe-Eugène Disdéri (1819–89) patents the *carte de visite*. The format is one of the most successful commercial applications of photography.	The Paris Exposition Universelle is held from 15 May to 15 November at the Palais de l'Industrie on the Champs-Elysées.	Philip Henry Delamotte (1821–89) publishes his images of the rebuilding of Crystal Palace. They strengthen the medium's links with industrial progress.	Alphonse Poitevin (1819–82) initiates photolithography and carbon printing.

Transporting the Bavaria Statue to Theresienwiese 185

ALOIS LÖCHERER 1815 – 62

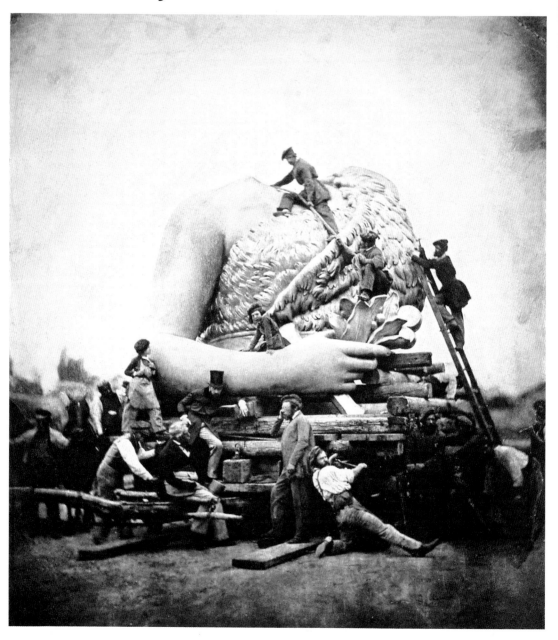

Salted paper print from a paper negative
9 ⅞ x 9 ⅞ in. | 25 x 23 cm
Museum Ludwig, Cologne, Germany

In the 1850s, one of the most fascinating uses to which photography was put was to document the progress of important construction projects. A particularly striking example of this was the installation of the monumental statue *Bavaria* in Munich. The photographer was Alois Löcherer, one of the pioneers of photography in Germany, who had established himself in the city as a professional portrait photographer in 1847.

The 60-foot (18-m) high statue—a gigantic personification of the region that still stands on the Theresienwiese—had been commissioned by King Ludwig I of Bavaria, who had a passion for building new architecture. As the first colossal sculpture made of cast bronze since antiquity, it was a remarkable technical achievement. The design, which was chosen by competition, came from Ludwig von Schwanthaler, a favourite court sculptor. *Bavaria* was cast in the Munich foundry of J. B. Stiglmair under the direction of Ferdinand von Miller and, because of its monumental size, was made in sections.

Public enthusiasm for the project inspired Löcherer to capture various stages of the statue's completion, including the transportation of the sections and their installation in front of Munich's Ruhmeshalle (Hall of Fame) in 1850. He made approximately six images, using the paper negative (calotype) process, of which the one reproduced here is the most successful. Löcherer's endeavour is one of the earliest photographic documentations of a major construction project, and one of the first instances of photo-reportage. **AEH**

FOCAL POINTS

1 BACKGROUND
Löcherer consciously masked out the background of his image to highlight the statue more prominently. It was common practice at the time for photographers to use paint or ink to blacken the sky area in the negative so that it would appear more uniform in tone in the final print.

2 STATUE
The sculptor chose to create a figure that possessed both classical and Romantic stylistic elements. He draped the massive figure's torso in a bearskin to endow her with what he felt would be a more Germanic character. Sadly, Schwanthaler did not live to see his work completed.

3 FOUNDRY HEAD AND WORKMAN
The head of the foundry where the statue was cast is standing in the lower centre of the image, wearing a beret. A workman to the right of the foundry head looks back at the photographer. Löcherer arranged the people to make their poses seem natural and compelling.

4 HORSES
The moving of the separate sections of the statue took place between June and August 1850. It required specially constructed wagons, each drawn by many horses. The last piece—the head—was finally set in place on 7 August and the official unveiling took place on 9 October.

PHOTOGRAPHER PROFILE

1815–39
Alois Löcherer was born in Munich and studied chemistry and pharmacology at Munich University from 1837 to 1839.

1840–49
Löcherer earned his living as a pharmacist from 1840 to 1848. He learnt the daguerreotype process in 1840. He first experimented with the calotype in 1844 and initiated that technique in Munich. He opened his first studio—in the house of the painter, lithographer and photographer Franz Hanfstaengl (1804–77)—in 1848. Löcherer provided photographic instruction to others and helped to popularize the medium in his region. From 1847 he specialized in portraits, particularly of prominent citizens, and also made genre studies and views of Munich.

1850–62
Löcherer documented the transportation and erection of *Bavaria* in Munich in 1850. Around 1853, he adopted the wet-collodion negative method, which he used to make many photographic reproductions of early northern Renaissance prints in Bavarian royal collections. He died in Munich in 1862.

EGYPT AND THE HOLY LAND

Within a few years of the invention of photography, daguerreotypy and calotypy were being used to record the monuments and wonders of the wider world, including Egypt and the Holy Land. Imperialist clashes between France and Britain had brought Napoleon to Egypt in 1798. His scientific camp followers and archaeologists created a newly sophisticated interest in the entire region. Jean-François Champollion's decipherment of Egyptian hieroglyphics in 1824 fired both scholarly interest and the public imagination, triggering a wave of orientalism. Written accounts of the area were soon accompanied by drawings and paintings, but these appeared strange to the public and were received with scepticism. One of photography's most exciting potential roles was that of a truthful eyewitness. Some photographers, such as John Beasly Greene (1832–56), visited the region to satisfy their own research interests (see p.72); others went on commission or joined expeditions.

Auguste Salzmann (1824–72) came from a family of French painters. After his first trip to the Holy Land in 1850, he returned to Paris and quickly mastered the new art. In 1852, the archaeologist Louis F. Caignart de Saulcy illustrated

his investigations of Jerusalem with his own drawings, which were soon denounced by critics as fanciful. In 1854, Salzmann was commissioned by the Ministry of Public Instruction to photograph the monuments left by crusading knights and de Saulcy hired him to substantiate the veracity of his drawings. Salzmann returned to Paris with more than 200 highly artistic paper negatives and largely proved de Saulcy to have been right: as the *Cosmos* observed, 'We can hardly accuse the sun of having an imagination.'

Maxime du Camp (1822–94) learnt photography with some difficulty. In 1849, in the company of Gustave Flaubert, he embarked on his one and only trip to Egypt. His image of one of the statues at the Abu Simbel temple (right) is typical of his photographic work—frontal, with strong geometry and the cool tones that distinguish Blanquart-Evrard process prints. After this journey, du Camp began a literary career and never photographed again. As a civil engineer, Félix Teynard (1817–92) brought a practised eye to photography. His *French Inscription on the Eastern Embrasure of the Pylon on the Island of Philae* displays a dichotomy possessed by many good photographs, presenting both hard facts and the imaginative flight of a novel. Every detail is rendered sharply in the raking light, but the viewer is brought up short by the jarring juxtaposition of this carefully carved ancient piece disfigured by graffiti—a French commander had marked his victory over the Mamelukes in 1799 on a wall.

The Paris firm of Goupil et Cie had by the late 1840s emerged as an industrial age powerhouse, with a catalogue of more than 3,000 prints and offices in other European capitals and New York. It had issued *Daguerreian Travels, Representing the Most Remarkable Views and Monuments in the World* from 1840 to 1842, but these reproductions were hybrids, hand-executed engravings based on daguerreotypes. For proper photographic reproductions, the firm turned to Adèle Elisabeth Hubert de Fonteny who, following in the footsteps of Anna Atkins (1799–1871), began to produce large runs of photographic prints at her Imprimerie Photographique H. de Fonteny et Cie, established in 1851 as 'the first in Paris'. Using the technology devised by William Henry Fox Talbot (1800–77), its prints were beautiful at first, but simply not permanent enough. The firm closed in 1854.

By 1860, Goupil would establish its own in-house photographic printing; in the meantime, like others, it turned to Louis Désiré Blanquart-Evrard (1802–72), a commanding figure in French photography and one considered by French writer Francis Wey to be the 'Gutenberg of photography'. Blanquart-Evrard devised a developed-out printing process that yielded highly stable photographic prints in any weather. His establishment at Lille was one of the first truly industrialized photographic operations, using precise manufacturing and timing to turn out up to 300 prints a day from a single negative. Although the albums and books produced were in limited quantities and very expensive, they began to establish a market that would be further satisfied when processes such as photogravure finally brought the photograph to the traditional printed page. **LJS**

1 *French Inscription on the Eastern Embrasure of the Pylon on the Island of Philae (c. 1851–52)*
Félix Teynard • salted paper print from a paper negative
9 ⅜ × 12 in. | 24 × 30.5 cm
Art Institute of Chicago, Illinois, USA

2 *Ibsamboul—Colosse Occidental du Spéos de Phrè (c. 1850)*
Maxime du Camp • salted paper print from a paper negative
8 ⅞ × 6 ¼ in. | 22.5 × 16 cm
Royal Photographic Society Collection, National Media Museum, Bradford, UK

1851	1852	1852	1853–54	1854	1865
Blanquart-Evrard establishes the Imprimerie Photographique in northern France at Loos-lez-Lille.	The German amateur photographer Ernest Beneke makes calotype views and figure studies as he passes through Egypt on his Mediterranean tour.	A luxury volume featuring the calotypes made by Maxime du Camp in the Middle East is published by Blanquart-Evrard.	Some 160 calotypes from the expedition made by Félix Teynard in 1851 to 1852 to Egypt and Nubia are published.	August Salzmann photographs archaeological sites in and around Jerusalem.	The Palestine Exploration Fund is established specifically to promote investigations of the Holy Land.

The Banks of the Nile at Thebes 1854

JOHN BEASLY GREENE 1832 – 56

1 MASS OF SKY
Greene's waxed-paper negatives were sensitive largely to light at the blue end of the spectrum, so sky areas exposed very fully. Some photographers minimized this effect by limiting the sky area; others artificially added clouds during printing. Greene chose to allow the sky to appear as an endless mass.

2 GROUP OF TREES
Had the mass of trees been isolated, an island would have been suggested and the picture would have been static. Had it filled the frame left to right, it would have been a barrier between earth and sky. Occupying only the centre, it is a destination for the eye while moving through the scene.

The photographs of John Beasly Greene, made on paper from waxed-paper negatives—he learnt the process from Gustave Le Gray—possess the boldness usually associated with images on hard metal plates. This image is his most extraordinary photograph, a proto-modernist rendition of nearly empty and forbidding space. Unlike the work of most of his peers, it lacks sharp definition. Greene's paper negative broke up fine detail—the work is more an exploration of tone than a document of a time and place. The elements of nature, the sky and the Nile, each occupy a distinct band. Separating them boldly is a narrow strip of arable land, its thin line emphasizing just how tenuous a grip life has on earth.

Very little is known about Greene's short life. He was born into a US banking family resident in France. Greene's patrimony enabled him to devote his life to being a dedicated amateur archaeologist and Egyptologist, and he went on to become a young member of the Société Asiatique and the Société Orientale. In the autumn of 1853, already deeply immersed in the study of his subject and well respected by specialists in the field, he embarked on a self-financed expedition to North Africa and Egypt. Returning to Paris in the summer of 1854, Greene became one of the founding members of the Société Française de Photographie.

He might have been expected to use his studies to guide his camera, directing it towards the making of sharply rendered documents that would aid contemporary scholarship. Yet Greene's images of Egypt, more than ninety of which were published by Louis Désiré Blanquart-Evrard in *Le Nil: Paysage, explorations photographiques* (1854), are more poetic than representational. Even when he photographed a temple from up close, and it was delineated as precisely as it was by his photographic contemporaries in the region, the viewer still senses his powerful aesthetic and emotional reaction to place. Most of the prints surviving from Greene's negatives were made by the photographer himself, although his archive preserves the maquette of a publication that he planned to have printed by Blanquart-Evrard. **LJS**

Salted paper print from a waxed-paper negative
9 x 10 ⅞ in. | 23 x 27.5 cm
George Eastman House, Rochester, New York, USA

3 RIVER
Egypt's bright light sometimes prolonged exposure times. An exposure of thirty seconds or of ten minutes (both plausible) would make little difference to this piece. There is one changing element, however: the River Nile. Its flow blurred reflections and other surface features, leaving it mysteriously indistinct.

4 BAND OF FERTILE LAND
The three horizontal bands in this photograph represent its major compositional element. The sky and river are represented as broad expanses of gentle tones. Sandwiched between the two is the thin line of fertile soil, its narrowness suggesting the limited sustenance in the region.

THE FRENCH CALOTYPE

The 1850s was a time of great progress for photography in France. Multiple schemes were born, and processes developed, to highlight the scientific and artistic legitimacy of the photographic practice. During the decade, the first ever photographic society, the Société Héliographique, was formed in Paris. The pace of urban development and the realization that photography was uniquely positioned to capture contemporary change led to projects such as the Mission Héliographique. The project, begun in 1851 at the direction of the French government agency, the Commission des Monuments Historiques, was the first of its kind. Its aim was to record the appearance of buildings throughout France. The society's periodical, *La Lumière*, named the five photographers chosen for the task: Edouard Baldus (1813–89), Hippolyte Bayard (1801–87), Gustave Le Gray (1820–84), Henri Le Secq (1818–82) and Auguste Mestral (1812–84).

Of the five photographers involved in the Mission Héliographique, three would work in various media and genres over the course of their prolific artistic lives. Baldus, Le Gray and Le Secq were trained painters who were experimental in their approach to photography, its form and technique, and fought for the

1841	1847	1848	1849	1850	1851
Talbot patents his calotype process in France as well as England, meaning that French practitioners must obtain and pay for a licence.	Louis Désiré Blanquart-Evrard's treatise on paper photography leads to an explosion of calotype activity among French photographers.	Frédéric Flacheron learns calotypy, it is thought, from Giacomo Caneva, a leading figure at the Caffè Greco, Rome, where photographers meet.	Gustave Le Gray opens his photographic workshop in Paris. Many of those whom he instructs in the art will become leading photographers.	Le Gray publishes *A Practical Treatise on Photography, upon Paper and Glass*, asserting 'the entire future of photography is on paper'.	The Société Héliographique, the first society for photography, is founded. It publishes the first issue of its periodical, *La Lumière*.

medium's place within the fine arts. Baldus and Le Gray published important treatises on each of their innovations with the paper negative (calotype) process. The group claimed the calotype—a process originally developed by the Englishman William Henry Fox Talbot (1800–77) but claimed for France by Le Gray on the basis of his refinements—as a means of artistic expression. The process allowed for greater technical experimentation and a wider variety of effects, and it was easier to use outside the studio. The world of photography in France was dynamic and these men were at its centre: they were expert technicians, who had an eye for composition and could balance important projects with their own practices.

The five photographers continued to work independently. They exploited the versatility of the calotype, creating prints of rich colouring and subtle delineation of details, making remarkable photographs such as the closely cropped everyday scene of bathers at the public baths (opposite). Le Secq's composition challenges the viewer's relationship to the scene depicted by leaving no natural place in the foreground in which to stand.

For the Mission Héliographique, France was divided into regions. Le Secq was employed to record buildings in the north-east of France, mainly in the Champagne, Alsace and Lorraine regions, whereas Le Gray and Mestral went to the south-west, together making nearly 600 paper negatives. The travels of the photographers were followed in articles published in *La Lumière*. The efforts of the Mission Héliographique were part of the movement to exploit what was regarded as the impartiality of the photograph for the purpose of systematically recording information. A revival of interest in architectural heritage was under way and it was thought that photographs provided a more detached view than the many engravings and sketches relied upon previously by architects, and that they were more immediate. As a result, architects began to use photography to document restoration work and as source material.

A large part of the discussion about architectural photographs, by architects themselves and critics writing in contemporary periodicals, focused on the communication and dissemination of facts. Photography was well suited to recording architectural sites, from their overall structures to minute details. The photographers involved in the Mission Héliographique aimed to capture both facades and particular architectural elements, documenting the buildings efficiently for architects and restorers while insisting on the artistic nature of photographic image-making.

In 1853 Le Secq and the photographer Charles Nègre (1820–80)—who had been passed over for the Mission Héliographique—came together to produce one of the most evocative and frequently reproduced images from the decade (right). This view of a top-hatted Le Secq standing on one of the balconies of Notre-Dame de Paris, next to the grimacing gargoyle known as 'the Vampire',

1 *Public Baths* (c. 1852–53)
Henri Le Secq • salted paper print from a waxed-paper negative
4 ⅞ x 6 ⅞ in. | 12.5 x 17.5 cm
Bibliothèque des Arts Décoratifs, Paris, France

2 *The Vampire* (1853)
Charles Nègre • salted paper print from a waxed-paper negative
12 ¾ x 9 in. | 32.5 x 23 cm
Musée d'Orsay, Paris, France

1851	1852	1852–53	1852	1854	1854
The names of the five photographers chosen for the Mission Héliographique are published in *La Lumière*.	Henri-Victor Regnault relocates to Sèvres. He photographs on the factory grounds, making architectural studies, still lifes and genre studies.	Eugène Le Dien calotypes in Rome and its environs. Le Gray joins him in 1852.	Amateur landscape photographer Adalbert Cuvelier meets artist Jean-Baptiste-Camille Corot, who takes a keen interest in photography.	Edouard Baldus is commissioned to document the progress of the reconstruction of the Palais du Louvre.	The Société Française de Photographie is established in the wake of the dissolution of the Société Héliographique.

is at once a study of Gothic architecture and a statement about the evolution of the modern city of Paris. Le Secq's urbane, black-suited figure stands looking out over the city, in bold contrast to the medieval stone sculpture and decorated moulding of the cathedral before which he stands. The collaborative nature of this photograph was typical of the period.

Architectural views of foreign countries proved a popular mode for photographers and later served the armchair tourist market well. Maxime du Camp (1822–94), a student of Le Gray, travelled to Egypt in 1851 with the writer Gustave Flaubert. There he captured the pyramids and other great monuments. Eugène Le Dien (1817–65) worked in Rome in the early 1850s, collaborating with Le Gray on a series of studies in 1852. Le Dien's *Sunken Road at the Gates of Rome* (below) is a study of the city seen from afar, brought to life by the use of chiaroscuro. The sunken road with slopes of foliage on either side was a popular framing device and one that here creates a stage for the dome in the distance.

French photographer Henri-Victor Regnault (1810–78) was an enormously significant figure in the practice of paper photography in France and had links with British photographic circles, too. With his image known as *The Ladder* (1853; see p.78), Regnault may have been paying tribute to the great English inventor of the paper process, William Henry Fox Talbot, whose publication *The Pencil of Nature* (1844–46) included two studies featuring ladders (see p.24).

Despite the apparent success of the Mission Héliographique and its contributing photographers, the French government did not publish the images. The public only saw those examples that the photographers chose to include in exhibitions. Organized by the Société Française de Photographie, the first annual exhibition dedicated to photography took place in the summer of 1855. Photographs in all subject areas were exhibited, including architectural and travel views, portraits, still lifes and landscapes. Articles in contemporary periodicals reviewing the exhibition reveal that critics were more often

interested in the process employed by a photographer, and the aesthetic achieved was of secondary concern, whereas photographers themselves sought a balance between technical and artistic merit. Photographers benefited from the publicity the exhibition generated, winning commissions for other work. For example, Baldus's sweeping, majestic landscape *Entrance to the Port of Boulogne* (above) comes from an album commissioned by Baron James de Rothschild, who owned the railway line that ran from Paris to Boulogne. The album was presented to Queen Victoria and Prince Albert during a state visit to France in 1855. Baldus's photograph depicts the jetties that guided ships in and out of the English Channel to the protected harbour. Out at sea towards the horizon, ships can be seen in the Channel waters, whereas in the foreground in the port entrance the blurred shape of a boat is just visible.

Le Gray's photographic career was shaped by his involvement with painting, and by working alongside the Barbizon School of painters in particular. The 'school' included Jean-Baptiste-Camille Corot, Charles-François Daubigny, Virgilio Díaz, Jean-François Millet and Théodore Rousseau, all of whom took inspiration from a direct engagement with nature and worked outdoors. Barbizon was then a village in the Forest of Fontainebleau, south-east of Paris, where the artists gathered to paint and where some of them made their homes. The beauty of the forest inspired a new school of landscape photography. The painters influenced their photographer colleagues greatly. Photography enabled them to capture effects of light and shade or other transitory natural effects, which was something that the painters of the Barbizon School sought. For example, the images that Le Gray and others composed in the forest embodied a new aesthetic in the field of photography and would see them later dubbed as 'Primitives', pioneers of artistic photography. The photographers took their surroundings as their subject matter and Le Gray's *The Forest at Fontainebleau* (c. 1855; see p.80) focuses on the dappled light created by a canopy of trees. Such photographs are distinctive studies of a particular time and place. **AG**

3 *Entrance to the Port of Boulogne* (1855)
Edouard Baldus • salted paper print from a paper negative
11 ⅜ x 17 ⅛ in. | 29 x 43.5 cm
Metropolitan Museum of Art, New York, USA

4 *Sunken Road at the Gates of Rome* (c. 1852)
Eugène Le Dien • lightly albumenized salt print from a paper negative
10 x 13 in. | 25 x 33 cm
Musée d'Orsay, Paris, France

The Ladder 1853
HENRI-VICTOR REGNAULT 1810 – 78

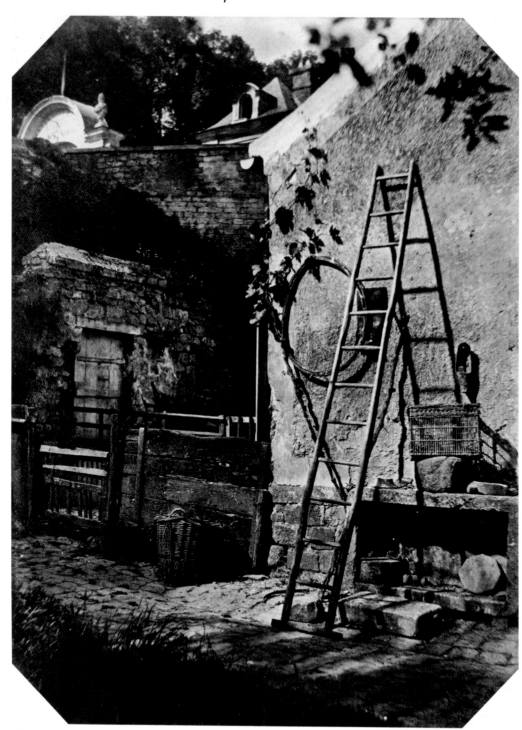

Salt print from paper negative
11 x 8 ¼ in. | 28 x 21 cm
The Royal Society, London, UK

With his nomination as director of the Manufacture Impériale de Porcelaine de Sèvres by Louis-Napoléon Bonaparte (the future Emperor Napoleon III) in 1852, Henri-Victor Regnault became one of the leading government appointees working with photography. Regnault's multiple series of photographs titled *Sèvres, Etudes photographiques* (*Sèvres, Photographic Studies*) were made in and around the town in which he lived, and often in collaboration with Louis-Rémy Robert (1810–82). Image number 205 of the second series (known as *The Ladder*) is a study of light and shadow. It depicts what may loosely be called a still life, in that the focus is on a carefully composed group of objects in the foreground, although the scene is set outdoors. The wooden ladder and basket have been chosen for the effects created when light passes through them. Regnault's use of the paper (calotype) process in the early 1850s resulted in images with a less sharply delineated appearance compared to daguerreotypes. This quality is suited to this study perfectly, which is not about conveying information but about the play of light on different surfaces. Although he captured the grandeur of the Sèvres works in other images, he has relegated the building to the upper left corner in this composition. There is, however, a strong compositional geometry that directs the eye from the grouping of the objects in the foreground to the top where part of the building can be seen. **AG**

👁 FOCAL POINTS

1 STONEWORK
The rough stonework on the left of the image contrasts with the rendered plaster on the wall on the right-hand side. Regnault has captured so much detail and texture in the walls, walkway and woven basket that it encourages the viewer's eye to roam the scene.

2 LADDER
The focal point is the ladder and its sharply delineated shadow. The strong light of midday creates a well-defined diagonal, beating down on the wall in the foreground. It emphasizes photography's ability to capture the shape of objects through light and shade.

3 BASKET
The woven basket is, like the other objects in Regnault's composition, from a pre-industrial age. These everyday items present a pleasing contrast to the factory methods employed in the Sèvres porcelain manufactory.

4 GRASS
The tall grass at the bottom of the image creates a slight remove from the scene. The viewer is not given a place to stand on the cobblestone walk but is pushed back from the foreground. Despite the assumed everyday use of the space, this is a quiet depiction of a moment of inactivity.

🕐 PHOTOGRAPHER PROFILE

1810–50
Henri-Victor Regnault trained as an engineer, graduating at the top of his class from the Ecole Polytechnique. He later furthered his studies in chemistry. Regnault was elected to the Académie des Sciences in 1840 and shortly after began experimenting with the daguerreotype process.

1851–54
Regnault was a founding member of the Société Héliographique. He was an influential advocate of the medium of photography and a high-level government appointee, serving as the director of the Manufacture Impériale de Porcelaine de Sèvres from 1852. Two years later the Société Française de Photographie was founded and Regnault was voted inaugural president.

1855–78
Regnault was involved in photographic circles in France and England, and was elected as an honorary member of the Photographic Society of London in 1855. He never included his photographs in any French exhibitions, taking photographs for his own pleasure and for scientific research.

The Forest at Fontainebleau *c.* 1855

GUSTAVE LE GRAY 1820 – 84

1 TREES AT CENTRE
Le Gray chose a central point, creating a balanced composition. The viewer is drawn to the cluster of trees in the middle, one of which stands in front of the others. The diagonal path originating at the bottom right-hand corner, as well as several other sight lines, lead to this tree trunk.

2 DIAGONAL TREE TRUNK
The tree trunk that cuts through the image diagonally at the top right-hand corner serves as a framing device and provides an immediate foreground. The light is concentrated in the centre and fades as the image recedes, drawing the viewer's eye deeper into the forest.

Salted paper print from a waxed-paper negative
11 ⅝ x 14 ¾ in. | 29.5 x 37.5 cm
Yale University Art Gallery, New Haven, Connecticut, USA

The Barbizon School of painters often operated outside of the mainstream world of the fine arts, although the artists attracted champions in the literary arts and popular periodicals, and had some success at the Paris Salon. Theirs was a romantic endeavour, hailed as a new way of representing one's surroundings. The painters did not idealize or classicize nature, but rather took often overlooked details as their subject matter. They had a lasting effect on the way in which artists engaged with landscape. In 1849 the painter turned photographer Gustave Le Gray joined the Barbizon School in the Forest of Fontainebleau outside of Paris, where he made photographs for the next three years. Painters such as Charles Jacque and Jean-François Millet, who was a pupil of the artist Paul Delaroche with Le Gray, were already working in the area by that time, creating landscapes and studies from nature.

This image by Le Gray is a study of the way in which light penetrates the canopy of trees, creating a dappled effect on the brush below. It highlights the contrast between the verticality of the tree trunks and the diagonal of the path on the right-hand side of the composition, which directs the viewer through the clearing and into the more dense woodland beyond. Le Gray also sets up a visual contrast between the expansiveness of the clearing and the density of the surrounding trees.

Le Gray was a master of both the aesthetic and technical aspects of photography. In 1851 he publicized his waxed-paper negative process, which often lent the negative greater translucency and could render finer detail in the resulting print; it also meant that negatives could be prepared in advance and more photographs taken in one session. Nonetheless, as this study, made from a waxed-paper negative, amply demonstrates, the process did not mean an end to the atmospheric, romantic effects of early calotype aesthetics. It is an excellent demonstration of Le Gray's 'theory of sacrifices', which placed broad effects above all-over detail. **AG**

3 CAMERA
Almost hidden in the far distance of the composition is a tripod camera, which is suggestive of the collaborative nature of art and photograph-making in Fontainebleau. Le Gray used light to delineate shapes, and the gaps between the tree trunks take on as much weight as the trees.

4 BLURRED FOREGROUND
The movement of the brush meant that Le Gray was unable to delineate certain parts of the foreground as sharply as others. The instantaneity of photography afforded success in capturing a moment and Le Gray was praised for his skill in depicting not the monumental, but the real in nature.

PHOTOGRAPHY AND THE FINE ARTS

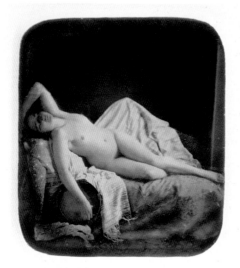 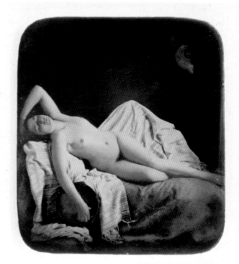

In the mid 19th century photography and painting had a fertile but often furtive relationship, with many painters employing photographs as part of their artistic process. Increasingly, photography became interwoven with painting on various levels. One successful marriage of art and photography was the *cliché-verre* (glass print). A number of artists, most famously Jean-Baptiste-Camille Corot, practised this process, which involved drawing or scratching on to a transparent support—often a piece of glass blackened with smoke—which was then placed on a photosensitized paper, exposed to light and developed. As the results look like etchings, they did not significantly challenge the status quo.

Differing opinions on the value of photographic prints and the degree of artistic ability that they evinced were expressed in the periodicals of the day. Some critics argued that photography stemmed from painting and that the former could not exist without the latter as its teacher. Yet painters learnt from photographers and, whether used as study tools or transferred on to canvases, photographs facilitated painted depictions. Despite this relationship, the give and take was seldom recognized and was scorned by many in the fine arts.

Gathering support among a core group of critics and the public in the 1850s, photography began to establish a place for itself in artists' consciousness. Photographic studios provided inspiration to painters and templates for their canvases. There were techniques such as the grid method for outlining the composition of a painting accurately but nothing was as

KEY EVENTS

c. 1839	1840	1843	1844	1850	1851
Daguerre makes a number of still life compositions featuring copies of art objects as demonstrations of the precision of his invention.	Hippolyte Bayard (1807–87) creates an imaginative self-portrait tableau in which he appears as a drowned man.	David Octavius Hill (1802–70) and Robert Adamson (1821–48) collaborate to create photographic portrait sketches for a painting by Hill.	William Henry Fox Talbot (1800–77) makes the photographic study *The Open Door*. It is in the tradition of the Dutch school of art.	Louis Désiré Blanquart-Evrard (1802–72) introduces albumen-coated paper. By the end of the decade it will supercede salted paper prints.	Eugène Delacroix is one of the founding members of the Société Héliographique in Paris.

immediate as photography. Photography-related periodicals featured articles on inventions and patents developed for the ultimate aid of painters. Many painters began to look to photography as part of their artistic process; photography was well suited to the arrangement of figure studies (see p.54). Photographers collaborated with painters to capture a model's pose, as did Eugène Durieu (1800–74) with the painter Eugène Delacroix, creating an album of nudes (c. 1854; see p.84). Similarly, it has been suggested that painter Gustave Courbet used prints by Julien Vallou de Villeneuve (1795–1866). The Roman studies of landscapes, architectural views, peasants and models by Giacomo Caneva (1813–65), such as *Roman Family with Child* (right), also provided painters with a variety of source material.

Many photographs of nudes, sometimes referred to as *études d'après nature* (studies from nature), can be categorized as belonging to the realm of art. They are carefully composed images focusing on the body in which a model may be draped in fabric and lit in such a way as to reveal the proportions and modelling of the human form. At the other end of the spectrum was pornography. Photography facilitated a surge in erotic imagery, from the titillating to the obscene. In pornographic photographs the model's face might be covered and only her genitals exposed, or she may be engaged in a lewd act—usually with a male figure. In many images, the model's clothing is depicted discarded on one side of the picture plane, calling attention to the act of undressing.

Distinctions between the two genres of nude photography—the academic and the indecent—were not always clear, however, and many photographic studios were prosecuted for distributing obscene imagery. As a result, numerous photographers blurred the line between artistic studies and pornographic pictures in the hope of evading censorship. Such images often incorporate elements derived from the fine arts, including orientalist poses and settings implied by the inclusion of exotic props and fabrics. They were undoubtedly useful when deployed as studies for paintings. Nonetheless, it is clear that many were purchased by those who had no intention of translating them into art: such photographs have a greater sexual charge than most artistic studies. In many the model looks at the viewer, which adds to the suggestiveness. Photographers such as Bruno Braquehais (1823–75) sometimes titled their nude photographs *études académiques* (academic studies), but posed their models provocatively. When French photographer Félix Jacques Antoine Moulin (1802–69) set up his photographic studio, he described himself as a 'specialist in *académies*'—in other words, nude studies. *Reclining Nude* (opposite) is a hand-tinted stereo daguerreotype, which when viewed in a stereo device would have appeared very lifelike. A number of Moulin's nude studies were seized by the police because they were deemed pornographic. As a result the photographer spent a month in prison in 1851. **AG**

1 *Reclining Nude* (c. 1855)
Félix Jacques Antoine Moulin
daguerreotype
3 ⅜ x 6 ⅞ in. | 8.5 x 17.5 cm
Musée d'Orsay, Paris, France

2 *Roman Family with Child* (c. 1850)
Giacomo Caneva • salted paper print
from paper negative
Collection Dietmar Siegert,
Munich, Germany

Plate XXIX from the Delacroix Album *c.* 1854
EUGÈNE DURIEU 1800 – 74

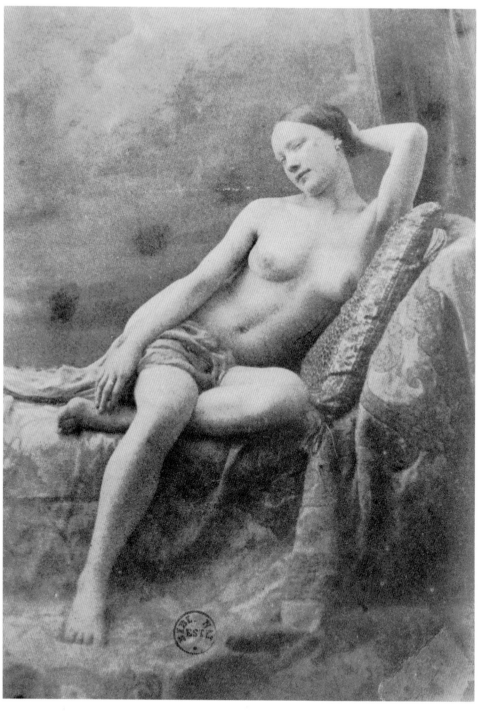

Salted paper print from a paper negative
5 ½ x 3 ¾ in. | 14 x 9.5 cm
Bibliothèque Nationale de France,
Paris, France

I n the summer of 1854 Eugène Durieu worked with his friend, the painter Eugène Delacroix, on a series of nude studies and this image is thought to be one of the results of their collaboration. It is found in an album of thirty-two photographs that was in Delacroix's possession at his death in 1863. Plates I to XXIX in the album are calotypes (paper prints made from paper negatives that were sometimes waxed); the rest are albumen prints made from glass negatives.

This study has the softness and muted range of tones associated with the calotype process, which some would say enhances the artistic effect. On 18 June 1854, Delacroix wrote in his journal: 'At eight o'clock, went to Durieu's place. Until nearly five o'clock we did nothing but pose.' Two months later he noted having sketched from the studies. His well-known painting *Odalisque* (1857) appears to have been based on this photograph, in which the model reclines on an embroidered drapery, leaning into a pillow in the manner of an odalisque. The other images preserved in the Delacroix album rely on a minimum of props, suggesting that they were also to be used as the basis for artworks. To the modern eye, these photographic sketches appear as fully realized works of art in their own right. **AG**

✦ NAVIGATOR

👁 FOCAL POINTS

1 FACE
The model's face has a slight smile and she looks out provocatively at the viewer. Durieu created many nude studies in which the model exposes her back or turns her head away from the camera and this image is unusual for its implied interaction with the viewer.

2 POSE
The model reclines on the chair, displaying her torso to best advantage. She is unadorned, apart from earrings, allowing for the focus to be entirely on her body. The model's flexed left arm contributes to understanding the anatomy of the female form.

3 PILLOW
The embroidered pillow on which the model leans is well defined. Along with the throw that covers the chair, it is the only patterning in the image, as the background appears to be of a uniform tone. Durieu often used bold patterns and animal prints as decorative elements in his nude studies.

4 DRAPERY
The only cover that the model has is positioned to cover her lap. This is placed strategically to prevent exposing too much and to avoid censorship, but at the same time it teases the viewer. It also creates texture to contrast with her smooth skin and the supple contours of her stomach and thighs.

⏱ PHOTOGRAPHER PROFILE

1800–50
Jean-Louis-Marie-Eugène Durieu was born in Nîmes, France. A lawyer by training, he took up photography no later than 1848 and practised as an amateur while serving in various official roles, including as director of the Administration des Cultes from 1848 to 1850. He had a studio in Paris.

1851–53
He became involved with the Commission des Monuments Historiques and supported the Mission Héliographique project, which aimed to record historic French architecture in photographs. Together with the Romantic painter Eugène Delacroix, he became one of the founding members of the Société Héliographique in Paris in 1851.

1854–74
Durieu and Delacroix collaborated to produce a series of studies of female and male nudes. Durieu was a founding member of the Société Française de Photographie in Paris in 1854 and served as the president of the society from 1855 to 1857. After that date he distanced himself from photographic circles.

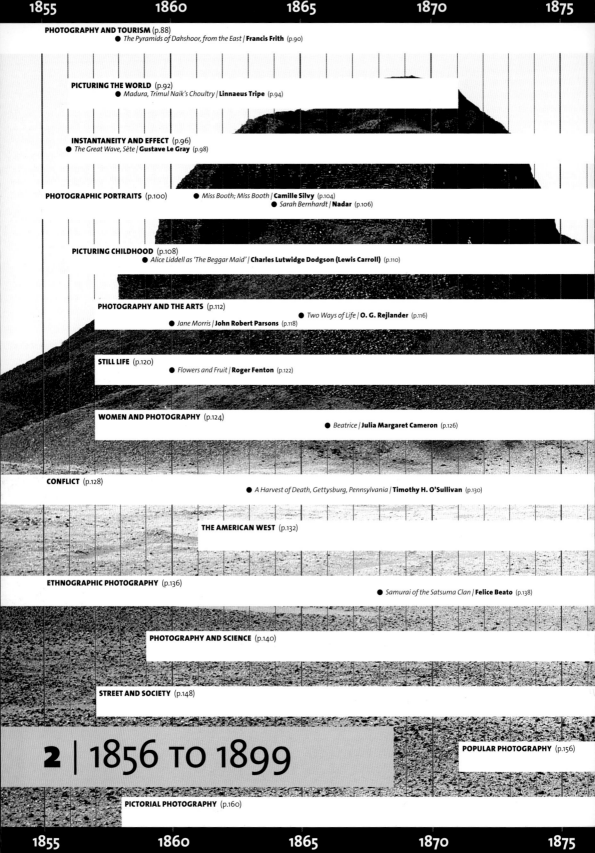

2 | 1856 TO 1899

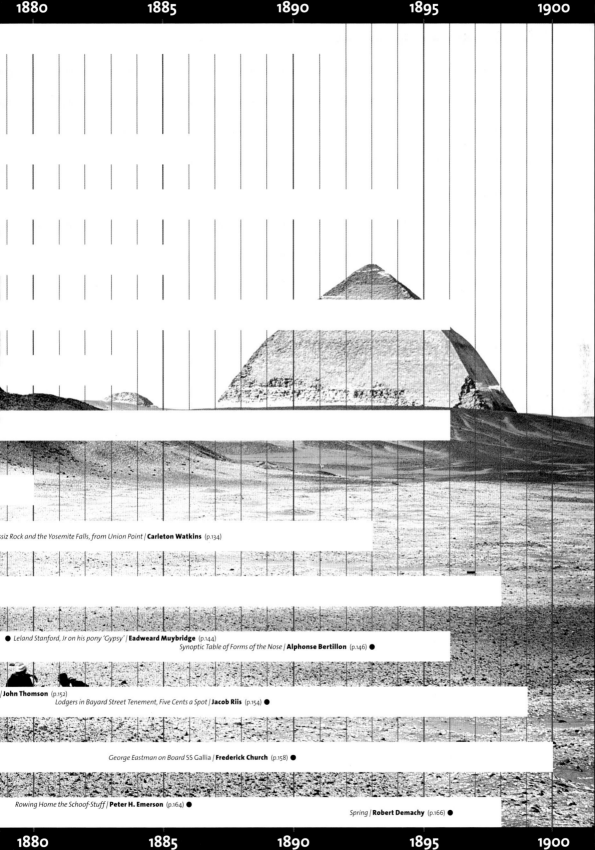

PHOTOGRAPHY AND TOURISM

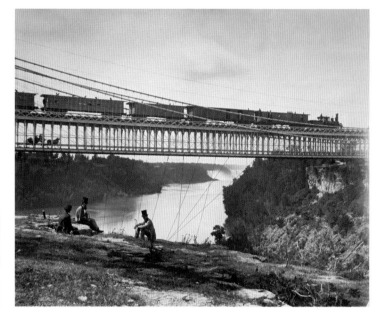

1 *Niagara Suspension Bridge* (1859)
William England • albumen print from
a wet collodion on glass plate negative
9 ½ x 11 ½ in. | 24 x 29 cm
Museum of Modern Art, New York, USA

2 *The New Road Near Rogi* (c. 1866)
Samuel Bourne • albumen print from
a wet collodion on glass plate negative
11 ⅜ x 9 ⅝ in. | 29 x 24.5 cm
Victoria and Albert Museum, London, UK

3 *Figures at the Fountain of Sultan Ahmet
III, Istanbul* (c. 1857)
Felice Beato and James Robertson
albumen print from a wet collodion
on glass plate negative
11 ⅞ x 10 ⅜ in. | 30 x 26 cm
National Galleries of Scotland,
Edinburgh, UK

The 19th century was a period defined by expanding empires and
triumphs of engineering and exploration. *Niagara Suspension Bridge*
(above) by William England (*c.* 1824–96) is notable for the way in which
it perfectly captures photography's place within the rapidly industrializing
Western world. The photograph symbolizes the steam age, a modern feat of
engineering, a group portrait and a scenic view — all juxtaposed with an image
of the fast-disappearing era in the form of a horse and buggy.

Working at the behest of publishers, governments and geographical societies,
early roving photographers came to cater for a public desire for 'true' scenes of
foreign lands. The Grand Tour — an expedition to historic European and Middle
Eastern sites traditionally undertaken by the upper classes to finish their
education — had evolved into a burgeoning tourist industry, of both the actual
and armchair variety. The growing demand for views from remote corners of
the world encouraged photographers to set up commercial studios for the
production and dissemination of images taken on their travels. Larger studios
employed teams of travelling employees working to a brief, turning the
photographic 'view' into a standardized product.

A major impetus to the trade in such photography was the refinement of
the stereoscope, a device through which two near-identical images are viewed,
giving the illusion of three-dimensional space. Embraced by Queen Victoria, by

KEY EVENTS

1849	1851	1851	1854	1855	1856
Scotsman Sir David Brewster (1781–1868) perfects the stereoscopic viewer that was first invented by Charles Wheatstone (1802–75) in 1832.	The Great Exhibition is held in London at Crystal Palace. It features the first major display of photographs, firing public interest in photography.	Frederick Scott Archer (1813–57) publishes his wet-collodion process. Louis Désiré Blanquart-Evrard (1802–72) founds his printing company in Lille, France.	The London Stereographic Society, one of the largest publishers of stereographic views, is founded.	Italian photographic firm Fratelli Alinari presents its work at the Paris Exposition. Its catalogue features photographs of Pisa, Florence and Siena.	Francis Frith travels to the Middle East and the Holy Land. He uses the images produced to establish the foundation for his photographic firm.

the late 1850s it was a common feature in bourgeois Victorian households. Stereoscopes offered an immersive virtual experience ideally suited to the wonders of travel photography. Stereo views began life as daguerreotype images that had limited distribution possibilities; when stereographs were made with albumen prints from negatives, they could be mass-produced. The capital gained from the sale of popular stereo cards facilitated the production of views of ever more exotic and remote locations. William England, who worked for the London Stereoscopic Company as its principal photographer, travelled internationally. His view of the tightrope walker, *The Great Blondin* (1858), crossing Niagara Falls eventually became the most popular stereographic image of all time, selling more than 100,000 copies worldwide. The demand for topographic, sensational, humorous and risqué stereo photographs sealed the penetration of photography into middle-class life that had begun with the portrait.

The most successful 19th-century travel photographer was Englishman Francis Frith (1822–98). Turning to photography after making his fortune as a grocer, in the second half of the 1850s Frith set off on a series of expeditions to document sights in the Holy Land and Egypt, including *The Pyramids of Dahshoor, from the East* (1858; see p.90). He later expanded the inventory of the company he founded in England—Francis Frith & Co.—to include Europe, India and the Far East as well as a comprehensive catalogue of British places of interest. The photographs of Turkish architecture taken by James Robertson (1813–88) and Felice Beato (1832–1909) in the mid to late 1850s showcased the medium's ability to efficiently record intricate details that would take an artist hours or even days to render. With *Figures at the Fountain of Sultan Ahmet III, Istanbul* (below right), the photographers captured the variety of Islamic decoration on the 18th-century architectural masterpiece that stands in front of the Imperial Gate of Topkapi Palace. The photographers demonstrated their mastery of the photographic process by rendering detail even in the shadowed areas, and the photograph is almost tactile in its recording of finely wrought decoration.

Although technological advances enabled the photographer to move outside the studio, the process was still fraught with difficulties particularly when faced with extremes of climate and terrain. To capture views such as *The New Road Near Rogi* (above right), Samuel Bourne (1834–1912), a leading commercial photographer based in colonial India, embarked on perilous expeditions with large convoys of servants loaded down with bulky equipment. He gave the British public its first 'real' glimpse of remote areas of the Himalayas.

The introduction in the 1880s of Kodak's simplified system ('You push the button—we do the rest'), which heralded the rise of popular photography (see p.156), sounded the death knell for the widespread purchase of the commercially produced travellers' photograph for the album. Its second heyday came in the form of the picture postcard, which by the end of the century was in wide circulation. **EL**

1857–58	1860s	1860–61	1862	1863–66	1891
The Indian Rebellion leads to direct British government in India.	Photographic firms supplying photographs of tourist views include Bourne & Shepherd (India), Maison Bonfils (Lebanon) and Bradley & Rulofson (California).	US photographer Carleton Watkins (1829–1916) takes his first pictures of Yosemite Valley in California, USA.	Francis Bedford (1816–94) documents the Royal Tour of the East made by the Prince of Wales. A set of 148 prints is published in 1863.	Samuel Bourne sails to India as a professional photographer. His accounts of his travels in northern India are published in the *British Journal of Photography*.	William Notman (1826–91) dies, having established the biggest photographic business in North America, with seven studios in Canada.

The Pyramids of Dahshoor, from the East 1858
FRANCIS FRITH 1822 – 98

1 CRUMBLING PYRAMID
The deterioration of the pyramid in the foreground contrasts sharply with the one in the background, which escaped the attention of scavengers due to its remote location. This disparity highlights the influence of modernization even upon the relics of ancient cultures.

2 CLOUDLESS SKY
The cloudless sky is an effect typical of early photography. Photographic emulsions were so sensitive to the blue end of the spectrum that by the time the photographer had exposed correctly for the land-based elements, the sky and clouds were overexposed, appearing white in the resulting print.

⬙ NAVIGATOR

Francis Frith's three photographic expeditions to Egypt and the Holy Land were by far the most ambitious of their time. They generated more than 500 unique images, which were published in a variety of formats, including the stereographic views that were widely popular at the time. His larger format prints, and particularly the mammoth-plate prints, such as *The Pyramids of Dahshoor, from the East*, established his reputation as one of the leading photographers of his day.

The wet-collodion technique, which required on-site preparation, was not suited to the sweltering and dusty desert conditions of Egypt. The mammoth-plate camera was particularly cumbersome, requiring a separate vehicle for its conveyance, which also operated as a darkroom. Frith's mastery of the technique in these conditions, and on this scale, secured his status. Perfect for depicting the monumentality of the ancient ruins in the vast desert, the mammoth-plate offered a wealth of detail that absorbed the viewer into the landscape. Frith also carefully composed his views, manoeuvering his equipment into exact locations in order to achieve pleasing compositions. Supporting the composition in this photograph is the arrangement of the three foreground figures, which mirrors the form of the three landscape elements.

Exhibited as early as 1857, Frith's mammoth-plate views were first published as a bound edition described as 'the largest book with the biggest, unenlarged prints ever published'. They were later offered by subscription in instalments, beginning in 1862. At first, Frith sold the publishing rights to his Middle Eastern stereo views to a commercial publisher, which was a common practice. However, the success of his Middle Eastern imagery was so great that he was encouraged to profit fully from his own work by establishing, at the end of the 1850s, his own photographic company in Reigate, Surrey. Francis Frith & Co. became the largest photographic printing company in England, and its projects included an edition of the Holy Bible, illustrated with Frith's photographic views of the Holy Land. It is now known that nearly all the works bearing the Frith stamp were taken by the company's travelling employees, including Robert Napper (1819–67), Frank Mason Good (1839–1928) and Frederick William Sutton (1832–83). Frith also bought up the negative stock of photographer Roger Fenton (1819–69). Frith's family continued to run the business after his death, and Francis Frith & Co. remained in operation until 1971. **EL**

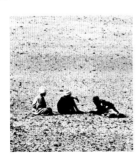

Albumen print from a wet collodion on glass negative
18 ¼ x 17 ½ in. | 46.5 x 44.5 cm
Victoria and Albert Museum, London, UK

3 FIGURES
Frith staged his photographs, directing figures to precise locations within the view to achieve specific pictorial effects. The three figures give a sense of scale, emphasizing the vast structure, and help viewers to identify with the view space by putting themselves in the place of the figures.

4 LIGHT ON SAND
The ability to distinguish detail, such as the play of light on the sand, is a testament to Frith's masterful technique. The use of the mammoth-plate camera with the wet-collodion process in conjunction with albumen paper resulted in an unsurpassed level of clarity and sharpness.

PICTURING THE WORLD

Shortly after photography was invented, daguerreotypists spread throughout Egypt and Russia and it would be only a matter of decades before photography's domain extended to the rest of the Middle East, India, China, Australia, and South and Central America. As a process that diligently recorded whatever was set before it, photography fulfilled the needs of governments, scientists, historians and travellers alike. It was quickly conscripted into attempts to map, inventory, index and categorize both the man-made and natural worlds. These projects invoked photography's reputation as a more reliable source than the artist's pencil and therefore constituted a new kind of visual experience. The resulting images were often used in support of colonial administrations, providing records of the people, places and things under their dominion. In c. 1860–61, for example, British soldiers in the Royal Engineers, who had been taught photography by Charles Thurston Thompson (1816–68)—photographer to the South Kensington Museum (later the Victoria and Albert Museum)—documented the cutting of the 49th Parallel between the Canadian and US border. By the mid 1850s, advances in

KEY EVENTS

c. 1856	1857	1858–60	1859	1862	1864
The rise of the dry-collodion plate allows photographers to prepare negatives in advance, lightening the load and facilitating travel photography.	After the Indian Rebellion, the East India Company folds and the British Raj begins. The focus of colonial photographic projects changes.	*Egypt and Palestine Photographed and Described*, by Francis Frith (1822–98), is published to great acclaim and financial success.	Charles Darwin's *On the Origin of Species* appears. His empiricism motivates others to apply photography to anthropological projects.	John Thomson travels to Asia at the age of twenty-five. Antonio Beato (1832–1906) opens a studio in Cairo.	Louis Vignes (1831–96) tours the Dead Sea with the Duc de Luynes. Charles Nègre (1820–80) publishes Vignes's images as photogravures.

technology, such as the glass negative and later the dry-plate negative, had made photography an even more useful tool for empirical projects. The glass negative allowed for more precise images than the paper negative, and the dry-plate process meant that photographers did not have to prepare and then develop their plates in the field.

In 1856, Linnaeus Tripe (1822–1902) became the official photographer to a division of the East India Company's government in India, for whom he pledged to produce photographs of almost everything under its authority. Tripe's photograph of Trimul Naik's choultry (1858; see p.94) demonstrates his ability to capture even the trickiest of interiors: here, he delivers a high degree of detail—without sacrificing dramatic presentation—despite the challenging play of light in the darkened nave. While British India supported Tripe's photographic practice, the French government sponsored Désiré Charnay (1828–1915), who journeyed to the Yucatán peninsula in Mexico in 1857. Inspired by the books of explorer John Lloyd Stephens, Charnay explored Mesoamerican ruins and produced large glass-plate negatives of the sites. He included the photographic prints in lavish publications that met with critical praise in London and Paris.

Mapping the world by photography did not just involve documenting lands that were exotic to Westerners; remote and inhospitable territories were similarly thrilling when first recorded in this way. In the 1850s, Alpine tourism was growing, and several photographers sought to capitalize on this potential market. Most of them photographed from the base of a mountain up, or across, but Auguste-Rosalie Bisson (1826–1900) saw the advantage that an ascent to the top of Mont Blanc would provide. It took three attempts, and no doubt many failed negatives and frozen equipment, but he finally reached the summit in July of 1861. The photograph made on an ascent in 1862 (right) points to the enormous challenges involved.

Scottish-born John Thomson (1837–1921) lacked any government support and so depended upon his own entrepreneurial skill to manage a series of photographic studios in Singapore, Hong Kong and London. He travelled extensively throughout Asia, transporting heavy and cumbersome photographic equipment, chemistry and delicate glass-plate negatives over awkward terrain. Thomson's combination of intrepid persistence and charm resulted in access to a wide variety of previously unphotographed sites: in 1866 he secured permission from the king of Siam to photograph the massive temple complex of Angkor Wat. He also produced a large body of compelling images of people and places in China. His photograph of the island temple on the River Min (opposite above) is carefully framed to present the temple as a beacon of isolated serenity. A long exposure time has slowed the rippling water to a flat expanse of mirrored glass that reflects the temple, transforming it into a shimmering apparition. **RL**

1 *The Island Pagoda* (c. 1871)
John Thomson • carbon print
8 ⅝ x 11 ⅜ in. | 22 x 29 cm
National Media Museum, Bradford, UK

2 *The Ascent of Mont Blanc Via a Crevice* (1862)
Auguste-Rosalie Bisson • albumen print from a wet collodion on glass negative
14 ¾ x 8 ½ in. | 37.5 x 21.5 cm
Bibliothèque Nationale de France, Paris, France

1867	1868	1870	1873–74	1875	1879
Timothy H. O'Sullivan (1840–82) travels through the American West as part of the United States Geological Survey, led by Clarence King.	Felice Beato (1832–1909) publishes two albums, each featuring around one hundred prints: *Photographic Views of Japan* and *Native Types of Japan*.	The French naval officer Paul-Emile Miot (1827–1900) photographs in the Marquesas Islands.	John Thomson's *Illustrations of China and Its People* is published, a model for future anthropological publications.	John Forbes Watson and John Kaye's eight-volume *The People of India* is completed, comprising 480 photographs of racial types.	Karel Klíč (1841–1926) perfects his photogravure process, making high-quality photographic reproductions for publication possible.

Madura, Trimul Naik's Choultry 1858
LINNAEUS TRIPE 1822 – 1902

1 ARCHED TOP
The arched frame at the top of the image served a purpose. If the resolution decreased towards the edges of the image, due to the limits of the photographic lens, it was usually thought of as a flaw. The corners were trimmed to eliminate this.

2 LIGHT FLARE
Tripe has reached the limits of the exposure time for this photograph—any longer and the individual columns on the right-hand side would blend together, forming a solid screen of light at the bottom half of the columns and leaving the top half of the columns hanging in the blank expanse.

L innaeus Tripe's picture of Trimul Naik's choultry (a resting place for travellers) is certainly one of his most ambitious. Ornately carved columns recede along the empty central axis, punctuated by blasts of sunlight filtering in from the right-hand side. It was essential that he achieve a good balance of sunlight and shadow in this print: too dark and the details would become impossible to see; too light and the right-hand side would be obliterated in a blaze of sunlight. This picture was included in Tripe's series of almost 300 photographs made for the Madras Presidency. Of those, only sixteen were made with a glass negative, this picture being one of them. Perhaps Tripe found that his usual waxed-paper negative required too long an exposure, or that it lacked sufficient detail in the darker areas. Nonetheless, this image demonstrates his technical proficiency with a photographic technology that often presented difficulties, particularly under the hot Indian sun. His photograph was translated into an engraving, and then embellished with small figures to serve as an illustration in James Fergusson's *History of Indian and Eastern Architecture* of 1876.

Tripe first travelled to India at the age of seventeen to join the East India Company as an ensign. Although the company was ostensibly a trading organization, by the 18th century it effectively controlled much of India, often exercising military power in defence of its commercial holdings. Having risen through the ranks in the military wing of the company, in 1856 Tripe was appointed official photographer to the Madras government, one of three 'presidencies' that governed in India. Relieved of his military duties, in his new capacity Tripe could focus on producing a photographic inventory of the architecture, ornament, landscape and races under the Madras government's authority. From this time on, he produced hundreds of paper and glass negatives each year until 1860, when the photographic department of the Madras Presidency was closed. **RL**

Albumen print from a wet collodion on glass negative
9 ½ x 12 ⅜ in | 24 x 31 cm
Peabody Essex Museum, Salem, USA

3 STONE FLOOR AND COLONNADE
The light gleaming off the well-worn stones serves as a counterpoint to the other textures of painted and unpainted surfaces on the 17th-century columns. The stones also provide a path for the eye to wander down, drawn by the warm glow emanating from the far end.

4 DETAIL AND ORNAMENT
For the most part, Tripe made paper negatives, which generally yielded softer results than glass negatives. This photograph, however, benefits from the superior clarity that a glass negative could provide. The ornamental details of the stonework are rendered with precision and definition.

INSTANTANEITY AND EFFECT

1 *River Scene, France* (1858)
Camille Silvy • albumen print from two
wet collodion on glass negatives
12 x 16 ½ in. | 30.5 x 42 cm
Victoria and Albert Museum, London, UK

2 *Rue du Chat-qui-Pêche* (c. 1868)
Charles Marville • albumen print from
a wet collodion on glass negative
14 ⅛ x 10 ⅝ in. | 36 x 27 cm
Metropolitan Museum of Art,
New York, USA

3 *Broadway, New York City in the Rain*
(c. 1860s)
Edward and Henry T. Anthony • albumen
print from wet collodion on glass negative
2 ¾ x 2 ¾ in. | 7 x 7 cm each
Metropolitan Museum of Art,
New York, USA

Despite its verisimilitude, in the 1850s photography was still impeded by the mechanics of photosensitivity and inadequate speed when capturing subjects in motion. This was true even for the new wet collodion on glass process, which on its introduction was marketed, mistakenly so, for its instantaneous capabilities. Before the introduction of the gelatin silver process later in the century, a successful fast exposure depended on the physics of the camera, as smaller sizes—paired with the use of new lenses and mechanical shutters—made it possible to capture detailed views in a fraction of a second.

Even landscape, a relatively static motif, proved a challenge for artistically inclined photographers to render naturalistically. Early photographic emulsions were highly sensitive to blue light, making it difficult to capture details of sky and ground in the same negative. Artistic photographers strove to represent landscape and sky using two or more separate negatives that were combined in printing to great effect. The pictorial unity realized in *River Scene, France* (above) by Camille Silvy (1834–1910) resulted from the synthesis of two separate negatives and skilful retouching.

More than any other subject, the sea offered the greatest challenge to landscape photographers. In an astute merging of art with spectacle, Gustave Le Gray (1820–84) debuted his large-format seascapes of France's coastlines to critical acclaim in exhibitions in the winter of 1856 to 1857. Le Gray had, in many instances, combined separate negatives of foreground and sky, but his most radical achievement was the near-instantaneous registration of waves in motion in *The Great Wave, Sète* (1856–59; see p.98), a success that confirmed

(see p.98)

KEY EVENTS

1856–57	1858	1860	1861	1863	1864–65
Gustave Le Gray exhibits his seascape *Brig on the Water* (1856) in Britain and France to much critical acclaim.	British inventor Thomas Skaife debuts his small 'pistolgraph' camera. The pistol-shaped camera is equipped with a fully mechanical shutter.	Camille Silvy publishes *Studies on Light*. Taken in 1859, the images include posed street scenes that stage the effect of instantaneity.	Studio Ferrier et Soulier exhibits instantaneous stereographic views on glass of Parisian streets at the Société Française de Photographie.	In *The Atlantic Monthly*, writer Oliver Wendell Holmes uses Edward Anthony's street views to analyse human locomotion.	Gaspard-Félix Tournachon (aka Nadar, 1820–1910) takes photographs underground using a battery-powered, carbon arc lamp.

photography's potential for art as well as its success in recording transitory natural phenomena, once considered to be outside the camera's reach.

In 1858 British photographer William Lake Price (1810–96) expressed his desire to record pictures instantaneously, looking forward to the day when 'views in distant and picturesque cities will not seem plague-stricken, by the deserted aspect of their streets and squares'. Yet for some photographers, the representation of unceasing urban life was to be avoided. Commissioned to document Baron Haussmann's ambitious programme of rebuilding in Paris, Charles Marville (1813–79) opted for longer exposures in order to ensure that he did not register casual passers-by, thus imparting a melancholic atmosphere to Paris and its timeworn alleyways (right).

It was not until the 1860s that instantaneous photography entered the public consciousness, as commercial studios began to churn out stereographic views of the modern city. The images issued by Edward (1818–88) and Henry T. Anthony (1814–84) in New York were by far the most impressive at the time, as illustrated in their candid study of hurried pedestrians captured mid stride on a rainy day outside their Broadway studio (below). The popularity of stereographic city views signalled photography's industrial turn, moving away from artistic practitioners overcoming technical limitations to achieve aesthetic unity, towards commercial operators using up-to-date technology to capture the sum of the world's fleeting details open to the camera. These new conditions lay the foundation for the rise of the scientific action photograph and the amateur snapshot. **JWL**

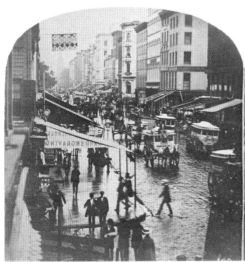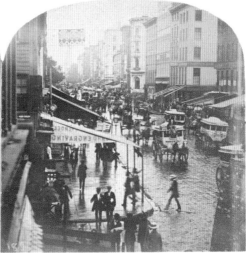

1866	1872	1872	1878	1881	1886
George N. Barnard (1819–1902) publishes *Photographic Views of Sherman's Campaign* during the US Civil War. It has composite images of sky and landscape.	Eadweard Muybridge (1830–1904) is commissioned to photograph a racehorse in motion.	Charles Darwin's *The Expression of the Emotions in Man and Animals* features retouched images by O. G. Rejlander (1813–75).	Charles Harper Bennett (1840–1927) refines the gelatin silver bromide technique into a workable and highly sensitive dry-plate process.	Innovator George Eastman founds the Eastman Dry Plate Company in Rochester, New York. It later becomes the Eastman Kodak Company.	*Die Moment-Photographie* (*Instantaneous Photography*) by Josef Maria Eder is published. It defines the role of amateur photography.

The Great Wave, Sète 1856 – 59
GUSTAVE LE GRAY 1820 – 84

1 SEA WALL

The sea wall that straddles the horizon line is sharply defined. It is balanced compositionally by the dark rocks in the lower right of the photograph. The sea wall's placement may have been a deliberate attempt by Le Gray to suggest that only one negative had been used to create the image.

2 HORIZON

The clearly articulated horizon line helped Le Gray to create a naturalistic scene. He was able to mask out the areas on the negatives that he did not wish to print, exposing the sky from one negative and the sea from another on to the same sheet of photographic paper to produce a harmonious image.

Albumen print from two wet collodion
on glass negatives
13 ¼ x 16 ¼ in. | 33.5 x 41.5 cm
Metropolitan Museum of Art,
New York, USA

◈ NAVIGATOR

G ustave Le Gray was a pioneer of innovative techniques that led to previously unobtainable photographic effects. His experimental approach allowed him to convey a sense of the immediacy found in nature. Achieving a naturalistic sky and foreground on the same negative was difficult because photographic emulsions were sensitive to the blue end of the spectrum; the sky area would therefore blacken on the negative, leaving the sky blank when printed. Exposure times were fast but not instantaneous, which meant that fleeting effects such as the movement of clouds or water and the fluttering of leaves in the breeze became blurred.

For *The Great Wave, Sète*, which was taken near Montpellier in the south of France, Le Gray made several images of the sky and of the sea under varying light conditions and exposed them in pairs on the same piece of photographic paper. The resulting disjuncture between the two images was in part overcome by toning the print a rich, violet-purple colour. However, Le Gray's techniques produced such a convincing impression that his seascapes were hailed by many of his contemporaries as triumphs of photographic art. Indeed, his artistry was such that it has only been widely noted in recent years that many of the seascapes were not achieved with a single negative. **KM**

◷ PHOTOGRAPHER PROFILE

1820–49
Gustave Le Gray was born in 1820 in Villiers-le-Bel. He trained as a painter under Paul Delaroche at the Ecole des Beaux-Arts and took up photography in the late 1840s.

1850–54
Le Gray was responsible for teaching many notable photographers of his generation. He developed the waxed-paper negative in 1850 and in 1851 was one of the founding members of the Société Heliographique in Paris. Also in that year he and Auguste Mestral (1812–84) collaborated on the Mission Héliographique project, backed by the Commission des Monuments Historiques. Le Gray was a founding member of the Société Française de Photographie in 1854.

1855–59
In the mid 1850s Le Gray exhibited and sold his renowned series of seascapes. His innovation was to print some of the seascapes from two separate negatives—one exposed for the sea, the other for the sky—on a single sheet of paper. He also produced portraits, views of Paris and studies of the military Camp de Châlons. Le Gray opened a commercial studio on the Boulevard des Capucines, Paris, where he concentrated on portraiture.

1860–84
Despite his success, Le Gray ran into financial difficulties. In 1860 he left France to tour the Mediterranean with Alexandre Dumas, père, and ultimately settled in Egypt, where he died in 1884.

3 MOONLIGHT EFFECT
The contrast of light and dark in the clouds in Le Gray's image suggested to many a moonlight effect. This effect was not always popular with contemporary critics, some of whom believed that it compromised the realism of the scene depicted. The clouds add to the dark, brooding atmosphere of the seascape.

4 WAVES
The clear action of the breaking and crashing waves amazed Le Gray's contemporaries. It was a mystery to them how he had achieved this instantaneous effect. The answer still eludes scholars today; it is said that he may have used an early version of a shutter and a developing chemistry of his own devising.

PHOTOGRAPHIC PORTRAITS

By the mid 1850s, photographic studios were becoming a feature of high streets all over Europe, the United States and beyond as fashionable places to see and be seen, attracting people from different strata of society. The newly empowered middle classes appreciated being able to be portrayed extensively—something that had previously been the prerogative of the aristocracy—with a method whose mechanical nature seemed to guarantee a direct connection between sitter and image. The upper classes were equally keen to be represented in this modern medium, which was supplanting engraving and lithography as the most common means by which famous people's faces became known through the publication of photographic 'portrait

galleries'. Even Charles Baudelaire, who was scathing of the new medium's artistic aspirations, had himself photographed several times, including by Etienne Carjat (1828–1906), whose portrait of the poet and art critic (right) went on to be used in the *Galerie contemporaine, littéraire, artistique* (*Contemporary Gallery of Writers and Artists*, 1876–84), a weekly series of portraits and biographies of French political and intellectual figures.

Not all commercial portraits were done in the studio. When English photographer Robert Howlett (1831–58) documented the construction of the *Great Eastern* steamship on the banks of the River Thames, he also photographed its engineer, Isambard Kingdom Brunel (opposite), in an example of environmental portraiture. Standing in front of the ship, hands in his pockets and cigar in his mouth, wearing a stove-pipe hat and stacked-heel boots, the great Victorian engineer looks into the distance, the anxiety in his eyes contradicting the confidence of his pose. The massive chains from the ship's stern-checking drum shown in the background emphasize Brunel's huge ambition and small stature, while his formal clothes are rumpled and soiled by the muddy construction site, perfectly representing a new profession that unusually combined a gentlemanly education with hands-on involvement.

In the 1850s photographic portraits were still relatively expensive and technically demanding, but became less so with the advent of the *carte de visite* (visiting card), made using a four-lensed camera. The method had been patented in France in 1854 by André-Adolphe-Eugène Disdéri (1819–89) who, busy with other projects and beset by financial problems, did not start to use it until 1857. The *carte de visite* allowed for up to eight different small portraits to be taken on one full-size plate, making each pose faster, cheaper and easier to compose, because eight poses could be made at one sitting. The process also allowed a degree of experimentation with exposure times. The print, on albumen paper, was then trimmed into individual photographs and usually mounted on card embossed with the studio's name. Each was the size of a calling card, used when paying social calls, measuring approximately 2 1/2 × 4 inches (6 × 10 cm). The lower price per print expanded the market for photographs, while the standardized format made *cartes de visite* easy to exchange, send and collect in special albums featuring pre-cut window mounts.

Their popularity boomed when the political and social elites started to use *cartes de visite* to make their portraits available to the general public. As the craze to collect *cartes de visite* spread across Europe, the United States and the rest of the world, pioneered by photographers such as Camille Silvy (1834–1910) with studies such as *Miss Booth; Miss Booth* (1861; see p.104), a vast array of portraits of people from the worlds of politics, entertainment, the arts and fashionable society were displayed in photographers' shop windows as examples of previous work and as items for sale. Photographers begged to photograph celebrities because of the almost certain profits to be made from

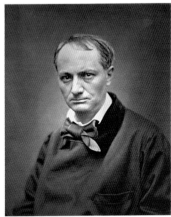

1 *Isambard Kingdom Brunel and the Launching Chains of the Great Eastern* (1857)
Robert Howlett • albumen print from a wet collodion on glass negative
11 1/4 x 9 1/8 in. | 28.5 x 23 cm
Victoria and Albert Museum, London, UK

2 *Charles Baudelaire* (c. 1863)
Etienne Carjat • Woodburytype
Metropolitan Museum of Art, New York, USA

1878	1880s	1880	1888	1889	1890s
Dry gelatin silver bromide plates, developed in 1871 by Richard Leach Maddox (1816–1902), become available on the market.	Cabinet prints, measuring approximately 4 3/8 x 5 7/8 in. (11 x 15 cm), outnumber *cartes de visite*.	Album manufacture is a considerable industry. In Berlin alone, there are forty-eight specialist firms that export worldwide.	Kodak markets the first roll-film camera, and processing and printing services, with the slogan 'You press the button—we do the rest.'	The Camera Gallery in London posthumously exhibits Cameron's photographs.	Halftone reproductions of photographic portraits of celebrities and public figures start to appear in magazines then newspapers.

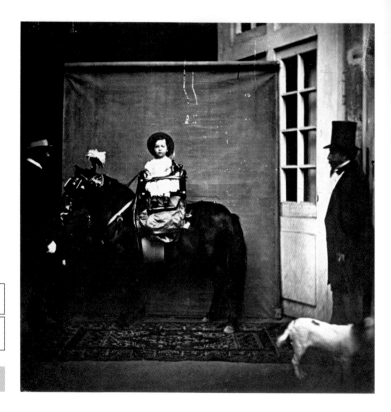

3 *The Prince Imperial on a Pony Beneath*
 a Window (c. 1859)
 Pierre-Louis Pierson • albumen print
 from wet collodion on glass negative
 Metropolitan Museum of Art,
 New York, USA

4 *Sir John F. W. Herschel* (1867)
 Julia Margaret Cameron • albumen print
 from wet collodion on glass negative
 14 x 10 ¾ in. | 35.5 x 27.5 cm
 Museum of Modern Art,
 New York, USA

5 *The Illustrator Aubrey Beardsley* (c. 1894)
 Frederick H. Evans • platinum print
 5 ⅞ x 3 ⅞ in. | 15 x 10 cm
 Musée d'Orsay, Paris, France

them; artists would receive pressing invitations from *carte de visite* photographers as soon as they were elected to their local academy; and photographs of anybody who was the talk of the town would sell, even if only for a few days. The volume of business meant that successful studios became lavishly appointed palaces, and were organized on a pre-industrial scale, maximizing the division of labour and the employment of low-skilled workers in the routine aspects of the job. Some firms specialized in printing large runs of popular *cartes de visite* and distributing them to the stationers and newsagents that sold them all over town.

In France, Disdéri's *carte de visite* of Napoleon III, Empress Eugenie and his son, Alexandre-Louis-Eugène, taken in 1860—looking like an ordinary if elegant well-to-do family—transformed him into a much sought-after photographer. Another firm favourite with the public was *The Prince Imperial on a Pony Beneath a Window* (above) taken by Pierre-Louis Pierson (1822–1913). Today, the details that were intended to be cut off in the finished *carte de visite*—the servant holding the horse, the emperor hovering in the wing, the dog walking out of the frame—are as interesting as the solemn little prince strapped inside the saddle and staring at the camera.

If the daguerreotype followed the aesthetics of the miniature portrait, focusing on the face of the sitter and emphasizing the reliclike qualities of photographs, the *carte de visite* recycled the signifiers of aristocratic status established by a tradition of portrait painting fashionable in Europe since Sir Anthony van Dyke: full-length figures, framed by pillars and billowing fabrics, against a background suggesting country house estates. *Cartes de visite* emphasized socially constructed identity, located not in the face as a mirror of the soul, but in the presentation of the whole body. In the studio, sitters strived to demonstrate how well they could perform gender, class and status, and perhaps personalize the standardized poses and backgrounds through nuances

of dress and posture. Identity was performed rather than expressed. Status, beauty and success were celebrated, signalled as aspirations, or simply made up for the camera. The conformity of studio photography emphasized this ambiguity between reality and role play.

It is not clear to what extent a portrait sold well because the person was famous, or a person was famous because the portrait sold well. Queen Victoria exploited this loop to turn the tide of her popularity when it was at an all-time low, becoming more well-liked through photography than she could ever have been without it. Actresses could become famous in advance of any actual performance by featuring in photographs: Gaspard-Félix Tournachon (1820–1910), known as 'Nadar', photographed Sarah Bernhardt before she was a celebrity (c. 1864; see p.106). Politicians enquired about the sale of their portraits to gauge their own popularity, and writers and artists were happy to oblige photographers because visibility stimulated interest in their work.

The demand for celebrity portraits was not new. Engraved portraits were collected before photography, as loose prints or bound in annuals and illustrated magazines. But they were editions for sale. Their owners could fantasize about knowing and being known to the people portrayed, but could not pretend that the portraits had been obtained through personal connections. *Carte* portraits, however, were the same whether exchanged in friendship or bought in a shop. Owning one of a famous person could imply knowing them well enough to exchange photographs, a gesture that could indicate a degree of intimacy, or simply knowing where to buy it.

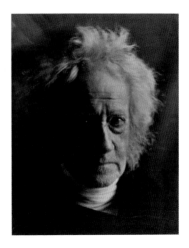

In the late 1860s, as the market was beginning to become saturated, new formats and styles were introduced. The cabinet card became widely used. Measuring approximately 5 1/2 x 4 inches (14 x 10 cm), it gave variety to album displays. Backgrounds became more varied, especially for head and bust portraits, and incorporated complicated props such as swings or even boats.

If, as historian Thomas Carlyle argued, a telling portrait can only be the result of an authentic encounter between portrayer and portrayed, this was understood instinctively by photographers working towards artistic aspirations rather than commercial success. Julia Margaret Cameron (1815–79) photographed her friend and mentor, Sir John Herschel (1792–1871)—a scientist, astronomer, experimental photographer and discoverer of the use of hypo to fix photographic images—four times. Cameron's large portraits of Herschel, closing in on his face and using directional lighting, aimed to record 'the greatness of the inner as well as the features of the outer man', showing him (above right) as a mystical figure with tousled hair, emerging from the dark background and glowing like one of the stars he studied. In the portrait of Aubrey Beardsley (below right) by Frederick H. Evans (1853–1943), the elegance of the pose is perfectly realized in the tonal richness of the platinum print. Evans, a publisher and friend of Beardsley's, exhibited this portrait in 1894 mounted on a photographic copy of one of Beardsley's black-and-white designs at the Photographic Salon of The Linked Ring, which championed art photography.

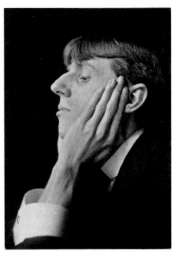

The market and style of portrait photography changed with the development of gelatin dry plates, which shortened exposure times and allowed manufacturing and processing to be separated from the act of taking pictures. George Eastman realized that future business expansion was not in taking photographs but in selling the means to take them. In 1888 he started to market Kodak cameras, and a year later the first commercial transparent roll film. The main convenience was the processing and printing services that Kodak provided, which were cheap and easy to use. After all the exposures had been taken, the camera was sent back to Kodak and returned loaded with film, accompanied by the prints from the previous roll. When technically successful, these amateur portraits, typically taken during a holiday or leisure outing, had an informality that could make studio portraits seem stiff and contrived. **PDB**

Miss Booth; Miss Booth 1861

CAMILLE SILVY 1834 – 1910

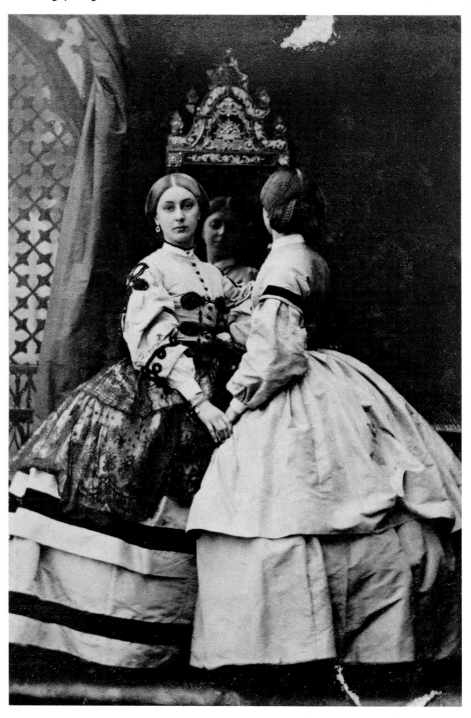

Albumen print from a wet collodion
on glass negative
3 ⅜ x 2 ¼ in. | 8.5 x 5.5 cm
National Portrait Gallery, London, UK

This photograph can be dated precisely because Camille Silvy kept daybooks with labelled proof prints of most of his portraits. His 'Repertory', as he titled the volumes, has since become an important source on the working of a major 19th-century studio. Like all of Silvy's *cartes de visite*, this study stands out for its elegant composition, flattering lighting and the rich tones of the print. The latter were achieved partly by using gold toning, which also made the prints less prone to fading.

Silvy's background as a diplomat distinguished him from many of his peers, who were often self-made men from relatively humble beginnings. Although it is not clear how much time he spent in his studio, he nonetheless gained a reputation as a superior photographer, and photographed aristocrats and royalty. He is said to have worn white gloves in order to avoid giving offence when touching his clients to improve their pose, something not all photographers were willing or able to do. Silvy was also renowned for the care that he, or his staff, took in personalizing his studio sets in order to suit the individual sitters. Scientists were posed with real scientific apparatus, and art lovers with real sculptures—many provided by his friend, the sculptor Baron Carlo Marochetti. Silvy's studio produced portraits that, however small in size, often appear rich with symbolism and suggested narratives. It is likely that he learnt how to achieve this by photographing actors, musicians and opera singers.

Women and mirrors had been a motif in paintings since the Renaissance as a symbol of the futility of vanity, because beauty, like a mirror image, will not last. In this photograph, the Venetian mirror emphasizes the sisters' beauty and resemblance, while also suggesting an allegorical significance for the pose; one of the women faces the photographer confidently while the other averts her eyes from her own reflection. **PDB**

◉ FOCAL POINTS

1 MIRROR
In the 19th century mirrors were still accessories with an aura of luxury, and were used in portraits of women to emphasize their all-round beauty. The mirror, however, is also a reference to photography itself, often described at the time as 'the mirror with a memory'.

3 POSE
The women hold hands in a gesture of intimacy, yet one sister turns away, showing the curves of her hairstyle and back. Her face is only visible in the reflection. The composition is reminiscent of classical mythology's The Three Graces, often interpreted at the time as three views of one woman.

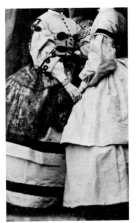

2 DRESS
Sisters were often portrayed together in paintings and photographs of the time. Their resemblance, coupled with the use of the mirror, suggests doubling. Their different personalities, implied by the pose, are reflected in their dresses that fill the frame, one more richly decorated than the other. Both outfits, however, are at the cutting edge of fashion for their time in their use of geometric patterns, linear trimmings and the latest flat-fronted crinolines.

◷ PHOTOGRAPHER PROFILE

1834–57
Camille-Léon-Louis Silvy was born in Nogent-le-Retrou, France. After studying law, he worked as a diplomat. Silvy took up photography in 1857 when he was posted to Algeria, where he photographed landscapes, architecture and still lifes.

1858–67
He had landscapes exhibited in Edinburgh, London and Paris. In 1859 Silvy gave up his diplomatic career to work as one of the first *carte de visite* portraitists in London.

1868–1910
The recession and changing fashions affected *carte de visite* studios, and Silvy sold his photographic business. He returned to consular duties and was based in Exeter, England.

Sarah Bernhardt *c.* 1864
NADAR 1820 – 1910

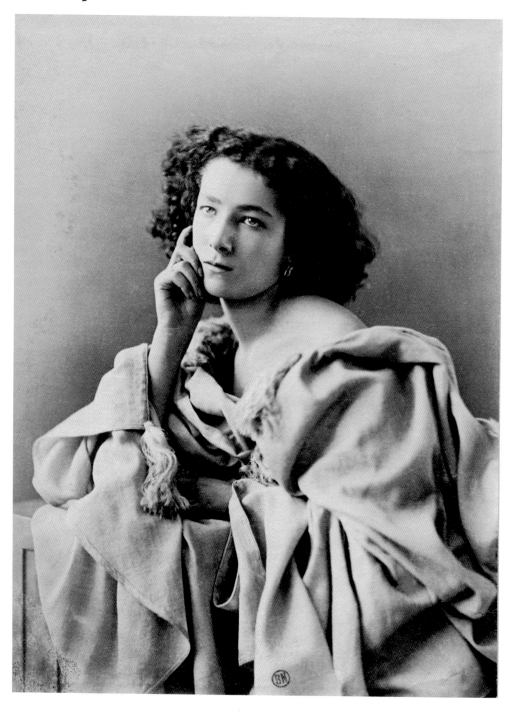

Modern positive image from original wet
collodion on glass negative
8 ⅜ x 6 ¼ in. | 22 x 16 cm
Bibliothèque Nationale de France, Paris, France

By the time this portrait was taken, Gaspard-Félix Tournachon—known as 'Nadar'—was leaving most of the photography in his studio to business partners. They used his signature as a trademark to entice customers who wanted a fashionable photographer's name on their otherwise standard *carte de visite* portraits. He pursued other interests such as ballooning, aerial photography and journalism, working at the studio only for noteworthy commissions. He must have seen something special in the young actress Sarah Bernhardt, who was yet to achieve the extraordinary success she went on to enjoy. Later in life, her celebrity made her one of the first media stars. The resulting photograph, which does not seem to have been widely circulated at the time and is now known through modern prints from the original negative, is in the same large format of his work in the 1850s, in the style that has made him one of the few photographers of his time to achieve both commercial and artistic success. **PDB**

FOCAL POINTS

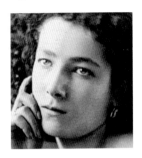

1 FACE
Unlike most commercial photographers, Nadar was willing to experiment with directional lighting. The side highlights emphasize Bernhardt's perfect jaw line, smooth skin and long neck. The eyes, slightly in shade by comparison, seem to shine with a brightness of their own.

2 DÉCOLLETAGE
A 'V' shape of bright tones draws the eye of the viewer towards Bernhardt's décolletage, which is shrouded in soft focus, shadows and fabrics. The sharp details pick out the sensual folds of the fabric draped over her arm. The drapes are arranged to suggest a shapely body underneath.

3 PILLAR AND CURTAIN
Nadar uses what were by then well-established stereotypes of *carte de visite* portraits, the ever-present pillar and curtain, but subverts them to turn the actress into a classic draped figure. Instead of cascading at the side of the composition, the fabric is used to wrap Bernhardt's body, and the viewer wonders if she is dressed under the drapes. As a result, the subject is not merely an actress in costume or a young woman in her best clothes, but a timeless beauty.

4 HANDS
The sitter's elegant hands and almond-shaped nails are in the sharper area of the composition. Hands were considered an important sign of gentility at the time, and Nadar's portraits often accentuate the character of a subject's hands as significant details formed by the sitter.

5 COMPOSITION
The focus of attention is the triangle formed by the eyes, the hands and the folds of fabric. The blurrier outer sections—the drape at the front and her hair at the back—give a three-dimensionality to the overall composition. The pale drapes resemble those of a classical marble statue.

PHOTOGRAPHER PROFILE

1820–53
Born in Paris, Gaspard-Félix Tournachon worked first as a journalist and then as a caricaturist for *Le Charivari* and other satirical newspapers, becoming known as 'Nadar'.

1854–59
Nadar took up photography and opened a portrait studio in Paris, photographing writers, artists and intellectuals. In 1858 he became one of the first to take pictures using artificial light—with a series of photographs of Paris sewers—and took the first successful aerial photograph from a balloon.

1860–1910
Business pressures forced him to adopt the *carte de visite* format. In 1886 Nadar pioneered the photo interview, with a series of photographs of French scientist Eugène Chevreul.

PICTURING CHILDHOOD

In the late 1850s and early 1860s, a second wave of amateur photographers with artistic inclinations emerged in Britain. Less cohesive than the network that surrounded William Henry Fox Talbot (1800–77) in the 1840s, these amateurs were nonetheless known to each other, and one of their shared artistic interests was the use of children and young women as models.

The most celebrated figure among these amateur photographers was Charles Lutwidge Dodgson (1832–98), the mathematician and Oxford don better known as Lewis Carroll. Nine years before he published his first book for children, *Alice's Adventures in Wonderland* (1865), Dodgson took up photography and became a prolific amateur. A significant proportion of his photography was of young girls, dressed in their best clothes or wearing costumes from his dressing-up box, partially undressed and, very occasionally, nude. Dodgson's photographs of young girls are remarkable for their imaginative play, as seen in *Alice Liddell as 'The Beggar Maid'* (c. 1859; see p.110). In a photograph of one of Dodgson's regular sitters, Irene MacDonald (above), the girl is not dressed in the prim and proper clothing of the period. Instead, she is posed as a partially dressed odalisque—the Orientalized female nude popular in 19th-century art—holding a fan. And yet the fiction of the little girl as harem temptress is not fully sustained: her patent Mary Jane shoes and ankle socks are clearly on display.

KEY EVENTS

1856	1858	c. 1860	1861	1862	1863
Roger Fenton (1819–69) photographs Princesses Helena and Louise, daughters of Queen Victoria, as part of his last commission for the royal family.	Henry Peach Robinson (1830–1901) produces his four-part *tableau vivant* of 'Little Red Riding Hood'. He uses a stuffed dog dressed in bedclothes for the wolf.	O. G. Rejlander (1813–75) makes *Night in Town*, showing a child in rags sitting on a doorstep. It is later used to highlight the plight of homeless children.	Henry Mayhew asserts 'the extreme animal fondness for the opposite sex' of 'street children' in volume four of *London Labour and the London Poor*.	Many commercial photographers show portraits of children at London's International Exhibition, displaying their naturalistic portraiture skills.	There are no entries in Charles Dodgson's diary for three days in late June. It is thought that this is when his friendship with the Liddell family ended.

Evidence suggests that Dodgson was obsessed with befriending young girls and, when possible, photographing them. This has led to debate as to whether his interest in young girls was platonic. However, Dodgson was not the only amateur photographer of the period who produced images of young children in varying states of dress and undress. Moreover, the most notable of these photographers were women.

Lady Clementina Hawarden (1822–65) had married into the aristocracy in 1845. A love match opposed by her husband's family, Clementina and the Hon. Cornwallis Maude had ten children, two of whom died in infancy. Hawarden is thought to have taken up photography in 1857 after her husband inherited the family title and estates. When they took a house in London's South Kensington in 1859, she used the rooms on the second floor as her studio. Hawarden's oeuvre runs to nearly 800 images and the majority of her work portrays her elder daughters. They are photographed in the fashionable dress of the day, in historical costume and, occasionally, in déshabillé.

It is not immediately obvious that *Photographic Study—Clementina Maude, 5 Princes Gardens* (right) is an eroticized image until the viewer realizes that Hawarden's eldest daughter is pictured in her chemise. Such a daring display of bare shoulders and arms would at this time have been confined to the dressing room. Unlike Irene MacDonald, who in Dodgson's photograph engages the viewer with her direct gaze, Clementina Maude is posed in a moment of reverie, seemingly oblivious to the fact that she is being photographed. A beautiful woman studying her own mirrored reflection was a conventional device borrowed from the fine arts.

Julia Margaret Cameron (1815–79) took up photography when she was forty-eight and the mother of five children. She went on to become a prolific photographer, portraying servants, family, friends, acquaintances and cultural celebrities in her distinctive, out-of-focus style. Her 'first success', as she called it, was a portrait of a local girl, Annie Philpot (1864). Children became a trademark of her work: pictured alone as in the religious image *The Infant Samuel* (1864), with other children as in the metaphorical study *The Double Star* (opposite below) and with adults as in the allegorical *The Whisper of the Muse* (1865), which features the artist George Frederic Watts. Cameron's child sitters, particularly babies, were often naked or partially undressed, yet she is never accused, as is Dodgson, of an unhealthy interest in young children.

Dodgson, Lady Hawarden and Cameron showed their photographs to others and even exhibited them at London's Photographic Society. Dodgson frequently gained the consent of the parents before photographing their daughter or daughters, and he sometimes presented the parents with prints from the sitting. This does not mean, however, that these photographs are entirely innocent. Depictions of children and young women at play served to critique the conventions that governed adult life. **JH**

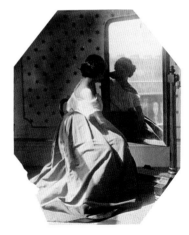

1 *Irene MacDonald* (1863)
Charles Lutwidge Dodgson • albumen print from a wet collodion on glass negative
Gernsheim Collection, Harry Ransom Center, University of Texas at Austin, USA

2 *Photographic Study—Clementina Maude, 5 Princes Gardens* (1861–62)
Lady Clementina Hawarden • albumen print from a wet collodion on glass negative
Victoria and Albert Museum, London, UK

3 *The Double Star* (1864)
Julia Margaret Cameron • albumen print from a wet collodion on glass negative
Victoria and Albert Museum, London, UK

1864	1865	1868	1871	1879	1885
Julia Margaret Cameron achieves what she calls 'my very first success in photography', a portrait of a young girl, Annie Philpot.	Having received silver medals for her photographs, Lady Clementina Hawarden dies from pneumonia at the age of forty-two.	W. & D. Downey issue their *carte de visite* portrait of Princess Alexandra giving her daughter a piggyback. It is said that 300,000 copies were sold.	O. G. Rejlander makes his popular study of a toddler crying. It comes to be known as 'Ginx's baby', a reference to the novel by Edward Jenkins (1870).	Charles Dodgson makes his nude study of a pre-pubescent Evelyn Hatch. She is posed with arms behind her head and eyes fixed on the lens.	William Stead publishes his exposé of the vice trade in London. The British Parliament passes a law raising the age of consent from thirteen to sixteen.

Alice Liddell as 'The Beggar Maid' *c.* 1859
CHARLES LUTWIDGE DODGSON (LEWIS CARROLL) 1832 – 98

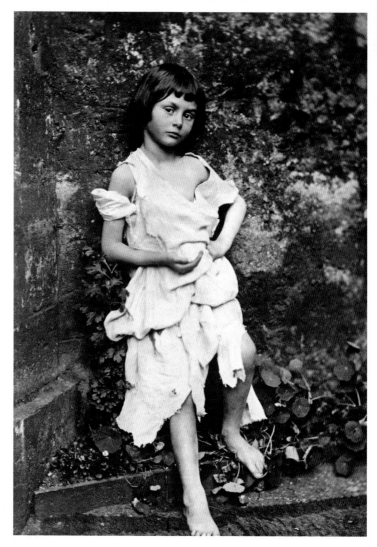

Albumen print from a wet collodion
on glass negative
6 ½ x 4 ⅜ in. | 16.5 x 11 cm
Gilman Collection, Metropolitan
Museum of Art, New York, USA

✜ NAVIGATOR

Charles Lutwidge Dodgson was a twenty-four-year-old Oxford mathematics don when he first took up photography in 1856. That same year he made the acquaintance of the Liddell family, who had come to live at the Deanery of his Oxford college, Christ Church. Dodgson—who seems to have enjoyed the company of children as much as that of adults—first made friends with Harry Liddell but, in time, came to think of Harry's sister, Alice, as his 'ideal child-friend'.

During the years that he was friendly with the Liddell family, Dodgson made numerous photographic studies of Alice, and her sisters Lorina and Edith, in their own clothes and in costume. This study of *Alice as 'The Beggar Maid'* (made when she was aged about seven) is thought to have been inspired by Alfred Tennyson's poem 'The Beggar Maid' (1842). Based on a medieval legend, the poem tells the story of King Cophetua, who encountered on the road a barefoot beggar maid of such beauty that he determined to marry her. **JH**

1 ALICE'S FACE
Her boyish crop, familiar today, was unusual at the time. This is not the meek beggar maid of Tennyson's poem but a spirited young girl who looks directly into the camera lens. Readers of Carroll's *Alice* books will note that the girl who inspired them looked nothing like John Tenniel's illustration of the character.

2 SETTING
Alice is placed before an old, moss-covered stone wall. The roughness of the stone and the moss sets off the softness of her skin. The setting is the outside wall of the Deanery of Christ Church, Alice's family home. This suggests that such play-acting was sanctioned by her parents. Dodgson gave Alice a hand-coloured print of this photograph, although the friendship was over by the time *Alice's Adventures in Wonderland* was published in 1865.

3 FEET AND FLOWERS
For the Victorian viewer, bare feet could signify both poverty and sexual availability. Dodgson would often wage a campaign on mothers to agree to allow their daughters to be photographed, in costume and/or partially dressed. He usually began by asking for 'bare feet'.

4 CLOTHES AND CUPPED HAND
Alice's rags are picturesque but they also allow for play outside the parameters of conventional propriety. Her shoulder and part of her chest are exposed —as is, possibly, her nipple. A cupped hand signifies her status as a beggar but its position close to her body (no doubt to keep her hand still during the exposure) lends the image a sexual dimension: worldly men who viewed this photograph would be reminded that children worked in the vice trade.

1832–45
Charles Lutwidge Dodgson was born in Daresbury, Cheshire, in north-west England. As a youngster, together with his ten siblings as collaborators and audience, Dodgson gave vent to his imagination in poems, drawings and short stories.

1846–53
In 1846 Dodgson was sent to Rugby, the boarding school immortalized by Thomas Hughes in *Tom Brown's Schooldays* (1857). He began his studies in Oxford in January 1851. Two days later, on the eve of his nineteenth birthday, his mother died.

1854–65
Dodgson earned a BA in 1854 and was appointed as a lecturer at Oxford in 1855. In 1856 he bought an Ottewill's folding tripod camera and began photographing in his spare time.

1866–79
After the success of *Alice's Adventures in Wonderland* (1865), Dodgson wrote academic texts (*Euclid and his Modern Rivals*, 1879), children's books (*Through the Looking-Glass, and What Alice Found There*, 1871) and nonsense poems (*The Hunting of the Snark*, 1874). He also pursued photography in Oxford.

1880–98
Dodgson gave up photography in 1880 and teaching a year later. He remained at Christ Church until his death in 1898.

LEWIS CARROLL'S ALICE

During a River Thames boating trip on 4 July 1862—in the company of Alice, Lorina and Edith Liddell, and a fellow Oxford don—Charles Lutwidge Dodgson made up a story about a young girl falling down a rabbit hole into a fantasy world. At the insistence of the ten-year-old Alice Liddell, Dodgson wrote down the story. He presented the handwritten and illustrated manuscript, then called *Alice's Adventures Under Ground*, to Alice as a Christmas gift in 1864. The following year, it was published under the author's pseudonym—Lewis Carroll—as *Alice's Adventures in Wonderland*. Dodgson had expanded the original text for the published version, adding episodes such as those featuring the Cheshire Cat and the 'Mad' Tea Party. The book, which included illustrations by John Tenniel, caused a publishing sensation and was soon loved by adults and children alike. Its early fans included Queen Victoria and Oscar Wilde. In 1871 a sequel—*Through the Looking-Glass, and What Alice Found There*—was published. The books made Lewis Carroll a household name. However, Alice Liddell's family 'broke' with Dodgson in 1863 for reasons never confirmed. Then in 1876, Mrs Liddell unexpectedly brought Lorina and Alice to see Dodgson, who photographed them one last time.

PHOTOGRAPHY AND THE ARTS

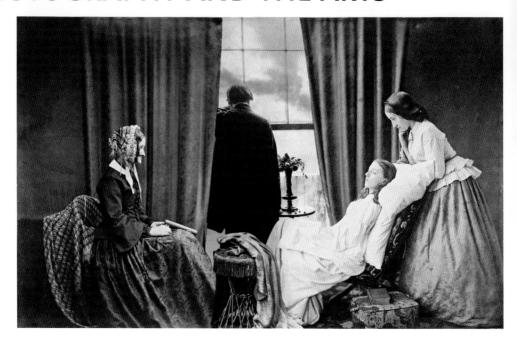

I n the decades following the announcements of the invention of photography by Louis-Jacques-Mandé Daguerre (1787–1851) and William Henry Fox Talbot (1800–77), debates about whether photography was an art or a science played out in various contexts. In 1857, for example, photographs were shown at the Manchester Art Treasures exhibition, which was dedicated to the fine and decorative arts. In 1862, the organizers of the International Exhibition in London declared that they would not exhibit photography alongside art, such as painting and sculpture, but in the section dedicated to machinery. When the photographic community objected, it was decided to present the photographs in the section for 'non-descripts', thus avoiding any classification. Despite the difficulty of reaching a consensus—legal or otherwise—of whether photography was indeed art, attempts to assert the artistic status of the medium were both extensive and ambitious.

Many critics felt that photography was not, and could never be, art because it is a mechanical process. Others argued that the camera was, like the paintbrush, simply one of many tools available for making art. Photographers who took the latter view turned their cameras towards picturesque subjects such as landscapes and ruins, applying established rules of artistic composition and lighting. Those most intent on demonstrating photography's artistic

potential chose themes that traditionally belonged to the realm of painting, such as narrative genre scenes or subjects that drew on the imagination. Roger Fenton (1819–69) was a particularly vocal advocate for photography's status as art. He came to photography from painting and was instrumental in founding the Photographic Society of London (now the Royal Photographic Society) in 1853. In addition to highly accomplished portraits, picturesque landscapes and lush still lifes, he made a series of Orientalist studies including *Pasha and Bayadère* (right). In this image, Fenton plays the role of the pasha (a high-ranking Ottoman official) and the landscape painter Frank Dillon, who had travelled in Egypt, poses as a musician.

In order to establish photography as a recognized art form, it was important to demonstrate to critics how imagination and idealization could be expressed photographically. One of the most ambitious and notorious photographs to stake a claim for photography's ability to depict not only the real but also the ideal was *Two Ways of Life* (1857; see p.116) by O. G. Rejlander (1813–75). Unable to photograph simultaneously the dozens of figures that make up this complex allegory of the merits of industry over idleness, Rejlander used more than thirty separate negatives to compose the picture. Composition photography—as this method of picture-making came to be known—was debated extensively in the photographic societies and within the pages of their journals. Its proponents argued that it was the perfect tool for creating artistic photographs because it allowed for full control over the various components of a picture; its detractors lamented its artifice.

Rejlander was not the first photographer to combine separate negatives in a single print—in France, Gustave Le Gray (1820–84) had produced dramatic seascapes (1856–59; see p.98) composed from two separately exposed negatives for sky and sea—but the use of such a large number of negatives was unprecedented. Rejlander soon taught the technique, also called combination printing, to Henry Peach Robinson (1830–1901). Robinson used the technique for much of his career and relied on it as a tool for promoting his firm belief that, in the hands of artists who understood the rules of composition and lighting, photography could aspire to—and achieve—the status of pictorial art.

Robinson's first combination print was *Fading Away* (opposite), a depiction of the final moments of a graceful young consumptive surrounded by her family. For Victorian viewers, the image evoked not only the distressing reality of disease but also the romantic associations of consumption, which was linked with artistic creativity and unrequited love. Indeed, Robinson exhibited a study of *Fading Away*'s central figure under the title 'She Never Told Her Love'. Although some viewers were disturbed to see such an intimate and morbid scene represented in a medium as realistic as photography, Victorian audiences recognized that Robinson had photographed a model acting a part, not an actual dying girl. The contrived nature of the print—made from five separate

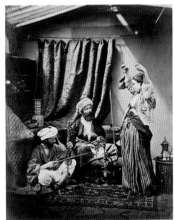

1 *Fading Away* (1858)
Henry Peach Robinson • albumen print from five wet collodion on glass negatives
11 ½ x 20 ½ in. | 29 x 52 cm
Royal Photographic Society Collection, National Media Museum, Bradford, UK

2 *Pasha and Bayadère* (1858)
Roger Fenton • albumen print from a wet collodion on glass negative
17 ¾ x 14 ¼ in. | 45 x 36 cm
J. Paul Getty Museum, Los Angeles, USA

1865	1869	1872	1874	1875	1888
Julia Margaret Cameron exhibits her photographs at the South Kensington Museum (later known as the Victoria and Albert Museum).	Henry Peach Robinson publishes *Pictorial Effect in Photography: Being Hints on Composition and Chiaroscuro for Photographers*.	Charles Darwin publishes *The Expression of the Emotions in Man and Animals*, illustrated with photographs by O. G. Rejlander and Duchenne de Boulogne.	The first Impressionist exhibition is held in Paris in the former studio of photographer Gaspard-Félix Tournachon (aka Nadar, 1820–1910).	The 'father of art photography', O. G. Rejlander, dies in poverty.	George Eastman manufactures the first Kodak camera. Popular photography invigorates the practice of photography as an art form.

3 *Dancer Adjusting Her Shoulder Strap*
(c. 1895–96)
Edgar Degas • gelatin dry-plate negative
7 x 5 ⅛ in. | 18 x 13 cm
Bibliothèque Nationale de France,
Paris, France

4 *G. F. Watts* (c. 1860s)
David Wilkie Wynfield • carbon print
8 ¼ x 6 ¼ in. | 21 x 16 cm
Royal Academy of Arts, London, UK

5 *Eakins's Students at the 'The Swimming
Hole'* (1884)
Thomas Eakins • albumen print from
a dry-plate negative
3 ⅝ x 4 ½ in. | 9 x 11.5 cm
J. Paul Getty Museum, Los Angeles, USA

negatives—may not have been immediately apparent, but the overtly
theatrical nature of the composition, with its friezelike arrangement of figures
framed by parted curtains, signalled that *Fading Away* was a staged scene.

The production of self-consciously artistic photographs flourished in
Victorian Britain, although there were examples made in the United States,
France and Germany. British photographers embraced the tactic of elevating
photography to 'high art' by combining the seemingly truthful medium of
photography with imaginary subject matter, often in the form of allegorical,
literary or historical scenes. Like Fenton and Robinson, many of the photographers
working in this vein had trained as artists. For example, David Wilkie Wynfield
(1837–87), one of the St John's Wood Clique of painters, photographed fellow
artists dressed in the historic costumes seen in the Old Master paintings that
they admired (opposite above). His close-up, soft-focus portraits were a source
of inspiration for Julia Margaret Cameron (1815–79), who is one of the most
revered artists in photography. Another artist turned photographer, William
Lake Price (1810–96), trained as an architect before becoming a watercolourist,
lithographer and photographer. His most characteristic photographs, including
one depicting Don Quixote surrounded by antiquities in his study, are
elaborately staged scenes from history or literature. After seeing the
Photographic Society exhibition of 1856, Charles Lutwidge Dodgson (aka

Lewis Carroll, 1832–98) noted his admiration for Lake Price's work in his diary and was inspired to make similar tableaulike photographs. Lake Price also wrote *A Manual of Photographic Manipulation, Treating of the Practice of the Art, and its Various Applications to Nature* (1858), which was the first photography guide to offer advice on aesthetic issues such as composition and lighting.

For some, the closest connection that photography had to art was as a 'handmaiden', capable of recording studies of the human anatomy and other subjects for the painter to copy. However, a suite of striking nude figure studies, among the most original of the period, remains unattributed, perhaps because very few 19th-century painters were open about their reliance on photographic studies. Nonetheless, some major artists were profoundly influenced by their engagement with the medium. Eugène Delacroix, for example, embraced photography early on. He learnt how to make daguerreotypes and collected photographs of nudes, some of which he posed himself (see p.84). Later in the century, Edgar Degas (1834–1917) took up photography in the latter stages of his career as a painter and sculptor. In addition to photographing family and friends, often dramatically and artificially lit, he made a series of studies of dancers, including *Dancer Adjusting Her Shoulder Strap* (opposite).

In the United States, painter and teacher Thomas Eakins (1844–1916) also made extensive use of photography. He appreciated it as a valuable tool for studying human anatomy and movement, which were essentially aspects of artistic training. There is close correspondence between certain photographs and paintings in his oeuvre, including the painting *The Swimming Hole* (1885) and a photograph of the same subject (below). In the photograph, the nude young men—in and out of the water—are Eakins's students; the only figure facing the camera is Eakins himself. Recent scholarship suggests that on other occasions Eakins worked even more directly from photographs by projecting them on to the canvas. In addition to producing many nude studies, he photographed his friends and family. He used the expensive platinum printing process for some of these photographs, which suggests that he viewed them as works of art in their own right. Like-minded photographers and critics continued to assert photography's status as art, as the relationship—harmonious at times and rivalrous at others—between photography and the traditional arts was explored in subsequent decades. **MW**

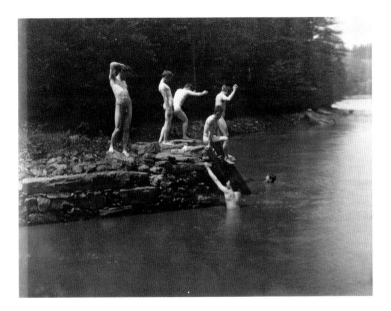

Two Ways of Life 1857

O. G. REJLANDER 1813 – 75

Carbon print after original
albumen print
16 x 30 ¾ in. | 40.5 x 78 cm
Royal Photographic Society Collection,
National Media Museum, Bradford, UK

When it was first exhibited at the Manchester Art Treasures exhibition in 1857, *Two Ways of Life* attracted controversy for its use of nudity, for the 'untruthful' nature of its production and for its lofty ambitions as a work of moralistic high art. It also raised O. G. Rejlander's professional profile considerably. He explained that he had intended the work as a competition piece that would demonstrate the excellence of British photography and the artistic potential of the medium. Both the allegorical subject matter and the technique of constructing a picture from independent parts—it was painstakingly constructed from more than thirty separate negatives—attested to the work's artistic ambition.

The profusion of nude figures disturbed the sensibilities of many viewers. Although the nude was an accepted subject for painting and sculpture, some critics considered it improper for such a realistic medium as photography. The nudity seemed all the more shocking to those who did not grasp the fact that the figures had not all gathered in front of the camera at once, but had been photographed individually. A complex and ambitious moral allegory, *Two Ways of Life* is representative of the desire among certain mid-19th-century British photographers to prove photography's worthiness as high art. **MW**

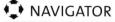 NAVIGATOR

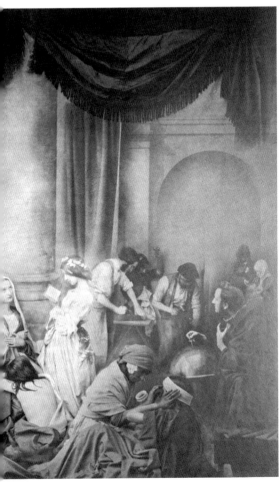

PHOTOGRAPHER PROFILE

1813–61

Oscar Gustave (or Gustaf) Rejlander, who styled his middle and last names in a variety of ways, was born in Sweden in 1813. He studied painting in Rome during the 1830s and did not take up photography until 1853, taking lessons in the wet-collodion process in the studio of Nicolaas Henneman (1813–98). He exhibited his first photograph in 1855.

1862–70

Rejlander moved to London in 1862, opening a studio in Malden Road, and then Victoria Street in 1869. In addition to portraits and staged narrative scenes, he made studies for artists, sometimes arranging his figures in direct imitation of figures in Old Master paintings.

1871–75

In 1871 Charles Darwin commissioned him to make photographs for his book *The Expression of the Emotions in Man and Animals* (1872). Rejlander died in London in 1875.

👁 FOCAL POINTS

1 SINFULNESS

The figures at the table on the left engage in sinful pursuits. Two semi-nude women 'display their charms to tempt the youth'; another two recline to embody Idleness. The haggard woman in the foreground warns of their inevitable downfall. The whispering women at the back represent Complicity.

2 THREE MEN AT THE CENTRE

At the centre a father, or sage, leads two brothers from the countryside of their youth into the world of adulthood, where they face a choice between the 'two ways of life'. The son on the left of the composition is lured by the attractions of a life of sin; the son on the right looks to the righteous path.

3 CURTAINS, ARCH AND COLUMNS

The curtains reinforce the theatricality of the picture. The arches and columns refer to Raphael's fresco *The School of Athens* (1509–10), as does the arrangement of the figures. The unadorned column on the right represents Purity, while the vine-covered one on the left denotes Decadence.

4 VIRTUE

The right side of the image represents the virtuous life. The woman with a penitent at her feet is Religion. To her right Knowledge reads a book. Behind her a group of artisans represent Industry. In the foreground Mercy helps a wounded figure and a man with a globe stands for Mental Application.

5 THREE WOMEN IN FOREGROUND

The composition of the central group is balanced by two nude figures, one seen from behind. The figure on the left holds a cup in each hand to represent drunkenness. Her opposite, with her veiled face turned away in shame, is Penitence. Her hand rests near an anchor, a symbol of hope.

Jane Morris 1865
JOHN ROBERT PARSONS C. 1825 – 1909

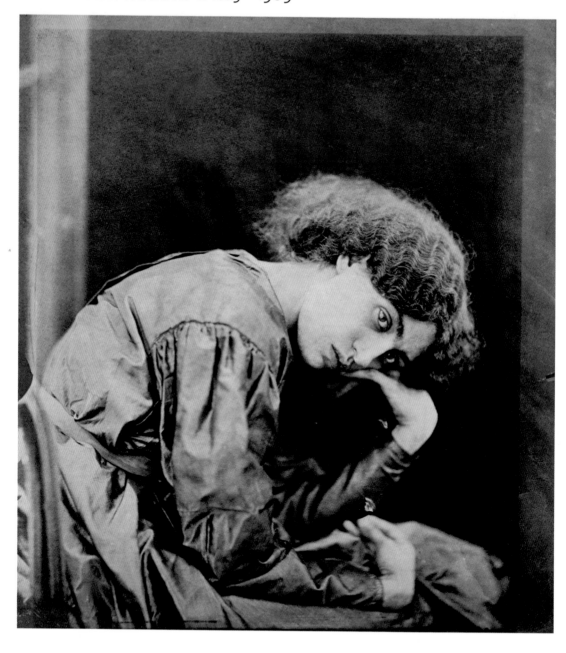

Albumen print from wet collodion on glass negative
15 ⅜ x 13 in. | 39 x 33 cm
Victoria and Albert Museum, London, UK

✦ NAVIGATOR

This striking image of Jane Morris is one of a series of eighteen portraits taken by John Robert Parsons. He made the photographs in the summer of 1865 in the garden of Tudor House, the London home of the poet, painter and co-founder of the Pre-Raphaelite Brotherhood, Dante Gabriel Rossetti. Rossetti commissioned Parsons to make the photographs but arranged the poses himself, and their relaxed intimacy is very different from the more formal portraits that the photographer made in his professional studio. Although Rossetti did not actually copy any of Parsons's photographs of Jane Morris—drawing directly from life was a key tenet of Pre-Raphaelitism—very similar poses appear in several of his drawings and paintings of Morris. Rather than serving as precise studies, Rossetti may have used the photographs to help him visualize certain poses and as an aide-memoire for when his model was not available.

Jane Morris was Rossetti's main model and muse from 1865 until the end of his life. She was the wife of the influential writer, designer and craftsman William Morris, who was a close friend of Rossetti. With her abundant hair, strong features and sensuous mouth, Jane Morris embodied Pre-Raphaelite notions of feminine beauty. Today, the photographs are remarkable records of her extraordinary looks and demonstrate that Rossetti's renderings of her are not as stylized as might be presumed. **MW**

◉ FOCAL POINTS

1 HAIR AND FACE
Illuminated by daylight, Jane Morris's sharply focused face stands out against the dark, out-of-focus background, accentuating her shapely lips, thick eyebrows and large eyes. Her dense mass of wavy hair is well defined around her face, but dissolves into a frizzy cloud around the back of her head.

2 EXPRESSION
Morris's expression acknowledges the camera, and her large eyes return its gaze with a look that is at once relaxed and confrontational. The gesture of a face resting on a hand suggests thoughtfulness, and Rossetti made a chalk drawing of Morris in the same pose titled *Reverie* (1868).

3 POSE
In contrast to the assertiveness of her expression, Morris's pose suggests a dreamy languor. Her face rests on one hand and her long back and neck form an elegant curve. Each of her hands, bent at the wrists and curled inward, echoes the form of her overall pose, which seems to spiral in on itself.

4 DRAPERY
Morris eschewed the body-confining corsets that were prevalent at the time. The camera records the minutiae of the folds and creases of her dress, picking up the texture and sheen of the fabric. This is the level of detail that many Pre-Raphaelites strove to depict in their paintings.

⏱ PHOTOGRAPHER PROFILE

c. 1825–49
The little that is known of John Robert Parsons's life has been pieced together by photographic historian Colin Ford. Parsons was probably born in County Cork, Ireland and moved to London in the 1840s.

1850–69
Parsons exhibited paintings at the Royal Academy of Arts, London from 1850 to 1868. By the 1860s, he had taken up photography and opened his first studio in Portman Square. In addition to making studio portraits, he photographed paintings by Dante Gabriel Rossetti and James Whistler.

1870–89
In the early 1870s Parsons went into partnership with Rossetti's dealer Charles Augustus Howell. He ran a studio in Wigmore Street from 1870 to 1877, but by 1878 had given up photography. According to his obituary in *The Times*, he exhibited his paintings for the last time in 1888.

1890–1909
Parsons declared bankruptcy in 1892 and died from natural causes alone in London in 1909.

STILL LIFE

S till life was a vibrant genre for photography in the mid to late 19th century. Although the technology available to photographers of the period was cumbersome, it was used to create elaborate compositions based on precedents from the fine arts, innovative design patterns and test images that showcased new developments such as colour photography. Derived from the 17th-century Dutch word *stilleven*, still life most often depicts everyday objects from the domestic and natural worlds. The great advantage of still life photography is that it allows the photographer to exert total control over the aesthetics and technicalities of the subject, to experiment with lighting and to practise on a subject that neither moves, complains nor changes unduly. The photographer can make the picture before actually taking it.

Roger Fenton (1819–69) practised every aspect of photography during his ten-year career. He turned his attention to still life in 1860 but only for a brief time. His visual cataloguing work for the British Museum over a six-year period, during which he photographed busts, paintings, statues and archaeological

KEY EVENTS

1857	1859	1860	1861	1861	1862
Roger Fenton exhibits eight photographs at the Manchester Art Treasures exhibition.	On 25 December Napoleon III awards Adolphe Braun the French Legion of Honour in recognition of his work.	Fenton's assistant in the Crimea, Marcus Sparling (1822–60), dies in April. Four days later, Fenton's only son, Anthony Maynard, dies aged fifteen months.	Physicist James Clerk Maxwell projects three black-and-white images of a tartan ribbon through red, blue and green filters to create a full colour image.	On 14 December Prince Albert dies unexpectedly of typhoid and British photography loses an important advocate.	Fenton wins a Prize Medal at the International Exhibition in London for his 'fruit and flower pictures' and 'good general photography'.

specimens, gave him expertise in using light and tone. His large-format, still life prints were widely exhibited, and pieces such as *Flowers and Fruit* (c. 1860; see p.122) state his artistic credentials emphatically. The still lifes were greeted with lavish praise by the photographic press (one reviewer remarked that they would be even more desirable in colour).

Still life played a distinguished part in the progress of colour photography during this period. From 1859, Louis Ducos du Hauron (1837–1920) anticipated, described and, occasionally, was even able to demonstrate every future development in colour photography over the next eighty years. He produced the marvellous *Still Life with Rooster* (opposite) of stuffed birds. The image is made up of three layers of pigmented gelatin on a shellac support, the three colours appearing around the edge. French inventor Charles Cros (1842–88), an equally inspired experimenter with colour, chose a domestic still life table setting for his demonstration of the trichrome process in 1869.

The Frenchman Adolphe Braun (1812–77) trained as a fabric designer before turning to photography. He intended his photographs of flowers to be transferred to printing blocks for wallpapers and textiles and he published a catalogue of 300 plates, *Fleurs photographiées* (*Flowers Photographed*, 1854). His floral still lifes typically have the apparent artlessness of botanical specimens, but on closer inspection it is obvious that the petals, leaves and stems have been precisely arranged in order to emphasize the design element of the composition as well as the texture and ephemerality of the flowers.

Frenchman Charles Aubry (1811–77) designed patterns for carpet, fabric and wallpaper manufacturers for thirty years before forming a company making plaster casts and photographs of plants, fruits and flowers. Initially he intended his photographs to be used by students in Parisian drawing schools in place of lithographs, but the French government was unsympathetic to funding such an idea. In 1869, he approached France's best-known photographer, Gaspard-Félix Tournachon (1820–1910) known as 'Nadar', with the suggestion that they form a partnership using Nadar's name and fame to market Aubry's images. Perhaps influenced by the success of Braun's business enterprise, Aubry envisaged that he and Nadar would make their fortunes. The venture was never realized. Aubry's still life compositions are less arranged, simpler and more immediate than those of Fenton, with a flat, abstract and naturalistic perspective. In 1864 he published an album, *Etudes de feuilles* (*Studies of Leaves*), from which *An Arrangement of Tobacco Leaves and Grass* (right) is taken. Printed large, the detail is exquisitely captured by a slow close-up lens and an exposure time of forty-five minutes. The leaves appear to have been dipped in a light coat of plaster—as was his practice—prior to being photographed, giving them a uniformity of colour and surface. His photographs are based largely around plant forms such as flowers and leaves, often delicately laid on a textural fabric such as lace, velvet, watered silk or tulle. **PGR**

1 *Still Life with Rooster* (c. 1879)
Louis Ducos du Hauron • three-colour carbon transparency
8 ⅛ x 8 ¾ in. | 20.5 x 22 cm
George Eastman House, Rochester, New York, USA

2 *An Arrangement of Tobacco Leaves and Grass* (1864)
Charles Aubry • albumen print from a wet collodion on glass negative
18 ½ x 14 ⅝ in. | 47 x 37.5 cm
J. Paul Getty Museum, Los Angeles, USA

1865	1868	1869	1870	1877	1883
Charles Aubry declares bankruptcy. He is able to pay off some debts when his studio in Paris is appropriated as part of Haussmann's renovation of the city.	Joseph Swan sets up the Autotype Company to produce carbon prints, a permanent photographic process. He sells the French rights to Braun.	Louis Ducos du Hauron publicly demonstrates his subtractive colour photographs on paper at a meeting of the Société Française de Photographie.	Adolphe Braun's firm, Adolphe Braun et Cie, becomes a highly successful studio and takes between 4,000 and 8,000 negatives in one year.	Charles Cros, pioneer of colour photography, invents a type of gramophone.	Adolphe Braun et Cie secures an exclusive thirty-year contract to photograph art objects at the Louvre.

Flowers and Fruit *c.* 1860
ROGER FENTON 1819 – 69

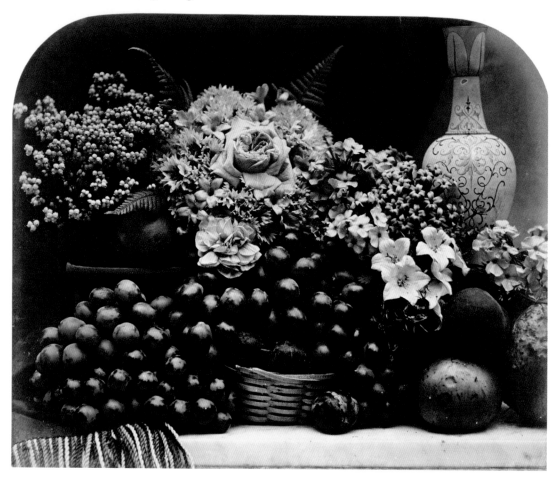

Albumen print from a wet collodion
on glass negative
11 ⅛ x 11 ⅜ in. | 28 x 29 cm
Royal Photographic Society Collection,
National Media Museum, Bradford, UK

✸ NAVIGATOR

Roger Fenton's series of more than forty negatives of lush and sculptural still life compositions of fruit and flowers, arranged on marble and fabric, was rapidly realized during the summer of 1860, when the wet, foggy weather made landscape photography impracticable. Fenton used the same fruits in more than one image, as can be seen from their gradual decay: true nature morte.

As photographer to the British Museum from 1853 to 1859, Fenton had plentiful opportunity to experiment with composition, lighting, chemistry and lenses while he photographed inanimate objects of various sizes and materials—sculptures, paintings, geological and anthropological specimens— in the museum's collections. He set up and photographed the still life series much as he had worked at the British Museum, using at least three different cameras, maybe four: stereo, medium, large and even larger format. It is often possible to see camera reflections in the polished surfaces of grapes and cherries. The still lifes reflect the interests and material resources of the wealthy Victorian middle classes: the new greenhouse technology, the exotic imported produce of the British Empire and the coded language of flowers. Poignantly, they also celebrate the brevity of life at a time when Fenton had recently lost both his son and his photographic assistant. **PGR**

◉ FOCAL POINTS

1 PILES OF FLOWERS AND FRUIT
By piling fruit and flowers in a fecund heap, Fenton takes the classical conventions of still life composition present in the work of contemporary Victorian painters such as George Lance and Edward Ladell and gives them three-dimensional reality. He fills the frame with abundant produce, photographing it at close range and at eye level to compress the space and immerse the viewer in the composition. The still lifes were met with praise from Fenton's peers.

2 GOLD TONING
Most of Fenton's still life albumen prints are gold toned with gold chloride giving them a rich purple-brown colour. Gold toning alleviated the problem of fading, which was a concern for early photographers, and Fenton chaired the Fading Committee set up by the Photographic Society in 1855 to research photographic longevity. Its findings emphasized the need for careful print washing, the use of protective varnishes and gold toning.

3 APPLE AND MELON
The apple at the front of the picture on the right shows dents and bruises accumulated from its starring role in several of Fenton's still lifes. The melon or squash on the edge of the frame shows a mould spot which, in later still lifes in the series, is cut away to show the fruit's ripe squashy interior.

4 FLOWER SYMBOLISM
Each flower has subtle nuances of meaning depending on its context. Fenton uses roses and lilies associated with the Virgin Mary and the Annunciation, as well as ferns, sweet William, pinks, China asters, hoya, lilacs and Canterbury bells for textural and visual emphasis.

5 GRAPES
Fenton may have intended his still life series to be an homage to the grape, which figures in approximately eighty per cent of his still life compositions. Often dusky with bloom, the grapes will ferment, mature and make wine. Wine glasses, decanters and other wine-related items appear in such images, emphasizing sensual experience. Close observation reveals that the bunch of grapes in the wicker basket appears in seven different still lifes by Fenton.

⏱ PHOTOGRAPHER PROFILE

1819–42
Roger Fenton was born at Crimble Hall, near Bury, Lancashire into a wealthy, land-owning family. Fenton attended University College London and studied law, intending to become a barrister.

1843–52
Fenton studied painting in Paris then in London; from 1847 he studied under history painter Charles Lucy and exhibited in several Royal Academy exhibitions. Resuming his legal studies, he qualified as a barrister in 1851. The next year he began to practise photography, possibly influenced by the display of photographs at the Great Exhibition in London. So began a successful ten-year photographic career. Also in 1852, he travelled to Moscow, Kiev and St Petersburg, photographing architecture.

1853–54
After visiting the Société Héliographique in Paris, Fenton proposed the formation of a similar photographic society in the British capital, the Photographic Society of London. In 1853 he became the society's first honorary secretary and was very active in its organization for nearly a decade; later it became the Royal Photographic Society. The same year he began working for the British Museum.

1855–59
Fenton covered the Crimean War and his photographs are among the first ever to depict war. They were published as engravings in *The Illustrated London News* and exhibited as a travelling show. He went on to photograph British landscape, topography, architecture and portraiture (including a series of informal portraits of Queen Victoria and her family). In 1858 he produced a series of costumed shoots resulting in fifty photographs depicting scenes based on Orientalist themes. He exhibited widely, winning many medals.

1860–69
He made a series of more than forty still lifes In 1862 he resigned from the Royal Photographic Society and sold his apparatus and negatives. Fenton retired from photography and returned to practise law. He died in 1869.

WOMEN AND PHOTOGRAPHY

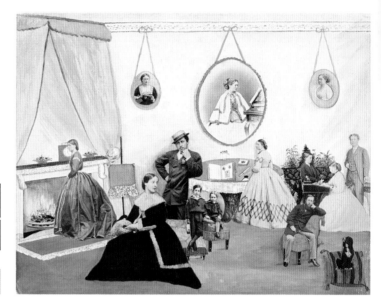

1 *Lady Filmer in her Drawing Room*
(mid 1860s)
Mary Georgiana Caroline, Lady Filmer
collage of watercolour and
albumen prints
8 7/8 x 11 1/8 in. | 22.5 x 28 cm
Paul F. Walter Collection,
New York, USA

2 *Scherzo di Follia*
(1863–66)
Pierre-Louis Pierson • silver print from
original glass negative
7 3/8 x 4 7/8 in. | 18.7 x 12.5 cm
Metropolitan Museum of Art,
New York, USA

3 *Self-portrait (as 'New Woman')* (c. 1896)
Frances Benjamin Johnston • silver print
4 3/4 x 3 3/4 in. | 12 x 9.5 cm
Library of Congress,
Washington, DC, USA

Women played a significant role in photography's early history—working alongside their husbands, printing for them and, of course, taking photographs themselves. By 1900, there were more than 7,000 professional female photographers in the United Kingdom and United States. Studios advertised the availability of 'lady operators' for women who felt more comfortable being photographed by a woman, especially because being posed might involve physical contact.

Marie Lydie Cabanis (1837–1918) worked at La Maison Bonfils, the Beirut studio she had founded with her husband Félix Bonfils (1831–85), while he travelled taking architectural and landscape photographs of the Middle East. In France, Geneviève Disdéri (c. 1817–78) ran photographic studios quite independently of her husband in her native Brest and later in Paris. Women amateurs such as Lady Clementina Hawarden (1822–65) were active in photographic clubs, producing some of the most interesting images of the time. Being an 'amateur' did not imply lower standards of quality, but simply that the photographs were not sold to provide an income. Julia Margaret Cameron (1815–79) used the freedom of the amateur to work with the medium as an artist, creating painterly works that frequently drew on literature for their inspiration, such as *Beatrice* (1866; see p.126).

Women played a crucial role in the reception of the new medium. In a society preoccupied with demonstrating social status, photograph albums

see p.126

KEY EVENTS

1857	1859	1860	1861	1862	1863–64
Art critic Lady Elizabeth Eastlake publishes her article on photography in the *Quarterly Review*. She notes that many women practice photography.	Harriet Tytler (1828–1907) exhibits photographs taken, with her husband Robert, of sites linked with the Indian Rebellion (1857–58).	Queen Victoria starts to collect *carte de visite* albums. By putting together albums, aristocratic women help to spread photographic culture.	The British census lists 168 women photographers and assistants. This figure would rise to 694 by 1871.	Hannah Maynard (1834–1918) opens a studio in Victoria, Canada. Her oeuvre includes portraits, landscapes and experimental work.	For two years running, Lady Clementina Hawarden wins medals from the Photographic Society of London for best work by an amateur.

visualized the social 'set' a family belonged to, aspired to enter or admired from afar. Upper-class English women such as Lady Mary Filmer (1838–1903) used their skills in drawing and cutting intricate paperwork to create photocollages that questioned the realism of photography and disrupted dominant notions of respectable femininity. In *Lady Filmer in her Drawing Room* (opposite) she is seen standing next to her albums, which are at the centre of her social gathering. The different scale of the original photographs—mainly commercial *cartes de visite*—highlights the centrality not of her husband, seated near the dog, but of the Prince of Wales, standing by the table. Cutting photographs to recontextualize them in handmade arrangements emphasizes Filmer's casual intimacy with the prince—she had so many photographs of him that she could afford to cut them up for fun—but someone acquainted with the gossip in the prince's 'set' might also recognize her glance towards him as an implication that they share more than an interest in photographs. The two were indeed involved in a 'flirtation', partly carried out through the exchange of photographs. Throughout her photocollage albums, Filmer emphasizes the ambiguity of the significance of exchanging portraits, and the indeterminate, flirtatious relationship between photographs and meaning. Like other 19th-century female photographers, she understood that photography enabled new forms of creativity based on using rather than making images.

In France, Virginia Countess de Castiglione worked with photographer Pierre-Louis Pierson (1822–1913) on a highly charged, almost obsessive series of photographs of herself in a variety of outfits, re-enacting scenes from popular culture or from her own life, and at times posing in daring close-ups of her naked limbs, the beauty of which had been legendary in the days when she was Napoleon III's mistress and a fashionable figure in French society. *Scherzo di Follia* (above right) comments on photography itself, as the countess mirrors the gaze of the lens using a photographic mount to frame her own eye, highlighting its beauty and expressiveness while also hiding her ageing face. If Filmer's album pages prefigure the semantic ambiguity and irony of 20th-century collage and photomontage, Castiglione's 'mad' photography highlights the phantasmagorical, hallucinatory qualities that the Surrealists later saw in all photographic portraits because of their supposed capacity to reveal the unconscious desires of the sitter or the viewer.

Frances Benjamin Johnston (1864–1952), a successful professional photographer, portrayed herself as a 'new woman' (right) in the late 1890s, striking a very masculine pose with a cigarette and a tankard. She was not the only US photographer to play with gender roles. Alice Austen (1866–1952), who had been taking photographs since the age of ten, embraced cross-dressing in *Julia Martin, Julia Bredt and Self Dressed Up as Men* (1891). She appears to have been unique for doing so in the context of a body of work portraying a lifestyle that today is read as lesbian. **PDB**

1864	1865	1888	1889	1896	1897
Shima Ryu (1823–c. 1900) photographs her husband, producing the earliest known photograph by a Japanese woman.	Julia Margaret Cameron has a one-woman show at Colnaghi, the prestigious London fine art print dealer.	In recognition of the rise of female interest in photography, Kodak markets cameras and processing services to mothers and 'new women'.	Catherine Barnes Ward (1851–1913) begins promoting women's photography. In 1890, she joins *American Amateur Photographer* journal as a writer.	Gertrude Käsebier (1852–1934) exhibits her Pictorialist photographs at the Boston Camera Club, and goes on to open a studio in New York.	Frances Benjamin Johnston publishes 'What a Woman Can Do with a Camera' in the *Ladies' Home Journal*.

Beatrice 1866
JULIA MARGARET CAMERON 1815 – 79

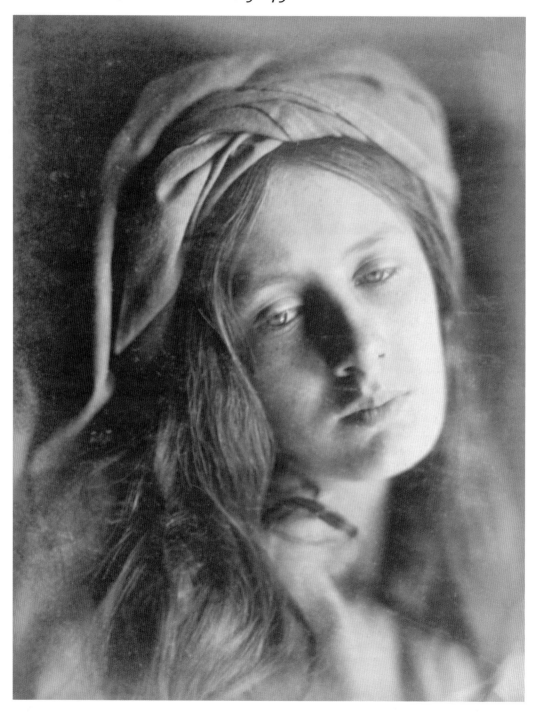

Albumen print from a wet collodion
on glass negative
13 ¼ x 10 ⅜ in. | 34 x 26 cm
J. Paul Getty Museum, Los Angeles, USA

As with many of her portraits, Julia Margaret Cameron crops in close to the face of the model (her niece, Emily Mary 'May' Prinsep) for greater intimacy, allowing the edges of the image to fade away softly. The subtle use of side-lighting gives rise to a range of tones across the image, from the deep background shadow to the brightly illuminated skin. Cameron often portrayed women as tragic heroines, beautiful through sorrow and moral strength. Beatrice Cenci was hanged in Rome in 1599 for having arranged to have her abusive father, Count Francesco, killed. The public saw in her a figure of resistance to male aristocrats' abuse of power. The historical theme and the sitter's flowing hair and wistful, faraway look underline Cameron's debt to Pre-Raphaelite painting.

Cameron utilized long exposures and blurred effects to avoid the over-detailed quality of photography that many felt barred the medium from becoming fine art, because it was generated by apparatus rather than by a conscious decision of the artist. Some critics disparaged her as a sloppy technician because she was happy to work with accidents such as fingerprints and chemical streaks. However, as she wrote in her journal of 1874, *Annals of My Glass House*, 'Who has the right to say what focus is the legitimate focus — My aspirations are to ennoble Photography and to secure for it the character and uses of High Art by combining the real & Ideal & sacrificing nothing of the Truth by all possible devotion to Beauty & poetry.' Her 'truth' was one of aesthetics — of ideas and feelings embedded in the formal qualities of the photographs — rather than prosaic, objective reproduction.

She went on to photograph many of the famous men and women in her circle of family, friends and social connections (including Alfred, Lord Tennyson and Charles Darwin) often overlapping portraiture with references to religious, classical and Arthurian narratives. **PDB**

:eye: FOCAL POINTS

1 HAIR AND HEADDRESS
It was unusual for respectable women to be seen with their hair down, except by their husbands, female relatives and maids, and so the loose locks add a frisson to this portrait. The headdress is inspired by one in a portrait of Beatrice, said to have been painted by Guido Reni, which had also inspired the poet Percy Bysshe Shelley. He wrote a tragic play, *The Cenci* (1819), that lauded her moral innocence and she became a Romantic heroine.

2 BLURRING
By deliberately blurring some areas, Cameron allows the focused areas to stand out even more. She explained: 'When focusing and coming to something which, to my eye, was very beautiful, I stopped there instead of screwing on the lens to the more definite focus which all other photographers insist upon.'

3 DOWNCAST EYES
The eyes of the sitter look downwards, rather than engaging with the viewer, implying that she has been captured in a private moment of reflection. Cameron made several versions of this image, some titled *Study of the Beatrice Cenci from May Prinsep*.

:clock: PHOTOGRAPHER PROFILE

1815–62
Julia Margaret Pattle was born in India but educated in France and England. Returning to India, she married lawyer Charles Hay Cameron in 1838. After his retirement in 1848, they moved to England, settling in the Isle of Wight in 1860.

1863–79
In 1863, she was given a camera by her daughter and son-in-law and rapidly became a prolific photographer, working with large plates and prints. She often asked famous people to sit for her; when they did, she asked them to sign her prints to increase their market value. In 1875 she made two volumes of images inspired by Alfred, Lord Tennyson's *Idylls of the King* (1856–85). The same year she moved to Ceylon (now Sri Lanka), where the family had a plantation. She died there in 1879.

CONFLICT

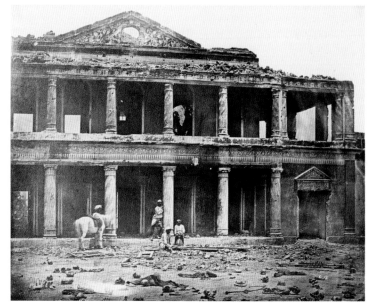

1 *Interior of 'Secundra Bagh' after the Massacre* (1858–62)
Felice Beato • albumen print
9 ⅜ x 11 ¼ in. | 24 x 29 cm
J. Paul Getty Museum, Los Angeles, USA

2 *Nunn, Potter and Deal, Coldstream Guards* (1856)
Robert Howlett and Joseph Cundall
albumen print
National Army Museum, London, UK

3 *Communards in their Coffins* (1871)
Photographer unknown • albumen print
12 ¼ x 16 ⅛ in. | 31 x 41 cm
Harry Ransom Center, University of Texas at Austin, USA

War photographs from the 19th century rarely show action, partly because of the slow exposure times and partly due to the bulky equipment required, which was difficult to operate close to the front line. The earliest war photographs date from the Mexican-American War of 1846 to 1848, but it was not until the 1850s that a concerted attempt was made to officially document a major conflict through photography. Between 1854 and 1856 Britain, France and Turkey were engaged in a costly, bloody war against Russia on the Black Sea peninsula of Crimea. Images of the war by Scotsman James Robertson (1813–88), taken from wood engravings based on original photographs, were published in *The Illustrated London News* in 1854.

A British photographic record of the war was finally made by Roger Fenton (1819–69) during an expedition in which he photographed *Valley of the Shadow of Death* (1855; see p.52). Also arriving in time to document the fall of Sebastopol was the French war historian and artist Jean-Charles Langlois (1789–1870). The works by Fenton, Robertson, Langlois and Léon-Eugène Méhédin (1828–1905) show views of battlefields, encampments and harbours that are devoid of action, and, in the case of Fenton, images taken in the camps. More emotive were photographs such as *Nunn, Potter and Deal, Coldstream Guards* (opposite above) by Robert Howlett (1831–58) and Joseph Cundall (1818–95), which celebrated the stoicism of the newly returned, often injured troops. Queen Victoria commissioned the series, which included studio portraits and location shots at the veterans' hospital at Woolwich, for her collection. The series, known as 'Crimean Braves' or 'Crimean Heroes', was sold commercially.

KEY EVENTS

1854	1854	1855	1855	1857	1860
Carol Szathmari (1812–87) photographs early sites of conflict during the Crimean War. His horse-drawn wagon is specially equipped with a darkroom.	A British civilian photographer, Richard Nicklin, is sent as an official photographer to the Crimea. He is lost at sea when his ship goes down in a storm.	After the fort at Sebastopol is stormed by the Allies, its destruction is photographed by James Robertson and Colonel Langlois.	Roger Fenton's images of the Crimean War are published as engravings in *The Illustrated London News* and exhibited as a travelling show.	Felice Beato's photographs of the aftermath of the First War of Independence in India show human remains, claimed to be those of the rebels.	In the last year of the Second Opium War in China, Felice Beato is 'embedded' with British troops.

In India in 1857 a mutiny broke out among the indigenous troops (sepoys) employed by the East India Company, a British trading operation that effectively ruled a large part of the subcontinent. The rebellion grew into a war of independence and atrocities were committed by both sides. Felice Beato (1832–1909), Robertson's brother-in-law and photographic collaborator, documented the aftermath of the conflict including the Siege of Lucknow. Beato's photograph of Secundra Bagh (opposite) was taken some weeks after British troops had retaken the city and killed 2,000 sepoys in the courtyard of a villa owned by the Nawab of Oudh. The photograph shows—or appears to show—the bones of mutineers left to lie in the sun, although they may have been disinterred and placed there for the purposes of staging Beato's photograph. The image's gruesome subject speaks of a need to justify the acts of vengeance that followed the slaughter of British women and children by the rebels during the mutiny. Other photographers managed to get much closer to the conflict than Beato had on that occasion in India. One of the most poignant images depicting the recently dead on a battlefield is the iconic *A Harvest of Death, Gettysburg, Pennsylvania* (1863; see p.130), taken by Timothy H. O'Sullivan (1840–82) during the US Civil War.

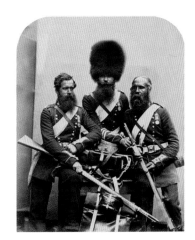

During the heady days of the Paris Commune of 1870, throughout which Republican activists took over the city besieged by the Prussians, the Communards commemorated their destruction of the Vendôme Column by posing for group photographs. When the French government finally regained control of Paris, the photographs were used to identify and track them down. The Communards were once again photographed—now lying dead in their coffins (below). **DS**

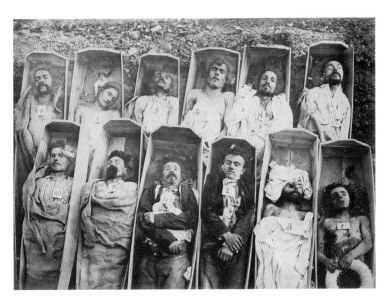

1860	1861–65	1863	1867	1870–71	1878–80
Gustave Le Gray (1820–84) photographs the uprising in Sicily led by Giuseppe Garibaldi. His portrait of Garibaldi is much reproduced.	The US Civil War sees more than 1,400 photographers make images connected with the conflict. Most of these images are made on the Union side.	Alexander Gardner (1821–82) photographs *Dead in Devil's Den (Rebel Sharpshooter)* during the US Civil War. It is now known to have been staged.	In Mexico, Emperor Maximilian is executed by firing squad. François Aubert (1829–1906) photographs the dead emperor.	During the Prussian siege of Paris, photographically reduced text is used to create messages that are taken out of the city by homing pigeon.	John Burke (1843–1900) photographs in Afghanistan during the Second Anglo-Afghan War.

A Harvest of Death, Gettysburg, Pennsylvania 1863
TIMOTHY H. O'SULLIVAN 1840 – 82

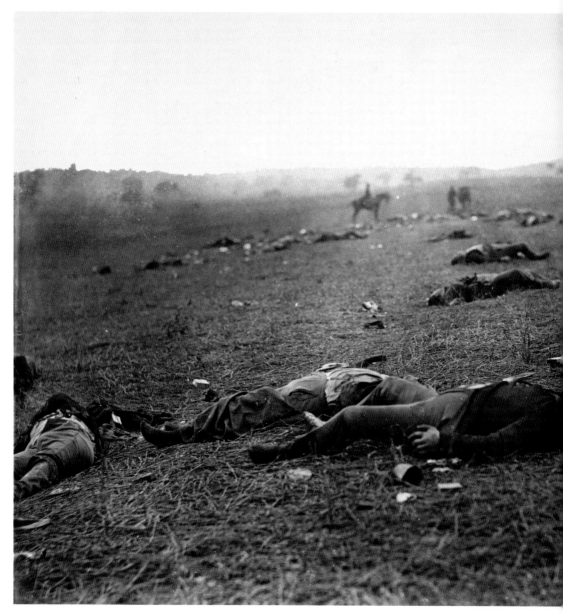

1 MORNING MIST
The gently undulating
countryside is bathed in
mist, as Gardner put it:
'Slowly, over the misty fields
of Gettysburg—as all reluctant
to expose their ghastly horrors
to the light—came the sunless
morn. . . .Through the shadowy
vapours, it was indeed,
a harvest of death.'

2 MAN ON HORSEBACK
The remote, blurry figures
of a man on horseback and
others on foot appear in an
almost impressionistic manner.
The inclusion of these figures
in the frame underlines the
harsh reality that, although
the battle is over, the war itself
goes on. The conflict finally
came to an end in April 1865.

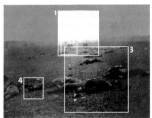

W hile still in his teens Timothy H. O'Sullivan became an apprentice in the New York photographic studio of Mathew Brady (*c.* 1823–96), the highly successful photographic portraitist and entrepreneur. By the time the US Civil War broke out in 1861, O'Sullivan was in Brady's Washington studio, run by Alexander Gardner. It was Brady who conceived the idea of creating a comprehensive photographic record of the war. He arranged for teams of photographers, each equipped with their own darkroom wagon, to travel with the Union armies. The photographers used wet-plate technology to make their images, meaning that their glass plates had to be coated with collodion emulsion immediately prior to exposure and developed straight afterwards. Although the photographers were often close to the line of battle, the cumbersome equipment ruled out scenes of actual fighting. The images made by Brady's photographic corps were generally attributed to Brady himself, including the stirring photographs of the dead from the Battle of Antietam in 1862. O'Sullivan, who was honourably discharged from the Union army in 1862, first worked for Brady's photographic corps and then for Gardner when the latter split from Brady. Under Gardner, O'Sullivan was credited for his work.

On 4 July 1863, O'Sullivan photographed the aftermath of the Battle of Gettysburg—the bloodiest conflict of the war. *A Harvest of Death* is both raw and tragic, indicating the epic nature of the battle and its human cost. After the war, the photograph was published in Gardner's *Photographic Sketch Book of the War* (1865–66), a collection of one hundred photographs in two volumes with a commentary by Gardner. He describes the dead in the photograph as Confederate rebels and notes: 'Killed in the frantic efforts to break the steady lines of an army of patriots, whose heroism only excelled theirs in motive, they paid with life the price of their treason, and when the wicked strife was finished, found nameless graves, far from home and kindred.' Scholars now suggest that the dead in the photograph were actually Union troops. **DS**

Albumen print from a wet collodion on glass negative
6 ¾ x 8 ¾ in. | 17 x 22 cm
George Eastman House, Rochester, New York, USA

3 CORPSES
The fields are littered with human remains. To a contemporary public, the corpses of fallen dead Americans would have been deeply shocking. As Gardner noted: 'Such a picture conveys a useful moral: it shows the blank horror and reality of war, in opposition to its pageantry.'

4 SHOELESS MEN
Shoes were in short supply and were taken from dead soldiers by the living. The turned-out pockets also point to other kinds of appropriation. Photography's capacity to highlight such telling detail suggested a superior veracity in the documentation of historical events.

THE AMERICAN WEST

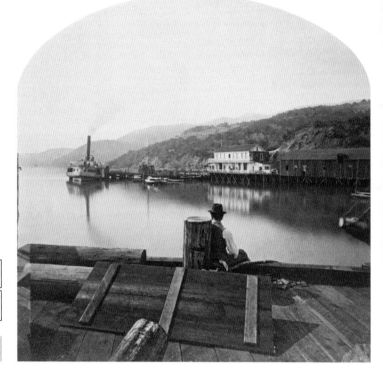

1 *Sausalito from the N.P.C.R.R. Wharf, Looking South* (c. 1868)
Eadweard Muybridge • albumen print
3 ⅛ x 3 ¾ in. | 10 x 9.5 cm
Metropolitan Museum of Art,
New York, USA

2 *Ancient Ruins in the Canon de Chelle* (1871–73)
Timothy H. O'Sullivan • albumen print
8 x 10 in. | 20 x 27.5 cm
Musée du quai Branly, Paris, France

3 *Old Faithful* (1870)
William Henry Jackson • albumen print
20 ¼ x 16 ⅝ in. | 51.5 x 42.5 cm
J. Paul Getty Museum, Los Angeles, USA

Photographs taken in the American West after the Civil War generated important ideas for citizens about the identity and future of the United States. The Civil War resolved disputes over the spread of slavery into Western territories and its conclusion released resources for Western exploration and development, particularly for the construction of railroads. Working for patrons ranging from railroad developers and military officials to naturalists, scientists and tourists, photographers needed high levels of skill and perseverance in order to succeed with the demands of exposing and processing wet-collodion negatives in the field. They put fragile glass plate negatives, large-format view cameras and stereograph cameras on to wagons, horseback and boats to take their images. Their photographs were produced in many formats and seen in varied contexts: from 'mammoth' albumen prints framed on gallery walls to wood-engraved reproductions in periodicals and books. By the end of the century, citizens travelling on the new railroad lines were discovering for themselves the mythic West pictured by photography.

KEY EVENTS

1861	1865	1867	1869	1871	1872
Carleton Watkins takes his first photographs of Yosemite Valley in California.	On 9 April Confederate General Robert E. Lee surrenders to Union General Ulysses S. Grant, ending the US Civil War.	Clarence R. King is named director of the 40th Parallel Survey. Timothy H. O'Sullivan is a photographer with the survey for two of its six years' work.	The US continent is linked by railroad from the Atlantic to Pacific coasts on the Union Pacific Railroad joined at Promontory, Utah territory.	The Hayden Geological Survey of the Yellowstone River region begins. William Henry Jackson is the survey photographer.	The Wheeler Survey of the 100th Meridian begins. Timothy H. O'Sullivan is the photographer for three of the survey's seven years' duration.

Government surveys had been undertaken in the region west of the Mississippi River before the 1860s and some photographers had worked in the landscape. The discovery of gold in the region near San Francisco in 1848 spurred migration and this prosperity generated a market for photographs, including the innovative, large-scale negatives that Carleton Watkins (1829–1916) was producing by the late 1850s. Watkins's astonishing photographs of the waterfalls, rock formations and giant trees of Yosemite Valley, including *Agassiz Rock and the Yosemite Falls, from Union Point* (c. 1878; see p.134), provoked a government declaration to preserve the valley as a national park.

Eadweard Muybridge (1830–1904) left his native England for the United States and by 1855 he was selling books and prints in San Francisco. *Sausalito from the N.P.C.R.R. Wharf, Looking South* (opposite) is one of Muybridge's views of the San Francisco area, in which a solitary figure on the dock observes the harbour scene. His photograph features one of the new, large boats carrying passengers from the wharves of San Francisco to the nearby town of Sausolito (now Sausalito). Muybridge's alteration of the contours of the wood beams on the left in order to give them a regular shape showed that he was willing to manipulate the negative to produce his final images. Muybridge created a picturesque and tranquil scene of what was in fact a hub of tourist and commercial activity.

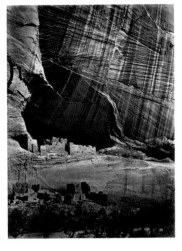

Government-sponsored survey projects resumed in earnest after the Civil War. The nature of the project and the photographer's role within the team informed the choice of compositions and subjects. Photographs by Timothy H. O'Sullivan (1840–82) of a canyon wall and the ruins of an Anasazi Indian pueblo—known as the 'White House'—in the Canon de Chelle (right) convey the site's imposing grandeur. The rock towers over the scene, obliterating the sky; two barely visible figures on top of a building indicate its scale. The rich delineation of striated rock is also aesthetically satisfying, as is the broad range of tones and textures displayed. When O'Sullivan photographed this New Mexico site for the Wheeler Survey of the 100th Meridian, he was also working as a supervisor of other non-photographic members of the party. The experience made him aware of the ways photographs related to the other information-gathering activities of the survey, including sketching and mapping.

In contrast, photography by William Henry Jackson (1843–1942) for the Hayden Geological Survey of the Yellowstone River was influenced by the work of fellow survey member Thomas Moran, a landscape painter. In 1870 Jackson took *Old Faithful* (right), a photograph of the famous geyser that erupts on a regular schedule. He took the photograph at enough of a distance to capture the complete form, with a human figure to indicate the gigantic scale. The photograph details the height and setting of the geyser, but the blurred forms of the water invoke a painter's use of suggestion to convey the majesty of the natural power forcing thousands of gallons of water into the sky. **JL**

1872	1879	1880	1887	1890	1893
Yellowstone is declared a national park, the first of its kind.	The US Geological Survey is established to coordinate multiple survey projects. The US Bureau of Ethnology is also set up to study native peoples.	The Santa Fe Trail, a major transportation route to the West since 1822, is displaced by the railroad.	The Dawes Severalty Act imposes private land ownership on American Indians despite a tradition of communal ownership by tribes.	The Wounded Knee Massacre of Lakota Sioux on 29 December by the Seventh Cavalry marks the end of the Indian Wars.	Historian Frederick Jackson Turner makes his famous argument on the centrality of the frontier to the American character.

Agassiz Rock and the Yosemite Falls, from Union Point *c.* 1878 CARLETON WATKINS 1829 – 1916

Albumen print from a wet collodion on glass negative
21 ⅜ x 15 ⅜ in. | 54.5 x 39 cm
J. Paul Getty Museum, Los Angeles, USA

Carleton Watkins conveys an impressive sense of depth and distance between the sharply focused Agassiz rock and the distant mountains and waterfall. The signs of civilization just visible on the floor of the valley below emphasize the height of Union Point from the ground. To capture both the grand scale of the Yosemite Valley and individual details of the scene, Watkins commissioned a cabinetmaker to build a camera capable of making 'mammoth' plates—up to 18 by 22 inches (45.5 x 56 cm)—the first of its kind. Although he was not the first photographer to work in Yosemite Valley, the large-scale prints and stereographic views that Watkins took there played an important role in the Congressional decision to award the Yosemite Grant in 1864, thereby preserving the area as a national park. He first photographed in Yosemite in 1861, a decade after the Mariposa War removed most of the indigenous Ahwahneechee from the area, and settlers, naturalists and tourists were beginning to journey there. **JL**

👁 FOCAL POINTS

1 ROCK SURFACE
The surface of the rock appears in rich detail, made possible by Watkins's use of a large-format, wet-collodion negative. At the time, the only way to produce a finely detailed print of such size was to create a large negative. Collodion, a sticky solution, would be poured on to a glass plate, which was immersed in silver nitrate (to make it light sensitive), put into a light-proof holder and inserted into the camera. To prepare and develop his negatives on site, Watkins had a portable darkroom.

2 DISTANT FALLS
Watkins has framed the right contour of the rock to echo the path of the distant Yosemite Falls. The pairing offers a series of contrasts too—the shadowy column, in sharp focus, against the hazy, sunlit falls and mountainside—which serves to underline the great distance between the two.

3 EVIDENCE OF CHANGE
Although Yosemite was preserved from development, tourism brought lodges, trails and transport to the area. In Watkins's photograph roads and buildings are visible, emerging in regular shapes against the rocks, and thin lines of roads trace across and along the valley.

WATKINS IN SAN FRANCISCO

Carleton Watkins embraced several different strands of photography during his career. In 1856 he was working as a portrait photographer, but soon branched out to take large-scale views of mines, landscapes and the emerging city of San Francisco. Watkins lived in San Francisco for nearly sixty years, during which time he photographed many stereographic views and panoramas of the city's harbours, buildings and spectacular natural sites, becoming one of a number of photographers, artists and engravers to depict its growth from a mining outpost to a vibrant metropolis. *View from Telegraph Hill of the Golden Gate* (below) was taken in 1868 to 1869; ships entering San Francisco Bay could be spotted from Telegraph Hill, one of the city's original 'seven hills'. Renowned in his lifetime as a photographer, Watkins was careless with money: he was declared bankrupt in the mid 1870s and was forced to sell his studio—Yosemite Art Gallery—along with his negatives. Photographer Isaiah West Taber (1830–1912) acquired them and went on to print them under his own name. The negatives and the studio were destroyed in the San Francisco earthquake and fire of 1906.

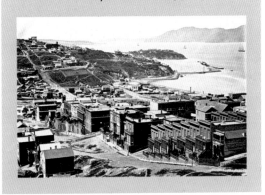

ETHNOGRAPHIC PHOTOGRAPHY

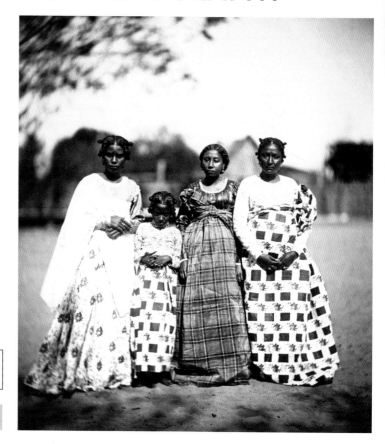

1 *Betsimisaraka Women* (1863)
Désiré Charnay • albumen print from
a glass negative
7¾ x 6¾ in. | 19.5 x 17 cm
Metropolitan Museum of Art,
New York, USA

2 *An Abacus Seller, St Petersburg* (c. 1860)
William Carrick • albumen print from
a wet collodion on glass negative
3¾ x 3¼ in. | 9.5 x 5.5 cm
National Galleries of Scotland,
Edinburgh, UK

Ethnography is a branch of anthropology that examines cultures. The evolutionary theory of cultures grew within the historical period of colonialism and imperialism, and in the 19th century the study of so-called 'primitive races' defined the role of anthropology. The ethnographic photograph was used by anthropologists as a tool in their scientific study of humankind. Armchair anthropologists did not go out into the field, however; they derived ethnographies, including photographs and reports, from colonial administrators, missionaries, explorers and travellers.

The Ethnological Society of London was founded in 1843 and it worked with the British Association for the Advancement of Science to produce *The Manual of Ethnological Inquiry* (1852), which endorsed the use of photography. Ethnography and photography were closely intertwined, and were influential

KEY EVENTS

1856	1857	1859	1859	1860	1862
The Second Opium War breaks out between Britain, France and China; it is covered by several photographers.	Felice Beato photographs the aftermath of the Indian Rebellion against the British East India Company.	The Ansei Treaties come into effect and Westerners can live at the Japanese ports of Yokohama, Niigata, Hakodate, Kobe and Nagasaki.	William Carrick sets up a studio in St Petersburg, Russia with John MacGregor.	Beato goes to China to photograph the Opium War and the signing of the peace treaty between the Chinese and British.	French naturalist and photographer Jacques-Philippe Potteau (1807–76) photographs samurai on the Takenouchi mission to Paris.

discourses and practices in public life in the second half of the 19th century. Ethnographic photography was a widely popular form, encapsulating the Western fascination with people regarded as primitive and exotic. The ethnographic stereograph, the *carte de visite* (visiting card) and the album were widely in circulation.

By the mid 19th century the Western interest in the Middle East and Asia had reached its zenith. Photographers traded in exotic and exploitative images of non-Europeans, couched within the genres of ethnography and landscape. They came from a variety of backgrounds and interests, including science, medicine and botany. Some worked in civil or military jobs, while business and commercial photographers often gained privileged access to events.

French archaeologist Désiré Charnay (1828–1915) was commissioned by the French government, and later by New York philanthropist Pierre Lorillard, to take photographs on his expeditions to Central America. Charnay took a collection of images of archaeological remains and peoples of Native American cultures. He travelled extensively in South America, Australia and Oceania and took *Betsimisaraka Women* (opposite) while on a trip to Madagascar. Scottish artist William Carrick (1827–78) established a photographic studio in St Petersburg. He and his assistant, John MacGregor (a.1857–78), produced *cartes de visite* of Russian types to sell to tourists, mostly portraying itinerant peasants and street vendors, such as *An Abacus Seller, St Petersburg* (right).

The ethnographic photograph was staged in the capitals of Europe and the United States, when non-Europeans made diplomatic visits or participated in the exhibitions that became popular after the Great Exhibition of 1851 in London. Gaspard-Félix Tournachon (1820–1910), known as 'Nadar', photographed Japanese representatives of the shogunate on a diplomatic mission to Paris in 1863. He produced large-format portraits and *cartes de visite* showing the samurai in their traditional dress.

Italian-British photographer Felice Beato (1832–1909) had a studio in Japan serving local foreign clientele consisting of merchants, missionaries and the French and British military forces stationed in Yokohama. He produced images such as his portrait featuring samurai of the Satsuma clan (1868–69; see p.138). Photography was also practised by indigenous photographers. In Japan Shimooka Renjo (1823–1914), Ueno Hikoma (1838–1904) and Kusakabe Kimbei (1841–1934) ran studios from the 1860s, selling photographs of Japanese subjects to Western collectors and wealthy Japanese.

During the late 19th century anthropologists attempted to distance themselves from popular ethnographic representations and to systemize their use of photography scientifically. By the beginning of the 20th century anthropologists had started to move towards observing peoples first-hand in the field. **ES**

1863	1868	1870	1871	1881	1898
The Anthropological Society of London is founded.	The Boshin War starts, in which anti-Bafuku forces unite to restore the Emperor Meiji, leading to the modernization of Japan.	French naval officer Paul-Emile Miot (1827–1900) photographs the royal family of Vai-Tahou in the Marquesas Islands.	The Ethnological Society of London and the Anthropological Society merge to become the Royal Anthropological Institute.	The Western powers Great Britain, France and Germany divide the continent of Africa between them in the 'Scramble for Africa'.	British anthropologist Alfred Court Haddon takes sound-recording, film and photographic equipment on an expedition to the Torres Strait Islands.

Samurai of the Satsuma Clan 1868 – 69

FELICE BEATO 1832 – 1909

1 CENTRAL FIGURE
The composition is based around the central figure, probably the commander, who looks confidently at the camera. The samurai are portrayed as engaged with the process of modernization by being photographed, yet traditional in their defiance of foreign authority.

2 SWORDS
The samurai's distinctive custom of carrying two swords is visible in Beato's photograph. By 1876 wearing these swords was prohibited by the new government under Emperor Meiji. Ironically, the samurai of Satsuma were instrumental in the Boshin War that restored Meiji to power.

⬡ NAVIGATOR

Hand-coloured albumen print

T his photograph shows a group of samurai from the Satsuma clan. The men's traditional *chonmage* haircuts and top knots are prominent in the image. The Satsuma samurai had a reputation for violence against foreigners. Felice Beato's business partner—journalist and artist Charles Wirgman—escaped from a band of samurai besieging the British embassy in 1861. Beato took this picture at a crucial moment in the transition of Japan's leadership, during the Boshin War (1868–69)—a civil war between the ruling Tokugawa shogunate and those who wanted to restore imperial power under Emperor Meiji. The samurai of Satsuma played a significant role in the restoration of the emperor. Beato's photograph marks the shift of Japan towards Western influence and signifies the compliance of a traditionally warlike group.

Beato and Wirgman's photographic studio in Yokohama received many visitors. Wirgman wrote in *The Illustrated London News*: 'My house is inundated with Japanese officers who come to see my sketches and my companion Signor Beato's photographs. They are extremely polite and bring presents of fruit, paper and fans. Tomorrow the present regiment leaves, and officers of the new one just arrived have already paid us a visit.' **ES**

⏱ PHOTOGRAPHER PROFILE

1832–54
Born most probably in Corfu, Felice Beato trained in photographic techniques with his brother Antonio (c. 1825–c. 1903), under photographer and engraver James Robertson (1813–88) in Constantinople, Turkey.

1855–59
Beato photographed the Crimean War. His pictures of the Indian Rebellion in 1857 were the first to show corpses. In 1859 he documented the aftermath of the Siege of Lucknow.

1860–62
He went to China to cover the Second Opium War; he covered many military campaigns during his career.

1863–67
He settled in Yokohama, Japan. In 1865 Beato set up a studio with Charles Wirgman, an artist and journalist for *The Illustrated London News*.

1868–83
Beato published a two-volume photograph album, titled *Native Types and Views of Japan*. In 1869 he set up his own studio in Yokohama. He branched out into other businesses and in 1877 sold his stock to Austrian photographer Baron Raimund von Stillfried (1839–1911).

1884–1909
Beato worked as a war photographer on campaigns in Sudan and Burma, then set up businesses in photography and curios in Burma.

3 SAMURAI DRESS
The traditional dress of the samurai is worn by a number of the men and a more Western-style military uniform by others, showing the transition from traditional to more modern styles of dress as Japan began to modernize.

4 MAP
The group are looking at the Western-style map of Japan stretched out in the centre of the frame. It is not only a visual marker of modernization, but also explains to the Western viewer which part of East Asia the photograph is displaying. It is probably a campaign map of the Boshin War.

PHOTOGRAPHY AND SCIENCE

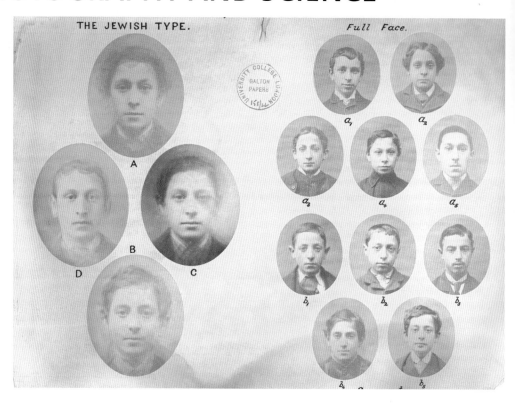

I n the mid to late 19th century, an increasing number of scientists started to take up photography to document natural phenomena and events as well as to observe humans and animals. *Nature*, an illustrated weekly science journal first published in 1869, featured articles by scientists, including John Tyndall, a physicist who promoted Charles Darwin's theory of evolution. By the 1890s, *Nature* had incorporated the use of photographs as visual illustration.

Anthropology was considered part of natural science in the early 19th century. Anthropologists often relied upon photographs that were not expressly made for 'scientific' enquiry, acquiring images from studio, commercial and travelling photographers; for example, anthropologist William Elliot Marshall used images by Samuel Bourne (1834–1912) and Charles Shepherd (a.1858–78) in his study of the Toda people of Southern India in 1873. Such photographs were used to inform ideas about the existence of 'primitive' people and to create racial typologies.

KEY EVENTS

1859	1865	1869	1872	1873	1874
Charles Darwin publishes *On the Origin of Species*, a theory of evolutionary biology of the natural selection of species and races.	Lewis Morris Rutherfurd, a US astronomer, makes a detailed photographic study that shows the surface of the moon.	*Nature*, an illustrated weekly journal of general science, begins publication under the editorship of Norman Lockyer, British scientist and astronomer.	Darwin's *The Expression of the Emotions in Man and Animals* includes photographs by Duchenne de Boulogne and O. G. Rejlander (1813–75).	The international press reports that, in 1872, Eadweard Muybridge had photographed the racehorse Occident running at 38 feet per second.	The transit of the planet Venus is photographed by international teams of astronomers.

140 PHOTOGRAPHIC COMMERCE AND ART 1856–99

From the late 1860s, however, various systems were devised to standardize the way in which photographic evidence was collected. The biologist Thomas Henry Huxley proposed to the Colonial Office that a photographic record should be made of the various races of people in the British Empire by using a system of measurement that involved subjects being photographed naked in precise poses next to a scale, with the camera set at a specified distance away from them. John H. Lamprey's scheme, presented to the Ethnological Society of London in 1869, employed a grid constructed by threads attached on to a large frame placed behind the subject. According to Lamprey, this background made it easier to measure features of the body, so that differences in physique could be recorded. His system was adopted widely by anthropologists and scientists in the second half of the 19th century.

The second half of the century saw photography applied to the study of the body for medical purposes. Gaspard-Félix Tournachon (1820–1910)—the 19th-century photographer known as 'Nadar'—briefly studied medicine in the late 1830s and his nine recorded photographs of a 'hermaphrodite' are said to be the first photographic images of an inter-sex subject. Hugh Welch Diamond (1809–86), a British medical doctor, photographed a number of his female mental patients at Surrey County Asylum in south-west London in the 1850s (see p.60). Guillaume-Benjamin-Amand Duchenne (aka Duchenne de Boulogne, 1806–75), a physician at La Salpêtrière hospital in Paris, photographed subjects in the mid 1850s, having taken instruction from Adrien Tournachon (1825–1903), brother of Nadar. The founder of electrotherapy, Duchenne applied electric stimulation to the facial muscles of sufferers of epilepsy, insanity and neurological problems. His photographs, such as *Fright* (right), were intended to represent a typology of human emotional expressions. The images were used to illustrate Duchenne's text *Mechanics of Human Physiognomy* (1862). Charles Darwin also included some of these photographs in *The Expression of the Emotions in Man and Animals, with Photographic and Other Illustrations* (1872). Jean-Martin Charcot (1825–93), a physician and neurologist who also worked at La Salpêtrière, sought to demonstrate that facial expression was an indicator of psychological states of mind. His photographs of female patients suffering from hysteria were subsequently used by his student Sigmund Freud.

In such ways, photography was employed to make evident symptoms of difference, categorized in terms of race, physical and mental capacities, illness and abnormality. British scientist, Francis Galton (1822–1911), the founder of psychometrics and the applied science of eugenics, exposed numerous portrait negatives of individuals on to one sheet of photographic paper (opposite above), creating composite portraits of racial and social types, to support his theory of a natural social order based on hereditary traits.

1 *Illustrations of Composite Portraiture, the Jewish Type* (1885)
Francis Galton · composite photograph on card
8 ⅝ x 11 ⅜ in. | 22 x 29 cm
Eugenics Archive, University College London, UK

2 *Fright* (1862)
Guillaume-Benjamin-Amand Duchenne
albumen print from a wet collodion on glass negative
4 ¾ x 3 ⅞ in. | 12 x 9.5 cm
Museum of Modern Art, New York, USA

1877	1882	1882	1887	1895	1895
Francis Galton begins his experiments in composite photography, attempting to map hereditary and racial characteristics.	The Parisian police adopt 'Bertillonage' and by 1883 have positively identified forty-nine men as criminals.	Etienne-Jules Marey perfects a 'chronophotographic gun', a device capable of taking twelve exposures per second.	The Paris Observatory initiates the international Carte du Ciel, a star-mapping project that uses photography.	Wilhelm Röntgen photographs the hand of Bertha, his wife, producing the first X-ray image to reveal human bones.	Brothers Auguste and Louis Lumière show their first projected moving pictures to a paying public in Paris, France.

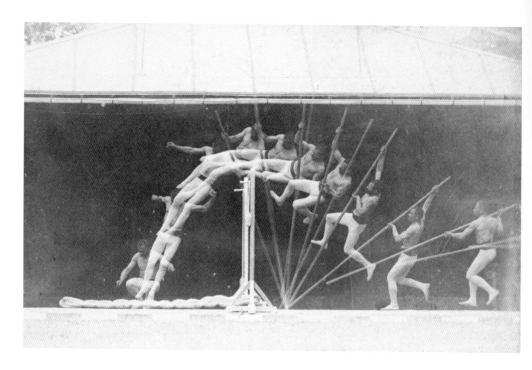

3 *Chronophotographic Study of Man Pole-vaulting* (1890–91)
Etienne-Jules Marey • albumen print
2 ¾ x 4 ⅛ in. | 7 x 10.5 cm
George Eastman House,
Rochester, New York, USA

4 *John Dewar of Glasgow with Indian Spirit* (1896)
Richard Boursnell • albumen print on dry plate negative
5 ⅛ x 3 ¼ in. | 13 x 8.5 cm
British Library, London, UK

5 *Frau Röntgen's Hand (X-ray)* (1895)
Wilhelm Röntgen • X-ray
Deutsches Röntgen Museum,
Remscheid, Germany

In this period, photographs of the human body also came to play a central role in law enforcement. Parisian police officer Alphonse Bertillon (1853–1914) combined anthropometry (the study of measurements of the human body) and photography to aid identification, as seen in *Synoptic Table of the Forms of the Nose* (c. 1893; see p.146). Although photographing the heads and facial features of people arrested on criminal charges would become a standard element of police practice, at this time the practice served ideas that have since been discredited. A number of scientists believed that criminality was associated with the notion of 'degeneracy', said to be a characteristic innate to particular sections of the populace. Havelock Ellis (1859–1939), a British physician and psychologist, used photographs of prisoners to explicate his theories of degeneracy in *The Criminal* (1890).

The use of photography in capturing and reproducing human and animal motion was one of the many important scientific achievements of this period. The question of how to capture bodies in motion with photographic cameras was debated as early as 1869 in London's *Photographic News*. A number of innovators and scientists were experimenting with the development of a shutter system, taking advantage of radically reduced exposure times to photograph horses and other animals. The most famous experiments were by Etienne-Jules Marey (1830–1904) and Eadweard Muybridge (1830–1904), which would lead ultimately to the emergence of cinema. Their experiments took different forms. Marey, a professor of physiology at the Collège de France, published his scientific analysis of animal locomotion in *La Machine Animal* (1873). His inventions were designed to record ten images per second on to a single plate. This system, known as 'chronophotography', was applied to many different subjects of motion, such as his well-known study of a man pole-vaulting (above). Muybridge, on the other hand, was a thriving commercial photographer before he succeeded in capturing and representing movement. He gained a reputation for his work on the motion of horses, such as *Leland Stanford, Jr on his pony 'Gypsy'* (1879; see p.144), and began to promote himself as a scientist to support his projects. He was sponsored by the University of

Pennsylvania, which established a committee to ensure the scientific value of his work. The anthropological interests of some members of the committee converged with their interests in movement and speed; one was a member of the Ethnological Society of London, while others went on to establish the American Anthropometric Society in 1889. Published in 1887, with 781 collotype prints, Muybridge's *Animal Locomotion: An Electro-photographic Investigation of Consecutive Phases of Animal Movement, 1872–1885* was organized according to a scientific 'logic' that followed a covert social hierarchy. It progressed through the movements of the 'highest' subject—the nude male—through women, children and the disabled, to the lowest—animals.

Photography was also applied to the microscope and telescope to produce images of natural objects and scientific phenomena. There were early achievements in astronomical photography in the 1840s that resulted in images of the sun, moon and solar system. The quality and detail of telescopic views rapidly advanced as photographic technology was refined, and in 1865 Lewis Morris Rutherfurd (1816–92), a US astronomer, succeeded in capturing a detailed rendering of the moon's surface. The transits of Venus were first photographed in 1874 and then again in 1882, engendering competition between national teams of astronomers and photographers. By the 1880s, photography's use in obtaining images of stars and planets, as well as the movement of comets and planets beyond what was observable through telescopes with the human eye, was well established. There were many contributors to these successes. Pierre César Jules Janssen (1824–1907), part of the French team that photographed the transits of Venus, went on to achieve images of solar eclipses and comets. Sir David Gill (1843–1914), a Scottish astronomer who photographed the Great Comet of 1882, pioneered the use of astrophotography (detailed stellar photography), and developed ways of measuring astronomical distances. He compiled an index of southern stars with the Dutch astronomer Jacobus Kapteyn, and contributed to the international project Carte du Ciel to photograph the star formation of the sky. Paul Henry (1848–1905) and Prosper Henry (1849–1903), known for their series of photographs of Jupiter and Saturn in 1886, developed telescopes used in this project in which twenty observatories were involved.

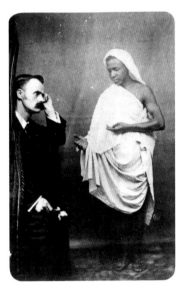

Photography was used not only to render the minute and the distant visible, but also the invisible. X-ray photography was first achieved in 1895 by Wilhelm Röntgen (1845–1923), a Dutch-German physicist who was experimenting with the cathode ray tube; his first X-ray illustration of bones was of his wife's hand (below right). The discovery revolutionized medical science, providing a tool for the detection of fractures and foreign objects inside the body as well as facilitating perception of the working of the body through the ingestion of observable liquids. By 1896, some hospitals were using radiographic machines. The idea that the X-ray had the power to reveal the invisible fuelled the popular imagination and photography became associated with spiritualism and the occult. 'Spirit photography', as it was often called, involved the attempt to capture on a negative plate the image of a living sitter with the spirit of a deceased loved one or spirit guide, as in *John Dewar of Glasgow with Indian Spirit* (above right) by Richard Boursnell (1832–1909).

The X-ray was to be followed by infrared and ultraviolet photography, both of which had been conceived of during the 19th century. The experiments with X-rays during the 1890s opened up exploration in physics research, leading to the atomic and nuclear discoveries of the 20th century. The science of photography, as writer and researcher Dr Kelley Wilder argues, developed in these instances in parallel with discoveries in radiation: 'These photographic methods, as the name implies, are more than just a causal use of photography. They are programmes of experiment in which photography is an integral part.' **ES**

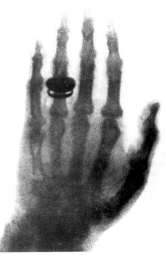

Leland Stanford, Jr on his pony 'Gypsy' 1879
EADWEARD MUYBRIDGE 1830–1904

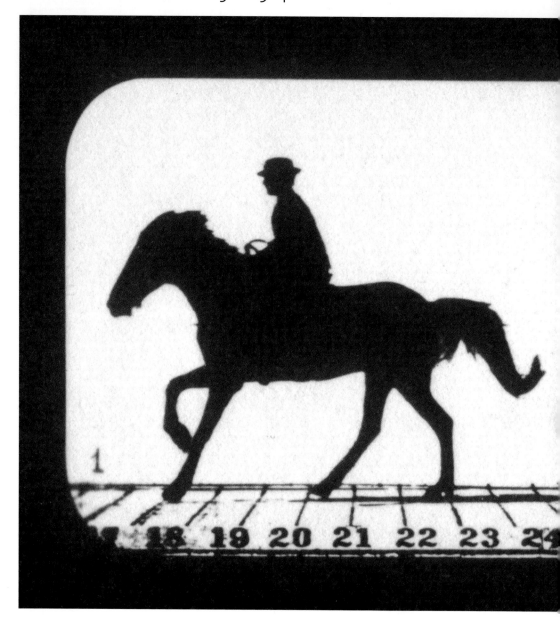

1 GRAPHIC LOOK OF THE PRINT
Muybridge used the wet-collodion process. At a fast shutter speed, the images that formed on the glass plates were hopelessly underexposed, 'But by intensifying them, probably with mercuric chloride,' notes scholar Philip Brookman, 'a printable result was obtained.'

2 WHITE BACKGROUND
The background is a canvas stretched over a fence, 30 feet (9 m) long and 8 feet (2.5 m) high, at an angle at the back of the track. It gives the picture a two-dimensional look but ensures that the images of the horse, rider and trainer at the back stand out by reflecting light back on to the subject.

T his image is one of hundreds taken by Eadweard Muybridge at the Palo Alto
stock farm track that were reproduced in his book *The Attitude of Animals in
Motion* (1881). The publication made him famous and he subsequently toured
Europe giving lectures on photography. However, Muybridge and his sponsor, Leland
Stanford, had major disagreements over the experiments and the ownership of the
work, and the following year Stanford published some of Muybridge's photographs
in a book titled *The Horse in Motion*. Muybridge took out a lawsuit against the
publishers, which he failed to win.

Stanford was a successful businessman—governor of the state of California
from 1862 to 1863 and president of the Central Pacific Railroad—and the young man
on the pony is his son. Stanford, Sr had initially employed Muybridge in 1872 to use
his prodigious photographic skills to capture his racehorse, Occident, in motion. He
wished to develop knowledge about how horses ran, and how horses might be trained
to run faster, at a time when horse racing was a very popular spectator sport and a
lucrative investment. Between 1872 and 1873, Muybridge photographed Occident in
motion, and after various attempts succeeded in capturing an instantaneous image
of the horse trotting at full speed, although the only surviving evidence of this is a
lithograph by Currier & Ives published in 1873. It would not be until 1878, however,
that Muybridge would furnish Leland with the photographic evidence as to whether
a running horse ever has all four legs off the ground.

Muybridge is likely to have begun his further experiments in 1876, using new
chemicals and equipment that increased the speed of his photographic exposures. He
set up multiple cameras—five, six or twelve at a time—first with mechanical shutters
and then electro-shutters tripped by the movement of the carriage or animal. Prior
to appearing in Muybridge and Stanford's separate texts, some of the images featured
in photographic and scientific journals, where they caused a minor sensation. Later
in life, Muybridge found a new sponsor, the University of Pennsylvania, which
established a committee to ensure the scientific value of his work. **ES**

Collodion positive on glass
Kingston Museum & Heritage Service, Kingston upon Thames, UK

3 NUMBERS
The numbers relate to each
camera and wire. On one side
of the track, up to twelve
cameras were set up, and wires
were connected to their lenses
and placed 21 inches (53 cm)
apart. The wires, which
triggered the electro-shutters
of the camera, were tripped by
the horse moving through them.

Synoptic Table of the Forms of the Nose *c.* 1893

ALPHONSE BERTILLON 1853 – 1914

Collotype
Wellcome Library, London, UK

Alphonse Bertillon's criminal identification images were part of an anthropometric system that he introduced to police procedure. The system created records of offenders, identifying aspects of their physique, through written details of body measurements, and any personal attributes and special characteristics, such as scars, alongside photographs of the prisoners taken in specific formats. One important aspect of his classification was the creation of photographic records of facial profiles. This process involved mapping the details of the human face in uniform portrayals with standardized framing and lighting. Key facial features that Bertillon photographed were noses, eyes, lips, foreheads and ears, with each part subdivided into dimensions and particularities.

Each image is described individually by its own handwritten legend that combines generic descriptors assigned across the grid. The tables were used with *portraits parlés* (word portraits), which listed physical characteristics such as the shape of noses, lips and ears, cranial measurements, hair and iris colour. This table appeared in Bertillon's book *Judicial Photography: With an Appendix on Anthropometrical Classification and Identification* (1890).

Later in the 1890s, fingerprinting was introduced as an identification technique and added to the Bertillon system in order to eliminate the difficulties encountered in identifying criminals caused by ageing or disguise. Bertillon was not keen on fingerprinting, but it proved more reliable than measurements and gradually replaced 'Bertillonage'. **ES**

👁 FOCAL POINTS

1 LEGEND
The legend for each image is headed *Nez à profil* (Nose in profile) followed by the descriptor for the combined point in the column and row. For example, the middle image is No. 5, described as '*rectiligne—horizontal*', or 'linear—straight'.

2 ROWS
The table rows propose a further three generic nasal shapes: upturned (*relevé*), straight (*horizontal*) and dropped (*abaissé*). Bertillon also concluded that ears were unique to individuals and categorized them according to eleven particular types.

3 MUG SHOT
Each image on the table is an individual profile portrait. Bertillon developed a number of systems for criminal identification, including taking a frontal and profile portrait photograph standardized in focal length, framing, lighting and distance, which became known as the 'mug shot'.

4 COLUMNS
The columns in Bertillon's table propose three generic nasal shapes: concave (*cave*), linear (*rectiligne*) and convex (*convexe*). Bertillon accorded the nose six descriptors: root, tip, dorsam, base, height and breadth. He identified fifteen categories of nose altogether. The points at which the columns and rows overlap on the table create individually defined shapes of noses in the grid of nine images, each described by a legend.

⏲ PHOTOGRAPHER PROFILE

1853–78
Alphonse Bertillon was born in Paris. He trained in physical anthropology and was interested in anthropometry—his father, Louise Adolphe Bertillon, was an expert in the subject.

1879–82
Bertillon began working as a clerk for the Paris police, creating criminal identification systems. He refined his anthropometric systems from measurements of the body, photographing facial features and recording special marks, such as scars.

1883–1914
'Bertillonage' became a uniform technique practised by the judicial system. Bertillon's book *Judicial Photography* (1890), along with his later publications, established the use of forensic science internationally. He worked for the police until his death.

STREET AND SOCIETY

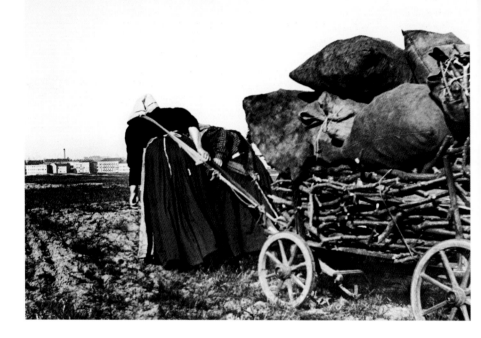

The second half of the 19th century witnessed the dawning of a new photographic tradition as the camera lens was trained on the urban poor. The Swedish-born O. G. Rejlander (1813–75) was a pioneer of the trend. Hailed in life as 'the father of art photography', Rejlander is best known for theatrical tableaux, such as *Two Ways of Life* (1857; see p.116). However, for *Night in Town* (opposite), he opted for a more documentary approach to record the growing urban phenomenon of the street urchin. The social reformist Henry Mayhew, in his book *London Labour and the London Poor* (1851), estimated that in London there were 10,000 to 20,000 destitute children under the age of fifteen. The street urchin was a subject to which Rejlander was clearly drawn; this portrait is one of at least fifteen similar. However, they are not straightforward documentary street-life images.

Rejlander's street urchin series is, in fact, as meticulously choreographed as his tableaux. In *Night in Town*, the bland, light-toned wall, devoid of grime, is a studio backdrop. The child has likely been dressed to satisfy the artist's sense of the picturesque. In fact, Rejlander was known to follow strangers across town to ask for pieces of clothing to use as costume in his compositions.

KEY EVENTS

1857	1861	1864	1864	1866	1866
Lady Elizabeth Eastlake describes the camera as 'an unreasoning machine' whose 'business is to give evidence of facts'.	There are 176 Ragged Schools (for educating destitute boys) in England, with as many as 25,000 pupils.	Making multiple permanent images becomes feasible with the newly patented invention of Walter Bentley Woodbury's Woodburytype.	The Photographic Society of London praises Joseph Swan's updated carbon process, comparing it favourably to silver-based prints.	Thomas Annan purchases Swan's carbon process patent rights for Scotland and uses it later for *Photographs of Old Closes, Streets, &c, Taken 1868–77*.	The Glasgow City Improvements Act is passed, precipitating what will become an 88-acre redevelopment of the city's 'wynds' (narrow streets).

Art historian Stephanie Spencer has commented that the child's posture bears a similarity to an urchin depicted in a cartoon called 'The Homeless Poor' from an edition of *Punch* magazine published in January 1859, and that this could have served as Rejlander's inspiration. Moreover, she argues that as Rejlander's London studio on Malden Road, north London was near to the Chalk Farm Ragged School for Boys, the child is not even homeless: 'The urchins in Rejlander's photographs look so clean and well-fed; they were not actual urchins off the streets but rather boys who were already the object of charity.' It would seem that Rejlander viewed street children according to a Dickensian blend of social conscience, sentimentality and humour. Appropriately, this picture is also known as 'Poor Jo', a reference to the child crossing-sweeper (crossing-sweepers swept away the road mud for pedestrians for tips) in Charles Dickens's novel *Bleak House* (1853).

A few decades later, the German illustrator and photographer Heinrich Zille (1858–1929) earned the monikers 'the father of the streets' and 'the poor man's artist' for a very different approach to picturing the working classes. By the time he died, he was held in such esteem that the city of Berlin held a funeral in his honour; however, he began life in penury with his father being sent to debtor's prison. Such experiences were doubtless formative, and by the 1890s Zille had turned to photographing the living conditions of his childhood. He roamed the streets of Berlin, rarely venturing beyond his local neighbourhood of Charlottenburg, snapping images that exude spontaneity. In *The Wood Gatherers* (opposite) the viewer can almost feel the exertion of the two women who, eyes to the ground, pull a heavy cart loaded with wood across the parade ground at Charlottenburg. Zille never actually published or exhibited these images during his lifetime. Instead, he filed them away in portfolios in his study and used them to inform his drawings and watercolours. Sometimes he would pen an exact copy of the photograph; at other times, he would replicate a fragment, such as an expression or a posture. Zille viewed his photographs as documents of snatched realities: tools to inject naturalism into his draughtsmanship.

While Zille was photographing the streets of Berlin, Eugène Atget (1857–1927) was doing the same in Paris. Although he has since been celebrated for his great originality—photography curator Robert Sobieszek dubbed him 'the culmination of everything photography aspired to in the 19th century'— the sign on the door to Atget's apartment on the rue Campagne-Première simply read: 'Documents pour Artistes'. As Brassaï (1899–1984) once explained: 'Atget considered himself not as an artistic photographer, but as a documenter capable of providing artists and decorators working for the theatre or films with any view of the city.' His clients included painters (Georges Braque, Pablo Picasso and Maurice Utrillo), illustrators, engravers, architects, decorators and sculptors. Between 1909 and 1915, Atget produced seven albums, each documenting different aspects of Paris: from architectural facades to parks,

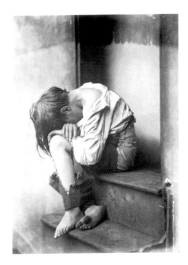

1 *The Wood Gatherers* (1900)
Heinrich Zille • silver print

2 *Night in Town* (c. 1860)
O. G. Rejlander • albumen print from a wet collodion on glass negative
8 x 5 ⅞ in. | 20 x 15 cm
George Eastman House, Rochester, New York, USA

1871	1872	1881	1883	1890	1895
Two years after Bowman Stephenson begins the Children's Home, Dr Barnardo establishes his first boys' home.	Heinrich Zille starts evening classes at the Berlin Academy of Arts and is initiated into the Berlin school of realism.	John Thomson's *Street Life in London* is reissued as *Street Incidents*. Thomson becomes 'Photographer to Her Majesty Queen Victoria'.	Annan travels to Vienna to meet the inventor of the photogravure, Karl Klič, and secures British rights for another 'permanent' process.	Jacob Riis's *How the Other Half Lives: Studies Among the Tenements of New York* is published.	Theodore Roosevelt becomes president of the city police board. Riis guides him on the first of many midnight tours to New York's destitute areas.

from horse-drawn carriages to the working classes. *Bitumiers* (above) was part of a series devoted to Paris's rapidly vanishing street trades, or *petits métiers*.

By the last third of the 19th century, photographs that recorded the humiliations and hardships of urban poverty were being used as propaganda for social reform. In May 1874, Dr Thomas John Barnardo added a photographic department to his Home for Working & Destitute Lads in Stepney, east London. Over the next thirty-one years, Thomas John Barnes (1840–99) and his successor Roderick Johnstone (1852–1931) produced 55,000 'before and after' portraits of Barnardo's boys. The 'before' tended to reveal the child in dirt and rags, purportedly straight off the street; the 'after' saw him scrubbed and smart. Barnardo ruthlessly marketed the photographs in order to drum up funding, publishing them in pamphlets and selling them in packs of twenty for five shillings, or singly for a sixpence. However, in 1876 the Reverend George Reynolds accused Barnardo of colluding with Barnes to hoodwink the public: for example, by tearing the children's clothes to make them appear more abject. The following year, Barnardo was in court on several counts of misconduct. It appears that, like Rejlander, Barnardo and Barnes felt that fiction could invest the facts with greater emotional impact.

Social rehabilitation and reform was on the agenda of two other British photographers. John Thomson (1837–1921) and Thomas Annan (1829–87) created the earliest books of photojournalism. *Street Life in London* (1877), featuring photographs by Thomson and essays by Adolphe Smith, chronicled the plight of the capital's urban poor with powerful portraits such as the desperate woman in *The Crawlers* (c. 1877; see p.152). Annan's book documented the thoroughfares in the heart of Scotland's largest city, Glasgow. It was first published late in 1878 or early the following year as *Photographs of Old Closes, Streets, &c., Taken 1868–77*. Annan was not a social reformer in Thomson's mould. His images are not directly concerned with the people. When figures appear, they are generally

seen at a distance and indistinct, almost as ghosts. Unlike Thomson, Annan was on commission, paid by the Glasgow City Improvements Trust to record the buildings before they were demolished. Nonetheless, his resulting portfolio was recognized by photography curator Anita Ventura Mozley as 'the earliest comprehensive series of photographs of an urban slum, and the very slum that was considered the worst in Great Britain'.

All these publications were made possible by new permanent photomechanical processes that enabled photographs to be used successfully as book illustrations: whereas Thomson took advantage of the Woodburytype, Annan opted first for the carbon print (like the Woodburytype, an actual print made using pigmented gelatin instead of silver salts and therefore much less subject to fading) and then photogravure (a high-quality reproduction made using printer's inks). For the first time, photographers could reach beyond the salon into the parlours of the bourgeois to influence public opinion.

Across the Atlantic, immigrants were docking in New York at unprecedented rates. By 1900, the island of Manhattan's population had swelled to 3.5 million and nearly half of these were recent arrivals. Immigrants tended to cluster together in neighbourhoods and there was an increased demand for food, clothes, garbage men and street cleaners. Alice Austen (1866–1952), a society woman and amateur photographer from Staten Island, would take the ferry to Manhattan in search of such characters. Unlike her contemporary Jacob Riis (1849–1914)—who homed in on the squalor of the growing slums in *Lodgers in Bayard Street Tenement, Five Cents a Spot* (1889; see p.154)—Austen was not moved by social injustice. In Austen's images, the working classes are portrayed without pity or outrage, as evidenced by the good-humoured grins on the faces that stare out from *Two Rag Collectors on a New York City Street* (below).

By the end of the 19th century, the urban poor had been immortalized by photography in various ways. They had been shown as desperate souls by Thomson and Riis, and as ghostly apparitions of a soon to be demolished world by Annan. They had been sentimentalized by Rejlander, and misrepresented for philanthropic reasons by Barnes and Barnardo. In Austen's images, however, the impoverished and destitute finally reclaimed a quiet, dignified pride. **JMH**

3 *Bitumiers* (1899–1900)
Eugène Atget
silver printing-out paper print
6 ⅞ x 8 ¼ in. | 17.5 x 21 cm
Museum of Modern Art,
New York, USA

4 *Two Rag Collectors on a New York City Street* (1897)
Alice Austen • silver print
4 ¾ x 3 ¾ in. | 12 x 9.5 cm
Library of Congress,
Washington, DC, USA

The Crawlers *c.* 1877
JOHN THOMSON 1837 – 1921

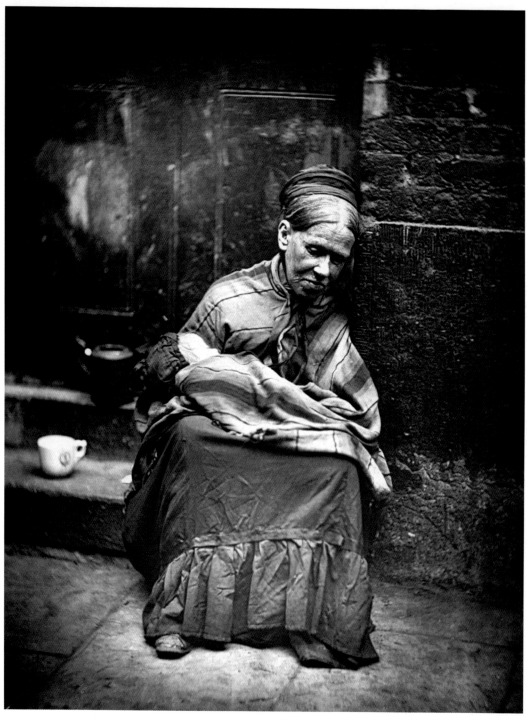

Woodburytype
4 ½ x 3 ½ in. | 11.5 x 9 cm
Museum of London, UK

The head of the woman in John Thomson's *The Crawlers* seems too large for her body. Her eyes are downcast, unwilling—or too weary—to face the viewer. Wrapped in her shawl, the baby also turns away. The woman is one of the 'crawlers' of the title: malnourished and too frail, or too dispirited, even to beg. Such women crawled, on hands and knees, to get hot water and make weak tea to sustain themselves. She is not the infant's mother; instead she is baby-sitting the child while the mother works nearby. In 1875, John Thomson noted: 'The camera should be a power in this age of instruction for the instruction of the age.' Two years later, he and Adolphe Smith (a journalist and social reformer) published what was probably the first major sociological study of British life to be supported by photographs—*Street Life in London*. It first appeared in February 1877 as a monthly magazine and continued for twelve issues. Each contained an essay by Smith and three of Thomson's photographs, printed as Woodburytypes. This relatively new method of photomechanical reproduction created pin-sharp detail, lending the images depth and realism. Thomson and Smith felt that these photographic prints presented the viewer with undeniable, objective fact. In December 1877, all the images and essays were published in a book of the same title with a decorated cloth binding and gilt edges, destined for the bourgeois parlour. It would be the vehicle for Thomson's assertion that the camera should be a power for instruction. **JMH**

FOCAL POINTS

1 WOMAN'S FACE
Weathered and etched with lines, the woman's face sharply contrasts with the baby's pale skin. It is as if she has been indelibly marked by hardship. In his essay, Smith notes: 'They have been reduced by vice and poverty to that degree of wretchedness that destroys even the energy to beg.'

2 BRICK WALL
The texture of the dark, brick wall behind the woman is finely rendered. The negative was made with the wet-collodion process; although the chemicals were cumbersome to carry around, they were famed at the time for producing images of unparalleled detail, particularly in shadows.

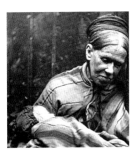

3 MADONNA AND CHILD
The image of a seated woman with a baby swathed in cloth on her knees inevitably recalls the Madonna and child from Christian art. Yet the grimness of the scene, the woman's worn and ageing face and her weariness—she is too tired even to face the child—make for a bleak parody of the original.

4 CUP AND TEAPOT
Thomson frames this image to include a cup and teapot—a reference to the derivation of the term 'crawler'. They seem out of place on the bare steps, though, and such dislocation adds poignancy to the scene. Pointedly, there is no sign of any food to provide genuine nourishment.

PHOTOGRAPHER PROFILE

1837–66
John Thomson was born in Edinburgh. He studied at the city's Watt Institution and School of Arts. In 1862, he embarked on extensive travels in the Far East.

1867–74
In 1867 Thomson published his first photography book, *The Antiquities of Cambodia*. Four volumes of *Illustrations of China and Its People* (1873–74) followed.

1875–1921
Thomson returned to Britain in 1875, settling in London. The following year, he started photographing the city's street life. In February 1877, he published the first of his images, alongside Adolphe Smith's essays, as the magazine *Street Life in London*. In 1879 he opened a portrait studio and published *Through Cyprus with the Camera in the Autumn of 1878*. Two years later, Queen Victoria appointed him photographer to the British Royal Family. In 1886, Thomson became professor of photography to the Royal Geographical Society. In 1898 he published *Through China With a Camera*. Thomson died of a heart attack in 1921.

Lodgers in Bayard Street Tenement, Five Cents a Spot

1889 JACOB RIIS 1849 – 1914

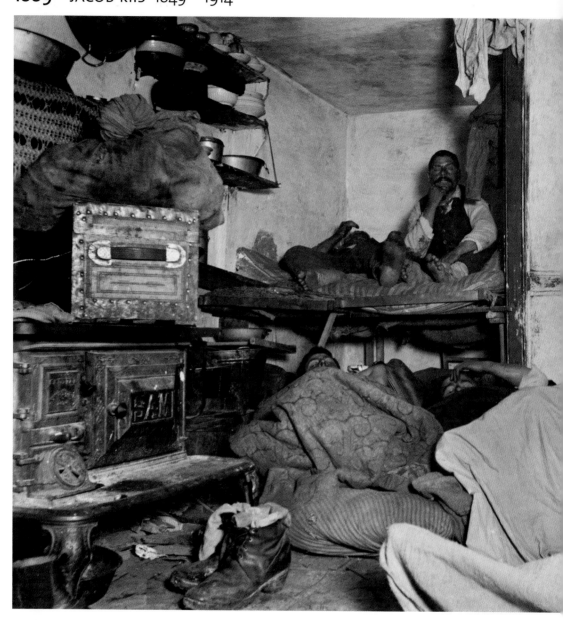

1 EYES CLOSED
The men in the scene have mostly been taken by surprise by Riis's sudden appearance; some are still asleep. There was little available light, save for a kerosene lamp, but Riis used newly invented flashlight chemicals to illuminate his image, rigging up a frying pan on which to ignite the powder.

2 BLURRED FACE
This man's face is obliterated in a blur. He probably moved while the lens cap was off but before the powder was fired and the flash sparked. Working with these flash chemicals was hazardous. Once, they exploded so near to Riis's eyes that he would have blinded himself had it not been for his glasses.

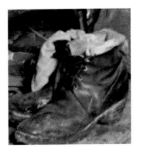

T his sobering image appears in Jacob Riis's influential book *How the Other Half Lives: Studies Among the Tenements of New York* (1890). Riis, who worked as a police photographer, took it during the 'graveyard' shift, accompanied by a policeman. The men crammed into the cramped, windowless room are mostly slumbering or half asleep; they have not had time to compose themselves for the photograph. Their slightly dazed appearance may, in part, be due to Riis's use of magnesium powder to create a flash to generate enough light to take the picture. To contemporary viewers, however, such awkwardness would only have added to the power of the photograph as a piece of reportage. It was taken in 'The Bend', a particularly bad slum on the Lower East Side of New York. Riis's essay on the area opens with the words: 'Where Mulberry Street crooks like an elbow within hail of the old depravity of Five Points, is "the Bend", the foul core of New York's slums. . . .There is but one "Bend" in the world and it is enough.'

The 'five cents a spot' lodgings of Riis's title flourished with immigrants who had no families. His text in *How the Other Half Lives* explains: 'From midnight until far into the small hours of the morning the policeman's thundering rap on closed doors is heard. . . .The doors are opened willingly enough. . .upon such scenes as the one presented in the picture.' In Riis's time, half a million people lived in the half square mile of Manhattan's Lower East Side. They were nearly all immigrants—from Germany, Ireland, China, Italy and Eastern Europe—and every day more flooded off the boats at the Ellis Island ferry terminal. Most ended up living in the pitifully squalid and cramped conditions of the tenements.

Riis had himself experienced the hardships and humiliations of the newly arrived immigrant (he had emigrated to the United States from Denmark when he was twenty-one years old). When he finally found work at the New York News Association, he fainted from hunger on his first day. He later wrote of his time as police reporter at the Mulberry Station, 'The sights I saw there gripped my heart until I felt that I must tell of them or burst.' **JMH**

Silver print
4 ¾ x 6 ⅛ in. | 12 x 15.5 cm
Museum of Modern Art, New York, USA

3 FEET UNDER BLANKET

If you assume the lump under the blanket at the front is the feet of another lodger, it brings the tally of people in this image to seven. However, not all those in the room were in the picture: Riis reported that the tiny room could sleep twelve men and women, two or three on the bunks, the others on the floor.

4 BOOTS

The pair of boots appears disproportionately large. This suggests that Riis was probably using a wide-angle lens—such lenses splay perspective, swelling objects in the foreground. It would have been the only way Riis could have taken such photographs in these overcrowded spaces.

POPULAR PHOTOGRAPHY

During its formative four decades, photography was a complicated business, confined to professionals and those amateurs who had the considerable time and money required to master the new medium. In the 1880s, however, technical advances brought increasing speed, mobility and convenience. Factory-produced, gelatin 'dry' plates relieved photographers of the need to sensitize their own plates and, because exposure times were greatly reduced, instantaneous 'snapshot' photographs taken with hand-held cameras became possible for the first time. One of the earliest exponents of such photography was Paul Martin (1864–1942), who used his hand-held camera to capture late Victorian Britain with spontaneous images, such as *Trippers at Cromer* (above), that had a freshness and immediacy in total contrast to contemporary 'pictorial' photography. Despite the greater convenience of dry plates, however, photographers still had to process their negatives and print their photographs, which required a darkroom and all the necessary equipment and skills.

The need to develop and print one's own pictures prevented photography from becoming a popular pastime. In 1888, however, a camera appeared that was to revolutionize the medium. The Kodak camera was the invention of US

KEY EVENTS

1871	1878	1880	1881	1883	1885
Richard Leach Maddox (1816–1902) develops dry-plate negatives— far more convenient for photographers on the move than their wet-plate equivalents.	The commercial manufacture of dry plates begins in Britain. They could be exposed and developed at the photographer's convenience.	George Eastman begins to manufacture dry plates in Rochester, New York for commercial sale.	Thomas Bolas (1848–1932) patents a hand-held, box-form camera that he calls a 'detective' camera.	Ottomar Anschütz (1846–1907) designs a focal plane shutter (patented in 1888) for exposures as fast as 1/1000 second.	George Eastman opens a branch in London in order to gain a foothold in the European market.

entrepreneur George Eastman. His ambition was to simplify photography, although his motive was financial rather than altruistic. He was convinced that there was an untapped market for cameras and photographic materials that was ripe for commercial exploitation. Taking a photograph with the Kodak was simple. Everything more than 4 feet (1 m) away was in focus and the camera's wide-angle lens meant that no viewfinder was needed. You just pointed the camera in the right direction and pushed the button to release the shutter. The Kodak brought a new spirit of freedom and spontaneity to photography as people recorded their everyday lives without regard to the established conventions of the medium, as exemplified by the snapshot of bathers in Conesus Lake, New York (right) taken in 1893.

Although it was ingenious, the Kodak did not embody any revolutionary technological innovations; it was not the first hand-held camera, neither was it the first camera designed solely for roll film. The true significance of the camera is that it was merely the first stage in a complete system of amateur photography. The Kodak was sold already loaded with enough film (at first paper film, later celluloid) for one hundred photographs. After the film had been exposed, the entire camera was sent back to the factory for the film to be developed. The camera, reloaded with fresh film, was then returned to its owner, together with a set of prints. Eastman had founded what would become the mass developing and printing industry. At a stroke, he had removed the single greatest barrier to the growth of photography. To sum up the Kodak system, Eastman devised the brilliantly simple sales slogan: 'You press the button—we do the rest.' US amateur photographer Frederick Church (1864–1925) took a Kodak snapshot, *George Eastman on Board SS Gallia* (1890; see p.158), featuring the entrepreneur holding one of his Kodak cameras in his hands.

Snapshot photography was still comparatively expensive. The Kodak cost five guineas (£5.25)—more than a month's wages for many people at the time. But, by using mass-production methods, Eastman quickly managed to reduce the cost of his cameras. The Pocket Kodak camera, introduced in 1895, cost only one guinea (£1.05), although even this was too much for many people. Consequently, in 1898, Eastman asked his camera designer, Frank Brownell, to design a camera that would be as cheap as possible while still being capable of taking successful photographs. The new camera, launched in 1900, was called the 'Brownie'—after characters created by the Canadian children's author Palmer Cox. In Britain the Brownie cost just 5 shillings (25 pence), making it widely affordable. Within a year, more than 100,000 had been sold and the Brownie became synonymous with popular photography.

The introduction of the Brownie camera finally removed the financial and technical constraints that had delayed the popularization of photography. For the first time, photography became truly accessible to millions of people. The snapshot had come of age. **CH**

1 *Trippers at Cromer* (1892)
Paul Martin • platinum print
3 x 3 ¾ in. | 8 x 9.5 cm
Victoria and Albert Museum, London, UK

2 *Conesus Lake, August 1893* (1893)
Photographer unknown • albumen print
2 ⅜ in. | 6 cm diameter
George Eastman House, Rochester, New York, USA

1888	1889	1890	1892	1895	1900
The first Kodak camera is introduced. Its clever advertising slogan proclaims: 'You press the button—we do the rest.'	George Eastman introduces the first commercial, transparent celluloid roll film.	Ferdinand Hurter (1844–98) and Vero Charles Driffield (1848–1915) devise a system to quantify the 'speed' of photographic emulsions.	Samuel Turner (1826–68) applies for a US patent for paper-backed, daylight-loading roll film.	The Pocket Kodak camera appears—the first mass-produced, snapshot camera.	The arrival of the Brownie—the camera that brings photography to the masses.

George Eastman on Board SS *Gallia* 1890
FREDERICK CHURCH 1864 – 1925

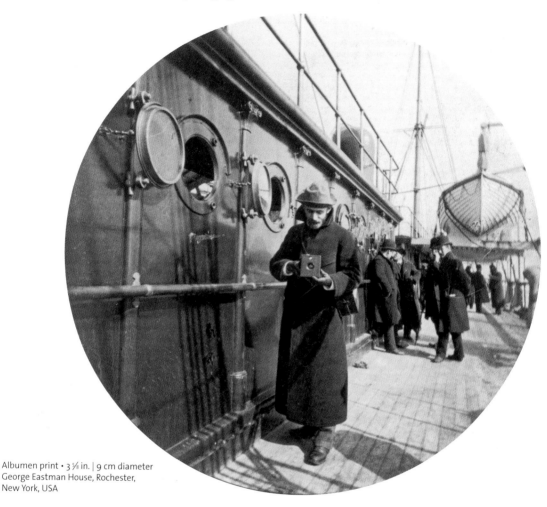

Albumen print • 3 ⅝ in. | 9 cm diameter
George Eastman House, Rochester,
New York, USA

⚙ NAVIGATOR

This photograph of George Eastman was taken in 1890 when he was on his way to becoming one of the world's most successful businessmen. Fittingly, he is photographed on a voyage—en route from New York to Liverpool on board the SS *Gallia*. In 1885 Eastman had opened a London branch of his company and he made frequent transatlantic trips to keep an eye on his business interests.

The photographer was Eastman's patent attorney, Frederick Church. His signature can be seen beneath Eastman's on the patent for the first Kodak camera, taken out just eighteen months earlier. Eastman recognized the crucial importance of patents and Church was one of his most valued business associates and friends. In many ways, Church epitomizes the sort of person the Kodak camera was marketed at—inexperienced in photography, but affluent and well travelled. Church's reaction to becoming a photographer is likely to have echoed that of another business associate of Eastman, Henry Strong. Eastman later recalled of Strong: 'It was the first time he had ever carried a camera, and he was as tickled with it as a boy over a new top. . . .He apparently had never realized that it was a possible thing to take pictures himself.' **CH**

👁 FOCAL POINTS

1 CAMERA

Eastman is holding a No. 2 Kodak camera, the same model used by Church to take this photograph. Due to limitations of the lenses used, the No. 2 Kodak camera, like the first Kodak, took circular photographs. This meant that the camera did not have to be held perfectly straight.

2 PROMENADE DECK

Church photographed Eastman on the promenade deck of SS *Gallia*. Built in 1878 for the Cunard Line, the SS *Gallia* operated on the busy transatlantic route between New York and Liverpool. Eastman would have travelled in comfort as one of up to 300 first-class passengers but the Gallia could also carry up to 1,200 third-class passengers. Some of his fellow passengers, dressed in formal dark suits and hats, are seen standing on the promenade deck.

3 ONLOOKERS

A passenger turns to see what is going on. Hand cameras were still a novelty and their use would have aroused curiosity. Eastman may have used the voyage to promote the merits of his cameras among his fellow travellers. Kodak adverts later proclaimed: 'As a tourist's camera it is unrivalled.'

4 WEATHER

The strong shadows on the promenade deck indicate that this photograph was taken on a bright winter's day—providing perfect conditions for snapshot photography. The SS *Gallia* left New York on 22 February 1890 and arrived in Liverpool nine days later. It would have been cold in the mid Atlantic at that time of year. Eastman is well wrapped up against the cold—wearing a hat, gloves and heavy overcoat with the collar turned up.

⏱ PROFILE: GEORGE EASTMAN

1854–80

George Eastman was born in 1854 in Waterville, New York State, USA. He left school aged fourteen and in 1874 joined the Rochester Savings Bank as a clerk. In 1880 he gave up his job in the bank to devote himself full time to photography, setting up in business making photographic dry plates.

1881–88

Eastman's dry-plate business expanded. In 1885 he designed a roll holder for sensitized strips of paper as an alternative to glass plates. In 1888 he introduced a hand camera called the Kodak, designed to use his specially produced roll film.

1889–1900

Following the success of the Kodak camera, Eastman introduced transparent celluloid roll film in 1889. Other products followed, including the Brownie camera in 1900. Eastman's company increased rapidly to become a successful worldwide business.

1901–32

Eastman Kodak became the world's biggest photographic manufacturing company. Gradually Eastman gave up the day-to-day running of his company in order to concentrate on philanthropic activities. After a long illness, he committed suicide in 1932. He left a note explaining: 'To my friends. My work is done. Why wait?'

THE 'KODAK' NAME

Eastman chose the name 'Kodak', which became one of the world's most famous trademarks, with great care. He later recalled: 'The letter "K" had been a favourite with me—it seems a strong, incisive sort of letter. It became a question of trying out a great number of combinations of letters that made words starting and ending with "K".' Eastman wrote to the British Patent Office, explaining the name: 'This is not a foreign name or word; it was constructed by me to serve a definite purpose. It has the following merits as a trademark word: first, it is short; second, it is not capable of mispronunciation; third, it does not resemble anything in the art and cannot be associated with anything in the art.' The name has served Eastman's cameras and their distinctive advertising (below) successfully for decades.

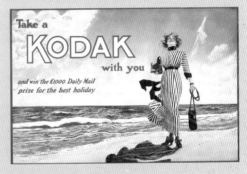

Take a KODAK with you and win the £1000 *Daily Mail* prize for the best holiday

PICTORIAL PHOTOGRAPHY

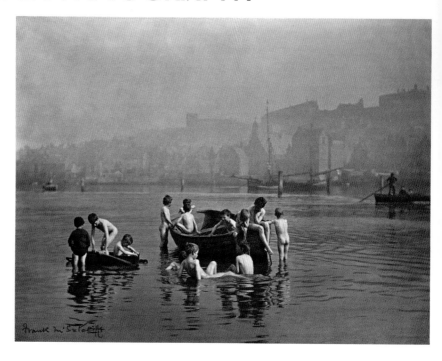

Pictorialism was the vanguard movement that applied the principles of fine art to photography from the mid 1880s to *c.* 1910, although Pictorial photography started before that date. Photography rapidly became more accessible to a wider market, owing to the availability of cheaper dry plates and the introduction of relatively simple Kodak cameras. Photography had also become a commercial business with an emphasis on technological progress — often to the detriment of creative artistry, however.

In his hugely influential book *Pictorial Effect in Photography* (1869), Henry Peach Robinson (1830–1901) had prescribed some pictorial ground rules. He emphasized that an interweaving of art, nature, truth, beauty and a fair bit of darkroom trickery were the key tenets to creating a satisfying pictorial — or more accurately in his case, picturesque — effect. They included the experience of art: 'However much a man might love beautiful scenery, his love for it would be greatly enhanced if he looked at it with the eye of an artist, and knew why it was beautiful.' Also, truth to nature: 'Art rules should be a guide only to the study of nature, and not. . .confine the ideas or. . .depress the faculty of original interpretation in the artist.' Crucially, he also insisted on permission for the photographer to intervene to create better art: 'Any dodge, trick and conjuration

KEY EVENTS

1858	1861	1866	1869	1873	1880
William Henry Fox Talbot perfects photoglyphic engraving, the forerunner of Karel Klíč's 1879 dust-grain photogravure process.	William Morris sets up Morris, Marshall, Faulkner & Co. It develops and popularizes the Arts and Crafts style, which influences Pictorialism.	John Henry Dallmeyer patents a Diffusion of Focus Portrait Lens, said to provide superior sharpness, reduced flare and vignetting, and less distortion.	Henry Peach Robinson publishes *Pictorial Effect in Photography*.	William Willis patents the platinotype process using ferric oxalate and potassium chloroplatinate and developed in a solution of potassium oxalate.	Willis sets up the Platinotype Company and by 1892 is selling Platinotype paper worldwide.

of any kind is open to the photographer's use....A great deal can be done and very beautiful pictures made, by a mixture of the real and the artificial in a picture.' This last recommendation—that the photographer's intervention and work on the negative and the print could improve on art and nature, that anything was allowed to arrive at beauty—was one of the attitudes that divided Pictorial photographers and eventually led to fracture and revolt in the ranks between those who practised manipulation and those who would go on to produce 'straight' photography (see p.280).

All over Europe, artists began breaking away from the establishment and setting up their own Secession groups. Well-heeled, amateur artist-photographers in Europe and the United States (the terms 'amateur' and 'artist' were considered synonymous) followed suit, organizing themselves into invitation-only groups and multinational associations with access denied to the despised 'snapshotters'. They held annual exhibitions, or salons, and published influential, beautifully produced journals. In 1891, the International Exhibition of Art Photographers was held in Vienna by the Club of Amateur Photographers (renamed the Vienna Camera Club in 1893); their number included Heinrich Kühn (1866–1944), Hugo Henneberg (1863–1918) and Hans Watzek (1848–1903), and the three went on to exhibit together in venues across Europe under the collective name of the Trifolium, or Das Kleeblatt. The three worked on coloured gum printing, and also 'combination' printing—working with multiple negatives.

In May 1892, the Linked Ring Brotherhood was formed in London by dissatisfied members of the Royal Photographic Society; it was led by the Pictorial supremo himself, Henry Peach Robinson. Purposely arcane, the Linked Ring Brotherhood met on a monthly basis, published papers, held dinners and made photographic excursions. Intriguingly, the Links' dictums of 'liberty' and 'loyalty' were scrupulously observed in the organization's first decade with mutual support and the organization gained great international respect. To be asked to be a member and to be exhibited at the Links' annual Photographic Salon was the highest accolade a Pictorial photographer could receive. Frank Meadow Sutcliffe (1853–1941) was a founder member. Perhaps best described as a documentary Pictorialist, Sutcliffe worked in Whitby most of his life and recorded the people, environs and way of life there. *The Water Rats* (opposite), which displays some differential focus with a sharp foreground and a hazy background, caused controversy at the time for supposed corruption of the young naked models. Much of Sutcliffe's work is printed in brown or grey carbon; it sold well to Whitby tourists, and still does today.

James Craig Annan (1864–1946), son of the photographer Thomas Annan (1829–97), initially worked for the family photographic business. He learnt photogravure in Vienna in 1893 from Czech photographer Karel Klíč (1841–1926) and rarely used any other printing method. *The White Friars* (right) was taken

1 *The Water Rats* (1886)
Frank Meadow Sutcliffe
albumen print
5 ¾ x 7 ¾ in. | 14.5 x 19.5 cm
Royal Photographic Society Collection,
National Media Museum, Bradford, UK

2 *The White Friars* (1894)
James Craig Annan • photogravure
4 x 3 ⅝ in. | 10.5 x 9.5 cm
National Galleries of Scotland,
Edinburgh, UK

1889	1889–91	1893	1894	1896	1898
Peter H. Emerson publishes *Naturalistic Photography for Students of the Art*.	*Sun Artists*—reproductions of the work of eight Pictorial photographers—is published by Kegan Paul, Trench, Trübner & Co. in London.	*Das Praesidium*, which includes Theodor (1863–1943) and Oskar Hofmeister (1871–1937) among its members, exhibits at Hamburg's Kunsthalle.	The Photographic Society of Great Britain receives a royal charter and becomes the Royal Photographic Society.	The new Dallmeyer-Bergheim soft-focus lens produces soft definition without losing the natural structure of the object being photographed.	Frederick H. Evans gives up his bookshop in Queen Street, London to devote all his time to photography.

in Venice in 1894 — using a Kodak hand-held snapshot camera to freeze the movement — when Annan was travelling in Italy with the Scottish artist and etcher David Young Cameron.

In 1894, the Photo-Club de Paris, including Robert Demachy (1859–1936), creator of *Spring* (1896; see p.166), and Emile Joachim Constant Puyo (1857–1933), seceded from the Société Française de Photographie; Kühn, Henneberg and Watzek became members and were also elected to the Linked Ring Brotherhood. Both Demachy and Constant Puyo excelled at the gum bichromate process, manipulating the negative during development to introduce painterly effects to a photograph. The Munich Secession was founded in 1892; the Berlin and Vienna Secessions followed six years later.

The goal of these organizations was to free photography from its documentary and technical stranglehold and to use it as a means of artistic expression. They believed that photography was becoming an objective mechanical procedure rather than a subjective aesthetic labour of love and so began using ever more elaborate manipulative techniques. Complex, time-consuming and meticulous processes involving platinum, gum, bichromate, carbon, photogravure, bromoil and oil-pigment printing were introduced, which resulted in the end product — the photograph — resembling a lithograph, an etching or a pastel or charcoal drawing. A limited number of prints was made from one negative, in order to enhance the value and emphasize the exclusivity of the work. Presentation was also critical and mounting, framing and hanging became an essential part of the aesthetic package.

James Craig Annan recommended the use of the small hand-held camera to his close friend and correspondent Alfred Stieglitz (1864–1946), who became the first American Link in 1894, an experience he later used to set up the Photo-Secession (see p.176) in New York in 1902. On his return to New York in 1890 after almost a decade in Europe, Stieglitz was forced to adapt to the very different subject matter that the dynamic city afforded him compared with the romantic and picturesque European scenes he had captured in earlier photographs such as *Sun Rays, Paula, Berlin* (1889). *The Terminal* (above) was

taken at the southern end of the Harlem streetcar route on Fifth Avenue using a 4 x 5-inch hand-held waterproof Folmer and Schwing camera, which allowed Stieglitz to capture movement and atmosphere in low light levels. He wrote of the photograph: 'From 1893 to 1895 I often walked the streets of New York downtown, near the East River, taking my hand camera with me. . . .[One day] I found myself in front of the old Post Office. . . .It was extremely cold. Snow lay on the ground. A driver in a rubber coat was watering his steaming car horses.'

One of Henry Peach Robinson's most vocal critics, and one of the most influential voices in photography during the 1880s, was Peter H. Emerson (1856–1936). He despised Robinson's combination printing (printing from several negatives to create a single image) and promoted realistic and naturalistic vision—as exemplified in *Rowing Home the Schoof-Stuff* (1886; see p.164), a collaboration between Emerson himself and the painter Thomas Frederick Goodall. For Emerson, photographic art was best learnt through practice and by applying naturalistic differential focusing, not through the application of artistic rules or by following the inappropriate 18th-century aesthetic principles of the art academies, as recommended by Robinson. Although Emerson often contradicted and eventually violently disagreed with his own theories—denying photographs any claim to art and calling them 'machine-made goods'—his assertion that photography was an independent art in its own right was a powerful and crucial one. In effect, he gave photography permission to be its own creation and create its own world.

In 1889, Emerson asked his friend Thomas R. Dallmeyer to design him a lens that would see 'like the eye' so that only part of the image was in sharp detail, the rest softened, but found it did not produce the desired effects. The challenge was taken up by George Davison (1855–1930), another founding member of the Links, who had been much impressed by Emerson's theories and advanced them further by using no lens at all for his first famous soft-focus impressionistic photograph exhibited in 1890, *The Old Farmstead*, later renamed *The Onion Field*. Taken with a pinhole in a sheet of metal and printed on rough-textured paper for enhanced breadth of tone, there is no sharp focus anywhere in the piece. The photograph caused a sensation when exhibited, although Davison's success earned him Emerson's enmity.

In the late 1890s, Boston-based Fred Holland Day (1864–1933) and his circle of Pictorialists—Sarah Choate Sears (1858–1935), George Seeley (1877–1921), Clarence H. White (1871–1925) and the young Alvin Langdon Coburn (1882–1966)—were influential for Pictorialism. The independently wealthy Day was able to pursue his passion for literature, art, aesthetics and photography. A Europhile, collector of Keatsiana, and acquaintance and publisher of William Morris, Oscar Wilde and Aubrey Beardsley, he was also a friend of Frederick H. Evans (1853–1943), and the two shared a passion for the complex presentation of their photographs on multi-layered coloured paper supports. Day's series of 250 negatives of scenes from the crucifixion (opposite below), including self-portraits of himself as the dying Christ in *The Seven Last Words*, aroused initial controversy then praise. While not fulfilling any of Emerson's credos of naturalism, Day's work asserts that the photographer, like the painter, can produce any type of art, even that of a religious nature.

Edward Steichen (1879–1973), who moved easily between the Day and Stieglitz circles throughout the next decade and was to play a hugely significant role in 20th-century US photography, signposted the directions Pictorial photography would take. Among his earliest work, aged nineteen, the eccentric *Self-portrait (Milwaukee)* (right), with Steichen half in, half out of the frame, boldly asserts his artistic credentials and anticipates abstract and modernist elements of design. **PGR**

3 *The Terminal* (1893)
Alfred Stieglitz • photogravure
8 x 10½ in. | 20.5 x 26.5 cm
George Eastman House,
Rochester, New York, USA

4 *Self-portrait (Milwaukee)* (1898)
Edward Steichen • platinum print
7⅞ x 4 in. | 20 x 10 cm
Museum of Modern Art, New York, USA

5 *The Crucifixion* (1898)
Fred Holland Day • platinum print
6½ x 3½ in. | 16.5 x 9 cm
Royal Photographic Society Collection,
National Media Museum, Bradford, UK

Rowing Home the Schoof-Stuff 1886
PETER H. EMERSON 1856 – 1936

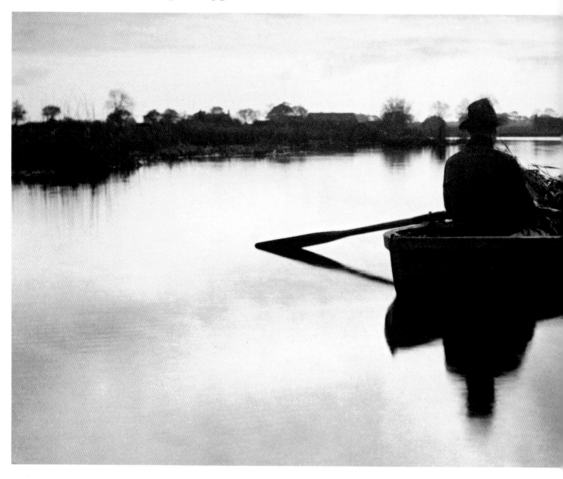

Platinum print
5 ⅜ x 11 in. | 14 x 30 cm
Royal Photographic Society Collection,
National Media Museum, Bradford, UK

NAVIGATOR

With his face turned away from the viewer, Peter H. Emerson's rower becomes a representative type—a noble peasant captured forever in a symbiotic relationship with the countryside. Emerson's beautiful and lyrical photographs concentrate on the land, its inhabitants and its weather and light conditions. Simplicity and integrity of vision was his aim—the distillation of a moment in nature.

From 1885 to 1895, intermittently accompanied by the artist Thomas Frederick Goodall, Emerson photographed the people, topography, weather and light of the Norfolk Broads, an area of atmospheric wetlands in eastern England. His work eulogized and mythologized the fishermen, reed cutters, hunters, gamekeepers and farm workers who made their often difficult living from the Broads, although he feared the area's bucolic charms would be lost to encroaching industry and tourism from the cities.

Emerson's work of this period reflected the principles of the third volume of Hermann von Helmholtz's *Handbook of Physiological Optics* (1867), which stated that the human eye focuses only on the centre of the field of vision. Emerson transmuted this into the ideas laid out in his *Naturalistic Photography for Students of the Art* (1889), wherein he held that photography could render artistic truth as successfully as any other art. He later rejected this theory. **PGR**

👁 FOCAL POINTS

1 SELECTIVE FOCUS
Improved lens technology meant that Emerson could choose to use differential focusing and peripheral diffusion. He delineates the solitary foreground figure, but the background is less sharp. This reflected his belief that photography should mirror the selective focus of our eyes, which cannot bring all the elements of a scene into sharp focus at the same time—particularly outside, where atmospheric conditions can blur details.

2 BLURRED BACKGROUND
The far distance fades slowly into softer tones, anticipating a line in Emerson's book, *Naturalistic Photography for Students of the Art* (1889): 'Nothing in nature has a hard outline, but everything is seen against something else, and its outlines fade gently into something else.'

3 SCHOOF-STUFF
A pile of schoof-stuff—a mix of marsh reeds and cut grass that was used as fuel in the manner of peat—can be seen stashed on the boat. Emerson's commentary to the photograph reads: 'This old Broadman has been along the Broad edge, cutting his schoof-stuff, and is now rowing it home to his cottage, where he will dry it and store it.' Emerson's photographs suggest a settled and unchanging way of life, even though he was aware of modernity's stealthy intrusion.

4 STILLNESS
The dark figure of the man and his shadow on the still water provide the sole vertical shape in this unpeopled scene of empty spaces and the flat East Anglian horizon. The title mentions 'rowing', but neither of the oars raises a ripple on the water's surface.

🕐 PHOTOGRAPHER PROFILE

1856–86
Born in Cuba into a wealthy family who owned a sugar plantation, Peter H. Emerson moved with his mother to Britain in 1869 after his father's death. He qualified as a doctor in 1885 but never practised medicine. He helped found the London Camera Club that year. On the Norfolk Broads he met the artist Thomas Frederick Goodall. The two would collaborate, initially on *Life and Landscape on the Norfolk Broads* (1886), featuring forty platinum prints.

1887–95
Emerson published the first of five luxury photobooks illustrated with photogravures. *Naturalistic Photography for Students of the Art* (1889) argued for photography to be seen as analogous to other arts. He renounced his view of photography as an art form in *Death of Naturalistic Photography* (1890).

1896–1936
In 1899, the third edition of *Naturalistic Photography* removed all references to photography's artistic credentials.

Spring 1896
ROBERT DEMACHY 1859 – 1936

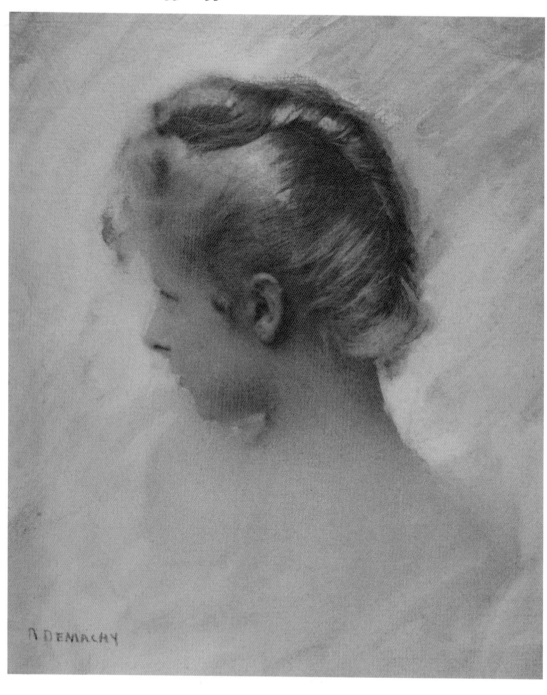

Gum bichromate print
8 ¾ x 7 ⅜ in. | 22 x 18.5 cm
Société Française de Photographie, Paris, France

Robert Demachy's preference for very young girls as models was not unusual at the time but seems rather more reprehensible now. A series of a dozen or so prints of the same model enacting *Spring*, clothed, nude and draped with gauze, often make for uncomfortable viewing. Nude or partially draped with chiffon and looking straight into the camera lens she is knowingly provocative, which only emphasizes how achingly young she is. When dressed in the frilly bonnets and petticoats of an older woman, the girl looks mawkish and rather overwhelmed by the extravagance of an 18th-century Marie Antoinette-type costume. It is only in the exposures showing the back of her head or profile, as here, that she maintains her dignity while betraying a touching vulnerability.

Demachy began to use the gum bichromate process in 1894 after reworked details of the process were published in Paris in the book *Sépia-Photo et Sanguine-Photo* by A. Rouillé-Ladevèze earlier the same year. Basic elements of the process had been understood for around fifty years and it was the Frenchman Alphonse Louis Poitevin who, in 1855, added a watercolour pigment to the basic gum arabic/dichromate emulsion to make the process altogether more artistic and creative. Based on the light sensitivity of dichromates when mixed with gum, the process was easily manipulable and produced painterly images from photographic negatives. **PGR**

👁 FOCAL POINTS

1 HAIR
Today, the swept-up hairstyle of the sitter, with a tangle of curls falling across the forehead, may seem to represent the epitome of belle epoque elegance. In fact, this style, complemented by the garland of flowers, is rather more *au naturel* than was in vogue at the time.

2 ADDED COLOUR
The gum bichromate process could involve multi-layered printing using several colours or just one, as here. Red ochre was one of the most popular in the early years of the process. A great deal of manipulation was possible; the brushlike strokes make the image look more like a drawing in pastels or crayons.

3 IMPRESSIONISM
Demachy's photographs are often compared in feel to Edgar Degas's drawings and pastels. The young female subject and her wispy gauze recall the ballet dancers that Degas so often used for his subjects. Demachy moved in artistic circles and would have been familiar with Impressionism.

🕐 PHOTOGRAPHER PROFILE

1859–75
Born into a wealthy Parisian banking family, Demachy had the luxury of being able to indulge his love of art and music and sought the company of bohemian artists. He developed an interest in photography in the late 1870s and became hugely proficient in the art.

1876–88
In 1882, Demachy joined the Société Française de Photographie but in 1888 he left to form the Photo-Club de Paris with Maurice Bucquet (c. 1860–1921).

1889–97
In 1893, Demachy married Julia Adelia Delano, whom he had first met at the Paris Exposition Universelle four years earlier. Having mastered the gum bichromate process by 1894, Demachy began to exhibit heavily manipulated prints, making adjustments to the image both as a negative and during the printing process. The same year he helped to set up the first Paris Salon for photography with Constant Puyo, René Le Bègue (1857–1914) and Maurice Bucquet. His first book on the subject of gum bichromate, *Photo-aquatint or Gum Bichromate Process*, produced with Alfred Maskell, was published in London in 1897.

1898–1911
From 1898 he began a correspondence with Alfred Stieglitz that lasted several years; Stieglitz reproduced his photographs in the journal *Camera Work*. Between 1901 and 1911, Demachy had five one-man exhibitions at the Royal Photographic Society, becoming a member in 1905. Demachy perfected the bromoil process and began working with Autochromes.

1912–36
Demachy began to practise art as well as photography and moved to an apartment in the artists' quarter of Montmartre in Paris. In 1914, he abandoned photography to pursue his drawing. Demachy lived out his last years at his farm at Hennequeville, Normandy.

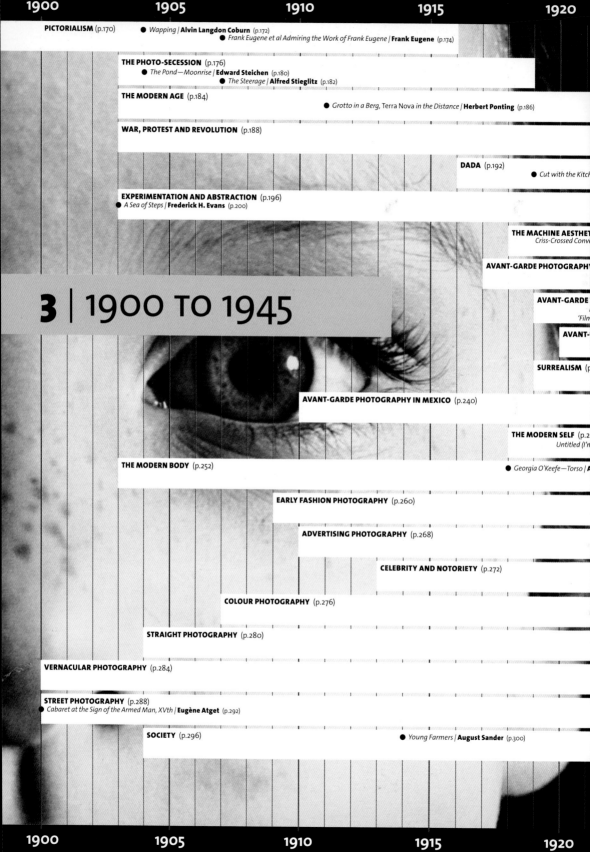

PICTORIALISM (p.170)
● *Wapping* | **Alvin Langdon Coburn** (p.172)
● *Frank Eugene et al Admiring the Work of Frank Eugene* | **Frank Eugene** (p.174)

THE PHOTO-SECESSION (p.176)
● *The Pond—Moonrise* | **Edward Steichen** (p.180)
● *The Steerage* | **Alfred Stieglitz** (p.182)

THE MODERN AGE (p.184)
● *Grotto in a Berg*, Terra Nova *in the Distance* | **Herbert Ponting** (p.186)

WAR, PROTEST AND REVOLUTION (p.188)

DADA (p.192)
● *Cut with the Kitch*

EXPERIMENTATION AND ABSTRACTION (p.196)
● *A Sea of Steps* | **Frederick H. Evans** (p.200)

THE MACHINE AESTHET
Criss-Crossed Conve

AVANT-GARDE PHOTOGRAPH

AVANT-GARDE
'Film

AVANT-

3 | 1900 TO 1945

SURREALISM (p

AVANT-GARDE PHOTOGRAPHY IN MEXICO (p.240)

THE MODERN SELF (p.2
Untitled (I'm

THE MODERN BODY (p.252)
● *Georgia O'Keefe—Torso* | **A**

EARLY FASHION PHOTOGRAPHY (p.260)

ADVERTISING PHOTOGRAPHY (p.268)

CELEBRITY AND NOTORIETY (p.272)

COLOUR PHOTOGRAPHY (p.276)

STRAIGHT PHOTOGRAPHY (p.280)

VERNACULAR PHOTOGRAPHY (p.284)

STREET PHOTOGRAPHY (p.288)
● *Cabaret at the Sign of the Armed Man, XVth* | **Eugène Atget** (p.292)

SOCIETY (p.296)
● *Young Farmers* | **August Sander** (p.300)

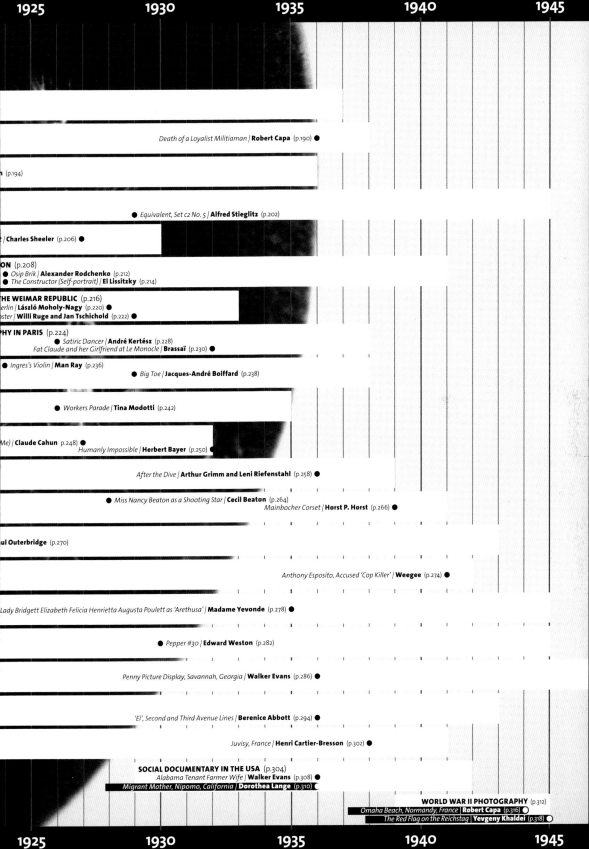

Death of a Loyalist Militiaman | **Robert Capa** (p.190) ●

...n (p.194)

● *Equivalent, Set c2 No. 5* | **Alfred Stieglitz** (p.202)

...t / **Charles Sheeler** (p.206) ●

...ON (p.208)
● *Osip Brik* | **Alexander Rodchenko** (p.212)
● *The Constructor (Self-portrait)* | **El Lissitzky** (p.214)

...THE WEIMAR REPUBLIC (p.216)
...erlin | **László Moholy-Nagy** (p.220) ●
...oster | **Willi Ruge and Jan Tschichold** (p.222) ●

...PHY IN PARIS (p.224)
● *Satiric Dancer* | **André Kertész** (p.228)
Fat Claude and her Girlfriend at Le Monocle | **Brassaï** (p.230) ●

● *Ingres's Violin* | **Man Ray** (p.236)

● *Big Toe* | **Jacques-André Boiffard** (p.238)

● *Workers Parade* | **Tina Modotti** (p.242)

...Me) / **Claude Cahun** p.248) ●
Humanly Impossible | **Herbert Bayer** (p.250) ●

After the Dive | **Arthur Grimm and Leni Riefenstahl** (p.258) ●

● *Miss Nancy Beaton as a Shooting Star* | **Cecil Beaton** (p.264)
Mainbocher Corset | **Horst P. Horst** (p.266) ●

...ul Outerbridge (p.270)

Anthony Esposito, Accused 'Cop Killer' | **Weegee** (p.274) ●

Lady Bridgett Elizabeth Felicia Henrietta Augusta Poulett as 'Arethusa' | **Madame Yevonde** (p.278) ●

● *Pepper #30* | **Edward Weston** (p.282)

Penny Picture Display, Savannah, Georgia | **Walker Evans** (p.286) ●

'El', Second and Third Avenue Lines | **Berenice Abbott** (p.294) ●

Juvisy, France | **Henri Cartier-Bresson** (p.302) ●

SOCIAL DOCUMENTARY IN THE USA (p.304)
Alabama Tenant Farmer Wife | **Walker Evans** (p.308) ●
Migrant Mother, Nipomo, California | **Dorothea Lange** (p.310) ●

WORLD WAR II PHOTOGRAPHY (p.312)
Omaha Beach, Normandy, France | **Robert Capa** (p.316) ●
The Red Flag on the Reichstag | **Yevgeny Khaldei** (p.318) ●

PICTORIALISM

1 *Ferris Wheel in the Tuileries Gardens*
(1900–05)
Pierre Dubreuil • silver print
6 ¼ x 8 ¼ in. | 16 x 21 cm
Musée d'Orsay, Paris, France

2 *Spring Showers* (c. 1900)
Alfred Stieglitz • silver print
3 ⅞ x 1 ½ in. | 10 x 4 cm
Museum of Modern Art, New York, USA

I n the 20th century Pictorialism became darker, more symbolic and personal, reflecting the rise of modernist art and the experience of displaced peoples across Europe and the United States. Complex printing techniques slowly gave way to easier to use gelatin silver prints and photogravure. The advantage of printing in photogravure was that multiple runs could be made for a fraction of the price of one platinum print. The 'new' Pictorialism was often urban based and explored the city and the place of the creative artist within it, finding beauty in unlikely locations. Alfred Stieglitz (1864–1946) continued to explore the potential of the New York streets, photographing at night or in wet, misty weather, as in *Spring Showers* (opposite). The composition of this image, printed on thick, semi-translucent Japanese vellum, shows the influence of Japanese art—then much in vogue, especially the *ukiyo-e* (pictures of the floating world) woodblock prints of Katsushika Hokusai and Utagawa Hiroshige.

KEY EVENTS

1904	1905	1905	1905	1907	1908
Discussions are held regarding an attempted reconciliation and merger of the Linked Ring and the Royal Photographic Society.	A proposal is made by the Linked Ring to form an International Society of Pictorial Photographers. Nothing comes of it.	Sidney Robert Carter (1880–1956) founds the short-lived Toronto Studio Club based on the British Linked Ring.	Thomas Manly's Ozobrome process, a simplified carbon process, becomes a favourite photographic process among Pictorialists.	Platinum becomes fifty-two times more expensive than silver as supplies are diverted for munitions use.	Coburn and Steichen, part of the selection committee for London's Photographic Salon, are accused of favouring US and Photo-Secessionist work.

Pierre Dubreuil (1872–1944), a Frenchman who lived in Belgium for some years, photographed the urban Parisian landscape and the machine as an icon of modernity, employing unexpected perspectives including extreme close-ups and shots taken from ground level. Dubreuil also emphasized design over content, working Cubist and Futurist ideas into his photography. The nocturnal reverie *Ferris Wheel in the Tuileries Gardens* (opposite) is a dark and moody study of shape and shadow, printed powerfully dark—a highly modernist and dramatic image for its time.

The darker reaches of the unconscious mind, which were being explored by Sigmund Freud and Carl Jung, served to encourage the artist's contemplation of his or her own psyche. The major early 20th-century Pictorialists—Stieglitz, Alvin Langdon Coburn (1882–1966), Edward Steichen (1879–1973) and Clarence H. White (1871–1925)—photographed each other, and often themselves, with self-obsessed regularity. There was renewed interest in the inner depths that could be revealed in a portrait, seen most tellingly in the work of Steichen, Coburn and Frank Eugene (1865–1936). The latter took a group portrait of four celebrated photographers, including himself, in 1907 (see p.174). Pictorialists began to take themselves very seriously indeed, promoting their work through interviews, articles, books, lectures and a whole gamut of exhibitions.

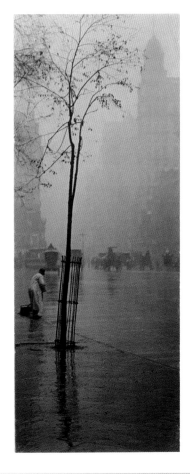

On 10 October 1900, 'The New School of American Photography' exhibition, organized by Boston photographer Fred Holland Day (1864–1933), opened at the Royal Photographic Society in London's Russell Square. The exhibition, a *succès de scandale* in both London and Paris, featured the work of Steichen, Coburn, White and Gertrude Käsebier (1852–1934), all of whom would become members of Stieglitz's Photo-Secession (see p.176) in 1902. Day's exotic subject matter—such as black African American male nudes—and his elaborate methods of presenting his platinum prints on multi-layered coloured paper supports in ornate gold Art Deco frames shocked sedate Edwardian London. Reviews in the photographic press veered between vitriolic sarcasm— 'fuzzygraphs' being a word most frequently used to describe the work on show—and heady praise. Clearly, however, US Pictorialism, formed on the European model, had now found its own direction.

Like Stieglitz, Coburn was also fascinated by the space and pattern of Japanese aesthetics, which he had discovered as a student of Arthur Wesley Dow (1857–1922) at Ipswich Summer School of Art, Massachusetts in 1902 and 1903. Dow more or less single-handedly changed the method of teaching art and photography in the United States in the first two decades of the 20th century, first at Brooklyn's Pratt Institute and then as the director of fine arts of the Columbia University Teachers College. He incorporated Japanese techniques alongside the design ethics of the Arts and Crafts Movement, and much of Coburn's work at this time, such as *Wapping* (1904; see p.172), shows Dow's influence. **PGR**

1908	1909	1910	1912	1916	1916
The Photographic Salon des Refusés is organized for those UK photographers whose work was rejected by the Photographic Salon selection committee.	The American Links (Photo-Secession members including Coburn, Steichen and Stieglitz) resign from the Linked Ring, which then disintegrates.	From the ashes of the Linked Ring rises the London Salon of Photography to put on an annual exhibition of Pictorialist work. It still survives today.	The editor of *Amateur Photographer*, Francis J. Mortimer, becomes editor of *Photograms of the Year* and spreads the Pictorialist gospel.	Harold Pierce Cazneaux (1878–1953) founds the Sydney Camera Club with a group of fellow Pictorialists.	José Ortiz Echagüe (1886–1980) publishes his first book *Tipos y Trajes* (*Peoples and Costumes*) using the carbon Fresson process.

Wapping 1904
ALVIN LANGDON COBURN 1882 – 1966

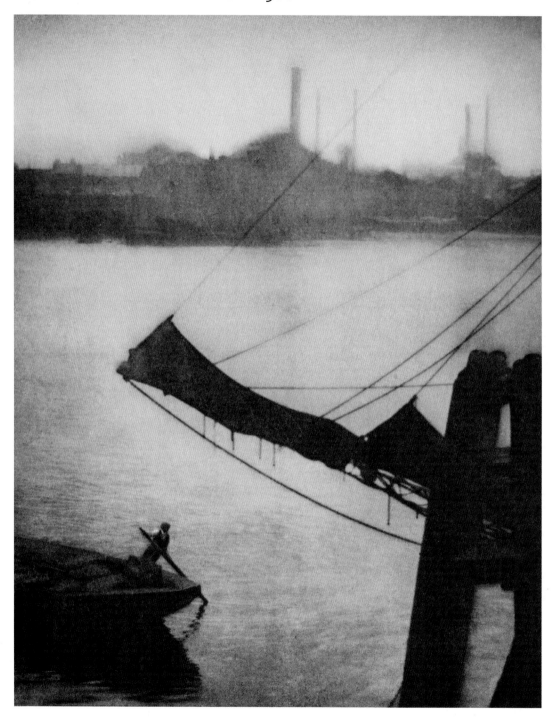

Gum platinum print
11 ⅛ x 8 ¾ in. | 28.5 x 22 cm
George Eastman House,
Rochester, New York, USA

Alvin Langdon Coburn thought London the most photogenic city in the world and was fascinated by capturing its many moods. While living in London, from 1904, he found himself especially drawn to the Thames, the shores of which he haunted, following in the footsteps of his idol James Abbott McNeill Whistler, who had painted the Thames at Wapping in south-east London between 1860 and 1864 when the area was bustling. By 1904, when Coburn's original negative of *Wapping* was made, the area was rather isolated, the busy river traffic having moved elsewhere. Coburn wrote that the play of sunlight on water formed the landscape photographer's finest subject matter. He looked for beauty in unlikely surroundings and would wait all day to find that perfect consummation of light, mood and self-expression. His London pictures are recognizably London but taken from a viewpoint that few others saw. In 1909, Coburn bought 'Thameside', an old four-storey house by Hammersmith Bridge. From his studio overlooking the river, he could watch the red-sailed barges float serenely by as the light changed and glinted on the water. **PGR**

✦ NAVIGATOR

👁 FOCAL POINTS

1 SUBTLE TONES
Coburn used the complex gum over platinum process. A platinum print, made from a negative, is coated with washes of gum arabic mixed with a coloured pigment before being re-exposed several times. This resulted in a subtly toned print with greater luminosity and rich, velvety depths.

2 LIMEHOUSE
Apart from its obvious pictorial qualities, Coburn visited Wapping often as it was adjacent to Limehouse, the area of London where many Chinese sailors had begun to settle in the late 1880s, establishing the capital's first Chinatown. He went there to experience Chinese culture and food.

3 NOTAN SYSTEM
Coburn used the principles of the Japanese notan system, using light and dark tones, parallel diagonals and spatial flattening. He was introduced to Japanese wood-block prints, particularly those of Hiroshige and Hokusai, while studying at Arthur Wesley Dow's Ipswich Summer School of Art. Many of the compositions in his book *London* (1909) can be compared directly to Japanese woodcuts. Here, the inspiration is Hiroshige's work *Ferry at Haneda* (1858).

4 BOAT
A solitary man steers the boat in the foreground. Boats and ships are a recurring theme in Coburn's work—sailing ships, tugs, barges and steamers appear regularly. In 1906 the British photographic press coined the word 'Coburnesques' for his moody, atmospheric waterscapes.

⏱ PHOTOGRAPHER PROFILE

1882–1905
Born in Boston, Coburn received a camera for his eighth birthday. In 1900–01 he visited Europe with art photographer Fred Holland Day, a distant relative, exhibiting in Day's show 'The New School of American Photography'. Apprenticed in Gertrude Käsebier's New York studio, Coburn became a friend of Stieglitz and a member of the Photo-Secession. He had his first one-man exhibition in New York in 1903 and returned to London in 1904, becoming a celebrity portraitist.

1906–12
Coburn's triumphant one-man exhibition at the Royal Photographic Society in 1906, showing portraits, landscapes and cityscapes, made him famous. From 1906 to 1909 he learnt photogravure and printed his own books, *London* (1909) and *New York* (1910). He returned to the United States where he photographed wild landscapes in Niagara, Yosemite and the Grand Canyon, creating abstract and Modernist cityscapes in Pittsburgh and New York. After he split from Stieglitz's circle, he embraced the Cubist ideas of artist Max Weber.

1913–66
Coburn exhibited his Vortographs, the first truly abstract photographs, in 1917. Traumatized by World War I, he moved to rural Wales in 1918 and began to explore spirituality, mysticism and the occult. He never returned to the United States and became a British citizen in 1933. He died twelve days after the publication of his autobiography.

Frank Eugene, Alfred Stieglitz, Heinrich Kühn and Edward Steichen Admiring the Work of Eugene 1907
FRANK EUGENE 1865 – 1936

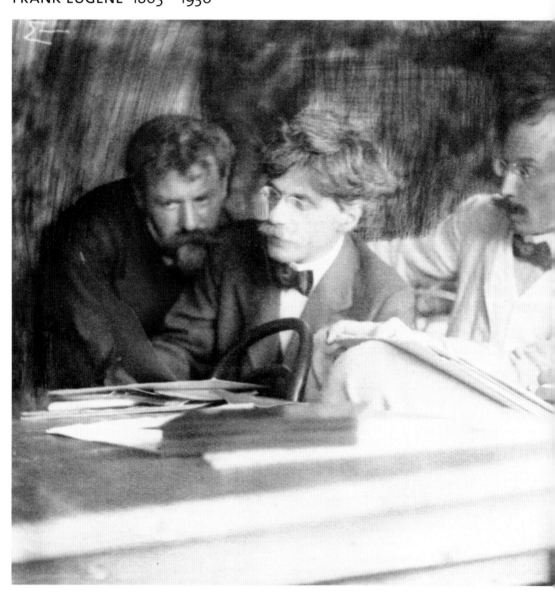

1 PAINTLIKE EFFECT
Eugene extensively reworked his negatives with oil and watercolour paint, graphite and ink and, most dramatically, with an etching needle, as seen here. His blending of art, photography, etching and printmaking was unique, but this hybridization often caused controversy.

2 ALFRED STIEGLITZ
Stieglitz is the main focus of the group here: his face is more brightly lit than any of the other photographers, so it stands out more, and it is he who holds up the sample for general scrutiny. Stieglitz always preserved his gravitas and was never photographed smiling.

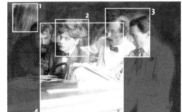

In July 1907 Frank Eugene arranged to meet Alfred Stieglitz—on one of the latter's recuperative trips to Germany with his family—and fellow photographers Edward Steichen and Heinrich Kühn at Tutzing, a small fishing village on Lake Starnberg in Upper Bavaria. The four men (from left to right: Eugene, Stieglitz, Kühn and Steichen) met to discuss and test the technicalities of the Autochrome—the first commercially available colour process on glass. The four are not shown, however, studying Autochromes (which were in short supply) but works on paper. Eugene has set up the camera on a tripod; the shutter release cable is under the table. The background is lost in a swirl of wild scratches—Eugene often modified his negatives in this way, using an etching needle—to concentrate instead on the significance of the meeting of these four photographers. The light glows around the pale suits of Kühn and Steichen, and Stieglitz's face, adding a momentous aura to the scene.

Over the next few years, all four, especially Steichen and Kühn, whose colour vision was enhanced by their practice as artists, produced some of the most beautiful examples of the Autochrome process. Stieglitz and Steichen had been in Paris on 10 June 1907 when the Lumière brothers announced their creation of the Autochrome, and the four photographers were anxious to experiment with this new colour technology. Steichen, although disappointed with the image content and quality of the plates exhibited by the Lumières, immediately bought plates, experimented for a week and achieved results that were thought, by his immediate circle, to surpass anything the inventors could produce. **PGR**

Platinum print
4 ⅜ x 6 ½ in. | 11 x 16.5 cm
Royal Photographic Society Collection, National Media Museum, Bradford, UK

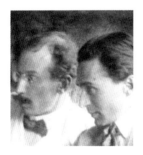

3 FOCUS ON MEN
By obscuring the background, Eugene throws the emphasis on to the foreground figures. The men are the prime subject of the piece, not Eugene's work. The startled expression on Kühn's face particularly keeps the viewer's eye focused on the photographers.

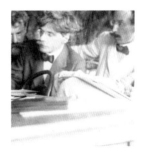

4 ANGLES
Eugene is mostly in shadow and is leaning forwards. The viewer's eye is subtly led towards him, however, by following a line along the near edge of the table, then up at an angle along the papers on Steichen's legs, via Stieglitz's bow tie, directly to the centre of Eugene's face.

THE PHOTO-SECESSION

|n 1904, Alfred Horsley Hinton, editor of the British magazine *Amateur Photographer* wrote: 'American photography is going to be the ruling note throughout the world unless others bestir themselves; indeed, the Photo-Secession pictures have already captured the highest places in the esteem of the civilized world. . . .It is Stieglitz who arranges terms, gets the pictures together, is responsible for their return. What an influence then he must have become. As one sees him today he is a man of highly nervous temperament, of ceaseless energy and fixed purpose.'

Alfred Stieglitz (1864–1946), the dominant force in US fine art photography for almost thirty years from 1892 to 1920, created the Photo-Secession in 1902, along European lines, from a group of Europhile US photographers, at first mostly based in New York. He had learnt photography himself from Dr Hermann Wilhelm Vogel at the Technische Hochschule in Berlin and during his years of higher education in Berlin from 1882 to 1890 became much influenced by the new radical European soft-focus Pictorial photography (see p.160) and the advance of the artist-photographer. This new breed of largely amateur, privately funded practitioners believed that the significance of a photograph lay not in its objective reality but in the subjective vision of the photographer.

KEY EVENTS

1903	1905	1907	1908	1908	1911
Highlights of the first issue of *Camera Work* include photogravures by Gertrude Käsebier, and a study of birds by A. Radclyffe Dugmore (1870–1955).	Stieglitz and Steichen open The Little Galleries of the Photo-Secession at 291 Fifth Avenue with a show of one hundred prints by Photo-Secessionists.	Stieglitz shows the first non-photography exhibition at the Little Galleries: drawings by Pamela Colman Smith.	The Little Galleries becomes '291' and moves to a new space at the same address. The rent is initially paid by Paul Haviland (1880–1950).	Drawings by Auguste Rodin and drawings, watercolours and lithographs by Henri Matisse are shown at 291. It is the first US exhibition for Matisse.	The first exhibition in the United States of Picasso's watercolours and drawings takes place at 291. The works are also reproduced in *Camera Work*.

On his return to New York in 1890, Stieglitz set about creating a national US Secession movement to give artistic photography a path to follow. His intent was to show that photography was an entity in its own right: rather than try to emulate art of the past, photography should simply be the major art form of the 20th century and beyond. From 1893 he was co-editor of *American Amateur Photographer* and in 1897 he became vice-president of the Camera Club of New York, which resulted from the merger of the Society of Amateur Photographers and the New York Camera Club. He also became editor of the club's new quarterly journal, *Camera Notes*, and turned it from a dreary house magazine into a state-of-the-art trophy production. Superb photogravure reproductions, made to Stieglitz's exacting specifications, and essays, articles and reviews commissioned from European and US intellectuals provoked controversy and discussion. There was no payment and *Camera Notes* was funded by advertising revenue and Stieglitz's own pocket.

By early 1902, Stieglitz had gathered a group of acolytes around him. Dallet Fuguet (1868–1933) and Joseph T. Keiley (1869–1914) worked as associate editors on *Camera Notes*. Photographers Edward Steichen (1879–1973), creator of *The Pond—Moonrise* (1904; see p.180), Alvin Langdon Coburn (1882–1966), Frank Eugene (1865–1936) and George H. Seeley (1880–1955) were staunch supporters of the Stieglitz behemoth. Stieglitz had amassed a diverse and international audience of art and photography lovers and was widely seen both at home and abroad as the leader of US artistic photography, but was finding it increasingly irksome to fight the Camera Club trustees for editorial control. One of Stieglitz's advocates, Clarence H. White (1871–1925)—who made his name with evocative portraits, especially of women or children as in *Drops of Rain* (right)—went on to found the Clarence H. White School of Photography in New York, which counted Dorothea Lange (1895–1965) and Paul Outerbridge (1896–1958) among its alumni. Another Stieglitz adherent, Gertrude Käsebier (1852–1934), celebrated for her carefully composed images of motherhood such as *The Picture Book* (opposite), was one of the most successful female photographers.

In March 1902, at the request of the National Arts Club, Stieglitz organized a critically acclaimed exhibition titled 'American Pictorial Photography Arranged by the Photo-Secession', the first time the name had been used in public to describe the loosely affiliated group. By this act, Stieglitz effectively declared his own secession from the Camera Club and, after reviewing the exhibition and writing a long editorial on the Photo-Secession in *Camera Notes*, he resigned his editorship. *Camera Notes* was discontinued shortly afterwards, but another publication was already waiting in the wings and the first issue of *Camera Work*, dated January 1903, was published in December 1902.

Camera Work was Stieglitz's visual and literary love poem to photography and art and closely reflected his escalating art education. A quarterly journal, it ran to fifty issues (including three unnumbered and three double issues), closing in 1917.

1 *The Picture Book* (1902)
Gertrude Käsebier • platinum print
9 ½ x 13 ⅝ in. | 24 x 35 cm
Museum of Modern Art, New York, USA

2 *Drops of Rain* (1903)
Clarence H. White • platinum print
7 ⅝ x 6 in. | 19 x 15 cm
Museum of Modern Art, New York, USA

1914	1915	1916	1917	1917	1919
Clarence H. White's School of Photography is founded to teach the art 'with construction and expression'. Karl Struss (1886–1981) is one of the students.	Stieglitz and artist Marius de Zayas launch proto-Dadaist arts magazine *291*, styled as a work of art in its own right. Only twelve issues are published.	White, Struss and Edward Dickson (1880–1922) found the Pictorial Photographers of America, to promote Pictorial photography.	The last *Camera Work*, issue 49/50, features eleven gravures by Paul Strand, including six New York street portraits.	The final show at 291 gallery features work by Georgia O'Keeffe, with whom Stieglitz has a relationship from 1916 until his death thirty years later.	Struss begins work as a cameraman for Cecil B. DeMille and, later, D. W. Griffith. He shares an Academy Award in 1929 for his work on the silent film *Sunrise*.

3 *The White Trees* (c. 1910)
George Seeley • photogravure
7 ⅛ x 6 ⅛ in. | 20 x 15.5 cm
Lee Gallery, Winchester,
Massachusetts, USA

4 *The Octopus* (1909)
Alvin Langdon Coburn
silver print
22 x 16 ½ in. | 56 x 42 cm
Museum of Modern Art, New York, USA

5 *Wall Street* (1915)
Paul Strand • platinum print
9 ⅞ x 12 ⅝ in. | 25 x 32 cm
Philadelphia Museum of Art, USA

Controlled, edited, funded and largely designed by Stieglitz, with major creative and practical input from Steichen, *Camera Work* would act as the house magazine of the Photo-Secession but, theoretically, be independent of it. In the *Supplement to Camera Work* of 3 July 1903, Stieglitz wrote that the object of the Photo-Secession was 'to advance photography as applied to pictorial expression; to draw together those Americans practicing or otherwise interested in the art, and to hold from time to time, at varying places, exhibitions not necessarily limited to the productions of the Photo-Secession or to American work.'

The most astonishing thing about *Camera Work* was the way it looked. The emphasis was placed on the illustrations, which were hand-pulled photogravures, such as George Seeley's *The White Trees* (above), printed on exquisitely delicate Japanese tissue, then mounted on high-quality, deckle-edged art paper. All were made to Stieglitz's exacting standards, at huge expense. Initially, the print run was 1,000 copies but subscriptions plummeted after modern art began to push Pictorial photography off the pages after 1907, and the print run was cut to 500. By 1917, when *Camera Work* closed, there were only thirty-six paying subscribers.

Camera Work mostly featured work by members of the Photo-Secession from 1902 to 1907—there were eventually more than one hundred members, fellows and associates, all appointed by Stieglitz—mixed with a sprinkling of art and interspersed with essays, reviews, poems and technical reviews. Contributing writers of note included Maurice Maeterlinck, George Bernard Shaw, Wassily Kandinsky, Gertrude Stein, H. G. Wells and Henri Bergson. In 1905, when Stieglitz

and Steichen opened the Little Galleries of the Photo-Secession, later known as '291' from its address on Fifth Avenue, *Camera Work* became the unofficial catalogue for the shows of photography, modern art and sculpture held there.

Many issues were devoted to the work of a single photographer—usually a member of the Photo-Secession—with a favourable critical essay, often by another member of the Photo-Secession. Steichen's work was most frequently reproduced, with sixty-eight images and five one-man editions, but Clarence H. White, Frank Eugene, Heinrich Kühn (1866–1944), Adolph de Meyer (1868–1949) and James Craig Annan (1864–1946) also had one-man issues, as did Alvin Langdon Coburn, creator of *The Octopus* (right), in which Pictorialism blends with more modernist elements, and the 'rediscovered' David Octavius Hill (1802–70)—along with his unattributed collaborator, Robert Adamson (1821–48). Stieglitz himself was equally capable of creating memorable images, such as *The Steerage* (1907; see p.182). Between 1900 and 1910, the work of White, Käsebier, Steichen, Seeley, Brigman, Coburn and Stieglitz himself embodied US Pictorial photography at its highest level.

In October 1910, the Albright Art Gallery in Buffalo, New York showed the 'International Exhibition of Pictorial Photography' of 600 photographs—mostly by members of the Photo-Secession and chosen by Stieglitz—to great acclaim, attracting 15,000 visitors in a month. The gallery also bought photographs by Photo-Secession members for its collection, the first US museum to do so.

Stieglitz's evolving aesthetics led him towards the European avant-garde. Using Steichen as his Europe-based talent scout, he turned to modernism, Cubism and Expressionism in art and away from Pictorialism in photography. From 1909 to 1917, only six of the sixty-one exhibitions at 291 featured photography. Work by Henri Matisse, Pablo Picasso, Paul Cézanne and young US artists such as Arthur G. Dove, John Marin and Max Weber replaced work by the Photo-Secessionists. The European Secessionist groups largely splintered; World War I affected the production of *Camera Work* and it was suspended until briefly revived for a final swan song. Abstract and modernist work of unequivocal power, such as *Wall Street* (below) by Paul Strand (1890–1976), was prominent in the penultimate and last issues of *Camera Work* in 1916–17. Printed in harsh, dark ink, the pure, direct images seemed brutal and all too real compared with the ethereal soft-edged Pictorialism of *Camera Work*'s early years. **PGR**

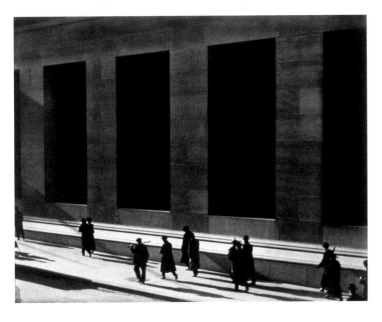

The Pond–Moonrise 1904

EDWARD STEICHEN 1879 – 1973

Multiple coloured gum bichromate
over platinum print
15 ⅝ x 19 in. | 40 x 48 cm
Metropolitan Museum of Art,
New York, USA

✦ NAVIGATOR

dward Steichen's *The Pond—Moonrise* is one of three existing images
printed from the same negative, albeit with widely differing techniques
applied to each. This particular version of the nocturnal scene is a
platinum print with applied Prussian blue and calcium-based white pigment,
likely hand-applied, to suggest a crepuscular blue-green light and reflected
moon glow. The negative was taken in the wetlands in Mamaroneck, a small
town in Westchester County on Long Island Sound, New York. Steichen and his
wife Clara had gone there after the birth of their first daughter, Mary, in July
1904, staying at the home of the art critic Charles H. Caffin.

During the first few years of the 20th century, Steichen strove to make
colour prints. It was not until 1907 that the Lumière brothers in Paris announced
their invention of the Autochrome, the first commercial and practical colour
process, which Steichen rapidly mastered and perfected. Prior to this, he had
produced a series of 'colour' images using complex printing processes—mixtures
of gum and pigment applied over a platinum or silver base. These large prints
were expensive and laborious to make. Their selling price was high and few
sold at the time, other than to Alfred Stieglitz. On 14 February 2006, a version of
The Pond—Moonrise, sold at Sotheby's in New York for more than US$2.9 million
(£1.67 million), breaking the then world record price for a photograph. **PGR**

1 PAINTERLY EFFECT
Steichen was also a painter, and in order to create a painterly effect, he brushed pigment held in light-sensitive gum across the photograph. It is the work of arch-nocturnist James Abbott McNeill Whistler that most resonates here. (Whistler's series *Nocturnes* inspired Steichen's photograph of the Flatiron Building in 1904.) Each of the three prints of this scene is unique, as distinct from the others as paintings in a series, and displays the selective hand and control of the artist.

2 MOONLIGHT
More shade than light, the scene has an ethereal quality that attracted Steichen, who often photographed or painted woods at dusk or in moonlight in the years before World War I. 'The romantic and mysterious quality of moonlight...made the strongest appeal to me,' he wrote in his autobiography *A Life in Photography* (1963). 'The real magician was light itself—mysterious and ever-changing light with its accompanying shadows rich and full of mystery.'

3 TREES
The lack of any sharp detail— the edges of the trees simply fade away—underlines the debt Steichen and the Pictorialists owed to Impressionism. In order to deliberately blur an image, he sometimes smeared his lens with petroleum jelly, sprinkled it with water, moved his tripod or manipulated the negative.

4 COLOUR
Steichen enriches the night scene with his subtle use of colour. In fact, at first he used his photographs of woodlands seen at night as 'sketches' to be developed later into paintings. He made accurate notes of the colours of a scene in situ and jotted down the pigments he would use in the painting itself.

1879–1904
Eduard Jean Steichen was born in Luxembourg. His family immigrated to the United States in 1881 and he trained as a lithographer at the American Fine Art Company, Milwaukee. He became a US citizen in 1900 and, after two years' study in Paris, he joined the Photo-Secession back in New York. He worked with Alfred Stieglitz on *Camera Work* and experimented with non-silver processes and early colour photography. He married Clara E. Smith in 1903.

1905–27
Steichen helped Stieglitz set up the Little Galleries of the Photo-Secession. Returning to Paris, he supplied cutting-edge modernist European art to the gallery until 1915. He was a US army photographer in World War I, embracing 'straight' photography (see p.280). In 1923, he became head photographer for Condé Nast, also working for advertising agency J. Walter Thompson. He abandoned painting, destroying his canvases.

1928–73
After serving in the US Naval Reserve during World War II, Steichen became head of the US Naval Photographic Institute in Washington and then director of the department of photography at the Museum of Modern Art, New York. His exhibition 'The Family of Man' (1955) toured worldwide for seven years. He died in 1973 after a series of strokes.

STEICHEN AT CONDÉ NAST

As early as 1907, Edward Steichen had photographed two smartly attired ladies at the Longchamp racetrack in Paris. Four years later, he was commissioned by *Art et Décoration* magazine to photograph dresses designed by Paul Poiret, but swiftly returned to fine art photography. By 1923, however, with a costly divorce behind him, Steichen was short of money and at a low ebb. Then, he was offered work at two of Condé Nast's most influential magazines: *Vanity Fair* (as house portraitist) and *Vogue* (on fashion shoots). Leaving behind the fine art photography that he had espoused alongside Alfred Stieglitz, Steichen embarked on an illustrious career as a photographer of high fashion and contemporary culture. His fastidious approach and broad imagination—he drew on his training as a painter and knowledge of avant-garde art as well as visual conventions from movies—made him a cornerstone of both publications. Steichen left Condé Nast in 1937. During his tenure, he had revitalized fashion photography and his influence can be seen in the work of a number of highly regarded fashion photographers, such as Horst P. Horst (1906–99), Richard Avedon (1923–2004) and George Hoyningen-Huene (1900–68). Steichen produced more than 1,000 portraits across a broad range of professions; his subjects included Winston Churchill, Rudolph Valentino, Igor Stravinsky, George Bernard Shaw, Henri Matisse, Martha Graham, Gloria Swanson and Greta Garbo.

The Steerage 1907
ALFRED STIEGLITZ 1864–1946

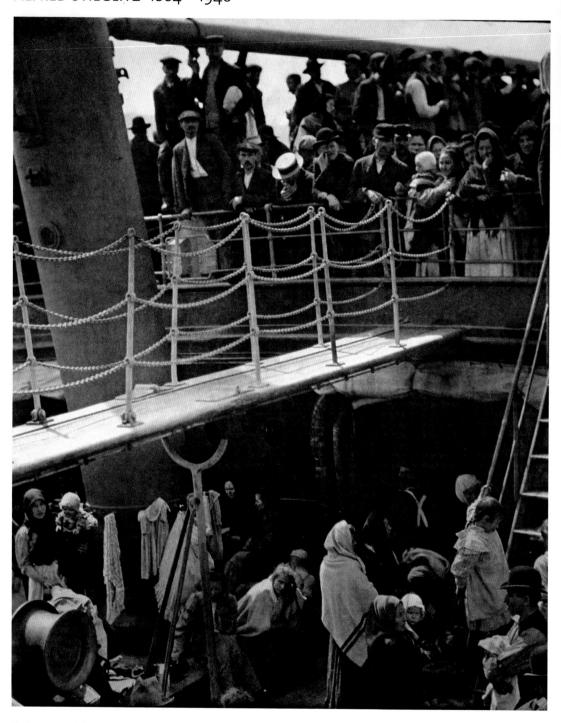

Photogravure print
13 ⅛ x 10 ⅜ in. | 33.5 x 26.5 cm
Royal Photographic Society Collection,
National Media Museum, Bradford, UK

Retrospectively claimed by Alfred Stieglitz as his first modernist work, *The Steerage* was taken in June 1907 on board the ship SS *Kaiser Wilhelm II* when the Stieglitzes, installed in a lavish first-class stateroom on the upper decks, were sailing to Europe to visit friends and family. Wandering around the ship and looking down on the cramped lower class quarters, Stieglitz was struck by the marked contrast in conditions between first and steerage class and the graphic and geometric possibilities of the image. The scene below the diagonal gangplank, which slices the image in two, shows mostly shrouded women and apprehensive children huddled into a cramped space and has the air of a grim refugee camp. Despite the much-vaunted spaciousness of the *Kaiser Wilhelm II* above decks, some 900 people could be crammed into steerage where they were often devoid of light, circulating air, sanitation, food and even water.

In 1907, Stieglitz was using a hand-held 4 × 5-inch Auto-Graflex with glass-plate negatives and had only one plate prepared on the ship. He used this to make the exposure, developing it on reaching Paris and then carrying it around with him for the rest of his stay in Europe. 'The scene fascinated me,' he recalled. 'A round straw hat; the funnel leaning left, the stairway leaning right; the white drawbridge, its railings made of chain; white suspenders crossed on the back of a man below; circular iron machinery; a mast that cut into the sky, completing the triangle. I stood spellbound for a while. I saw shapes related to one another—a picture of shapes, and underlying it, a new vision that held me: simple people; the feeling of ship, ocean, sky.' By Stieglitz's standards *The Steerage* is a very busy image, but it is tightly pulled together, and framed, by the solidity of the funnel or mast far left and the ascending gangplank and ladder. Symmetry, harmony and perhaps hope are suggested by the delicate white looped chains of the gangplank, leading to a better place.

Although the photograph marks Stieglitz's departure from a painterly style to harder edged documentary, he was slow to realize the potential of this influential image. He did not publish it in *Camera Work* until October 1911, nor exhibit it at 291 gallery as an enlarged photogravure until 1913, nor acknowledge satisfaction with it at the time. It was only some years later that he wrote, 'If all my photographs were lost, and I were represented only by *The Steerage*, that would be quite all right.' **PGR**

⏱ PHOTOGRAPHER PROFILE

1864–91
Born in Hoboken, New Jersey to parents of German-Jewish origin, Alfred Stieglitz's later education (1881–90) was in Berlin. There he studied photochemistry under Professor Vogel and made prize-winning amateur photographs before returning to New York in 1890 and becoming a partner in a photogravure company.

1892–1901
Stieglitz began writing for *The American Amateur Photographer* and in 1893 was appointed editor. From 1897, he edited *Camera Notes* for the Camera Club of New York, and in 1899 he held his first solo exhibition at the Camera Club. The following year he met Edward Steichen at the First Chicago Photographic Salon and the two photographers became close friends.

1902–04
In 1902, Stieglitz founded the Photo-Secession, which aimed to advance US Pictorial photography along the lines of European artistic Secession movements. From 1903, he published, directed and edited the influential journal *Camera Work*.

1905–17
With Edward Steichen, he opened the Little Galleries of the Photo-Secession (later renamed 291) in New York in 1905, showing photography and, latterly, introducing European and US modern art to the United States. After the final Photo-Secession show at the Albright Art Gallery, Buffalo in 1910, the movement imploded. Stieglitz focused on art and also began a relationship with Georgia O'Keeffe. The final two issues of *Camera Work* featured the straight photography of Paul Strand (1890–1976), and in 1917 *Camera Work* and 291 closed.

1918–46
Stieglitz began to embrace modernism in his own photography, which had been largely put on hold during his publishing years. O'Keeffe became his muse and between 1918 and 1925 Stieglitz photographed her continually, producing a prolific body of work. His opened two galleries—Intimate Gallery (1925–29) and An American Place (1929–46)—and both showed European and US modern art, with some photography. Stieglitz's health began to deteriorate in 1938 and he died in 1946.

THE MODERN AGE

The early 20th century brought exciting advances in technology, transport and exploration. It was the period of the pioneer aviators, the start of automobile land-speed records and the charting of the world's last unmapped territories. Whether made as art, science or reportage, these changes would all be recorded for posterity by the camera. *Grand Prix of the Automobile Club of France, Course at Dieppe* (above) by Jacques Henri Lartigue (1894–1986) is typical of the pictorial innovations of the period. It is both a defining image of speed and an example of photography pushed to its limits. The distortion of the forward movement of the car against the sloping figures of the bystanders is the result of the vertical shutter of Lartigue's camera being too slow to register accurately either the speeding car or the static spectators as the photographer panned to follow the subject. The privately wealthy Lartigue was a keen motorist and aviator and his images of these subjects reflect his enthusiasm for the possibilities of the new century.

The photographs of Antarctica taken in the early 20th century were thrilling to the public. Herbert Ponting (1870–1935), accompanying explorer Captain Robert Falcon Scott, and Frank Hurley (1885–1962), travelling with Ernest Shackleton, made images under the most arduous conditions imaginable. Not only was their equipment cumbersome, but the sub-zero conditions also interfered with the technology and chemistry. Ponting joined the British Antarctic Expedition in 1910, returning to London in early 1912 with more than 1,700 plates and unaware of Scott's death during the trek to the South

KEY EVENTS

1903	1907	1910	1913	1914	1914
A photograph captures the first aeroplane flight; it shows Orville Wright piloting and his brother, Wilbur, watching from the ground.	The first viable colour photographic process, Autochrome Lumière, is launched in France.	Herbert Ponting joins the British Antarctic Expedition as official photographer and cinematographer.	An exhibition of Ponting's photographs of Scott's expedition opens in London. It includes images taken at the South Pole by the ill-fated explorers.	After the assassination of Archduke Franz Ferdinand on 28 June, Austria-Hungary declares war against Serbia, precipitating World War I.	Edward Steichen (1879–1973) becomes commander of the photographic division of aerial photography in the American Expeditionary Forces.

Pole. Shackleton's Imperial Transantarctic Expedition of 1914 to 1917 saw the *Endurance* become stuck in the pack ice and begin to break up. As the ship was crushed around him, Hurley tried to rescue his plates by diving into the freezing water flooding her hold. Shackleton and Hurley could not carry all the plates, so they chose the best 120 from more than 500 Hurley had made and destroyed the rest. Hurley and Ponting were intrepid photographers who risked their lives to make images worthy of their subject matter. Nonetheless, their Antarctic photographs look back to an earlier era of maritime and landscape painting. Ponting's images, even when taken from the rigging of the *Terra Nova* in a storm, are carefully composed. His *Grotto in a Berg,* Terra Nova *in the Distance* (1911; see p.186) shows the entrance to a cavern framing a view of the *Terra Nova* lying at an icefoot a mile away, accentuating the imposing landscape.

By the mid 1930s, the concept of air travel had been tarnished by several major airship accidents in the United States and Europe; only the German Zeppelins seemed able to realize the dream of safe, intercontinental airship travel. On the evening of 6 May 1937 the Zeppelin *Hindenburg* was docking at Lakehurst, New Jersey at the end of another successful transatlantic flight. It exploded just minutes before it was about to land. The world's press were present to witness the disaster; the photograph of the *Hindenburg* fireball (below), taken by *New York Daily News* photographer Charles Hoff (1920–75), illustrates photography's power at scenes of tragedy as well as triumph. **DS**

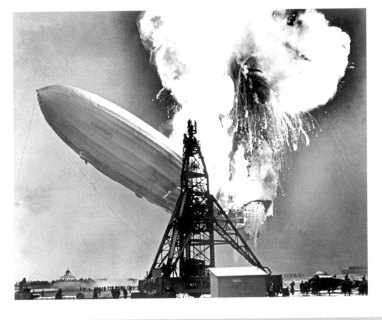

1 *Grand Prix of the Automobile Club of France, Course at Dieppe* (1912)
Jacques Henri Lartigue
silver print
10 x 13 ½ in. | 25.5 x 34.5 cm
Museum of Modern Art, New York, USA

2 *The* Hindenburg *Explodes into Flames* (1937)
Charles Hoff • silver print
8 x 10 in. | 20.5 x 25.5 cm
New York Daily News Archive, USA

1915	1924	1927	1927	1930	1937
On 27 October Ernest Shackleton gives the order to abandon the trapped *Endurance*; Frank Hurley saves his cameras and some of his negatives.	The hand-held Leica I camera launches in Germany. It enhances instantaneity and opens up possibilities for new perspectives in composition.	*Malerei, Fotografie, Film (Painting, Photography, Film)* by László Moholy-Nagy (1895–1946) promotes the use of photography to depict the modern age.	The Ford Motor Company hires Charles Sheeler (1883–1965) to photograph its Detroit plant; his industrial images suggest a technological utopia.	Lewis Hine (1874–1940) receives a commission to photograph workers constructing the Empire State Building high above the streets of New York.	The press capture disturbing images of the *Hindenburg* exploding at Lakehurst, New Jersey while docking after a transatlantic flight.

Grotto in a Berg, *Terra Nova* in the Distance 1911

HERBERT PONTING 1870 – 1935

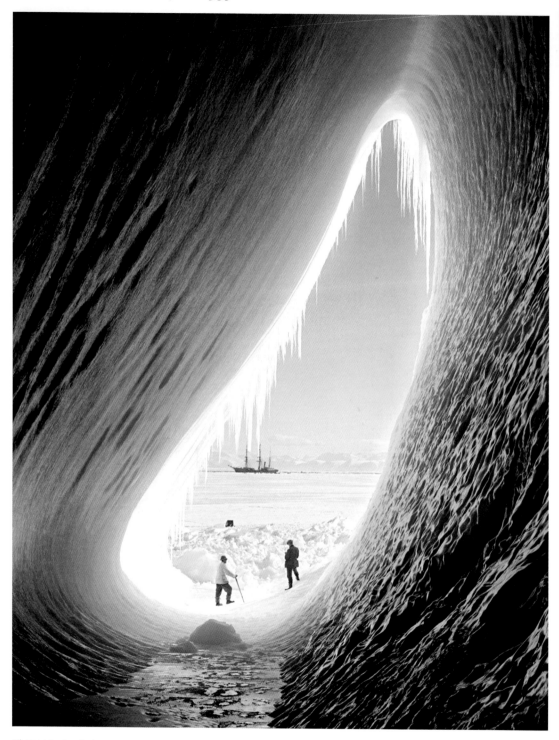

Silver print • 7 x 5 in. | 17.5 x 12.5 cm
Scott Polar Research Institute, Cambridge, UK

W hen Herbert Ponting joined Captain Robert Falcon Scott's British Antarctic Expedition in 1910 he became the first professional photographer to accompany an expedition to the South Pole. For this gifted photographer of nature, the encounter with the 'Great White South' proved to be the defining highlight of his career. His studies of the Antarctic have a remarkable beauty, and his portraits of Scott's team have a formal dignity that illustrates the sincerity of the undertaking.

Like all of Ponting's images, this scene is composed carefully and artfully to deliver a specific effect. The inclusion of the explorers and the distant silhouette of the expedition ship, the *Terra Nova*, mean that the photograph is far more than a geological study: it is a photographic tour de force that conveys eloquently the epic nature of the voyage and the heroic bravery of those who ventured into an alien landscape.

Ponting described himself as a 'camera-artist' and, despite the arduous conditions, he did not compromise his technique, using 7 x 5-inch and 5 x 4-inch glass plates for his negatives. These yielded exquisite detail and were printed as large as 29 inches (73.5 cm) high or wide. Although his film was black and white, generally Ponting's photographs were printed as fine art prints in carbon. When ordering one of his Antarctica photographs, buyers chose from a limited range of hues; the photographs that are preserved are generally a midnight blue, pale green or grey. **DS**

FOCAL POINTS

1 GROTTO WALL
The sun touches the outer rim of the grotto, accentuating the outline of the cavern mouth and reflecting into the interior, allowing the viewer to appreciate its strange form. The grotto's shape echoes the hollow of a wave and the vertical framing emphasizes the sense of frozen motion.

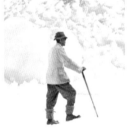

2 DISTANT SHIP
The grotto mouth frames a freezing sea and distant horizon, against which the *Terra Nova* appears. Its presence offsets the emptiness of the landscape and Ponting places his camera so that icicles appear to touch the rigging of the ship, stressing the danger posed by nature.

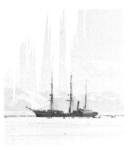

3 FIGURE RIGHT
Meteorologist Charles Wright stands in the entrance to the ice grotto. Including human figures in the photograph gives a sense of scale. The pair of brave explorers appears tiny and vulnerable: dwarfed by the vast amount of inhospitable ice that stretches in all directions.

4 ALIEN LANDSCAPE
Leaning on his walking stick, geologist Thomas Griffith Taylor cuts a curiously quaint figure in this alien landscape. In 1911, exploration of the Antarctic was as futuristic as the conquest of space. The image inspires and foreshadows popular imagery in 20th-century science fiction.

PHOTOGRAPHER PROFILE

1870–1903
Herbert Ponting was born in Salisbury, Wiltshire, England. He followed his father into banking, but then moved to California where he worked as a farmer. When his ranch failed in 1900, he became a freelance photographer.

1904–09
Ponting covered the Russo-Japanese War of 1904 to 1905, and went on to photograph in Japan, India, China, Korea, Java and Burma for major English-language periodicals.

1910–12
In 1910, he collected his photographs of Japan into a book, *In Lotus-Land Japan*, and became a Fellow of the Royal Geographical Society. The same year, he signed on with Scott's British Antarctic Expedition and was with the expedition until late February 1912.

1913–35
After Scott's death, Ponting worked to ensure that his heroism would not be forgotten, touring the United Kingdom to give lectures. He published a book, *The Great White South* (1921), and released his expedition film *90° South* in 1933.

WAR, PROTEST AND REVOLUTION

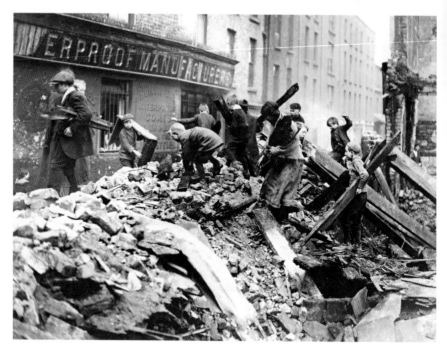

S ociety experienced enormous cultural, social and political change in the early 20th century. As Marxism spread, social unrest followed in its wake: the working classes took to the streets from Russia to Mexico; women protested for the right to vote; cracks appeared in empires as colonialism came into question; and World War I changed the map of Europe. Mass media was on the rise thanks to improved communications and printing technology that made it possible to reproduce photographs cheaply in magazines and newspapers. The appetite for photographs to fill news pages led to the birth of the photojournalist and the public was able to see world events from the viewpoint of an eyewitness at the scene.

Photography was able to document the devastating consequences of protest, war and revolution across the globe. *Scavengers* (above) shows poor children in Dublin, Ireland collecting firewood from ruined buildings that had been damaged during the Easter Rising of 1916 against British rule, in which almost 2,000 people, mostly civilians, were killed or injured. The image of young children desperately foraging among the rubble and ruins highlights the plight of the poverty stricken at that time. The revolt and its repression by the British helped to increase the resolve of the Irish republicans.

KEY EVENTS

1903	1910	1911	1913	1914	1916
Emmeline Pankhurst founds the Women's Social and Political Union, a militant movement to win the vote for women.	London's *Daily Mirror* prints a photograph of suffragette Ada Wright being brutally treated by the police during the Black Friday march on 18 November.	Images of British Home Secretary Winston Churchill at the siege of Sidney Street appear in newspapers. Parliament asks why he was there.	Emily Davison is fatally injured as she tries to stop the king's horse on Derby Day. Press photographer Arthur Barrett captures the moment.	World War I begins. It results in the break-up of the German, Russian, Ottoman and Austro-Hungarian empires.	French magazine *Le Miroir* publishes a photograph of trench casualties taken at Combles on its cover.

In Russia, the revolution provided the opportunity for dramatic works of photo-reportage. Viktor Bulla (1883–1938) photographed *Government Troops Firing on Demonstrators, Corner of Nevsky Prospect and Sadovaya Street, St Petersburg, Russia* (below) on 4 July 1917, during what became known as the 'July Days', when provisional government troops killed fifty-six people who were demonstrating peacefully. The son of Karl Bulla (*c.* 1853–1929), often described as the 'father of photo-reporting in Russia', Viktor also became a photojournalist. He covered the Russo-Japanese War, World War I, October Revolution and Russian Civil War and became the chief photographer of the Leningrad Soviet, before falling from grace during Stalin's Great Purge.

During the revolution Viktor never left home without a camera: 'Events of the revolutionary life took place with unimaginable speed, I had to keep up and be everywhere. . . .I was never at home, but roamed the streets of the city, as a real hunter for something to happen.' When he heard gunfire on Sadovaya Street on that fateful day in July, Viktor climbed on to the roof of a department store to ensure that he could take a photograph showing the scale of the protest, but was shocked when people were killed. Although his hands shook, he continued to document the atrocity and the resulting image depicts the chaos, with protesters fleeing in fear and those hit by gunfire falling to the ground.

By the time the Spanish Civil War broke out, the public expected action shots from an ongoing conflict. Among the international observers was the young Robert Capa (1913–54) and his photograph of a soldier killed by a bullet, *Death of a Loyalist Militiaman* (1936; see p.190), appeared in numerous publications and became an iconic image. **CK**

1 *Scavengers* (1916)
Photographer unknown • silver print
Hulton Archive/Getty Images

2 *Government Troops Firing on Demonstrators, Corner of Nevsky Prospect and Sadovaya Street, St Petersburg, Russia* (1917)
Viktor Bulla • silver print
4 ¾ x 13 ⅜ in. | 12 x 21.5 cm
Metropolitan Museum of Art, New York, USA

1916	1917	1918	1936	1937	1938
Irish republicans stage the Easter Uprising from 24 to 30 April, aiming to end British rule and establish an Irish republic.	The October Revolution takes place in Russia and the new Soviet state is created.	The armistice ends World War I. The British Parliament decrees that women over the age of thirty can vote.	The Spanish Civil War begins. Foreign correspondents, including Robert Capa, Ernest Hemingway and George Orwell, report on the conflict.	Viktor Bulla is arrested as a spy for the Germans. He is sentenced to death and executed by firing squad a year later.	On 3 December *Picture Post* devotes eleven pages to Capa's images of the Spanish Civil War and hails him as the world's 'greatest war photographer'.

Death of a Loyalist Militiaman 1936
ROBERT CAPA 1913 – 54

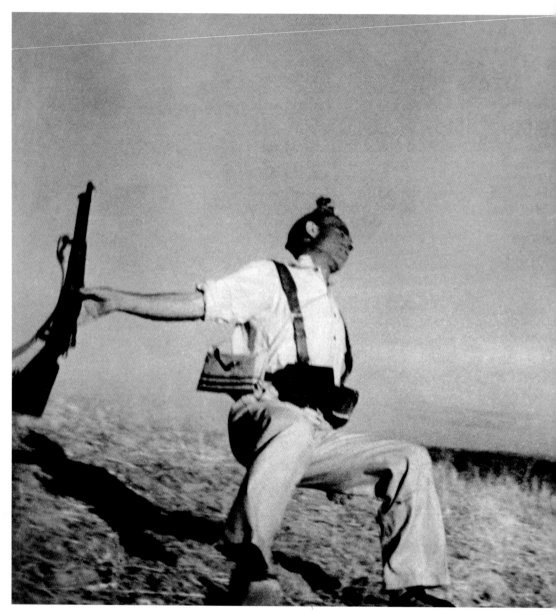

1 HAND AND RIFLE
The rifle falls from the man's hand as his body crumples to the ground. Capa's image shows the moment of death and startles viewers with its terrifying immediacy. The absence of blood makes the image more shocking because it powerfully illustrates how sudden death can be.

2 MOUNTAINS
Experts have studied the mountains in order to clarify their exact location. The debate says as much about our interest in how photographs serve as visual historical records as it does about doubts over authenticity. War images can serve as propaganda and as historical documents.

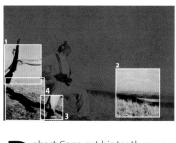

R obert Capa cut his teeth as a war photographer during the Spanish Civil War and gained international renown with this image. Taken at the Córdoba front during the early months of the war, it shows a soldier who has just been shot. First published in the 23 September issue of French magazine *Vu*, the photograph was reprinted widely. It became the defining image of the conflict, as well as one of the most famous war photographs ever taken. Two years later, British magazine *Picture Post* published a spread of twenty-six photographs taken during the war and declared the twenty-five-year-old Capa to be 'the greatest war photographer in the world'.

The image is also controversial and there has been considerable debate about the circumstances of its creation. It has been claimed that it was staged and that the man was killed while posing for a photograph rather than in battle; that the subject is not the anarchist Federico Borrell García, as thought in the 1990s; and that the location is Espejo, 35 miles (56 km) from Cerro Muriano, where the picture was located in the 1980s. Capa may well have been staging a shoot of a soldier when he was razed to the ground by a sniper's bullet and thus felt partially responsible for his death, resulting in a blurring of the facts. This demonstrates the danger of war both for the military and those reporting on it, recalling Capa's comment: 'If your photographs aren't good enough, you're not close enough.' **CK**

Death of a Loyalist Militiaman, Córdoba Front, Spain, September 1936
Silver print
11 x 15 in. | 28 x 38 cm
International Center of Photography, New York, USA

3 BLUR OF MOVEMENT
Cameras were not automatic at this time and the subject is slightly out of focus. The blur adds to the tension and increases the image's impact. The photograph marks the moment when Capa became a combat photographer: he chose to take the shot despite its tragic circumstances.

4 SHADOW
The long shadow behind the falling loyalist soldier suggests that the photograph may have been taken late in the afternoon. He falls backwards to the ground towards his own shadow—the long, dark shape of which is macabrely reminiscent of an open grave.

DADA

W hile war raged in Europe in early spring 1916, a group of international artists prepared for the first soirée of a newly opened cabaret in the Swiss city of Zurich. Most were emigrés from surrounding countries, either trying to evade the draft or seeking shelter in politically neutral Switzerland from the aggressive nationalism in their home countries. The establishment they founded, the Cabaret Voltaire, is regarded as the nucleus of Dada, although earlier traces of its distinctive characteristics can be found in other centres of the emerging Dadaist spirit, such as New York, Paris, Berlin, Hanover and Cologne.

The movement was defined more by shared beliefs and a set of recurring artistic strategies (media pranks, scandal, chance and automatism) than by a common style. Forms that were to shape 20th-century art—such as collage, montage, assemblage, performance and the ready-made—were introduced by Dada. The Dadaists were unified in their firm opposition to the war and a deeply rooted scepticism towards traditional values and ideologies, which—in light of the terrible death toll of World War I—seemed to have failed. Similarly, they saw established arts and arts institutions as unable to cope either with conveying the experience of war or with accelerating technological development. Photography offered Dadaists a means to integrate the mundane and everyday into artistic practice and thus to flatten the boundaries between those two spheres. Moreover, they felt that the medium had not yet been corrupted by an artistic tradition.

KEY EVENTS

1916	1916	1917	1918	1918	1920
On 5 February, Cabaret Voltaire, the nucleus of the international Dada movement, opens in Zurich.	Hugo Ball recites the first Dada Manifesto at Zunfthaus zur Waag, Zurich on 14 July, during the first public Dada event.	Richard Huelsenbeck, who had returned to Germany from Zurich the previous winter, moves to Berlin, spreading Dadaist ideas to artists there.	Tristan Tzara publishes his 'Manifeste Dada'—a key text for the movement—in the third issue of the journal *Dada*.	An uprising of German sailors leads to the November Revolution; the German monarchy is toppled and a republic is declared. World War I ends.	On 24 June, the Erste Internationale Dada Messe (First International Dada Fair) opens in the Gallery Otto Burchard in Berlin.

In New York, the Dada spirit was represented by a group of international artists, among them Marcel Duchamp, Jean Crotti, Man Ray (1890–1976) and Francis Picabia, who had gathered regularly in the salon of art patrons Louise and Walter Arensberg since 1915. In 1917, Duchamp produced a veritable Dadaistic scandal when he submitted one of his legendary ready-mades to an exhibition of the Society of Independent Artists: *Fountain*, a plain white urinal signed with the pseudonym 'R. Mutt'. It was rejected, but was presented to the public later that year in an exhibition organized by Alfred Stieglitz (1864–1946), whose photograph of the urinal (1917) appeared in the Dada periodical *The Blind Man*.

German artist Christian Schad (1894–1982) was associated with Dada Zurich by way of his close friend Walter Serner, one of the key theorists of the international Dada movement together with Tristan Tzara. Schad began experimenting with photographic paper, covering it with ordinary objects—often found in the streets—then exposing the arrangement to direct sunlight. He worked with printing-out paper, whose rather slow reation to light allowed him to rearrange the objects during exposure. The pictures created from this process, such as *Amourette* (opposite), were small photograms, which playfully oscillate between a direct reference to the everyday objects and an abstract artistic reality. Years later Tzara coined the term 'Schadographs' for the images, alluding to the artist's name and to the shadows that the objects seem to leave on the light-sensitive paper. In assembling mundane fragments and making them into a work of art, Schad's photograms owe as much to Duchamp's ready-mades as to the photomontages of the Berlin Dadaists.

If World War I had the feel of a distant thunder in New York, its political and economical aftermath had a far more direct impact on life in Berlin. The activities of the Berlin Dadaists are therefore among the most aggressive and politically subversive of the international Dada movement. Photomontage became a favourite means of expression, with Hannah Höch (1889–1978)—whose *Cut with the Kitchen Knife* (1919–20; see p.194) also addresses the women's movement—Raoul Hausmann, George Grosz and John Heartfield (1891–1968) working widely in this medium. Heartfield was born Helmut Herzfeld, but anglicized his name during the war in protest against widespread anti-English propaganda. Like most of the Berlin Dadaists, he sympathized with the revolutionary forces who toppled the Kaiser in 1918 and joined the German Communist Party the same year. After Dada Berlin had passed its peak, Heartfield increasingly employed his art as a weapon in the political struggles of the Weimar Republic. *Adolf, the Superman, Swallows Gold and Spouts Junk* (right) appeared in the Communist newspaper *Arbeiter Illustrierte Zeitung* during the rally for the general election of 1932. It combines an X-ray of a chest with a then popular image of Hitler. The montage refers to the heavy funding of the Nazi party by industrialists and high financiers, presenting Hitler, despite his working-class rhetoric, as a friend of the bourgeoisie. **FK**

1 *Amourette* (1918)
Christian Schad • silver printing-out paper print
2 ⅛ x 3 ⅛ in. | 6.5 x 9 cm
Museum of Modern Art, New York, USA

2 *Adolf, the Superman, Swallows Gold and Spouts Junk* (1932)
John Heartfield • photomechanical reproduction
Metropolitan Museum of Art, New York, USA

ADOLF – DER ÜBERMENSCH

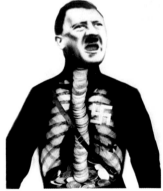

SCHLUCKT GOLD UND REDET BLECH

1921	1922	1923	1925	1933	1936
The first and only issue of *New York Dada* appears with a cover showing a photograph of Marcel Duchamp, disguised as his female alter ego Rrose Sélavy.	Both Man Ray and László Moholy-Nagy (1895–1946) begin to experiment with the photogram technique.	Hyperinflation in Germany, caused by the enormous costs of the war, reaches its peak in November, with 4.2 trillion marks equalling one dollar.	Sergei M. Eisenstein releases his film *Battleship Potemkin*, which is based on his concept of montage.	Adolf Hitler is named chancellor by German President Paul von Hindenburg, the former commander of the country's armed forces in World War I.	The 'Fantastic Art, Dada and Surrealism' exhibition is staged at New York's Museum of Modern Art. Some 700 works are shown.

Cut with the Kitchen Knife 1919–20

HANNAH HÖCH 1889 – 1978

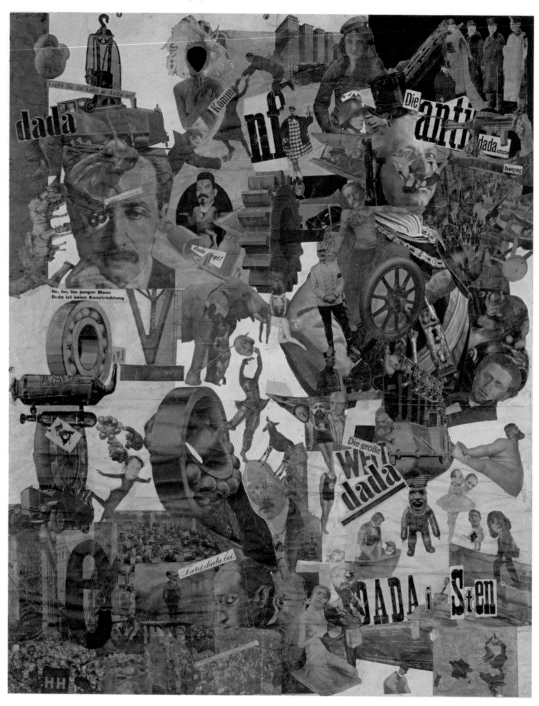

Cut with the Kitchen Knife Dada Through the Last Weimar Beer-Belly
Cultural Epoch in Germany
Photomontage and collage with watercolour
44 ⅞ x 35 ⅜ in. | 114 x 90 cm
Neue Nationalgalerie, Berlin, Germany

H annah Höch was the only woman to take part in the First International Dada Fair at Gallery Otto Burchard in Berlin, in 1920. The exhibition marked the peak of the Berlin Dadaists, with more than twenty-five artists participating. Höch showed a photomontage that she had worked on during the previous year: *Cut with the Kitchen Knife Dada Through the Last Weimar Beer-Belly Cultural Epoch in Germany*. The crowded multi-focal composition evokes the political and social upheaval that shattered the newly founded German republic after the war—especially Berlin, the capital. The fragments are mostly taken from the illustrated press, which was expanding rapidly at the time. Between pieces of machinery and snippets of words, an impressive cast of people from the spheres of politics and the arts appears. In the upper right quarter, under the headline 'The anti Dadaistic movement', representatives of conservative or reactionary forces of both the old empire and the new republic gather around a bust of Kaiser Wilhelm II in a tiny top hat. They are opposed in the quarter below, where 'The great world Dada' unifies Berlin Dadaists and fellow artists with revolutionaries and leftist theorists such as Karl Marx. Women play a decisive role in the dynamics of the montage. Whereas most of the men have static poses, the women appear to have kept their mobility. Like the figure of the ice skater in the lower left, they keep a delicate balance despite the turmoil around them. **FK**

FOCAL POINTS

1 DANCER
With an elegant pirouette, the headless body of dancer Niddy Impekoven seems to set in motion the ball bearing beside her, while balancing the severed head of painter Käthe Kollwitz. Both were highly respected artists, their independence a role model for the modern new woman.

2 MACHINE-MAN
At the centre of the group of Dadaists, Höch's partner Raoul Hausmann appears. His portrait is mounted on a scuba suit, an enormous engine growing out of his head. This draws upon the image of the machine-man, a popular topic among the Dadaists and contemporary arts in general.

3 MAP
In the lower right corner, where Höch usually signed her works, a map of Europe shows the countries where women were already, or soon to be, allowed to vote. In 1919, Germany had granted this right in the new constitution. At the top of the map, Höch herself appears as a small cut-out portrait.

4 AGITATED MASSES
A speaker with the head of a then well-known revolutionary sailors' leader addresses the crowd. Although not directly inciting political revolution, he calls upon the people to 'join Dada.' To his left, a giant 'e' floats above the masses, as if to embody their powerful but incomprehensible outcry.

ARTIST PROFILE

1889–1926
Hannah Höch grew up in a bourgeois home in the German town of Gotha. In 1912, she enrolled at a school of applied arts in Berlin, where she created designs for glass, wallpaper and embroidery. At the start of the war, she briefly returned to Gotha to work for the Red Cross. In 1915, Höch met artist Raoul Hausmann, who introduced her to the emerging Berlin Dada circle. The two had an intense but difficult relationship until 1922. From 1916 to 1926 she worked part time for the foremost German illustrated press publisher, creating patterns and designs for popular women's magazines.

1927–45
Höch befriended members of the De Stijl group in the 1920s and lived in the Netherlands for three years, where she started a relationship with female Dutch writer Til Brugman. During the Nazi regime, she stopped taking part in exhibitions and spent the war in a small garden house on the outskirts of Berlin.

1946–78
After the war, Höch continued to create montages and paintings and exhibited internationally. She died in Berlin in 1978.

EXPERIMENTATION AND ABSTRACTION

At the turn of the 20th century, Pictorialist photographers (see p.160) insisted—and proved—that photography was an art form in its own right. At the same time, it was becoming clear that its potential might well be limitless. Chronophotography could catch and freeze moments that were invisible to the naked eye, but could also be speeded up into cinematography, whereby those frozen moments merged into a seamless whole, moving faster than the eye could register. X-ray and infrared photography revealed what could not be seen—and so apparently, for those who believed in it, could spirit photography.

It was also implicit that photography could actually be about itself: about the image and the process of image-making. Photographers interpreted this new abstraction along different lines—technical, symbolic, spiritual and experimental. *A Sea of Steps* (1903; see p.200) by Frederick H. Evans (1853–1943) is not a step-by-step rendering of a cathedral staircase; combining many years of research and experimentation, it is imbued with Evans's personal experience and the theme of his own spiritual regeneration. Similarly, Alfred Stieglitz (1864–1946) wrote to US poet Hart Crane on 10 December 1923 of his cloud studies, *Equivalents* (1922–35; see p.202): 'I also know that there is more of the really abstract in some "representation" than in most of the dead representations of the so-called abstract so fashionable now.' The two men were of a generation whose aesthetic development had been informed by symbolism rather than conceptualism, although Stieglitz embraced modernist art with a passion.

KEY EVENTS

1903	1908	1911	1913	1914	1918–19
Henri Becquerel works with Parisian scientists (including Marie Curie) on an apparatus to show various parts of radioactive alpha, beta and gamma rays.	At the Franco-British Exhibition, Coburn photographs a fairground ride, reflecting an early modernist fascination with such machinery.	*Interpretation Picasso: the Express Train*, by Pierre Dubreuil (1872–1944), is a Futurist/modernist photograph about speed and machines.	*New York from its Pinnacles* by Alvin Langdon Coburn, shown in London, offers views of the city as geometric forms.	Erwin Quedenfeldt (1869–1948) shows abstract photographs *Symmetrical Patterns from Natural Forms* at the Werkbund Exhibition in Cologne.	Paul Strand (1890–1976) works as a photographer for the US Army Medical Corps, making X-ray plates and close-ups of medical practices.

After military service, Edward Steichen (1879–1973) returned to France in 1920 and used a combination of palladium printing and the cyanotype process to make a series of abstract modernist images, reasoning, 'If it was possible to photograph objects in a way that makes them suggest something else entirely, perhaps it would be possible to give abstract meaning to very literal photographs.' He constructed still lifes using everyday objects to represent volume, scale and weight and gave them a one- or two-day exposure. *Time-Space Continuum* (opposite) is intended to represent Einstein's Theory of Relativity. The card of seeming cuneiform script is actually a locksmith's pattern sheet, here used to suggest a sense of abstract symbolism.

In an essay titled 'The Future of Pictorial Photography' in *Photograms of the Year* (1916), Alvin Langdon Coburn (1882–1966) challengingly and prophetically wrote, 'Why should not the camera also throw off the shackles of conventional representation?' He went on to suggest some of the future uses that the camera should explore: rapid movement study, multiple exposures on the same plate and 'neglected or unobserved' angles of perspective. Coburn had already used multiple exposure for portraits, most tellingly in a portrait of artist Marius de Zayas taken in 1914. He had also explored unexpected angles of perspective as early as 1909 in New York when he photographed Madison Square from the top of the Metropolitan Life Insurance Company Tower; paths cleared through the snow made an abstract pattern shaped like an octopus. This and other 'bird's-eye' perspective photographs taken from the same building were published as 'Metropolitan Pictures' in *Metropolitan Magazine* (June 1909). *Octopus* (1909), the daringly distorted *Station Roofs, Pittsburgh* (1910) and Coburn's 'Cubist fantasy' photograph of the New York Liberty Tower, *House of a Thousand Windows* (1912), taken from the top of the Singer Building (he was accompanied by Cubist artist Max Weber, who also painted the same scene), clearly illustrate how he had already begun to challenge the accepted norms. But more was to come.

He ended the *Photograms* article, 'Think of the joy of doing something which it would be impossible to classify, or to tell which was the top and which the bottom!' And set out to do just that in 1916–17 when, briefly linked with the British Vorticist movement led by Wyndham Lewis and Ezra Pound as a response to the European Futurist and Cubist movements, he produced a series of 'Vortographs' (right). These were abstract images of pieces of glass and wood photographed on a glass tabletop with the camera lens pushed through a triangular arrangement of mirrors—which Pound named the 'Vortoscope'—to form a kaleidoscopic swirl of multiple reflections of abstract and geometric patterns. Coburn's peers found his experiments in abstraction incomprehensible and absurd, but he maintained a fondness for these images. When his Vortographs were hung in exhibitions of his work in the early 1960s during his 'rediscovery', he was happy for them to be hung any way up.

1919	1920	1924	1931	1937–38	1945
Coburn creates angled shots of geometric girder shapes taken as Liverpool's Anglican Cathedral is being built.	The Devětsil, an association of Czech avant-garde artists, is founded in Prague. In 1923, Jaroslav Rössler (1902–90) becomes its only photographer.	Russian avant-gardist El Lissitzky (1890–1941) incorporates photography in his design work and uses Moholy-Nagy's photogram techniques.	Man Ray produces a limited edition portfolio of ten Rayographs in photogravure for a French electricity company.	Herbert List (1903–75) composes still lifes of dream states and fantastic imagery using mirrors, in what he terms his 'Fotografia Metafisica' style.	Pilot William A. Garnett (1916–2006) creates Abstract Expressionist aerial photographs that reveal geometric patterns as well as potential eco-hazards.

Coburn was among the first to produce non-representational photography but he was not alone. Filippo Tommaso Marinetti (1876–1944), leader of the Italian Futurist movement, decreed that technology was changing the experience of life, and the Futurists articulated this in their art. The first Futurist Manifesto in 1909 proclaimed: 'We will sing of the nightly fervour of arsenals and shipyards blazing with violent electric moons, greedy railway stations that devour smoke-plumed serpents.' The Futurists were interested in capturing dynamism—the total experience of noisy modern machines, speed and motion—and were initially ambivalent about photography because it undynamically froze time, captured a moment and, being static, deadened the sense of movement. In 1911, Italian brothers Anton Giulio (1890–1960) and Arturo Bragaglia (1893–1962) were able to capture a sense of repeated motion in a still image by using a form of chronophotography that they called 'photodynamism'. This technique used long exposures and a repeating flash gun to seize ghostly images in a dense micro-narrative. In the brothers' study of a typewriter (above), the fluttering fingers also evoke the evanescence of spirit photography. The Futurists declared war 'the world's only hygiene' but the movement was largely over by the start of World War I and, after the war, abstract and experimental photography embraced simpler, quieter topics.

Like Steichen, Czech photographer Jaromír Funke (1896–1945) abandoned his early soft-focus Pictorialist landscapes for a more modernist vision. Initially, he photographed clearly focused still lifes, suppressing spatial perspectives and creating abstract harmonies between space and objects by using light and shadow, as in *Composition* (opposite below). He later simplified his work even further by removing the camera and making photograms—camera-less images that enjoyed a renaissance between the wars in the work of Christian Schad (1894–1982), Man Ray (1890–1976) and László Moholy-Nagy (1895–1946). His fellow Czech Jaroslav Rössler, apprenticed to František Drtikol (1883–1961) in Prague at the age of fourteen, produced Cubo-Futuristic montages and used Constructivist elements in his compositions before turning to photograms in the early 1920s. When one of Schad's 'Schadographs' was published in Paris by Tristan Tzara (who coined the term) in March 1920 in the magazine *Dada 7 (DADAphone)*, it is likely that Man Ray saw it along with other examples of

3 *Photodynamic Typewriter* (1911)
Anton Giulio Bragaglia and Arturo Bragaglia • silver print
Private collection

4 *Rayograph* (1922)
Man Ray • silver print
9 ⅜ x 7 in. | 24 x 18 cm
Museum of Modern Art, New York, USA

5 *Composition* (1923)
Jaromír Funke • silver print
8 ⅝ x 11 ⅜ in. | 22 x 29 cm
Museum of Fine Arts, Houston, Texas, USA

Schad's work at Tzara's home in Paris, where he had relocated in 1921. Man Ray, however, wanted to imprint his own vision on photograms, having created them during his childhood using leaves, flowers and lace, much as William Henry Fox Talbot (1800–77) had done. In true unabashed Dadaist fashion, he named them 'Rayographs' and produced a series from 1922 to 1928, using everyday objects — magnifying glasses (right), cigarettes, coils of wire, razor blades — moving the objects around during the exposure and varying the lighting and exposure times on individual objects. Lyrically abstract but recognizably representational, and shrewdly encompassing both the Dadaist principle of the found object and the dreamy absurdism of Surrealism (see p.232), the Rayographs evoked a positive response from Man Ray's avant-garde circle. By 1930, the definition of a Rayograph had evolved to encompass a mixed-media combination of multiple exposures, photograms, negatives and camera-based images whereby the negative was projected on to paper.

Simultaneously, and knowing nothing of either Schadographs or Rayographs, Moholy-Nagy experimented endlessly with photograms from 1922 in Berlin until his death in Chicago in 1946. Self-effacingly, he did not name them Moholygrams. He and his wife, Lucia Moholy-Nagy (1894–1989), described how they made their early photograms — using mirrors, lenses, liquid, cut glass or crystals to reflect shapes cut from paper — in an article 'Produktion-Reproduktion' (*De Stijl*, July 1922). Moholy-Nagy also experimented with oil squirted into developer and sandwiched between sheets of glass during exposure on to light-sensitive paper. Moholy-Nagy sculpted with light — often a flashlight — rather than using identifiable, if enigmatic, objects — as did Man Ray, although his later photograms are more conventional in the sense that they mix objects with movement in exposure.

The impetus for abstract and experimental photography largely came from a European aesthetic and it was only after he had moved to London in 1928 that US Pictorialist photographer Francis Bruguière (1879–1945) rapidly moved into modernism. He had previously produced multiple exposures but now made dramatically lit, twisted cut-paper abstractions — some figurative, some abstract — lit by a single lamp. In 1930, he produced the first British abstract film, *Light Rhythms*, with Oswell Blakeston (1907–85). As Coburn had predicted two decades earlier, photography was now rushing headlong to throw off the shackles of conventional representation. **PGR**

A Sea of Steps 1903

FREDERICK H. EVANS 1853 – 1943

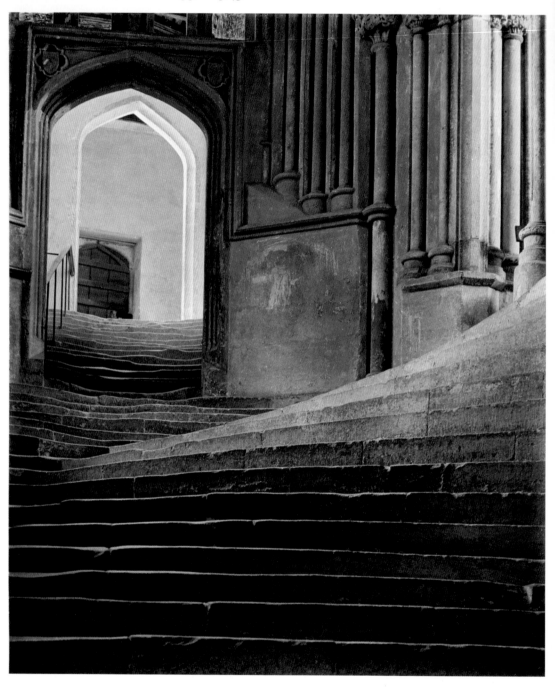

A Sea of Steps: the Stairway to the Chapter House and Bridge to the Vicar's Close,
Wells Cathedral • platinum print
9 ¼ x 7 ½ in. | 23.5 x 19 cm
Museum of Modern Art, New York, USA

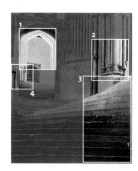

Frederick H. Evans found one of his most imaginative and graphic images in this depiction of rising steps, surging and seething like breaking waves. *A Sea of Steps: the Stairway to the Chapter House and Bridge to the Vicar's Close, Wells Cathedral* is noteworthy because of the balance and proportion and, ultimately, the minimalism and abstraction of its composition, a flattened perspective achieved by using a telephoto lens. The massive swell of steps pulls the viewer irresistibly into the image, drawing the eye to the safety of the radiant pointed doorway where the 'waves' have become gentle. Evans had photographed these sinuous 13th-century steps several times before he arrived at this final reworking in the summer of 1903. His intent was not simply to record architectural detail but also to convey his emotional response to the subject matter with perfect lighting and composition, achieving a symbolic balance between the spiritual and the actual. 'A record of emotion rather than a piece of topography,' he commented. **PGR**

FOCAL POINTS

1 ARCHWAY
Subtle use of shadow and light leads the viewer's eye up to the archway. Evans liked to inhabit a cathedral for several weeks, observing every part of it at every hour of the day and learning where the light fell so that he felt he truly knew it. He could then compose what he termed his 'poems in stone'.

2 PILLARS
The vertical fluted pillars are a strong component of the composition. Together with the steps, the glowing arch and the huge central stone support, they seem to soar heavenwards. Three-quarters of the image's composition comprises horizontal and vertical elements.

3 STEPS
In order to achieve a more realistic sense of the height and steepness of the steps as they rise up to the corridor of the bridge, Evans used his favourite 19-inch (48-cm) Zeiss anastigmat lens on a camera holding a 10 x 8-inch glass negative. He placed the camera on a tripod on the stairs, swinging the focus at the archway to the bridge. The steps show the ascent in Evans's visual and spiritual journey from complexity to simplicity and purity of vision.

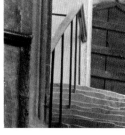

4 HANDRAIL
The iron handrail far left and the erosion evident in the top portions of the steps suggest centuries of human traffic. Evans never included people in his cathedral photographs but was aware that the stone blocks and soaring columns could be overwhelming without some intimate human counterpoint.

PHOTOGRAPHER PROFILE

1853–97
Frederick H. Evans was a clerk before taking over a London bookshop in 1890. He began practising photography around 1883, and produced photomicrographs that were later made into lantern slides by George Smith of the Sciopticon Company. He also exhibited his work, some of which won awards.

1898–1902
In 1898, Evans sold his bookshop in order to concentrate on photography. He married Ada Emily Longhurst in 1900; they had two children. He also joined the Linked Ring group of Pictorial photographers. Evans's architectural photographs were much praised, published and exhibited during the early 1900s and from 1900 he wrote extensively and influentially for the British photographic press.

1903–11
In 1903, Alfred Stieglitz devoted an issue of *Camera Work* to Evans. In 1904 he began a long and fruitful collaboration (until 1920) with the British periodical *Country Life*, as their roving photographer, and curated the Linked Ring's annual Salon exhibitions until 1905. In 1911, he photographed in Westminster Abbey prior to the coronation of King George V and Queen Mary.

1912–43
Evans turned to silver prints after the scarcity of platinum during World War I. He privately published volumes of wood and linoleum cuts and had a number of retrospective exhibitions before his death in 1943.

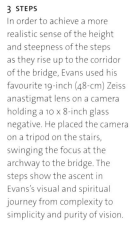

Equivalent, Set C2, No. 5 *c.* 1929
ALFRED STIEGLITZ 1864 – 1946

Silver print
4 ⅝ x 3 ⅝ in. | 11.5 x 9.5 cm
Metropolitan Museum of Art, New York, USA

For Alfred Stieglitz, the series of cloud studies that he made from 1922 to 1935, generally known as *Equivalents*, is about the outward expression of inner meaning. At pains to explain the work, he allowed a private letter that he had written to London photographer Ward Muir to be published in the British *Amateur Photographer and Photography* magazine on 19 September 1923. He wrote of his thirty-five-year fascination with photographing clouds and his decision to devote weeks to the subject in the autumn of 1922. He was searching for the same purity of abstract expression of emotion that music evoked, and perhaps some elements of synaesthesia—sound experienced as visual images (or colour) and vice versa—which was associated with the works of artists he admired such as Wassily Kandinsky, Pamela Colman Smith and Arthur G. Dove.

Stieglitz's images, at once abstract expressions and representational portraits, expressed truths about himself, his thoughts and feelings. He worked through his emotions during the series, seemingly treating it as therapy. There was despair and depression at the death of his mother, sadness at the degeneration of the family's country estate at Lake George, and worries over illness and money. At the same time, there is great exuberance and confidence in the cloud studies and they are often romantic, doubtless because of the photographer's relationship with Georgia O'Keeffe. As he wrote to John Dudley Johnston, president and curator of the Royal Photographic Society in London, on 3 April 1925: 'My photographs are ever born of an inner need—an experience of spirit....I have a vision of life and I try to find equivalents for it sometimes in the form of photographs. There is no such thing as progress or improvement in art. There is art or no art. There is nothing in between.'

He finally showed ten cloud studies with which he was satisfied—*Music: A Sequence of Ten Cloud Photographs* (also called *Clouds in Ten Movements*)—to the composer Ernst Bloch (also a photographer) who could instantly 'hear' the music in them. Or so Stieglitz claimed. This first series of cloud photographs was made with a 10 x 8-inch camera, but in the summer and autumn of 1923, he used a 5 x 4-inch Graflex camera, which was lighter to hold up into the sky, to make a series titled *Songs of the Sky*, again emphasizing the relationship with music. **PGR**

GALLERY WORK

Alfred Stieglitz ran galleries and curated exhibitions in New York for forty years, all of it unpaid. He organized more than 190 shows, promoting Pictorialist photography, African art and European and US modern art. He did so mostly in tiny galleries. The main room of 291 gallery (right) was just 14 ½ feet square (4.5 sq m). The Intimate Gallery (aka The Room) was not much bigger. His largest space—An American Place (aka The Place)—comprised five rooms at 509 Madison Avenue; there, Stieglitz had his own darkroom for the first time.

THE MACHINE AESTHETIC

In the aftermath of World War I, photographers, artists, composers and writers throughout Europe and the United States began exploring their relationship to the rapid technological advancements of the period. The 'Machine Age', as it eventually came to be known, was an inspiration to avant-garde photographers in particular as their medium was an invention of the industrial age.

There are two main strands within what is now known as the 'Machine Aesthetic'. One features theoretical investigations of the impact of technology through the use of primarily invented abstract forms and is most closely associated with painting and the graphic arts. The other consists of studies of objects rendered within the Western perspectival tradition but subject to dramatic close-ups and dynamic compositions. Individual connecting parts of machines, such as gears and ball bearings, were often featured in abstracted (but not abstract) photographs. Dynamic angles of view, intense close-ups and geometric crops provided a modern visual language with which to picture— and to celebrate—the triumph of the machine in liberating humankind from the toil of back-breaking labour.

KEY EVENTS

1918	1920	1920–22	1921	1921	1923
World War I ends. The interwar period sees the peak of the Machine Age.	As part of the booming industrialization in the United States, the first radio news programme is broadcast on 31 August by 8MK station in Detroit, Michigan.	Artist Joseph Stella paints *The Voice of the City of New York Interpreted*; its five panels are an ode to New York's industrial future and skyscrapers.	Lewis Hine (1874–1940) produces *Steamfitter*, his iconic industrial photograph showing a power house mechanic working on a steam pump.	Charles Sheeler and Paul Strand make the short film *Manhatta*. They use extreme angles to represent the dynamic energy of the city.	In Paris, Les Ballet Russes performs *Les noces* (*The Wedding*) to a score originally written for mechanical instruments.

While travelling through Paris, Marseille, Amsterdam and Rotterdam, Polish-born French-German photographer Germaine Krull (1897–1985) used dramatic angles and unusual viewpoints and crops to document geometrical, intricate parts of machinery and industrial structures (opposite). She published a portfolio of sixty-four photographs *Métal* (Metal; 1928), a seminal series of studies of machinery in Holland and Paris. Her style is akin to that of the New Vision photography most closely associated with Hungarian photographer and painter László Moholy-Nagy (1895–1946). Also in the mid 1920s, Albert Renger-Patzsch (1897–1966) travelled in Germany documenting the novel structures that would come to dominate modern life, such as *Factory Smokestacks* (c. 1925). Although this image is executed in a visual mode akin to that of New Vision photography, Renger-Patzsch generally subscribed to the Neue Sachlichkeit (New Objectivity) school of thought, which relied less on radical compositional strategies and more upon an aesthetics of materiality.

Images of factories, bridges and machinery spoke of the increasing technological dependency of Western Europe and the United States, but it was aesthetics rather than social commentary that was at stake for many artists. A set of factory smokestacks inspired Edward Weston (1886–1958) to reject Pictorialism (see p.170) in favour of a radically modern photographic aesthetic. When travelling from California to New York City in 1922, Weston visited the American Rolling Mill Company in Middletown, Ohio and his picture *Armco Steel*, with its modern subject and simple composition, demonstrates the evolution of his avant-garde aesthetic. Charles Sheeler (1883–1965) is one of the founders of the Precisionist movement, a monumentalizing aesthetic style of painting and photography that attended to modernization in the United States in a geometric, abstracted and stylistically precise fashion. Precisionist works were not meant to encourage social awareness; the intention was to create icons of contemporary industrial forms. His *Criss-Crossed Conveyors, Ford Plant, Detroit* (1927; see p.206) is quintessentially modernist in composition and subject, and symbolizes the significance of US industry.

Motion-picture cameras, with their complex inner workings, exemplified the relationship between technology and culture. Paul Strand (1890–1976) was enthralled by the possibilities of the new technology and purchased an Akeley movie camera. His admiration for its intricate parts and fine craftsmanship is evident in his *Akeley Motion Picture Camera* (right). The photograph shows the film-movement mechanism at a striking angle. Strand believed that by documenting individual parts of the camera's machinery, he could educate his audience about its mechanisms and motivate them to embrace technological advancement. Photography was the perfect medium to celebrate the Machine Age, the technology that drove it and the industrial products that came to define it. Despite the emphasis on the machine and the mechanistic, these images were crucial to the evolution of photography as a creative medium. **AB**

1 *Untitled* (c. 1928)
Germaine Krull • silver print
6 ⅝ x 9 in. | 17 x 23 cm
Museum of Modern Art, New York, USA

2 *Akeley Motion Picture Camera* (1922)
Paul Strand • silver print
9 ⅝ x 7 ¾ in. | 24.5 x 19.5 cm
Metropolitan Museum of Art,
New York, USA

1927	1927	1927	1928	1929	1930
Ford Motor Company rolls out the Model A at its River Rouge plant near Detroit, which has ninety-three buildings and 120 miles (193 km) of conveyors.	Charles Sheeler spends six weeks at the Ford River Rouge plant. The most famous image he takes is *Criss-Crossed Conveyors, Ford Plant, Detroit* (see p.206).	Margaret Bourke-White (1904–71) gains recognition when she photographs the steelworks at the Otis Steel Company in Cleveland, Ohio.	Albert Renger-Patzsch publishes *Die Welt ist schön* (The World is Beautiful), a collection of images of natural, industrial and mass-produced objects.	The Wall Street crash in October damages Americans' sense of confidence and pride in the economic dominance of the United States.	Poet Harold Hart Crane writes an epic poem, *The Bridge*, as an homage to New York's Brooklyn Bridge.

Criss-Crossed Conveyors, Ford Plant, Detroit 1927

CHARLES SHEELER 1883 – 1965

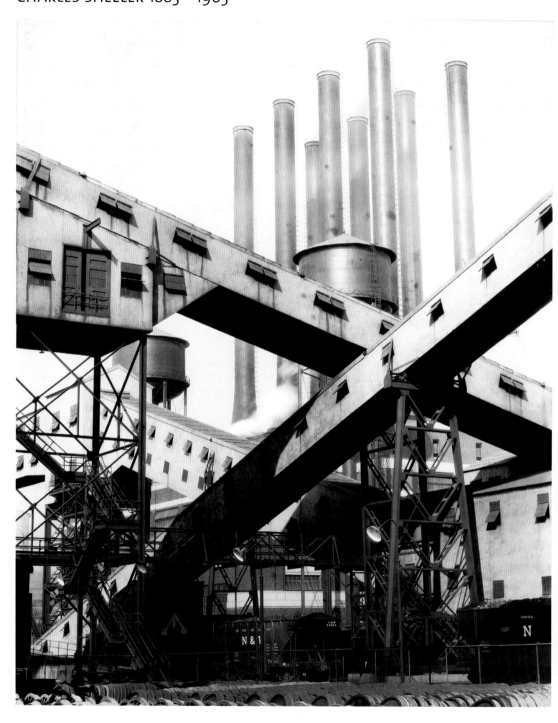

Silver print
9 ⅜ x 7 ½ in. | 24 x 19 cm
Museum of Modern Art, New York, USA

Charles Sheeler, an admirer of French artist Marcel Duchamp, created this iconic photograph in 1927 when he travelled to the Ford River Rouge plant outside Detroit, which manufactured the Model A automobile. He was commissioned by the company to create a series of photographs to be used as advertising imagery. Later this image was published as art photography in magazines such as *The Hound & Horn* and *Vanity Fair*. Sheeler created iconic photographs that monumentalized industrial production at the plant. The Ford automobile and the production line assembly of its manufacture epitomized the achievements of the Machine Age and provided the motifs for countless avant-garde compositions.

This booming industrial period in the United States gave rise to a technological sublime that, in the desire to celebrate New World ingenuity and economic power, could become overly romanticized. Sheeler's image is neither idealistic nor enhanced. He uses composition and framing to energize a seemingly banal subject, making use of sharp diagonals to form an 'X' shape across the scene. The smokestacks fill the upper portion of the image and balance the visual details below. There is a dynamic tension between the strongly abstract compositional geometry and the realist mode that is crucial to advertising imagery. Every space within the frame is accounted for, and the layers of industrial materials and forms create an industrial, urban landscape. **AB**

FOCAL POINTS

1 SMOKESTACKS
The smokestacks reach skywards as the smoke mixes with clouds. The camera is aimed towards them. They are critical to the overall composition because their column shape balances the hard edges and grids elsewhere. Smokestacks are a recurring motif in Machine Age imagery.

2 'X' SHAPE CONVEYORS
The crossing conveyors and the shapes that they form remind the viewer that Sheeler was inspired in his commercial work by the latest avant-garde experiments. The balanced geometric formations in the lower half, along with the 'X' shape, are reminiscent of Russian Constructivist designs.

3 LINE OF BARRELS
The line of barrels shown along the bottom edge of the frame balances the white sky above, further confirming Sheeler's concern with the symmetry of his composition. The curved shapes of the barrels, like the smokestacks, act as a foil to the linear architecture of the factory.

4 ABSENCE OF WORKERS
The foreground is devoid of human activity—a common practice for Sheeler. He did not want the picture to be seen as social commentary, which might happen if workers were present. Made on commission for Ford, later the images were reproduced as examples of photographic art.

PHOTOGRAPHER PROFILE

1883–1907
Charles Sheeler was raised in Philadelphia, Pennsylvania. He attended the Pennsylvania School of Industrial Art and the Pennsylvania Academy of the Fine Arts, where he studied under the painter William Merritt Chase.

1908–18
Sheeler went to Paris and was introduced to modernist avant-garde practices. Upon returning to the United States, he turned away from painting and focused on commercial photography, mainly shooting architectural structures.

1919–38
Sheeler moved to New York and started photographing skyscrapers. He associated himself with the Precisionist movement, exemplified by his solo exhibition in 1922. Sheeler was commissioned to photograph the Ford Motor Company's plant near Detroit, Michigan in 1927.

1939–65
The Museum of Modern Art in New York exhibited a retrospective of Sheeler's work as a painter and photographer in 1939. He continued to live in New York until his death.

AVANT-GARDE PHOTOGRAPHY IN THE SOVIET UNION

1 *Runner in the City* (c. 1926)
El Lissitzky • silver print
5 ⅛ x 5 in. | 13 x 12.5 cm
Metropolitan Museum of Art,
New York, USA

2 *Spartakiada Moskva* (1928)
Gustav Klutsis • letterpress
5 ¾ x 4 ⅛ in. | 14 x 10.5 cm
Museum of Modern Art, New York, USA

A distinctively Soviet type of photography developed in the early 20th century from two main factors: the involvement with abstract painting of many of the key figures, including El Lissitzky (1890–1941), Alexander Rodchenko (1891–1956) and Gustav Klutsis (1895–1938), in the years immediately before they took up photography; and the relative isolation of Russia and the then nascent Soviet Union during World War I, the Communist revolution and the ensuing civil war. Although Soviet photography used techniques such as photomontage that were also being developed in Germany, initially Soviet photomontage was quite different from its German counterpart. Soviet artists continually posed the question of what tasks an artist should perform in the service of the revolution and how they could give art a more concrete social role. Unlike many of their Western counterparts, they found themselves on the side of a political ideology to which they were deeply committed. Rodchenko, Klutsis

KEY EVENTS

1917	1918	1921	1922	1923	1924
The February and October Revolutions depose the tsar and establish Lenin in his place.	Gustav Klutsis produces the first Soviet photomontages, derived from his paintings inspired by Suprematist painter Kasimir Malevich.	El Lissitzky arrives in Berlin, Germany. It is there that he takes up photography.	Alexander Rodchenko begins to produce photomontages using found images, such as photographs published in newspapers.	Vladimir Mayakovsky publishes his poem 'Pro eto' (About This), which is accompanied by a series of photomontages by his friend Rodchenko.	Vladimir Lenin dies. The rise of Stalinism sees the slow decline of the avant-garde in the arts and Socialist Realism is imposed eight years later.

and Lissitzky are all described as Russian Constructivists, reminding us that their activities included not only photography but also most aspects of art and design.

The first photomontages produced in the Soviet Union were made by Klutsis in 1918 and 1919. There is little evidence that Klutsis knew of the photomontages of contemporary German Dada artists (see p.192). The style of Klutsis's photomontages is indebted to his work as a painter, with photographs being applied to the geometric shapes associated with the Suprematist paintings of Kasimir Malevich, in whose studio Klutsis was working.

Lissitzky, who had also worked with Malevich, did not take up photography until after he moved to Berlin in late 1921, where he was employed as a form of cultural attaché charged with promoting Soviet art. Lissitzky's early photographic experiments were photomontages in which he used found photographs to illustrate a writer's text. He then moved on to produce photograms, placing an object directly on to light-sensitive developing paper. Following these works, Lissitzky developed his own distinctive photographic style that was based on the combination of multiple negatives in the darkroom. In 1924 he produced *The Constructor (Self-portrait)* (see p.214) using his darkroom expertise. At this point Lissitzky had been out of the Soviet Union for three years and photographically he was producing work that was based on photogram techniques. On his return to the Soviet Union in 1925, Lissitzky made use of the techniques he had employed in the West in order to produce photographs that were more obviously linked to the Soviet Union. His first works were connected to the planned construction of an International Red Stadium in Moscow, for which he designed a yacht club. Although the club was never built, *Runner in the City* (opposite) was envisaged as part of a frieze, titled *Record*, for its interior. The hurdler clearing an obstacle is an invocation of Soviet concerns with physical culture, the active promotion by the state of physical exercise. This theme was part of a general move in the later 1920s and early 1930s to document Soviet everyday life, albeit in a highly favourable light.

In 1928 Klutsis produced a set of cut and pasted photomontage postcards for the Moscow Spartakiada. Conceived as a Soviet equivalent to the Olympic Games, the Spartakiada was run by an agency called Red Sport International. The Spartakiada photomontages are all brightly coloured and in the image of the discus thrower (right) a female athlete is poised to throw the discus but looks at the camera. She dominates the top half of the postcard while Vladimir Lenin looks on approvingly. In 1932 Rodchenko produced several photographs of the Dynamo sports club marching in its new stadium.

In 1928 Rodchenko was a founder member of the October Association and formed its own photography section with Boris Ignatovich in 1930. The association was comparatively loose, sufficiently so to accommodate the differing viewpoints of Rodchenko, Lissitzky and Klutsis, who were all members. Committed to photojournalism by this point, Rodchenko set out to photograph

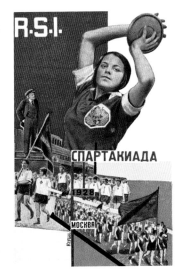

1925	1928	1933	1936	1938	1941
Lissitzky returns to the Soviet Union and incorporates techniques he used in the West into his projects.	Klutsis produces the Spartakiada photomontages.	Rodchenko photographs the major engineering project to build the White Sea Canal. His works are published in *USSR in Construction*.	Rodchenko publishes an essay 'Perestroika khudozhnikov' (Reconstruction of an Artist), which discusses his forced apology for aestheticism of 1935.	Klutsis is arrested, accused of participating in a Latvian nationalist organization and executed three weeks later.	Lissitzky dies shortly after producing his last poster, a piece of propaganda to rally workers to build more tanks for the fight against Germany.

the AMO automobile factory and Ignatovich photographed *Regulators for Trams* (c. 1930), with its serried ranks of tram handles produced by a firm in Moscow. The group members sought to distinguish their photography from that of Western abstract photographers, namely Man Ray (1890–1976) and László Moholy-Nagy (1895–1946), but also defined themselves against the emerging Socialist Realism school of 'identical workers with hammers and sickles'. They promoted a 'revolutionary photography, materialist, socially grounded and technically well equipped, one that sets itself the aim of promulgating and agitating for a socialist way of life and a Communist culture'. To this end, members were expected to publish their photojournalism in newspapers, journals and magazines, thereby entering into production themselves.

Although many Soviet Constructivist practitioners began their artistic careers as painters, their reaction against painting became severe, particularly in the circle of artists around Rodchenko, which comprised collaborators in the *Pervaia rabochaia gruppa konstruktivistov* (First Working Group of Constructivists) and the *Levy Front Iskusstv* (Left Front of the Arts) group, which produced the avant-garde magazine *Lef* (1923–25). In 1923 the second issue of *Lef* urged artists to 'stop colour patching on moth-eaten canvases. Stop decorating the easy life of the bourgeoisie'. Rodchenko had stopped painting in 1921 and the following year he produced his first photomontages. However, he did not start taking his own photographs until 1924, and these were often portraits of close associates, such as that of the literary critic Osip Brik (1924; see p.212). Rodchenko used darkroom manipulation rarely, favouring a direct presentation of the object, often from an unusual angle, part of what he considered to be photojournalism's task to free itself from the yoke of painting. In *Assembling for a Demonstration* (left) Rodchenko produced one of his most striking photographs, taken while leaning over the railing of the balcony of his Moscow apartment. He employed a bird's-eye view against 'a biased, routine education of human visual perception, and a one-sided distortion of visual thought' that he dismissed as being photography from the navel or eye level.

In 1931 another group of Russian photographers formed the *Rossiiskoe ob'edinenie proletarskikh fotoreporterov* (Russian Society of Proletarian Photographers, or ROPF), which exhibited alongside the October group. Works by members of ROPF share many of the preoccupations of the October group: Simon Fridland (1905–64) photographed GUM, Moscow's main department store—for which Rodchenko had designed advertisements in the 1920s—from a low-angle viewpoint highlighting its iron and glass roof. However, ROPF as a whole stood opposed to what it perceived as the October group's debt to Western models such as Moholy-Nagy: charges that Rodchenko had been defending himself against since 1928. ROPF favoured a more overt, narrative propaganda photography. This position developed into the Soviet orthodoxy, and Rodchenko, Ignatovich and fellow photographer Eleazar Langman (1895–1940) came under increasing attack for their supposed aestheticization of the medium.

At the same time as this debate was taking place, Klutsis was producing his most famous works—a series of propaganda posters that differed from his earlier Spartakiada designs both in their deployment of superimposition of negatives, as opposed to the cut and paste of the earlier works, and in their more limited colour scheme. In *Under the Banner of Lenin—Socialist Construction* (opposite) Klutsis sets a black-and-white photomontage against a red background. Lenin is the main focus of the piece, his face superimposed over that of Joseph Stalin, while both leaders are surrounded by photographs of Soviet industry, ranging from coal mines on the right to automobile production on the left. Such themes were central to Soviet ideology and were given added impetus by Stalin's Five Year Plans, which were designed to boost the economy.

Experimentation was increasingly confined to the international journal *USSR im Bau* (*USSR in Construction*, 1930–41), which was published in Russian, French, English, German and Spanish, and showcased Soviet society, state institutions and engineering projects to the wider world. Following the official adoption of Socialist Realism in 1932, *USSR in Construction* tolerated more experimental work than the domestic photographic journals did during the 1930s with Lissitzky and Rodchenko, who had by this time both established their international reputations and were assuming editorial control of some of the issues. Lissitzky produced elaborate spreads on the Red Army, and Rodchenko concentrated on parachutists and, in 1933, on the White Sea Canal project. Brutally harsh, the project to build a canal claimed the lives of an estimated 200,000 workers, mostly political prisoners, who were used as forced labour as part of their rehabilitation. Rodchenko's photographs were touched up prior to publication in an effort to disguise the conditions.

From 1936 to 1938 more than seven million people were arrested during Stalin's Great Purge, of whom some three million were executed or died in prison or labour camps. Although Rodchenko escaped direct persecution, he performed a delicate balancing act throughout the 1930s before finally abandoning photography in 1942 to return to painting. One of his *Lef* comrades, the writer Sergei Tretyakov, was not so fortunate and died in a labour camp in 1937. The following year Klutsis was arrested and executed. **BV**

3 *Under the Banner of Lenin — Socialist Construction* (1930)
Gustav Klutsis • lithograph
38 ⅜ x 28 ¼ in. | 97.5 x 72 cm
Museum of Modern Art, New York, USA

4 *Assembling for a Demonstration* (1928–30)
Alexander Rodchenko • silver print
19 ½ x 13 ⅞ in. | 49.5 x 35.5 cm
Museum of Modern Art, New York, USA

Osip Brik 1924
ALEXANDER RODCHENKO 1891 – 1956

Silver print, with gouache
9 ¼ x 7 ⅛ in. | 23.5 x 18 cm
Pushkin State Museum of Fine Arts,
Moscow, Russia

NAVIGATOR

Alexander Rodchenko's initial photographic works were often portraits of close associates among the avant-garde. The literary critic Osip Brik was one of Rodchenko's circle, but this portrayal reveals little of their friendship. Brik is positioned almost square on to the camera and his head turns slightly so that he meets its gaze head on, as if scrutinizing the viewer. Every inch the Soviet intellectual, with his cropped hair, pebble glasses, pencil moustache, jacket and tie, Brik fills the frame. His eyes command attention; they are no longer 'windows to the soul' as in Renaissance portraiture. His left eye reveals nothing about his personality, other than the attention appropriate to a close reader of literary texts. His right eye is obscured by a reflection from the lens of his glasses, on which three Cyrillic letters appear. Rodchenko added the lettering over the initial image, in which Brik's lens was filled with a bright white reflection. The letters translate as 'Lef', short for *Levy Front Iskusstv*, meaning 'Left Front of the Arts', the title of the magazine that Rodchenko and his circle, including Brik, had been producing since 1923. The image was considered for use on the front cover, before eventually being used in an advertising leaflet for the magazine's successor, *Noyvi Lef* (*New Lef*, 1927–29). In place of any insight into Brik's character, Brik is identified with his work for *Lef*, evidence of his commitment to the revolution. **BV**

FOCAL POINTS

1 CLOSELY SHAVED HAIR
Many members of the *Lef* group shaved their heads. Rodchenko's daughter, Varvara, claimed that it was her father who began the trend in 1920. It was part of an effort to reject bohemian notions of artists as long-haired dilettantes and align their productive work with the proletariat.

2 RIGHT EYE
The lettering in Brik's glasses cements Brik's personal link to Rodchenko, who had designed this masthead for *Lef*, creating the typography from wood in the absence of commercially available sans-serif lettering. In 1923 Brik published an essay in *Lef* in praise of Rodchenko's move away from painting.

3 INITIALS
The 'A' and 'P' in the lower right-hand corner are Rodchenko's initials. The 'P' is the Cyrillic letter equivalent to the Western 'R'. His daughter recalled: 'Rodchenko was conscientious. He always signed his negatives, kept a record of his work...and bound books and magazines.'

4 CLOTHING
The photograph that Rodchenko used as the basis for this image was a fuller length portrait. In cropping the image, the portrait places the viewer into a more direct engagement with Brik. Just enough of Brik's shirt, tie and jacket is included to identify him as an intellectual.

PHOTOGRAPHER PROFILE

1891–1916
Alexander Rodchenko was born in St Petersburg and attended the Kazan School of Art. After graduating he went to Moscow to study architecture and sculpture.

1917–21
Rodchenko came to prominence as an artist after the Russian Revolution of 1917, particularly as a creator of abstract non-objective paintings. He abandoned painting in 1921.

1922–29
Rodchenko was active in many fields: he produced theatre and architectural designs; was a typographer and poster designer; and designed the interior of a Workers' Club, built as part of the Soviet contribution to the Exposition Internationale des Arts Décoratifs et Industriels Modernes in Paris in 1925.

1930–56
His photographic works were published in many journals, including *Lef*, *Noyvi Lef* (both of which he designed), *Sovetskoe Foto* (Soviet Photography) and *USSR in Construction*. He gave up photography in 1942 and returned to painting.

The Constructor (Self-portrait) 1924

EL LISSITZKY 1890 – 1941

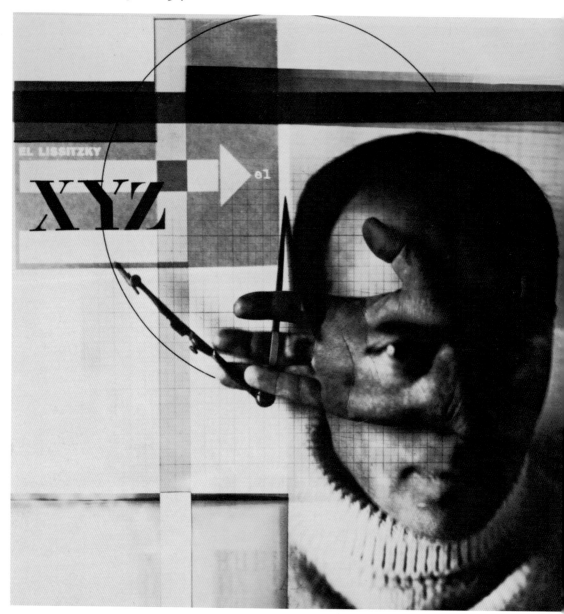

1 LETTERING

The letters 'XYZ' have been interpreted as the axes of a grid, a reference to X-rays (Lissitzky was X-rayed as part of his treatment for tuberculosis) or a coded reference to the Swiss architectural group ABC, with whom Lissitzky was collaborating on the first issue of its journal.

2 BLACK SQUARE

The black square is an emblem of the Suprematist movement and a frequent motif in Lissitzky's own work. Here it also marks the incorporation of Lissitzky's letterhead — reproduced in negative — a reversed letter 'L' crossed by an arrow that points to his initials.

Silver print
3 x 3 ⅜ in. | 7.5 x 8.5 cm
Museum of Modern Art, New York, USA

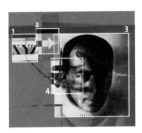

Produced during a stay in a Swiss sanatorium, where he was undergoing treatment for tuberculosis, El Lissitzky's self-portrait is the most famous realization of the darkroom techniques that he had been working on since his arrival in Western Europe in 1921. Termed *fotopis* (light writing), the work relies on superimposition in order to produce an image that has most often been read as encompassing the rational and technical sides of Russian Constructivism. Lissitzky's head appears merged with his hand holding a pair of compasses. Set against a background of graph paper, these elements combine to present Lissitzky, with close-cropped hair and a turtle-neck sweater, as more of an engineer than a bohemian artist. Recent scholarship has noted that there are many areas of the work where Lissitzky's own craftsmanship is still evident. The close conjunction of Lissitzky's right eye and his hand emphasizes a role for the handcrafted skill of the artist, and the image itself is a triumph of Lissitzky's own manipulation in the darkroom. The work exists in several different versions. It gained wide exposure when it was used as the cover of *Foto-Auge: 76 Fotos der Zeit* (*Photo-Eye: 76 Photographs of the Period*), published to coincide with the 'Film und Foto' (Film and Photo) exhibition held in Stuttgart, Germany in 1929 (see p.222). **BV**

⏱ PHOTOGRAPHER PROFILE

1890–1908
Lazar Markovich Lissitzky was born in Pochinok, Russia. He passed the entrance exam to study art at an academy in St Petersburg but was rejected because he was Jewish.

1909–18
Lissitzky went to Germany to study architectural engineering and then travelled to Paris and Italy. He returned to Russia when World War I broke out, where he worked in architectural firms and as an illustrator for Yiddish children's books.

1919–20
He went to teach graphic art, printing and arts in Vitebsk where he came under the influence of the Suprematist painter Kasimir Malevich. Lissitzky began his series of *Proun* abstract paintings, prints and drawings, which he continued to produce for eight years.

1921–24
In 1921 he accompanied the 'Erste Russische Kunstausstellung' (First Russian Art Exhibition) to Berlin. The key figure in updating Western Europe about events in the Soviet Union, he also made contact with the Dada group. He was diagnosed with tuberculosis in 1923 and a year later attended a sanatorium in Brione, Switzerland.

1925–41
Lissitzky returned to the Soviet Union. In 1925 he coauthored a book on modern art, *Die Kunstismen* (*The Isms of Art*), with the Dada artist Jean Arp. Gradually, Lissitzky abandoned painting for photography, typography and designing exhibition stands, including that for the Soviet contribution to the 'Pressa' press industry exhibition in Cologne in 1928. He coedited the magazine *USSR im Bau* (*USSR in Construction*, 1930–41).

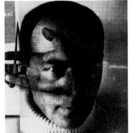

3 SELF-PORTRAIT
When Lissitzky worked with artist Kasimir Malevich in Vitebsk, he wore an artist's smock and had a long beard. Here he is clean shaven and wearing a turtle-neck sweater. The changes reinforce the image of Lissitzky as a rational engineer, especially when set against the graph paper.

4 HAND
Lissitzky often used a hand as a motif. He used this motif as the cover of the book *Architecture: Works by the Architectural Faculty of VKhUTEMAS* (1927). He also used the same motif in an advertisement for the German stationery company Pelikan.

AVANT-GARDE PHOTOGRAPHY IN THE WEIMAR REPUBLIC

I n order to understand the evolution of trends in 20th-century photography, it is vital to appreciate the significance of avant-garde photography in the Weimar Republic (1919–33). As technology rather than craft, photography was an ideal form of expression for the rapidly modernizing society of the 20th century. Some avant-garde artists valued the medium as the ideal mode for challenging visual conventions. For others, photography offered the possibility of an objective visual mode with which to counter the subjective psychological intensity of Expressionism. These two aesthetic positions were known as Neue Optik (New Vision) and Neue Sachlichkeit (New Objectivity) respectively.

The years 1923 to 1929 were a dynamic period for avant-garde photography in Weimar Germany, and the Staatliches Bauhaus was its most important forum—despite the fact that it did not add photography to the curriculum until 1929. The main catalyst was the arrival of László Moholy-Nagy (1895–1946), an innovator not only in photography but also in typography, sculpture, painting, printmaking and industrial design. Arguably the most influential photographer within the German avant-garde (although he was Hungarian by birth), Moholy-Nagy believed that photography offered a universal visual

KEY EVENTS

1919	1920s	1922	1922	1925	1927
Staatliches Bauhaus, the Bauhaus school, is founded by Walter Gropius in Weimar. The school relocates to Dessau in 1925 and to Berlin in 1932.	Russian Constructivist artists promote photography as an ideal medium for a post-revolutionary society. Some go on to teach at the Bauhaus.	Fritz Lang's film *Dr Mabuse, der Spieler* (*Dr Mabuse, the Gambler*) captures the chaotic mood of post-war Berlin.	Russian artist Wassily Kandinsky accepts a teaching position at the Bauhaus and remains until the school closes.	Moholy-Nagy publishes *Malerei, Fotographie, Film* (*Painting, Photography, Film*) via the Bauhaus, outlining his theories of the New Vision.	German filmmaker Fritz Lang makes the acclaimed dystopian film *Metropolis*, which addresses his concerns about capitalism in an Expressionist manner.

language ideally suited to the progressive needs of modern society. In 1925, he outlined his New Vision aesthetic in *Malerei, Fotographie, Film* (*Painting, Photography, Film*). By means of the camera, the New Vision could establish a new relationship with the visible world and overcome the limitations of human sight by challenging conventional ideas of vision, space and light: this view is exemplified in *From the Radio Tower, Berlin* (1928; see p.220). The New Vision also embraced unconventional forms and techniques, such as photograms and photomontages that combined photographs with modern typography.

Photographers associated with the Bauhaus in the 1920s, including T. Lux Feininger (1910–2011), Lucia Moholy (1894–1989) and Herbert Bayer (1900–85), devised new methods of photographing subjects in order to condition viewers to visualize reality in a 'revolutionary' way. The compact, portable Leica A camera, introduced to the public in the mid 1920s, fostered the spontaneity and ease of use necessary to create New Vision imagery. With *Lotte (Eye)* (opposite), a larger than life image of his daughter, photographer Max Burchartz (1887–1961) produced an iconic example of Weimar avant-garde photography. Although Burchartz did not study at the Bauhaus school, his work reflected the New Vision use of radical formal strategies to defamiliarize common subjects. The creation of new visual strategies that encapsulated 'the modern' formulated a new aesthetic language for photography.

Another feature of Weimar photography was the use of 'stop-action' pictures. These typically showed people in mid motion, highlighting photography's capacity, above all other art forms, to capture movement. It was not only the image within the frame that was significant, but also the way in which the camera itself made the composition possible. Photographers would often lengthen the image's depth of field in order to distort subjects within the composition, as seen in T. Lux Feininger's *The Jump Over the Bauhaus* (right). An art student at the Bauhaus, Theodore Lucas Feininger was known as 'Lux' from the Latin for 'light'. By shooting at an upward angle, he created the illusion of two men leaping above the Bauhaus school. The camera, free from the gravitational constraints of the easel or the tripod, is able to capture the men, liberated in mid flight. They almost appear as abstract forms on the flattened space, their limbs forming geometric angles, giving viewers a new and dynamic perceptual experience.

Moholy-Nagy created self-referential still life compositions that demonstrated possibilities that were, so it was argued, unique to photography. Pictures of everyday objects seen through glass became a common theme, together with photograms and superimpositions, as they referred directly to the glass plate negatives being used inside the camera. Willy Otto Zielke (1902–89)—an influential Polish-born, Munich-based photographer who rejected Pictorialism (see p.170) in favour of a radically pared-down modernist aesthetic—frequently used plates of glass and water in his compositions. Water, when placed between sheets of glass and photographed with light, morphs into geometric patterns.

1 *Lotte (Eye)* (c. 1928)
 Max Burchartz • silver print
 11 ⅞ x 15 ¾ in. | 30 x 40 cm
 Museum of Modern Art, New York, USA

2 *The Jump Over the Bauhaus* (c. 1927)
 T. Lux Feininger • silver print
 9 ¼ x 7 ⅛ in. | 23.5 x 18 cm
 Bauhaus-Archiv, Berlin, Germany

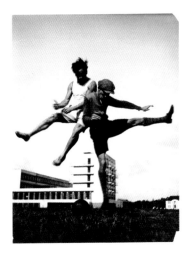

1927	1928	1929	1929	1931	1933
Philosopher Martin Heidegger publishes his profoundly influential book *Sein und Zeit* (*Being and Time*).	Albert Renger-Patzsch publishes his book *Die Welt ist Schön* (*The World is Beautiful*), which exemplifies his New Objectivity aesthetic.	The exhibition 'Film und Foto' (Film and Photo) is held in Stuttgart from 18 May to 7 July.	August Sander publishes images from his series *People of the 20th Century* in *Antlitz der Zeit* (*Face of Our Time*).	Inspired by Moholy-Nagy's exhibit in 'Film und Foto', Walter Benjamin writes the essay 'A Short History of Photography'.	Under pressure from its Nazi detractors, the Bauhaus closes.

Conventional rules of picture-making were similarly challenged when photographers pointed the camera either straight up or down, used diagonal lines or heightened details by creating dramatic close-ups. Aerial views of urban streets or landscapes transformed common surfaces into geometric patterns, as seen in *Mystery of the Street* (above) by Otto 'Umbo' Umbehr (1902–80). Utilizing dramatic light and shadow to turn an urban street into an abstract form, the photograph demonstrates avant-garde 'top-down' perspective. An innovator in photojournalism and a student of the Bauhaus from 1921 to 1923, Umbo's stark images expanded the visual grammar of photography.

Held in Stuttgart in 1929, the 'Film und Foto' (Film and Photo) exhibition showed the work of avant-garde artists from Western Europe, Russia and the United States and brought together the avant-garde photographic and cinematic trends of the 1920s. A groundbreaking book, *Es Kommt der Neue Fotograf!* (*Here Comes the New Photographer!*), which accompanied the show, illustrated definitive strategies such as angling the composition, shooting up or down and creating montages. The 'Film und Foto' exhibition poster (1929; see p.222) designed by Jan Tschichold and featuring a photograph by Willi Ruge (1882–1961) emphasized the exhibitors' desire to educate viewers in the principles of the New Vision.

Equally as influential as Moholy-Nagy was Albert Renger-Patzsch (1897–1966), who championed the aesthetic ideology known as New Objectivity. This was initially developed by German painters between the wars as a response to Expressionism—then the dominant avant-garde mode. Renger-Patzsch believed that photography should be subject to what he saw as the camera's main function:

documenting reality. The viewer should not be subjected to the photographer's subjective vision or eye-catching compositional strategies and the role of the photographer was to enhance the appreciation of an object by reproducing it in fine, realistic detail. This was often accomplished by placing the subject in the centre of the perfectly proportioned frame, giving the viewer no option but to ponder the subject itself, as in Renger-Patzsch's image *The Sapling* (below). The tree is centred within the frame and against the horizon line, while the expanding lines formed by the branches are mirrored by the lines of snow in the bottom half of the composition. The empty background forces the viewer to focus on the tree's form, the variety of grey tones in the trunk and the overlapping lines of the branches.

Moholy-Nagy and Renger-Patzsch announced their opposing aims in the magazine *Das Deutsche Lichtbild* (*The German Photograph*) in 1927. Despite their aesthetic differences, the two men had much in common. Both believed that photography was an independent art form, and both formulated a 'straight' (unmanipulated) aesthetic for photography that was highly influential for their contemporaries and for later photographers, too. In the late 1950s, for example, Bernd Becher (1931–2007) and his wife Hilla (b.1934) incorporated principles of New Objectivity into their practice and promoted them in their teachings at the Düsseldorf Kunstakademie (see p.442). **AB**

3 *Mystery of the Street* (1928)
Otto Umbehr • silver print
11 ⅛ x 9 ¼ in. | 29 x 23.5 cm
Metropolitan Museum of Art,
New York, USA

4 *The Sapling* (1929)
Albert Renger-Patzsch • silver print
9 x 6 ¾ in. | 23 x 17 cm
Albert Renger-Patzsch Archive, Germany

From the Radio Tower, Berlin 1928

LÁSZLÓ MOHOLY-NAGY 1895 – 1946

Silver print
11 ⅛ x 8 ⅜ in. | 28 x 21.5 cm
Museum of Modern Art,
New York, USA

László Moholy-Nagy took a number of photographs from the top of the Funkturm Berlin (Radio Tower, Berlin), which was built between 1924 and 1926 and was Germany's newest steel construction at that time. This photograph is one of the most abstract and geometric of the series, and a defining example of its artist's New Vision aesthetic. The tower provided opportunities for Moholy-Nagy to experiment with a bird's-eye perspective, while simultaneously expressing his interest in industrial forms. There are no reference points within the composition: the tower is not visible and there are no people or roads. The space is flattened and abstracted, the location ambiguous. Moreover, by boldly cropping the image, Moholy-Nagy limits the viewer's ability to assess the scene, turning conventional objects into areas of tone and abstract shapes.

Moholy-Nagy's restless invention saw him experiment simultaneously with photograms, photomontage and straight photography in an effort to develop his New Vision. Prior to becoming a teacher at the Staatliches Bauhaus in Weimar, he had dabbled in Dadaist and Constructivist painting and his impulse to defamiliarize known objects owes a debt to both. The use of a camera to dramatically re-invent everyday scenes was not new, however: in *Octopus* (1909), Alvin Langdon Coburn (1882–1966) had photographed pathways radiating out from a central island, using aerial perspective to similarly striking effect. **AB**

FOCAL POINTS

1 HARD EDGES
The hard edges of the building frame the path's circular curves. The snow blanks out any detail on the rooftop, emphasizing the sets of lines on the building's edge, which contrast with the softer, flowing lines in the lower half of the frame, creating a visually satisfying composition.

2 UP-DOWN ANGLE
Moholy-Nagy frequently employed a bird's-eye view in his photographs, forcing viewers to see the details in a new, abstract way. The drastic up-down camera angle was also a feature of Constructivist photographs, especially those by Alexander Rodchenko and El Lissitzky.

3 SNOW
The snow in this photograph provides an interesting light study. The bright sun on the snow creates dark shadows, sharp whites and a sense of texture. Moholy-Nagy was interested in interpreting the design of light and must have appreciated the atypical, wintry view from the tower.

4 BULL'S-EYE EFFECT
The paths and fountain create a bull's-eye effect of circular patterns, in contrast to the rectangular rows of the building. The black shovelled area of path to the left balances the white pathways to the right. The high angle transforms this everyday scene into groups of geometric designs.

PHOTOGRAPHER PROFILE

1895–1917
László Moholy-Nagy was born in modern-day Hungary and raised in what is now Serbia. His law studies in Budapest were interrupted by World War I, in which he served and was injured.

1918–21
After the war, he became active in the Budapest art scene. In late 1919 he briefly moved to Vienna and contributed to the modernist journal *MA*. The next year, he moved to Berlin and began exploring Dadaist concerns of light, form, time and space.

1922–31
Moholy-Nagy became a teacher at the Bauhaus, taking over the foundation course and the school's metal workshop. In 1925 he moved to Dessau with the Bauhaus, but resigned in 1928, returning to Berlin.

1932–46
He moved to Amsterdam and the Stedelijk Museum held a retrospective for him in 1934. After a brief stay in London, he settled in the United States as director of the New Bauhaus in Chicago. After it closed he opened the School of Design, in 1939. His book *Vision of Motion* was published a year after his death.

'Film und Foto' Exhibition Poster 1929
WILLI RUGE 1882 – 1961 JAN TSCHICHOLD 1902 – 74

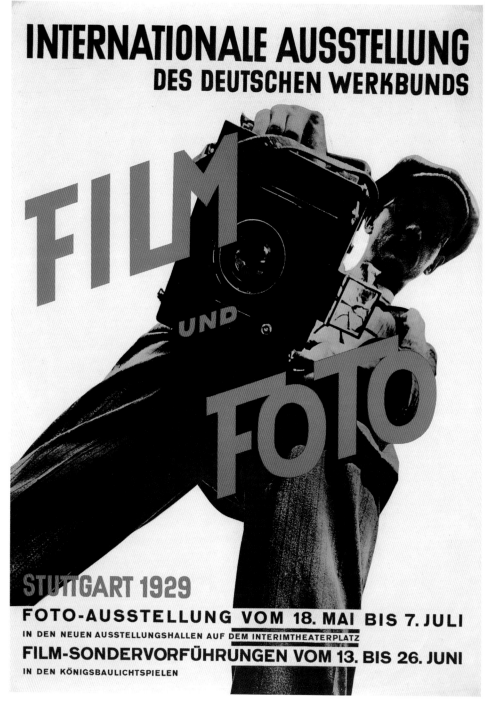

Offset lithograph
33 x 23 ⅛ in. | 84 x 58.5 cm
Museum of Modern Art,
New York, USA

Key to this dynamic poster designed for the 'Film und Foto' exhibition is a photograph taken by German photojournalist Willi Ruge. It utilizes a typical New Vision device, the 'up-down' shot, here taken from ground level looking upwards. Viewed from below, the figure—a photographer—appears as a colossus; his camera's lens stares directly at the viewer, like an eye, and is placed vertically central in the poster for maximum impact. The figure is asymmetrical and set diagonally across the poster; the legs, placed apart, form another angle. Jan Tschichold's bold typography and design in the poster is resolutely modernist; he uses a limited palette. These stylistic elements reflect his approach to design outlined in *Die Neue Typographie*, published the previous year.

Coordinated by the influential group of artists, designers and industrialists known as the Deutscher Werkbund, 'Film und Foto' showcased avant-garde cinematic and photographic trends of the 1920s. The exhibition (Tschichold was one of the organizers) highlighted experimental forms of the still and moving image, such as unusual camera angles, superimpositions and montage. Around 200 photographers from Europe, the Soviet Union and the United States displayed 1,200 images. 'Film und Foto' set a new artistic agenda in the aftermath of World War I and championed a revolutionary role for the camera that is powerfully conveyed in Ruge and Tschichold's exhibition poster. **AB**

⬡ NAVIGATOR

👁 FOCAL POINTS

1 DYNAMIC TYPE

The title, location and date of the show are picked out in bold orange. The title is emphasized by its size and by being set at its own distinctive angle. In his use of diagonals to add dynamism, Tschichold was influenced by Soviet posters as well as design trends emanating from the Weimar Bauhaus.

2 CAMERA

The camera is set in the centre of the poster, underlining photography's pivotal role in the exhibition. Held 'over' the viewer in this way, it becomes a powerful device, almost like a weapon. In 1929, the year the exhibition took place, film speed was standardized at twenty-four (still) frames per second.

3 ANONYMOUS FIGURE

Cropped and cut out from its background, the figure has no context; it is almost an abstract shape. A cap covers the man's head; his features are mostly in shadow, his eyes hidden behind glasses. He is anonymous. The viewer's eyes are instead invited to focus on the camera rather than the photographer.

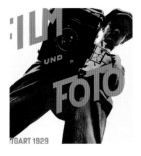

4 THE PHOTOGRAPHER

Symmetry suggests stasis. Set off at an angle, the asymmetric figure of the photographer implies movement, change, and newness. The man is the photographer Arno Böttcher, a friend of Willi Ruge, who took this shot in 1927. Ruge was known for such dramatic angles and the two often collaborated.

🕐 PHOTOGRAPHER PROFILE

1882–31

Willi Ruge was born in Germany but little is known about his early life. In the 1920s the mass media grew rapidly in Germany and Ruge began work as a photojournalist in Berlin, specializing in sports and aviation. As competition in the illustrated press grew, editors were keen to experiment with more dynamic layouts. Ruge exemplified the modern daredevil photojournalist; in 1931 *Berliner Illustrierte Zeitung* published *The Photographer*, a photograph with a vertiginous view that Ruge took during a seven-minute parachute jump over Berlin.

1932–44

Ruge served as an official air force photographer during both World Wars. His picture archive was destroyed in 1943.

1945–61

After the war Ruge worked for *Weltbild* and *Quick* magazines. He died in 1961. Examples of his work are held in New York's Metropolitan Museum of Art and the San Francisco Museum of Modern Art. His work featured in the exhibition 'Foto: Modernity in Central Europe, 1918–45' held at the Solomon R. Guggenheim Museum in New York in 2007.

AVANT-GARDE PHOTOGRAPHY IN PARIS

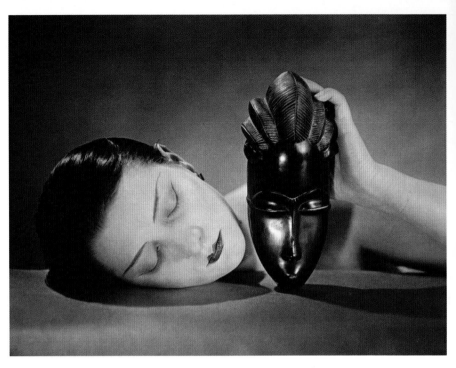

S oon after the end of World War I, Paris consolidated its position at the centre of the European art world. The international group of artists, photographers, writers, intellectuals, actors, musicians and models who moved to the city in the 1920s and 1930s paved the way for perhaps the most significant avant-garde moment in the history of art. Photography triumphed as an exemplary instrument of modernist expression, and as Dadaism (see p.192) gave way to Surrealism (see p.232), artists found new and radical ways of challenging long-held notions of reality and rationality. Among the photographers based in Paris were Man Ray (1890–1976) and Florence Henri (1893–1982)— who had come from the United States; Germaine Krull (1897–1985), Horst P. Horst (1906–99) and Hans Bellmer (1902–75)—from Germany; and Brassaï (1899–1984) and André Kertész (1894–1985)—from Hungary. Both Brassaï and Kertész would win lasting recognition for their visions of Parisian life during the period.

Man Ray was a significant presence, both artistically and socially, in Paris between the wars. A photographer, painter, filmmaker and sculptor, Ray moved to the city in 1921 and became a preeminent figure in the Montparnasse scene.

KEY EVENTS

1920	1921	1926	1927	1928–40	1928
Litterature, the journal founded by André Breton, Louis Aragon, and Philippe Soupault, features 'Twenty-three Dada Manifestos', to welcome Dada to Paris.	Man Ray moves to Paris. The 'Exposition Dada Man Ray' opens in the city. Its catalogue features notes by Tristan Tzara and Jean Arp among others.	A series of articles in newspaper *Le Matin* titled 'Paris: Hospital of the World' implies that the city has the capacity to restore and inspire foreign artists.	Michel Seuphor and Paul Dermee publish *Documents internationaux de l'esprit nouveau*; André Kertész is their main photographer.	*Vu* is founded. One of the first weekly photographically illustrated journals, it often features work by avant-garde Paris-based photographers.	The 'Premier salon indépendent de la photographie' is held in the stairwell gallery of the Théâtre des Champs-Elysées.

He was both prolific and technically adventurous, using solarization, camera-less prints (Rayographs) and grain enlargement to achieve effects that expanded the vocabulary of photographic vision. There was hardly a crosscurrent in avant-garde artistic production to which he did not make a significant contribution. He was also a key figure in the evolution of Dada into Surrealism. He was closely acquainted with other influential artists, such as Marcel Duchamp, Alfred Stieglitz (1864–1946) and Salvador Dalí and produced portraits of Paris's avant-garde elite, such as Ernest Hemingway, Gertrude Stein, Henri Matisse and James Joyce. Man Ray worked with Lee Miller (1907–77) , while Bill Brandt (1904–83) and Berenice Abbott (1898–1991) were just two of his many assistants who became renowned photographers in their own right. Man Ray's celebrated photograph *Black and White* (opposite) reflects the contemporary avant-garde's interest in African art. It features a striking tableau that juxtaposes two heads: the pale white face of Man Ray's favourite model Alice Prin (aka Kiki de Montparnasse) and an ebony African ceremonial mask. Both faces are elongated and have their eyes closed. The contrasting black and white faces could be seen as a playful take on the photographic process itself.

Active in Paris from 1926 the modernist photographer Germaine Krull mixed with many artists and writers in avant-garde circles, including Eli Lotar (1905–69), Sonia and Robert Delaunay, André Gide and Jean Cocteau. Krull was an innovative and versatile photographer whose work embraced fashion, portraits, ironic female nudes, avant-garde montages and street photography. By the time her pioneering portfolio of industrial imagery, *Métal* (Metal), was published in 1928, she was regarded as one of the most important photographers in Paris, together with Man Ray and Kertész. Krull took several photographs of her friend Jean Cocteau. In the portrait of 1929 (right) the French writer's head has been cropped at the neck and his seated and elegantly suited figure fills the frame. His graceful hands form the central focus of the composition; the cuffs of his jacket are turned back revealing his white shirt cuffs, drawing the eye to his loosely crossed hands.

Paris was an ideal base for André Kertész: the artistic community supported him and the rich, diverse city provided expansive material. He was drawn to the streets of Paris, particularly its circuses, fairs and flea markets. Kertész was given a solo show at the Sacre du Printemps Gallery in 1927, which connected him to the avant-garde artists of the period. His photographs were widely published, sealing his reputation as one of the leading photographers in the city. Kertész did not use darkroom techniques such as solarization to manipulate his prints, but took straight compositions from real life. He was part of a group of Hungarian expatriates who met at the Café du Dôme. Two fellow emigrés—sculptor István Beöthy and cabaret performer Magda Förstner— played a pivotal role in Kertész's *Satiric Dancer* (1926; see p.228).

1 *Black and White* (1926)
Man Ray • silver print
6 ¾ x 8 ⅞ in. | 17 x 22.5 cm
Museum of Modern Art, New York, USA

2 *Jean Cocteau* (1929)
Germaine Krull • silver print
8 ⅞ x 6 ⅜ in. | 22.5 x 16 cm
Museum of Modern Art, New York, USA

1929	1931	1933	1935–36	1937	1938
Germaine Krull publishes her photography book *100 x Paris*, in which she documents the city with her distinctive modernist aesthetic.	Julien Levy opens his New York gallery. An exhibition of modern European photography has works by Kertész, Lee Miller, Brassaï and Maurice Tabard.	Brassaï publishes his first book, *Paris de nuit*. A collection of around sixty images of the city after dark, it becomes a highly influential photobook.	The 'Exposition internationale de la photographie contemporaine' is held in Paris, combining modern and 19th-century photography.	Beaumont Newhall's show 'Photography: 1839–1937' at New York's Museum of Modern Art showcases European avant-garde photographers.	In response to the Munich Agreement, Surrealists publish a manifesto called 'Neither Your War nor Your Peace', opposing totalitarian regimes.

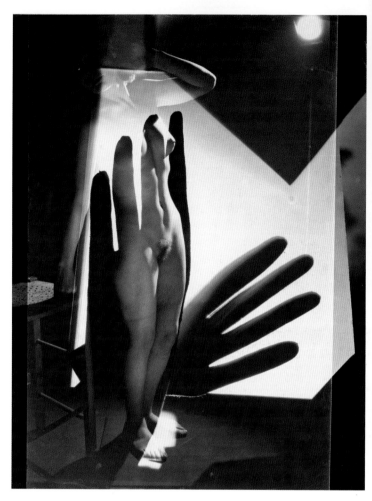

3 *Composition* (1929)
 Maurice Tabard • silver print
 9 x 6 ⅞ in. | 30 x 17.5 cm
 Metropolitan Museum of Art,
 New York, USA

4 *Aux abattoirs de La Villette* (1929)
 Eli Lotar • silver print
 8 ¾ x 6 ⅜ in. | 22 x 16 cm
 Metropolitan Museum of Art,
 New York, USA

5 *Composition* (1928)
 Florence Henri • silver print
 10 ¼ x 14 ½ in. | 26 x 37 cm
 Museum of Modern Art, New York, USA

Brassaï, famously nicknamed 'the eye of Paris' by writer Henry Miller, was one of the most revered photographers of the period. Having worked as a journalist in Berlin, he moved to Paris in 1924; by early 1930, he had purchased his own camera and was taking his own pictures. Brassaï's record of the French capital is a distinctive mix of inspiration and deliberation. He photographed all aspects of Parisian life, including high society, intellectuals and friends, and was instinctively drawn to the nightlife of Montparnasse. While finishing his seminal book *Paris de nuit* (*Paris at Night*, 1933), Brassaï began photographing the underworld of Paris nightlife—dance halls, opium dens, theatres, bordellos, lesbian bars—including *Fat Claude and her Girlfriend at Le Monocle* (1932; see p.230), which was first published in *Voluptés de Paris* (*Pleasures of Paris*, 1935).

Maurice Tabard (1897–1984) returned to France in 1928 after a ten-year stay in New York, where he honed his photographic skills working as a fashion photographer. Upon arriving in Paris he became acquainted with the Surrealist writer Philippe Soupault, as well as Man Ray and René Magritte. Tabard's photographs often incorporated solarization (a technique that he learnt from Man Ray), montage, negative printing or double exposures, as seen in *Composition* (above), for which Tabard drew on his experiences as an X-ray technician. In this instance he printed through a sandwich of negatives to create a ghostly montage featuring a pair of gloved hands superimposed over a standing female nude.

The streets of Paris provided endless subjects for photographers. One source was the Parisian abattoirs, the largest of which, La Villette, was situated on the north-eastern edge of the city. Eli Lotar, a French photographer who aligned himself with Surrealism, photographed La Villette in 1929. Although the impulse was his own, the pictures he took there are now mainly associated with Georges Bataille's Surrealist magazine, *Documents*. Bataille featured three of Lotar's abattoir photographs in issue six of the magazine in November 1929, shortly after they were taken, and supplemented the images with his own explanatory text. In the most shocking of the sequence, *Aux abattoirs de La Villette* (right), a row of cow hooves stands against a wall, and on first glance it resembles a row of people. The word 'PICHARD' is printed on a wall above the hooves, which likely is the name of the butcher who now owns them.

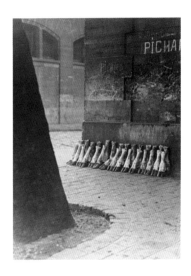

Avant-garde activity in Paris was in part sustained by the many periodicals that were published during the period. Artists and writers contributed to a wide range of publications, with magazines, newspapers, manifestos, literary journals and photography books providing both avant-garde and popular outlets for communication. Image-led magazines such as *Vu*, *Vogue*, *Marie-Claire*, *Bifur* and *Paris-Soir* provided steady income for photographers.

Many avant-garde photographers of the time began their careers as painters (or turned to painting later). Florence Henri was a painter devoted to Cubist and Constructivist theories, who gravitated to photography after visiting the Bauhaus in Dessau in 1927, where she met László Moholy-Nagy (1895–1946), during a course taught by him on Russo-German Constructivism. Encouraged by his wife, Lucia, she began to study photography. Moholy-Nagy's belief that photography was an ideal medium for Constructivism may in part explain Henri's fascination with shapes and geometric compositions, which appear in her paintings, photomontages and photographs such as *Composition* (below). When she returned to Paris, she retained her new-found appreciation for the camera and created formal, bright, geometric, abstract photographs. Henri embodies the artistic and intellectual exchange between Germany and France, a significant aspect of avant-garde development.

The relative political calm that had existed during the 1920s was gradually dispelled during the following decade and the vibrant society of artists in Paris disbanded with the onset of World War II. Avant-garde practices continued in exile, however, and their influence would be evident in the work of countless artists and writers throughout the 20th century. **AB**

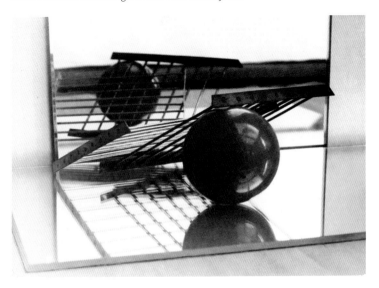

Satiric Dancer 1926
ANDRÉ KERTÉSZ 1894 – 1985

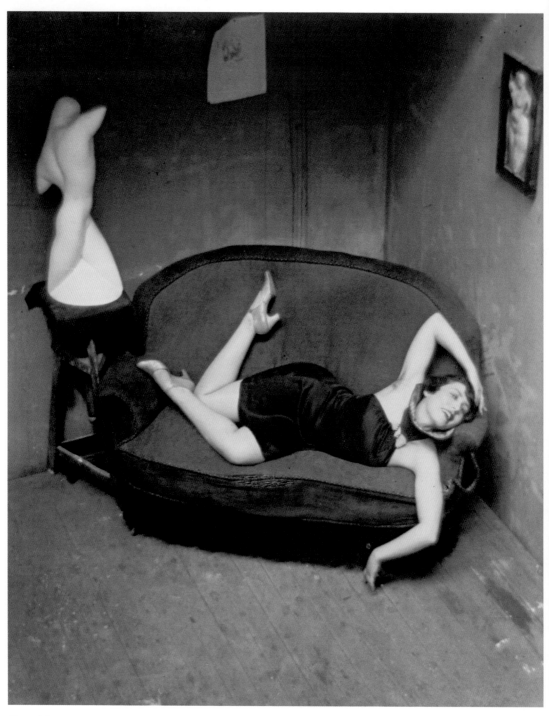

Silver print
9 ¾ x 7 ¾ in. | 25 x 20 cm
J. Paul Getty Museum,
Los Angeles, USA

André Kertész was a friend of the Hungarian sculptor István Beöthy and took *Satiric Dancer* in Beöthy's home. The model is Magda Förstner, a Hungarian cabaret dancer and aspiring actress, who had thrown herself on to the divan in an attempt to mirror Beöthy's sculpture of a male torso nearby. Kertész had invited Förstner to the studio specifically for the shoot. 'I said to her, "Do something with the spirit of the studio corner," and she started to move on the sofa,' he recalled. 'She just made a movement. I took only two photographs. . . .People in motion are wonderful to photograph. It means catching the right moment—the moment when something changes into something else.'

When Kertész photographed people he was motivated by compassion; his intention was not to sensationalize but to connect emotionally. He was not concerned with creating political commentary or aligning himself with a particular movement; he portrayed social realities without intentional underlying messages but with a developed sense of modernist form and a playful humour. Kertész was given a solo exhibit at the Sacre du Printemps Gallery in 1927 that connected him to the 'new spirit' promoted by avant-garde artists in the period. His photographs, widely published in illustrated journals, sealed his reputation as one of the leading photographers in Paris. His works, designed to capture the modern, now seem timeless in their appeal. **AB**

◆ NAVIGATOR

◉ FOCAL POINTS

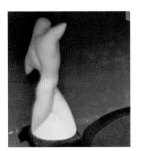

1 SCULPTURE

Beöthy's sculpture of a nude male torso stands to the left of the couch. The athletic stance of the sculpture is mimicked by Förstner. Intriguingly, her white limbs represent the parts of the statue that are missing. If the two were combined, they would make a complete figure.

2 FRAMED SCULPTURE

A framed image of a female nude sculpture hangs on the wall to the right. This, together with the torso sculpture opposite and Förstner herself, forms a triangle. The trio of components—all related to the human body—gives the composition a dynamic visual energy.

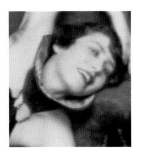

3 MAGDA FÖRSTNER

Judging by Förstner's expression, she seems to be enjoying herself. Her arms and elbows are playfully set at sharp angles. There is a sense of spontaneous fun, which is a common theme in Kertész's photography. He preferred chance encounters to more formalized compositions.

◷ PHOTOGRAPHER PROFILE

1894–1925

Andor (later André) Kertész was born in Budapest and raised by his mother after his father's death in 1908. By the age of eighteen Kertész had taken his first photograph and he had his camera with him when he left to fight in World War I. After the war he returned to Hungary and continued to photograph; his images were frequently reproduced in Hungarian magazines. Craving more stimulation than Budapest could offer, however, he moved to Paris in 1925.

1926–35

Kertész used a lightweight 35mm Leica to photograph in Paris. He was married briefly to Rosza Klein (the photographer known as Rogi André), but devoted himself throughout his life to Erzsebet Salomon (later, Saly) whom he married in 1933. Kertész published his first book, *Enfants*, in 1933 while also accepting commissions from French and German magazines such as *Vu*, *Art et médecine*, *Neueste Illustrierte* and *Die Dame*. Within this ten-year span, Kertész was featured in exhibitions in Paris, Stuttgart (the 'Film und Foto' show in 1929), Munich and New York.

1936–63

In 1936, the Kertészes left Paris for New York, a city in which the photographer was never happy. Beaumont Newhall, the director of the photography department at the Museum of Modern Art , included some of Kertész's *Distortions* in the exhibition 'Photography 1839–1937'. Kertész photographed for *Harper's Bazaar*, *Town and Country* and *Life* magazines.

1964–85

In 1964, the new director of photography at the Museum of Modern Art, John Szarkowski, featured some of Kertész's work in a solo exhibition. The photographer became increasingly well known thereafter and received the National Grand Prize of Photography in Paris in 1982, three years before his death in New York.

Fat Claude and her Girlfriend at Le Monocle 1932
BRASSAÏ 1899 – 1984

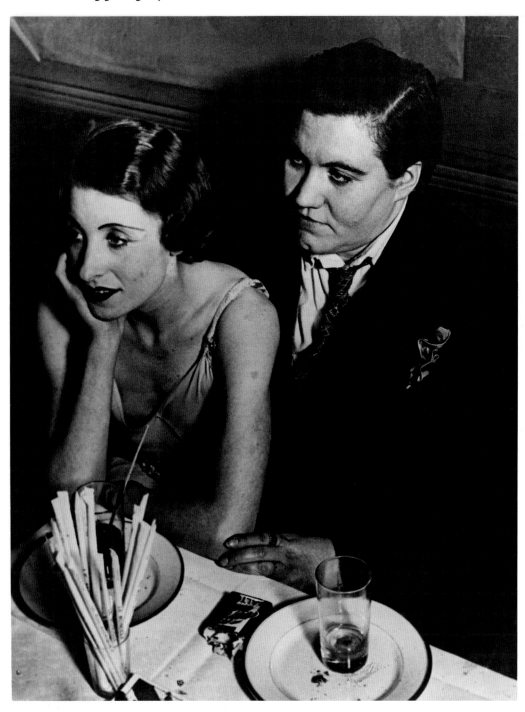

Silver print
10 ⅞ x 8 ½ in. | 27.5 x 21.5 cm
Metropolitan Museum of Art,
New York, USA

Taken in a popular lesbian bar called Le Monocle, on the Boulevard Edgar-Quinet, this photograph is a concoction of opposites: feminine and masculine; the thin woman with her larger, rounded partner; one figure in a light, revealing dress, the other covered up in a dark suit, shirt and tie. The image seems to reinforce gender roles, until we realize that the subjects are both women. Brassaï sympathized with people on the fringes of society, such as homosexuals and cross-dressers. He felt that this side of Paris was essential to the city's true character and wanted to prove that there was also beauty to be found there. He photographed a number of cross-dressing lesbians in this bar in the early 1930s, and was likely the only male there. It is a scene that few people in Paris would have known about and Brassaï's image brings the viewer into close (and perhaps thrilling) proximity with these bohemian types. Although the images often appear candid, Brassaï admitted to staging his photographs and arranging the sitters to suit his compositional needs. He used a 2 ½ x 3 ½-inch (6.5 x 9 cm) Voigtländer Bergheil, which used glass plates and necessitated lengthy exposure times—requiring a compliant sitter.

In 1935, a volume of Brassaï's photographs of Paris was published as *Voluptés de Paris*, but he was disappointed with the quality of its images. Forty years later, he published the series as he had envisioned it, under the title *The Secret Paris of the 30s*. **AB**

◷ PHOTOGRAPHER PROFILE

1899–1924
Brassaï was born Gyula Halász in Brassó, Transylvania. (The pseudonym 'Brassaï' means 'from Brassó'.) From 1920 he worked as a journalist in Berlin and moved to Paris in 1924, where he lived until his death.

1925–39
Brassaï became acquainted with other immigrant artists at the Café du Dôme in Paris. He grew close to André Kertész and Eugène Atget, and began photographing in 1930, with support from Kertész. His first photographic project, *Paris de nuit* (1933), featured nocturnal scenes of the city and proved a great success. Brassaï's images were used in the Surrealist magazine *Minotaure* and André Breton's book *L'amour fou*. In 1939, Brassaï was included in Beaumont Newhall's exhibition 'Photography: 1839–1937' at New York's Museum of Modern Art.

1940–67
His novel *Histoire de Marie*—with an introduction by Henry Miller, whom he had befriended during his earliest years in Paris—was published in 1948, when he also produced a photographic series of graffiti. A year later, he became a French citizen, after some years spent without an official nationality. In 1954, he bought a 16mm film camera, and the following year produced *Tant qu'il y aura des bêtes*, shot in Vincennes zoo. It won the Cannes Festival Palme d'Or for Most Original Movie (1956). In 1961, he stopped taking photographs and focused on sculpture, working in bronze and stone. Three years later, he published *Conversations with Picasso*, memoirs of the artist reconstructed from notes on scraps of paper that Brassaï had made during their times together.

1968–84
Brassaï was given a one-man exhibition at the Museum of Modern Art in 1968. He continued to photograph and write, and published *Henry Miller—Grandeur Nature* in 1975. He remained in France until his death.

BRASSAÏ'S PARIS

Brassaï was intrigued by the life of Paris at night. His most renowned photographs of the city from the 1930s evoke the nocturnal atmosphere of the capital, and its shadowy underworld in particular. Here he can be seen at work in *c.* 1931 with his Voigtländer Bergheil camera and tripod on the Boulevard Saint-Jacques.

SURREALISM

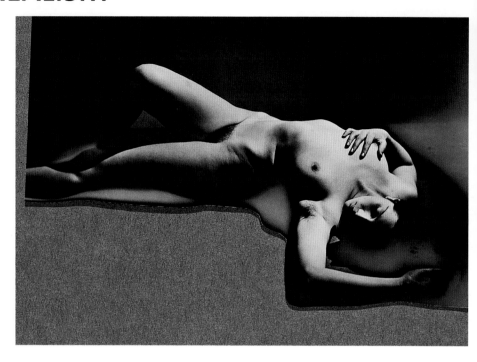

I n 1924 the French writer André Breton published the *Manifeste du surréalisme* (*Surrealist Manifesto*), his first manifesto concerning Surrealist aesthetics. Separating himself from the Dadaists (see p.192) in Paris, he set out to create what would become a movement that embraced fine art, photography and philosophy. Breton felt that it was time for art to assist in the exploration of the meaning of existence and reality. Deeply moved by his work in a trauma centre during World War I, he thought that contemporary art needed to explore the human subconscious using the precepts of psychoanalysis, such as the meaning of dreams and the concept of the uncanny. Breton believed that what is thought of as reality is in fact externalized projections of true reality, the subconscious. The subconscious in turn lent subjective meaning to quotidian reality.

Many of the iconic visual works from the period were made as photographs. Breton stressed that in order to capture the reality of uninhibited thoughts, or 'psychic automatism in its pure state', artists needed to rely on two things: dream narratives and automatic writing. As it was thought that photography did not interpret reality but simply transcribed it, the medium in effect mimicked the idea of automatic creation. *La Révolution surréaliste* (*The*

KEY EVENTS

1919	1923	1924	1924	1928	1929
Sigmund Freud publishes his essay 'Das Unheimliche' (The Uncanny). It references repetition and doubling, influencing Surrealist artists.	André Breton and other Surrealists turn against Dadaism, rioting at a Paris theatre showing the Dadaist play *Le Coeur à gaz* (*The Gas Heart*).	The first issue of *The Surrealist Revolution* appears. Edited by Breton, the journal is filled with literary and artistic experiments claimed for Surrealism.	The Centrale Surréaliste (Bureau of Surrealist Research) opens in Paris; Surrealists can meet and facilitate discourse on the movement.	Breton publishes his second novel *Nadja*, which includes photographs of Paris taken by Jacques-André Boiffard.	Salvador Dalí joins the Surrealists in Paris and during the next five years creates some of his most well-known Surrealist paintings and films.

Surrealist Revolution, 1924–29), the journal edited by Breton, featured photographs taken by Eugène Atget (1857–1927) and Man Ray (1890–1976), among others. The journal also included reproductions of paintings and drawings by Max Ernst, Pablo Picasso and Paul Klee. The camera was used to mediate directly between the concept of the work and the mind of the viewer.

Photography was ideal for exploring the nature of representation, a key concept for Breton's Surrealism. Mirrors, double negatives, negative layering and mannequins all create a 'double', a species of representation of an actuality rather than the actuality itself. Another method of emphasizing art as psychic representation rather than a reflection of external reality was called 'spacing', which refers to the frame of the photograph and of the film still. The frame disrupts the replication of three-dimensional space and reminds viewers that the cropped image is only a representation of the moment captured.

The philosopher Georges Bataille was similarly drawn to the insights that Surrealism had to offer. He conceived of an alternative form of Surrealism and expressed his theories in the magazine *Documents* (1929–30), which he edited. Although Bataille also focused on the human subconscious, he was less interested in reality and representation, and more interested in the connection between desire and repulsion within the human mind. For Bataille, visceral reactions to disturbing words and images would unlock reflexive, unpleasant sensations and feelings that had often been repressed. Such unconscious sensations were, for Bataille, related to death, which he defined as the most obscene form of desire. *Documents* contained images that were visually unnerving.

The first photographer Breton claimed for Surrealism was Man Ray, a key figure within the avant-garde in Paris (see p.224). Man Ray was a relentless innovator in terms of subject matter, composition and technique, using solarization and photograms, which he called 'Rayographs', to create strikingly modern imagery. Solarization appealed to Surrealists, and Man Ray especially; the process created an uncanny effect by overexposing a negative or print during the printing process so that tones are reversed, causing the reversal of shadows and highlights. Man Ray solarized portraits and figure studies, such as the nude portrayal of Swiss artist Méret Oppenheim in *The Primacy of Matter over Thought* (opposite). Overexposure has resulted in a black border, causing the body to float in the centre of the composition. Man Ray was inspired by Neoclassical art and drew on a painting by artist Jean-Auguste-Dominique Ingres for *Ingres's Violin* (1924; see p.236), one of his most celebrated Surrealist photographs.

Inspired by Man Ray, Belgian artist Raoul Ubac (1910–85) used photomontages, solarization and *brûlage*—a singeing of the negative or negatives—to create striking and complex compositions such as *La Conciliabule* (right). These murallike works, made at the time of the Spanish Civil War and

1 *The Primacy of Matter over Thought* (1929)
Man Ray • cutout solarized silver print on paper
3 x 4 ⅝ in. | 7.5 x 11.5 cm
Baltimore Museum of Art, Baltimore, USA

2 *La Conciliabule* (1938)
Raoul Ubac • silver print
15 ⅜ x 11 ⅜ in. | 39 x 29 cm
Musée National d'Art Moderne, Centre Pompidou, Paris, France

1929	1929	1930	1933	1938	1938
Georges Bataille edits the first of fifteen issues of the dissident Surrealist periodical *Documents* as a response to *The Surrealist Revolution*.	Breton publishes the *Second manifeste du surréalisme* (*Second Surrealist Manifesto*) in an effort to unite Surrealists when the movement fractures.	Breton publishes the first of six issues of *Surréalisme au service de la révolution* (*Surrealism in the Service of the Revolution*).	The Surrealist periodical *Minotaure* is published in Paris. The first of thirteen issues, it features artworks by Pablo Picasso and Hans Bellmer, among others.	Breton travels to Mexico and sees the work of avant-garde photographers such as Manuel Alvarez Bravo (1902–2002), which he deems Surrealist.	US poet and playwright Gertrude Stein writes the libretto for a Surrealist opera, *Doctor Faustus Lights the Lights*.

3 *Portrait of Space* (1937)
Lee Miller • silver print
5 ¼ x 4 ⅞ in. | 13.5 x 12.5 cm
Lee Miller Archives, Chiddingly, UK

4 *Father Ubu* (1936)
Dora Maar • silver print
15 ½ x 11 in. | 39.5 x 28 cm
Metropolitan Museum of Art,
New York, USA

5 *The Doll, Variations on the Assemblage
of an Articulated Minor* (1933)
Hans Bellmer • silver print
7 ⅝ x 11 ¾ in. | 19.5 x 30 cm
Musée Cantini, Marseille, France

the build-up to World War II, combine the idealized female form with distortions and seeming dismemberment to suggest the irrational human behaviour that can be unleashed by war.

One of Man Ray's photographic assistants, the US expatriate Lee Miller (1907–77), became an important figure within the Surrealist movement in the 1920s. A well-known model for Condé Nast, she became a photographer and, like Man Ray, she worked commercially on assignment and artistically for herself. Miller and Man Ray became involved, and she is often relegated to the role of his lover and muse, although it seems that she was as much, if not more, well-versed in Surrealist aesthetics as he was. In 1934 Miller moved to Egypt with Egyptian businessman Aziz Eloui Bey whom she had married that year. By then she was an experienced photographer but her commissioned and personal work never lost its Surrealist edge. One of her most celebrated images, *Portrait of Space* (above), is taken in a desert near Siwa. Torn mosquito netting with ragged edges frames the scene and elicits a feeling of confinement. A mirror in the centre of the composition emphasizes that this is not reportage but representation. The picture suggests that each viewer who peers through the screen at the Egyptian desert will interpret the landscape subjectively.

French painter and poet Dora Maar (1909–97) is best known for being one of Pablo Picasso's lovers and muses, but she also supported herself by working as a commercial photographer in Paris during the 1920s and 1930s. Associated with Bataille, Man Ray and Breton, she made avant-garde photographs, such as her photograph *Father Ubu* (opposite above), which was modelled after the infamous anti-hero of Alfred Jarry's play *Ubu Roi* (*King Ubu*, 1896). The play is regarded as an important precursor to Surrealism, satirizing bourgeois abuse of power and success through the play's main character, Ubu, who embodies those traits. Maar's use of a baby armadillo to represent Ubu, together with the

stark lighting, creates a highly unnerving composition that is difficult to look at and yet compelling. A feeling of discomfort was a desired effect of Surrealist imagery because such works were intended to unlock the subconscious. The extreme close-up of the armadillo's face is reminiscent of the disconcerting close-ups by Jacques-André Boiffard (1902–61), such as *Big Toe* (1929; see p.238), which featured in *Documents*.

The German artist Hans Bellmer (1902–75) was introduced to the French Surrealists in 1934 when a series of his photographs was featured in the journal *Minotaure* (*Minotaur*, 1933–39), which was coedited by Breton. Although Bellmer created his work in Berlin, it is generally claimed for Surrealism. The series consists of eighteen photographs of a female, life-size mannequin in various poses and degrees of dismemberment across a double-page spread with the title *The Doll, Variations on the Assemblage of an Articulated Minor* (below). The doll is staged within scenarios that were created inside Bellmer's photography studio and outdoors; they variously include props such as wigs, artificial flowers, pieces of clothing and veils. The doll was an appealing motif for Surrealists because it epitomized the idea of doubling and invoked the uncanny. The images of the doll's dismembered body parts, often grouped in piles or reattached to the wrong parts of the body, elicit a sense of repulsion.

Brassaï (1899–1984) made photographs that adhered to both Bataille and Breton's Surrealist aesthetics with his eerie series *Involuntary Sculptures* (1932), which consists of six photographs depicting seemingly floating ephemeral objects. Brassaï took close-up photographs of bus tickets, soap, toothpaste and other banal objects, defamiliarizing them through the use of intense lighting against a textured backdrop. The series was reproduced in *Minotaure* in 1933 accompanied by captions written by Surrealist artist Salvador Dalí. Brassaï said: 'The surrealism of my pictures was only reality made more eerie by my way of seeing. I never sought to express anything but reality itself, than which there is nothing more surreal.'

Breton and Bataille's methods, and those of the writers and artists they promoted, varied but both men made the human subconscious the subject of sustained aesthetic enquiry. Neither championed photography as an art form, yet its prominence within Surrealist production and the journals they edited suggests that they prized the medium as capable of creating uncanny visual imagery that speaks to the subconscious mind. **AB**

Ingres's Violin 1924

MAN RAY 1890 – 1976

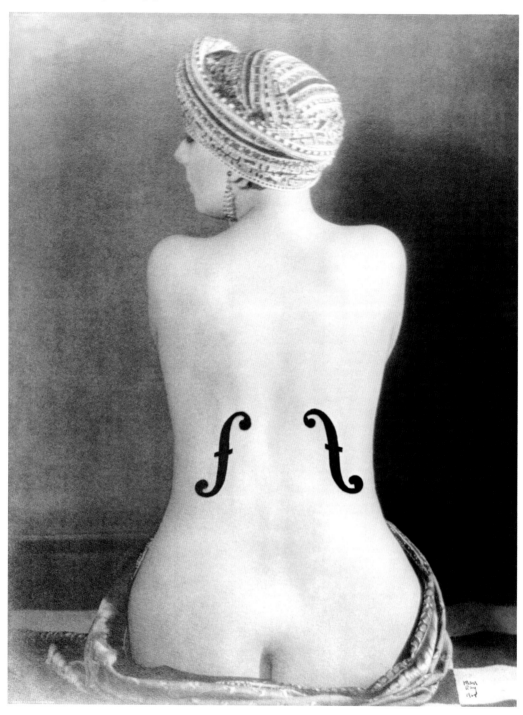

Silver print retouched with pencil and Indian ink
11 x 8 ⅞ in. | 28 x 22.5 cm
Musée National d'Art Moderne, Centre Pompidou,
Paris, France

M an Ray, who admired Neoclassical artist Jean-Auguste-Dominique Ingres greatly, created this photograph inspired by the French painter's nudes and it is one of the photographer's most celebrated works. The original title, *Le Violon d'Ingres*, is a pun on the French expression for 'hobby horse' (*violon d'Ingres*), which derived from Ingres's enthusiasm for the violin and his insistence on playing it to guests when they came to see his paintings. In transforming his muse and lover Alice Prin into an Ingres-like odalisque, and then into a violin, Man Ray perhaps claims the female form as his own *violon d'Ingres*.

By the age of fourteen, Prin was supporting herself by posing nude for artists. In the 1920s she became known as the cabaret performer 'Kiki of Montparnasse' and the 'Queen of Montparnasse'. In 1921 she met Man Ray and became his model, muse and lover for eight years. For the *Ingres* series, Prin posed nude wearing only a turban. In this image Man Ray hand-painted the F-holes of a violin on to the print, effecting a Surrealist puncturing of the body. It is not a portrait of Prin but an objectification of her as an instrument that is played by another. The exotic turban and the fabric that is pulled down to emphasize the curves of her body further heighten its erotic charge.

The picture was published in 1924 in the French periodical *Littérature* (*Literature*, 1919–24). André Breton, the journal's editor, retained the original photograph for his collection; it is now in the French national collection in Paris. All other prints of the subject that have been traced appear to have been made from a copy negative. The combination of manipulated reality, objectified female form and teasing title makes this photograph definitively Surrealist and quintessentially Man Ray. **AB**

◉ FOCAL POINTS

1 TURBAN
Prin had a distinctive short black bob. The turban was used to help conceal her identity and aid the process of abstraction. It may also be a reference to Ingres's paintings the *Valpinçon Bather* (1808) and the *Turkish Bath* (1862), which portray naked women wearing turbans.

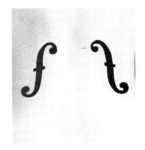

3 VIOLIN F-HOLES
The F-holes and the title of the picture suggest Ingres's love both of the violin and of women. Man Ray's playful and witty allusion reveals his rejection of the high-minded morality and rationalism of Neoclassical art, which was the antithesis of what Surrealism espoused and represented.

2 LIMBLESS BODY
This view of Prin renders her limbless. Man Ray concealed her arms and legs in order to portray the female form as object; the viewer is to see her form as an instrument, not a female body. Dismemberment was a recurrent theme among all forms of Surrealist art. The lack of visible limbs also makes the model's shapely torso resemble the curved form of a violin more closely and thus reference the tradition of making music as an allegory for love play.

⏲ PHOTOGRAPHER PROFILE

1890–1920
Man Ray was born Emmanuel Radnitzky in South Philadelphia, Pennsylvania but in 1897 his family moved to New York City. His parents were Russian-Jewish immigrants and changed their surname to 'Ray' in 1912. He worked as a commercial artist and studied painting before turning to photography.

1921–39
He moved to Paris where he became a tireless photographic experimenter as well as an innovative painter, sculptor and filmmaker, and he photographed many artists and actors.

1940–76
Man Ray moved back to the United States to escape the German Occupation. He returned to Paris in 1951 and won the Gold Medal for photography at the Venice Biennale in 1961.

Big Toe 1929

JACQUES-ANDRÉ BOIFFARD 1902 – 61

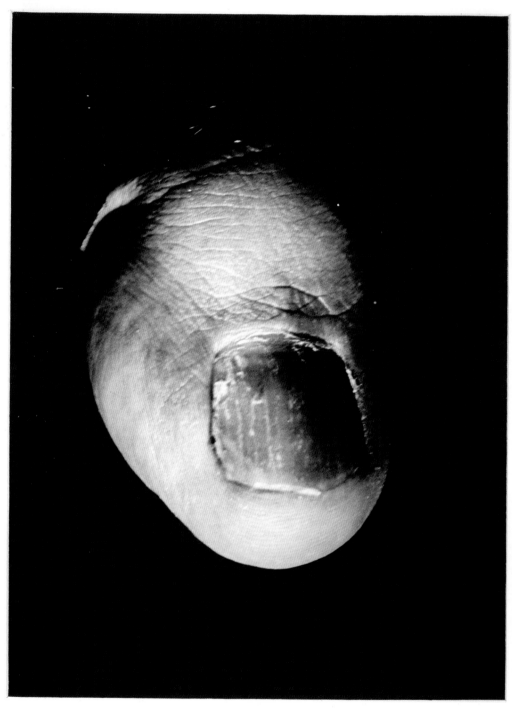

Silver print
12 ¼ x 9 ⅜ in. | 31 x 24 cm
Musée National d'Art Moderne,
Centre Pompidou, Paris, France

Jacques-André Boiffard was a medical student who became interested in art and Surrealism after meeting André Breton in 1924. He worked closely with Breton and Man Ray, and provided the preface for the first issue of *La Révolution surréaliste* (*The Surrealist Revolution*) in 1924. Breton and Boiffard severed ties shortly after. Boiffard then associated himself with Georges Bataille, who used Boiffard's photographs to illustrate articles in *Documents* (1929–30). Bataille filled *Documents* with fragmented, magnified, anti-aesthetic pictures in order to affect viewers on a subconscious level. *Big Toe* accompanied Bataille's article of the same name in issue six and has become emblematic of Surrealism. Although two other photographs of toes were also featured, this one—subtitled 'Masculine subject, thirty years old'—has been reproduced most often. The three toes—two male, one female—occupied a full page of the journal, with realistic details magnified to larger than life proportions. In the article Bataille described how feet are a common sexual fetish. Boiffard staged the toe against a black background as if removed from the human form. The toe's strangeness is enhanced by its isolation and encourages viewers to contemplate the object as fetish. It is both unattractive and yet sexualized. This relates directly to Bataille's preoccupation with repulsion and desire, and his belief that one depends on the other. **AB**

🧭 NAVIGATOR

👁 FOCAL POINTS

1 BASE OF TOE
Boiffard's framing disassociates the toe from the human form, as if dismembered. Bataille believed that desired parts of the body should be made into fractions, because fetishism isolates them from the person to whom they belong. The chiaroscuro isolates the erotic symbol, the toe.

2 BLACK BACKGROUND
The stark black background creates a provocative atmosphere and ensures that the toe is the composition's sole focus. There is no context in which to place the object; it stands alone within the frame. The toe is an independent form containing its own symbolism, in this case related to desire.

3 ANGLED TOE
By rotating the toe Boiffard disorientates the viewer, adding to their feeling of repulsion and dread. The view makes the toe more abstract and emphasizes details such as the hair. Disrupting typical associations was thought to be a way to access the unconscious.

4 WRINKLED SKIN
The elements of the toe are gruesome and appear almost obscene. The magnification forces the viewer to consider each detail: wrinkled skin, hair follicles and textured toenail all translate as ugly, monstrous and impossibly real. The image's sexual allure is linked to the fact that the big toe is repellent.

⏱ PHOTOGRAPHER PROFILE

1902–28
Jacques-André Boiffard was born in Paris. He was a medical student until a mutual friend introduced him to André Breton. When the Centrale Surréaliste (Bureau of Surrealist Research) opened in Paris in 1924, Boiffard worked there researching the movement. He worked as Man Ray's assistant until 1928 and illustrated Breton's novel *Nadja* (1928). The same year, he was expelled from Breton's circle after photographing Breton's first wife, Simone.

1929–34
Boiffard aligned himself with Georges Bataille and some of his photographs were published in Bataille's periodical *Documents*. He contributed to a pamphlet titled *Un Cadavre* (*A Corpse*, 1930), which criticized Breton's ideology, and joined the Association des Écrivains et Artistes Révolutionnaires (Association of Revolutionary Writers and Artists).

1935–61
Boiffard gave up photography after his father died in 1935. He gained a doctorate in medicine and spent the rest of his working life as a radiologist.

AVANT-GARDE PHOTOGRAPHY IN MEXICO

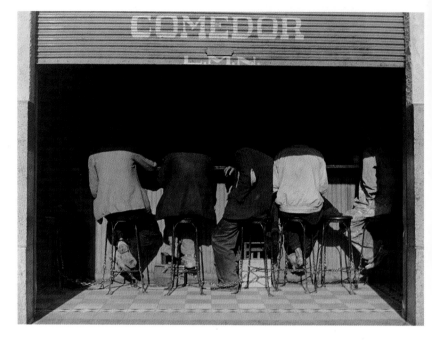

In 1910 revolution erupted in Mexico and a decade of strife ensued. Many artists, writers and intellectuals responded to the conflict by embracing an avant-garde agenda that sought new cultural forms. In turn, the post-revolution government recognized the key role of the arts in consolidating a unique Mexican cultural identity. Artists such as Diego Rivera and David Siqueiros were commissioned to paint murals on the walls of Mexico's municipal buildings, which photographers, including Manuel Alvarez Bravo (1902–2002), then documented. This cultural moment—referred to as the Mexican Renaissance—brought together Mexican artists and photographers with those from the United States and Western Europe.

By the mid 1930s many US and European photographers had joined Mexican artistic circles. Edward Weston (1886–1958) arrived in the early 1920s with his lover and muse of the time, Tina Modotti (1896–1942), who became a respected photographer in her own right. Weston and Modotti were enamored of Mexico and photographed it prolifically. Modotti incorporated political and social concerns into her images, such as *Workers Parade* (1926; see p.242), while Weston kept an aesthetic focus, recording the landscape and folk art. In Weston's photograph *Tina on the Azotea* (1924), a nude Modotti lies on a traditional Mexican blanket, with direct sunlight creating a dramatic shadow on the side of her body.

KEY EVENTS

1910	1912	1917	1922	1924	1925
The Mexican Revolution begins. Many artists and writers flock to Mexico, and photography becomes intrinsic to the artistic revolution.	Weekly newspaper *La Prensa* is founded. Published in Spanish in Los Angeles, it provides political news of the Mexican Revolution.	The Mexican Constitution calls for educational reform, which depends upon art and its ability to educate the illiterate poor.	Painters are first commissioned to decorate public spaces with murals that glorify Mexican history and culture. They are seen as politically radical.	In Peru student leader Victor Raul Haya de la Torre founds an alliance to promote revolutionary principles throughout Latin America.	*El Machete* becomes the official newspaper of the Mexican Communist Party. The machete becomes a symbol of the country and a subject of art.

Alvarez Bravo was a leading figure of the Mexican avant-garde. Although he was introduced to photography at a young age, his major work took place after he met Weston and Modotti. Central to his work was Mexico's indigenous culture, people and landscape, which he celebrated in unsentimental scenes. In *The Crouched Ones* (opposite), he captures everyday Mexican life in a line of anonymous working men sitting at a bar. The men appear to be chained together, although it is actually the bar stools that are chained. Alvarez Bravo often concealed his subjects' faces (here the mens' heads are in shadow), seeking to symbolize society as a whole rather than the individual. His poetic and sometimes politically charged photographs exposed Mexican culture to the world and serve as an enduring archive of Mexican life in the 20th century.

Alvarez Bravo met French photographer Henri Cartier-Bresson (1908–2004) in 1934 and the pair shared a joint exhibition the following year in Mexico and New York. Cartier-Bresson was enthralled by the artistic and revolutionary atmosphere of Mexico and, like Modotti, the photographs he took there addressed both political and aesthetic concerns. A partially undressed man, whose suffering is implied by his clenched fists and the 'X' formed by his arms across his chest, is presented in *Santa Clara, Mexico* (below). The man's face is mostly concealed, erasing his individuality and making him representative of the collective Mexican worker. The piles of formal shoes beside him suggest bourgeois consumption; situated next to the (seemingly) suffering man, they serve to highlight a class divide. In this masterful composition the man and shoes perfectly balance one another, while the dark corners of the cabinet balance the lighter grey tone of the man's skin and the wall behind him. **AB**

1 *The Crouched Ones* (1934)
Manuel Alvarez Bravo • silver print
7 x 9 ⅜ in. | 18 x 24 cm
Museum of Modern Art, New York, USA

2 *Santa Clara, Mexico* (1934–35)
Henri Cartier-Bresson • silver print
6 ⅝ x 9 ⅞ in. | 17 x 25 cm
Museum of Modern Art, New York, USA

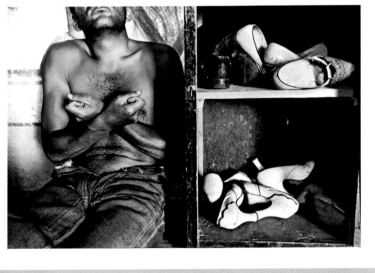

1927	1929	1929	1932	1932–34	1934
D. H. Lawrence's collection of travel essays titled *Mornings in Mexico* is published. The British writer first visited Mexico in 1923.	Mexico's Institutional Revolutionary Party comes to power. The party will remain in government until the early 1990s.	Mexican painter Frida Kahlo creates her iconic *Self-portrait: Time Flies*, which represents national pride and awareness during that period.	Diego Rivera studies the facilities at Ford's River Rouge Complex, which serve as inspiration for his mural series titled *Detroit Industry*.	Paul Strand (1890–1976) travels to Mexico, creating photographs for *Mexican Portfolio* (1940). They focus on the people, landscape and architecture.	LEAR (League of Revolutionary Artists and Writers) is set up. Its mission is to restore diplomatic relations between Mexico and Soviet Russia.

Workers Parade 1926
TINA MODOTTI 1896 – 1942

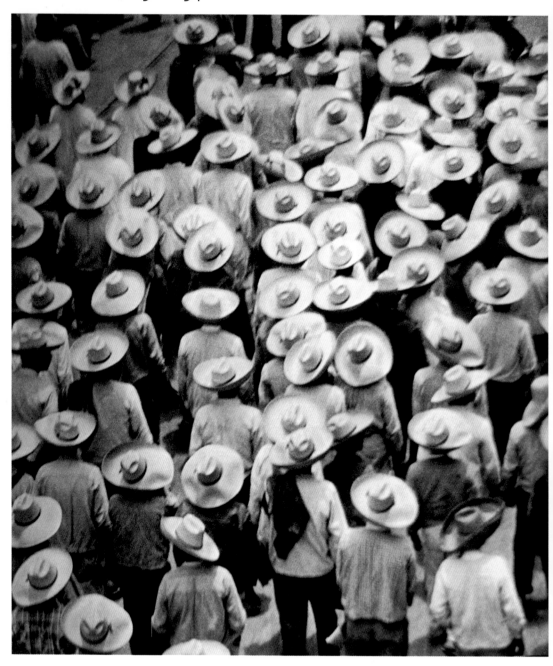

Silver print
8 ⅜ x 7 ¼ in. | 21.5 x 18.5 cm
Museum of Modern Art, New York, USA

Although Tina Modotti was Italian by birth, her adulthood was defined by the time that she spent in Mexico. Her photographs were sensitive to Mexican culture while simultaneously reflecting her evolving political beliefs. Immersing herself in the Mexican avant-garde scene, she created a significant photographic archive of Mexican culture and politics in the revolution's aftermath. Modotti made herself vital to the avant-garde movement and fostered awareness of Mexican revolutionary ideals through her emotional, politically motivated images. She was so attuned to the culture that people—Edward Weston included—often confused her photographs with those taken by leading Mexican photographer Manuel Alvarez Bravo.

Modotti tried to balance the dichotomy of aesthetics and politics. She wanted to ensure that her images gracefully combined both, and *Workers Parade* exemplifies a beautiful fusion. This image of peasant farmers, shot from an elevated vantage point, was taken during a parade on 1 May 1926. May Day was especially meaningful in Mexico during the 1920s because it honored workers' rights and celebrated the activists who had died as a result of the Haymarket Affair of Chicago in 1886. *Workers Parade* was reproduced in the August/September 1926 issue of *Mexican Folkways*, an influential magazine that often featured Modotti's work. **AB**

NAVIGATOR

FOCAL POINTS

1 BLURRED HATS
Some of the sombrero hats of the peasant farmers in the May Day parade are blurred. This evokes a sense of movement—it is clear that the massive group of figures is moving or marching forwards. Modotti slowed her shutter speed in order to capture the action as it happened.

2 CONCEALED FACES
Modotti chose not to show the workers' faces. Everyone is viewed from behind, wearing similar hats, which creates a sense of unity. Individuality no longer exists, just as the workers are fighting for their collective rights. In focusing on the group, Modotti reveals her political sensibility.

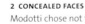

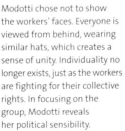

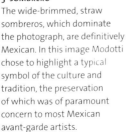

3 SOMBRERO
The wide-brimmed, straw sombreros, which dominate the photograph, are definitively Mexican. In this image Modotti chose to highlight a typical symbol of the culture and tradition, the preservation of which was of paramount concern to most Mexican avant-garde artists.

PHOTOGRAPHER PROFILE

1896–1917
Tina Modotti was born in Italy and immigrated to San Francisco, California to join her father when she was a teenager. While there, she often modelled for artists and occasionally acted in silent films.

1918–23
Modotti moved to Los Angeles with a US artist, Roubaix de l'Abrie Richey (Robo), with whom she lived (although they never legally married). She continued to work as an actress in Hollywood. She met the photographer Edward Weston through friends and began to model for him; she also started to study photography with him. By 1921 Modotti was Weston's favourite model and soon became his lover. Robo, who had travelled to Mexico for work and to promote Weston's photographs, died there in 1922. Modotti then travelled to Mexico City with Weston, where she acted as studio manager in exchange for lessons in the darkroom.

1924–29
Modotti immersed herself in Mexican culture and politics. She opened a portrait studio with Manuel Alvarez Bravo, took photographs for the Mexican muralists, including Diego Rivera and José Clemente Orozco, and became a committed political activist. She worked as an editor and photographer for *Mexican Folkways*, a bilingual—Spanish and English—magazine about Mexican art and culture. The majority of photographs for which she is known were taken during this period. In 1927 Modotti joined the Mexican Communist Party.

1930–42
Modotti was deported from Mexico in 1930 because of her revolutionary activities. She made her way through Europe to Moscow where she became involved in political activism and the Soviet avant-garde scene. She travelled to Spain during the Spanish Civil War and finally returned to Mexico, where she died aged forty-six.

AVANT-GARDE PHOTOGRAPHY IN MEXICO 243

THE MODERN SELF

When World War I ripped apart the social fabric of Europe and Russia, the repercussions were felt throughout the globe. The years before World War II marked an extraordinary period of unrest and revolution. Artists responded to the crisis of traditional authority in a manner of ways, creating a kaleidoscope of avant-garde groupings that had an array of agendas. In photography, the diversity and unpredictability of these modernist visions are characterized perfectly by how the modern self was perceived and pictured in both portraiture and self-portraiture.

Hungarian-born, Bauhaus-based artist László Moholy-Nagy (1895–1946) hailed the camera as nothing short of 'a new instrument of vision' and photography as 'the new vision'. His infamous eight varieties of photographic sight—from abstract to exact, rapid to slow, micro to X-ray, and simultaneous superimposition to distortion—enabled the photographer to recast the world. In 1936 he eulogized: 'Thanks to the photographer, humanity has acquired the power of perceiving its surroundings, and its very existence with new eyes.' Crucially he, and his followers, believed that the mechanical camera

KEY EVENTS

1918	1919	1920	1923	1923	1923
World War I ends. Many writers, artists and intellectuals congregate around Paris, the centre of a burgeoning artistic scene.	Hugo Erfurth (1874–1948) makes a portrait of Austrian artist and writer Oskar Koskoschka in his Dresden studio.	After the fall of the Communist regime in Hungary, László Moholy-Nagy moves first to Vienna and eventually to Berlin.	Pierre Dubreuil resumes photography in Belgium having lost much of his photographic work when his house was looted during the war.	Sigmund Freud publishes his paper 'The Ego and the Id', outlining his theories regarding the psychodynamics of the id, ego and super-ego.	László Moholy-Nagy joins the Bauhaus faculty and introduces experimental photography to the Bauhaus canon.

invested this new vision with optical truth. With regard to portraiture, he suggested that the sitter was 'to be photographed as impartially as an object so that the photographic result shall not be encumbered by subjective intention.' Framing the subject as if it were no more significant than an inanimate doll or piece of furniture, as mere object, chimed with the other dominant avant-garde aesthetic that was German in origin: Neue Sachlichkeit (New Objectivity).

In order to realize how radical this call for objectivity was, it is necessary to remember how portraiture had been viewed previously. Even late into the 19th century, people subscribed to the notion that one's face mirrored one's innermost character. Thus the photographic portrait could be claimed as the perfect expression of the subject's self: their soul. For those engaged in making what they saw as artistic photography, the role of the artist was to picture their sitter's physiognomy in such a way as to reveal their true character: 'recording faithfully the greatness of the inner as well as the features of the outer man', as Julia Margaret Cameron (1815–79) said of her portrait practice.

Moholy-Nagy's portrait (right) was taken by his wife, Lucia Moholy (1894–1989), two years before they left the Bauhaus in Dessau. Although Moholy-Nagy is remembered as the leading figure of Bauhaus photography, the couple often worked collaboratively. Lucia may have taken the exposure but the image exemplifies László's approach to the photographic portrait. He appears without context, in one corner of the frame, looming out of a dark, featureless background. The pattern of light and shade presents a study in chiaroscuro. Moreover, his face is obscured by his hand and what remains is fixed as a motion-blur that seems suspended in a strange multidimensional space-time. The overall effect is to render Moholy-Nagy more as object than subject. The viewer does not feel inclined to wonder about his character, to probe beyond the surface in search of psychological depths. The face is more like a blank canvas that is likely to reflect the subjectivity of the artist, or perhaps the viewer, if any at all.

In the 19th century commercial photographic portraiture was identified with status rather than identity, and this role continued in the 20th century. The point can be made in one striking photograph: *Couple in Raccoon Coats* (opposite). Taken on West 127th Street in 1932 by James Van Der Zee (1886–1983), it is one of his photographs documenting the 'Harlem Renaissance', the period between the wars when a new affluent middle class of African Americans emerged in New York and there was a flowering of African American literature, art and music. Although rendered in a crisp modern style, the photograph updates traditional ideas of portraiture. The attractive couple are pictured in their furs, alongside the seductive curves of a prestigious Cadillac Roadster, to signify their wealth and aspirations. The concern here is more with status than psychology.

1 *Couple in Raccoon Coats* (1932)
James Van Der Zee • silver print
8 x 10 in. | 20.5 x 25.5 cm
Wedge Gallery, Toronto, Canada

2 *László Moholy-Nagy* (1925–26)
Lucia Moholy • silver print
10 ⅛ x 7 ⅞ in. | 25.5 x 20 cm
Metropolitan Museum of Art,
New York, USA

1924	1928	1929	1929	1930	1932
French poet André Breton initiates the Surrealist movement in Paris by publishing its first manifesto.	Albert Renger-Patzsch (1897–1966) publishes his book *Die Welt ist schön* (*The World is Beautiful*), which exemplifies the New Objectivity movement.	In May the exhibition 'Film und Foto' (Film and Photo) opens in Stuttgart showcasing European and US modern photography.	In October the Wall Street Crash precipitates the Great Depression and a global economic crisis.	Wanda Wulz joins the Futurist movement. She participates in its exhibitions and experiments with photodynamism.	Moholy-Nagy publishes *A New Instrument of Vision* in English, outlining eight varieties of photographic vision.

3 *Self-portrait in Mirrors* (1931)
Ilse Bing • silver print
10 ½ x 12 in. | 27 x 31 cm
Museum of Modern Art,
New York, USA

4 *The First Round* (c. 1932)
Pierre Dubreuil • oil print
9 ⅝ x 7 ¾ in. | 24.5 x 20 cm
Private collection

5 *The Cat and I* (1932)
Wanda Wulz • silver print
11 ⅝ x 9 ⅛ in. | 29.5 x 23 cm
Metropolitan Museum of Art,
New York, USA

Many leading modernist photographers had the roots of their practice in Pictorialism (see p.170) and created works that are suggestive of a transition between the two styles, rather than a radical break. Frenchman Pierre Dubreuil (1872–1944) has been called one of the first modernists. An elected member of the Linked Ring, a British Pictorialist photography society, he became an avid follower of the Photo-Secession movement (see p.176) established by Alfred Stieglitz (1864–1946). However, he worked with processes associated with Pictorialism, and experimented with carbon, platinum and gum printing, before settling on the Rawlins oil process and earning the accolade of being its greatest practitioner. His portrait *The First Round* (opposite above) is printed in this fashion. Nonetheless, he generally eschewed the symbolic subjects, self-consciously artistic compositions and soft-focus renderings favoured by Pictorialists. Dubreuil photographed modernist icons such as automobiles and the Eiffel Tower with a resolutely modernist eye. Indeed, the tight framing of the boxer in *The First Round* dramatically crops the face and glove, and emphasizes the flatness of the picture plane in a way that appears wholly fresh.

Artists were inspired by new ideas on the science of the self that came in with the 20th century. Physiognomy lost credibility and was rebranded as pseudoscience as psychoanalysis took hold. With the spread of the theories of Sigmund Freud into intellectual life, the notion of a core self, the singular stable subject, was exploded. The self fractured and metamorphosed into something ever shifting and mercurial. It splintered into Pablo Picasso's many faceted faces and into Paul Klee's masks. For Cubists, the face became a site of deconstruction; for Surrealists (see p.232) it became a theatre of masquerade; for Futurists it became a battleground of dislocation. *Self-portrait in Mirrors* (above), by Ilse Bing (1899–1998), is symptomatic of the concept of a fractured self. She held her miniature Leica camera up to her eye while gazing into a mirror that reflected an image of herself that was in turn reflected by another mirror, creating multiple images of herself facing the camera and in profile. The inclusion of her camera enhances its power and the artificiality of the image.

The portrait *The Cat and I* (opposite below) by Italian photographer Wanda Wulz (1903–84) is one of the best-known Futurist photographic works. Wulz

had met Filippo Tommaso Marinetti and joined the Futurist movement the year before. Anton Giulio Bragaglia (1890–1960) had already used the camera to depict himself 'unconsciously divided into two' with a double exposure on the same negative. Likewise Umberto Boccioni (1882–1916), in his photomontage *Io-Noi* (*I-We*, 1908), pictured himself reflected five times. These multiple exposures hinted at multiple personalities, but in Wulz's hallucinatory portrait, she appears as if she is morphing into a cat, or vice versa—part human, part feline—as she ensured that her eyes, nose and mouth and those of the cat were about the same size and set the same distance apart.

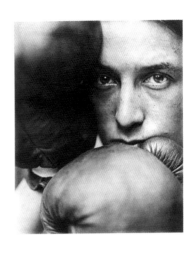

Although an acclaimed graphic designer and typographer at the Bauhaus, Herbert Bayer (1900–85) was also a successful photographer. He executed his first ever photomontage in 1929 and his ensuing explorations in this arena, such as *Humanly Impossible* (1932; see p.250), constitute his best-known photographic work. His self-portrait showing what at first resembles a dismembered statue in a mirror is in keeping with Surrealist preoccupations of the period, yet it is also symptomatic of the overriding interest in how to portray the self. By contrast, *Self-portrait (I Am in Training, Don't Kiss Me)* (1927; see p.248), taken by Claude Cahun (1894–1954), is typical of how Surrealists explored androgyny in their work, although Cahun focuses on the theme of female sexuality while many of her male colleagues chose to depict women as objects of male desire. **JMH**

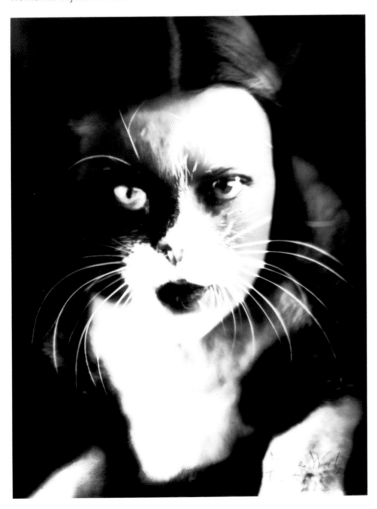

Self-portrait (I Am in Training, Don't Kiss Me) 1927
CLAUDE CAHUN 1894 – 1954

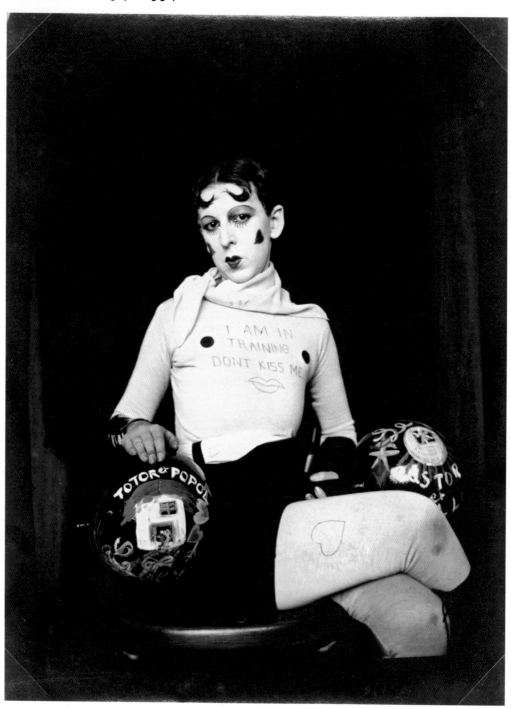

Silver print
4 ½ x 3 ½ in. | 11.5 x 9 cm
Jersey Museum and Art Gallery,
St Helier, UK

Lucy Schwob started using a pseudonym in 1914; she changed her name from Claude Courlis to Daniel Douglas, and then to Claude Cahun. She chose 'Cahun' in memory of the woman who raised her—Mathilde Cahun, her father's mother—thus referencing her Jewish heritage. She selected 'Claude', a name that reads as male or female, as a refusal to adhere to binary gender roles. By this time she had already met her life-long partner, Suzanne Malherbe, whose alter ego was Marcel Moore.

Cahun's photographic output is predominantly self-portraiture. However, in the strictest sense, the works are not self-portraits because they were made in collaboration with Moore. Moreover, they are not portraits of herself either as Schwob or Cahun; they are performances. Like an actor dons costume and persona, so Cahun stepped into a variety of parts. Arguably, Cahun's oeuvre consists entirely of theatrical tableaux. The gender-ambivalent figure whom Cahun impersonates in *Self-portrait (I Am in Training, Don't Kiss Me)* features in a series and is typical of her work. The image was made when Cahun and Moore were moving in vanguard circles in Paris; they were involved in avant-garde theatre and mixed with the Surrealists, who are known for exploring androgyny in their work. In this picture Cahun plays with the idea that sexuality and identity are not set in stone but are instead assumed, and as changeable as a costume. **JMH**

FOCAL POINTS

1 FEMINIZED FACE
Cahun's disguise overstates the elements regarded as feminine. She has painted her lips in an exaggerated pout, applied long spiderlike eyelashes and lacquered down her spit-curls. By exaggerating her femininity while in male attire, she appears as a hybrid of male and female, or a third sex.

2 CURTAIN BACKDROP
Cahun is sitting on a chair in front of a curtain on what appears to be an improvised stage. The backdrop provides a fitting setting for Cahun's masquerade or performance as a boxer or circus performer. The artifice of the setting emphasizes the juggling act to balance male and female.

3 TOTOR AND POPOL
Painted on the weight beneath Cahun's right hand are the names of the comic book heroes 'Totor and Popol', inventions of Hergé, who is better known for his character Tintin. By alluding to these cartoon characters, Cahun seems to make light of the gender issues she raises.

4 WORDS ON LEOTARD
The words across the leotard 'I am in training, don't kiss me' prompt the viewer to ask what the figure is in training for: to be a boxer, a woman, a man or androgynous? Given that she appears to be between the male and female, she disrupts the notion of woman as the object of the male gaze.

PHOTOGRAPHER PROFILE

1894–1908
Lucy Renée Mathilde Schwob was born in Nantes. Her mother was soon diagnosed insane and committed to a Parisian asylum, so she was brought up by her paternal grandmother.

1909–21
She met Suzanne Malherbe, who became her life-long partner. They changed their names to Claude Cahun and Marcel Moore. Cahun's father opposed their relationship, but then in 1917 he married Moore's mother.

1922–36
Cahun and Moore moved to Paris where Cahun took some of her best-known photographs. In 1932 she met André Breton and began to collaborate with the Surrealists.

1937–54
Cahun and Moore bought a house in Jersey. When Germany invaded in 1940, they mounted a resistance campaign. In 1944 they were arrested by the Gestapo and condemned to death, but Germany surrendered before they could be executed. Cahun's health was weakened during her imprisonment and she died in 1954. Moore committed suicide in 1972.

Humanly Impossible 1932

HERBERT BAYER 1900 – 85

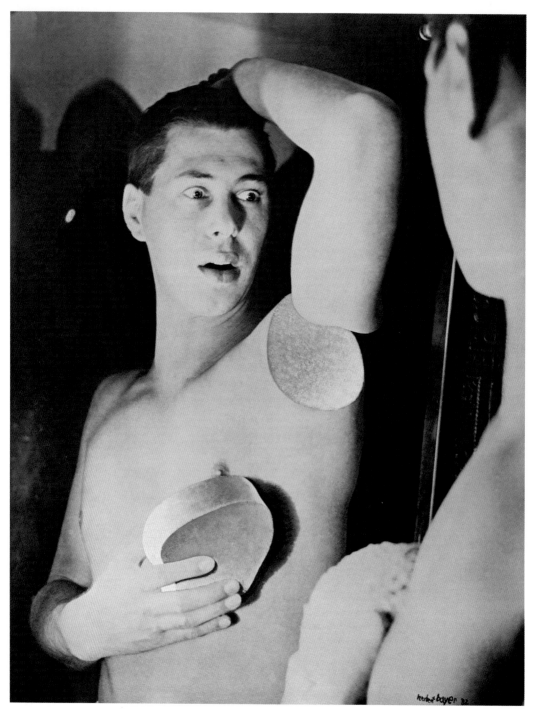

Silver print
15 ⅜ x 11 ½ in. | 39 x 29.5 cm
Museum of Modern Art,
New York, USA

Herbert Bayer was a leading light of the revolutionary German Bauhaus school of art. This self-portrait is from a photomontage series that was inspired by a dream he once had. The series was made mainly between 1931 and 1932, and eleven photomontages were issued in 1936 as a portfolio titled 'Mensch und Traum' (Man and Dream). All the images create ethereal, often haunting fantasies. This picture is perhaps the most disturbing of them all. It conjures up fears of estrangement and separation between the body and the self, and between experience and reality. Bayer made it during a tumultuous time in his life; he was trying to establish himself in Berlin after almost a decade at the Bauhaus, and had recently separated from his wife, whom he had met there. The image and the series it comes from give the impression that Bayer was a Surrealist artist. However, he was first and foremost a proponent of the Bauhaus ethos, which advocated simplicity of form and functionality. **JMH**

FOCAL POINTS

1 EYES
Bayer has contorted his face in horror just as an actor might to convey shock. His eyes are not directed at the severed arm itself, but at its reflection. As Bayer performed for his self-portrait, he knew exactly the image he would create and where he would maim his photographic reflection.

2 REFLECTION
The bizarre reflection forces the viewer to consider the split between the artist's self and his reflection, and between mind and body. A photograph is also a reflection—in 1859, writer Oliver Wendell Holmes, Sr called the daguerreotype 'a mirror with a memory'. So by mirroring Bayer's reflection, the image creates a further level of estrangement that questions the fabric of reality. The Surrealists were also interested in mirrors because they create a 'double' of the self.

3 PIECE OF ARM IN HAND
Bayer is holding a sponge in his left hand. In the mirror, this mutates into a chunk of marble that seems sliced from the artist's shoulder. His mutilated arm is floating in mid air with his right hand on his head in a gesture of amazement, making the impossible seem possible.

4 PHOTOGRAPHER'S BODY
At first the photograph reads like a nightmare apparition of a marble statue coming to life. Because Bayer's body is only just visible along the right edge of the frame, the viewer notices it on close examination and realizes Bayer is standing before a mirror looking at his frightening reflection.

5 SLICED ARM
The juncture between the torso and disembodied arm suggests how Bayer doctored the original photograph, creating a collage over his armpit and marking out the severed edge of his arm. Both his hands are involved in the staging and a collaborator may have taken the image from behind.

PHOTOGRAPHER PROFILE

1900–24
Herbert Bayer was born in Haag am Hausruck, Austria. He saw Walter Gropius's *Bauhaus-Manifest* (*Bauhaus Manifesto*, 1919) and determined to join the Bauhaus; he did so in 1921.

1925–27
Gropius appointed Bayer to direct the Bauhaus workshops for printing and advertising in 1925. The same year he married Bauhaus student and photographer Irene Angela Hecht.

1928–85
Bayer moved to Berlin to work as a commercial artist, graphic designer and painter. In 1938 he immigrated to the United States and the same year he helped design the 'Bauhaus: 1919–28' exhibition for New York's Museum of Modern Art. Bayer went on to work in advertising for J. Walter Thompson.

THE MODERN BODY

The early 20th century saw ideas spread more rapidly than ever before thanks to improved communications and travel, the rise of the illustrated press and the advent of cinema. Avant-garde artists, writers and thinkers migrated from Eastern to Western Europe, usually Paris, fleeing political change, oppression and revolution. The result was a fertile exchange between political radicals, artists, composers, dancers, philosophers and writers regarding art, sexuality, psychology and politics. Repelled by the hypocrisies of modern 'civilized' society, there was an interest in so-called 'primitive' societies and—what was seen as—the direct, unmediated nature of African and Oceanic art.

Inspired in part by the arrival of Cubism in art and Art Deco in design, soft-focus, Pictorialist photographs of flowing tresses and drapery with a painterly quality gave way to clean lines, stark stylization, exotic subjects and geometric shapes. Czech photographer František Drtikol (1883–1961) was at the vanguard of the new aesthetic saying: 'I am inspired by three things: decorativeness, motion, and the stillness and expression of individual lines. I then use the background and props—simple objects such as circles, wavy lines and columns—accordingly. I let the beauty of the line itself make an impact, without embellishment, by suppressing everything that is secondary. . .or else

1903	1912	1913	1915	1917	1927
Isadora Duncan gives a lecture in Berlin, titled 'The Dance of the Future', which is later published as a pamphlet.	František Drtikol documents Russian actress Olga Gzovska performing her *Salome* dance-drama in Prague in a series of twelve photographs.	Sergei Diaghilev's Ballets Russes premieres *The Rite of Spring* at the Théâtre des Champs-Elysées in Paris to a shocked audience.	US society dancer Irene Castle introduces the bob hairstyle to the United States after seeing it sported by Parisians while she was touring Europe.	Alfred Stieglitz begins his photographic cycle of portraits of Georgia O'Keeffe; it ends thirty years later.	Rudolf Koppitz exhibits at the prestigious Pittsburgh Salon of Photographic Art at the Carnegie Museum of Art, Pennsylvania.

I use the body as a decorative object, positioning it in various settings and lights.' His picture *The Bow* (opposite) shows a woman's taut, elongated body fused with the solid curves around her, as if she is part of an abstract canvas. Drtikol employed lighting techniques that had been developed for silent movies, and his use of light and shadow emphasizes the simple but strong shapes and forms in his image, outlining the pubic hair in a neat triangle, the dark background punctuated by an arc and the ovoid shapes of the breasts. The model's slim physique and narrow hips are typical of the new ideal of beauty. Her hair is cut in a fringed bob, associated with the 'flapper' girl who was keen to flout convention with an androgynous look that symbolized emancipation.

Like the Futurists in art, photographers also became interested in depicting movement, both by capturing figures in motion and by experimenting with their images. Dance was at the forefront of the avant-garde in the arts primarily thanks to Russian ballet impresario Sergei Diaghilev and his Ballets Russes. Diaghilev invited artists and fashion designers to work with him in what proved to be an innovative crossover for the arts. Inspired by classical Greek art, US dancer and choreographer Isadora Duncan reinvented dance, promoting athleticism and improvised 'naturalness'. Barefoot dancers took to the stage semi-clad in skimpy costumes, running and leaping in wild abandon. Physical self-expression without the restraint of dress was a potent symbol of a new world order in which conventional hierarchies would be overthrown.

Modern expressive dance came to be seen as the embodiment of freedom from moribund values and was a popular subject among photographers such as Czech Rudolf Koppitz (1884–1936). *Movement Study No. 1* (right) features dancers from the Viennese State Opera. Early in his career Koppitz worked in Vienna and the grouping of women in this photograph reflects the friezelike imagery of the 19th-century Viennese Secessionists, such as artist Gustav Klimt. Yet in terms of its subject and style this photograph is symptomatic of a 20th-century zeitgeist rather than one that looks back. The bobbed hair and bare feet of the dancers speak of modern dance, and the naked woman is thought to be Russian dancer Tatyana Gsovsky, who studied at Isadora Duncan's studio in Moscow. Koppitz's use of dramatic lighting, clear lines and the dynamic pose of the nude, with her body arched backwards in reverie, owes more to modernism than Symbolism.

Western women gained more freedom with the new century, both in law and with greater access to art schools, and female artists began to explore this liberation in their work. Images such as the nude self-portrait (c. 1906) by Imogen Cunningham (1883–1976) of herself lying in long grass in a field are rare, however. Most photographic nudes of the period, no matter how radical, were produced by men. Artist Georgia O'Keeffe was often photographed nude (1918; see p.256) by her lover and later husband, Alfred Stieglitz (1864–1946). His black-and-white studies of his muse and protégée were groundbreaking

1 *The Bow* (1921)
František Drtikol • pigment print
8 ⅜ x 11 ⅜ in. | 21.5 x 29 cm
George Eastman House, Rochester, New York, USA

2 *Movement Study No. 1* (1925)
Rudolf Koppitz • silver print
15 x 11 ¼ in. | 38 x 28.5 cm
Royal Photographic Society Collection, National Media Museum, Bradford, UK

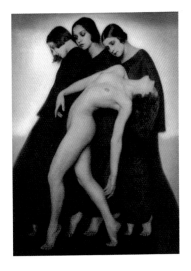

1929	1933	1936	1936	1937	1939
Nelly's photographs of a nude ballerina posed in the Parthenon appear in the French periodical *L'Illustration* and cause uproar in the Greek press.	André Kertész publishes a collection of his work in his book *Distortions*.	Edward Weston starts his series of nudes and sand dunes at Oceano, California.	Nelly photographs the Berlin Olympic Games, where she meets Leni Riefenstahl. They go to Olympia where Riefenstahl shoots part of her documentary.	Riefenstahl's book *Schönheit im Olympischen Kampf* (*Beauty in Olympic Struggle*) is published; it features images of the games in 1936.	Nelly decorates the interior of the Greek pavilion at New York's World Fair. She makes a photocollage of modern portraits and ancient sculpture.

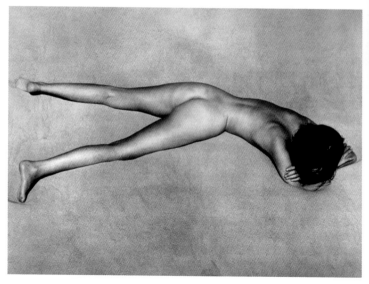

3 *Nude on Sand, Oceano* (1936)
Edward Weston • silver print
7 ⅝ x 9 ⅞ in. | 19.5 x 24 cm
Metropolitan Museum of Art,
New York, USA

4 *Distorted Nude #40* (1933)
André Kertész • silver print
8 x 10 in. | 20.5 x 25.5 cm
Spencer Museum of Art, University
of Kansas, Lawrence, Kansas, USA

in their concept and composition, often showing only fragmented parts of her body. They belong to a portrait series that spanned thirty years: a composite portrait of his subject that is suggestive of the fractured self of 20th-century psychology.

The renowned photographer Edward Weston (1886–1958) is well-known for having a string of wives and lovers who feature in his photographs. The traditional muse is a female subject whose beauty serves as inspiration for the male artist. It seems, however, that Weston's muses played a much more active role in his art: recent scholarship suggests that Weston himself was liberated sexually and artistically through his involvement with liberated women. Weston began taking nude photographs of his nineteen-year-old assistant, Charis Wilson, in 1934. They became lovers and were later married, and Weston continued to photograph her until she left him in 1945. At first the sittings took place in a studio, but from 1936 Weston started to take images of her posed naked among the sand dunes at Oceano, near Santa Monica, California. Wilson said the impetus for the project was her decision to take off her clothes and play in the sand. If it were not for her lack of inhibition and the intimate relationship between them, the series may never have been created.

Weston had photographed nudes before, but at the time was best known for his highly controlled, meticulously printed still lifes, such as *Pepper #30* (1930; see p.282). When he began to produce images such as *Nude on Sand, Oceano* (above), the precision he had employed in photographing inanimate objects was transferred to the study of the nude. A champion of straight photography (see p.280), he applied its principles of sharp focus and pared-down modernist aesthetics to his studies of both the shifting sand dunes of the Oceano landscape and those of Wilson lying on the sand like a piece of driftwood. Weston focuses on the youthful body of his subject, whose slim form appears almost boyish in comparison to the curvaceous (and corseted) ideal of feminine beauty at the time. The photographs are suffused with an erotic charge that relies not upon the passivity of the traditional nude, but on the frisson of the sexually liberated modern woman. Only a few images from the Oceano nudes series were exhibited in Weston's lifetime as he regarded them as too erotic.

A Greek born in Turkey, photographer Elli 'Nelly' Souyioultzoglou-Seraïdari (1899–1998) trained in Germany with Franz Fiedler (1885–1956). It was through working as Fiedler's assistant that she was introduced to modern dance: in 1923

she assisted Fiedler when he made a series of studies taken *en plein-air* of dancers from the Mary Wigman School of Expressive Dance. Two years later Souyioultzoglou opened her own studio in Athens under the name 'Nelly'. Her most famous work is *Nicolska, Dancing at the Parthenon* (1929), which features the Hungarian dancer and musicologist Lila Nicolska dancing almost nude at the Acropolis in Athens. Like Nelly, German photographer and filmmaker Leni Riefenstahl (1902–2003) revered the classical past. The women collaborated when they covered the Berlin Olympic Games in 1936, where Riefenstahl shot a documentary and directed the taking of stills photographs including *After the Dive* (1936; see p.258). Former dancer Riefenstahl, who idealized the athletic form, grew close to Germany's Fascist leadership; Nelly became the official photographer for the authoritarian Fourth of August Regime that ruled Greece from 1936 to 1941. Such associations besmirched the reputations of both women.

Photographers also sought to depict the dynamism of movement and change using experimental techniques employed in Constructivist and Dadaist art and design. German photographer Heinz Hajek-Halke (1898–1983) was a master of manipulation, experimenting with photomontage, double exposures, photocollage and light montage. His *Black and White Nude* (1930–36) uses superimposed negatives to create a mirror effect, showing the same woman twisted with her arms raised. Hajek-Halke's technical skill was such that the boundaries between the two images are not visible.

Hungarian André Kertész (1884–1985) left his homeland to live in Paris in 1925, where he mixed with the avant-garde set. He employed a similar playful inventiveness and love of the illogical to the Surrealists in works such as *Distorted Nude #40* (below). Using an early zoom lens, it shows the reflection of a naked woman created by three distorted mirrors: her limbs are out of proportion and her head is tiny in the distance. It is one of a series of male and female nudes that Kertész was commissioned to produce for men's magazine *Le Sourire*, and he said of the shoot: 'Sometimes, just by a half-a-step left or right, all the shapes and forms have changed. I viewed the changes and stopped whenever I liked the combination of distorted body shapes.' As modernism had become the artistic orthodoxy, so depictions of the body were freed from conventional strictures, even those of form and volume. **CK**

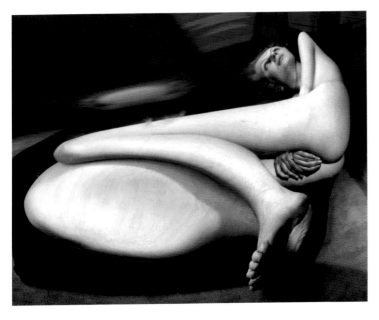

Georgia O'Keeffe—Torso 1918
ALFRED STIEGLITZ 1864 – 1946

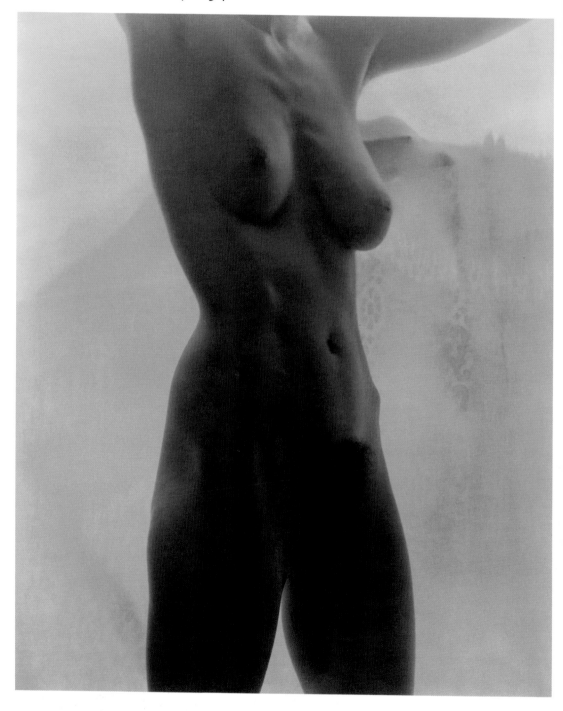

Silver print
9 ¼ x 7 ⅜ in. | 23.5 x 19 cm
Metropolitan Museum of Art,
New York, USA

Alfred Stieglitz's photograph of Georgia O'Keeffe is one of more than 350 portraits that he took of her between 1917 and 1937. The series not only constitutes a portrait of O'Keeffe but also documents the love affair and changing rapport between the photographer and his muse. Stieglitz photographed O'Keeffe in black and white, often nude, and sometimes portrayed only parts of her body, such as her hands, in close-up. He believed that a one-off photograph of a person's face was insufficient as a portrait, and that observing the whole person over a period of time and creating a composite portrait would better capture the sitter.

In *Georgia O'Keeffe — Torso*, Stieglitz knowingly places his portrait within an art historical tradition. The subject poses against a backdrop whose shapes are resonant of a distant hill and trees, as seen in Renaissance painting featuring a saint or Madonna. Thus O'Keeffe appears as if sanctified and a person of import, possessing qualities of purity, piety and goodness that are to be revered. However, her pose is suggestive of sexual frankness and intimacy, with her arms raised and legs slightly apart. The viewer sees her body from the side rather than in a submissive full-frontal pose, as is common in nude portraits that are designed to titillate. This image is not intended to be pornographic, rather the viewer feels privileged to share in Stieglitz's portrayal of his lover. However, by consciously cropping out his subject's face and concentrating on her torso, the photographer makes the image about everywoman as much as about O'Keeffe.

Stieglitz photographs his subject in fine detail and there is a rich tonal range created by the light and shade playing across the angles and curves of her body. His aesthetic was in keeping with the modernist use of shifting viewpoints, fragmented planes and geometric forms. The series of images reflects the contemporary preoccupation with drawing a psychological portrait of the sitter. It not only documents O'Keeffe's changing physical appearance but is also suggestive of her varied inner life. As she said of the portraits more than sixty years later: 'It is as if in my one life I have lived many lives.' On occasion Stieglitz photographed O'Keeffe in front of her paintings, seeking to meld the artist within her work. In *Georgia O'Keeffe — Torso*, taken at the beginning of their artistic and emotional collaboration, it is Stieglitz's physical passion for O'Keeffe that is in the ascendant. **CK**

STIEGLITZ AND O'KEEFFE

When Alfred Stieglitz first met artist Georgia O'Keeffe (right, pictured in 1929) in 1916 he was attracted to her instantly. Their meeting sparked an intense relationship that spanned forty years, during which time they wrote to each other continually, sometimes more than once a day. Stieglitz began to take photographs of O'Keeffe in the spring of 1917 at his 291 gallery in New York and then at his home the next year. When his first wife asked him to stop seeing O'Keeffe, Stieglitz filed for divorce and he and O'Keeffe moved in together. She became his muse and he devoted years to photographing her. They married in 1924, but by then they often spent long periods apart, with Stieglitz spending most of his time in New York while O'Keeffe painted in New Mexico. Although Stieglitz later took a young lover, the couple remained married and O'Keeffe was with him when he died. They influenced each other's work: Stieglitz promoted his wife's oeuvre with regular exhibitions, whereas O'Keeffe was interested in the flat surfaces and close-ups made possible by photography, which inspired the large-scale paintings of natural forms for which she became renowned.

After the Dive 1936

ARTHUR GRIMM 1908 – 90 LENI RIEFENSTAHL 1902 – 2003

Silver print
10 ¾ x 8 ⅝ in. | 27.5 x 22 cm
Private collection

This image is taken from Leni Riefenstahl's controversial book *Schönheit im Olympischen Kampf* (*Beauty in Olympic Struggle*) published in 1937. It features still photographs taken by Arthur Grimm under Riefenstahl's direction while she filmed the Olympic Games held in Berlin in 1936 for her sports study *Olympia* (1938). The latter was the first feature documentary ever made about the Olympics—photographers had never before been allowed to shoot so close up to the competitors. Adolf Hitler commissioned Riefenstahl to make the film, which was seen as an opportunity to glorify German athletes and the Aryan idea of beauty disseminated by the ruling Nationalist Socialist Party. The book, like the movie, begins with a series of images of Greek temples and athletes posing to look like their ancient Greek counterparts before moving on to the opening ceremony and the sporting events. Riefenstahl's photographs and cinematography won plaudits internationally at the time, but since then her close association with Hitler and propagation of Nazi ideals have cast a shadow over her career. Nevertheless, she produced groundbreaking work, both technically in her use of camera angles, cropping and close-ups, and aesthetically as she focused on the muscular forms of the athletes and their balletic movements so that they appear almost godlike. Although Riefenstahl remains a contentious figure, her innovative techniques and her vision of the athlete as the ultimate example of bodily perfection have influenced sports photography ever since. **CK**

FOCAL POINTS

1 SYMBOLIC REBIRTH
The diver enters the water as if he is plunging headfirst into the water of a baptismal pool. The image symbolizes the rebirth of the German nation under Hitler's leadership. The photographs and film about the Olympics celebrate the Nazis' Aryan concept of idealized, athletic beauty.

2 ECSTATIC BUBBLES
The bubbles in the water obscure the diver's body. At first glance, the figure could be male or female; a closer look reveals the male torso, adding a sexualized, homoerotic edge to the image. The organic, almost floral shapes in the water suggest a moment of release and ecstasy.

3 DYNAMIC DIVER
The diver is like a knife slicing through the water. The vertical composition of the image, taken from below and tightly cropped to feature the subject diagonally crossing the centre, suggests rhythm and dynamism. Such an image of muscular strength fitted perfectly with Nationalist Socialist ideology.

4 POOL DEPTHS
The subject dives from light into darkness, unafraid to penetrate the shadowy depths of the pool. This is an image of confidence when faced by the dark of the unknown. Uncowed, his muscular athleticism is portrayed as heroic, in a nod to the Olympics of ancient Greece.

PHOTOGRAPHER PROFILE

1902–33
Born in Berlin to a middle-class family, Leni Riefenstahl studied dance and painting. In 1926 she starred in Arnold Fanck's *Der Heilige Berg* (*The Holy Mountain*). In 1932 she directed her first film, *Das Blaue Licht* (*The Blue Light*). The same year she saw Adolf Hitler speak at a rally in Berlin and asked to interview him. The next year she made her first film for the Nazis, *Der Sieg des Glaubens* (*Victory of Faith*), documenting the fifth rally of the National Socialist Party at Nuremberg.

1934–45
Riefenstahl made a documentary of the sixth Nazi Party congress in Nuremberg in 1934. *Triumph des Willens* (*Triumph of the Will*), which won the international prize at the Venice Biennale in 1935. In 1938 *Olympia*, her study of the Berlin Olympic Games held in 1936 was released.

1946–2003
After World War II ended, Riefenstahl was regarded as a pariah. She visited Africa and published *The Last of the Nuba* (1974). She took up scuba diving and made underwater photographs. She died in Pöcking, Germany.

EARLY FASHION PHOTOGRAPHY

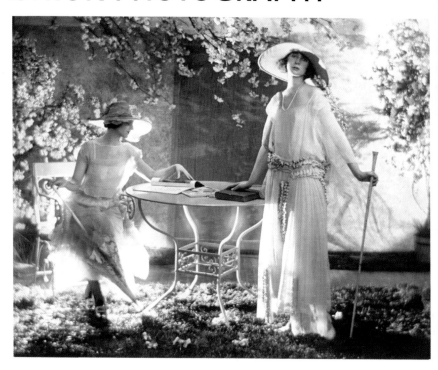

The emergence of fashion photography as a distinct genre in the early 20th century goes hand in hand with the burgeoning illustrated magazine industry. Magazines such as *Vogue* and *Harper's Bazaar* employed some of the period's most celebrated art photographers. Such titles were aimed both at wealthy women and at those who aspired to a life of luxury. The production of fashion images was a creative collaboration between professionals: photographers, models, art directors, editors, photographic assistants and retouchers. In editorial shoots and advertisements, fashion photography was both inspired by and shaped contemporary culture, and has left a compelling record of the dramatic shift in roles for women between 1900 and 1945.

Early fashion photography had its roots in 19th-century photographic portraiture and the engraved fashion plate. From the late 1850s, it was de rigeur for society ladies, debutantes and actresses to pose full length in their finest attire in the studios of high-class portrait photographers such as Karl Reutlinger (1816–80) and Camille Silvy (1835–1910). Before the advent of photography, fashion magazines were rare and it was not until the development of the halftone printing process in the 1880s that illustrated magazines became widely available. In 1911

KEY EVENTS

1909	1913	1913	1913	1914	1916
Publisher Condé Nast purchases the modest US society magazine *Vogue*, with the aim of transforming it into a high-class fashion publication.	In New York Condé Montrose Nast buys men's fashion magazine *Dress*, which he renames *Dress and Vanity Fair*.	William Randolph Hearst relaunches *Harper's Bazar* as a rival publication to *Vogue*. In 1929 its name is altered to *Harper's Bazaar*.	Condé Nast hires Adolph de Meyer as *Vogue*'s first full-time photographer and Edna Woolman Chase as editor in chief.	In June Condé Nast Publications relaunches *Dress and Vanity Fair* as *Vanity Fair*.	The British edition of *Vogue* is launched and the French edition follows in 1921.

luxury periodical *Art et Décoration* (*Art and Decoration*) commissioned Edward Steichen (1879–1973) to photograph dresses by flamboyant belle époque designer Paul Poiret. Thirteen soft-focus images were printed with the article *L' Art de la Robe* (*The Art of the Dress*). Steichen, who did not return to fashion until the 1920s, later called them 'the first serious fashion photographs ever made'.

In 1913 Steichen's fellow Pictorialist Adolph de Meyer (1868–1946) became *Vogue*'s first contract photographer. Condé Montrose Nast had purchased the US society magazine in 1909 and invested large sums in improving printing techniques. He launched sister publication *Vanity Fair* in 1913, and British and French editions of *Vogue* in 1916 and 1921 respectively. Nast was drawn to de Meyer as much for his social connections as for his renown as a portrait photographer. In 1899 de Meyer had married the socialite Olga Caracciolo, rumoured to be the illegitimate daughter of her godfather, Edward, Prince of Wales. In 1901 de Meyer was made a baron by Frederick Augustus III, King of Saxony, at Edward's request so that he could attend the latter's coronation. The chic couple travelled Europe together and de Meyer photographed many of their famous acquaintances in a style influenced by the painters of the Aesthetic movement. His sparkling fashion pictures, romantic portraits and still lifes appeared in *Vogue* alongside fashion illustrations by artists such as Georges Barbier, Pierre Brissaud and Charles Martin. He depicted women as cosseted and passive creatures; wearing ethereal creations by Parisian couturiers, they lounged in elegant interiors or sun-dappled gardens. Photographs that seemed to be taken outdoors, such as his study of two models at a table (opposite), were in fact taken in the studio. De Meyer used an 8 x 10-inch plate camera with a ground-glass back that was sharp in the centre but less so around the edges. His masterful use of backlighting creates an aureole around each of the women, transforming their hats into halos. In 1922 he was lured to *Harper's Bazar* (later renamed *Harper's Bazaar*) to become its chief photographer in Paris.

Dadaism (see p.192) and Surrealism (see p.232) had a profound effect on the arts from the 1920s onwards. During the interwar years, creative talents from Europe, Russia and the United States converged on the French capital and there was an intense cross-fertilization of ideas between art forms. Designer Elsa Schiaparelli collaborated with artist Salvador Dalí, and the dreamlike landscapes of Dalí and Giorgio de Chirico featured in *Vogue* alongside avant-garde photographs by Man Ray (1890–1976). Ray's images ranged from the bizarre to the simple. In a study of April 1936 (right), printed with the caption 'Mainbocher's triumph in black net', there are no elaborate sets or camera tricks to detract from the dress itself. The power of the image lies in the model's dramatic pose, as though frozen at the climactic moment of a dance. Spotlighting illuminates her upward-tilted profile and accentuates the diaphanous fabric. Man Ray turned to fashion after the financial failure of his first exhibition of paintings in Paris. In 1922 Poiret asked him to photograph his latest dress

1 *Unpublished fashion study for Vogue* (1919)
Adolph de Meyer • silver print
7 ⅛ x 8 ⅞ in. | 18 x 22.5 cm
Victoria and Albert Museum, London, UK

2 *Mainbocher's Triumph in Black Net* (1936)
Man Ray • silver print
Man Ray Trust / ADAGP, Paris, France

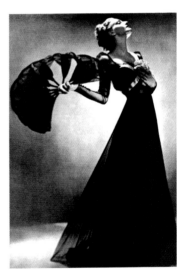

1925	1932	1933	1934	1935	1939
The Paris World Fair of modern decorative arts receives more than sixteen million visitors. It promotes what comes to be recognized as Art Deco style.	Steichen produces the first photographic cover for *Vogue*, depicting a model in a red-and-white bathing suit and white swimming cap.	Carmel Snow at *Harper's Bazaar* hires Martin Munkácsi, whose experience as a sports photographer helps to transform fashion imagery.	Alexey Brodovitch becomes art director of *Harper's Bazaar*. His bold page layouts complement the geometry of fashion photographs.	Norman Parkinson is recruited by *Harper's Bazaar* and uses his hand-held Graflex to photograph models strolling in London's Hyde Park.	World War II breaks out. Many European artists, designers and photographers flee to New York. The fashion industry suffers heavily during the war years.

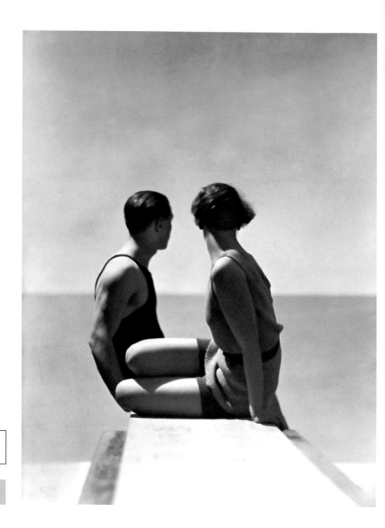

3

4

3 *Divers. Horst with model, Paris* (1930)
George Hoyningen-Huene • silver print
Staley-Wise Gallery, New York, USA

4 *Unpublished variant of an image from
'Portfolio de Vogue: La Tour Eiffel', dress
by Lucien Lelong* (1939)
Erwin Blumenfeld • silver print

designs, seeking 'original pictures of his mannequins and gowns, something different...not the ordinary showing of gowns, but portraiture as well....' It was while in the darkroom, making prints for Poiret, that Man Ray stumbled upon the technique for making camera-less photographs that he called 'Rayographs'—images produced by placing objects directly on photographic paper and exposing it to light. For *Harper's Bazaar* in 1934, he created Rayographs showing his impressions of the French collections for the first 'Fashions by Radio'—images sent by short wave from Paris to New York.

In 1923 Steichen joined Condé Nast as chief of photography, bringing a sharply modern aesthetic to fashion imagery that chimed with the geometric principles of Art Deco design. Initially he worked only with daylight, which streamed through the vast window of *Vogue*'s New York studio, but later he realized that electric light would bring more variety to his work. By the late 1930s, he was using simple arrangements of black, white or grey planes as backdrops. His ideal model was Marion Morehouse, whose willowy silhouette was perfect for the flapper fashions of the Jazz Age. In 1923 he also signed a contract with advertising agency J. Walter Thompson. Just as photographs gradually took over from line drawings in fashion and lifestyle magazines, photography began to eclipse the graphic arts in advertising. In 1923 less than 15 per cent of illustrated advertisements in mainstream magazines used photography; within a decade, the figure was nearly 80 per cent.

Steichen is the best known of the early fashion photographers, but many others also made significant contributions to the genre. They included society portraitists Bertram Park (1883–1972) and Hugh Cecil (1892–1974) in Britain, while in the United States Nicklas Muray (1892–1965) and James Abbe (1883–1973) captured the screen idols in the golden age of Hollywood cinema. In Britain, *Vogue*'s first star photographer was Cecil Beaton (1904–80), whose images appeared in the magazine from the late 1920s until the 1970s. With *Miss Nancy Beaton as a Shooting Star* (1928; see p.264) he formulated the distinctive style that he brought to fashion photography. The Surrealist-derived idiom of Man Ray's fashion work influenced others, including Herbert List (1903–75), André Durst (1907–49) and George Hoyningen-Huene (1900–68). He also collaborated with Hoyningen-Huene to produce a portfolio of 'the most beautiful women in Paris'. Hoyningen-Huene explained: 'Man was to take the pictures and I was to supply the sitters as well as the props and backgrounds.' Its success led Hoyningen-Huene to join French *Vogue* in 1926, where he produced coolly refined studio pictures, often inspired by ancient Greek sculpture and classical forms.

Hoyningen-Huene's *Divers. Horst with model, Paris* (opposite) was published in US *Vogue* with the caption: 'Two-piece swimming suit with garnet-red trunks and mixed red-and-white top of machine-knit alpaca wool, resembling a sweater weave,' a precise description that was essential at a time when colour in magazines was rare. The image was meticulously constructed and reveals Hoyningen-Huene's painterly sense of geometry, volume, light and shade. The athletic couple appear to sit on a diving board, gazing out on a hazy sea or pool—a serene illusion that was created using props on the roof of *Vogue*'s Paris studio above the bustle of the Champs-Elysées. He was the first fashion photographer to employ male models extensively. One of his early male models was Horst P. Horst (1906–99), who was also his protégé and companion. Horst went on to produce similarly inventive images that fuse Surrealist and classical motifs, as seen in *Mainbocher Corset* (1939; see p.266).

The outdoor setting and informality of *Divers* prefigured the trend for more natural fashion images in the 1930s. Portable cameras such as the Leica enabled photographers to work with photojournalistic realism outside the confines of the studio. In 1933 *Harper's Bazaar* hired Martin Munkácsi (1896–1963), then one of the world's highest paid sports photographers. His fashion pictures depict independent and active US women, and his ability to capture movement revolutionized fashion photography. Munkácsi explained his approach in 'Think While You Shoot', an article he wrote for *Harper's Bazaar* in 1935: 'Never pose your subjects. Let them move about naturally. All great photographs today are snapshots. Take back views. Take running views. . . .Pick unexpected angles, but never without reason.' Norman Parkinson (1913–90) promoted a similarly 'action realist' vision in the shoots he carried out for British style magazines.

The experimental spirit of Dada was translated into fashion photography by Erwin Blumenfeld (1897–1969). As a young man, Blumenfeld declared himself 'the erotic president of the Dada movement' and between 1916 and 1933 he made striking and sometimes Dada-esque montages. Having taken up professional photography in the 1930s, Blumenfeld went on to produce some of fashion's most enduring images, including those of model Lisa Fonssagrives on the girders of the Eiffel Tower (right), for a special issue of French *Vogue* in May 1939 celebrating the fiftieth anniversary of the iconic landmark. After war broke out, Blumenfeld was held in several French internment camps, but fled to New York in 1941 where he worked for the next two decades as a talented innovator both in fashion photography and in his personal work. He continues to inspire new generations of photographers, some of whom have paid homage to him by recreating his greatest images: Peter Lindbergh (b.1944) produced modern interpretations of his famous Eiffel Tower shot in 1989 and 2008. **SB**

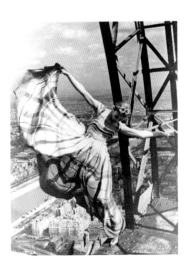

Miss Nancy Beaton as a Shooting Star 1928

CECIL BEATON 1904 – 80

Silver print
19 ¼ x 15 ¼ in. | 49 x 39 cm
Victoria and Albert Museum,
London, UK

Cecil Beaton began to pursue photography at an early age. He spent his teenage years attempting to recreate the look of portraits by photographers such as Lallie Charles (1869–1919), substituting his sisters Nancy and Barbara for the stars of stage and screen. A social climber, he submitted his portraits of female relations to newspapers and magazines, where they appeared on the society pages under pseudonyms such as 'Crivelli' after Renaissance artist Carlo Crivelli. He launched his career as a society photographer in 1927 with an exhibition in London that won him a contract with *Vogue*. Beaton's first contributions to the publication were delicate, spidery sketches, but soon he began photographing fashions. Sparkling with theatrical artifice, *Miss Nancy Beaton as a Shooting Star* exemplifies Beaton at his romantic and whimsical best. Its style has much in common with Beaton's early fashion studies for *Vogue*, which he described as a counterpoint to Edward Steichen's harder edged approach. **SB**

⬙ NAVIGATOR

◉ FOCAL POINTS

1 HALO OF LIGHT
There is a bright nimbus of light around the sitter's head and shoulders almost as though she is radiating light. Beaton created the effect by placing a 1000-watt light bulb directly behind the sitter to bleach out part of the backdrop and allow the face to stand out against the pale area behind.

2 ROD
The rod in the sitter's right hand produces a diagonal line from roughly the bottom left to the top right, bisecting the picture plane. Often the diagonal is used by photographers to add a sense of dynamism and to draw the viewer's eye through the image. The subject's spiky headpiece creates a shorter parallel line running above the main diagonal. The effect is to imply movement as befits the dressing of her hair as a cluster of shooting stars.

3 FABRIC BACKDROP
The backdrop of shimmering fabric helps to produce a fairy tale vision. In the 1920s Beaton often used backdrops of beautiful fabric or other material to surround a subject, creating lavish sets for his portraits and fashion studies that sometimes took precedence over the sitters.

4 FANCY DRESS COSTUME
The subject is wearing a fancy dress outfit made from cellophane. Costume balls and charity galas were central to the diaries of wealthy young socialites and Beaton often designed his sisters' elaborate outfits. He made this costume with the aid of the artist and stage designer Oliver Messel.

5 FACE AND HAIR
Artfully retouching the face and hair was a vital stage in the creation of an idealized study such as this. The delicate task was carried out by a skilled retoucher, who could define the eyelashes and lips, smooth wrinkles and neaten hairstyles, with careful guidance from the photographer.

⏱ PHOTOGRAPHER PROFILE

1904–26
Cecil Beaton was born in Hampstead, London. The son of a timber merchant he was the first of four children. His sisters' nanny encouraged Beaton to take photographs.

1927–67
His first solo exhibition, held at the Cooling Galleries in London, established him as a leading portrait photographer and he began working for *Vogue*. In 1939 he photographed Queen Elizabeth, the Queen Mother. Beaton designed the costumes for the Broadway production of *My Fair Lady*. He won two Oscars for the film version in 1964.

1968–80
In 1968, London's National Portrait Gallery staged an exhibition of more than 500 Beaton photographs. He was knighted in 1972.

Mainbocher Corset 1939
HORST P. HORST 1906 – 99

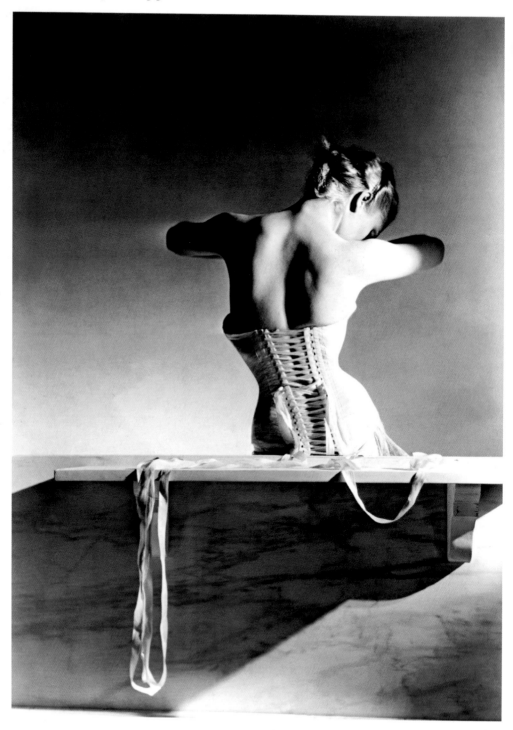

Silver print
Victoria and Albert Museum, London, UK

Horst P. Horst was the only major fashion photographer of the 20th century whose work comprehensively straddled both the pre-war and post-war periods. He witnessed the development of fashion photography from early elaborate sets to an understated elegance. He never limited himself to fashion photography and excelled at many genres, from portraiture to *trompe l'oeil* still life. He drew inspiration from Bauhaus design, Surrealism and Neo-Romanticism, and his fascination with the shapes, proportions and poses of classical Greek sculpture is evident in his early work. Horst's meticulously planned studio photographs requisitioned the talents of *Vogue*'s team of decorators, craftsmen, assistants and lighting experts. His most iconic fashion image depicts an unknown model wearing a back-lacing corset made by Detolle for Mainbocher. The picture represented the end of an era for Horst because it was the last photograph he took in Paris before he left for New York just before World War II broke out. **SB**

◉ FOCAL POINTS

1 CORSET
The corseted waist silhouette harked back to wasp-waisted fashions of the Victorian era. In *Vogue*'s published version of the photograph, the corset was retouched to appear to cling tightly to the body. However, the unretouched original is more provocative, as the corset hangs loosely at one side.

2 LIGHT AND SHADOW
Horst was a master of dramatic studio lighting and known to spend days perfecting the arrangement of lights for a shoot. To create the deep shadows and highlights here he used spotlights and reflectors. So complex was the lighting, Horst said he would not be able to recreate it.

3 TANGLED RIBBONS
The corseted waist that featured in Mainbocher's Paris collections in 1939 caused uproar in the fashion world. Horst possessed an astute eye for detail, but did not make his photographs entirely immaculate. The ribbons that trail in the lower portion of the image create balance in a picture that might otherwise appear too pristine and add a touch of reality to the image. Horst said: 'My best pictures always have a little mess—a dirty ashtray, something....'

4 MARBLE BALUSTRADE
The marblelike appearance and elegant simplicity of the balustrade evoke classical architecture. Horst designed some studio sets by himself; others were created for him. *Vogue*'s skilled craftsmen could make inexpensive materials, such as plaster, resemble more luxurious ones, such as marble.

5 SCULPTED FLESH
The model appears as a living statue, the proportions and contours of her body as perfect as Aphrodite, Greek goddess of beauty. Horst visited the Louvre frequently to study the sculpture collection, learning from history's greatest artists how to develop a feeling for form and volume.

◷ PHOTOGRAPHER PROFILE

1906–29
Horst Paul Albert Bohrmann was born in Weissenfels, Germany. He studied furniture design and carpentry at the Hamburg Kunstgewerbeschule (School of Arts and Crafts).

1930–38
Horst moved to Paris. After a brief internship with Le Corbusier, he became the protégé of George Hoyningen-Huene. Horst began to photograph for *Vogue* in 1931.

1939–99
He went to the United States during World War II where he changed his name to Horst P. Horst. After falling out of favour at *Vogue*, he worked for *House & Garden*, then *Vogue* again. New York's International Center of Photography held a retrospective of his work in 1984.

ADVERTISING PHOTOGRAPHY

1 *Glasses* (c. 1927)
Albert Renger-Patzsch • silver print
6 ⅝ x 9 in. | 17 x 23 cm
National Gallery of Australia,
Canberra, Australia

2 *Untitled for Elizabeth Arden* (1931)
Adolph de Meyer • silver print

3 *Dixie Ray for Woodbury Soap* (1935)
Edward Steichen • silver print
Condé Nast Archive, New York, USA

fter the introduction of rotogravure printing in 1911, it became possible
to reproduce photographs of ladies' fashion, beauty and consumer
products in magazines and newspapers rather than using the previously
hand-drawn illustrations or artists' impressions. Rotogravure enabled quality
halftone reproductions to be printed cheaply and at high speed on a variety
of inexpensive paper stock on a large scale. Opportunities for commercial
photography rapidly expanded and mass-market advertising was born.

Fresh from a dazzling Pictorialist career in London, and a strong association
with the Photo-Secessionists (see p.176) and Alfred Stieglitz (1864–1946) in
New York, the German-born Adolph de Meyer (1864–1949) became the first
staff photographer at Condé Nast for *Vogue* and *Vanity Fair*. Famed for
his elegant society and portrait photography and described by British
photographer Cecil Beaton (1904–80) as the 'Debussy of the camera', de Meyer
used flattering backlighting, soft-focus lenses, extravagant props and striking
patterns of light and shade to make women look dramatic and beautiful.

In 1922 he left Condé Nast to become chief photographer for *Harper's Bazar*
(later retitled *Harper's Bazaar*) in Paris, persuaded by a substantial increase in
salary. It was there that he photographed a series of advertisements for the
Elizabeth Arden cosmetics company, including some featuring the model
Roberte Cusey (opposite above), who was one of fashion designer Madeleine
Vionnet's favourite models and had previously won the Miss France title in
1926. Her head is bandaged because face-strapping was much favoured by the

KEY EVENTS

1910	1920	1922	1923	1925	1926
Advertising for Kodak, featuring a 'Kodak Girl' in a striped dress modelling a folding camera, is based on a photograph rather than a line drawing.	The Art Directors' Club is founded in New York to investigate the idea that advertising can be judged by the same standards as fine art.	Paul Outerbridge's photograph *Kitchen Table* (1921) is published as a full page in the July issue of *Vanity Fair*.	Edward Steichen joins Condé Nast, to the outrage of his fellow fine art photographer Alfred Stieglitz.	Outerbridge works in collaboration with Edward Steichen at *Vogue* in Paris but leaves after five weeks.	The essay 'Advertising and Photography' by Margaret Watkins (1884–1969) stresses the narrowing gap between the fine and commercial artist.

Elizabeth Arden salons to lift sagging facial muscles with an Ardena chin strap made of silk webbing. The advertisements became increasingly surreal and bizarre when the living model Cusey was eventually replaced by a stylized wax mannequin surrounded by studio props and Arden products.

De Meyer was instrumental in creating images for luxury brands that pushed their products into the modern era, but his soaring career hit the doldrums in the 1930s when he failed to adapt to more modern, avant-garde influences. His position at Condé Nast was filled by Edward Steichen (1879–1973), who had rapidly become the highest paid and most successful advertising photographer of his day. Steichen also worked for the J. Walter Thompson advertising agency and took on private commissions for textile firms such as silk manufacturer Stehli & Company. Earlier advertising photographers had discovered that artistic sex sold in an age when using a woman's nude body to sell a product was a scandal. However, Steichen's nudes oozed respectability. Referring back to his Parisian Pictorialist nudes of the early 1900s, he used the model Dixie Ray in advertisements for Woodbury Soap (below right) and Cannon Towels in 1935, but replaced his soft-focus haziness with a crisp modernist contrast of light and shadow and brilliantly illuminating lighting on the body. Published in *Vogue* on 1 January 1936, this was commercial photography as art. The message was clear: use Woodbury Soap and you will look as gorgeous and sexy as this.

The majority of advertising photography in magazines of the 1920s and 1930s was aimed at selling fashion, home and beauty products to women, or in the case of the highly stylized advertisement by Paul Outerbridge (1896–1958) for a shirt collar (1922; see p.270) to men, but manufacturing industries were beginning to commission photographers to give their products a new image and the impetus for this work came from Europe. German photographer Albert Renger-Patzsch (1897–1966) and his Swiss contemporary Hans Finsler (1891–1972) were involved in the Neue Sachlichkeit (New Objectivity) movement, which developed in the 1920s in Germany to promote photography's inherent ability to present forensic, scientific detail without sentimentality or subjectivity. Finsler worked with companies such as lighting manufacturer Osram and furniture makers Emru to produce images for advertising, and used his images of new technology to teach students at the Kunstgewerbeschule (School of Arts and Crafts) in Halle, Germany. Similarly, Renger-Patzsch undertook commercial assignments but applied the same cool, sharp, detailed aesthetic that he used in his personal works of nature, landscape or figure studies to his industrial commissions, as seen in his delicate interpretation of glassware (opposite), which featured in *Die Welt ist schön* (*The World is Beautiful*), a collection of his photographs published in 1928. Precise objectivity, formal sharpness, absolute fidelity to the subject and an avoidance of romanticization were crucial to his work, as was rendering the commonplace exquisite. **PGR**

1927	1931	1932	1935	1942	1943
Medical manufacturer Davis & Geck's 'Surgery Through the Ages' adverts by Lejaren à Hiller (1880–1969) appear. They are made into a book in 1944.	New York Arts Center hosts the 'Foreign Advertising Photography' show. Its 200 photographs introduce viewers to international trends.	Albert Renger-Patzsch begins to work for the Jenaer Glaswerken Schott in Mainz, Germany.	Condé Nast's book *Color Sells* features adverts by in-house photographers Anton Bruehl (1900–82) and Fernand Bourges (a. 1930–60).	Condé Nast dies. *Time* magazine defines him as the man from whom millions of US women 'got most of their ideas about the desirable standard of living'.	Irving Penn (1917–2009) starts working at *Vogue*. He becomes the photographer with the longest tenure in the history of Condé Nast.

Idle Collar 1922

PAUL OUTERBRIDGE 1896 – 1958

Platinum print
4 ¾ x 3 ⅝ in | 12 x 9 cm
Museum of Fine Arts, Houston, Texas, USA

Paul Outerbridge committed to photography in 1921 when he enrolled in the Clarence H. White School of Photography in New York. Influenced by the school's focus on modernist design and the aesthetics of abstraction, Outerbridge concentrated on still life compositions featuring everyday objects such as kitchen tables, eggs, milk bottles and, here, in his first commercial assignment, a man's shirt collar made by the George P. Ide Company of Troy, New York. Outerbridge took a utilitarian and unromantic item and turned it into abstract art. By using a chessboard background that is all squares when the collar is all curves, and emphasizing the collar's curvature with careful lighting, he produced an art object. The image was reproduced in *Vanity Fair* in November 1922 and by 1925 he was established as an innovative advertising photographer, with his work published by *Vogue* and *Good Housekeeping*, for example. Outerbridge's compositions radiate an elegant simplicity that directly conveyed the advertiser's message, but their resemblance to abstract modernist art meant that they appealed to both the fashion and art worlds. Over the next few years he worked in Paris, London, Berlin and New York. From the early 1930s Outerbridge began to work exclusively in colour, using the complex tricolour carbro process, which gave a rich, lush, saturated result, and he became the highest paid advertising photographer in New York. **PGR**

FOCAL POINTS

1 SHARP FOCUS

The sharp focus on the product—the collar—makes it possible to read both the company name and the collar size thus immediately imparting all the information necessary for purchase. The collar looks good on its own and conveys the message that it would look good around a man's neck.

2 CHESSBOARD

Outerbridge hand-sized the chessboard squares himself in order to underscore the slightly surreal and anomalous proportions of the collar to the board. Such attention to detail makes the commonplace look serious as it recalls a piece of finely crafted monumental sculpture on a tiled floor.

3 LIGHTING

The flattering lighting gives an aura of preciousness to the starched, detachable collar, as if the image is a stylized still life rather than a way of promoting an item of clothing. The collar's curved form is accentuated by Outerbridge's crisp lighting and the sharp lines of the chessboard.

PHOTOGRAPHER PROFILE

1896–1920

Paul Outerbridge, Jr was born in New York to a wealthy family. He studied at the Art Students League in New York and began his career as an illustrator and theatrical designer. In 1917 Outerbridge enlisted in the Royal Flying Corps in Canada but was discharged after an accident. He then joined the US army, where he learnt photography when he had to document materials in a lumber camp.

1921–24

Outerbridge studied at the Clarence H. White School of Photography in New York. In 1923 he met Alfred Stieglitz and studied sculpture under Alexander Archipenko. Outerbridge soon became a sought-after advertising photographer, working for major magazines such as *Harper's Bazaar*, *Vogue* and *Vanity Fair*.

1925–27

In 1925 Outerbridge went to London where he was invited to become a member of the Royal Photographic Society. The same year he moved to Paris, where he worked briefly for *Vogue* with Edward Steichen and mixed with avant-garde artists, including Marcel Duchamp. Outerbridge opened a large, expensively equipped advertising studio, but it failed.

1928–39

He worked in the film industry in Berlin and London as a set adviser. In 1929 Outerbridge showed work in the influential 'Film und Foto' (Film and Photo) exhibition in Stuttgart and returned to New York the same year. There he pioneered colour photography (see p.276) and began working on a series of erotic nudes that were not exhibited publicly until he died.

1940–58

Outerbridge published his book *Photographing in Color*. In 1943 he moved to California and set up a small portrait studio. He contributed photojournalistic articles to various magazines based on his travels to Mexico and South America.

CELEBRITY AND NOTORIETY

Many of the best-known celebrity portraits of the 1920s and 1930s were taken by Edward Steichen (1879–1973), who joined magazine publishers Condé Nast as chief of photography in 1923. Steichen's decision to work commercially with photography appalled Alfred Stieglitz (1864–1946), the high priest of photographic art for art's sake. Steichen's advertising work for J. Walter Thompson, portrait commissions for *Vanity Fair* and fashion assignments for *Vogue* all deployed elements of his art practice, which disseminated avant-garde aesthetics into more popular cultural forms.

KEY EVENTS

1913	1924	1925	1928	1928–29	1930
Condé Nast launches *Vanity Fair*. Its editor commissions photographers such as Edward Steichen, Cecil Beaton (1904–80) and Man Ray (1890–1976).	Clarence Bull (1896–1979) becomes head of MGM's stills department. He produces enduring portraits of many legendary film stars.	Leitz's Leica introduces the 35mm format to photography; rolls of film advance smoothly and quietly on sprockets.	French news weekly *Vu* is launched. Editor Lucien Vogel hires photographers such as André Kertész (1894–1985) and Brassaï (1899–1984).	The *Berliner Illustrierte Zeitung* prints photographs of politicians and celebrities caught off-guard.	The flashbulb changes the nature of photography in tabloids. Weegee is one of the first photographers to use the new tool.

Steichen's most acclaimed portrait for *Vanity Fair* is that of silent film star Gloria Swanson (opposite), the most bankable actress in Hollywood in the 1920s. A style icon, the actress had been widely photographed but Steichen created a completely novel image of her. Sporting a turban, she stares straight at the viewer, her wide eyes visible behind veil-like lace as if she were in mourning. The portrait was taken at the end of a long studio session and, so it is said, when Steichen dangled a piece of black lace in front of her face, the actress knew exactly what he wanted. Swanson appears like an exotic animal peering through foliage—mysterious and alluring, elusive and wary. The portrait is a haunting image of the Faustian nature of celebrity.

During the Great Depression and World War II, the public's desire for photographs of celebrities grew as they sought to distract themselves from the anxieties of daily life. The major Hollywood studios supplied promotional shots of their stars to the fan magazines and illustrated magazines that portrayed them as modern-day gods and goddesses. Known as the 'Grand Seigneur of the Hollywood Portrait', George Hurrell (1904–92) was the stars' favourite portraitist, photographing big names such as Greta Garbo, Clark Gable and Joan Crawford for Metro-Goldwyn-Mayer, Warner Brothers and Columbia Pictures. His *Seductive Rita* (right) captures Rita Hayworth in a pose that is suffused with magnetism and sexual allure. Hurrell had invented the boom light that cast highlights on the hair and cheekbones and shadows under the nose and eyes, making for the perfect glamour shot.

The idea of being able to control the image of celebrity came under increasing stress in the early 20th century. The rise of the press barons, their investment in new printing technology and the advent of the hand-held camera all contributed to the creation of a new type of reportage: what German photographer Erich Salomon (1886–1944) called *bildjournalismus* (photojournalism). In an effort to increase sales, the editors of the illustrated press responded with gusto to the growing public interest in images of the famous and the notorious caught off-guard. Salomon was a pioneer of what is now called 'candid photography'. He used a Leica camera that was sometimes concealed in an attaché case fitted with levers to trigger the shutter. Images such as the one he took of newspaper magnate William Randolph Hearst (1929) sitting casually on the edge of his sofa at his home in California were revolutionary for the time, offering a view of the great and the good that seemed to be the antithesis of the sanctioned publicity portrait.

The public appetite for candid photography was also fed by photographers such as Arthur Fellig (1899–1968). Better known by his pseudonym Weegee, he was renowned for his black-and-white images depicting urban life and crime. As a press photographer working on New York's Lower East Side, Weegee documented the work of the city's emergency services with unflinching realism in images such as *Anthony Esposito, Accused 'Cop Killer'* (1941; see p.274). **CK**

1 *Gloria Swanson* (1924)
Edward Steichen • silver print
16 ½ x 13 ⅜ in. | 42 x 34 cm
Museum of Modern Art, New York, USA

2 *Seductive Rita* (1942)
George Hurrell • silver print
John Kobal Collection/Getty Images

1930	1931	1932	1936	1937	1938
The MGM studio hires George Hurrell as head of its portrait gallery. His mastery with lighting makes many Hollywood careers.	Erich Salomon's book, *Berühmte Zeitgenossen in unbewachte Augenblicken (Famous Contemporaries in Unguarded Moments)* is released.	James Abbe (1883–1973) photographs *Joseph Stalin in the Kremlin*. It is published all over the world and serves to halt rumours that the Soviet leader is ill.	In the United States Henry Luce relaunches *Life* magazine as a weekly publication with a strong emphasis on photojournalism.	In London German editor Stefan Lorant founds innovative, picture-led magazine *Lilliput*. A year later he cofounds *Picture Post* with Sir Edward Hulton.	Weegee becomes the first civilian to obtain permission to install a short wave radio in his car to receive police and fire service transmissions.

Anthony Esposito, Accused 'Cop Killer' 1941
WEEGEE 1899 – 1968

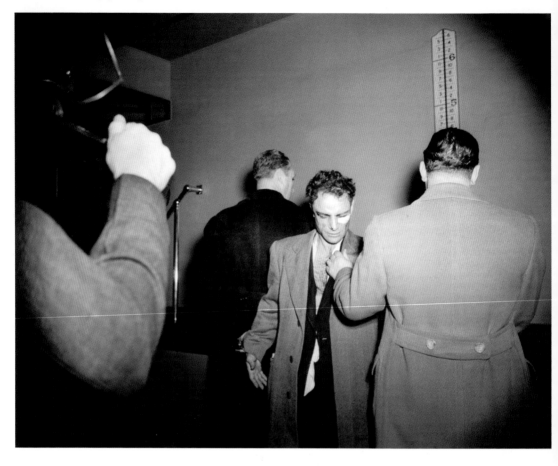

Silver print
9 ¼ x 12 in. | 23.5 x 30.5 cm
International Center of Photography,
New York, USA

◆ NAVIGATOR

Press photographer Weegee is best known for capturing New York by night, documenting its tragedies and violent underbelly in graphic shots of car crashes, suicides, prostitutes, fires, hoodlums and corpses sprawled across pavements. He took to the streets at a time when mobsters held sway and hired killers—nicknamed 'Murder Incorporated' by the media—exacted gangland executions. His images of bloody streets, scattered firearms, gangsters shielding their faces, burly cops and grieving relatives of victims earned him the title 'official photographer of Murder, Inc.' from his colleagues.

Weegee, whose soubriquet derived from the Ouija board because of his uncanny ability to seek out a 'meaty story', was able to be the first photographer at a crime scene because in 1938 he became the first citizen to be given a permit for a short wave radio to monitor police radio transmissions. He cruised New York in a Chevy Coupe, sometimes arriving at a crime scene before the police. His images are disturbing, but Weegee's dramatic use of composition and lighting brings out the humanity in his subjects, as seen in *Anthony Esposito, Accused 'Cop Killer'*. One of the first photographers to use flash lighting, he was skilled enough to make the grotesque palatable, and sometimes even poignant or humorous. His use of contrast was such that his photographs still had impact when printed in a newspaper's halftone. His high-contrast, gritty style is said to have inspired the look of Hollywood film noir. **CK**

◉ FOCAL POINTS

1 THE POLICE PHOTOGRAPHER
Weegee includes the police photographer and his camera, ready to take a standard mug shot against the height chart. In contrast, Weegee focuses on the human drama of the event. Showing the photographer heightens the tension of the moment and the image is like a still from a film noir movie.

2 THE DETECTIVE
A tall detective stands to the right of Anthony Esposito. He grabs Esposito's coat lapel, which seems unnecessary as the suspect is already manacled to a second police officer behind him. The detective is anonymous; he has his back turned away from the camera so that his face does not appear in the newspapers. The two detectives frame the subject in a tableau formation that evokes pity for the subject despite the brutality of his crime.

3 THE KILLER
The man arrested was Sicilian American Anthony Esposito, who was under indictment with his brother, William, for the murder of a businessman and a policeman while attempting a robbery in what became known as the 'Battle of Fifth Avenue'. New York's Police Commissioner later labelled the two brothers 'mad dogs'. Weegee's gritty trademark style captures the brooding violence of the killer, whom he later described as 'a stubborn surly, snarling animal'.

4 USE OF FLASH
Weegee took the photograph from a distance of about 6 feet (1.8 m) using his Speed Graphic camera. The use of flash creates an iris effect in the dark space, what he called his 'Rembrandt light', stressing Esposito's humanity by focusing on his bruised face. It makes Esposito look vulnerable.

▲ This portrait format crop is more famous than Weegee's original landscape image. The absence of the police photographer makes it more personal and greater contrast highlights Esposito's beaten face.

⏱ PHOTOGRAPHER PROFILE

1899–1920
Weegee was born Usher (later anglicized to Arthur at Ellis Island) Fellig, near Lemberg, Austria (now Ukraine). In 1910 his family moved to the United States. He left school in 1913 to help support his parents. In 1918 he started work as an assistant at Ducket and Adler photography studios, New York.

1921–34
Weegee joined the *New York Times* as an assistant in the darkroom. From 1924 he worked at Acme Newspictures as a darkroom technician, printer and photographer. He had his first solo exhibition at the Photo League, New York in 1941, titled 'Weegee: Murder is My Business'.

1935–44
He left Acme to pursue a career as a freelance photographer, producing some of his most famous images, which appeared in publications such as the *Daily News* and *PM Daily*. His work featured in two shows at New York's Museum of Modern Art—'Action Photography' (1943) and 'Art in Progress' (1944).

1945–68
Weegee published his first book in 1945, *Naked City*, and a year later his second, *Weegee's People*. He began to produce distorted photographs that appeared in his third book, *Naked Hollywood* (1953). His autobiography, *Weegee by Weegee*, was published in 1961. He died seven years later in New York.

COLOUR PHOTOGRAPHY

On 10 June 1907, Louis Jean Lumière (1864–1948) and his brother Auguste Marie Nicolas (1862–1954) began a revolution in colour photography when they demonstrated the Autochrome plate—the first commercially available colour process—to an eager audience in Paris. On a glass rather than a paper base, the Autochrome was the first additive colour process that was simple enough to be mastered by any reasonably competent photographer. The Lumière brothers had researched the process for fourteen years, benefiting from work by Louis Ducos du Hauron (1837–1920) thirty years previously.

The Autochrome, and its imitators, took a colour-starved photography world by storm. The glass plate, coated with millions of microscopic grains of potato starch dyed orange-red, green and blue-violet that acted as tiny colour filters, could be used in any standard camera; processing and developing were quickly learnt. The tiny coloured grains tended to form clusters visible to the naked eye, creating a pointillist effect that became one of the process's greatest attractions. Autochromes offered a luminous and lush colour palette to leisured amateurs and artist photographers, none more so than the Pictorialists (see p.170) and Photo-Secessionists (see p.176), many of whom seized upon its romantic and nostalgic possibilities. Notable practitioners included Alfred Stieglitz (1864–1946), Edward Steichen (1879–1973) and, most successfully of all, Heinrich Kühn (1866–1944).

KEY EVENTS

1907	1907	1912–31	1931	1933	1936
The Autochrome—the first viable colour photography process—is launched by the Lumière brothers in France.	Kühn comments: 'Only somebody [with] a delicate sense of colours, should work with [Autochrome], the palette is somewhat dangerously colourful.'	Banker Albert Kahn pays photographers to travel globally to create Autochromes and colour films for his Archives de la Planète.	Nickolas Muray's tricolour carbro shots of models in beachwear are the first colour images in popular US magazine *Ladies Home Journal*.	Negatives strapped on to her body, Gisèle Freund leaves Berlin for Paris to photograph intellectuals and the avant-garde on 35mm colour film.	In June, 30,000 visitors (among them Madame Yevonde) see the International Surrealist Exhibition at the New Burlington Galleries in London in three weeks.

Kühn's Autochromes are ethereal dreams of childhood, full of vaulted sunny skies and giddy perspectives, as gloriously cathartic as they are emotionally charged. Kühn was a friend of artist Gustav Klimt, moved in artistic Viennese Secessionist circles and had worked in colour for several years, so the Autochrome seemed to be second nature to him. A widower, with four young children under the care of their Scottish nanny, Mary Warner, Kühn used his domestic life as subject matter. In *Miss Mary and Edeltrude Lying on Grass* (opposite), the nanny and Kühn's youngest child relax in a halcyon dream landscape.

Each Autochrome was a unique positive image with no negative (and could only be viewed against a backlight or as a projected image. Artist photographers soon gave up the process because of the difficulties inherent in reproduction and exhibition. By its demise in 1932, more than twenty million Autochrome plates had been sold worldwide, but the future of colour photography was to be on paper not glass. Theoretical experiments in tricolour photography by Louis Ducos du Hauron and Charles Cros (1842–88) were now a reality as the processes they predicted became commercialized and available to a wider public — at a price.

In the 1930s, colour photography was adopted with alacrity by advertising agencies, Hollywood and the new 'lifestyle' magazine publishing industry, and so became associated with commerce rather than art. Only a few photographers, including Edward Steichen, Nickolas Muray (1892–1965), Paul Outerbridge (1896–1958), Madame Yevonde (1893–1975; see p.278) and Gisèle Freund (1908–2000) used colour in the workplace and for their own artistic passions. Muray, a renowned celebrity portraitist, set up one of the first colour film laboratories in the United States and became one of the earliest commercial photographers to embrace colour. For many, the artistic impetus came from the European avant-garde, especially the Surrealists (see p.232). Outerbridge, Freund, Man Ray (1890–1976) and László Moholy-Nagy (1895–1946) all spent time in Paris mixing in these circles.

Outerbridge had absorbed modernist aesthetics while working in Paris in the 1920s and applied them to photography. His mastery of the technicalities of the complex tricolour carbro process — where absolute precision, painstaking meticulousness and several hours' work might eventually produce one acceptable print — was legendary. Outerbridge believed that nude photographs should be relatively impersonal and that it was a fatal error to have a model establish too personal or intimate contact with the viewer. *Woman with Claws* (right) is a disturbing and remarkable image juxtaposing the soft warm tones — all the more realistic in gorgeous colour printing — and unnaturally hairless curves of the woman's body with the piercing, metallic spiked gloves. By the 1940s, colour photography had finally come out of the studio, into the pocket and on to the road in the form of 35mm cameras and Kodachrome colour transparency roll film. **PGR**

1936	1939	1939–43	1940	1942	1945
Fortune magazine commissions Yevonde to photograph the fitting-out of the Cunard liner, *Queen Mary*, for a twelve-page colour spread.	In New York Nickolas Muray photographs artist Frida Kahlo (with whom he was having an affair) in colour. The studies are as vibrant as her paintings.	Members of the Farm Security Administration amass one of the most significant bodies of 35mm and larger format colour photography.	Paul Outerbridge publishes his only book, *Photographing in Color*, which becomes a photographic industry classic.	Kodacolor, the first 35mm colour negative roll film from which colour prints could be made, is launched.	The rich, subtle Kodak dye-transfer process is introduced. Used mainly for advertising or commercial work, it is also appreciated by art photographers.

Lady Bridgett Elizabeth Felicia Henrietta Augusta Poulett as 'Arethusa' 1935

MADAME YEVONDE 1893 – 1975

Vivex colour print
16 ½ x 10 ⅞ in. | 42 x 27.5 cm
National Portrait Gallery, London, UK

⬡ NAVIGATOR

Madame Yevonde had been a successful society photographer for two decades when she embarked on a series of portraits of British society ladies dressed as classical mythological deities. *Goddesses* was inspired by the Olympian Party, a charity ball held at Claridge's on 5 March 1935, that many of Yevonde's sitters had attended. These society beauties were persuaded to recreate their fantastically elaborate costumes for Yevonde's lens, and the resulting colour images—more than thirty variants exist—were exhibited in July 1935 at the launch of Yevonde's new studio in Mayfair.

Yevonde strove to emphasize the women's beauty and mysterious sexual allure without losing the stunning power of the colour. Naturalism was never the aim of a woman whose maxim was 'Be original or die!' The artificiality and extravagance of the costumes, poses and props are heightened by Yevonde's instinctive and creative use of the new Vivex colour process. She took enormous risks experimenting with both studio and printing technology in order to achieve the requisite emotional and visual effects.

The much-photographed Lady Bridgett Poulett was one of the most beautiful women of her generation. Here she depicts Arethusa, a water nymph who unwittingly bathed in the River Alpheus, arousing the lust of the river god from whose advances she fled. The goddess Artemis helped Arethusa to escape by transforming her into an underground stream, then a freshwater spring on the island of Ortygia in Sicily. **PGR**

👁 FOCAL POINTS

1 'SEAWEED' HAIR
The 'seaweed' hair (actually strips of green cellophane) streaming from Arethusa's head suggests her transit under the sea and eventual metamorphosis into a fountain. It adds a fantastical air to the portrait and reflects the influence of Surrealism (see p.232) on Yevonde.

2 YELLOW FLOWERS
The deep yellow of the flowers is created by pigment dyes, which give a strong colour effect. The use of pigments made the Vivex colour process permanent, non-fade and intense. Vintage prints have a colour balance, surface sheen and texture that is impossible to replicate with modern dyes.

3 GLASS FISH
The strip of glass fish Yevonde added at the bottom of the print emphasizes Arethusa's general watery existence. Arethusa was often depicted on Roman coins accompanied by dolphins. Taken from Yevonde's props box, the fish make frequent appearances in her later still life photographs.

4 GREENISH SKIN
Arethusa's skin has an ethereal, greenish tinge to it, reflecting her domain under the sea. Madame Yevonde achieved this sickly tinge on Poulett's flesh by covering the camera lens with green cellophane. She also instructed the printers to reduce the red pigment when they made the print.

⏱ PHOTOGRAPHER PROFILE

1893–1931
Yevonde Cumbers was born into a prosperous family in Streatham, south London. After a three-year apprenticeship with Edwardian society portrait photographer Lallie Charles (1869–1919), Yevonde opened her own studio in 1914. She quickly capitalized on the demand for modern celebrity photography, working for the new, glossy, illustrated lifestyle and fashion magazines.

1932–63
Yevonde embraced the artifice and exaggerations of 1930s colour photography and used the British Vivex colour process in her commercial, portrait and allegorical work, most famously in *Goddesses* in 1935. Her autobiography, *In Camera*, was published in 1940. When enlistment for World War II closed the Vivex factory, Yevonde returned to monochrome photography, later experimenting with solarization.

1964–75
In 1964 Yevonde photographed Emperor Haile Selassie in Ethiopia. She celebrated sixty years in photography with a Royal Photographic Society exhibition in 1973. She died in 1975.

STRAIGHT PHOTOGRAPHY

1 *Magnolia Blossom* (c. 1925)
Imogen Cunningham • silver print
6 ¾ x 8 ½ in. | 17 x 21.5 cm
Museum of Modern Art,
New York, USA

2 *Moonrise, Hernandez, New Mexico* (1941)
Ansel Adams • silver print
10 ½ x 13 ⅜ in. | 27 x 34 cm
San Francisco Museum of Modern Art,
California, USA

In the first decades of the 20th century, a small group of US photographers rebelled against the Pictorialist images (see p.170) that were popular in camera clubs and salons of the day. Rather than imitate the look of charcoal drawings or heavily inked prints, these modernists argued for graphic, black-and-white photographs full of texture and detail. Instead of allegorical or symbolist-inspired subjects, they chose to focus their cameras on everyday things. Alfred Stieglitz (1864–1946) became the modernists' spokesman and great supporter, although he had founded the Photo-Secession (see p.176) and was an early promoter of Pictorialism. His protégés—Charles Sheeler (1883–1965), Edward Steichen (1879–1973) and Paul Strand (1890–1976) on the East Coast—and their West Coast counterparts Ansel Adams (1902–84), Edward Weston (1886–1958) and Imogen Cunningham (1883–1976)—took up large-format cameras and revelled in the spectacular clarity and gradations of tone they were able to achieve.

During the 1920s, Cunningham produced a pioneering series of close-up botanical subjects, of which *Magnolia Blossom* (above) is the best known. With its luxuriant natural light, extreme perspective and tight cropping, the image captures in microscopic detail all the elements that make up what she liked to call 'the innards' of the flower. Weston also made a group of close-up views of quotidian objects, such as fruit and vegetables, during the 1920s, and his *Pepper #30* (1930; see p.282) is widely thought to be the masterpiece of the series. He resolved to create photographs that could 'truthfully represent natural objects

KEY EVENTS

1904	1917	1922	1923–25	1927	1929
Sadakichi Hartmann (1867–1944) first uses the phrase 'straight photography' in an essay in *Camera Work*, to differentiate it from soft-focus Pictorialism.	Paul Strand's essay 'Photography and the New God', in the final issue of *Camera Work*, argues for images to be sharply focused and clearly camera-made.	Edward Weston goes to New York to meet Alfred Stieglitz. His photographs of Armco Steel plant in Ohio, en route, mark his move away from Pictorialism.	Imogen Cunningham makes a series of photographs of magnolias, using tight cropping and extreme close-ups to bring out their abstract qualities.	Weston begins a major group of still lifes—featuring organic subjects, such as peppers, shells and eggs—accentuating their sculptural form.	Weston and Edward Steichen organize the US section of the 'Film und Foto' (Film and Photo) exhibition in Stuttgart, Germany.

[without] trick, device or subterfuge' and in 1932 he became one of the founding members of Group f/64, a loose-knit group of photographers from San Francisco's Bay Area with a shared commitment to large-format cameras and unmanipulated, sharp, 'straight' prints. The f/64 name referred to the aperture setting that allowed for maximum sharpness and greatest depth of field, and the group's manifesto argued for the use of 'purely photographic methods'. The original members of this short-lived collective included Cunningham, Adams, Willard van Dyke (1906–86) and Sonya Noskowiak (1900–75) among others. They also invited a few like-minded photographers to join them in their groundbreaking exhibition at San Francisco's M. H. de Young Museum in 1932, including Consuelo Kanaga (1894–1978), who developed a particular interest in documenting the lives and faces of African Americans.

Perhaps the most outspoken advocate of straight photography on the West Coast, however, was Ansel Adams. His technical tour de force, *Moonrise, Hernandez, New Mexico* (below), was taken only a year before he formally codified the method of exposure and development he called the Zone System. Adams was driving along the highway towards Santa Fe under the rising moon, when the small town and white cemetery crosses caught his attention. Acting quickly, Adams stopped and frantically set up his camera. He despaired when he could not find his light meter, but then remembered the luminance of the moon and used that to estimate his exposure. **KH**

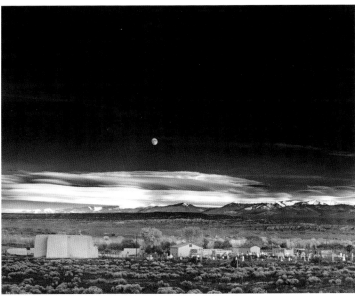

1932	1935	1937	1939–40	1940	1945
Group f/64 is founded by several Bay Area photographers, including Edward Weston, Ansel Adams, Imogen Cunningham and Willard van Dyke.	*Making a Photograph* by Ansel Adams is the first photography guide to tackle both the mechanics and the aesthetics of the medium.	Weston is the first photographer to receive a Guggenheim fellowship and he begins a two-year documentary project on the American West.	Ansel Adams and Fred Archer codify the Zone System technique for exposure and development control.	Adams is involved in founding a department of photography at New York's Museum of Modern Art. It is the first of its kind in the United States.	Adams sets up a fine art photography department at the California School of Fine Arts. Cunningham and Dorothea Lange (1895–1965) join him.

Pepper #30 1930
EDWARD WESTON 1886 – 1958

Silver print
9 ½ x 7 ½ in. | 24 x 19 cm
San Francisco Museum
of Modern Art, USA

Edward Weston's photograph *Pepper #30* is often described as *the* iconic US modernist still life. With its tightly cropped composition and sensuous curves bathed in natural light, it is the best known of more than forty different images of peppers made by Weston between 1927 and 1930. Like a number of his West Coast contemporaries, including Ansel Adams (1902–84) and Imogen Cunningham (1883–1976), Weston began his career working in the soft-focus Pictorialist style that had been popular at the turn of the 20th century. By the mid 1920s, however, he had abandoned his early, atmospheric platinum prints in favour of the more graphic and sharply focused look of black-and-white gelatin silver photographs.

In *Pepper #30*, the subject almost fills the entire frame and is set against a plain background. By isolating the simple green pepper and moving his large-format camera in very close, Weston transforms it from a lowly vegetable into an object of intense contemplation. His skilful use of natural light emphasizes the sculptural silhouette of the pepper and draws the viewer's eye to its undulating curves set off by velvety, dark shadows. Its elegant, anthropomorphic shape is reminiscent of the female nudes that Weston was making during the 1930s, many of which were highly abstract, fragmentary studies of body parts rather than entire figures. The smooth textures, rounded form and deep shadows also recall the sculptures of Constantin Brancusi, although contemporary critics point to the influence of other European artists, including Pablo Picasso, Wassily Kandinsky and the Surrealists Joan Miró and Jean Arp.

Weston's first experiments with still life date from the mid 1920s, during his period of transition from Pictorialism to modernism, when he and his lover Tina Modotti (1896–1942) were working together in Mexico City. While waiting for clients to arrive for their portrait sittings, Weston delighted in arranging his collection of folk art objects and toys and recording them with his large-format camera. These fanciful Mexican photographs, along with his groundbreaking close-ups of a pear-shaped nude and streamlined wash basin and porcelain toilet, directly inspired the high modernist still lifes that he made after his return to the United States. **KH**

⏱ PHOTOGRAPHER PROFILE

1886–1908
Edward Weston was born in Highland Park, Illinois, but spent much of his childhood in Chicago. When he was aged sixteen, his father gave him a Kodak Bull's Eye #2 camera, which he used to take photographs around the city. In 1906 he found work in California as a surveyor and attempted to set himself up as a photographer there too, but opted to go back east for formal training at Illinois College of Photography in 1908, returning six months later.

1909–21
In 1909 Weston was married for the first time, to Flora Chandler; they had four children. In 1911 he opened a portrait studio in Tropico, California, and his soft-focus Pictorialist photographs were widely published, winning numerous awards in the salons of the day.

1922–26
A trip to New York in 1922, during which he met Alfred Stieglitz, Charles Sheeler and Paul Strand, had a major influence on the direction of his career. The following year, he relocated to Mexico City with his lover and assistant Tina Modotti.

1927–39
Back in the United States, he began to make the still lifes, nudes, nature studies and landscapes for which he is best known. In 1932 he was one of the founders of Group f/64. In 1937 he became the first photographer to receive a Guggenheim grant and for the next two years he travelled throughout California and the West with his future wife, Charis Wilson.

1940–47
In 1941 Weston was commissioned to supply images for a new edition of Walt Whitman's well-known poetry collection *Leaves of Grass*. A major retrospective of his work was held at the Museum of Modern Art in New York in 1946, by which time he was beginning to suffer from the effects of Parkinson's disease and could no longer handle his large-format camera.

1948–58
Having produced a prolific series of seascapes and landscapes in Point Lobos, California, he took his last photograph there in 1948. Two of his sons, Brett and Cole, continued to print from his negatives under his supervision until his death in 1958.

VERNACULAR PHOTOGRAPHY

Although people have produced, used, collected and discarded photographs in escalating numbers since the medium's inception in the early 19th century, most art historians and curators ignored everyday photographs. It was only in the late 20th century that scholars turned to previously overlooked images to construct a broader approach to the history of photography. Vernacular photography emerged as a field of study that encompassed amateur images as well as the entirety of photographic production, including commercial, industrial, erotic and artistic photographs primarily taken by unidentified photographers.

The growing interest in vernacular photography was rooted in earlier decades. In his book *The Photographer's Eye* (1966), which is based on an exhibition of the same name at the Museum of Modern Art in New York in 1964, critic, curator and photographer John Szarkowski (1925–2007) looked to the range of photographic production to outline the essential qualities of photography. He illustrated a modernist photographic vocabulary through an eclectic selection of images from art, commerce, history and personal life. His celebration of the simple and direct in photography is seen in the bedroom interior (above) that appeared on the cover of *The Photographer's Eye*.

Szarkowski championed the work of early vernacular photographer Ernest J. Bellocq (1873–1949), a commercial practitioner who worked in New Orleans, Louisiana. He became known posthumously for a series of eighty-nine portraits of prostitutes in Storyville, a legalized red-light district. The *Storyville Portraits* include photographs of women posed nude and clothed and were likely part

KEY EVENTS

1900	1908	1908	c. 1912	1917	1924
Eastman Kodak launches the Brownie camera. Its low cost and ease of use introduce the concept of the snapshot to the public.	Austrian critic Joseph August Lux champions the snapshot in his article 'Künstlerliche Kodakgeheimnisse' (Artistic Secrets of the Kodak).	Kodak produces the first commercially practical safety film using a cellulose acetate base instead of the highly flammable cellulose nitrate base.	Commercial photographer Ernest J. Bellocq takes a series of eighty-nine images of brothels and prostitutes in New Orleans, Louisiana.	Nippon Kogaku Kogyo Kabushikigaisha, which will eventually become Nikon, is established in Tokyo, Japan.	The Leica, a small, lightweight camera that utilizes roll film (the precursor to the hand-held 35mm camera), launches in Germany.

of a private body of work that Bellocq shared with a limited circle of associates. In some images, such as *Untitled* (below), the women's faces are obscured or they wear masks. Others are intimately candid portraits with the women clearly recognizable. After Bellocq died the gelatin dry-plate negatives were uncovered and in 1966 purchased by US photographer Lee Friedlander (b.1934), who printed the images and showed them to Szarkowski at the Museum of Modern Art. They were exhibited there in 1970 as a group in 'E. J. Bellocq: Storyville Portraits'. The photographs maintain an erotic appeal and the sparse information known about their maker and the sitters perpetuates an air of titillating mystery that heightens their appreciation by viewers and collectors.

Mike Disfarmer (1884–1959) was another relatively unknown commercial photographer working in the United States during the first half of the 20th century. Disfarmer operated a small studio where he produced strikingly straightforward portraits of the members of the rural community of Heber Springs, Arkansas. A book of his compelling portraits was later published, with an exhibition at the International Center of Photography, New York in 1977.

While vernacular photographs are now the subject of exhibitions and books, it is the idea of the vernacular that is most central to the history of photographic art. Figures such as Walker Evans (1903–75), with works such as *Penny Picture Display, Savannah, Georgia* (1936; see p.286), defined the modern in US photography by invoking the vernacular, the democratic and the everyday. **SMC**

1 *Bedroom with Eye Chart* (c. 1910)
Photographer unknown • silver print
Wisconsin Historical Society, Madison, Wisconsin, USA

2 *Untitled* (c. 1912)
Ernest J. Bellocq • silver printing-out paper print
10 x 8 in. | 25.5 x 20 cm
Museum of Modern Art, New York, USA

1936	1936	1937	1938	1940	1948
Kodak releases Kodachrome as slide film in 35mm formats. It is the first commercially successful amateur colour film.	Henry Luce launches *Life* magazine. Within four months its circulation has exceeded one million copies per week.	*Popular Photography* magazine launches in the United States.	Walker Evans's exhibition 'American Photographs', held at the Museum of Modern Art in New York, raises the profile of 'straight' photography.	The Museum of Modern Art develops a department of photography with Beaumont Newhall (1908–93) as its founding director.	Polaroid unveils the first Land camera (the prototype for all Polaroid instant cameras produced for the next fifteen years) in New York.

Penny Picture Display, Savannah, Georgia 1936
WALKER EVANS 1903 – 75

Silver print
8 ⅝ x 6 ⅞ in. | 22 x 17.5 cm
Museum of Modern Art,
New York, USA

🔆 NAVIGATOR

W alker Evans recorded the harsh realities of a population suffering from economic despair during the Great Depression. His photographs are intertwined with a search for an authentic US culture that permeated the arts, literature and cultural criticism in the 1930s. Evans's style relies upon an unmanipulated idiom that is, at first glance, social documentary. Yet once the viewer becomes accustomed to the stark, frontal, pared-down appearance of the images, a poetics of the image emerges that links the subject and the nature of its depiction.

Evans cultivated a literary approach to photography, believing that photographs should have structure (their own grammar) and be readable as a text. *Penny Picture Display, Savannah, Georgia* demonstrates both his attention to the details of everyday life and the viewpoint of a dispassionate historical observer. He photographed the window display of a local photographer's studio. The original display showcases the inexpensive portraits that are available for manufacture and sale. The constellation of sitters creates an anonymously democratic photographic community. Evans celebrates and reinvents the penny portrait, moving it out of its vernacular photographic history and giving it a new aesthetic identity. In choosing the vernacular photographic display as his subject, he unites the commercial marketability of inexpensive studio portraits with the interests of fine art photography. **SMC**

👁 FOCAL POINTS

1 PICTURE WITHIN A PICTURE
The image is a single picture made up of many pictures. The original window display was constructed from a series of fifteen blocks of fifteen photographs each, with a total of 225 penny portraits. Several of the sitters are repeated in various combinations throughout the grid.

2 ELIMINATION OF BACKGROUND
Evans has cropped the image tightly, eliminating surrounding background details. The word 'studio' and the penny pictures are the only visual information available to the viewer. He cropped and edited photographs in the darkroom in order to achieve the desired perspective.

3 FRONTAL PERSPECTIVE
As with most of his photographs, Evans took a straightforward view in this image. Shooting the scene directly, he takes an almost clinical view that flirts with a modernist-derived notion of unmediated depiction through its simplicity and objective observation of detail.

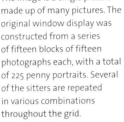

4 THE WORD 'STUDIO'
The word 'studio' is the focal point of the image. The thick black line around each letter mirrors the white border that separates each grid of portraits. Evans was fascinated by words and photographed their often quirky or ironic appearance in the US landscape as signage or advertising.

⏱ PHOTOGRAPHER PROFILE

1903–34
Born in St Louis, Missouri, Walker Evans arrived in New York in 1927 with dreams of being a writer. He took up photography the following year. He photographed the Cuban revolt in 1933.

1935–37
Evans started working for the Resettlement Administration that was later folded into the Farm Security Administration. His independent vision caused friction and he was dismissed.

1938–42
Evans's solo photography show at New York's Museum of Modern Art established his prominence. The same year he took his first photographs in the New York subway with a camera hidden in his coat. *Let Us Now Praise Famous Men*, a project about three farming families in Alabama developed in 1936 when Evans and journalist James Agee were on assignment for *Fortune*, was published as a book in 1941.

1943–75
Evans joined *Time* magazine and later *Fortune*. The reissue of Evans's key publications in the early 1960s created renewed interest in, and new audiences for, his photography.

STREET PHOTOGRAPHY

S treet photography is a form of documentary photography, although unlike photojournalism or reportage, it rarely tells a story. The most effective street photography captures attention when it points to the extraordinary or the surreal in the everyday. The genre is almost as old as the medium itself. The Parisian street and market scenes by Charles Nègre (1820–80), a French painter who took up photography in 1844 as an aid to his art practice, appear candid and instantaneous: characteristics that would come to define street photography.

Central to the emergence of street photography as a genre in the 20th century is the work of French photographer Eugène Atget (1857–1927). Working in obscurity for most of his life, in the early 1920s he attracted the attention of the artist and photographer Man Ray (1890–1976), whose Paris studio was on the same street as Atget's apartment. Man Ray saw Surrealist possibilities in Atget's photographs, which were produced using an old-fashioned view camera, and approached him requesting permission to publish his photographs in the periodical *La Révolution surréaliste* (*The Surrealist Revolution*). Atget, who was recording the rapidly disappearing architecture of Old Paris along with street scenes, at first refused, insisting: 'These are simply documents that I make.' He sold his work to artists, libraries and historical institutions as research material, eschewing any association with art

1 *Avenue des Acacias, Paris* (1911)
Jacques Henri Lartigue
silver print
11 ½ x 15 ⅝ in. | 29 x 40 cm
Museum of Modern Art, New York, USA

2 *Behind the Gare St Lazare, Paris* (1932)
Henri Cartier-Bresson • silver print
14 ¾ x 9 ½ in. | 37.5 x 24 cm
Museum of Modern Art, New York, USA

KEY EVENTS

1902	1924	1925	1926	1926	1927
Gaumont & Cie's small 'Block-Notes' camera allows photographers greater freedom to work on the move outdoors.	Ermanox releases the 'Ernox' camera, initially with an f2 lens, then a 'fast' f1.8 lens, making it suitable for taking candid photographs unobserved.	The highly portable 35mm hand-held camera Leica A is introduced. It enables photographers to work fast with available natural light.	Man Ray, recognizing Surrealist tendencies in Eugène Atget's work, publishes a Parisian street photograph on the cover of *The Surrealist Revolution*.	Louis Aragon publishes 'Le Paysan de Paris', a central text of Surrealism, inspired by the streets of Paris.	Atget dies. Afraid that his archive might be lost, Berenice Abbott arranges to purchase the photographer's estate of over 8,000 prints and negatives.

photography. Man Ray persevered until Atget relented, with the stipulation that his name not be used. In 1926 Atget's unattributed image from 1912 of a Parisian crowd viewing a solar eclipse appeared as the cover image on the avant-garde periodical.

What Man Ray had recognized was a photographic language unlike any that had preceded it. Decidedly anti-Pictorial in style, Atget's images speak of an impassive observer, catching the beauty of the overlooked or unusual detail. In the approximately 10,000 images that he made, there are few human figures. The occasional appearance of ghostly reflections and odd juxtapositions impart a strangeness to his images, as do the rich aubergine tones of his prints. Yet his frontal, seemingly unmediated mode of depiction in photographs such as *Cabaret at the Sign of the Armed Man, XVth* (1900; see p.292) suggests a fidelity to fact. It is their stillness and impassivity that in 1936 provoked the critic Walter Benjamin to claim that Atget's images appear, unintentionally, as if taken at the 'scene of a crime'.

Jacques Henri Lartigue (1894–1986) also made photographs on the streets of belle époque Paris but as an amateur not a professional. He took his first photographs at the age of eight, producing his most enduring works as a young man. Employing one of the newly available portable hand cameras, which were replacing the large tripod-based cameras, Lartigue seized upon action as the subject for his camera. His eye was tuned acutely to the pageantry of modern society and the exuberance and humour of youth; his photographs appear as an attempt to freeze the march of time. Lartigue was an astute observer of his own wealthy milieu, which can be seen in his study of a woman swathed in furs promenading with her small dogs (opposite) taken on Avenue des Acacias in the Bois de Boulogne. In the background an automobile on the left appears to be chasing a horse-drawn carriage on the right, as if the new century is chasing the old out of the frame.

It was not until the 1930s that a fully developed vocabulary of street photography emerged—initially in Europe and then taking in the United States, influenced by avant-garde artists and writers for whom the modern metropolis was a source of subject matter and a tableau upon which the randomness of daily life exposed its meaning. Henri Cartier-Bresson (1908–2004) took a great many photographs of Paris during the 1930s; they are defined by aesthetic risks that could only exist within the context of Surrealism. They include arresting juxtapositions or unanticipated compositional tensions, as seen in his early work *Behind the Gare St Lazare, Paris* (right). The image of the jumping man, mirrored perfectly by his own shadow, is repeated by the leaping figures on the circus posters in the background. Cartier-Bresson had a legendary instinct for such juxtapositions, establishing a new look in photography in which the viewer is drawn to the image by arrested moments that appear fortuitous in conception, naturalistic in style and Surrealist in effect.

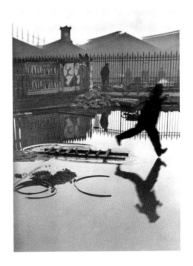

1928	1933	1935	1935	1938	1943
André Breton publishes his novel *Nadja*, illustrated with photographs of Paris by Jacques-André Boiffard (1902–61).	Paris-based photographer Brassaï publishes *Paris By Night*, his photographs of street scenes, brothels and nightlife.	Julien Levy holds an exhibition of (primarily street) photographs by Walker Evans, Henri Cartier-Bresson and Manuel Alvarez Bravo.	Abbott proposes her project 'Changing New York' to the Federal Art Project. In 1939 her landmark series is published as *Changing New York*.	London-based photographer Bill Brandt publishes *A Night in London*, portraying life on the city's streets.	Helen Levitt has a solo exhibition, 'Photographs of Children', at New York's Museum of Modern Art, showing children playing in the streets.

3 *Two Street Toughs, Paris XIVth* (1932–33)
Brassaï • silver print
19 ½ x 14 ⅞ in. | 49.5 x 38 cm
Metropolitan Museum of Art,
New York, USA

4 *New York City* (c. 1940)
Helen Levitt • silver print
6 ¼ x 8 ¾ in. | 16 x 22.5 cm
Museum of Modern Art,
New York, USA
© Estate of Helen Levitt

Another Paris-based street photographer with Surrealist tendencies was Brassaï (1899–1984). Born Gyula Halász in Transylvania (then Hungary), from 1920 he worked as a photojournalist in Berlin then in 1924 moved to France, where he adopted his pseudonym. He is best known for his series of photographs published as *Paris By Night* (1933), which portrays the city's seedy underworld of prostitutes, homosexuals, street toughs and hustlers. Brassaï was a master of composition, creating strong graphic patterns by using deep shadows and the halation of light. He often asked his subjects for their permission in advance, and treated the dark cafes and bistros as atmospheric stage sets. He also manipulated his work in the darkroom. The artifice involved in *Two Street Toughs, Paris XIVth* (above) included the masking-out of three men from an original negative that featured five. The black wall around which the two menacing toughs emerge is a fabrication. Brassaï defended his methods, saying: 'I don't like snapshots. I like to seize hold of things, and the form is very important for this...only through form can the image enter into our memory.'

London was the primary setting for the street photographs of Bill Brandt (1904–83). Born in Germany, Brandt assisted Man Ray in Paris before arriving in London in 1934, and he spent the rest of his life working in Britain. His early work focused on the social complexion of Britain, and although it owed a debt

to the Surrealist tendencies he encountered in Paris, Brandt forged a unique signature style. One of his earliest books, *A Night in London* (1938), alludes to Brassaï's earlier work, picturing life on the streets under the cover of darkness.

Street photography in the United States was heavily influenced by the social documentary projects that fostered the study of ordinary people supported by institutions created during the Great Depression. The most important organizations were the Federal Art Project (FAP), sponsored by the New Deal's Works Progress Administration (WPA), and the Farm Security Administration (FSA) headed by Roy Stryker (1893–1975). However, the work of Helen Levitt (1913–2009), a WPA artist, has the closest affinity to that of Cartier-Bresson. She saw his work at the Julien Levy Gallery in New York and met him in 1935. Known for her images of New York children at play in the most common of spaces, the city street, Levitt sought out spontaneity. A right-angled viewfinder attached to her hand-held Leica enabled her to take pictures sideways and so photograph her subjects unnoticed, capturing the moment. *New York City* (below), showing young boys playing with toy guns, transcends the immediate subject to become emblematic of something beyond the frame.

US photographer Berenice Abbott (1898–1991) was responsible for securing Atget's place in the history of photography. As an assistant of Man Ray in Paris, Abbott knew of Atget's work and upon his death purchased the contents of his estate with the assistance of New York gallerist Julien Levy. Abbott's efforts ensured that Atget became the seminal influence for a new generation of street photographers. Abbott returned to New York in 1929 and, although she had lived there in her early twenties, it was as if she were seeing the city for the first time. Atget's influence is seen in the images she produced for the FAP project 'Changing New York', which she began working on in 1935. Like Atget, Abbott used a large-format view camera, creating images that sacrificed foreground focus for sharper backgrounds that highlighted the architecture. Using acute angles and a graphic style to capture the poetry in the relationship between old and new New York, Abbott created intensely subjective images with a Surrealist eye, as seen in her *'El', Second and Third Avenue Lines* (1936; see p.294).

What defines street photography from this period, from Atget through to Abbott, is the search for a visual mode expressive of modern life: its change, speed and the resulting alienation. A later generation of US artists working in this genre—Diane Arbus (1923–71), Garry Winogrand (1928–84) and Lee Friedlander (b.1934)—would be seen as its finest exponents (see p.368). **EL**

Cabaret at the Sign of the Armed Man, XVth 1900

EUGÈNE ATGET 1857 – 1927

Albumen print
8 ½ x 6 ¾ in. | 21.5 x 17 cm
Bibliothèque Nationale
de France, Paris, France

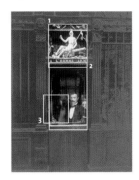

Eugène Atget began to record the disappearing neighbourhoods and buildings of Old Paris in the late 1890s for a client base of museums, antiquarians, archives and libraries. He made use of the dry-plate negative, which meant that he did not have to develop his negatives immediately and could spend all day photographing the streets of Paris. The demand for his images was fuelled by the radical transformation of the city that occurred during the 1860s. Antiquarian interest developed in old shop signs, created when literacy was not universal, which mostly survived above the doors of bars and taverns as they were attached to the grillwork that was required by law for establishments selling alcohol. In this image a waiter appears in the window pane of the bar's entrance, peering out at the photographer, who has set up his camera opposite. It is one of the many photographs by Atget featuring historic shop signs that he organized into an album and sold to the Bibliothèque Nationale de France in 1913. **EL**

👁 FOCAL POINTS

1 SHOP SIGN
Wrought-iron signs such as this dating from the 15th century, showing a warrior seated on a cannon with a glass in his hand and an unopened bottle at his feet, had largely disappeared by the 19th century. Atget's clients would have valued this historical artefact.

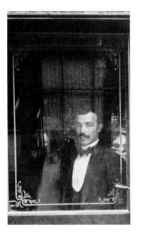

2 WINDOW PANE
Atget claimed that his work was purely for documentation purposes. Yet here he positioned his camera directly centred on the entrance, thus focusing the viewer's attention on the window pane of the door. The empty space of the pane was not an important element in terms of the value of the image to Atget's intended clients, and so he was free to capture the appearance of the formally dressed waiter. The photograph is therefore both document and art.

3 GHOSTLY SHADOWS
The barely visible form of another figure in the window to the left of the waiter suggests a dreamlike atmosphere; such details attracted the Surrealists to Atget's photographs. The shadows and the reflections work against the clarity demanded by the creation of photographic documentation.

🕐 PHOTOGRAPHER PROFILE

1857–77
Eugène Atget was born to working-class parents in Libourne, on the Dordogne River in the Gironde region of south-west France. Orphaned at the age of five, he was raised by his maternal grandparents and upon graduation from secondary school, like many of the local male youths, signed up as a cabin boy on a ship.

1878–87
He moved to Paris but failed to gain admission to the prestigious Conservatoire de Paris (Paris Conservatory) music and drama college. Atget was drafted into military service and after one year successfully reapplied to the college, enrolling in the autumn of 1879. Despite initial favourable reports from his professors, he was not asked to return the following year. Without a degree, Atget was excluded from legitimate French theatre and pursued acting with provincial troupes, playing minor roles and receiving little recognition. Atget quit acting for good in 1887.

1888–96
In searching for a new career direction, Atget took up painting. While he continued to paint on an amateur level throughout his life, he began to take photographs in c. 1888. Atget established a studio in Paris creating documents for artists, including landscapes, animals, flowers, monuments and reproductions of paintings.

1897–1917
In c. 1897 the subject of Atget's photographs changed, focusing on the architecture of Old Paris that was disappearing rapidly. Atget produced an extensive archive of Paris's old shops, streets, houses and architectural ornamentation, including shop signs, metalwork, door knockers and stairways. Atget's client base expanded to include libraries, museums, archives and antiquarians.

1918–27
After World War I Atget's style shifted to one that was more subjective and he pursued themes that referenced decay, death and the passage of time. In 1920 he sold many of his glass-plate negatives of urban architecture to the French government. In the mid 1920s he came to the attention of Man Ray and the Surrealists.

'El', Second and Third Avenue Lines 1936

BERENICE ABBOTT 1898 – 1991

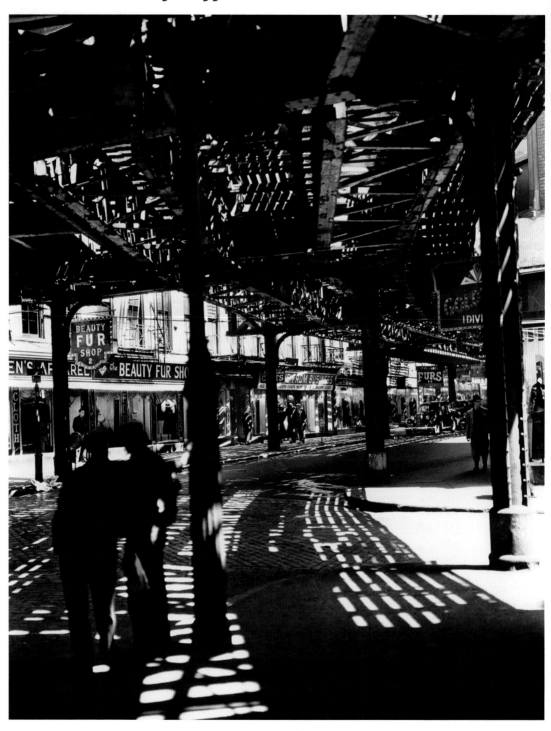

Silver print
9 ⅜ x 7 ⅞ in. | 24.5 x 20 cm
Smithsonian American Art Museum, Washington, DC, USA

I n 1929, at the height of her career as an expatriate portrait photographer in Paris, Berenice Abbott returned to New York. She went back armed with the majority of Eugène Atget's extensive archive, whose example helped her to develop her idea of a modern photographic eye. Inspired by the rapid changes taking place in the dynamic metropolis, Abbott embarked upon an ambitious photographic project that would capture her enthusiasm for the urban built environment and which was later funded by the Federal Art Project of the Works Project Administration. Like Atget, she chose to work with an 8 x 10-inch view camera, whereas many of her contemporaries had already adopted the portable hand cameras that used roll film or the newly invented 35mm film. Taken at street level, this emblematic work operates as an accurate document of the changing aspect of the city and serves as a visual metaphor for the cityscape as a clamorous pastiche of old and new. **EL**

FOCAL POINTS

1 'EL' TRACKS
Abbott composed the shot carefully to reveal the city both as a reality and as a symbol. The truncated form of the elevated tracks, known as the 'El', destabilizes the viewer. Thus the picture conveys the feeling of the dizzying assault on the senses that was, and is, New York street life.

2 SHADOW
Abbott composed in an abstract manner, seeing the distribution of shadow and light in terms of its design. Shadow is the dominant compositional element: it camouflages the organization of the streetscape, which is ostensibly the subject of the photograph.

3 SILHOUETTE FIGURES
More interested in the architecture and the signs and structures of the city than the human subject, Abbott kept her figures anonymous. She either shrouded them in shadow or captured them in the far recesses of her photographs. She used a view camera with its inversion of the image on the ground-glass back, which enabled her to momentarily forget the subject and focus on the fitful visual rhythm of the architecture and structures of the city.

4 SHOP SIGNS
Like Atget, Abbott was interested in shop signs. They clamour for the viewer's attention as part of the visual chaos that Abbott sought to portray. As remnants of an older New York, they also serve as a contrast to the transport network that was transforming the city at the time.

PHOTOGRAPHER PROFILE

1898–1920
Born in Springfield, Ohio in 1917 Berenice Abbott enrolled at Ohio State University with the hope of becoming a journalist, but by 1918 she had abandoned her studies and moved to New York where she turned her energies to sculpture. There she met Marcel Duchamp, who introduced her to Man Ray.

1921–25
Abbott embarked for Europe, studying sculpture in Paris and Berlin. In 1923 she began working as a studio assistant to Man Ray, who introduced Abbott to the work of Atget in 1925.

1926–28
She quit Man Ray's studio and established her own photographic studio in Paris in 1926, specializing in portraits of Europe's avant-garde. When Atget died in 1927, Abbott negotiated to acquire the remains of his archive.

1929–38
Abbot returned to New York and began photographing the city; her work evolved into the series 'Changing New York'. She published her first book *Atget, photographe de Paris* (*Atget, Photographer of Paris*) in 1930. She began teaching photography at New York's The New School in 1935.

1939–91
Abbotts's project 'Changing New York' was published in a book, *Changing New York*, in 1939. In 1966 she moved to Maine and published *A Portrait of Maine* in 1968.

SOCIETY

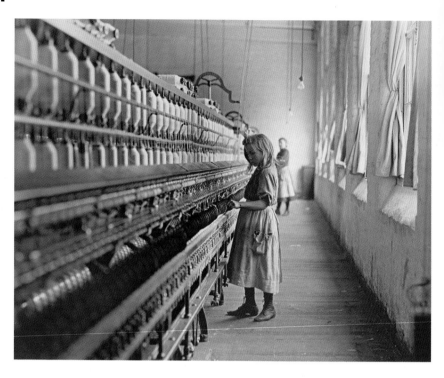

The first years of the 20th century were marked by the growth of modern industry and the wealth it afforded the era's upper and middle classes. However, those less fortunate continued to live and work in derelict conditions. Efforts to photograph the effects of social and economic changes dovetailed with the rise of the illustrated press, which published photographs and essays on various social groups. While many portraits of society from the period appealed to sentiment, the documentation of child workers by Lewis Hine (1874–1940) took a more factual approach. Hine became active in the Progressivist movement in New York and, rather than asking the wealthy to pity the poor, he sought to change public opinion about the working class and the unemployed. His photographs, such as *Sadie Pfeifer, a Cotton Mill Spinner, Lancaster, South Carolina* (above), appeared on posters and in bulletins and journals that advocated for the reform of child labour laws. Hine chose a vantage point that emphasizes the enormity of the spinning machine in relation to the young girl. Despite her diminutive size, the child appears to work competently while a supervisor watches in the background. By providing the name of the young child, Hine presented the worker as an individual and lent

specificity and credibility to his investigative report. Often Hine gained permission to enter factories under false pretenses by convincing supervisors that he was a salesman photographing machines rather than child workers. His activities played a key role in the eventual passage of child labour laws.

A number of photographers produced illustrated books that attempted to define various aspects of society. Such books exemplify photography's transformation of portraiture into a form of sociological and ethnographic study. Through the collection of images, photographers attempted to represent cultures and societies rather than isolated individuals. One of the most elaborate of these projects is the twenty-volume *The North American Indian* (1907–30) by Edward S. Curtis (1868–1952). Curtis selected *The Vanishing Race—Navaho* (below) as the frontispiece to the first volume in his study. The breadth and encyclopedic organization of Curtis's study give it an air of scientific objectivity, but often he embellished his photographs and aspired to depict the idealized 'noble savage' that his white, bourgeois audience expected. The softened focus of *The Vanishing Race—Navaho* encourages a Romantic fascination with its subject. Curtis captures a long line of Navaho people on horseback, seen from behind at a distance. The lack of detail allows the scene to resonate as a general statement about the waning presence of Native American identity. The movement of the group towards the horizon symbolizes their poignant migration and the eventual disappearance of their culture.

1 *Sadie Pfeifer, a Cotton Mill Spinner, Lancaster, South Carolina* (1908)
Lewis Hine • silver print
10 ½ x 13 ½ in. | 26.5 x 34.5 cm
Museum of Modern Art, New York, USA

2 *The Vanishing Race—Navaho* (c. 1904)
Edward S. Curtis • platinum print
6 ¼ x 8 in. | 15.5 x 20.5 cm
Library of Congress, Washington, DC, USA

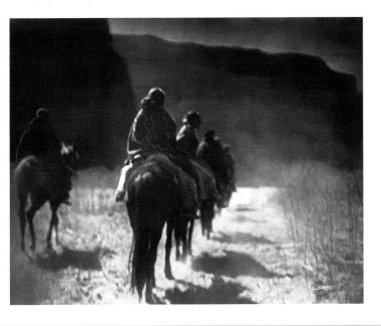

3 *Jarrow Marchers in Trafalgar Square*
(1936)
Humphrey Spender • silver print
11 ¾ x 15 ⅞ in. | 30 x 40.5 cm
Museum of London, UK

4 *Master William Dennis
Simmons, London* (1922)
E. O. Hoppé • silver print
E. O. Hoppé Estate Collection, Pasadena,
California, USA

5 *Subway Passengers, New York City*
(1938)
Walker Evans • silver print
5 ½ x 8 in. | 14 x 20.5 cm
Metropolitan Museum of Art,
New York, USA

Many photographers of this period sought to preserve aspects of society
that they thought might disappear. Their goal was not only to inform, but
also to record a particular way of life for posterity. Born in Munich, E. O. Hoppé
(1878–1972) moved to London at the turn of the century and soon became
one of the city's most successful portrait photographers. Although Hoppé's
studio served elite members of society, from King George V to Arthur Conan
Doyle, the photographer was fascinated by London street life and sought to
capture a wider range of society. He aspired to make a pictorial record of the
distinctive types of people that he believed would disappear because of
changing conditions, which he published in two books: *Taken from Life* (1922)
and *London Types* (1926). Hoppé photographed many of the city's colourful
characters, such as the boy seen in *Master William Dennis Simmons, London*
(opposite above) from his series *The Pearlies*. The term 'Pearlies' refers to people
who celebrate London working-class culture by wearing elaborate costumes
sewn with small white buttons on black fabric. The attire evolved from the
19th-century custom among the capital's 'costermongers' (market sellers) of
wearing pearl buttons on the seams of their trousers. Variety theatre kept the
tradition of the Pearlies alive long after the costume disappeared from daily life.
Hoppé presents his sitter as a charming figure from London's lower social
spectrum. He took the time to converse with his sitters in an effort to ensure
that the resulting photographs would present distinct individuals rather than
anonymous types. Like Hine, he was careful to include the boy's full name.

Humphrey Spender (1910–2005) took up photography as a form of social
activism in England. Photographically his influences came from Germany and
Eastern Europe. In 1936 the socialist journal *Left Review* commissioned Spender
to photograph more than 200 men who were participating in a protest march
from Jarrow, Tyneside to London (above). The men made the journey to demand
jobs for the growing number of unemployed and impoverished in their home
town. The publication of Spender's photographs helped draw attention to the
march. He later joined Mass Observation, a large-scale investigation into the
habits of people in Britain that was started in Bolton in 1937. By 1938 he had
taken more than 900 pictures of the industrial town and its inhabitants.
Spender believed that he could produce the most accurate record of behaviour

when people were unaware of being observed. When he joined the Mass Observation team he used a Zeiss Contax camera because of its almost silent shutter release, making it ideal for being the unobserved observer.

Elsewhere, in the United States, Walker Evans (1903–75) also resorted to subterfuge in order to take photographs unobserved. Evans became best known for his work chronicling the effects of the Great Depression for the Farm Security Administration (FSA). However, in 1938, the year he finished at the FSA, he embarked on a three-year project on the New York subway during which he surreptitiously photographed passengers using a hidden 35mm camera (below). Evans was attempting to produce anonymous portraits and the serial nature of the images suggests a universality among the passengers as they travel through the subterranean world of the city's subway system.

Antlitz der Zeit: 60 Fotos Deutscher Menschen (*Face of Our Time*) by August Sander (1876–1964), which includes *Young Farmers* (1914; see p.300), was one of the many photographic books of portraits published during the last years of Germany's Weimar Republic. It responded to the instability of contemporary social identities—brought on by Germany's economic and political turmoil— and attempted to define a link between appearance and German character. Photographers sought to achieve this connection in a variety of ways. Sander maintained a respectful distance from his sitters and allowed them to have some control over how they appeared before his lens. *Face of Our Time* presents a cross section of the German nation organized according to occupational and social types. Starting with portraits of farmers, it ends with portraits of those that later the Nazis would describe as 'degenerate': the sick, disabled and insane, gypsies and beggars. Its heterogeneity is why the Nazis destroyed copies of both the book and the publisher's printing blocks in 1936.

In France, the Popular Front came to power in 1936 and passed a law guaranteeing French workers two weeks of paid vacation. The work of photographer Henri Cartier-Bresson (1908–2004) responded to the political changes and his approach to photography went from an intuitive, personal aesthetic to a more socially engaged practice. His *Juvisy, France* (1938; see p.302) references the progress of workers' rights under the new left-wing government while acknowledging the spectre of fascism and an air of unease. **PS**

Young Farmers 1914
AUGUST SANDER 1876 – 1964

Silver print
9 ⅛ x 6 ⅛ in. | 23 x 17 cm
Die Photographische Sammlung/SK Stiftung Kultur,
Cologne, Germany

◈ NAVIGATOR

August Sander had the idea to make a comprehensive portrait of German society of his time. Titled *People of the 20th Century*, he intended to publish the project as a collection of *c.* 500–600 photographs, however, this ambitious project remained a work in progress. In 1929 Sander published sixty portraits from the collection as a book—*Antlitz der Zeit: 60 Fotos Deutscher Menschen* (*Face of Our Time*)—organized according to occupational and social types. Sander defined his sitters according to where they appear in the book as much as how they look in a single photograph. This image is one of several portraits of farmers at the beginning of *Face of Our Time*. Many of the book's portraits share its full-length format, which lends the work a sense of objectivity and regularity. The three men exemplify the strong agrarian roots that endured in Germany despite its rapid industrialization. Yet their modern suits and cigarettes allude to changes that threatened traditional ways of life. **PS**

◉ FOCAL POINTS

1 CENTRAL FIGURE
The slight smirk on the face of the central figure embodies the captivating contradictions of Sander's project. The young man's nonchalance reads as a desire to leave behind his—and his country's—agrarian roots. His suspicious gaze signals hostility towards the camera's documentary eye.

2 HORIZON LINE
The high horizon line and blurry background help to focus attention on the farmers. The viewer's eye is drawn by the horizon line cutting across the men at neck level. To define their identity, Sander placed his subjects in settings that were familiar to them—in this instance the countryside.

3 SUITS
The three farmers' smart dark suits indicate that they are dressed to look at home in a modern city, which is the likely destination of their journey because the image is also known as *Young Farmers on Way to a Dance.* Yet their urban clothing clashes with the rural setting, capturing the tension between the modern and traditional ways of life present in early 20th-century Germany. Sander's portrait presents social identity in flux.

4 SHOES
Despite the men's dapper dress, their worn, dirty shoes reveal their farming roots. Clear visual cues, such as tools and attire, shape the identity of Sander's subjects. This allowed him to present them objectively, as if capturing what appears before the camera's lens indifferently.

5 WALKING CANES
While adding to the men's debonair appearance, their walking canes also ground them in the soil. Together with their formal suits and similar poses, the canes emphasize conformity rather than individualism. They signify both bourgeois style and a connection to the land.

⏱ PHOTOGRAPHER PROFILE

1876–1908
Born in Germany, August Sander worked as a miner before doing military service from 1897 to 1899. In 1901, he started working at a photographic studio in Linz, Austria.

1909–43
Sander returned to Germany and in 1910 opened a studio in Cologne and began his *People of the 20th Century* portrait archive. *Face of Our Time* was published in 1929 but it was banned by the Nazi regime in 1936. He mixed with the Gruppe Progressiver Künstler Köln (Cologne Progressive Artists Group).

1944–64
Sander's studio was bombed during World War II and many of his negatives were destroyed. However, after the war he continued to take photographs and to work on various projects.

Juvisy, France 1938

HENRI CARTIER-BRESSON 1908 – 2004

Silver print
9 ⅛ x 13 ¾ in. | 23.5 x 35 cm
Museum of Modern Art, New York, USA

Trained as a painter, Henri Cartier-Bresson references the Impressionist tradition of depicting Parisian workers spending a leisurely afternoon outside the city at Juvisy. He creates an image that appears informal yet is profoundly symbolic. It addresses everyday social activity at a time of uncertainty in France because of the Great Depression and the palpable threat of fascism in the 1930s. Shedding their jackets and enjoying a picnic, the city dwellers seem all too willing to turn away from the pressing social and political concerns of the time. However, Cartier-Bresson's focus on their carefree behaviour and the awkwardness of their makeshift meal constitute a subtle commentary on society's inattention to its possible future. **PS**

⊙ FOCAL POINTS

1 BOAT
The boat provides the only indication of spatial depth in the upper half of the composition and recalls Claude Monet's studies of reflections. The image used to be known as *Sunday on the Banks of the Marne*, referencing Georges-Pierre Seurat's *A Sunday on La Grand Jatte—1884* (1884–86).

2 WATER
The expanse of still water in the upper half flattens the composition and focuses attention on the figures on the bank. There is no horizon line or view to the other side of the river. The bare space contrasts sharply with the activity of the foreground and its strongly articulated sense of depth.

3 WOMAN IN CAMISOLE
Cartier-Bresson photographs the group, including the woman who has stripped down to her camisole, from behind. This adds to the apparent spontaneity of the composition, as if the workers are oblivious to his presence. Spontaneity is a key part of his desire to capture the 'decisive moment'.

4 EMPTY PLATES
The empty plates and overturned bottles in the foreground define the activity taking place. They add to a sense of overindulgence, which is also alluded to by the workers' rotund bodies. Rather than idealizing the working class, Cartier-Bresson strives to show their human failings.

5 FLAT CAP
A flat cap was typical attire for a working-class man of the time. The wearer's face and those of his companions are unseen. They are symbolic of a type rather than individuals. Cartier-Bresson links a scene of relaxation to contemporary advances in workers' rights by the left-wing government.

✦ NAVIGATOR

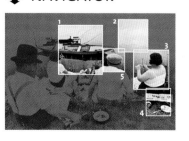

SOCIAL DOCUMENTARY IN THE USA

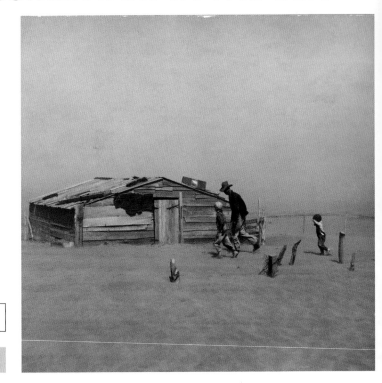

1 *Farmer and Sons Walking in the Face of a Dust Storm* (1936)
Arthur Rothstein • silver print
8 x 10 in. | 20.5 x 25.5 cm
Library of Congress,
Washington, DC, USA

2 *White Angel Bread Line, San Francisco* (1933)
Dorothea Lange • silver print
10 ¾ x 8 ⅞ in. | 27.5 x 22.5 cm
Museum of Modern Art, New York, USA

As demonstrated by the earlier work of Jacob Riis (1849–1914) and Lewis Hine (1874–1940), documentary photography often responds to moments of social hardship. Like their US predecessors, photographers who worked for the Farm Security Administration (first known as the Resettlement Administration) sought to bring attention to those suffering in society. Initiated in 1935, the body aimed to counteract the devastating social and economic effects of the Great Depression (1929–*c.* 1940) by overseeing loans, setting up migrant camps and assisting distressed farmers to relocate to more economically prosperous regions.

The Farm Security Administration (FSA) established an historical section to document its activities and advocate for government aid, hiring economics instructor Roy Stryker (1893–1975) as its director. Stryker had no background in photography but he was key in shaping the appearance and purpose of photographs produced for the FSA, and launched the careers of some of the 20th century's most famous US photographers. The FSA employed twenty photographers, and the Library of Congress, Washington holds a collection

KEY EVENTS

1929	1931	1933	1933	1935	1935
The Wall Street Crash in October heralds the start of the Great Depression.	The price of US cotton plummets to six cents a pound.	US President Franklin D. Roosevelt begins a series of economic programmes known as the 'New Deal' to tackle the effects of the Great Depression.	Dust storms rip across the Southern and Central Great Plains in the United States, removing topsoil and devastating farmlands.	Roosevelt creates the Resettlement Administration to relocate struggling families and build relief camps.	Roy Stryker sends Ben Shahn to Pulaski County, Arkansas to document the struggle of cotton pickers and sharecroppers.

of some 77,000 images made between 1935 and 1942. In an effort to educate the public, these photographs appeared in a variety of media, including magazines, flyers and government-sponsored exhibitions and brochures. Decisions about framing, printing and subject matter were determined by bureaucratic needs rather than by artistic impulses. Stryker assigned the locations that photographers visited and told them what kind of subjects to depict. Initially, Stryker was almost exclusively responsible for reviewing images and determining which ones were suitable for print. It was important that FSA photographs appeared unbiased. Stryker cultivated an approach that reinforced associations of photography with fact, and the ability to present the FSA's perspective and interests as the unmediated truth is what made its photographs so effective.

Photographers developed a variety of ways to align their work with objectivity. Arthur Rothstein (1915–85) was one of the first photographers hired to work for the FSA. His *Farmer and Sons Walking in the Face of a Dust Storm* (opposite) was taken during the Dust Bowl era—which lasted for most of the 1930s—when drought and poor farming practices caused a series of devastating dust storms in Texas, Oklahoma and the surrounding Great Plains. Shot in Cimarron County, Oklahoma, the image shows a father and two young sons bracing themselves against the wind of a dust storm, which has partially buried their farmhouse shown behind them. Caught in a moment of crisis, the three figures appear to be unaware of the camera's presence, which ensures the image's immediacy. Rothstein shot the figures from a distance, as if he spotted them running across the landscape. While adding to the effect of spontaneity, this distance emphasizes the brutality of the landscape. The bareness of the ground and its similarity to the sky above reinforces the farmer's disorientation.

Dorothea Lange (1895–1965) had already developed a strikingly effective way of documenting victims of the Great Depression in San Francisco when Stryker hired her in 1935. Her *White Angel Bread Line, San Francisco* (right) has the symbolic resonance that Stryker wanted to cultivate for the FSA. Its title references a wealthy San Francisco woman, who became known as the 'white angel' when she established a soup kitchen to feed the hungry. By capturing a crowd of people, Lange communicates the great need for public services. Yet she focuses on a single man, who has turned away from the group in a moment of contemplation. Rather than isolating his face, which is hidden by his weathered hat, Lange tells the story of the Depression through his stance; the inability of the men to support themselves financially correlates to their struggle to stand erect, and he leans against a wooden railing for support. His hands symbolize a lifetime of labour and are posed in a gesture that pleads for assistance. Symbolism features in much of Lange's work for the FSA, notably her photograph of a mother and her children on the brink of starvation, *Migrant Mother, Nipomo, California* (1936; see p.310), which brought attention to the hardship of Californian farmers.

1936	1937	1937	1937	1937	1942
Henry Luce hires Margaret Bourke-White as the first female photojournalist for *Life* magazine.	The Resettlement Administration is folded into a new body and renamed the Farm Security Administration (FSA).	Walker Evans leaves the FSA and returns to New York where he prepares his photographs for the book *Let Us Now Praise Famous Men*.	Margaret Bourke-White and Erskine Caldwell publish *You Have Seen their Faces*.	Arthur Rothstein travels to Gee's Bend, Alabama to photograph tenant farmers for the FSA.	The FSA's photographic unit transfers to the Office of War Information.

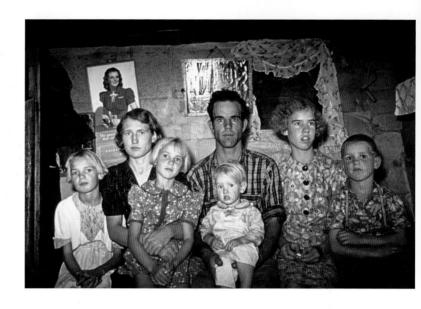

FSA photographers constructed an image of US identity as being strong and resilient at a moment of economic collapse. For many, the Great Depression signified the need to return to traditional values and a simpler way of life. Rather than focusing on modernization and technology, FSA photography presents the farmer as the backbone of US society. As in Lange's *Migrant Mother*, FSA photographs often present women as mothers and wives, roles that reinforce traditional notions of gender relations and familial stability. A portrait titled *Jack Whinery, Homesteader, and his Family, Pie Town, New Mexico* (above) by Russell Lee (1903–86) shows members of a community formed by migrant farmers from the Dust Bowl in Texas and Oklahoma. It exemplifies how FSA photography used the family unit to promote traditional US values. Lee depicts a father and mother with five children, rather than the extended family that was most common in farm life. The presence of Whinery's young children underscores the family's vulnerability and helplessness. The portrait encourages compassion by defining a concept of family most identifiable to a contemporary urban audience. FSA photographers began to use Kodachrome film in 1939 and the use of colour in Lee's image encourages the viewer to connect with the sitters. Yet Lee marks the difference between the Whinerys' circumstances and more affluent lifestyles. The fashionable dress and manicured appearance of the woman shown in the advertisement that decorates the Whinery family's home contrasts with the plain face of the woman sitting below it. The juxtaposition calls attention to the disparity between the lives of those hardest hit by the economic downturn and the fantasies constructed by a growing consumer culture.

Ben Shahn (1898–1969) was an established printmaker and painter when he joined the FSA. Shahn's image of a deputy sheriff during a strike in Morgantown, West Virginia (opposite below) looks as if it was literally shot from the hip, providing an unconventional view of the rear of a police officer and a blurred car in motion to the right. Despite the apparent spontaneity of the photograph, Shahn has composed it deliberately so that the police officer's head is cut off and the focus is on his gun, which resonates as a symbol of authority and power.

Despite their bureaucratic role, most FSA photographers managed to develop a unique approach to their work while fulfilling the needs of the institution. However, some photographers bristled under the FSA's rigid control

3

4

5

3 *Jack Whinery, Homesteader, and his Family, Pie Town, New Mexico* (1940)
Russell Lee • colour film copy slide
Library of Congress,
Washington, DC, USA

4 *St Tammany Parish, Louisiana* (1937)
Margaret Bourke-White
photomechanical print
Library of Congress,
Washington, DC, USA

5 *Deputy in West Virginia Mining Town* (1935)
Ben Shahn • silver print
6 ⅛ x 9 ½ in. | 15.5 x 24 cm
Museum of Modern Art, New York, USA

and Walker Evans (1903–75) notoriously rebelled against Stryker's authority as he sought to create photographs that he saw as a pure record of events rather than propaganda. Such a belief brought him into conflict with Stryker, who required photographs that would be useful to the agency in promoting social change, and Evans left the FSA in 1937. But Evans's time at the institution was not wasted and it was during a leave of absence in 1936 that he shot a series of photographs that would be used later in his book *Let Us Now Praise Famous Men* (1941), and which includes *Alabama Tenant Farmer Wife* (1936; see p.308). Co-authored with James Agee, it documents the lives of those suffering from the effects of the Great Depression in the southern part of the United States.

ST. TAMMANY PARISH, LOUISIANA. "I've only been misbehaving."

The documentary approach to photography developed by FSA photographers influenced an entire generation of photojournalists. Carl Mydans (1907–2004) began his photographic career with the FSA in 1935 and was quickly hired away by *Life* magazine in 1936. From his time working at the FSA, Mydans learnt to communicate social circumstances efficiently by including text. Margaret Bourke-White (1904–71) also mastered the subtleties of documentary style, although she never worked for the FSA. Bourke-White was commissioned by the Otis Steel Company in 1927 to take promotional photographs of its factories in Cleveland, Ohio. The commission led to her employment as a photographer for *Fortune* and *Life* magazines. In addition to being the first photojournalist allowed into the Soviet Union, she devoted much of her work to documenting the social hardships of people in the United States. With novelist Erskine Caldwell, Bourke-White published the book *You Have Seen their Faces* in 1937, which tells the story of the American South in the Great Depression. It captures the disparity between the lives of poor African American Southerners and the American dream at a time when many activists were unconvinced that the New Deal responded sufficiently to the needs of African Americans. Text plays a key role in the book, both working alongside and within the images. Bourke-White took the pictures and Caldwell wrote the body of the text; both wrote the first-person captions rather than quoting what people may have said. Bourke-White's photograph (right) of an African American man looking through the bars of a jail cell in St Tammany Parish, Louisiana is captioned: 'I've only been misbehaving.' **PS**

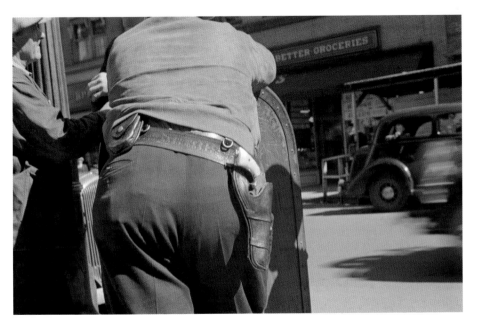

Alabama Tenant Farmer Wife 1936

WALKER EVANS 1903 – 75

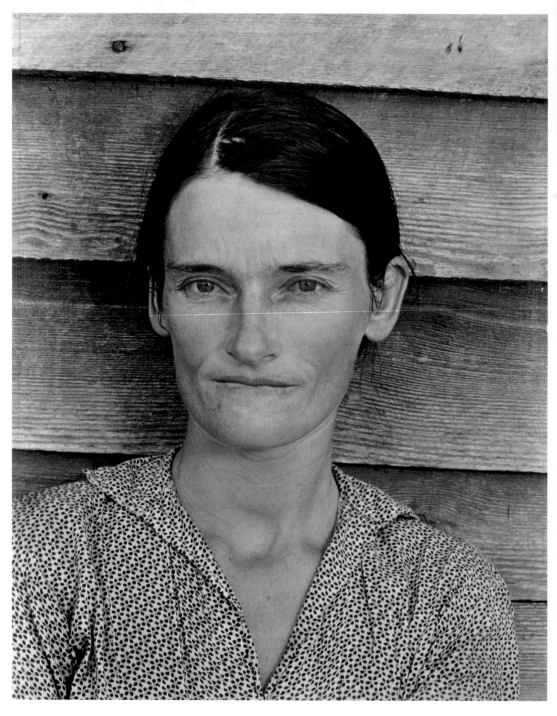

Silver print
8 x 10 in. | 20.5 x 25.5 cm
Walker Evans Archive, Metropolitan Museum
of Art, New York, USA

W alker Evans struggled with the conventions of documentary photography to which the Farm Security Administration wanted him to conform. Often he rebelled against the requests of his supervisor. Eventually, he set out to prove the intellectual sophistication of documentary photography and reinvented the genre as a way to spark an original way of seeing. *Let Us Now Praise Famous Men* (1941; see panel), a book he produced with writer James Agee, is one of Evans's most successful attempts at such a reinvention.

The book chronicles the lives of three families of poor cotton farmers in Alabama. While the need to inform viewers about the poverty of the nation's farmers was central to the project, *Let Us Now Praise Famous Men* introduces Evans's independent sense of composition, marked by sparse, geometric spaces and subtle rhetorical juxtapositions. Evans made four images of Allie Mae Burroughs outside the family's simple home. In others in the series, she looks more comfortable and welcoming. However, Evans chose this portrait for *Let Us Now Praise Famous Men*, because her intense expression echoes the starkness of her environment. The close proximity of the portrait traps the woman in the shallow space between the wall and the camera. **PS**

◉ FOCAL POINTS

1 WOODEN PLANKS
The broad lines of the wooden boards create a stark, abstract composition. The bare planks unite the photographs of the family and anchor them in a common time and place. Many of the photographs Evans took of the Burroughs family in 1936 are set against the side of their house.

2 THIN LIPS
The thin line of Burroughs's lips echoes the linear pattern of the wooden boards behind her, which Evans uses to help shape the complex psychology of his sitter. While Evans took other photographs of Burroughs in which she appears more at ease, here she seems hardened and world-weary.

3 BLOUSE
The dotted pattern of the blouse contrasts with the linear texture of the wood behind Burroughs. Such areas flatten the composition and underline her discomfort. This composition reveals Evans's familiarity with the formalism and dynamic abstraction of European modernism.

LET US NOW PRAISE FAMOUS MEN

James Agee and Walker Evans travelled to Alabama in 1936 to document the lives of white sharecroppers for *Fortune* magazine. When *Fortune* lost interest in the project, Evans and Agee published their work as a book—*Let Us Now Praise Famous Men*—in 1941 (below). Evans took most of the photographs while staying with the Burroughs family in their four-room cabin in August 1936. While Agee and Evans's project can be characterized as an ethnographic study of the daily lives of those hardest hit by the Great Depression, the book is also an experiment in the relationship between photography and text. In the original edition all thirty-one of Evans's images appear as a portfolio between the front cover and the title page, which is followed by Agee's long essay. Rather than allowing Agee's

words to explain and comment on Evans's imagery, the book's format announces that the two modes of communication, photography and text, are separate but equal. Through the sequencing of his images, Evans asserted the ability of his photographs to tell a story on their own.

Migrant Mother, Nipomo, California 1936
DOROTHEA LANGE 1895 – 1965

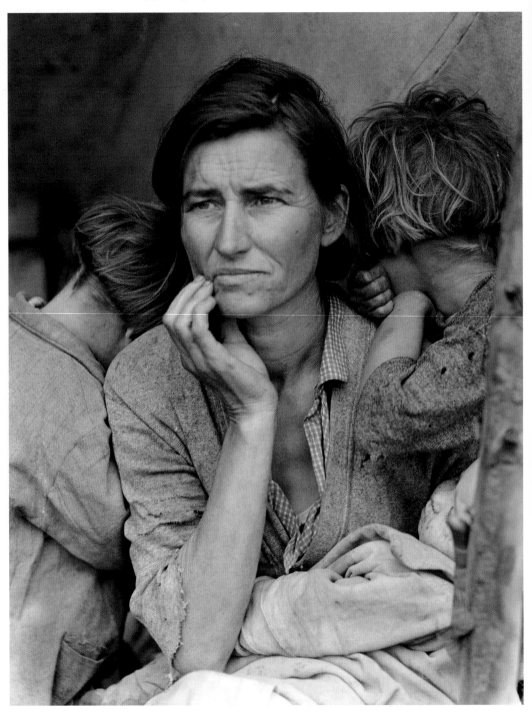

Silver print
11 ⅛ x 8 ⅝ in. | 28.5 x 22 cm
Museum of Modern Art,
New York, USA

Dorothea Lange's *Migrant Mother, Nipomo, California* is emblematic of the struggle of the Great Depression in the United States and is perhaps the best-known photograph produced as part of the Farm Security Administration project. Lange claimed that she came upon the woman and her seven children accidentally and took a series of photographs of this migrant agricultural family in only ten minutes. This narrative reinforces the documentary value of the image and assures viewers that they are encountering an authentic moment in the woman's life.

At the same time the image conforms to the conventions of portrayal that Lange cultivated as a Farm Security Administration photographer. Lange focuses on a single person and portrays her as an archetype not an individual, depicting the victims of the Depression through the traditional leitmotif of motherhood and family. Lange did not report the name of the woman but decades later it was revealed that she is Florence Owens Thompson, who grew up on the Indian Territory of the Cherokee Nation in Oklahoma. Both of Thompson's parents claimed blood rights to the Cherokee Indians. Lange cast Thompson as Madonna, a symbol of dignity and virtue from a Christian tradition that might have been different from her own beliefs. Lange's choice to disregard Thompson's identity complicates the transparent status of documentary photography and the image of US values that the FSA was attempting to define. **PS**

FOCAL POINTS

1 MOTHER
Florence Owens Thompson is central to Lange's image. Thompson continued travelling around California in search of work and became involved in efforts to organize and advocate for farm labour. Years later she expressed displeasure that Lange's images eternalized her identity as poor.

2 TENT
The stitching of a makeshift tent where the family was living is just visible in the background, hinting at their dislocation. The image includes little else to distract from the mother's bleak expression. The lack of context emphasizes the rootlessness experienced by the farmers.

3 MOTHER'S HAND
Often Lange focused on hands in her photographs as symbols of hard work and endurance. The mother brings her hand to her mouth in a gesture of hardship and concern. Her dirty fingernails and weathered skin attest to the laborious life of migrant farmers during the Great Depression.

4 CHILD LEANING
A child leans against the mother for support. This child is mirrored by another child leaning on the other side; together they frame the mother's figure. Lange poses each child with their face turned away, so they do not distract from their mother's distraught expression.

PHOTOGRAPHER PROFILE

1895–1917
Dorothea Nutzhorn was born in Hoboken, New Jersey. She adopted her mother's maiden name 'Lange' after her father abandoned the family when she was a child. In 1917 she began to study photography under Clarence H. White (1871–1925) at New York's Columbia University.

1918–41
Lange moved to San Francisco, where she opened a successful portrait studio. When the Great Depression took hold, she started to use photography as a way to advocate for the poor and hungry. Lange was hired by the Resettlement Administration (later the Farm Security Administration) in 1935.

1942–65
During World War II, Lange worked for the War Relocation Authority photographing Japanese-Americans who were relocated to internment camps, and then from 1943 for the Office of War Information. After the war, she began to teach on the first fine art photography course at the California School of Fine Arts. In 1952 Lange co-founded the photographic magazine *Aperture*. She died in 1965.

WORLD WAR II PHOTOGRAPHY

World War II broke out in the year of photography's centenary. The bulky, tripod-supported box cameras of the mid 19th century, with their heavy glass plates, had given way to more portable, hand-held models. War photographers were no longer confined to subjects such as fortification lines, posed groupings of troops behind the lines or the corpse-strewn aftermath of a battle. Moreover, the plethora of illustrated photo magazines provided a steady market for the imagery of conflict.

It was not only journals that realized the power of war photography. Governments also recognized the need to convey a positive propaganda message to their allies and enemies, to the public and even to their own beleaguered forces. Britain entered the war in 1939 and its government rapidly set up a Ministry of Information, responsible for information policy and to produce propaganda for Allied and neutral countries. Among the photographers it employed was Bill Brandt (1904–83), who had made a name for himself with his studies of life in modern Britain published in *Lilliput* and *Picture Post*. When Germany's strategic bombing of Britain began in 1940, Brandt was commissioned to take pictures to show how well Londoners were coping with the relentless

air raids. The ministry sent Brandt's photographs to Washington, DC as part of the effort to persuade the United States to join the war on the Allies' side.

Soviet photojournalists were required to serve in the war. Dmitri Baltermants (1912–90) joined the Soviet army as captain and staff photographer for the Communist Party newspaper *Izvestia* in June 1941. He was injured twice during the war, once nearly losing a leg. On 2 October 1941, only months after Baltermants joined the theatre of war, Adolf Hitler's army began its advance on Moscow. Baltermants's picture *Attack* (opposite) was taken during the Soviet counter-action that winter. It shows infantrymen with bayonets leaping across a foxhole during a charge. Taken from a low angle and dramatically cropped, it conveys a sense of a relentless and fearless army. The photograph was criticized when it was first published, however, because it depicts 'half a man' and was therefore not in keeping with the tenets of Socialist Realism.

Old Glory Goes Up on Mt Suribachi, Iwo Jima (below) by Joe Rosenthal (1911–2006)—better known as *Raising the Flag on Iwo Jima*—is a classic example of war photography used as propaganda. It depicts US marines and a navy corpsman raising the Stars and Stripes on top of Mount Suribachi. The capture of the island of Iwo Jima was highly significant because it was the first part of Japan to be conquered by the Allies. A flag was raised on the morning of 23 February 1945, but was later given to the Secretary of the Navy as a souvenir. Not wanting the strategic point left empty, the military found a second flag to

1 *Attack* (1941)
Dmitri Baltermants • silver print
10 ½ x 16 ⅛ in. | 26.5 x 41 cm
Private collection

2 *Old Glory Goes Up on Mt Suribachi, Iwo Jima* (1945)
Joe Rosenthal • silver print
13 ⅝ x 10 ⅜ in. | 34.5 x 26.5 cm
George Eastman House, Rochester, New York, USA

1945	1945	1945	1945	1945	1945
The British 11th Armoured Division liberates Bergen-Belsen camp on 15 April. George Rodger is the first photographer there.	The US 7th Army liberates Dachau concentration camp on 29 April.	Soviet army troops capture the Reichstag on 30 April during the Battle of Berlin. Yevgeny Khaldei recreates the moment on film (see p.318).	The Allies accept the unconditional surrender of Nazi Germany on 8 May, Victory in Europe (V-E) Day.	Atomic bombs are dropped on Hiroshima and Nagasaki on 6 and 9 August respectively. US forces photograph the resultant mushroom clouds.	Japan announces its surrender in the afternoon of 15 August (local time, 14 August in other areas), effectively ending World War II.

3

4

5

3 *Former camp guard Anneliese Kohlmann is forced to bury the victims at the liberated Bergen-Belsen concentration camp* (1945)
George Rodger • silver print
39 ⅜ x 33 ¾ in. | 100 x 86 cm
Time Life Pictures/Getty Images

4 *V-J Day in Times Square* (1945)
Alfred Eisenstaedt • silver print
17 ⅜ x 13 ¼ in. | 44 x 33 cm
Time Life Pictures/Getty Images

5 *Dead SS Guard Floating in Canal* (1945)
Lee Miller • silver print
46 ½ x 83 ½ in. | 118 x 212 cm
Lee Miller Archives, Chiddingly, UK

take its place, and Rosenthal, using a Speed Graphic camera, photographed it being raised. His negative was quickly printed and Associated Press sent the image to New York in less than a day.

President Franklin D. Roosevelt soon grasped the impact of the image and decided to use it as a symbol for a forthcoming war bond drive, ordering that the marines in the photograph be identified and called home. Three of the marines who had raised the flag helped to garner US$26.3 billion on a fundraising tour. The image has been reproduced in numerous forms, most notably as the basis for the US Marine Corps War Memorial in Arlington, Virginia. Such was its influence that Soviet photographer Yevgeny Khaldei (1917–97) sought to create a similar impact two months later with *The Red Flag on the Reichstag, Berlin* (1945; see p.318). Rosenthal's photograph won him the Pulitzer Prize for Photography in 1945 despite the fact that some refused to believe that such a powerful composition had come about by chance.

British photographer George Rodger (1908–95) reported for *Life* magazine, travelling extensively through all the major war zones. In 1945, he was one of the first people to enter Bergen-Belsen concentration camp in Lower Saxony, when it was liberated in April of that year. Rodger described his experience: 'The dead were lying around, 4,000 of them, and I found I was getting bodies into photographic compositions. And I said my God what has happened to me? ...It had to be photographed because people had to know and so I just couldn't just leave it....But at the same time I swore I would never take another war picture and I didn't. That was the end.' His photograph of former camp guard Anneliese Kohlmann being forced to bury bodies at Bergen-Belsen (above) is both a powerful visual testimony to the Holocaust and a symbol of a murderous regime forced to acknowledge its crimes. Kohlmann served as one of only six women guards at the Neugraben camp at Hamburg, but had escaped, exchanged her SS uniform for prisoner clothes and cycled to Belsen. She was recognized by former prisoners and arrested, and became one of the SS personnel whom the

Allies forced to bury bodies at the typhus-ridden camp. After the war she was found guilty of war crimes and sentenced to two years' imprisonment.

Lee Miller (1907–77), a former model and Surrealist artist (see p.232), became a war correspondent for Condé Nast and was the only official female photojournalist in combat areas. She covered the liberation of Dachau concentration camp, and later said: 'I could never get the stench of Dachau out of my nostrils.' Her photograph *Dead SS Guard Floating in Canal* (below) evokes a range of responses regarding humanity and inhumanity. A corpse of a German soldier is partially submerged in the murky waters of a canal; light dapples across the water and the viewer is struck both by his youth and by the impression that he is at peace. The 'enemy' here appears in the guise of a dead son or lover.

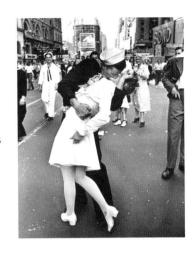

It seems fitting that it was the Jewish-German photographer Alfred Eisenstaedt (1898–1995) who took one of the most iconic images of the war's end, *V-J Day in Times Square* (right). Eisenstaedt had worked as a freelancer in Germany, where he had photographed both Hitler and Joseph Goebbels, but immigrated to the United States in 1935 to escape growing anti-Semitism. His picture of a sailor kissing a nurse in celebration of Japan's surrender captures the euphoria of the Allies when the war ended on 14 August 1945. A sailor and a nurse, symbolizing the troops and the medical corps that supported them, are finally freed from duty and, for one exhilarating day, from social convention.

The term 'embedded photographer' only came into common use in the 21st century, but the idea of a freelance photographer accompanying the military to document its efforts was not new. Combat photographers joined the Allied forces in North Africa and Europe during World War II. In the case of Robert Capa (1913–54), his photographs of the D-Day landing on Omaha Beach in France (1944; see p.316) suggested that the photographer had exposed himself to the same dangers as the troops. If such images were sometimes slightly blurred or out of focus, it seemingly only enhanced the verité of their visual accounts. **CK**

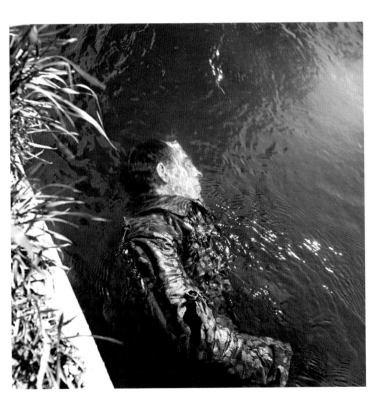

Omaha Beach, Normandy, France 1944
ROBERT CAPA 1913 – 54

*American Soldiers Landing on Omaha
Beach, D-Day, Normandy, France,
June 6, 1944*
Silver print
10 ⅝ x 16 in. | 40.5 x 51 cm
International Center of Photography,
New York, USA

World War II saw Robert Capa visit various parts of the European theatre of combat as the Allies' only 'enemy alien' photographer. One of his assignments was to cover the Allied invasion of north-west Europe, code named Operation Overlord, which took him to Omaha Beach on 6 June 1944 to cover D-Day. He swam ashore with Company E of the 16th Regiment of the 1st Infantry Division of the US army. By then an experienced combat photographer, Capa said of his decision to witness one of the largest amphibious military assaults in history: 'The war correspondent has his stake—his life—in his own hands, and he can put it on this horse or that horse, or he can put it back in his pocket at the very last minute. . . .I am a gambler. I decided to go in with Company E in the first wave.'

Capa took two Contax II cameras mounted with 50mm lenses and several rolls of spare film with him. During the first few hours of the Normandy invasion he shot 106 photographs. Caught under heavy fire, Capa was lucky to escape unscathed. He did so by making for a landing craft that took him to the English shore at Weymouth in Dorset; from there the negatives were taken by motorcycle courier to the London office of *Life* magazine. Capa returned to France the next day. However, in the rush to develop the images at the *Life* bureau in London, a fifteen-year-old darkroom assistant made an error: he set the dryer too high and melted the emulsion in the negatives. Only eleven negatives were recovered and *Life* published five of the images on 19 June. Although blurred and grainy, the photographs demonstrated that the Allies were finally making their advance into war-torn Europe. Capa's photographs provided the definitive image of that heroic day for future generations. **CK**

✪ NAVIGATOR

👁 FOCAL POINTS

1 LANDING CRAFT
A group of landing craft is shown behind the subject, bizarre steel structures poking out of the water like spectral mechanized insects. Their inclusion demonstrates the vast scale of the invasion and the Allies' military power as the craft are ready to spit out more men on to the beach.

2 GRAINY SMOKE
The lack of definition in this imperfect, grainy photograph accentuates the fact that it is a smoke-filled action shot taken at dawn. Ironically, the mistake made by an assistant when developing the film may have contributed to the distinctively distorted appearance of the surviving exposures.

3 GI'S FACE
The GI looks straight ahead. Although facing a smoke-ridden beach and machine gun fire, he does not flinch from facing the enemy. Capa's photograph documents the soldier's courage and was a perfect propaganda tool for the Allies to show their resolve in defeating the Nazis.

4 VIEWPOINT
Capa is close to the action, as is evident in his proximity to the GI crawling towards the beach. Capa stood in the stern of his landing craft and then swam ashore to take photographs of the men arriving. It was a dangerous assignment and the photographer and the troops came under heavy fire. The Allies carried their waterproofed rifles with them, and the subject's right arm is extended and almost hugging his firearm, ready to go into action.

5 BLURRING
The blurriness of the image adds to its dynamism. Capa admitted that his hands were trembling and his body shook as 'the bullets tore holes in the water around me. . . .' Casualties were heaviest among the troops that landed at each end of Omaha, including 'Easy Red' beach where Capa took this shot. Steven Spielberg tried to echo the imperfect look of Capa's images for the landing sequence in *Saving Private Ryan* (1998) by stripping the coating from his camera lenses.

CAPA AND WORLD WAR II

Robert Capa's D-Day shots were slightly out of focus because his hands were shaking as he photographed the battle unfolding around him. Capa (right, with his Rolleiflex camera in Arras, France, in March 1945) later used the words as the title of his autobiographical account of World War II (1947). When war broke out, the Hungarian-born photographer was in the United States and, technically, an enemy alien. He first worked for *Collier's Weekly* and joined the Allied convoy to North Africa in 1942 before moving to *Life*. Capa parachuted into Sicily in July 1943 with US paratroopers when the island was liberated and then headed to mainland Italy, where he photographed the Naples post office bombing. Later that year he went on to Monte Cassino and then France, where he photographed the liberation of Paris in 1944. He continued with the US army to the Ardennes in Belgium in December, where he took photographs at the Battle of the Bulge. In March 1945 he parachuted with US troops into Germany as they advanced on the Rhine, and went on to Berlin in August after the city had surrendered.

The Red Flag on the Reichstag, Berlin 1945
YEVGENY KHALDEI 1917 – 97

1 SMOKE
Two columns of smoke rise in the background, implying that the bloody Battle of Berlin is still taking place. In the original image the two plumes of smoke in the distance are very faint. Khaldei, therefore, chose to copy smoke from another photograph to increase the sense of drama.

2 THE REICHSTAG
The 19th-century building was important in German history as the seat of parliament, and during the Third Reich it was used for propaganda and military purposes. The Soviet capture of the building encapsulated the enemy's crushing defeat and was of great propaganda value.

Sometimes referred to as the 'Russian [Robert] Capa', Ukrainian photographer Yevgeny Khaldei worked for the Telegraph Agency of the Soviet Union throughout World War II, and his powerful images of the Red Army's advance across the European battlegounds helped to establish him as Russia's greatest combat photographer. His photograph of Soviet army troops raising the national flag on top of Berlin's crumbling Reichstag building commemorates the moment when Soviet forces captured the building on 30 April 1945, during the Battle of Berlin. The photograph appeared in *Ogonyok* on 13 May, after which it was widely published and became one of the defining images of the war.

The photograph was staged by Khaldei on the morning of 2 May, days after the event, because no one had photographed the flag-raising at the time, and he saw the opportunity to create a masterpiece akin to Joe Rosenthal's *Old Glory Goes Up on Mt Suribachi* taken earlier that year. Khaldei was not only seeking to create an iconic shot to glorify himself. As a Communist loyal to his motherland, he also realized the propaganda value that such a dramatic image would have in raising the spirits of his people, illustrating the Soviet Union's crushing victory over the Nazis and enacting revenge on behalf of the more than thirty million people who had died on the Eastern Front. The Nazi commander had capitulated only hours before Khaldei reconstructed the victorious moment by scaling the building with his Leica and some comrades whom he had persuaded to join him. He shot thirty-six photographs, which were edited later to appear more dramatic and to please the Soviet censors.

Although Khaldei's images were lauded at the time, they were published unaccredited and, shortly after the war, the photographer found himself struggling for work—as a Jew, he suffered under Joseph Stalin's anti-Semitic policy. It was only after the fall of the Berlin Wall that he was acknowledged as the author of this image and gained the recognition he deserved. **CK**

Silver print
8 x 11 in. | 20.5 x 28 cm
George Eastman House, Rochester, New York, USA

3 TROOPS
When the image was published on 13 May, the troops were claimed to be Mikhail Yegorov and—to make the Georgian-born Stalin happy—a Georgian, Meliton Kantaria. After the end of the Cold War, it was revealed that the man hoisting the flag was in fact a Ukrainian, Alyosha Kovalyov.

4 FLAG
Khaldei was keen to create an iconic image but had no flag with which to do it. Undeterred, he flew to Moscow, where he located three red tablecloths used for official functions. He spent the night sewing the hammer and sickle on to them before flying back to Berlin to take the photograph.

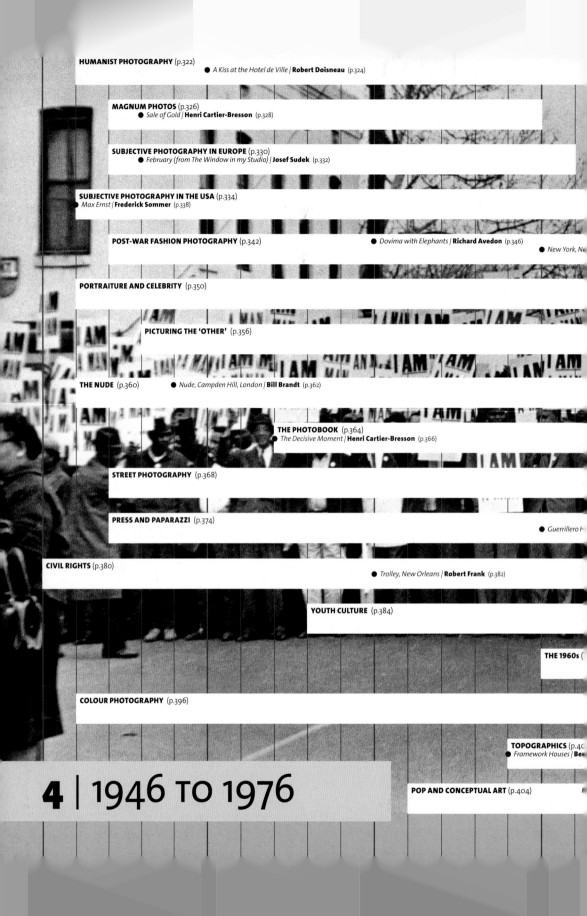

4 | 1946 TO 1976

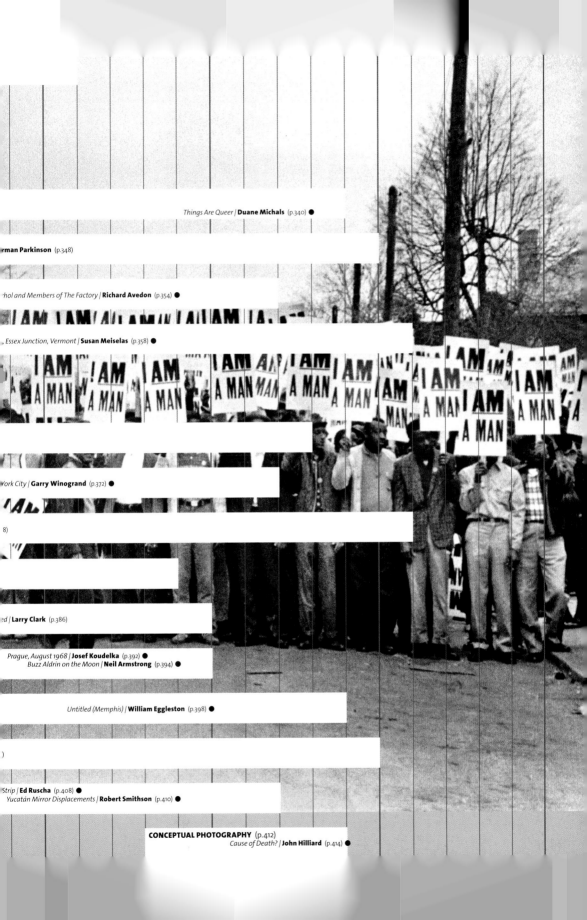

HUMANIST PHOTOGRAPHY

W idely considered to have its roots in the socially concerned, left-wing ideology of France in the 1930s, humanist photography became an established genre worldwide at the end of World War II. Its emergence coincided with a desire for renewal after the destruction and suffering brought about by the recent global conflict. A sub-genre of documentary photography, it was also a reaction to the perceived artificiality of modernist photography. Its defining characteristics included a focus on street life, everyday events and the misfits of society, as well as a general preference for the medium of black-and-white film rather than colour.

The most enduring humanist photography achieves a seemingly artless lyricism, suggesting spontaneity and immediacy, and echoes the work of Italian neorealist films of the 1940s and 1950s. The leading photographer associated with humanist photography, which was never a school or credo, was Henri Cartier-Bresson (1908–2004). Like many of his contemporaries, Cartier-Bresson provided popular magazines of the day with images that spoke of a universal human condition and captured something remarkable or emotionally engaging in scenes taken from daily life.

In the post-war period, photography was promoted as a transparent, universal language that could be understood by anyone. 'The Family of Man'—an epic exhibition of humanist photography—aimed to transmit a message of global solidarity through the medium of still images. Curated by Edward Steichen (1879–1973), the exhibition was first held in 1955 at the Museum of Modern Art in New York, after which it travelled the world and was

1 *Mother and Child, New York* (1953)
Elliott Erwitt • silver print
Magnum Photos

2 *Petite fille aux feuilles mortes* (1946)
Edouard Boubat • silver print
14 x 9 ⅜ in. | 35.5 x 23.5 cm
Herbert F. Johnson Museum of Art,
Cornell University, Ithaca, New York, USA

3 *The Walk to Paradise Garden* (1946)
W. Eugene Smith • silver print
12 ¼ x 10 ½ in. | 31.5 x 26.5 cm
Museum of Modern Art, New York, USA

KEY EVENTS

1946	1947	1951	1952	1954	1954
Henri Cartier-Bresson is given a solo exhibition at the Museum of Modern Art in New York.	Robert Capa (1913–54), Henri Cartier-Bresson, David 'Chim' Seymour (1911–56) and George Rodger (1908–95) found the Magnum agency.	W. Eugene Smith's notable photoessay 'Spanish Village', featuring the small village of Deleitosa, is published in *Life* magazine.	Cartier-Bresson's *Images à la sauvette* (*The Decisive Moment*) is published by Editions Verve in Paris.	Capa dies in Indochina, killed when he steps on a landmine while covering the First Indochina War.	Leica's new M3 camera has an advanced, combined rangefinder and viewfinder. Its bayonet mount allows lenses to be changed with one hand.

seen by approximately nine million visitors. The show featured work by prominent humanist photographers of the time, and included many images that had been sourced from back issues of the US magazine *Life*. The exhibition covered grand human narratives, drawing on enduring themes such as love, birth, old age, death and worship. The ideals of universal brotherhood and equality that ran through 'The Family of Man' were also an effective means by which to promote the democratic values that underpinned US imperialism in the Cold War era. This hidden political bias to the show has been much criticized by recent scholars. The exhibition continues to attract visitors today in its permanent location at the Castle of Clervaux in Luxembourg.

Humanist photographs often appear to represent unchoreographed 'slices of life', whether or not this was in fact the case. The moment of seemingly unguarded domestic intimacy caught in *Mother and Child, New York* (opposite), by the US photographer Elliott Erwitt (b.1928), features as its subjects his own wife, his six-day-old daughter and the family cat. The title of the photograph is typical of the humanist sensibility, which sought to examine universal themes by means of particular subjects. Erwitt only began taking photographs in 1949, during a trip to Europe, but rose rapidly to fame and joined the photojournalist agency Magnum (see p.326) in 1953.

The Kiss at the Hotel de Ville (*c*. 1950; see p.324), one of the signature images of Robert Doisneau (1912–94), was not included in 'The Family of Man'—Elliott's *Mother and Child* was included—although three images from the same series were shown in the exhibition's first section, on the theme of love. An exotic 'Frenchness' and a sense of joie de vivre, as well as the skilful capture of Cartier-Bresson's 'decisive moment', were at work in Doisneau's series on lovers.

A rather more wistful, nostalgic mood is evident in *Petite fille aux feuilles mortes* (above right) by Edouard Boubat (1923–99), which featured in 'The Family of Man' alongside other images of pensive children. Taken in the Jardin du Luxembourg in Paris, it was first shown at the National Salon of Photography, probably in 1946. Seen from behind, the little girl appears to be alone in an autumnal park, engaging the viewer on an emotional level despite, or perhaps because of, the fact that her expression is hidden from view.

After suffering shrapnel wounds on one of his photojournalistic expeditions with the US army during World War II, W. Eugene Smith (1918–78) was forced to spend a long period convalescing. *The Walk to Paradise Garden* (right), featuring Smith's own children Patrick and Juanita, was the first photograph he took after two years spent recovering in hospital under the impression that he might never be able to take a photograph again. Smith was determined to capture a 'gentle moment of spirited purity' in deliberate contrast to the depravity of war he had so recently witnessed. The allusion to the story of creation in the photograph's title lends symbolic resonance to the children's progress from darkness into dappled light. **MC**

1955	1956	1958	1959	1964	1966
Edward Steichen curates 'The Family of Man' at the Museum of Modern Art in New York. Three million copies of the catalogue are sold.	*Life Is Good & Good For You in New York*—a highly influential photostudy of New York street culture by William Klein (b.1928)—is published.	*The Americans* by Swiss-born Robert Frank (b.1924) is published in France by Robert Delpire. The US version is published in 1959, amid controversy.	Nikon presents the F model, the first reflex camera aimed at professionals. With the Leica M3, it becomes the standard choice for photoreporters.	Karl Pawek opens the first version of his 'World Exhibition of Photography' in West Germany, modelled on (and a subversion of) 'The Family of Man'.	Cornell Capa (1918–2008) sets up the International Fund for Concerned Photography to promote humanitarian documentary work.

The Kiss at the Hotel de Ville *c.* 1950

ROBERT DOISNEAU 1912 – 94

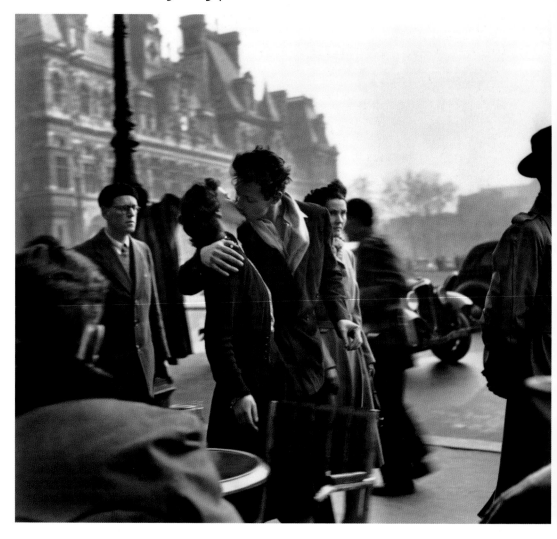

Silver print
Gamma-Rapho Agency, Paris, France

Robert Doisneau's *The Kiss at the Hotel de Ville* was part of a series of photographs for a feature on the theme of lovers in Paris during the springtime, which appeared in *Life* magazine in June 1950. The light-hearted photograph of a couple kissing outside the city hall was one of a sequence of studies of Parisian lovers seemingly snapped by Doisneau unawares. It offers a romantic twist on Doisneau's signature style, which was one of photographic *désobéissance* (naughtiness)—employing a humorous or unusual juxtaposition of opposites to create an arresting image that would take the viewer by surprise.

Although it looks as though the young lovers were oblivious to the photographer's presence, it was eventually revealed that Doisneau had paid two young actors, Françoise Delbart and Jacques Carteaud, to pose for him. Such is the fame of the photograph that in 1993 a lawsuit was filed against Doisneau by three individuals who claimed that they had not been paid their dues for posing for him in 1950. After a long and much publicized trial, the court decided in Doisneau's favour in 1994, the year that he died. **MC**

👁 FOCAL POINTS

1 HOTEL DE VILLE
The slightly blurred Hotel de Ville of the title, one of the most recognizable Parisian landmarks to foreigners and French alike, provides a grand metropolitan setting for this snatched intimate moment. The kissing couple and the citizens in the background around them are seen from the vantage point of a customer at a pavement cafe. The viewer is party to what is both an everyday scene and a perfect universal emblem of young love.

2 COUPLE
The lovers are in their early twenties and casually dressed. The young man's open shirt and big scarf and the young woman's unbuttoned cardigan are suggestive of a carefree, bohemian lifestyle, as is the fact that they are not wearing hats. The blurred imagery around them reinforces the sense of their kiss as a stylishly spontaneous, self-confident act: their focused figures offer a moment of calm assurance among the hazy rush of modern life around them.

3 KISS
Doisneau's photograph of a kissing couple promoted the image of the French as a romantic people who did not possess the same inhibitions as Americans. The subject offered a respite from some of the weightier issues in the news such as McCarthyism and the Cold War.

4 HANDS
A triangle of hands binds the couple together. The man holds the woman's shoulder firmly, a contrast with her own limp hand. His left hand casually holds a cigarette, suggestive of a certain type of (perhaps stereotypical) masculinity—protective, sensual and laid-back.

5 MONOCHROME
The gravity of tonal greys, blacks and whites lends the photograph a nostalgic atmosphere. Black-and-white film was the preferred choice for humanist photographers, despite the fact that colour film was readily available and had been used regularly in periodicals since World War II. Familiar from newspapers and magazines, the monochrome image invoked reportage for the contemporary viewer, implying that the photograph is of a scene from real life.

🕐 PHOTOGRAPHER PROFILE

1912–28
Robert Doisneau was born into a working-class family in Gentilly, Val-de-Marne, a Parisian suburb. His mother died when he was a young boy. He attended Gentilly's Ecole Communale but left at the age of thirteen, enrolling at the craft school Ecole Estienne in Chantilly. He studied engraving and lithography, and attended evening classes in drawing.

1929–33
In 1929, Doisneau graduated from the Ecole Estienne and began working as a draughtsman for design studio Atelier Ullmann. He later became assistant to the artist André Vigneau, who introduced him to his avant-garde circle of friends, including Man Ray (1890–1976) and Jacques Prévert. Doisneau's first photostory appeared in the French magazine *Excelsior* in 1932.

1934–39
In 1934 he married Pierrette Chaumaison and the same year he began working as a publicity photographer for Renault. He was fired five years later because of his lack of punctuality. In 1939, he met Charles Rado, the founder of the photographic agency Rapho, and began work as a freelance photographer. He joined the French army at the outbreak of World War II.

1940–46
Doisneau left the army to join the French Resistance, using his photographic skills to provide forged documents for its fighters. He photographed the Occupation and Liberation of Paris. He joined Rapho in 1946.

1947–60
Doisneau won the Kodak Photography Prize in 1947 and was soon attracting commissions from *Life* and *Vogue*. In 1952, he began using a Leica, which was more portable than his previous Rolleiflex. In 1956, he won the Niépce Photography Prize.

1961–94
During the 1960s, Doisneau experimented with photomontage and colour, but eventually returned to his favourite subject, the *banlieue* (suburb), in the 1970s. He died in 1994, six months after Pierrette. They are buried side by side in a churchyard in the forest of Rambouillet, France.

MAGNUM PHOTOS

1 *Vultures of the Battlefield* (1952)
Werner Bischof • silver print
Magnum Photos

2 *The Nubas* (1949)
George Rodger • silver print
Magnum Photos

3 *Pablo Picasso and Françoise Gilot* (1948)
Robert Capa • silver print
Magnum Photos

Magnum Photos was founded in 1947 by the photographers Robert Capa (1913–54), Henri Cartier-Bresson (1908–2004), George Rodger (1908–95) and David 'Chim' Seymour (1911–56). Following a cooperative model, the agency was intended to give its members independence from magazines, which until then had held on to the rights of photographs produced on assignment. Instead, Magnum photographers would pitch group projects to publications and focus on long-term personal projects funded in part by the resale of their images through the Magnum archive.

The idea of Magnum coalesced around Capa's dynamic leadership. As legend has it, Capa announced the agency's founding in New York's Museum of Modern Art over a bottle of champagne; his co-founders were all on assignment and telegrammed in their membership. With offices in New York and Paris, Magnum's members were assigned to cover global events.

Capa pitched ambitious group projects, such as 'People Are People the World Over' and 'Generation X', to magazines such as the *Ladies' Home Journal*, necessitating an expansion of the membership. During the next few years, the agency swelled. Swiss photographer Werner Bischof (1916–54) was the first to join in 1949. Like Magnum's founders, Bischof felt that photography had the ability to change public opinion, and he was wary of what he saw as the sensationalism and superficiality of the magazine business. His wry picture, sometimes known as *Vultures of the Battlefield* (above), taken in Kaesong,

KEY EVENTS

1947	1948	1949	1949	1951	1951
In the year of its foundation, *Ladies' Home Journal* funds Magnum's earliest group commission, 'People Are People the World Over'.	Henri Cartier-Bresson records Mohandas Karamchand 'Mahatma' Gandhi's lying in state and funeral in January.	Werner Bischof joins Magnum and a year later Austrian photographer Ernst Haas (1921–86) joins.	Magnum sends George Rodger to the mountains in the Kordofan province in Sudan, then almost unknown territory, to find the Nuba tribe.	Eve Arnold (1912–2012) joins Magnum. She becomes a full member in 1957.	Bischof documents the famine in the state of Bihar in India.

South Korea shows the tussle to capture a shot that he witnessed when he turned his camera on other photographers covering the Korean War; it reveals an element of disdain for his profession.

Early work produced by Magnum's photographers sits firmly within the wider move towards humanism in Europe after the horrors of World War II. However, Magnum's roots stretch back into the inter-war period. Capa, Cartier-Bresson and Seymour were working in France when the Spanish Civil War broke out. Capa and Seymour had already fled the rising tide of anti-Semitism in Eastern Europe, and all supported the French Popular Front's fight against the fascists. The war in Spain saw the combining of two of the key elements in early 20th-century photojournalism: the use of the hand-held camera and the birth of picture magazines. It was also the catalyst for Capa's rise to fame with photographs such as *Death of a Loyalist Militiaman* (1936; see p.190). Much has been made of the tension between journalism and art within Magnum. In contrast to Capa's imperfect, immediate picture-taking, the work of Cartier-Bresson represents a considered, composed approach. However, all Magnum photographers tell a story using a traditional photojournalistic narrative built from groups of images that follow the arc of a story. After World War II Cartier-Bresson travelled in India and Asia, catching Shanghai's gold rush (1948; see p.328), among other subjects. In 1952 he published his manifesto on photography, *Images à la sauvette* (*The Decisive Moment*), setting out his belief in photography's ability to elevate reality.

Capa met Magnum's fourth member, Rodger, in Naples during the Allied advance in 1943 when both worked for *Life*. An Englishman, Rodger had made his name with his images of the Blitz in the magazine. He went on to photograph the Bergen-Belsen concentration camp, which proved such a harrowing experience that he gave up war photography. After the war he travelled in Africa and the Middle East where he took pictures of wildlife and people, such as *The Nubas* (above right). Shot in Kordofan, Sudan, it shows the victor of a wrestling match being carried on the shoulders of his opponent.

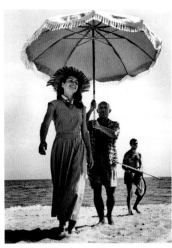

From the outset, Magnum's members not only recorded the major historical events of the day but also photographed key figures from popular culture. Between war assignments Capa found time to make portraits of famous friends, including his whimsical shot of the artist Pablo Picasso sheltering his muse and lover, Françoise Gilot, with an umbrella on the sands at Golfe-Juan, France (right). Magnum served as a microcosm for shifts in photographic practice. When picture magazines moved to using colour in the 1960s, many of Magnum's photographers followed suit. In the 1960s and 1970s, with the primacy of television as the means of disseminating news, Magnum experimented with the moving image. Magnum's membership has continued to grow through self-selection to the present day, representing a diverse range of approaches to documentary photography. **SW**

1952	1953	1954	1956	1960	1960
Magnum sets up a board of directors with Robert Capa as president.	Magnum's second international group project 'Generation X', also known as 'Youth and the World', appears in *Picture Post* and *Holiday*.	Capa is killed by a landmine while covering the Indochina War and Bischof dies in a car accident in Peru. Seymour takes over as Magnum president.	Seymour is killed photographing the Suez Crisis and Capa's brother, Cornell (1918–2008), becomes Magnum president.	Nine Magnum photographers are invited to shoot at the Nevada desert location of *The Misfits* (1961), changing how films are publicized.	Magnum member Ian Berry (b.1934) records the Sharpeville Massacre in South Africa. His images are later used at trial to prove the victims' innocence.

Sale of Gold 1948
HENRI CARTIER-BRESSON 1908 – 2004

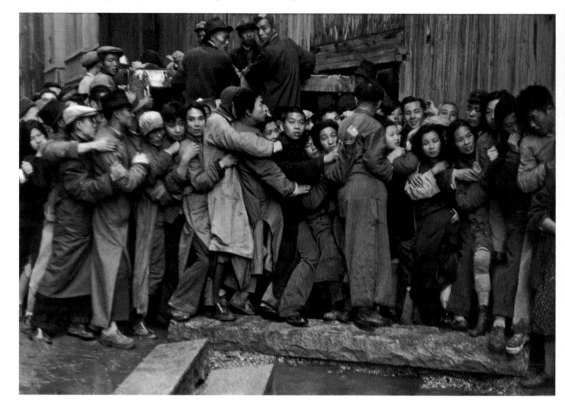

Sale of Gold in the Last Days of the Kuomintang, Shanghai, China
Silver print
9 ⅛ x 14 in. | 29 x 35.5 cm
Magnum Photos

Henri Cartier-Bresson spent much of 1947 and 1948 travelling in India and Asia, the area of the world allotted to him as a member of Magnum Photos. While travelling in Rangoon in December 1948, *Life* cabled to ask him to go to China, where Nationalist forces were losing ground to the Communist army of Mao Tse-tung. Cartier-Bresson went first to Beijing and then to Shanghai before the city fell to the Communists. There he rented an apartment near *Life*'s office. On his journey to work one morning, Cartier-Bresson encountered a crowd of people jostling outside one of the city's four government banks. With the value of the local currency sinking, the Kuomintang party decided to distribute 1.2 troy ounces (40 gg) of gold per person. Cartier-Bresson ran upstairs to get an overview of the scene and began taking photographs. However, it was only when he returned to street level and became one of the crowd that he captured the distinctive composition seen in *Sale of Gold*.

As with many of Cartier-Bresson's best photographs, the image reflects the immediacy of the moment and transcends it as a lasting symbol of the population's rising panic during regime change. It is the human element in the story—rather than particulars such as the bank itself, which is absent from the picture—that Cartier-Bresson's photograph records so eloquently. The blurred tangle of citizens, crushing together in a line, perfectly illustrates the desperate circumstances. The police, equipped with only the remnants of the army that was then fighting Mao, were unable to keep order and Cartier-Bresson's picture caption states that ten people were crushed to death during the gold rush. **SW**

⬢ NAVIGATOR

⊚ FOCAL POINTS

1 OUT OF FOCUS
Given Cartier-Bresson's reputation as a perfectionist, it is intriguing that this picture is far from a perfect photographic image and much of the picture is blurred. This is caused by the frantic tussle among the people queuing and many of them are out of focus. However, rather than detract from the picture, the effect gives an immediacy, energy and emotional resonance to the scene, as if the stress experienced by the subjects vibrates from the photograph.

2 ARMS
The crowd's interlocking arms form a series of trianglular shapes, and these shapes give a sense of wavy rhythm and movement as if they form part of a bas-relief in a sculptural frieze. This points to the influence of the geometric shapes of Cubism on the photographer.

3 MAN STARING
The man staring at the viewer looks shocked and unhappy that he has been caught on camera. Taking photographs in China at this time was not straightforward. Cartier-Bresson was challenged by Chinese etiquette, which disapproves of impromptu photography.

4 SMILING MAN
Adding to the strangeness of the scene, some figures are smiling. Magnum photographers are synonymous with storytelling. Cartier-Bresson believed in the 'decisive moment' where multiple compositional and narrative elements coalesce to form a unified image. The viewer looks at parts of the picture to see what story they tell. Single images such as this bring together a story's elements in one outstanding composition.

5 LINE OF BODIES
In a strange conga line the bodies of the Chinese subjects are almost lifted from the ground in the crush, with knees bent and arms wrapped around those in front of them. The image draws the viewer into its complex composition because of the viewer's incredulity at a scene captured without clear reference points to the context. Cartier-Bresson turned to photojournalism at Robert Capa's urging but never gave up his Surrealist (see p.232) sense of the absurd.

MAGNUM MEMBERSHIP

Magnum Photos remains a cooperative owned and run by its member photographers. In its early days existing members such as Cartier-Bresson and George Rodger (below, left and right centre) invited photographers to join as stringers or associates. Ian Berry recalls submitting his contact sheets to Cartier-Bresson prior to being offered membership in 1962: 'Although there was a procedure for joining. . .really all you had to do was to be OK'd by Henri. This involved going down to the bistro below Magnum and letting him look at your snaps.' As the agency grew the process of joining became more formal. Each year Magnum's photographers and senior staff gather for the Annual General Meeting, which rotates between the New York, Paris and London offices. This is when portfolio submissions are considered. If a photographer is accepted they become a 'nominee'. After two years, nominees submit another portfolio and, if chosen, achieve 'associate' status. Two years later they present their work again and full membership is granted with 60 per cent of the vote; this is a lifetime role and the photographer becomes a shareholder and director.

SUBJECTIVE PHOTOGRAPHY IN EUROPE

The immediate post-war period in Europe saw a return to using photography as an artistic and expressive medium as photographers increasingly chose to move away from the straight documentary tradition. Rather than use the camera to record external realities faithfully, they employed it to articulate a highly personal vision by abstracting the appearance of the world around them.

Otto Steinert (1915–78) emerged as a key figure in theorizing and promoting an experimental style of photography in Germany. He taught photography in his home town of Saarbrücken after the war and helped to establish the Fotoform group in 1949. In his founding manifesto, he voiced the need for 'a new photographic style' that served 'the demands of our time'. Whereas applied photography served documentary or commercial ends, the Fotoform group made images that expressed a privileged subjectivity using purely photographic means. Steinert's *Call* (opposite) constructs an imagined nocturnal city in the darkroom through a combination of negative and positive montage printing. A blurry silhouette moves across a disorientating, almost hallucinatory urban landscape.

Utilizing montage, solarization and photograms, the activities of the Fotoform group owed much to the avant-garde photography developed in the 1920s by László Moholy-Nagy (1895–1946), Herbert Bayer (1900–85) and

KEY EVENTS

c. 1947	1948	1949	1950	1951	1951
Having studied medicine and served as a medical officer during World War II, Otto Steinert becomes a portrait photographer.	Steinert inaugurates a photography class at the College of Arts and Crafts in Saarbrücken, Germany.	The Fotoform group is established by Otto Steinert, Peter Keetman and Siegfried Lauterwasser (1913–2000) among others.	The first Photokina— a large and important trade fair for the photographic industries—takes place in Cologne.	Steinert organizes the first 'Subjektive Fotografie' exhibition in Saarbrücken, featuring humanistic reportage and more experimental work.	Edouard Boubat's work is shown at Galerie La Hune in Paris along with that of Brassaï (1899–1984), Robert Doisneau (1912–94) and Izis (1911–80).

Man Ray (1890–1976). Steinert advocated further experimentation—multiple exposures, manipulation of light, radical cropping, strong black-and-white contrasts—to generate a specifically photographic means of expression.

Fellow Fotoform member Peter Keetman (1916–2005) often worked with long exposures, leaving the camera shutter open to record patterns of moving traffic at night, or to register the motion of a lit torch swinging in the darkroom. Alongside these experiments stand Keetman's straight 'abstract' images. *Reflecting Drops* (opposite) is part of a series of closely cropped photographs of water and oil droplets. Subject matter is subordinated to a concentration on form, pattern and tonal contrasts. A hazy figure can be discerned reflected in the drops: the creative artist standing symbolically at the centre of his work.

The group exhibited its work under the label 'Subjektive Fotografie'. The first exhibition was organized by Steinert in 1951 in Saarbrücken, with two later shows in 1954 and 1958. Non-objective abstract works were shown alongside humanist reportage photography. Steinert's photographic vocabulary found advocates in Europe and Japan, and correlated to developments in the United States (see p.334), where Harry Callahan (1912–99), Aaron Siskind (1903–91) and Minor White (1908–76) were pursuing an abstract, metaphorical style of art photography. Exhibitions overseas spread Steinert's concept of 'subjective photography' to an informal network of artists. Edouard Boubat (1923–99) featured in Steinert's exhibition in 1954. A photojournalist for the French *Réalités* magazine, his work focused on the poetry of everyday life. *Self-portrait with Lella* (1951), Boubat's wife and muse, marked a turn in his work towards more personal subject matter. Josef Sudek (1896–1976) was also concerned with capturing a profoundly personal experience in his *The Window in My Studio* series (1940–54; see p.332). Hailed as the 'poet of Prague', Sudek's landscapes and architectural studies express his evocative and poetic vision.

Working as a photojournalist, Herbert List (1903–75) immersed himself in the Italian landscape during the 1950s. A series of images taken from the window of an apartment in Rome demonstrates his creative attitude to reportage. Adopting a bird's-eye perspective, his photographs defamiliarize and abstract the cityscape. The graphic form of the photograph becomes as crucial as its narrative content. List's photographs in Italy invite comparison with the work of Mario Giacomelli (1925–2000), who was based in the small town of Senigallia. Giacomelli's most renowned work is the series *There Are No Hands to Caress My Face* (1961–63), created at the local Episcopal seminary. He photographed young priests from a rooftop as they played ring-a-ring-o-roses below, his elevated viewpoint placing the subjects in an unreal space, as if suspended in mid air. Extending the interests of the Fotoform group, the form-led reportage of List and Giacomelli exemplifies the post-war interest in photography both as a document that can grasp reality and as an aesthetic object that can transform that reality into an expression of the artist's subjective vision. **SJG**

1 *Reflecting Drops* (1950)
Peter Keetman • silver print
9 ½ x 12 ¼ in. | 24 x 31 cm
Museum Folkwang, Essen, Germany

2 *Call* (1950)
Otto Steinert • silver print
23 ⅝ x 18 ⅜ in. | 60 x 47 cm
Metropolitan Museum of Art,
New York, USA

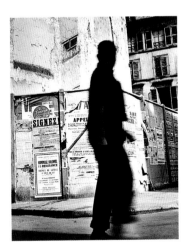

1953	1956	1958	1959	1959	1961
Peter Keetman photographs the production line in the Volkswagen Works in Wolfsburg, combining scientific objectivity with abstraction.	Mario Giacomelli joins the group La Bussola. Members seek to distinguish their work from photojournalism by asserting themselves as artists.	Steinert organizes the last Fotoform exhibition after which he decides to leave the group; it subsequently folds.	Using an antique Kodak Panoram camera, Josef Sudek produces *Praha Panoramaticka*, an acclaimed study of the city of Prague.	Steinert begins teaching at Essen's Folkwang School. He organizes exhibitions and works on the photography collection at the city's Museum Folkwang.	Josef Sudek becomes the first photographer to receive the Artist of Merit Award from the Czech government.

February (from The Window in my Studio) 1948

JOSEF SUDEK 1896 – 1976

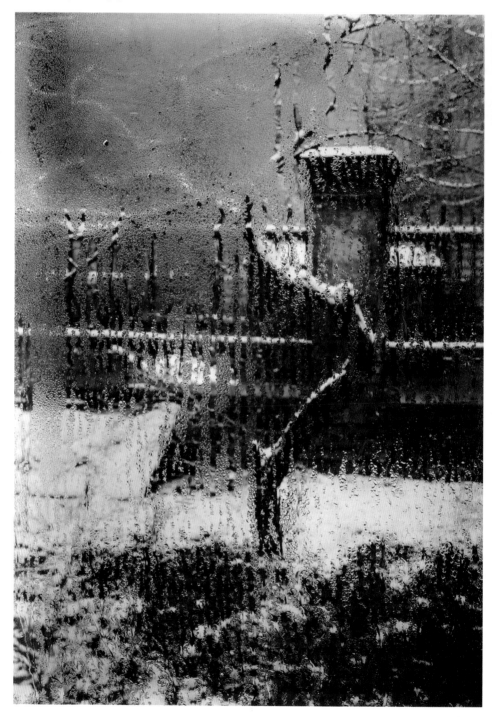

Silver print
8 ⅞ x 6 ⅛ in. | 22.5 x 15.5 cm
National Gallery of Australia,
Canberra, Australia

The year 1940, when Prague was occupied by the Germans, saw Josef Sudek begin a series of photographs taken from the studio in his garden, a theme that he continued for fourteen years. From his studio window, Sudek chronicled the changing seasons and the diverse refractions of light on glass. Although 'realist' by definition, these brooding and evocative images transcend a simple delineation of the objects before the camera. By utilizing the photographic means at his disposal— perspective, framing, tonal rendering—Sudek imbues his studies with additional significance. The focus is not the window, the leafless tree or the snow- covered landscape. Instead, Sudek's photograph generates a melancholic atmosphere that resonates personally for him. The creative faculty of the artist is foregrounded, transforming a description of outward realities into an intensely subjective experience of that world.

Known as 'the poet of Prague', Sudek is perhaps comparable only to Eugène Atget (1857–1927) in his dedication to photographing one city. In the 1930s, he began to focus on personal projects: still lifes in his studio, urban views of Prague and lyrical studies of the parks and forests of Bohemia. He purposefully returned to antiquated photographic methods in his non-commercial work, favouring natural light, unwieldy large-format cameras and contact prints rather than enlargements. **SJG**

FOCAL POINTS

1 TONE AND DETAIL
From 1940, Sudek returned to using large-format cameras, making contact prints directly from the negatives. This gives his photographs a fineness of detail and allows for rich tonal variation. The subtle rendering of tone is key to lending his subject matter atmosphere and poetic meaning.

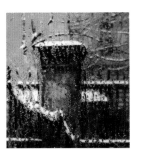

2 GERMAN OCCUPATION
During the occupation of Prague, Sudek dedicated himself to creating imagery out of his immediate surroundings. Here, he uses the familiar landscape of his garden, the scope of his vision bounded by the fence. He also made still life studies of the objects in his studio.

3 TREE
The bare, leafless tree at the centre of the composition takes on something of the aspect of a living being. Sudek referred to dead trees in his photographs of woodlands as 'sleeping giants'. In many of his photographs, people are absent; instead, inanimate objects 'stand in' for them.

4 CONDENSATION
The window of Sudek's studio is clouded with condensation, creating a veil of moisture and light. Separating the domestic and exterior environments, the condensation distorts the landscape outside and acts as a filter for Sudek's imagination.

PHOTOGRAPHER PROFILE

1896–26
Josef (Václav František) Sudek initially trained as an apprentice bookbinder. He was wounded during World War I, losing his arm; while recovering, he took photographs of hospital patients. In 1921 he joined Prague's Bohemian Amateur Photography Association. At the State School of Graphic Arts in Prague, Sudek studied for a professional licence in photography. A co-founder of the Czech Photographic Society, he championed a style of pictorial modernism.

1927–59
Having opened a successful studio, in 1928 Sudek published a widely acclaimed album of prints documenting the rebuilding of St Vitus Cathedral. Focusing increasingly on personal projects, from around 1936 he began to use large-format cameras and contact prints. In 1959 he published a series of panoramas of Prague using a Kodak Panoram camera from 1894.

1960–76
Sudek became the first photographer to receive the Artist of Merit Award from the Czech government in 1961, and his work increasingly featured in international retrospectives.

SUBJECTIVE PHOTOGRAPHY IN THE USA

In the post-war period, a number of US photographers moved away from socially and politically motivated documentary work and turned instead to abstraction or surrealism as strategies for expressing a highly individual photographic vision. The Chicago Institute of Design (formerly the New Bauhaus) was fundamental in cultivating this subjective sensibility. Its founder, László Moholy-Nagy (1895–1946), placed photography at the centre of the curriculum. In 1946 he invited Harry Callahan (1912–99) to join the photography faculty. Callahan took simple themes as his subject matter: landscapes, street scenes and intimate portraits of his wife. Drawing on the Bauhaus avant-garde tradition, he experimented with multiple exposures and development times to reveal these everyday forms in innovative ways.

At Callahan's request, Aaron Siskind (1903–91) joined the photography department in 1951. Both men trained their cameras on the surrounding cityscape; both moulded and abstracted this raw material according to their own vision. In *Chicago 68* (above) Siskind presents a calligraphic paint mark on a cracked wall. Disassociated from its usual context, the daub appears as an emblem or symbol. There is no pretence of three-dimensionality but instead an insistence on the

KEY EVENTS

1946	1947	1947	1949	1949	1951
Minor White and Ansel Adams establish the United States' first fine art photography faculty at the California School of Fine Arts in San Francisco.	Edward Steichen (1879–1973) becomes director of photography at New York's Museum of Modern Art.	At the request of the New York Photo League, Louis Stettner (b.1922) organizes a major exhibition of post-war French photography.	Harry Callahan becomes head of photography studies at the Institute of Design in Chicago (part of the Illinois Institute of Technology from 1949).	George Eastman House, the first museum dedicated to photography, is founded in Rochester, New York, USA.	The New York Photo League, which had promoted socially engaged photography, disbands after being listed as a Communist front organization.

illusionistic space constructed by the photographer on a flat piece of paper. Before the war, Siskind had been an influential member of the New York Photo League, a cooperative promoting socially concerned documentary photography. His later work eliminates all narrative content to concentrate on texture, detail and form, marking a shift from 'what the world looks like to what we feel about the world and what we want the world to mean'.

In a period dominated by straight photography (see p.280), darkroom experiments and manipulations were deemed wholly 'unphotographic', and were condemned at the Aspen Photographic Conference in 1951 as a perversion of the photographic process. It was at this same conference that a new journal for contemporary photography was first discussed by Ansel Adams (1902–84), Barbara Morgan (1900–92) and Beaumont Newhall (1908–93). The first edition of *Aperture* magazine appeared the next year; Minor White (1908–76) would be its editor for more than twenty years. Inspired by his interest in Eastern philosophy, White encouraged readers to think of photographs as independent units of meaning, simulating the experience of a Zen Buddhist *koan*, or riddle: contemplating an image at length opens up the viewer's abilities to see beyond surface realities and intuit the metaphoric and expressive mode in which it can operate. White's *Sun in Rock* (below) reads as a carefully composed landscape of dark rock forms and luminescent, rippling water. He cropped the image closely, divorcing its elements from their usual associations. Like Alfred

1 *Chicago 68* (1960)
Aaron Siskind • silver print
10 ½ x 13 ⅜ in. | 26.5 x 34 cm
Museum of Modern Art,
New York, USA

2 *Sun in Rock* (1947)
Minor White • silver print
3 ½ x 4 ⅝ in. | 9 x 12 cm
George Eastman House,
Rochester, New York, USA

1951	1952	1959	1962	1967	1974
Aaron Siskind joins Harry Callahan at the Chicago Institute of Design, ushering in a period of 'high formalist' photography at the institute.	Minor White, Ansel Adams, Dorothea Lange (1895–1965) and Barbara Morgan launch the monthly photography periodical *Aperture*.	Larry Siegel founds Image Gallery in New York, the only gallery devoted specifically to photography at this time.	John Szarkowksi takes over from Steichen at the Museum of Modern Art. He stages 'The Photographer's Eye' (1964) and 'New Documents' (1967).	'The Persistence of Vision' show opens at George Eastman House, featuring manipulated images by Ray Metzker (b.1931) and Jerry Uelsmann.	Ralph E. Meatyard's book *The Family Album of Lucybelle Crater* appears posthumously, featuring disquieting images of masked figures in suburbia.

3 *Romance of Ambrose Bierce #3* (1964)
Ralph Eugene Meatyard • silver print
6 ⅝ x 6 ⅞ in. | 17 x 17.5 cm
Museum of Contemporary Photography,
Chicago, USA

4 *Nancy, Danville, Virginia* (1969)
Emmet Gowin • silver print
5 ½ x 6 ¾ in. | 14 x 17 cm
Museum of Modern Art,
New York, USA

Stieglitz (1864–1946), he believed that abstract forms could metaphorically reveal inner states of mind and emotions: the straight photograph as a gateway to new possibilities of meaning. White's students at the California School of Fine Arts similarly engaged with the symbolic, meditative qualities of photographs: sharing his interest in Eastern philosophies, Paul Caponigro (b.1932) charges his poetic landscapes with suggestive force.

The notion that a photograph could faithfully record the world and also communicate metaphorically was taken up by a number of artists. O. Winston Link (1914–2001) took more than 2,000 photographs of the Norfolk & Western Railway line in the late 1950s, mostly at night. On one level, the photographs serve as a document of life in 1950s rural America. On another, the symbols of planes, trains and automobiles testify to the country's technological might.

Ralph Eugene Meatyard (1925–72) also attended courses led by White during the 1950s. Meatyard photographed his friends and family in bizarre, surreal and sometimes disturbing tableaux that have a psychological resonance, such as *Romance of Ambrose Bierce #3* (above). The title references the US writer Ambrose Bierce's satirical book *The Devil's Dictionary* (1911) in which two modes of literature—the novel and the romance—are contrasted: in the novel, the writer's thought is tethered to faithfully reporting things as they are; in romance, the writer's imagination is freed and lawless.

In 1960, Harry Callahan established a photography department at Rhode Island School of Design. Studying there in the late 1960s, Emmet Gowin (b.1941) made an intimate portrayal of family life in rural Virginia that recalls Callahan's portraits of his wife Eleanor. The iconography of Gowin's imagery, in his seemingly simple snapshots, expresses a microcosm of universal cycles of experience: birth, childhood, slaughter and death. *Nancy, Danville, Virginia* (opposite) features a young girl with closed eyes and arms intertwined, holding two eggs in her outstretched hands. The eggs assume a powerful symbolism as reproductive ovaries, their shape evoking the circular nature of life.

In its subject matter, composition and printing, Gowin's work embraces the influence of Frederick Sommer (1905–99), his long-time friend and mentor. Both artists open up their images to the possibilities of allusion and metaphor. Alongside straight images, Sommer exploited the effects of composite prints—in works such as *Max Ernst* (1946; see p.338)—collages and *clichés verres*, constructing negatives from oil paint sandwiched between sheets of cellophane. Clarence John Laughlin (1905–85) also experimented with printing multiple negatives in combination in order to create strange and fantastical images. Influenced by the French Symbolists, his evocative gothic visions invite the viewer to delve into the depths of their imagination.

Jerry Uelsmann (b.1934) studied with Minor White at Rochester Institute of Technology. Referencing 19th-century photographers such as Henry Peach Robinson (1830–1901) and O. G. Rejlander (1813–75), Uelsmann seamlessly prints multiple negatives in combination to create disconcerting juxtapositions. Duane Michals (b.1932) similarly positions his work at the threshold between appearance and reality, as seen in *Things Are Queer* (1973; see p.340). Michals stages scenes for the camera, creating complex multi-frame narratives that draw on psychological and metaphysical concerns.

Uelsmann and Paul Caponigro featured in an exhibition by John Szarkowski (1925–2007) titled 'Mirrors and Windows: American Photography since 1960' (1978) at the Museum of Modern Art, New York. The show highlighted a split in the work of late 20th-century US photographers, between those who use the medium as a window on to the world and those who use it for self-expression. Szarkowski's appointment as director of photography at the Museum of Modern Art in 1962 signalled a period in which photography began to take on a higher profile in US art. The proliferation of fine art photography courses spearheaded by renowned figures, and the continuing presence of *Aperture* magazine, changed the perception of photography. Such developments laid the foundations for the increasing acceptance of photography as an art form. **SJG**

Max Ernst 1946

FREDERICK SOMMER 1905 – 99

Silver print
7½ x 9½ in. | 19 x 24 cm
Museum of Modern Art, New York, USA

NAVIGATOR

Photographing German Surrealist painter Max Ernst against the wooden exterior of his new home in Sedona, Arizona, Frederick Sommer printed this negative over another showing the abstract detail of a cement wall, stained white in parts by water damage. Bringing the two elements together transforms a straightforward portrait into a peculiar and enigmatic image that Ernst came to consider his definitive portrait. The textures of smooth human skin, knotted wood and rough concrete overlap, creating an unresolved tension over the status of Ernst's body. The ambiguous materiality of his semi-transparent body positions Ernst at the threshold of a boundary between different states of existence. Areas of white weathering invoke a sense of poetic decay, hinting at Ernst's advancing age and mortality.

Sommer was introduced to Ernst during a trip to California in 1941; a strong artistic friendship developed five years later when Ernst moved to Arizona. Ernst encouraged Sommer's Surrealist sensibilities and selected two of his horizonless landscapes for inclusion in an edition of *VVV*, the US Surrealist journal, published in 1944. Sommer's portrait of Ernst appeared on the cover of an edition of *Aperture* in 1956, with its editor Minor White regularly featuring Sommer's work in the magazine. Commenting on Sommer's photographs, White observed: 'A superficial glance at his pictures reveals about as much as a locked trunk of its contents.' **SJG**

⊙ FOCAL POINTS

1 BIBLICAL SYMBOLISM
The two negatives have been aligned to set the body at the centre of the two crosses, created by two vertical planks and a horizontal panel across Ernst's eyes. Together with the interplay between wood and nails in the cabin, the narrative of Christ's crucifixion and resurrection is subtly invoked.

2 EYES
A recessed panel draws attention to Ernst's eyes. Eyes were of great significance to the Surrealists: to avoid becoming 'a prisoner of external perception', André Breton advocated closing one's eyes and retreating into one's mind. Sommer positions Ernst at this frontier between the exterior and interior worlds.

3 FLATTENED EFFECT
Combining the two negatives has a flattening effect on the composition, similar to that seen in Sommer's photographs of desert landscapes in the early 1940s. Ernst's chest and muscular arms lose their three-dimensionality as if reduced to abstract, painterly markings.

4 LEFT ARM
The weathered texture of Ernst's naked torso resembles sculptures from antiquity. Sommer said: 'Max Ernst superimposed on concrete makes for the finest Pentelic marble.' A line runs over the left arm, suggesting a connection with the damaged arm of the *Apollo Belvedere* (c. 120–40).

5 TEXTURE
The large-format negative allows a high level of detail, in which the wood grain, the texture of the skin and even Ernst's stubble are revealed. Ernst also created images using textures, developing an 'automatic' frottage technique by layering paper over surfaces and rubbing it with a pencil.

⊙ PHOTOGRAPHER PROFILE

1905–30
Born in Angri, Italy, Frederick Sommer spent his early years in Brazil and then trained as a landscape architect at Cornell University in Ithaca, New York.

1931–40
Sommer settled in Arizona at the height of the Great Depression. He bought his first camera in 1931, but photography remained secondary to painting and drawing until a meeting with Alfred Stieglitz in 1935. Influenced by Edward Weston (1886–1958), from 1938 Sommer began using an 8 x 10-inch camera to photograph still life arrangements of found objects.

1941–56
On a trip to California in 1941, he met Man Ray (1890–1976) and Max Ernst, and became loosely involved with the Surrealists. Photographing the Arizona landscape, he created abstract, textural photographs of rocks, cacti and vegetation.

1957–99
Sommer served as a sabbatical replacement for Harry Callahan at the Institute of Design in Chicago from 1957 to 1958. From the late 1950s he experimented with *cliché verre* negatives, cut-paper photographs and collages, painted, drew and composed musical scores.

COMPOSITE PRINTING

Frederick Sommer printed two 8 x 10-inch negatives on to a single sheet of photographic paper to form an image of his friend, the Dada and Surrealist artist and poet Max Ernst, who moved to Sedona, Arizona in 1946 with his wife, Dorothea Tanning. Sommer felt that individually neither negative justified printing. He was disappointed that areas of the original portrait of Ernst (below) became blurred after an unexpected breath during the exposure. By combining the two elements, Sommer created a collage that becomes more than the sum of its constituent parts, transforming a straight portrait into a wonderfully surreal image.

Things Are Queer 1973

DUANE MICHALS b. 1932

THINGS ARE QUEER

Silver prints
5 x 7 in. | 13 x 18 cm each
Sidney Janis Gallery, New York, USA

A self-taught photographer, Duane Michals turned to photography as a means for raising metaphysical questions and exploring psychological narratives. Rather than documenting outward realities, he turns his vision inward in order to fabricate complex and improbable scenarios out of his own dreams, fears and emotions. Working between appearance and reality, Michals deliberately stages scenes for the camera that point to a reality beyond the immediate grasp of the senses.

In the late 1960s Michals began to experiment with his first sequenced images: multi-frame compositions in which set narratives are enacted. *Things Are Queer* pulls the viewer through a series of nine staged tableaux that follow a pre-planned narrative. The first image depicts a simple bathroom suite. With each subsequent photograph, the camera retreats a step back, enlarging the frame through which the viewer is able to observe the scene. In a final twist, the concluding image returns the sequence to where it began, identically repeating and reframing the first image in the series. Each new photograph makes the viewer less confident about what is being shown.

The title references homosexuality, but the narrative of the sequence suggests another level of connotation. What is queer, Michals suggests, is the certainty with which people believe themselves able to grasp the world through fragmentary and superficial photographic representations. The series subverts the viewer's faith in photography as a faithful window on to the world: seeing does not equate to knowing or understanding. **SJG**

FOCAL POINTS

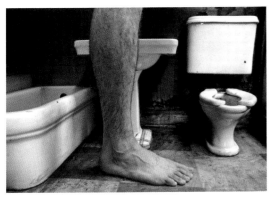

LEG
The leg is life size; the bathroom is a scale model. Michals is drawing attention to the illusionistic nature of photographic space: the appearance of reality should not be confused with reality itself.

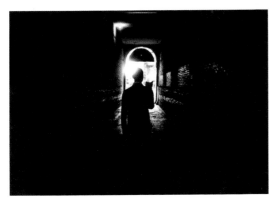

SURREALISM
The dark interiors create a disquieting, dreamlike mood. Michals's work is influenced by the strange landscapes of Surrealist painter René Magritte, whom he photographed in 1965.

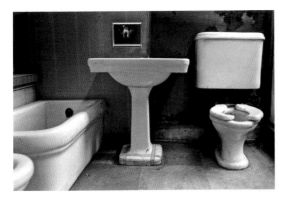

BATHROOM SCENE
An identical photograph appears at the start and the end of the series. The circularity of Michals's sequence suggests its own inexhaustibility, with the potential to continue looping indefinitely.

PHOTOGRAPHER PROFILE

1932–57
Born in McKeesport, Pennsylvania, Duane Michals studied at the University of Denver before serving in the military. Harbouring intentions of a career in graphic design, in 1956 Michals enrolled at Parsons School of Design in New York but left after a year.

1958–67
In 1958 he made a short trip to the USSR, taking with him a borrowed camera, after which he decided to become a photographer. By 1960 he was active as a freelance commercial photographer in New York. At the same time he used photography for personal projects, experimenting with the effects of multiple exposures and blurred focus. He created his first photo-sequence in 1966.

1968–73
The Mexican government hired Michals to photograph the Olympics in 1968. He published his first photobook, *Sequences*, in 1970. In the same year, the Museum of Modern Art, New York hosted his first solo exhibition.

1974–PRESENT
Michals photographed the filming of *The Great Gatsby* (1974) for *Vogue* magazine, creating ethereal portraits of Mia Farrow. He also photographed the British band The Police for the cover of their album *Synchronicity* (1983).

STORYTELLING

Duane Michals defines himself as a narrator and his sequences of photographs follow in a tradition of storytelling using serial pictures that stretches from the ancients to contemporary cartoon strips. Michals is a fan of Lewis Carroll's *Through the Looking-Glass, and What Alice Found There* (1871). In *Dr Heisenberg's Magic Mirror of Uncertainty* (1998; below), Michals uses a mirror as a tool for his subject to explore her interior world. However, in this work Michals is also telling a story about the nature of photography and his role as a creator. He once said: 'I am a reflection photographing other reflections inside a reflection.' Michals creates a portrait of the sitter who, by looking at her reflection, is viewing her own self-portrait: it is only when she looks out of the frame, sees the photographer and becomes a viewer rather than the viewed that her features disappear from the mirror.

POST-WAR FASHION PHOTOGRAPHY

During World War II the prevailing approach to fashion had been one of austerity. French *Vogue* temporarily ceased publication, but the British and US editions continued to appear. Cecil Beaton (1904–80) used the bomb-damaged Inner Temple as a backdrop for one of the most striking wartime fashion pictures: an image of a suited model in a defiant pose, captioned 'Fashion is indestructible' in British *Vogue*, September 1941. After the war, a new generation of New York–based photographers, led by Irving Penn (1917–2009) and Richard Avedon (1923–2004) with images including Avedon's *Dovima with Elephants* (1955; see p.346), helped to rehabilitate the French couture houses and promote the ready-to-wear industry in the United States. Avedon looked to the work of Martin Munkácsi (1896–1963) for inspiration, whereas Penn revelled in the control he could exercise within the studio.

In 1947 fashion designer Christian Dior presented his first Paris collection. His designs heralded the revival of voluptuous femininity and decadent dressing, a style dubbed the 'New Look' by *Harper's Bazaar*. Characterized by pronounced hips, a tiny cinched waist and full, long skirt, Dior's creations drew upon the work of British-born couturier Charles James. In 1948 Beaton captured James's lavish evening gowns in an image (above) that typifies Beaton's shift away from the

KEY EVENTS

1947	1948	1952	1957	1958	1960
Designer Christian Dior launches his couture house on 12 February. By 1949 Dior fashions provide five per cent of France's export revenue.	The first Hasselblad cameras are marketed. Erwin Blumenfeld (1897–1969) pioneers the use of the Hasselblad for fashion photography.	A consumer style title for men, *Man About Town*, launches in the United Kingdom. The magazine's title later changes to *About Town* and then to *Town*.	The Soviet Union launches the artificial satellite Sputnik 1 into Earth's orbit. Over the next decade, the space race inspires a radical new look in fashion.	Influential art director Alexey Brodovitch leaves *Harper's Bazaar*, having brought many leading photographers and a new vibrancy to the title.	David Bailey gains prominence in London when his picture of model Paulene Stone kneeling to talk to a squirrel is published in the *Daily Express*.

surreal, contrived approach evident in his work of the previous decade. Eight women bask in the Neoclassical salon of New York antiques dealer P. W. French & Company. They appear absorbed in their own beauty, with little to do but admire their exquisite reflections. The décor, with its marquetry furniture and crystal chandelier, signals a return to civilized living. The pastel shades of swathed silk and the porcelain-hued faces of the models evoke works by Beaton's hero, the 19th-century painter Franz Xaver Winterhalter.

Such colour images leapt from magazine pages in the post-war period. Working for *Harper's Bazaar*, Louise Dahl-Wolfe (1895–1989) used Kodachrome film to capture casual US fashions of the 1940s and 1950s. From 1936 to 1958, she produced eighty-six cover photographs for the magazine in collaboration with editor Carmel Snow, art director Alexey Brodovitch and fashion editor Diana Vreeland. Dahl-Wolfe pioneered the use of natural lighting and became renowned for shooting in exotic locations. In 1950 she travelled to Hammamet, Tunisia to photograph model Natalie Paine, and the shoot displays Dahl-Wolfe's sensitivity as a colourist (below). She balances the deep green of the swimsuit with rich red lips and fingernails. The North African sunshine, intricately carved architecture, map and exotic white flowers symbolize the lifestyle of the modern US woman as a confident international traveller.

1 *Charles James Gowns in French & Company's 18th-century French Panelled Room* (1948)
Cecil Beaton • Cibachrome colour print
Condé Nast / Cecil Beaton Studio Archive

2 *Natalie Paine in Claire McCardell Swimwear* (1950)
Louise Dahl-Wolfe • Kodachrome print
Museum at the Fashion Institute of Technology, New York, USA

1961	1962	1966	1967	1974	1975
Marvin Israel is appointed art director of *Harper's Bazaar*. He uses photographers such as Diane Arbus (1923–71) and Lee Friedlander (b.1934).	*The Sunday Times* colour supplement launches in the United Kingdom. Antony Armstrong-Jones (b.1930) becomes a photographic adviser.	Willowy teenage model Twiggy becomes a global phenomenon, embodying fashion's buzzwords 'Youthquake' and 'Young Idea'.	The 'New Documents' exhibition at New York's Museum of Modern Art displays the works of Arbus, Friedlander and Garry Winogrand.	Beverly Johnson is the first African American model to appear on the cover of US *Vogue*, in a photograph by Francesco Scavullo (1921–2004).	Critic Hilton Kramer rails against fashion photography of the period in his article 'The Dubious Art of Fashion Photography' in *The New York Times*.

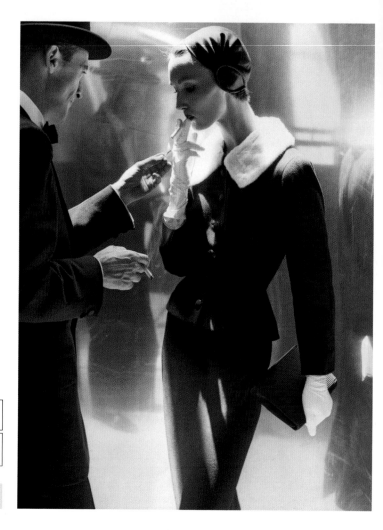

3

4

5

3 *By Night, Shining Wool and Towering Heel, Suit by Handmacher, Evelyn Tripp, New York* (1954)
Lillian Bassman • silver print
20 x 16 in. | 51 x 40.5 cm
Joseph Bellows Gallery, La Jolla, California, USA

4 *After Van Dongen* (1959)
Norman Parkinson • colour
hand-processed print on Kodak
Supra Endura paper
20 x 16 in. | 51 x 40.5 cm
Norman Parkinson Archive, London, UK

5 *Isabella Albonico and model wear André Courrèges* (1965)
William Klein • silver print
Elton John Photography Collection, London, UK

Dahl-Wolfe was one of several women who transformed US fashion photography in the post-war era. Brooklyn-born photographer Lillian Bassman (b.1917) trained as an artist before becoming Brodovitch's assistant at *Harper's Bazaar*. She eschewed colour but possessed a romantic vision, manifest in her advertising campaigns for the fashion houses Chanel and Balenciaga and sensual fashion shoots for *Harper's Bazaar*. Yet Bassman's misty images could frustrate the magazine's editor, Snow, who warned her while on assignment on a shoot in Paris in 1949: 'You are not here to make art, you are here to show buttons and bows.'

Later in the century, female photographers such as Sarah Moon (b.1941) would embrace the less descriptive approach that Bassman pioneered, in which the evocation of a mood or lifestyle takes precedence over the details of the object for sale. Bassman revolutionized the photography of lingerie and her most original work used techniques such as printing negatives through tissue or removing one element of the camera lens in order to produce a soft-focus effect. Frequently she posed her models to emphasize their slender necks. In the image *By Night, Shining Wool and Towering Heel* (above) for *Harper's Bazaar*, Evelyn Tripp's pale, elongated neck has a swanlike grace. Dazzling light shines on the perfectly chic New York couple, and the reflective surface behind them enhances the play of light, shadow and form.

One of the first women to be hired by Associated Press was Genevieve Naylor (1915–89), who began her career in 1933 as a news photographer. When she joined *Harper's Bazaar* a decade later, shooting on the city's streets came naturally to her. Naylor followed Munkácsi's advice to photograph back views and use unexpected camera angles. In the 1950s, New York also took centre stage in the photographs of William Klein (b.1928), whose art teacher, artist Fernand Léger, had advised him to leave the studio and explore the streets. Klein joined *Vogue* in 1955, and used wide-angle and telephoto lenses to create fashion pictures that reflected the dynamism of the modern metropolis. Frank Horvat (b.1928) and Bruce Davidson (b.1933) share Klein's background in 35mm reportage photography, and their approach turned fashion spreads into visual narratives that echoed the look of French New Wave cinema. A similar aesthetic would soon be taken up by young photographers in London.

In the 1950s Norman Parkinson (1913–90) spent part of every year in New York producing exuberant images such as *New York, New York, East River Drive* (1960; see p.348). An unusually contemplative image is *After Van Dongen* (above right), featuring Adèle Collins in soft focus against heavily textured, tattered brocade. The image is Parkinson's homage to *The Corn Poppy*, a portrait by Dutch Fauvist Kees van Dongen of his chic young sister, painted in *c.* 1919. Collins is depicted as the modern-day version of van Dongen's model. Her kohl-rimmed eyes imitate the sideways glance in van Dongen's portrait, while the red of her hat and lips closely echoes the coloration of the painted portrait. Red lipstick had gained popularity in the 1920s and was worn as a symbol of independence both then and later in the century. Glossy crimson lips also featured on several *Vogue* covers by Erwin Blumenfeld (1897–1969), most notably 'The Doe Eye' cover featuring model Jean Patchett in January 1950.

By the late 1950s, haute couture was in decline and the central axis of the fashion world was shifting once again. In a period of dramatic social evolution, London became a creative epicentre for young fashion photographers and designers, the heart of the cultural movement termed 'Youthquake' in 1963 by *Vogue*'s then editor-in-chief, Vreeland. Newspapers featured fashion images, as stylish but affordable mass-produced garments became widely available. John French (1907–66) pioneered high-contrast photography, creating the necessary resolution for black-and-white images to be reproduced effectively on cheap newsprint. Two of French's young assistants, David Bailey (b.1938) and Terence Donovan (1936–96), went on to become star photographers of the 1960s.

Bailey was employed to revamp the 'Young Idea' section of British *Vogue*. The vivacious documentary approach of Bailey and his contemporaries turned teenage models such as Jean Shrimpton and Lesley Hornby, aka 'Twiggy', into international stars. The era also gave birth to an influential men's fashion magazine, *Town*. It employed the likes of Donovan and Bailey to photograph male models cast as James Bond–style heroes under the guidance of art director Tom Wolsey. Their photographs were given suitably enigmatic titles, including *Thermodynamic* (1960) and *The Secrets of an Agent* (1961).

Klein's photograph of futuristic outfits and 'Eskimo' glasses designed by André Courrèges (right) shows the dramatic impact that the space race had on fashion. Avedon posed models in couture at Cape Canaveral, Florida in 1959 and James 'Jimmy' Moore (1937–2007) used the McDonnell Aircraft Space Center in St Louis for the 'St Louis Night In Space' feature for *Harper's Bazaar* in October 1965. In the same decade, the notion of what constituted ideal beauty broadened in mainstream magazines. In March 1966 Donyale Luna became the first African American model to appear on the cover of British *Vogue*, photographed by Bailey. In the 1970s, photographers such as Helmut Newton (1920–2004) and Guy Bourdin (1928–91) tested the limits of acceptable fashion imagery and contemporary attitudes to femininity and sexuality. **SB**

Dovima with Elephants 1955

RICHARD AVEDON 1923 – 2004

Dovima with elephants, evening dress by Dior,
Cirque d'Hiver, Paris, August 1955
Silver print
© The Richard Avedon Foundation, New York, USA

Inspired by Martin Munkácsi, Richard Avedon sought to imbue his images with vitality and humour. Working primarily outside the studio, Avedon photographed fashion in some of the most dramatic and unexpected locations in the world, from Florida's Cape Canaveral Air Force Station to Paris's Cirque d'Hiver theatre, as seen here in *Dovima with Elephants*. When Avedon found this location, he knew at once that it had the potential to create what he described as 'a kind of dream image'. It is an extraordinary photograph of opposites: black and white, youthful and aged, freedom and captivity, lithe and lumbering. Like so many of Avedon's photographs, at its heart is the subject of ageing. His large-format camera captured every wrinkle in the elephants' skin and every dry stalk of straw on the ground. So powerful is the central composition and the sense of dramatic movement, at first glance the viewer barely notices that heavy ankle chains restrain the animals.

Standing with one foot forward to create a narrow, tapering silhouette, the model Dovima wears a black velvet evening gown from Christian Dior's Autumn/Winter 1955 to 1956 collection, which was one of the first evening dresses designed for Dior by his nineteen-year-old assistant, Yves Saint-Laurent. Avedon later described Dovima as 'the most remarkable and unconventional beauty of her time'. The photograph was first published in *Harper's Bazaar* in September 1955. **SB**

👁 FOCAL POINTS

1 DOVIMA
Instead of adopting the hunched posture commonly seen in fashion images of the period, Dovima pulls her shoulders back and tilts her chin upwards, highlighting the elegant line of her neck. Avedon juxtaposes Dovima's grace with the immense size and power of the elephants.

2 SATIN SASH
The cascading satin sash cuts the black velvet into thin panels and forms a strong parallel with the elephant's leg closest to the model. Avedon was critical of the composition, saying: 'I don't know why I didn't have the sash blowing out to the left to complete the line of the picture.'

3 CONTRAST OF SKIN
The rough and deeply furrowed elephant hide contrasts with the flawless pale skin of Avedon's model Dorothy Virginia Margaret Juba (aka Dovima, from the first two letters of her three given names). This is accentuated by the placing of Dovima's hand on the elephant's trunk.

🕐 PHOTOGRAPHER PROFILE

1923–44
Richard Avedon was born in New York to a family of Russian Jewish immigrants. He worked as a photographer in the United States Merchant Marines from 1942 to 1944, before studying at the Design Laboratory of the New School for Social Research, led by Alexey Brodovitch.

1945–78
Avedon was appointed staff photographer at *Harper's Bazaar*, where he worked alongside Brodovitch, Marvin Israel, Carmel Snow and Diana Vreeland. He acted as a visual consultant on the film *Funny Face* (1957), which was based loosely on his life. In 1958 Avedon was named as one of the world's top ten photographers by *Popular Photography* magazine. He joined *Vogue* in 1966 as a staff photographer for an unprecedented annual salary of US$1 million. In 1976, on a commission for *Rolling Stone* magazine, Avedon produced the series *The Family*, a composite portrait of the United States' power elite at the time of the country's bicentennial election. In 1978 New York's Metropolitan Museum staged the retrospective 'Avedon: Photographs 1947–1977'.

1979–91
In 1979 Avedon embarked on one of the most important projects of his career, titled 'In the American West'. He spent six years photographing members of the working class, drifters and the disenfranchised in the region. The project culminated in a book and an exhibition at the Amon Carter Museum, Fort Worth, Texas. In 1991 he was awarded the Erna and Victor Hasselblad Foundation International Photography Prize.

1992–2004
Avedon was appointed the first staff photographer at *The New Yorker* in 1992. The next year he published *An Autobiography*. In 1994 an international retrospective of Avedon's work, 'Evidence 1944–94', took place. He died in 2004 while on location in Texas, working on his project 'Democracy' for *The New Yorker*.

New York, New York, East River Drive 1960
NORMAN PARKINSON 1913 – 90

Silver print
20 x 16 in. | 51 x 40.5 cm
Norman Parkinson Archive,
London, UK

I n 1949 Norman Parkinson made the first of many trips to Manhattan to take photographs for US *Vogue*, which was eager to hire English photographers at the time. So began a photographic love affair with New York as Parkinson portrayed its post-war glamour, wealth and sense of optimism by photographing models outdoors on the streets of the city.

He photographed *New York, New York, East River Drive* for *Go* magazine in his pioneering 'action realist' style, which helped revolutionize fashion photography. Dressed as though on their way to or from work, a couple are shown racing along a street in a show of youthful *joie de vivre*. The female figure is an example of the new breed of woman that Parkinson depicted as strong and independent. The man and woman, who were not actually a couple—British playwright Robin Miller and Pippa Diggle—lived in the same New York apartment block as Parkinson and his wife Wenda. Taken from the South Street Viaduct section of East River Drive, a freeway on the east side of Manhattan adjacent to the East River, the image is as much an homage to the city's vibrant energy and breathtaking architecture as a fashion photograph. It shows the west end of Brooklyn Bridge and the tallest building in Downtown Manhattan—the towering skyscraper of the Cities Service Building (now American International)—in the distance. **CK**

⬥ NAVIGATOR

👁 FOCAL POINTS

1 SKYLINE
Parkinson uses the Manhattan skyline as a backdrop. The image shows the Bank of Manhattan Trust Building (left; now the Trump Building) and 1 Chase Manhattan Plaza (right), which was then being built. Its construction was an example of the post-war economic boom in the borough.

2 WOMAN'S FACE
The woman is smiling and her expression is exuberant. Dressed in a smart, dark coat, she exemplifies the independent young, middle-class women of the time. US women were finding new opportunities to go out to work in white-collar jobs after World War II.

3 MAN'S FEET
The man's feet seem barely to touch the ground, adding a sense of dynamism and movement. From the 1930s Parkinson had followed the lead of Martin Munkácsi by photographing models in outdoor settings. 'My aim,' he said, 'was to take moving pictures with a still camera. . . .'

4 BRIEFCASE
The man holds a briefcase in one hand; the other stretches across the woman. The figures epitomize the affluence of post-war Manhattan. The image evokes the lifestyle that New York could offer young married couples as the man and woman run along the street, almost leaping for joy.

🕐 PHOTOGRAPHER PROFILE

1913–33
Norman Parkinson was born Ronald William Parkinson Smith in Roehampton, London and educated at Westminster School. From 1931 to 1933 he was apprenticed to the court photographers Speaight & Sons of 157 Bond Street, London.

1934–44
Parkinson set up the Norman Parkinson studio, specializing in portraiture of debutantes. In 1935 he had his first solo exhibition, held at his studio, which included portraits of Vivien Leigh and Noel Coward. The same year he was recruited by *Harper's Bazaar*. Parkinson closed his studio in 1939; many of his prints and negatives were destroyed during the Blitz.

1945–90
Parkinson began working for *Vogue*, taking fashion and portrait photographs. In 1949 he made his first trip to Manhattan to work for US *Vogue*. He was associate contributing editor of *Queen* from 1960 to 1964. Parkinson continued to work for *Vogue* into the 1970s, working notably with Jerry Hall and Grace Coddington. He died in Singapore in 1990, while on location for *Town & Country* magazine.

PORTRAITURE AND CELEBRITY

1

2

3

1 *Igor Stravinsky, New York City* (1946)
Arnold Newman • silver print
Harry Ransom Center, University of Texas
at Austin, USA

2 *Audrey Hepburn* (1950)
Angus McBean • bromide print
17 ½ x 13 ⅛ in. | 44.5 x 35.5 cm
National Portrait Gallery,
London, UK

3 *The Photojournalist* (1951)
Andreas Feininger • silver print
Time & Life Pictures/Getty Images

The late 1940s saw Hollywood cinema in the middle of its golden age, transforming actors into international stars. A renewed interest in culture and the arts also saw figures from music, art and literature become the celebrities of their day. The meticulously constructed portrait became crucial in cultivating the aura of celebrity. Carefully lit, artfully styled and skilfully retouched, such portraits shaped and fixed the image of a star in the public consciousness.

Throughout the 1940s, Arnold Newman (1918–2006) was commissioned by magazines such as *Life*, *Fortune* and *Harper's Bazaar* to take photographic portraits of influential personalities from the world of culture. Among Newman's best-known works is a sitting with Igor Stravinsky (above), frequently hailed as the greatest composer of the 20th century. Taken with a large-format camera, the original negative was severely cropped to create a starkly graphic and linear composition in which the piano top dominates and Stravinsky is pushed to the very corner of the frame. Newman noted how the piano lid resembled the strong, hard and linear shape of a B-flat musical note, the same qualities that characterize Stravinsky's musical compositions. By placing his subject within a setting that reflected his or her profession or personality, Newman developed a signature 'environmental' portraiture style.

Angus McBean (1904–90) was well placed to document the upsurge of interest in the London theatre. Commissioned in 1936 by Ivor Novello to take production photographs, McBean quickly garnered a reputation for creating artificially staged, Surrealist (see p.232) portraits of the leading stars of stage

KEY EVENTS

1947	1948	1956	1957	1960	1962
The House Committee on Un-American Activities investigates allegations of Communist propaganda in Hollywood films.	Irving Penn travels to Europe. He shoots portraits of figures from the arts such as Balthus in Paris, and Roberto Rossellini and Anna Magnani in Rome.	Beat Generation writer Allen Ginsberg publishes his poem *Howl*. Its publisher is charged with disseminating obscene literature.	Richard Avedon is a visual consultant on the movie *Funny Face*, starring Audrey Hepburn and Fred Astaire.	Federico Fellini's film *La dolce vita* gives rise to *paparazzo*—the term used to describe intrusive photographers.	Commissioned by *Vogue*, Bert Stern (b.1929) is the last photographer Marilyn Monroe sits for before her death.

and screen, which appeared in titles such as illustrated newspaper *The Sketch*. Early in Audrey Hepburn's career, McBean picked out her elfin features from a West End chorus line to feature in an advertisement for a beauty product that appeared in chemists' windows across the nation. The portrait of Hepburn (above right) remains one of his most anthologized images, a fact that did not escape him: 'Perhaps if I ever go down in photographic history, it will be as the man who took the picture of Audrey Hepburn in the sand. . . .' With the clever use of props and set design to create visual tricks, Hepburn appears to emerge naked from a desert of sand, populated by architectural columns. Combining strange distortions of scale with bizarre juxtapositions, McBean fabricated a remarkable tableau that concocts a playful sense of fantasy.

Firmly behind the fabrication of celebrity was the media industry, with its ability to keep stars in the public eye through hugely popular publications. Picture magazines were in their heyday, with publications such as *Life* and *Look* circulating photographs of stars to an extensive readership. In 1951 *Life* launched a contest for young photographers. Andreas Feininger (1906–99), a staff photographer at the magazine for almost twenty years, was commissioned to photograph the winner, Dennis Stock (1928–2010). In Feininger's composition (below right), Stock holds a camera to his face, suggesting an equivalence between Stock's eyes and the lens and viewfinder of his camera: a comment on the specifically photographic vision of the new breed of photojournalist. Stock went on to join the Magnum Photos (see p.326) cooperative agency and became a successful documentary photographer, best known for his photoessay on actor James Dean published in *Life* magazine shortly before the star's death in 1955.

The notion of the Hollywood superstar gained currency in the 1950s with actors such as Marlon Brando and Grace Kelly reaching new heights of fame. Fashion magazines increasingly featured film stars and cultural figures on their pages. *Vogue*'s most prolific photographer, Irving Penn (1917–2009), shot portraits for the magazine for more than half a century. In the late 1940s *Vogue* commissioned him to take a series of portraits of famous personalities from the arts that included artist Marcel Duchamp, writer W. H. Auden, musician Yehudi Menuhin and fashion designer Christian Dior. The resulting photographs serve as a compendium of the cultural figures that came to define the post-war period. Photographing within an anonymous studio space, Penn made little attempt to fawn to the sitter and often emphasized the contrived studio setting through the inclusion of electric cables and constructed backdrops. Typically, Penn chose a neutral backdrop that refuted any suggestion of narrative, with no elaborate props or styled environments to hint at the nature of the sitter's celebrity. Cigarette butts, pieces of rug and lengths of cable often littered Penn's unpainted studio floor, generating what Alexander Liberman, *Vogue*'s art director, came to recognize as a 'grubbiness of the times'.

1964	1966	1966	1969	1969	1972
The Beatles appear on *The Ed Sullivan Show*. As the hottest stars on the world music scene, they are trailed by photographers wherever they go.	*Time* magazine defines London as 'swinging', celebrating its youth-oriented fashions and flourishing vibrant cultural life.	Michelangelo Antonioni's thriller *Blow-Up* depicts a day in the glamorous life of a brash young fashion photographer.	Andy Warhol founds *Interview* magazine. It becomes a promotional vehicle for celebrities and up-and-coming photographers.	Woodstock takes place in Bethel, New York. Photographers such as Henry Diltz (b.1938) and Elliott Landy (b.1942) take iconic shots of rock stars.	*Life* magazine announces it is to cease regular publication because of a decline in advertising revenue. It closes in 1978.

Celebrities themselves were increasingly aware of the way in which photographs could be used to manipulate their public image. As a young actress in the early 1950s, Marilyn Monroe cleverly exploited the potency of photography and the public's insatiable appetite for picture magazines to generate publicity and cultivate her fame. Magnum photographer Eve Arnold (1912–2012) worked with Monroe several times in relaxed and personal settings, capturing some of the most tender images of the actress. Taken outdoors, *Marilyn Monroe, Long Island, New York* (left) shows the actress sitting on a merry-go-round in a children's playground, and resembles a casual snapshot when compared to the posed and artificial genre of studio portraiture. Monroe kept a copy of James Joyce's *Ulysses* (1922) in her car; when she started reading it, Arnold shot her engrossed in the last few pages of the novel. This intimate portrait seemingly permits the viewer a glimpse behind Monroe's constructed public persona of guilt-free sexuality in an unguarded moment. Arnold continued to photograph Monroe for the rest of her life, famously on the set of the star's last movie, *The Misfits* (1961), which was released only a year before she died.

Employed as a staff photographer by *Vogue* in the 1940s and 1950s, John Deakin (1912–72) excelled at photographing London's social scene. He took portraits of his bohemian circle of friends, including the artists Francis Bacon and Lucian Freud, in the pubs and clubs of Soho—then the centre of artistic life in post-war London. Deakin responded to the austerity of the post-war years with a decidedly bleak vision. Showing little regard for the finished image, often Deakin's prints are crumpled and ripped, held together with tape and covered with paint. Deakin's disregard for his work stemmed from his thwarted ambition to become a painter. His volatile temperament and alcoholism proved too much for the editors at *Vogue*, who fired him on two separate occasions. Nevertheless, Bacon continued to support Deakin with photographic commissions that he used as the basis for paintings, describing Deakin's portraits as 'the best since Nadar and Julia Margaret Cameron'.

While films and magazines were filled with idealized portrayals of glamorous men and women, a youth culture was emerging that demanded an exciting and darker idea of celebrity. Influenced by Beat Generation writers Allen Ginsberg and Jack Kerouac, the Beatnik literary movement expressed a growing weariness with the stagnancy of life in the late 1950s and paved the way for a generation ready to rebel against convention. Seeking thrills in all their forms, young people were attracted to the candour and spontaneity of Beatnik culture, which came to be associated with a hedonistic lifestyle fuelled by sex, drugs and alcohol. A portrait taken by Richard Avedon (1923–2004) in 1963 shows Ginsberg and his partner, poet Peter Orlovksy, clasping each other in a naked embrace in a celebration of freedom and disregard for convention. The same year Pop artist Andy Warhol (1928–87) began occupying a studio space in Manhattan on East 47th Street, dubbed 'The Factory'. Warhol's coterie of avant-garde writers, filmmakers, rock stars and social misfits emerged out of the lifestyle developed by the Beatniks. Photographed by Avedon in 1969 (see p.354), The Factory achieved mythic status for glamorizing a subversive way of life. Avedon's signature portraiture style possesses an iconoclastic sensibility. Isolating a figure against a white background levels all subjects: film stars, politicians and blue-collar workers all feature in his images. In an epoch of change, the social order upon which ideas of celebrity had been based was eroded rapidly.

The rise of paparazzi photographers, combined with technical developments in flash, fast film and long lenses, meant that the boundary between a celebrity's private and public life was being eliminated. Terry O'Neill (b.1938) rose to prominence photographing celebrities of the swinging sixties in unconventional surroundings. O'Neill's photograph *Frank Sinatra with His*

4 *Marilyn Monroe, Long Island,*
New York (1955)
Eve Arnold • chromogenic colour print
Magnum Photos

5 *Mick Jagger; Bianca Jagger* (1971)
Patrick Lichfield • archival inkjet print
on foam board mount
41½ x 61½ in. | 105.5 x 156 cm
National Portrait Gallery, London, UK

Bodyguards (1968) shows the actor and singer with his entourage arriving at Miami Beach while filming on location. Close inspection reveals a man wearing an identical suit: Sinatra's body double or decoy. O'Neill's free pass into Sinatra's world became part of a subtle game played by celebrities to control their image, as their constructed public personae were being tested for authenticity.

An increasingly dominant youth culture fuelled the meteoric rise of pop icons in the 1960s. Bands such as the Beatles and the Rolling Stones became the superstars of their day, popularized by the mass media of television and radio. As the appeal of picture magazines began to wane, carefully worked portraiture came to be replaced with candid journalistic snapshots with their titillating promise of access and authenticity. Patrick Lichfield (1939–2005) emerged from this culture. His talent for glamorizing the beautiful and famous, combined with his charm and aristocratic background (a first cousin once removed of Queen Elizabeth II, he was the 5th Earl of Lichfield), helped to establish him on the celebrity circuit. Photographing rock singer Mick Jagger in a Bentley after his wedding to Bianca Pérez Morena de Macias in Saint-Tropez in 1971, an open bottle of champagne placed in a phallic position between his legs and a cigarette in hand (below), Lichfield offers viewers the sense that they are present at a happy moment shared with only a handful of people close to what were rock royalty. Not only did Lichfield's photographs capture the spirit of the era, but he was also submerged in the world of celebrity he photographed: it was Lichfield who gave the bride away at the wedding.

The late 1950s marked a shift in the status of the photographer. Avedon's career was celebrated in the movie *Funny Face* (1957), with Fred Astaire starring as a charismatic fashion photographer. The likes of O'Neill, Lichfield, Anthony Armstrong-Jones (b.1930), David Bailey (b.1938) and Terence Donovan (1936–96) revelled in their talent and connections, making the most of the jet-set lifestyle on offer. Michelangelo Antonioni's film *Blow-Up* (1966) about a brash young photographer about town is said to be inspired by Bailey and Donovan. The new generation of photographers—male, heterosexual, bohemian and, mostly, working class—fast became the stars of the entertainment scene, as the men behind the cameras became as famous as the celebrities who posed for them. **SJG**

Andy Warhol and Members of The Factory 1969

RICHARD AVEDON 1923 – 2004

Andy Warhol and Members of The Factory,
New York, 30 October, 1969
Three silver prints mounted as a triptych
© The Richard Avedon Foundation,
New York, USA

By the time Richard Avedon photographed Andy Warhol and his entourage of aspiring actors and directors, 'The Factory' had become the symbol of an emerging alternative culture, drawing the outrageous, the talented and the disreputable through its doors. A site of prolific film production, it became a place where anybody could become a star. Only a year prior to Avedon's portrait, Warhol had pronounced, 'In the future everybody will be world famous for fifteen minutes.' Divorcing Warhol and his entourage from their Factory surroundings, Avedon focuses the viewer's attention on the individuals themselves, their gestures and their expressions. Avedon was fascinated by the way his sitters performed and posed: 'A photographic portrait is a picture of someone who knows he's being photographed. What he does with this knowledge is as much a part of the photograph as what he's wearing or how he looks.'

Three separate images are aligned side by side, each framed by the partial borders of the negative. The resulting triptych resembles a classical frieze, or successive frames in a film strip. The viewer is excluded from any final denouement: Avedon rejected a concluding frame in which Warhol appears to videotape Joe Dallesandro in a post-coital state. The arrangement of figures and abandoned clothes suggests an improvised and spontaneous group portrait that reflects the louche world of Warhol's Factory. Yet closer inspection reveals figures that recur, exposing Avedon's image as a meticulously staged tableau: actor Joe Dalassandro appears naked on the left-hand panel and reappears fully clothed next to Warhol on the right; film director Paul Morrissey also materializes twice. The recurrence of figures implies a lapse in time and promises narrative progression. When printed to a larger-than-life-size scale, nonchalantly naked figures fill the frame and engulf the viewer in their expanse, generating a face-to-face encounter with the photographed subjects. Warhol is positioned at the helm of a cultural coup d'état, in which the old social order was giving way to a new generation. **SJG**

INTERVIEW MAGAZINE

Interview was founded in 1969 by Andy Warhol and his Factory collaborators Gerard Malanga, Paul Morrissey and John Wilcock, whose names all appeared as editors on the masthead of the first issue of the magazine. *Interview* started life as an underground film journal. Refused free tickets to the New York Film Festival in 1969, Warhol reportedly declared, 'If we start a film magazine, they'll have to let us in.' *Interview* cultivated Warhol's own celebrity, ensuring access to the most fashionable parties and the most influential people. Dubbed the 'Crystal Ball of Pop Culture', each issue featured celebrities interviewing fellow celebrities, film and fashion news, and celebrity gossip. The spectacular large-format photographic spreads provided valuable exposure for emerging photographers, including Peter Beard (b.1938), Robert Mapplethorpe (1946–89) and Bruce Weber (b.1946). Bob Colacello, editor of *Interview* (1975–83), said of Warhol and the magazine: 'I think Andy has had a huge influence on young artists, and in so many ways. He opened the door to so much. . . .He also legitimized photography as art. I remember in 1974 we did an issue of *Interview* called "Is Photography Art?" because [Richard] Avedon was having his first show of portraits at the Marlborough Gallery. We thought it was astounding that such a gallery would show a photographer.'

⏱ PROFILE: ANDY WARHOL

1928–48
Born Andrew Warhola to a working-class immigrant family in Pittsburgh, Pennsylvania, Warhol trained as a commercial artist at the Carnegie Institute of Technology.

1949–62
He moved to New York and became a successful illustrator. In May 1962 Warhol held his first fine art exhibition, showing thirty-two canvases of Campbell's soup cans in Los Angeles. He was identified with Pop art, the critical sensation of that year, and adopted silk-screen printing.

1963–67
Warhol established a studio in Manhattan at 231 East 47th Street. He called it 'The Factory' and it became the focus of an underground circle of artists, actors, musicians, drug addicts and misfits. Warhol produced large numbers of series paintings, mostly manufactured by his assistants. In 1963 he began making experimental films using his friends as actors.

1968–69
In June 1968 Warhol was shot and almost killed by Valerie Solanas, a feminist extremist whom he had offended. He suffered physical effects for the remainder of his life and never fully recovered from the ordeal. From the end of the radical 1960s Warhol lost his perhaps spurious association with a counterculture opposed to US capitalism.

1970–87
He shamelessly touted for portrait commissions from the rich and emphasized his commitment to art as business. Warhol died from a cardiac arrhythmia after a gall bladder operation.

PICTURING THE 'OTHER'

In 1922 US journalist Walter Lippmann first used the word 'stereotype' in a metaphorical sense, defining it as 'the projection upon the world of our own sense of our own value, our own position and our own rights'. Photographs are particularly prone to such judgements when they depict members from different social, ethnic or class groups. These images say more about the photographer's perspective or world view than they do about the person in front of the lens.

Although the work that Irving Penn (1917–2009) did for *Vogue* has come to define 20th-century US fashion and celebrity photography, at the start of his career Penn dreamt of embarking on a very different personal project, documenting the 'remarkable strangers. . .the disappearing aborigines in remote parts of the earth'. That dream was realized in December 1948 when, after an assignment photographing dresses for *Vogue* in Lima, he travelled to Cuzco in Peru. Penn said of his arrival in Cuzco: 'The look of the inhabitants enchanted me—small, tight little ¾-scale people, wandering aimlessly and slowly in the streets of the town. . . .It is difficult to imagine the present inhabitants as descendants of the brilliant engineers of the Inca cities'. On arriving he rented a local portrait studio where he made a series of photographs that includes *Cuzco Children* (1948). The

KEY EVENTS

1948	1948	1950	1953	1955	1967
Robert Frank travels to Peru to escape the New York fashion world. He says he hopes 'to satisfy my own nature, to be free to work for myself'.	Irving Penn travels to Cuzco in Peru: with one weekly flight, 'almost no one went there except for a few archaeologists.'	Penn begins his *Small Trades* series that creates a typology of the working classes of London, Paris and New York.	Frank documents the daily life of a middle-aged Welsh miner, Ben James, who had been working in the pits since the age of fourteen.	Zurich-born Frank is the first European photographer to be given a Guggenheim Fellowship. He sets out on an odyssey across the United States.	Diane Arbus (1923–71) creates *Identical Twins, Roselle, New Jersey*. Her work is also included in 'New Documents' at the Museum of Modern Art.

generic title offers no clues as to the two children's identity and individuality: Penn simply adds, 'A brother and a sister, dressed for a visit to Cuzco'. He used his trademark tonal backdrop, claiming, 'I found pictures trying to show people in their natural circumstances generally disappointing. . .I preferred the limited task of dealing only with the person himself, away from the accidents of his daily life, simply in his own clothes and adornments'. Indeed, other than the children's threadbare attire, the only other prop in the photograph is a piano stool, included as Penn desired to tell 'something of their tiny size'. The language barrier prevented him from talking to his subjects, so he posed them by hand. His first editor at *Vogue*, Rosamond Bernier, felt he arranged their positions 'as impersonally as he has organized still lives,' adding that he 'observes them but does not want to know them'. *Cuzco Children* does not portray individuality so much as exoticism: it is more an ethnographic study than a portrait.

Documentary images that picture social, ethnic or class groups seem the antithesis of artistic projects such as Penn's. They generally seek to offer an insight into the lives of those pictured, as with *Lena on the Bally Box, Essex Junction, Vermont* (1973; see p.358) by US photographer Susan Meiselas (b.1948). Swiss-born photographer Robert Frank (b.1924) worked in a similar vein to produce his images of a fifty-three-year-old miner from South Wales named Ben James. Frank and his family lived with Ben James during the assignment in 1953 and he uses the title of his photograph—*Wales (Ben James, Coal Miner, Caerau)*—to give information and place his subject within his environment.

British photographer Colin Jones (b.1936) also photographed working-class subjects. He became a professional photographer in 1962 but started his career as a dancer with the Royal Ballet. It was while on a tour with the dance company in Australia in 1958 that he bought his first camera and began to take photographs. He went on to take images of miners, shipbuilders, dockers and dancers in the north of England, which were used later for his photobook *Grafters* (2002). His photograph *Liverpool Docks* (opposite) focuses on an unidentified man surrounded by other flat cap-wearing dockers. Jones photographed the men at a meeting held to protest against employers using only casual labour. The rugged appearance and determined expression of the docker facing the camera lends dignity and humanity to the subject, a piece of visual rhetoric that confounds the popular view of strikers as an unthinking mob.

Despite the desire of photographers such as Frank and Jones to give access to the lives of those rarely encountered in middle-class life, such portraits almost inevitably stereotype their subjects. Jones's *Liverpool Docks* and Frank's *Wales (Ben James, Coal Miner, Caerau)* are made to personify the impoverished miner and poor dock worker, for those wishing to 'know' about worlds other than, indeed alien to, their own. **JMH**

1 *Liverpool Docks* (1963)
Colin Jones • silver print
16 x 20 in. | 40.5 x 51 cm
Michael Hoppen Gallery, London, UK

1968	1972	1973	1974	1975	1976
Self-taught US photographer Danny Lyon (b.1942) publishes *The Bikeriders*, his seminal study of the Chicago Outlaw Motorcycle Club.	Documenting a carnival in Bangor, Maine, Susan Meiselas comes across a show called 'Girls Galore'. Barred from entering, she resolves to find out more.	Colin Jones begins his project photographing at a hostel for troubled young black men, known as 'The Black House', in Islington, London.	Penn publishes *Worlds in a Small Room*. Different ethnic groups from Cuzco to Cameroon appear, as do subcultures such as hippies.	Meiselas has her first solo exhibition, 'Carnival Strippers', in Buffalo, New York. Fairground sounds and interviews play out in the gallery.	Meiselas joins Magnum. Seven years later, the second edition of *Carnival Strippers* is released with an audio CD of interviews.

Lena on the Bally Box, Essex Junction, Vermont 1973

SUSAN MEISELAS b. 1948

👁 FOCAL POINTS

1 THE 'BARKER'
The 'barker' performs the bally call to draw in punters: 'You're going to see burlesque, striptease, hootchie-kootchie, and dadday-o it's all the way. The show starts right now. . . right down front in the finger-lickin good row, where you can look up and see the whole, I mean the *whole* damn show'.

2 LENA
The image was taken during Lena's first season. She told Meiselas: 'I'm going to strip till I get on my feet. When I get on my feet I'll decide what to do. Right now, I got no place to go.' Two years later she said: 'We aren't professional show girls, we're prostitutes pretending to be show girls. . .It's a tough life'.

This photograph is taken from *Carnival Strippers* by Susan Meiselas. In the summers from 1973 to 1975, Meiselas, who was not long out of college, followed the carnival circuit around New England, Pennsylvania and South Carolina, training her lens on the strip scene. She photographed girls, like Lena, posing on the Bally Box, trying to rustle up a fairground audience. However, she also managed access into the tent beyond where previously the only women allowed were those that stripped. Meiselas elaborates in the book of the series, 'Again and again, throughout day and night, the women performers move from the front stage, with its bally call—the talker's spiel that entices the crowd—to the back stage where they each perform for the duration of a 45 pop record. The all-male audience typically includes farmers, bankers, fathers, and sons, but "no ladies and no babies".'

In following the girls' day-to-day and night-to-night activities, over the years Meiselas got to know them well. She even corresponded with Lena long after the project ended. Meiselas was all too aware of the tendency of the photograph to stereotype. Ultimately, her photographs work to strip Lena of her individuality and redress her as the 'down-on-luck stripper'. To counteract this, Meiselas decided to tape interviews with her subjects and include them as transcripts in the book of *Carnival Strippers*. Moreover, in the second edition published in 2003, she edited together a CD of the girls speaking alongside their manager and clients. She explains, 'There is a lot of honesty revealed by Lena, that is her expression of personality; at the same time she is obviously in a system and it is difficult to counteract the social stereotypes and perceptions OF her. The whole point of hearing voices is to challenge what the pictures themselves show, that is the tension and power of "stereotypes"; contextualizing with voices/texts hopes to counterbalance and reveal what is missed by images alone.' **JMH**

Silver print
Magnum Photos

◷ PHOTOGRAPHER PROFILE

1948–71
Susan Meiselas was born in Baltimore, USA. She graduated from Harvard University with an MA in visual education. She was assistant editor on the documentary *Basic Training* (1971).

1972–79
From 1972 to 1974 she ran workshops in the South Bronx, New York and set up film and photography programmes for schools in South Carolina and Mississippi. Her first major series *Carnival Strippers* was published in 1976. The same year she joined Magnum and began documenting events in Nicaragua, for which she was awarded the Robert Capa Gold Medal in 1979.

1980–98
She contributed to books, including *El Salvador: The Work of Thirty Photographers* (1983). In 1984 she received the Hasselblad Award. She co-directed films, including *Pictures from a Revolution* (1991). In 1997 she curated a visual history of Kurdistan and created an online archive (www.akaKURDISTAN.com).

1999–PRESENT
Pandora's Box, a monograph of her work at an S&M club in New York, was published in 2001. An overview of her documentary work, 'Susan Meiselas: In History', was held at the International Center of Photography, New York in 2008–09.

THE NUDE

1 *Eleanor, Aix-en-Provence* (1958)
Harry Callahan • silver print

2 *Provençal Nude, Gordes* (1949)
Willy Ronis • silver print

3 *Classic Torso* (1952)
Ruth Bernhard • silver print
13 ⅜ x 10 ¼ in. | 34 x 26 cm
Princeton University Art Museum,
New Jersey, USA

In the post-war period, a number of photographers returned to—and revitalized—the female nude as a subject for their work. In fashion photography it was usually the bodies of slender young women that featured in the pictures. Surprisingly, Irving Penn (1917–2009) moved away from this in his personal work, when he chose to photograph large women with abundant flesh, a project he began in 1949.

A number of street and documentary photographers also made the nude genre their own. When Bill Brandt (1904–83) turned to the nude, in works such as *Nude, Campden Hill, London* (1949; see p.362), and Harry Callahan (1912–99) chose to photograph his wife Eleanor in the nude, they did so not only as a means to explore new formal and technical strategies, but also to give expression to their artistic and emotional subjectivity. Indeed, many male

KEY EVENTS

1946	1946	1947	1949	1950s	1952
Edward Weston has a retrospective exhibition at the Museum of Modern Art in New York, which includes his nudes.	Imogen Cunningham photographs *Pregnant Nude, Happy Valley* at a time when a picture of a naked pregnant woman was an unusual subject in US culture.	Harry Callahan begins his figure studies of his wife, Eleanor, which he continues throughout his career.	In the summer, between fashion assignments, Irving Penn embarks on his nude studies of soft, fleshy women.	Josef Breitenbach begins producing nudes for the series *This Beautiful Landscape*.	Cunningham prints her work *After the Bath*, which shows a nude female figure—a subject she would return to throughout her career.

photographers regarded their female subjects as their muse, working intensely either with life-long partners or with professional models.

Willy Ronis (1910–2009) is best known for his street photography, but the female nude appears throughout his life's work. *Provençal Nude, Gordes* (above right) is a study of his wife, the painter Anne-Marie Lansiaux. Ronis described how he captured the image by chance when he saw his wife go to refresh herself on a hot day in July. He rushed to grab his twin-lens reflex camera and took four shots quickly. There is an intimacy in the view of a woman bending over a sink to carry out her ablutions, seemingly unaware of being watched; it is romantic rather than titillating. The image is reminiscent of French artist Pierre Bonnard's studies of his companion Marthe, who later became his wife.

Harry Callahan is also better known as a photographer of street scenes, but throughout his career he created a series of figure studies of his wife Eleanor (and later his daughter Barbara, too). In many of these studies Eleanor poses nude, both indoors and outside. His series *Aix-En-Provence* (1956–58) mainly looks at the landscape; however in a number of works Eleanor's body makes an appearance (opposite). Her figure casts a ghostly shadow over her husband's atmospheric studies of nature; the series has almost surreal overtones and is evidence of Callahan's abiding interest in technical experimentation to achieve new effects and juxtapositions.

Ruth Bernhard (1905–2006) was one of the few women photographers of the 20th century who demonstrated that the female nude could be a genre in which women artists could also excel. She made the nude her subject of study by chance. Bernhard was working in New York in 1934 when she asked a friend, who was happy to pose nude, to sit inside a large steel bowl she was photographing for an industrial designer. This became Bernhard's work *Embryo* and sparked a life-long interest in studying the female form. Bernhard was influenced by Edward Weston (1886–1958) whom she met in Los Angeles in 1935. Weston made nude studies of his wives and lovers throughout his career and Bernhard had an artistic empathy for his work. She also became involved with the Round Table of Photography, which included influential photographers Imogen Cunningham (1883–1976), Dorothea Lange (1895–1965), Minor White (1908–76) and Wynn Bullock (1902–75). Cunningham also focused on the female form after an early series of nude studies of her husband, Roi Partridge, was deemed risqué. Bernhard concentrated fully on the female form in her work from the 1950s, producing images mostly in black and white.

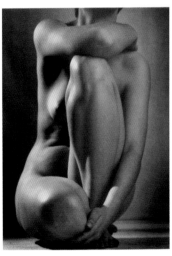

Female nudes in photography often rely upon an explicit or implicit sexualization of the female form that is designed for the pleasure of the heterosexual male viewer. The body is abstracted and objectified, as seen in *This Beautiful Landscape* (1963), a series of nudes by Josef Breitenbach (1896–1984). In contrast, Bernhard's work portrays female models modestly posed, rather than exposed, and in *Classic Torso* (right) the viewer is directed to think of sculpture rather than a naked body. Bernhard said: 'I felt that so many artists treated the female form badly, like it was an object that was tied up with their own sexual desires. I wanted to show the female form as filled with grace.' **CB**

1953	1960	1960	1961	1961	1962
One of the nude photographs of actress Marilyn Monroe taken by Tom Kelley (1914–84) in 1949 appears in the first issue of *Playboy*.	Jean-Philippe Charbonnier (1921–2004) photographs naked female performers backstage at Paris's Folies Bergère.	Artist Yves Klein begins a series of performances using naked women as living paintbrushes to create his 'anthropometries' (body paintings).	Eikoh Hosoe (b.1933) publishes *Otoko to Onna (Man and Woman)*, containing nude portraits.	Bill Brandt's photobook of female nudes, *Perspective of Nudes*, is published. His use of an antique camera distorted the female form.	Ruth Bernhard creates *In the Box, Horizontal*, depicting a female nude reclining inside a cardboard packing box.

Nude, Campden Hill, London 1949

BILL BRANDT 1904 – 83

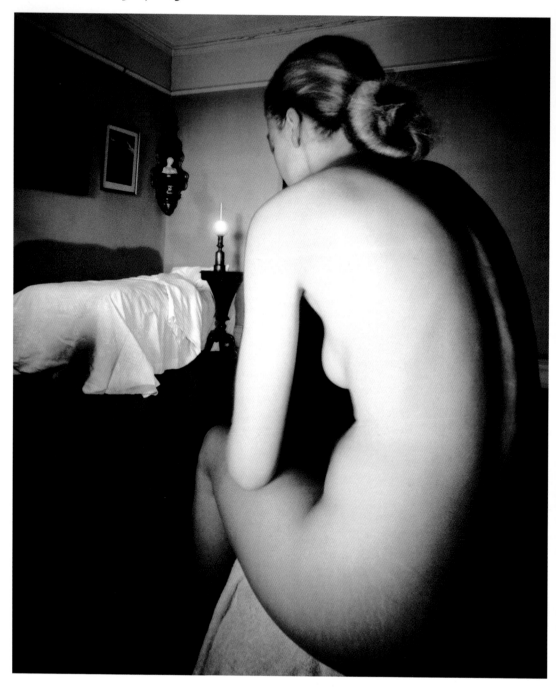

Silver print
9 ½ x 7 ¾ in. | 24 x 19.5 cm
Metropolitan Museum of Art,
New York, USA

Between 1945 and 1960 Bill Brandt worked on a series of nude studies that culminated in his photobook *Perspective of Nudes* (1961). The work marks a stark departure from his social documentary practice before and during World War II. With his nudes, Brandt was able to explore his interest in Surrealism (see p.232), which began when he was in Paris in 1929, where he assisted Man Ray (1890–1976) in his studio. Set in an interior, *Nude, Campden Hill, London* is a haunting and atmospheric photograph with a dreamlike quality. Brandt's interest in Victorian literature and poetry is evident in the room's Victoriana furniture, and the image has been read as an homage to Lewis Carroll's fantasy novel *Alice's Adventures in Wonderland* (1865), with the unusually large figure—perhaps representing Alice—shown in the foreground of the image and viewed from behind, leading the viewer into the scene.

Brandt used an antique camera to take the photograph because he was interested in the visual distortion that the apparatus offered, although this meant that he lost some control over the technical process: 'When I began to photograph nudes, I let myself be guided by this camera, and instead of photographing what I saw, I photographed what the camera was seeing. I interfered very little, and the lens produced anatomical images and shapes which my eyes had never observed.' **CB**

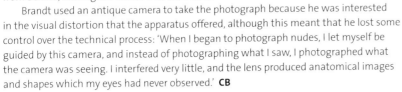

👁 FOCAL POINTS

1 CORNER OF THE ROOM
Brandt placed his camera opposite this corner of the room so that he could include as much of the room as possible in his photograph. The camera compressed the space viewed into one condensed image. This has the effect of distorting the image, resulting in incongruous inversions of scale.

2 LAMP
Brandt took the photograph at twilight and ensured that there was no harsh lighting in the room by using low light sources, such as the lamp in the background. Brandt emphasized the dark, shadowy areas of the image during the printing process. The darkness lends the picture a sinister edge.

3 MODEL
Brandt used chiaroscuro to create a surreal air of mystery and add a feeling of depth to his photograph. The nude appears in the foreground, looming out of the darkness and dominating the room's interior. The light shining on the back of the subject gives the model her shape.

4 BED
Brandt used a 1931 Kodak camera that he had bought secondhand to take the photograph. It had no shutter and its wide-angle lens focused on infinity from where it was placed, in this case the unmade bed. The presence of the bed in the room underscores the image's dreamlike quality.

🕐 PHOTOGRAPHER PROFILE

1904–33
Bill Brandt was born in Hamburg, Germany. He began his career as a photographer in 1928 in Vienna. Brandt then moved to Paris where he assisted Man Ray.

1934–38
Brandt settled in Belsize Park, London and remained in the United Kingdom for the rest of his life. His first photobook, *The English at Home* (1936), attempted to provide a complete survey of English life. His second book, *A Night in London* (1938), pictures life on the street under the cover of darkness.

1939–45
During World War II he worked producing propaganda for the Ministry of Information, famously photographing civilians taking shelter in the London Underground stations during the Blitz in 1940.

1946–83
After the war Brandt began working on a series of nudes that he published as *Perspective of Nudes* (1961). He also produced landscapes and portraiture, contributing to magazines such as *Lilliput*, *Picture Post* and *Harper's Bazaar*.

THE PHOTOBOOK

There has been a long relationship between photography and the book, partly because of the compatibility between the photographic medium and the printed page. The book format allows an author control over the sequence and pacing of photographs, and how text and image sit together. This particularly suits photographers who work in series. As early as the 1920s photographers conceived their projects to be realized as books. Key works such as *Perspective of Nudes* (1961; see p.362) by Bill Brandt (1904–83) and *Gitans: la fin du voyage* (*Gypsies*, 1975) by Josef Koudelka (b.1938) are seen as the most complete expressions of their aesthetic vision. Other photographers, such as Henri Cartier-Bresson (1908–2004) with *The Decisive Moment* (1952; see p.366), have used the photobook to explain their photographic practice and philosophy.

The Americans (1959; see p.382) by Robert Frank (b.1924), which was based on a road trip in the United States, was hugely influential on photographers when it was published. Sequenced visually rather than following a map or chronology, the book shows the United States as Frank saw it, rather than how it might like to be seen. In contrast, William Klein (b.1928) made a photobook about one city, New York, titled *Life is Good & Good For You in New York: Trance*

Witness Revels (1956). Klein was born in New York but spent two years in the US army stationed in Germany and France, after which he settled in Paris. He made a trip to New York in 1954 after an eight-year absence. His book replicates his experience of dislocation on his return, overwhelmed as he walked around the city's busy streets, producing photographs with a hand-held camera, such as *Christmas Shopping, Macy's, New York* (opposite), that capture the chaos of urban life. Klein was both the photographer and the designer for his book; it depicts the city and its inhabitants in a brash way, featuring photomontages and double-page bleeds. He used a Photostat machine to enlarge his images, interspersing the typography seen in magazines of the day to symbolize the city's commercialization. This format lent his work a contemporary feel and punchy energy that would have been hard to convey in any other format.

The photobook as a work of art was taken to another level in Japan in the 1960s and 1970s with works such as *Barakei (Ordeal by Roses*; 1963) made by photographer Eikoh Hosoe (b.1933) and writer Yukio Mishima. It features a series of theatrical and erotically charged images of Mishima. In *Barakei (Ordeal by Roses) #32* (below) Mishima stares menacingly while smelling a rose. Hosoe wrote: 'Photography is. . .the balance between the interior and the exterior,' and the book's psychological intensity demonstrates this well. Viewers see Mishima's troubled soul laid bare as he writhes and directly confronts the camera. A version of the book titled *Barakei Shinshuban (Ordeal by Roses Re-edited)* and featuring a black velvet cover was published in 1971 and includes painted montages by Tadanori Yokoo. Mishima conceived the book as a memorial to himself, and committed suicide at the same time the book was due to be published in 1970. **CB**

1 *Christmas Shopping, Macy's, New York* (1954)
William Klein • silver print
11 ½ x 13 ⅞ in. | 28 x 35.5 cm
Metropolitan Museum of Art, New York, USA

2 *Barakei (Ordeal by Roses) #32* (1961)
Eikoh Hosoe • silver print
7 ¼ x 10 ¾ in. | 18.5 x 27.5 cm
Victoria and Albert Museum, London, UK

1967	1967	1968	1970	1971	1973
The Pop art book *Index*, by Andy Warhol (1928–87), includes stream of consciousness images by photographers such as Billy Name (b.1940).	*House of Bondage* by Ernest Cole (1940–90) records life for black people under apartheid. Published in the United States, it is banned in South Africa.	The political and philosophical photography journal *Provoke*, investigating the relation between photography and text, launches in Japan.	A series by Bruce Davidson (b.1933) about the inhabitants of a housing block in East Harlem, New York is published as *East 100th Street*.	Nobuyoshi Araki (b.1940) publishes *Sentimental Journey*, an intimate account of his honeymoon with his wife, Yoko.	In *Suburbia*, Bill Owens (b.1938) pairs photographs with captions based on interviews with his subjects from the Californian suburbs.

The Decisive Moment 1952
HENRI CARTIER-BRESSON 1908 – 2004

Seville, Andalucia, Spain (above)
Spanish Morocco, Asilah (opposite)
Valencia, Spain (opposite)
Madrid, Spain (opposite)
All taken from *The Decisive Moment*
Silver prints
Magnum Photos

Henri Cartier-Bresson published one of the most influential photobooks of all time in 1952 in France. Ambitious in scale and format, *The Decisive Moment* was a huge success. The book is similar to a retrospective, bringing together a range of work spanning Cartier-Bresson's prolific career, and it is compiled in two sections. The first part includes photographs made in Europe and the second part features images that were produced in India and the East. Throughout, Cartier-Bresson outlined his philosophy as a photographer. The way he wrote—looking at subject, composition and technique—made the book serve as a masterclass in photography. Cartier-Bresson included images of major world events and everyday moments that tell powerful human stories.

A good example of this can be seen in the poetic images that Cartier-Bresson took of children in Spain in the 1930s, during the run-up to the civil war, when violence occurred in the streets of Spanish cities. He used juxtaposition, bold light and shadow, eccentric framing, odd angles and arrested motion to show what constitutes 'the decisive moment'. His photograph *Seville, Andalucia, Spain* (above) is framed by an opening in a bullet-ridden wall, through which the viewer sees a group of children. Something has amused them and they are giggling in an unexpected way. Towards the front of the image a crippled boy moves through the rubble on a pair of crutches. None of the children seem aware of Cartier-Bresson photographing them. He captures the children's spontaneity and joy at being alive. His images highlight how resilient children can be and that daily life, even in war-torn areas of the world, continues. **CB**

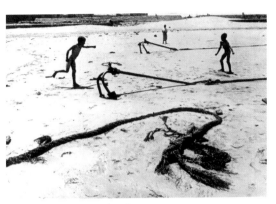

SPANISH MOROCCO, ASILAH (1933)
Asilah is a town on the north-west tip of the Atlantic coast and in 1933 was part of Spanish Morocco. Cartier-Bresson transforms a scene of children playing on a beach into a surreal study of patterns.

VALENCIA, SPAIN (1933)
Walking beside a dilapidated facade, a boy appears to be in a reverie. Cartier-Bresson removes the context: in reality the boy was waiting to catch a ball he had thrown in the air.

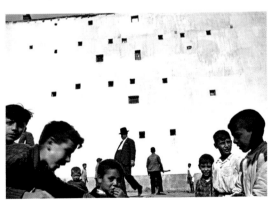

MADRID, SPAIN (1933)
Boys play in the foreground, dwarfed by a bright, high wall behind them. Cartier-Bresson juxtaposes their innocence and vibrant energy against the formal geometry of the backdrop.

⏱ PHOTOGRAPHER PROFILE

1908–32
Henri Cartier-Bresson studied painting in Paris and then literature and art at the University of Cambridge. He acquired his first Leica camera in 1932. Cartier-Bresson travelled to Germany, Poland, Austria, Czechoslovakia and Hungary.

1933–39
He visited Provence, Italy and Spain. Cartier-Bresson then went to Mexico and the United States before returning to France in 1935, where he worked as an assistant to film director Jean Renoir. In 1937 he co-directed the documentary film *La Victoire de la vie* (*Return to Life*) about medical relief on the Republican side of the Spanish Civil War.

1940–46
Cartier-Bresson joined the French army in World War II, but was captured and spent time as a prisoner of war. He escaped and worked for the French Resistance in a photographic unit.

1947–65
Cartier-Bresson co-founded the Magnum Photos agency (see p.326). It aimed to assert the rights of photographers to the integrity of the images they shot.

1966–2004
He left Magnum in 1966 and devoted himself to drawing and painting. The Fondation Henri Cartier-Bresson opened in Paris in 2003, showcasing his and other photographers' work.

MATISSE COVER

The French edition of Henri Cartier-Bresson's photobook was produced by a Greek-born French publisher, Tériade, with whom Cartier-Bresson had a long-standing friendship. In the United States it appeared with the English title *The Decisive Moment*, and this title derives from Cartier-Bresson's introduction: 'There is nothing in this world that does not have a decisive moment.' He described photography as 'the simultaneous recognition. . .of the significance of an event as well as the precise organization of forms which gives that event its proper expression'. The cover of both editions of the book (below) was designed by Henri Matisse. Cartier-Bresson, who began his career as a painter, made a compelling series of portraits of Matisse in 1944.

STREET PHOTOGRAPHY

On 28 February 1967, in the months leading up to the so-called 'summer of love', an exhibition opened at the Museum of Modern Art in New York that caused a stir. The show, 'New Documents', promoted a radical rethink of documentary photography through the work of three relatively unknown photographers: Diane Arbus (1923–71), Garry Winogrand (1928–84) and Lee Friedlander (b.1934). The director of the photography department, John Szarkowski (1925–2007), said: 'In the past decade this new generation of photographers has redirected the technique and aesthetic of documentary photography to more personal ends. Their aim has been not to reform life but to know it. . . .' The revolution in street photography had started almost a decade before, when Robert Frank (b.1924) published *The Americans* (1959; see p.382) in the United States. His idea of photography as a reflexive action that privileged the artist's instinct, emotion and subjectivity is what drew Winogrand, Arbus, Friedlander and many others to the practice of street photography.

Among those inspired by Frank was Tod Papageorge (b.1940). When he arrived in New York he visited photography salons in Winogrand's apartment. Papageorge said: 'Taking my cue from Winogrand, I came to understand that strong photographs were not necessarily the result of seeing something rare

KEY EVENTS

1947	1947	1955	1955	1959	1961
Yonosuke Natori (1910–62) hires Shigeichi Nagano as editor of the new weekly magazine, *Shukan San Nyusu* (*Weekly Sun News*).	Robert Frank arrives in New York. Alexey Brodovitch makes him a staff photographer at *Harper's Bazaar* and introduces him to the 35mm Leica.	'The Family of Man' exhibition opens at New York's Museum of Modern Art in January. It aims to reveal the common humanity of all people.	Roger Mayne starts his *Southam Street* photographic series depicting life on the street in working-class London.	Robert Frank's *The Americans* is published in the United States, a year after being published in France as *Les Américains*.	Tony Ray-Jones arrives in the United States to study at Yale School of Art on a scholarship.

368 POST-WAR TO THE PERMISSIVE SOCIETY 1946–76

or striking or strange. . . .Where, before, I searched for subjects for my pictures, I now looked for, well nothing in particular, instead more nearly photographing everything in general as my appetites, changing understanding of photography, and intuition directed me.' Papageorge, Winogrand and another photographer, Joel Meyerowitz (b.1938), became inseparable. Together they scanned the New York streets in search of photographic subjects. Papageorge described using a 35mm lens on his Leica: 'To even loosely fill the picture frame I was forced to move physically up on what I photographed.' Yet in *Central Park, New York* (opposite), the couple kissing and the girl have not reacted to the click of his shutter. The off-kilter tree trunks suggest that the image was snapped in a heartbeat, hinting at the predatory nature of taking a picture. The photograph was taken near the beginning of Papageorge's project *Passing Through Eden*, a series of black-and-white photographs of Manhattan's Central Park produced between 1969 and 1991. He published the images as a photobook in 2007, and the book's sequence and structure were inspired by the Bible's Book of Genesis.

Lee Friedlander's work is markedly different and more self-conscious than that of Winogrand. Friedlander toyed with the photographic error, using cropping heads and framing poles to obstruct views, to comment on the picture-making process and the act of viewing. Looking through contact sheets, he became intrigued by how often his shadow or reflection, as seen in *New Orleans, Louisiana* (below), would appear like an intruder. When the opportunity arose for him to publish some of his work, *Self Portrait* (1970) was the result: a collection of images, including *New Orleans, Louisiana*, in which Friedlander intrudes as a fleeting shadow, in car side-view mirrors, shop

1 *Central Park, New York* (1969)
Tod Papageorge • silver print

2 *New Orleans, Louisiana* (1968)
Lee Friedlander • silver print
6 ⅛ x 9 ⅛ in. | 15.5 x 23.5 cm
Museum of Modern Art, New York, USA

1962	1964	1967	1969	1969	1972
John Szarkowski becomes director of the photography department at New York's Museum of Modern Art.	'The Family of Man' reaches the end of its global tour. The exhibition travelled to thirty-eight countries and had more than nine million visitors.	'New Documents' opens at New York's Museum of Modern Art. It advocates a very different approach to documentary photography.	Tod Papageorge starts his Central Park project. A year later he receives his first Guggenheim Fellowship to pursue photographic work.	Garry Winogrand publishes his first photobook, *The Animals*, based on trips to the zoo in New York's Central Park.	Ray-Jones dies of leukaemia. Two years later his photobook, *A Day Off: An English Journal*, is published.

windows and on the polished surface of a cigarette vending machine, for example. In the rare instances that he presents his face to the camera, he blots it out with an object as mundane as a light bulb, deftly disrupting the traditional self-portrait. Friedlander highlights the artifice of photographing oneself by getting it wrong deliberately, and in doing so blurs the boundary of whether street photography is fact or fiction.

Winogrand and Arbus transformed US street photography in the 1960s with images that document sociopolitical turmoil and a sense of unease. Initially a fashion photographer, Arbus switched to street photography in the late 1950s in an attempt to investigate the medium's creative potential, and she began exploring Coney Island, Times Square and Central Park with a camera. Her provocative photograph of a young boy grimacing in Central Park, *Child with a Toy Hand Grenade* (1962), has become an iconic image and embodies the tension between primal violence and childhood naughtiness. Winogrand set forth every day with a Leica and a pre-focused wide-angle lens to see what he could find on the streets of New York. In the 1960s his favourite hunting ground for subjects was the city's zoo, creating images such as *Central Park Zoo, New York City* (1967; see p.372), which also draw parallels between humans and animals.

New York's post-war explosion of street photography has often been attributed to the fact that the city was entering an era of upheaval and turmoil. Its streets were crying out to be immortalized. The same was true in Tokyo. Japan was emerging from defeat in World War II when atomic bombs were launched first on Hiroshima and then Nagasaki. Cities underwent reconstruction and economic transformation, nowhere more so than Tokyo. Shigeichi Nagano (b.1925) was so inspired by the speed of change in the capital that he set about documenting what it meant for ordinary people. The resulting series, published as the photobook *Japan's Dream Age* (1978), includes *White-collar Workers at 5pm, Marunouchi, Tokyo* (above). Taken as offices closed for the day in Marunouchi, the commercial district of Tokyo, it shows a line of office workers waiting to cross a street and records the birth of the Japanese *sarariman* (salaried employee). The series marks a departure in Nagano's stylistic approach, away from realism towards a more personal interpretation, as he wanted to use his 'camera like a knife to dig out fragments of the city'.

3 *White-collar Workers at 5pm, Marunouchi, Tokyo* (1959)
Shigeichi Nagano • silver print
9 ⅞ x 14 ⅝ in. | 25 x 37 cm
Studio Equis, Paris, France

4 *Beauty Contest, Southport* (1967)
Tony Ray-Jones • silver print
5 ½ x 8 ¼ in. | 14 x 21 cm
National Media Museum,
Bradford, UK

Street photography was also thriving in Britain. Six years before the 'New Documents' exhibition, Roger Mayne (b.1929) said: 'I feel I occupy a rather unfashionable mid-position; neither on the abstract extreme nor the social-realist extreme. . .My way of working is intuitive. . .as opposed to the know what you want and get it approach.' His series *Southam Street* (1956–61) examined street life in a poor area in London's Notting Dale (now Notting Hill). Mayne had to wait until the 1980s, by which time the area had been redeveloped, for his work to receive due recognition.

Englishman Tony Ray-Jones (1941–72) went to the United States in 1961 to study at Yale School of Art. After graduating he worked as a freelance photographer in New York, where he spent time with Winogrand, Meyerowitz and Friedlander, sharing their explorations of intuitive approaches to photography. When he returned to Britain in 1966, he decided to create a photobook 'to communicate something of the spirit and the mentality of the English, their habits and their way of life, the ironies that exist in the way they do things'. He set off with his wife, Anna Coates, in their Volkswagen Camper van to scour the countryside in search of such quintessentially English moments. He recorded the unguarded actions of people from all sections of British society. The resulting photographs present a wry look at the British at play. *Beauty Contest, Southport* (below) is typical of his approach: by picturing what others might leave out of the frame, Ray-Jones directs viewers to the contrast between the glamorous aspirations of the women and the parochial nature of the holiday resort contest. Ray-Jones took the image the same year that the 'New Documents' exhibition was held. He died before realizing his dream of producing a photobook, and *A Day Off: An English Journal*—containing photographs taken between 1967 and 1970—was published posthumously in 1974. His words can be used to describe the street photography phenomenon: 'Photography can be a mirror and reflect life as it is, but I also think that perhaps it is possible to walk, like Alice, through a looking-glass, and find another kind of world with the camera.' **JMH**

Central Park Zoo, New York City 1967
GARRY WINOGRAND 1928 – 84

Silver print
8 ⅞ x 13 ½ in. | 22.5 x 34.5 cm
J. Paul Getty Museum, Los Angeles, USA

When Garry Winogrand snapped *Central Park Zoo, New York City*, he had divorced his first wife, Adrienne Lubow, and would spend many afternoons at the Central Park Zoo with their children, Laurie and Ethan. Visiting the city's zoos and its aquarium at Coney Island to photograph their inhabitants and the paying public became an obsession, resulting in Winogrand's first photobook, *The Animals* (1969).

Winogrand was once asked to explain why so many of his photographs feature apes. He replied that a photograph is as interesting as the 'photographic problem it states' and that the photographer's role is to create the problem as a 'contest between content and form'. Winogrand believed that a good image relies on dramatic content: '...if you run into a monkey in some idiot context, automatically you've got a very real problem taking place in the photograph'. The chimpanzees in *Central Park Zoo, New York City* are arresting to the viewer because they are dressed up and being cradled like children. However, at the time, the handsome interracial pair holding them may well have caused more of a stir. Racial tensions were running high: New York had witnessed race riots in 1964, Malcolm X had been assassinated in 1965 and the civil rights movement was gathering momentum. The year Winogrand took this photograph, the US Supreme Court overturned laws banning interracial marriage.

The picture of an African American man and a white woman carrying a pair of apes dressed as children may have offended both those who supported racial discrimination and those who sought to abolish it. Winogrand was not shy of tackling difficult subjects, but did so in such a way as to direct the viewer to the issue, rather than pronounce upon it. **JMH**

✦ NAVIGATOR

FOCAL POINTS

1 CHIMPANZEES
The chimpanzees in the photograph are dressed like children and mirror the human child standing beside the man and woman. In an image of social satire, Winogrand suggests that there is a sense of animality in humans and humanity in animals.

2 WINOGRAND'S SHADOW
Evidence of Winogrand's close proximity to his subjects can be seen in the shadow that he casts on the man. In the silhouette of the shadow, his head, with Leica raised to eye, is visible. There is something threatening about the shadow, as if it stalks the couple, yet in the split second it took to fix them, they appear oblivious to the photographer's presence. Winogrand's snapshot style has often been labelled as predatory.

3 CROWD
Winogrand's use of a 28mm wide-angle lens expands the field of view and introduces so much information—a sea of faces and a web of trees—that the image verges on chaos. He chose the lens because 'you have more to contend with. Maybe it makes the problem a little bit more interesting.'

4 CHILD
The small child in the foreground, caught in profile, would have been looking at something behind the man and woman carrying the chimpanzees. However, because photographs flatten reality—turning three dimensions into two—the child becomes implicated in the drama. He looks like he is staring at one of the apes. His profile is mirrored in their profiles, encouraging their reading as simian children.

▲ This characteristically spontaneous photograph by Garry Winogrand appeared on the cover of his photobook *Women Are Beautiful*, which was published in 1975.

PHOTOGRAPHER PROFILE

1928–47
Garry Winogrand was born into a Jewish working-class family in New York. He started taking photographs while serving in the US Air Force during World War II.

1948–50
He studied photography at Columbia University in New York. In 1949 he took an art and journalism class taught by Alexey Brodovitch at the Design Laboratory of the New School for Social Research.

1951–66
Winogrand landed his first assignment at *Harper's Bazaar* magazine, where Brodovitch was art director. In 1955 he married Adrienne Lubow. Edward Steichen (1879–1973) selected two of Winogrand's photographs for 'The Family of Man' exhibition at the Museum of Modern Art, New York in 1955. His first solo show was held at the Image Gallery in New York in 1959. In the early 1960s he started to roam the city's streets taking photographs using a 35mm Leica camera, with prefocused wide angle lens. In 1966 his work was exhibited in the exhibition 'Toward a Social Landscape' at George Eastman House, Rochester, New York, alongside the work of Lee Friedlander, Duane Michals and Bruce Davidson.

1967–74
John Szarkowski showcased Winogrand's work in the 'New Documents' exhibition at the Museum of Modern Art, New York in 1967. The same year he married Judy Teller. In 1969 his photographs of Bronx Zoo and the Coney Island Aquarium appeared in his first book, *The Animals*, published to accompany an exhibition of the same name at the Museum of Modern Art, New York. In 1972 he married Eileen Adele Hale.

1975–84
He published *Women Are Beautiful* in 1975, followed in 1977 by *Public Relations*. His last book, *Stock Photographs: The Fort Worth Fat Stock Show and Rodeo*, was published in 1980. Winogrand died in 1984 and left behind nearly 300,000 unedited images and more than 2,500 undeveloped rolls of film.

PRESS AND PAPARAZZI

1 *Celebrity Photographer in Tree* (1962)
Unknown photographer • silver print

2 *Jack Ruby Shooting Lee Harvey Oswald*
(1963)
Robert Jackson • silver print
6 ⅝ x 7 ⅝ in. | 17 x 19.5 cm
Metropolitan Museum of Art,
New York, USA

The post-1945 era was a golden age of photojournalism. The expanding use of photographs in newspapers and the success of prestigious mass-market illustrated magazines such as *Life*, *Look*, *Paris-Match* and *Picture Post* generated an insatiable demand for pictures of dramatic news events and aspects of contemporary society. Star photojournalists such as Robert Capa (1913–54), Alfred Eisenstaedt (1898–1995) and Don McCullin (b.1935) became well known for their work, but it was not a genre that thrived on individual style. Writing of photojournalism, critic Susan Sontag spoke of 'the difficulty of distinguishing one superior photographer's work from another'. Many of the images that in retrospect define the epoch were the work of unpretentious staff or agency photographers who were simply doing their job.

The public's appetite for vivid images drove an unbridled pursuit of 'candid' photographs of celebrities and the rich, which first became a prominent feature of photojournalism in the 1950s and 1960s. When news broke that Elizabeth Taylor was having an affair with Richard Burton, photographers went

KEY EVENTS

1947	1951	1955	1956	1962	1962
The Magnum Photos international photographic agency is founded (see p.326).	*African Drum* (later *Drum*) magazine is published in South Africa and makes its name reporting on life under apartheid.	Tazio Secchiaroli founds the Agenzia Roma Press Photo together with Sergio Spinelli (b.1929).	Alberto Diaz Gutiérrez co-founds a studio in Havana named after film directors Alexander and Zoltan Korda, and adopts the 'Korda' name himself.	Marcello Geppetti (1933–98) uses a long telephoto lens to snap Richard Burton and Elizabeth Taylor kissing on a yacht on the Amalfi Coast during their affair.	South African photographer Peter Magubane photographs Nelson Mandela during the Rivonia Trial.

to great lengths to photograph her at her Appian Way villa (opposite). The freelancers who tracked and hounded the famous came to be called 'paparazzi' after Paparazzo, the Vespa-riding photographer in Federico Fellini's movie *La dolce vita* (1960). The film was partly inspired by a notorious incident involving one of the original paparazzi, Tazio Secchiaroli (1925–98). His photograph of a young Lebanese dancer, Aïché Nana, performing an erotic dance at a private party in 1958 provoked outrage when published in an Italian scandal sheet, but went on to achieve international fame, appearing on the pages of *Life* magazine.

If glamour and celebrity were part of the photojournalists' stock in trade, so were war, poverty, social conflict and natural disaster. The photographer needed physical courage, strong nerves, quick reflexes and a sharp eye to bring back the best pictures from war zones and other scenes of violence. They also needed luck. Many of the best-known images of historic moments were taken by photographers who unexpectedly found dramatic events unfolding in front of their lenses. Robert Jackson (b.1934), for example, was working as a staff photographer for the *Times Herald* in Dallas, Texas at the time of the assassination of President Kennedy in 1963. On 24 November Jackson was waiting at the city jail on a routine assignment to photograph the accused assassin, Lee Harvey Oswald, when Oswald was shot by Jack Ruby. Snapping instinctively, Jackson feared he had missed the event altogether, but when the image (below) was developed, it showed he had captured the precise moment when the bullet struck and created one of the world's great news photographs.

1964	1964	1968	1972	1973	1973
Robert Jackson wins the Pulitzer Prize for Photography for his photograph of the murder of Lee Harvey Oswald by Jack Ruby.	Don McCullin wins the World Press Photo of the Year for his image of a mourning Turkish woman during the conflict in Cyprus.	Giangiacomo Feltrinelli publishes Che Guevara's *Bolivian Diary* and uses Korda's *Guerrillero Heroico* (1960; see p.378) for the cover.	US President Nixon expresses his doubts about the authenticity of Nick Ut's image of Vietnamese children fleeing after a napalm attack.	Ut wins the Pulitzer Prize for Photography for his photograph of Vietnamese children fleeing after a napalm attack.	US military involvement in the Vietnam War ends; the war continues for another two years.

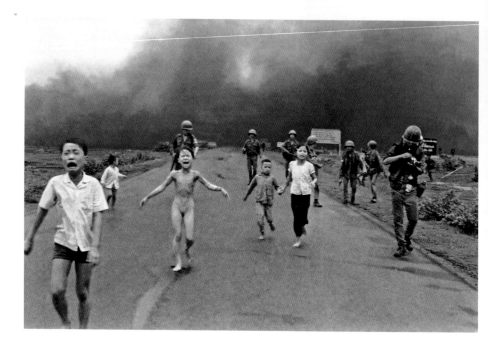

Another striking example of the role of serendipity in photojournalism is provided by Vietnamese photographer Huynh Cong 'Nick' Ut (b.1951). Ut was one of many photographers covering the Vietnam War for Associated Press. In June 1972 he witnessed the dropping of napalm by South Vietnamese aircraft. His image of terrified children fleeing the scene of the napalm strike (above) caused an instant sensation. The figure of nine-year-old Kim Phuc, the naked and badly burned child in the centre of the shot, with pain and trauma etched into her expression, made this an enduring symbol of the horror of war. The impact is enhanced by the background of billowing dark smoke and by the apparent nonchalance and indifference of the battle-hardened South Vietnamese soldiers seen around the children.

The most elevated tradition of photojournalism saw the duty to witness and report as a high moral calling. This ethical gravity, associated with heightened aesthetic aspirations, characterized the most ambitious photojournalism and documentary photography of the period. Uncompromising US photographer William Eugene Smith (1918–78) was a man who placed himself in the front line from World War II through to Japan in the 1970s, where he was physically attacked because of his insistence on publicizing the toxic effects of industrial pollution. Welsh photographer Philip Jones Griffiths (1936–2008) spent three years in Vietnam from 1966 to 1969, meticulously documenting a country at war. Setting the horrors of the conflict against scenes of everyday life for civilians and soldiers, Griffiths achieved intensity of vision by avoiding the overdramatization to which the photographic record of the Vietnam War was prone. His work appeared in book form as *Vietnam Inc.* in 1971.

In the context of the 1960s and 1970s, with their impassioned liberation struggles and heightened social conflicts, photojournalism was drawn into the advocacy of political causes and identification with radical movements, in contrast to the broadly humanistic stance of the 1930s and 1940s. Photography made a major contribution to the United States' passionate debate over civil rights in the 1960s: images of white violence against African Americans carrying a similar emotional charge to the speeches of Martin Luther King. US photographer Jill Freedman (b.1939) was among those who created memorable

3 *Children Fleeing a South Vietnamese Napalm Strike* (1972)
Nick Ut • silver print

4 *Soweto Uprising* (1976)
Peter Magubane • silver print

images of the civil rights movement published as *Old News: Resurrection City* in 1970. Photography at times shaded into direct political activism. Cuban photographer Alberto Korda (1928–2001), for example, devoted himself to promoting the revolution that brought Fidel Castro to power in 1959. Korda's portrait of Ernesto 'Che' Guevara (1960; see p.378) epitomized the spirit of the revolutionary hero and created a symbol for radicals worldwide.

South Africa was a country in which photojournalists were intensively engaged in political action. Often working for the popular magazine *Drum*, photographers such as Ernest Cole (1940–90) and David Goldblatt (b.1930) documented the oppressed lives of black South Africans under apartheid. As a young man growing up in South Africa, Peter Magubane (b.1932) was inspired by the images in *Drum* to himself become a photographer for the magazine. Able to report events on the ground when the access of international photojournalists was severely restricted by the white South African government, Magubane documented the Sharpeville massacre in 1960 and Nelson Mandela's trial in 1964, along with many other key events and demonstrations. Often using a hidden camera, he worked at great personal risk, surviving imprisonment and beatings at the hands of the South African police. His coverage of the anti-apartheid riots by students in Soweto in 1976 (below) won international acclaim.

From a US perspective, the ending of photojournalism's golden age is often dated to the fall of the photo magazines. The closing down of *Look* in 1971 and the decision to cease weekly publication of *Life* in 1972 provide neat indicators of the decline in the iconic power of the news photograph. The war in Vietnam in the late 1960s and early 1970s had provided photographers with opportunities to create some of the strongest images of conflict ever recorded, yet it was to be remembered nonetheless as the first 'TV war'. Television news cameramen were superseding the photographer in prestige and in impact on public opinion, although competition from other media was not the only issue. Changing times presented less clear-cut perspectives of liberation or progress to celebrate. A cynical and sophisticated critique of a world saturated in images was undermining simplistic faith in the photograph as a representation of reality. Ironically, the growth in the sheer quantity of photographs detracted from the impact of the individual image. News photographs and paparazzi-style celebrity shots had become so omnipresent as to decline in visibility. **CB/RG**

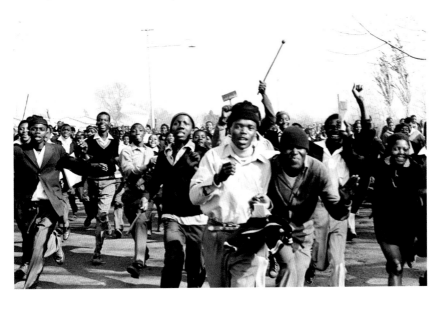

Guerrillero Heroico 1960
ALBERTO KORDA 1928 – 2001

Silver print
Centro de Estudios Che Guevara,
Havana, Cuba

Cuban photographer Alberto Díaz Gutiérrez, known as 'Alberto Korda', began working for the *Revolución* newspaper in 1959. He acted as official photographer to Cuban leader Fidel Castro for nine years, accompanying him on trips abroad to Canada, Latin America, the USSR and China. On 4 March 1960 the French freighter *La Coubre* was carrying munitions from Antwerp in Belgium to the Castro regime when it was blown up in Havana harbour. More than seventy-five people were killed by the explosion, which Castro claimed was orchestrated by the US government. The next day a mass funeral was held in the city. Korda was photographing the speakers when Ernesto 'Che' Guevara entered his camera's field of vision for a few seconds and he snapped two frames on his Leica. Unaware that he was being photographed, Guevara is captured gazing into the distance.

Korda created a cropped version of the picture that he hung on a wall in his studio. Later he gave two copies of the photograph to left-wing Italian publisher Giangiacomo Feltrinelli. On his return to Italy, Feltrinelli disseminated thousands of posters of the image to raise awareness of the danger Guevara was in when he was fighting in Bolivia. After Guevara was executed in Bolivia in 1967, the image was printed on a banner used as a backdrop when Castro announced his comrade's death on 18 October in Havana to almost one million people. When posters were produced of the image in Cuba and Guevara's supporters took to the streets with them, the image began to acquire its status as a radical icon. Since then the portrait has been reproduced on T-shirts, album covers and in advertisements. The commercialization of the cropped image upset Korda, who felt it conflicted with Guevara's Marxist revolutionary ethos. Ironically, it is probably the most widely reproduced photographic image in history. **CB**

⏱ PHOTOGRAPHER PROFILE

1928–55
Alberto Díaz Gutiérrez was born in Havana, Cuba in 1928. From 1946 to 1950 he attended business school in Havana, while also working in local photographic studios.

1956–58
Together with a friend he opened his own studio in 1956, which they named after the Hungarian film directors Alexander and Zoltan Korda, whose work they admired. Alberto took on the name Korda. From 1953 he became one of the principal photographers to document the Cuban Revolution. Korda also established a reputation as a fashion photographer and he later married the Cuban model, Norka Mendez.

1959–68
From 1959 to 1968 Korda was Fidel Castro's personal photographer, accompanying him and Che Guevara on their travels.

1969–2001
Korda developed a passion for underwater photography. In 2000 he went to a London high court to assert copyright of his iconic photograph of Che Guevara and to prevent it being used in a Smirnoff vodka advertisement. He died in Paris in 2001 and is buried in Cuba.

CIVIL RIGHTS

P hotography played an important role in documenting the US civil rights movement of the 1950s and 1960s, raising public awareness of the plight of African Americans subject to racial segregation laws across the south of the nation. Photographers took images of the activities of racist organization the Ku Klux Klan, the drive for voter registration and protesters' sit-ins, marches and rallies. They put themselves in the same danger as the activists, who often experienced brutal treatment at the hands of the authorities. Their pictures appeared in mainstream publications, such as *Life* and *Look*, and in the growing number of picture magazines aimed at African Americans, such as *Ebony* and *Jet*.

In 1955—a pivotal year for the civil rights movement—an African American woman named Rosa Parks refused to give up her seat on a bus to a white man, igniting the Montgomery Bus Boycott, which was led by Dr Martin Luther King, Jr. *Trolley—New Orleans* (1955; see p.382), by Robert Frank (b.1924) highlights this kind of segregation. In the same year, a fourteen-year-old African American boy, Emmett Till, was killed and mutilated in a racist attack. An all-male, all-white jury acquitted the two white men charged with slaying Till, but later—protected by the double-jeopardy law—the killers bragged of their culpability in an interview for *Look*. Till's mother allowed a graphic photograph of her murdered son in his coffin to be published so that the public could bear witness to this tragic crime.

KEY EVENTS

1945	1952	1955	1958	1959	1961
John H. Johnson launches *Ebony*, a photo magazine that highlights African American achievements and role models.	Roy DeCarava (1919–2009) becomes the first African American photographer to win a Guggenheim Fellowship.	*Jet* prints a photograph of Emmett Till in an open coffin. Till was lynched in Money, Mississippi, after allegedly whistling at a white girl.	Charles Moore photographs Dr Martin Luther King, Jr being arrested for loitering and being taken into custody in Montgomery, Alabama.	Robert Frank's study *The Americans* is published in the United States; its portrayal of a racially divided nation proves controversial.	Bruce Davidson (b.1933) begins chronicling the civil rights movement in the United States. In 1962 he is awarded a Guggenheim Fellowship.

Ernest C. Withers (1922–2007) was the photographer for Till's murder trial, which he documented in the pamphlet *Complete Photo Story of Till Murder Case*. He went on to become the premier photographer of the civil rights movement, his work appearing in newspapers such as *The New York Times* and *The Washington Post*. Withers went on to shoot some of the best-known images of the civil rights movement, including *I Am a Man, Sanitation Workers Strike, Memphis, Tennessee* (below) taken during a strike for better pay and the right to join a union. The strikers hold up placards while assembled in front of Clayborn Temple for a solidarity march led by Dr Martin Luther King, Jr. The repetition of the words 'I am a man' above the heads of a line of well-dressed men emphasizes that this is not an unruly mob but a group of US citizens asserting their rights. Dr King was assassinated while standing on a balcony at the city's Lorraine Motel a week after Withers captured this image. Withers developed the photograph, taken by a young African American man, of King dead on the balcony.

King's inspiring leadership had energized the movement and one of the photographers who covered his campaign was Charles Moore (1931–2010), whose *Policemen Use Police Dogs During Civil Rights Demonstrations, Birmingham Protests* (opposite) shows the racial hatred endemic in parts of the country. It is one of several that Moore took depicting fire-hose and dog attacks on the marchers and he was arrested on trumped-up charges for his efforts. He fled the state as a fugitive together with his photographs, which garnered international support for the movement when they were published in *Life*. **CK**

1 *Policemen Use Police Dogs During Civil Rights Demonstrations, Birmingham Protests* (1963)
Charles Moore • silver print
Private collection

2 *I Am a Man, Sanitation Workers Strike, Memphis, Tennessee* (1968)
Ernest C. Withers • silver print
11 ¾ x 19 ¼ in. | 30 x 49 cm
Chrysler Museum of Art,
Norfolk, Virginia, USA

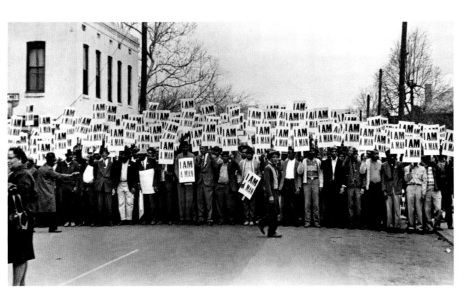

1963	1963	1965	1965	1968	1969
Life magazine commissions photographer Gordon Parks (1912–2006) to document his travels with civil rights leader Malcolm X.	Moore takes his best-known series of photographs, depicting police clashes with protesters in Birmingham, Alabama.	James 'Spider' Martin (1939–2003) records state troopers attacking protesters on the 'Bloody Sunday' march from Selma to Montgomery, Alabama.	Davidson receives the first photography grant from the National Endowment of the Arts, for his documentation of poverty in East Harlem, New York.	*Ebony* photographer Moneta Sleet, Jr (1926–96) becomes the first African American to win the Pulitzer Prize for Feature Photography.	DeCarava refuses to exhibit in the 'Harlem on My Mind' show at the Metropolitan Museum, saying it represents the view of its white curators.

Trolley—New Orleans 1955

ROBERT FRANK b. 1924

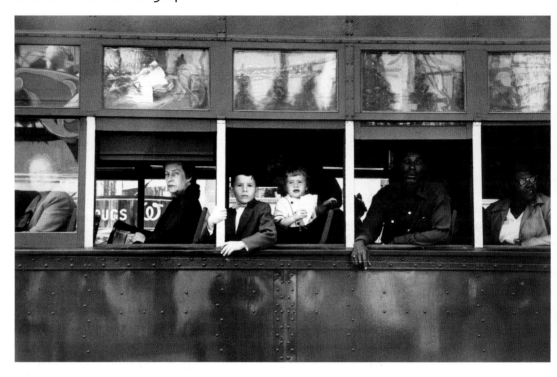

Silver print
9 x 13 ⅜ in. | 23 x 34 cm
Museum of Fine Arts, Houston, USA

Robert Frank's photograph of an everyday scene in New Orleans is often assumed to be a work of social critique. Later that year in Montgomery, Alabama, Rosa Parks's act of civil disobedience made history. Yet Frank has stated: 'I wasn't thinking about segregation when I shot it. But I did feel that the black people were more dignified.' Nevertheless he was evidently tuned into the zeitgeist. His photograph's depiction of the status quo, where racial segregation was the norm on public transport, shows institutional racism in practice. Frank planned to publish the image in a book of eighty-three photographs selected from 28,000 negatives that he took on the road in the United States from 1955 to 1956. He had difficulty finding a publisher in the United States, however, and the book first appeared in Paris in 1958 as *Les Américains*, published by Robert Delpire. When the book was published by Grove Press in the United States a year later, this image appeared on the cover. By then, Parks's action was known the world over and the decision to feature the image prominently was provocative. The book reproduces Frank's photographs without any accompanying narrative; his radical compositions similarly eschewed traditional narrative strategies. The absence of narrative implies that the visual rhymes between the images are expressive of more than formal affinities. The original maquette suggests a sequence of at least four sections, each opening with a photograph of the US flag. In some editions *Trolley—New Orleans* appears after *Fourth of July—Jay, New York*, an image of a picnic on Independence Day, dominated by a US flag so threadbare that it is transparent. The vertical lines of the window frames in *Trolley* echo those of the vertical Stars and Stripes in *Fourth of July*, an oblique reference perhaps to the lack of equality and freedom of ethnic minorities in the United States at the time. **CK**

PHOTOGRAPHER PROFILE

1924–46
Robert Frank was born in Zurich, Switzerland to a wealthy Jewish family. After leaving high school in 1941 he began an apprenticeship as a photographer and went on to work as a commercial photographer. His handmade book of photographs, *40 Fotos*, appeared in 1946.

1947–49
Frank immigrated to the United States, where he worked as a fashion photographer in New York for *Harper's Bazaar*. He then travelled in South America and Europe.

1950–54
He returned to the United States where he participated in '51 American Photographers' at New York's Museum of Modern Art. His early optimism regarding his adopted country faded as he became aware of its materialistic culture and he moved to Paris. In 1953 Frank went back to New York where he worked for magazines such as *Fortune* and *Vogue*.

1955–60
Frank won the first Guggenheim Fellowship in photography awarded to a non-American and used it to travel across the United States in 1955 and 1956. His photobook based on the trip was published in Paris as *Les Américains* in 1958 and then in the United States as *The Americans* in 1959. The book proved groundbreaking for its style and content. However, Frank diversified into making movies, gaining a reputation as an avant-garde filmmaker when he co-directed *Pull My Daisy* (1959), which was written by Beat generation novelist Jack Kerouac and starred poet Allen Ginsberg.

1961–93
Frank had his first solo show, 'Robert Frank: Photographer' at the Art Institute of Chicago. Frank concentrated on making films but after he wrote his autobiography, *The Lines of My Hand*, in 1972, he was inspired to take up still photography once more.

1994–2008
The National Gallery of Art in Washington, DC held a retrospective 'Robert Frank: Moving Out' in 1994. He won the Hasselblad Award two years later. In 2004 the Tate Modern in London staged the retrospective 'Robert Frank: Storylines'.

2009–PRESENT
The touring exhibition 'Looking In: Robert Frank's "The Americans"' travelled from Washington, DC to San Francisco and New York to celebrate the fiftieth anniversary of Frank's iconic book of photographs.

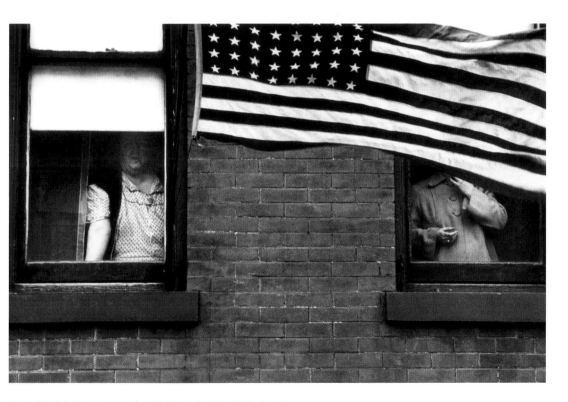

▲ *Parade—Hoboken, New Jersey* (1955) is from Robert Frank's *The Americans*. Frank travelled more than 10,000 miles (16,000 km) across the United States taking the photographs that would form his iconic book. His insightful images dug under the surface to reveal a nation suffering from social inequality.

YOUTH CULTURE

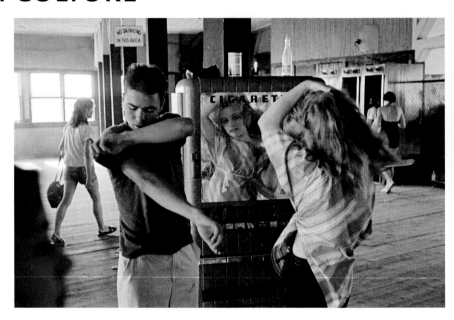

I n the 1950s a new social phenomenon emerged: youth culture. In the United States and Europe young people began to distinguish themselves from adult society by the beliefs, dialects and behaviour they adopted. Identifying themselves through their dress and musical tastes, they seemed to both intimidate and challenge mainstream society. In a number of areas discontented young people were an increasingly visible and threatening force.

The dilemma for photographers was how to gain access to such wary and alienated groups. Some such as Larry Clark (b.1943) were insiders, part of a group of young, disaffected people. The untitled photograph of a man with a baby (1963; see p.386) appears in his early photobook *Tulsa* (1971), which documents the lives of a collection of drug addicts. Other photographers had to find ways to infiltrate a circle of young people and gain the trust required to photograph them. In the summer of 1959 Bruce Davidson (b.1933) photographed a gang of troubled and often violent teenagers from Brooklyn, who called themselves the 'Jokers', for his series *Brooklyn Gang* (1959). He spent long periods of time with his subjects, getting to know what their lives were like in order to photograph them, snapping them in Brooklyn, Coney Island and Prospect Park. His picture *Two Youths, Coney Island* (above) shows some of the gang on a day out at a Coney Island bathhouse. It portrays the close attention that adolescents pay to their appearance, focusing on a girl fixing her hair while looking in the mirrored panel of a cigarette machine. Years later Davidson

KEY EVENTS

1953	1954	1955	1956	1959	1961
Marlon Brando stars as a wayward biker in the movie *The Wild One*, in which biker gangs invade a small town and cause trouble.	Rock 'n' roll singer Elvis Presley makes his first recordings for the Sun label in Memphis, Tennessee.	Robert Frank (b.1924) photographs a group of eight male students in front of a high school in Port Gibson, Mississippi for his book *The Americans* (1959).	Ed van der Elsken (1925–90) publishes his photonovel *Een liefdesgeschiedenis in Saint-Germain-des-Prés* (*Love on the Left Bank*) about bohemian Paris.	Bruce Davidson spends the summer photographing a Brooklyn gang of teenagers.	The film version of the musical *West Side Story* about two rival teenage gangs, the Jets and the Sharks, is released.

met the girl, who had married the gang's leader and by then had a teenage daughter. Looking at the photograph she said: 'We all had a dream, but we lost it. Most of the kids we knew are on drugs, in crime, or dead.'

Malick Sidibé (b.c. 1935) worked as a commercial photographer with a small portable camera in Bamako, Mali in the late 1950s and 1960s. His images of young people dancing closely together for the first time capture their youthful enthusiasm, pride and confidence at a time when they were experiencing a newfound freedom. His photograph of two boys dressing up in his studio, *Yokoro* (below), reveals a similarly significant moment when traditional and modern influences were coinciding in the vibrant African city.

In the 1970s US photographer Joseph Szabo (b.1944) gained access to a group of young adults to photograph when he taught art and photography at Malverne High School in Long Island, New York. He gained the trust of his students and began photographing them at parties and on the beach. Brought together in his photobook *Almost Grown* (1978), his images depict adolescents on the cusp of adulthood, brimming with attitude and sexual latency. **CB**

1 *Two Youths, Coney Island* (1959)
Bruce Davidson • silver print
7 ½ x 4 ¾ in. | 19 x 12 cm
George Eastman House, Rochester,
New York, USA

2 *Yokoro* (1970)
Malick Sidibé • silver print
Jack Shainman Gallery, New York, USA

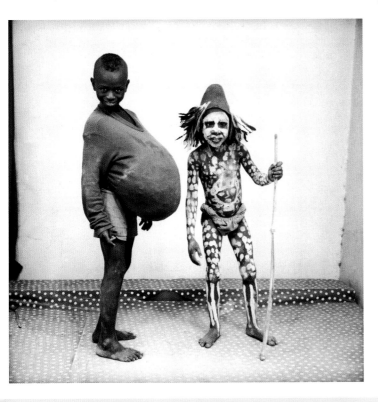

1962	1963	1964	1964	1967	1967
Psychologist Timothy Leary founds the International Foundation for Internal Freedom in Cambridge, Massachusetts to promote LSD research.	Larry Clark begins taking photographs of a circle of friends that will appear in his photobook *Tulsa* (1971).	The Beatles' first tour of the United States helps to initiate a swing away from American to British youth culture.	Pitched battles between teenage gangs of mods and rockers take place at resorts on the south coast of England.	Mick Jagger and Keith Richards, from rock band The Rolling Stones, are arrested on drugs charges.	Swedish photographer Anders Petersen (b.1944) begins his project depicting alternative culture in Hamburg's Café Lehmitz.

Untitled 1963

LARRY CLARK b. 1943

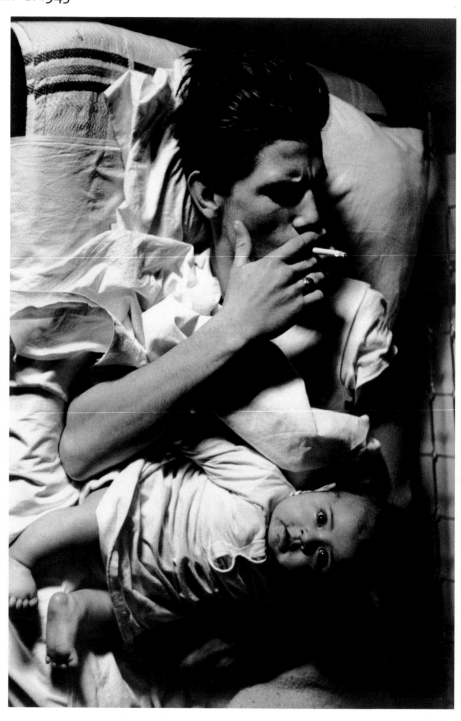

Silver print, edition of 25
14 x 11 in. | 35.5 x 28 cm
Luhring Augustine Gallery,
New York, USA

This image is taken from Larry Clark's seminal photobook *Tulsa* (1971), which centres on a group of friends in his home town of Tulsa, Oklahoma. The book records the life and habits of a number of speed freaks. He took the images in 1963, 1968 and 1971. This example features Billy Mann, one of the dysfunctional young men who appear throughout the book. He is also featured on the book's cover, posturing with a gun. Mann died of an overdose in 1970 and the book has become a memorial to him and his lifestyle, with the epitaph 'Death is more perfect than life'.

Tulsa was startling and raw when it was first published and remains so. It depicts the violent and troubled lives of a group of drug addicts. Clark's photographs show them injecting drugs, having sex and taking part in violent exchanges. The images have a sense of foreboding and death, emphasized by their dark black tones and Clark's use of low lighting. Accustomed to Clark's presence with a camera, Mann seems oblivious to the photographer. Mann also appears unaware of the baby on top of him; his arm supports its head but not in an embrace. The book's photo-diary style and Clark's close relationship to the people portrayed in it reveal that he lived the experience he documented, as opposed to just observing it, which has been key to its influence on future generations of artists. **CB**

FOCAL POINTS

1 MANN'S HEAD
Mann looks as if he has stepped out of a movie about drug culture and alienated male youth. Clark's images resemble film stills and inspired visuals in *Taxi Driver* (1975), *Rumble Fish* (1983) and *Drugstore Cowboy* (1989) directed by Martin Scorsese, Francis Ford Coppola and Gus van Sant respectively.

2 CIGARETTE
The cigarette is the focus of Mann's attention rather than the baby lying on his stomach. Clark had been a drug user and the image is one of a series that documents addiction. The love affair Clark recorded is that between his subjects and their vices: drugs, cigarettes and alcohol.

3 CHILD'S FACE
The child is incidental in the scene, which is really a portrait of Mann. However, the baby looks up at the photographer and out at the viewer indicating its presence. The infant is a symbol of innocence and hope, yet its position in the lap of an indifferent adult underscores its vulnerability.

4 MANN'S RIGHT ARM
The image of a man and baby is a subversion of the mother and child images in Christian religious painting, in which the Virgin Mary is shown holding the infant Jesus in her lap, perhaps making a sign of benediction. Mann does not cradle the baby, leaving it exposed to its future fate.

PHOTOGRAPHER PROFILE

1943–62
Lawrence Donald Clark was born in Tulsa, Oklahoma. He worked in the family baby portrait business. Clark began injecting amphetamines in 1959. He studied photography at the Layton School of Art in Milwaukee, Wisconsin.

1963–71
While working as a freelance photographer, Clark developed an independent documentary project recording himself and his friends. From 1964 to 1966 he served in the US army in the Vietnam War. Clark's images were published in 1971 in the photobook *Tulsa*, which established his reputation.

1972–94
Clark continued to document teenage alienation in the photobooks *Teenage Lust* (1983), *The Perfect Childhood* (1991) and *1992* (1992).

1995–PRESENT
Clark extended his work to filmmaking when he directed *Kids* (1995). He has gone on to direct other films featuring adolescents including *Bully* (2001), *Teenage Caveman* (2002), *Ken Park* (2002) and *Wassup Rockers* (2006).

THE 1960s

Taken at the dawn of the decade, the monochrome photograph by Astrid Kirchherr (b.1938) of the pre-fame Beatles in Hamburg's municipal funfair (above) portrays them as a gang of unsmiling rockers. This stark image of the five-piece framed against bare metal—taken during their Hamburg stay (Kirchherr was the first to take formal photographs of the band)—is one of the earliest memorable images of the group. It reminds viewers of how complete and definitive the break with the 1950s was in terms of culture and style.

Politically, the 1960s felt the shadow of the Cold War on almost every front. The battle between the capitalist ideology of the West and the Communism of the East raged on through the decade, threatening at points to escalate into full-scale nuclear war. The war was fought on many different fronts, leading to conflict in Vietnam, Cuba and Czechoslovakia. It was even fought in space. British politics underwent upheaval in 1963, when the secretary of state for war, John Profumo, was found to have had an inappropriate relationship with a model and showgirl named Christine Keeler—who, unbeknown to Profumo, was also involved with Russian Captain Eugene Ivanov, a naval attaché at the Russian Embassy, thought to be a spy. The portrait of Keeler (opposite) by Lewis Morley (b.1925)—taken when the scandal was at its height—was the last exposure made during a session intended to produce publicity shots for a film that was never made.

KEY EVENTS

1960	1961	1962	1963	1964	1964
Peter Magubane (b.1932) photographs the Sharpeville massacre in South Africa. Police open fire on demonstrators, killing sixty-nine.	Russia wins a victory in the space race when Soviet cosmonaut Major Yuri Gagarin becomes the first man to orbit in space in Vostok 1.	'Fifth Beatle' Stuart Sutcliffe, fiancé of photographer Astrid Kirchherr, dies in Hamburg after collapsing during an art class.	Dr Martin Luther King delivers his 'I Have a Dream' speech in front of the Lincoln Memorial during the March on Washington for Jobs and Freedom.	Don McCullin is awarded the World Press Photo Award for his coverage of the war in Cyprus.	David Bailey's box of poster prints of 1960s celebrities is published. It features Terence Stamp, The Beatles, Andy Warhol and the Kray twins.

Sitting astride a copy of an Arne Jacobsen 3107 chair, Keeler's pose is provocative, although in no way explicit. There is a coolness and classicism to Morley's image, built around a series of triangles: Keeler's legs, the chair back, her bent arms.

In their book *Goodbye Baby and Amen: a Saraband for the Sixties*, David Bailey (b.1938) and Peter Evans cited the Profumo affair as being the moment when what was to be called the 'swinging sixties' in London was born. They observed of the decade: 'Its personality was vibrant, brash, moody, young and perhaps pathetically transient. It was the age of affluence and adolescence. . .and London and New York were primarily where it fermented, flourished and finally finished.' As a documenter of the London scene, Bailey photographed the rock

1 *The Beatles, Hugo Hasse Funfair, Hamburg* (1960)
Astrid Kirchherr • silver print
8 ½ x 7 ¼ in. | 21.5 x 18.5 cm
Astrid Kirchherr Photographic Archive, New York, USA

2 *Christine Keeler* (1963)
Lewis Morley • silver print
Victoria and Albert Museum, London, UK

1964	1967	1968	1969	1969	1971
Michelangelo Antonio's film *Blow-Up*, about a fashionable young photographer working in London, is released.	Marc Riboud takes a photograph of a girl holding a flower and standing in front of armed US soldiers at an anti-war protest at The Pentagon.	Astronaut William Anders takes a colour photograph of Earth during Apollo 8, the first manned voyage to orbit the moon.	United States Apollo 11 is the first manned mission to land on the moon on 20 July. It is broadcast to an estimated audience of 600 million people.	Eddie Adams wins the Pulitzer Prize and World Press Photo Award for his image of a Vietcong general executing a prisoner.	Photographer Larry Burrows dies with fellow photojournalist Henri Huet (1927–71) when their helicopter is shot down over Laos.

stars and enfants terribles of the day. He took the cover photograph for The Rolling Stones' second album and himself became a cult figure during the decade. It is generally thought that the key character of a hip young photographer in Michelangelo Antonioni's London-based film *Blow-Up* (1966) was based on him.

Like Bailey, Terence Donovan (1935–96) was raised in London's East End and established himself as a fashion photographer, working for *Vogue*—where Bailey made his name—and *Harper's Bazaar* among other magazines. Donovan's signature shots set models against unglamorous urban backdrops, often in acrobatic poses. Together with Bailey and Brian Duffy (1933–2010), he became one of the earliest 'celebrity photographers'—famous in their own right.

In photography, and particularly photojournalism, the Vietnam War cast a long shadow during the decade. British photographers Larry Burrows (1926–71), Philip Jones Griffiths (1936–2008) and Don McCullin (b.1935), and Frenchman Marc Riboud (b.1923) were based in the centre of the action in Vietnam. All were cynical about the way in which the war was being fought, an attitude reflected in their uncompromising photographs. With their hard-hitting coverage, all of them changed the way war was perceived by the public.

Burrows—winner of the Robert Capa Gold Medal for still photography on three occasions—made his name with the celebrated *Life* magazine photoessay in 1965 'One Ride with Yankee Papa 13', which covered a heart-stopping mission by a helicopter crew. *Vietnam Inc.* (1971), Jones Griffiths's record of the country and people, stemmed from his personal quest to investigate the mismatch between the official stance on the war and the reality on the ground, and was several years in the making. He consciously avoided extreme imagery, later noting that, counterproductively, it made most viewers turn away: 'You don't reach people with gore.' McCullin showed the human consequences of war with images such as *Shell-shocked Soldier, Hue* (1968). Tim Page (b.1944) established himself with memorable photographs in Cambodia and Saigon, as well as the Six-Day War in the

3 *South Vietnam National Police Chief Nguyen Ngoc Loan Executes a Suspected VietCong Member* (1968)
Eddie Adams • silver print
World Press Photo/The Associated Press, New York, USA

4 *Night between the 10 and 11 May 1968, Boulevard St Michel, Paris* (1968)
Bruno Barbey • silver print
Magnum Photos

Middle East in 1967. His penchant for danger saw him injured on four occasions: the last, in 1969, left him requiring neurosurgery. Page memorably observed, 'Ultimately any good war photography becomes anti-war.'

Nonetheless, one photograph from the 1960s stands out for its shocking nature: the brutal image taken by Eddie Adams (1933–2004) of the police chief General Nguyen Ngoc Loan executing Nguyen Van Lem, a Vietcong prisoner, on a Saigon street on 1 February 1968 (opposite). It depicts the seemingly quotidian inhumanity and horror of war. The level of access that the Vietnam War photographers were given has not been replicated for professional photographers in war zones since. In part, this is because of the role their work was seen to play in the anti-war movement in the United States and in Europe.

Such images illustrate how powerful photography can be as an agent for change, tapping into a sense of empowerment felt over the decade particularly by the post-war generation. However, the images of the period also document the failures of radical action and the strength of reactionary forces in the 1960s. Images taken by French photojournalist Gilles Caron (1939–70) and Moroccan-born Bruno Barbey (b.1941) during the violent street demonstrations in Paris in May 1968 show that the 'old order' was not ready to be replaced. Barbey's photograph (below) records the night of 10 May when French riot police received the order to charge the barricades of the student demonstrators amid explosions of tear gas. Czech photographer Josef Koudelka (b.1938) photographed the Soviet-led invasion of Czechoslovakia in August 1968, which crushed hopes for a liberalization of the country's communist regime raised in the 'Prague Spring' earlier in the year. Koudelka's impressive images (see p.392) are heavy with defeat and despair, as well as defiance.

One event, from the last months of the decade, seemed to demonstrate that some of the optimism so often associated with the 1960s was still warranted. Broadcast initially in grainy black-and-white images, and with crackling sound on television sets, on 20 July 1969 the world witnessed Neil Armstrong and Buzz Aldrin land on the moon. Armstrong's detailed colour lunar photographs (1969; see p.394) later appeared on magazine and newspaper covers throughout the world. **CB**

Prague, August 1968 1968

JOSEF KOUDELKA b. 1938

1 NARROW SKY
Angled downwards, the camera almost eliminates the sky over the occupied city. Along with the narrowing perspective of the deserted boulevard, disappearing towards vanishing point, it generates a grimly claustrophobic atmosphere, heavy with menace and overtones of oppression.

2 ARM
Koudelka had a bystander thrust out his arm to provide the foreground of the shot. The clenched fist, although the natural way of showing the time on a watch, also stands as a gesture of defiant resistance to the occupying forces, angry and anonymous, emphasizing the tension of the moment.

⬡ NAVIGATOR

Silver print
Magnum Photos

In August 1968 the Soviet Union sent tanks into Czechoslovakia to suppress a wave of liberal reform that had swept the country since the previous spring. Photographer Josef Koudelka was fortuitously on hand to document the Soviet occupation of Prague. His testimony to the oppression of the Czech people consisted mostly of images of conflict on the streets: tanks defied by demonstrators, individual gestures of resistance, the faces of shocked and grief-stricken onlookers. This stark image stands apart. Devoid of dramatic action, it records a moment at which protesters had withdrawn from the centre of Prague in order to deny the Soviets a pretext for a violent crackdown. The resulting image is in one sense reportage—the time on the wristwatch fixes the image as a record of a precise moment in the crisis—yet borders on expressionistic in its bold juxtaposition of the fist and ominous wristwatch with the eerily abandoned street. The image endows Prague with the air of a city from which all life has departed, as if struck by some sudden catastrophe— as indeed it had been. Koudelka's photograph appeared in the book *Invasion 68: Prague*, published in 2008. **RG**

⏲ PHOTOGRAPHER PROFILE

1938–67
Born in a small town in Moravia, then in Czechoslovakia, Josef Koudelka worked as an aeronautical engineer before becoming a full-time photographer in 1967. His first major project was photographing gypsies in Slovakia and Romania.

1968–70
Koudelka photographed the Soviet occupation of Prague in 1968. Smuggled to the West, these powerful images were published anonymously. Unable to work freely in Czechoslovakia, Koudelka sought political asylum in Britain in 1970.

1971–PRESENT
Koudelka joined Magnum in 1971. In 1975 he published his first book, *Gypsies*, and was awarded the prestigious Prix Nadar in 1978. He took French nationality in 1987 and published his second book, *Exiles*, the following year. His work has appeared in numerous exhibitions at major galleries and museums.

3 WATCH
Originally Koudelka had the idea of showing the watch as a practical way of recording the time of day—early evening—at which the usually bustling street was deserted. It supplies the focal point of the image, ferrying an irrational sense of unease and foreboding, as if time itself has stopped.

Buzz Aldrin on the Moon 1969

NEIL ARMSTRONG b. 1930

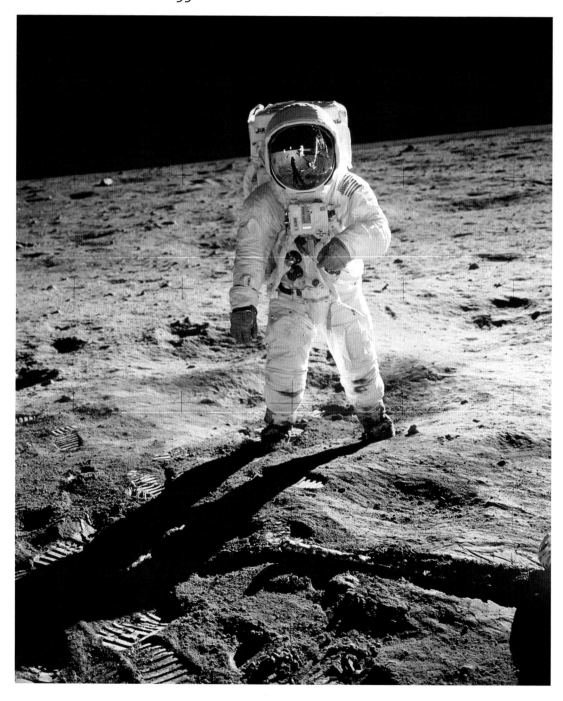

Colour print
Time & Life Pictures/Getty Images

On 20 July 1969 Apollo 11 successfully achieved its mission of landing two men, Neil Armstrong and Edwin E. 'Buzz' Aldrin, on the lunar surface. The event was watched by more than 600 million people on televisions across the world. Prior to these images, space had been much imagined but had never before been seen. The grainy, black-and-white television pictures are incomparable, however, to the startling clarity and close-up detail of those taken by astronaut Neil Armstrong. This image shows Buzz Aldrin, although Armstrong can also be seen reflected in the helmet visor as he takes the photograph. A cropped version of Armstrong's photograph appeared on the cover of *Life* magazine with the headline 'To the Moon and Back' on 11 August. It went on to become one of the most widely circulated and iconic images of the decade.

The two men spent only two and a half hours on the moon's surface collecting samples, carrying out experiments and taking photographs. Their colleague, Michael Collins, was left in orbit in *Columbia*, Apollo 11's command module. The men were fulfilling President John F. Kennedy's goal, set in 1961, that Americans would land on the moon before the end of the decade. However, it was also key that they returned to Earth safely. It was a great relief when news arrived on 24 July 1969 that the three men had landed in the Pacific Ocean. The astronauts were honoured with a ticker tape parade in New York City soon after. **CB**

FOCAL POINTS

1 REFLECTIVE VISOR
In the visor the viewer can see what is in front of Aldrin. A section of the *Eagle* landing craft—wrapped in reflective material—is visible. It is also possible to make out Armstrong in his white space suit taking the photograph, as well as the long shadows cast by both men.

2 US FLAG
The US flag is prominent on Aldrin's suit. The event became a symbol of US power. Dennis Mason recalled watching it: 'It was night-time. . .and that added to the sensation, knowing that the moon would float above us with men on it for the first time. We knew it was a magic moment.'

3 FOOTPRINTS
The men's footprints soon showed on the surface. They spoke back to radio control in Houston about what they were seeing. Armstrong said: 'The surface is fine and powdery. . .I can pick it up loosely with my toe. It does adhere in fine layers like powdered charcoal to the sole and sides of my boot.'

4 REFERENCE CROSSES
Armstrong's camera was a specially designed version of the motorized Hasselblad 500EL, equipped with a Biogon lens and polarization filter mounted on the lens. A glass plate, containing reference crosses, which record on the film during exposure, was in contact with the film.

PHOTOGRAPHER PROFILE

1930–55
Neil Armstrong was born in Ohio, USA in 1930. He gained a Master of Science in aerospace engineering from the University of Southern California in 1949. After serving as a naval aviator from 1949 to 1952, Armstrong joined the National Advisory Committee for Aeronautics (NACA) in 1955.

1956–69
Over the next seventeen years, Armstrong was an engineer, test pilot and astronaut at NACA's successor agency, the National Aeronautics and Space Administration (NASA). He transferred to astronaut status in 1962. He was command pilot for the Gemini 8 mission in 1966. As spacecraft commander for Apollo 11, Armstrong gained the distinction of being the first man to walk on the moon.

1970–PRESENT
Armstrong was professor of aerospace engineering at the University of Cincinnati from 1971 to 1979. He was chairman of computing technologies for Aviation, Inc, Charlottesville from 1982 to 1992. Armstrong is the recipient of many special honours, including the Presidential Medal of Freedom.

COLOUR PHOTOGRAPHY

In the thirty years after the end of World War II a plethora of new and easier to use colour processes came on to the market, including Kodak Ektachrome, dye transfer and Cibachrome. Product research accelerated as manufacturers recognized that there was money to be made from user-friendly colour processes. Within the Condé Nast stable of niche magazines throughout the 1950s—among them *Vogue*, *Vanity Fair* and *House & Garden*—the publisher's art director Alexander Liberman encouraged the use of colour photography to give the titles a bold, modern look. Not to be left behind, *Life* magazine published twenty-four pages of colour photographs of New York taken by émigré Austrian photographer Ernst Haas (1921–86) in September 1953. So successful were Condé Nast publications in spreading colour through advertising and fashion that it was in danger of acquiring a reputation for commercial populist frivolity, whereas black-and-white imagery signified artistry and serious endeavour.

However, there was a new breed of photographer that embraced colour for its own sake. Stephen Shore (b.1947) photographed the US vernacular landscape in a documentary and expressionless fashion, rendering it

KEY EVENTS

1946	1950	1950	1951	1962	1962
The first colour negative film that amateurs could process at home, Kodak Ektachrome, is launched.	New York's Museum of Modern Art holds its first exhibition of all colour photographs.	US photographer Paul Outerbridge (1896–1958) visits Mexico taking a 35mm camera to create Kodachrome transparencies.	Austrian Ernst Haas visits the United States on assignment. He is made vice president of US operations for Magnum Photos (see p.326).	John Szarkowski becomes director of the photography department at New York's Museum of Modern Art.	British newspaper *The Sunday Times* launches the first colour supplement.

enigmatic, as if a constructed theatrical set. He began to make road trips in the United States and Canada in the 1970s, photographing in colour, first on 35mm, then on 4 x 5 inch and finally with an 8 x 10-inch view camera, making contact prints from his large-format negatives. His photographs are composed formally. They are serious and considered portraits of contemporary North America, misshapen by urban sprawl, housing and other forms of human intervention in the environment. Yet the warm brown and green tones used in *US 10, Post Falls, Idaho* (opposite) and the inclusion of shadow detail render the banal grocery store a welcoming place. Shore's work was included in the influential group show 'New Topographics: Photographs of a Man-altered Landscape' at the International Museum of Photography at George Eastman House in Rochester, New York in 1975.

As director of the photography department at New York's Museum of Modern Art, Edward Steichen (1879–1973) showed exhibitions of colour photographs in 1950 and 1953. In the latter, a group show—titled 'Always the Young Strangers'—of mixed colour, black-and-white prints and transparencies, he included five (probably) black-and-white photographs by Saul Leiter (b.1923) 'of a surrealist nature'. Leiter switched from black and white to colour in 1948, using it to find a delicate urban romance in the gritty, hectic mean streets of New York. Leiter coaxed soft, muted, reassuring colours from out-of-date film stock, or used cheaper, more unpredictable film from obscure companies to create his own colour palette. His unique palette, intriguing compositional graphics and fearless use of dissecting planes of colour, exemplified in *Through Boards* (right), echo in photographic form the Abstract Expressionism of painters Mark Rothko, Barnett Newman and Richard Pousette-Dart.

Not since the Autochrome was marketed in 1907 had colour photography been used so successfully to capture the natural world as it was by Eliot Porter (1901–90). He began to use colour film in 1939 to achieve more accurate records of birds, but found the results so rewarding that he used it in all his nature and landscape photography. Porter's books, many published by the influential conservation group the Sierra Club, used his evocative colour photographs to spread the message of environmental and ecological awareness. Porter's colour photography, with its outstanding harmonious and lyrical qualities, invested nature and wild unknown places with a sense of calm familiarity, in the process producing pieces of abstract art.

The man credited with turning the next generation of photographers on to colour, however, is William Eggleston (b.1939) whose colour cast, even when filled with sunshine, always seems vaguely threatening, unsettling and noirish, as seen in *Untitled (Memphis)* (1970; see p.398). Influenced by 1960s Pop art and photorealism, his eclectic and untoward eye produced singular work that caught the attention of John Szarkowski (1925–2007) at New York's Museum of Modern Art, who gave Eggleston his own show. **PGR**

1 *US 10, Post Falls, Idaho* (1974)
Stephen Shore • chromogenic colour print
7½ x 9½ in. | 19 x 24 cm
Museum of Modern Art, New York, USA

2 *Through Boards* (1957)
Saul Leiter • chromogenic colour print
13½ x 8⅞ in. | 34 x 22.5 cm
National Gallery of Art, Washington, DC, USA

1963	1963	1963	1965	1971	1972
The Kodak Instamatic 126 camera, with Kodacolor negative cartridge film at ASA 64, brings colour photography to the mass market.	The first presentation of a Cibachrome print is at the 'Photokina' exhibition in Cologne. Cibachrome is in widespread use by the decade's end.	Polaroid launches the first instant picture colour process, Polacolor. It produces small, one-off colour prints on paper.	The autumn TV prime-time schedules of NBC, ABC and CBS in the United States are almost entirely in colour, impacting on public perception.	Kodak launches the Instamatic 110 with Kodacolor II cartridge film. It becomes the standard for colour negative film.	Polaroid unveils the SX-70, the first instant single-lens reflex camera and the first to use its Polacolor SX-70 integral print film.

Untitled (Memphis) 1970
WILLIAM EGGLESTON b. 1939

1 HANDLEBARS

Eggleston often overexposed his film by three stops or so, changing Kodak's recommended ASA ratings. Here the overexposure means the sky is effectively washed out, a sweep of grey, which serves to emphasize the colour on the tricycle, especially the red grips on the handlebars.

2 SEAT

The photograph poses questions about the tricycle's missing owner. On a symbolic level, it may have belonged to the photographer himself: in a documentary in 2008 by Reiner Holzemer a family snapshot shows a young Eggleston with his own trike behind him, a symbol of the artist's youth.

W illiam Eggleston's solo exhibition of colour photographs at New York's Museum of Modern Art in 1976 was controversial and provocative, challenging the claim of colour photography to be accepted as art. Eggleston initially showed his colour prints and Kodachromes to the Museum of Modern Art's John Szarkowski in 1967; between then and 1976, he edited them down from 400 images taken between 1969 and 1971 to a group of seventy-five photographs as if compiled for a family album. They depicted the everyday, the ordinary, the unremarkable—each image like a captured moment from a story that continued outside the frame of the print. The accompanying catalogue, *William Eggleston's Guide*—with an insightful introduction by Szarkowski—continued the family album concept and was bound in leatherette with this image on the cover.

However, Eggleston's masterstroke was to print these mundane images as glorious dye transfers—an aesthetic as well as a highly conceptual choice. The expensive dye-transfer print conveyed the commercial implications of the advertising and magazine industries, whose favourite medium it was to sell often glamorous and desirable consumer products. This was subverted by Eggleston's use of dye transfers to print images of the everyday that were decidedly unglamorous, such as this old rusting tricycle on a Memphis sidewalk. Although Eggleston's work was dismissed in 1976 as 'snapshot chic' by *New York Times* art critic Hilton Kramer, it is now accepted as one of the defining bodies of work that began the restitution of colour photography from commerce to art. **PGR**

Dye-transfer print
11 ¾ x 18 in. | 30 x 45.5 cm
Museum of Modern Art, New York, USA

3 PERSPECTIVE
Eggleston worked with a moderate wide-angle lens to exaggerate perspective. Here, he has gone even further by taking a position lower than the eye level of the tricycle's child owner. Eggleston said of the radical viewpoint: 'It is an insect's view or it could be a child's view.'

4 MEMPHIS HOUSE
Eggleston was born in Memphis into an eminent family and raised on a cotton plantation in the Mississippi Delta. Memphis was an inspiration for him and he found that using colour added an emotional warmth to his pictures that investigate the qualities found in the ordinary.

TOPOGRAPHICS

1 *Colorado Springs, Colorado* (1968)
Robert Adams • silver print
6 x 6 in. | 15 X 15 cm
Museum of Modern Art, New York, USA

2 *A Line Made by Walking* (1967)
Richard Long • photograph and pencil
on board
14 ¾ x 12 ¾ in. | 37.5 x 32.5 cm
Tate Collection, London, UK

The idea of topographics as applied to the photographed landscape stems from the exhibition 'New Topographics: Photographs of a Man-altered Landscape' held in 1975 at the International Museum of Photography at George Eastman House in Rochester, New York. The show emerged as a watershed moment in defining the direction of contemporary landscape photography in the late 20th century. The exhibition included images by eight US photographers—Robert Adams (b.1937), Lewis Baltz (b.1945), Joe Deal (1947–2010), Frank Gohlke (b.1942), Nicholas Nixon (b.1947), Stephen Shore (b.1947) and Henry Wessel Jr (b.1942)—and works by Germans Bernd (1931–2007) and Hilla Becher (b.1934). The exhibits by the group of mostly young photographers from the United States shifted photographic perception and representation of the landscape. It was a radical contrast to the work of their predecessors, who clung to 19th-century modes of photographing the landscape for its historic and poetic associations or sublime manifestations. The photographs were not romanticized images of the vast outdoors of the American West but depictions of everyday suburban sprawl. They focused on

KEY EVENTS

1959	1961	1962	1962	1968	1970
Bernd and Hilla Becher begin photographing framework houses in Siegerland, Germany.	Polaroid Corporation introduces Type 55, the first black-and-white film that produces both a positive and a negative image.	US artist and photographer Ed Ruscha (b.1937) publishes *Twentysix Gasoline Stations*. It contains shots of gas stations on Route 66.	*American Photographs* by Walker Evans (1903–75) is reissued, generating renewed interest in the social documentary tradition.	Robert Adams embarks on what will become 'The New West', a three-year photographic survey of the changing landscape in Colorado.	Earth Day is first observed in the United States and reveals popular support for an environmental agenda.

manufactured, industrialized landscapes, paying particular attention to the environment altered by humankind. They looked to the suburban tract houses, strip malls, land developments and industrial parks that populated the late 20th-century terrain, making it clear that the idea of an untouched landscape, both in the past and the present, is a myth. In another departure from the norm, the photographers whose work was on display were predominantly graduate school trained. Robert Adams was the eldest US photographer in the exhibition and, although he had a doctorate in English from the University of Southern California, he was self-taught in photography. He became troubled by the rapid transformation of the landscape he saw around him and looked to photography as a means of recording the destruction of the American West. His photographs, such as *Colorado Springs, Colorado* (opposite), avoid both the romantic and the propagandistic, symbolizing such destruction by picturing an everyday suburban vista. Neither mundane nor picturesque, his stark, tightly composed black-and-white photographs speak of the sterility and alienation of the suburban experience. Works by the German collaborative photographers Bernd and Hilla Becher, such as *Framework Houses* (1959–73; see p.402), also featured in the show. Their oeuvre is pivotal to a generation of European and US photographers who cultivated a systematic approach to photography.

Writing in the exhibition catalogue, curator William Jenkins orients the term 'topography', emphasizing its usage as a means of accurately describing a particular place in detail. Jenkins links this act of describing to the photographic act itself, arguing that what photography does best is to describe its subjects. He takes account of the contemporary critical stance of questioning photographic veracity, suggesting that photography's 'pretense to truthfulness' allows the medium to be remarkably misleading. The unifying thread of the exhibition was an underlying impulse to systematically register subject matter in a neutral way. This approach to landscape linked the New Topographics to similar motivations driving the Conceptual and Minimalist art movements of the time. Nonetheless, it was a modest show that was part of a regular series showcasing contemporary trends in photography. The subsequent reputation of New Topographics as a pivotal 20th-century photographic moment came as somewhat of a surprise to the curator and photographers involved. The exhibition has since been recreated in various locations around the world.

British Conceptual artist Richard Long (b.1945) also makes human presence known through its absence. While the New Topographics group were capturing the suburban scene, Long produced photographs of performative acts he enacted in the British countryside. Long physically and photographically inscribes the landscape by the act of being there. *A Line Made by Walking* (right) depicts the imprint of a straight line he created by walking across a field of grass. Such ephemeral interventions, made permanent only by means of photography, invoke the density of humankind's impact on the environment. **SMC**

Framework Houses 1959–73

BERND BECHER 1931–2007 HILLA BECHER b. 1934

Silver prints
18 ¼ x 22 ¼ in. | 46.5 x 56.5 cm each
Sonnabend Gallery, New York, USA

B ernd and Hilla Becher's imprint on late 20th-century photography practice, both through the influence of their photographic typologies and their pedagogy, was vast. Their work was pivotal to a generation of European and US photographers who cultivated a systematic approach to the medium. They spent years methodically recording various manifestations of industrial, civic, vernacular and utility architecture, taking photographs of structures including cooling towers, blast furnaces, pitheads and silos. Their photographs document the often overlooked industrial landscape that was beginning to deteriorate and disappear as Europe transitioned from an industrial to a technological economy in the second half of the 20th century.

They adopted an archaeological perspective, not only working in the serial format, but also collecting data on their subjects, including building dimensions, materials and dates of construction. Their life-long photographic project was comprehensively cumulative in its aims, breadth and scope. The Bechers created black-and-white photographs of tightly framed, isolated structures, often taken from an elevated vantage point. Each subject in a series is positioned the same distance from the lens with the same orientation and a blank sky as background. The subject of half-timbered houses surrounding the city of Siegen, east of Cologne in Germany, was their focus when they started working together in 1959. They documented the domestic architecture systematically, and extensively photographed the nearby streets and villages to create a more complete survey of the industrial region and its forms. **SMC**

✦ NAVIGATOR

FOCAL POINTS

1 REPETITION
Similar photographs of individual subjects are presented in successive repetition, mimicking scientific, anthropological or bureaucratic approaches to image and data management. The photograph embraces the architecture's qualities yet effaces it through monotonous repetition.

2 GRID
The Bechers created vast and detailed photographic archives of their subjects from a variety of perspectives, including close-up and detailed views. By presenting them in grid formats, they created typologies of industrial structures that typically represent a continuous point of view.

3 ABSENCE OF PEOPLE
There is a deliberate lack of human presence in the photographs. By divorcing the buildings from their function in society, the Bechers render the structures anonymous, to be appreciated for their aesthetic quality as sculptural forms within a uniform landscape.

PHOTOGRAPHERS PROFILE

1931–60
Bernd Becher was born in Siegen, Germany in 1931; Hilla Wobeser was born in Berlin in 1934. From 1953 to 1956, Bernd studied lithography and painting at Stuttgart's Staatliche Akademie der Bildenden Künste. In 1957, he enrolled at the Kunstakademie in Düsseldorf to study typography. There, he met Hilla, who was studying printing and graphics. In 1959, the two collaborated on a series depicting half-timbered workers' houses in North Rhine-Westphalia.

1961–75
Bernd and Hilla married and began work as freelance photographers. In 1963, they had their first gallery exhibition, at Siegen's Galerie Ruth Nohl. Their first book, *Anonyme Skulpturen: Eine Typologie technischer Bauten* (*Anonymous Sculpture: A Typology of Technical Constructions*) was published in 1970. The same year, their work featured in the Conceptual art show 'Information' at New York's Museum of Modern Art. In 1974, London's Institute of Contemporary Arts staged an exhibition of their work.

1976–89
Bernd started teaching photography at his alma mater where he and Hilla influenced a group of young photographers, who later formed the Düsseldorf School (see p.444). The couple's photographic series of houses in the Siegerland was published in 1977 as *Fachwerkhäuser des Siegener Industriegebietes* (*Framework Houses of the Siegen Industrial Region*). A retrospective of their work was organized at the Stedelijk Van Abbemuseum in Eindhoven in 1981.

1990–PRESENT
The Bechers won the Golden Lion at the Venice Biennale (1990) and the Hasselblad Award (2004). In 2002 they received the Erasmus Prize in recognition of their work at Düsseldorf's Kunstakademie. Bernd died in 2007. New York's Museum of Modern Art held a retrospective of their work a year later.

INDUSTRIAL PHOTOGRAPHY

Industrial structures have long been of interest to photographers, especially since World War I and the rise of the 'Machine Aesthetic' (see p.204). US photographers such as Charles Sheeler (1883–1965) favoured dynamic angles and close-ups, but the Bechers focused on the sculptural qualities of industrial structures such as those in *Winding Towers* (1966–68; right). Their aim was to objectively record industrial architecture that was disappearing from the landscape. The use of repetition reveals the similarities and differences between each structure; the resulting images evoke a sense of nostalgia for the 19th century in a post-industrial age.

POP AND CONCEPTUAL ART

In an interview in 1963 with critic Gene Swenson, Andy Warhol (1928–87) described Pop art as 'liking things'. Warhol's words capture Pop art's embrace of mass-media imagery, consumer goods and popular culture. Critic Lawrence Alloway, at the time the director of the London Institute of Contemporary Arts, began referring to the art of The Independent Group, including that of Eduardo Paolozzi and Richard Hamilton (1922–2011), as 'popular art', a term that was eventually shortened to 'Pop art'. Turning away from the large, emotive canvases of Abstract Expressionists such as Jackson Pollock and Barnett Newman, Pop artists in the United States and Europe looked to everyday life as a source for their work. Engaging with the masses of cheap, readily accessible commodities that flooded markets in the 1960s, Pop artists in Europe, the United States, Japan, Brazil and elsewhere explored the role that images of these goods played in people's relationship to them. Consequently, photography played a central role in Pop art practices. Rather than taking their own photographs, in a departure from established ideas of originality and artistry, these artists appropriated ready-made images. The images in Hamilton's seminal collage *Just What Is It That Makes Today's Homes*

KEY EVENTS

1956	1962	1962	1963	1966	1967
The Independent Group presents 'This is Tomorrow' at London's Whitechapel Gallery. The show includes works inspired by popular culture.	Andy Warhol has his first solo show at the Ferus Gallery in Los Angeles, California. The Campbell's soup cans are exhibited for the first time.	Warhol creates *Marilyn Diptych*, a silkscreen painting based on an original publicity photograph by Gene Korman (b.1927).	Warhol establishes a studio in Manhattan at 231 East 47th Street, which is dubbed 'The Factory'.	In December *Arts Magazine* publishes images from Dan Graham's *Homes for America* accompanied by short texts.	US artist Sol LeWitt coins the term 'Conceptual art' in an article titled 'Paragraphs on Conceptual Art' for the journal *Artforum*.

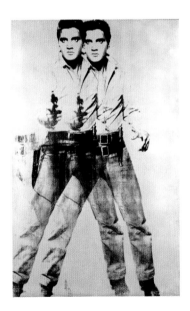

So Different, So Appealing? (1956) were taken predominantly from US magazines and emphasize the omnipresence of consumer products and mass media. Hamilton adopted a similar technique and approach for *Interior* (opposite), in which he placed an image of a contemporary woman within a collage of contrasting home interiors, ranging from the ornately decorative to the colourful but clean planes of modernism.

Warhol's silkscreen print *Double Elvis* (right) turns the iconic rock 'n' roll star Elvis Presley into a mechanically reproduced, doubled image. Borrowing a still from the Western film *Flaming Star* (1960), Warhol and his assistants who worked with him in his studio—aptly named 'The Factory'—screenprinted the photographs twice in black ink on a silver background. While the silver signifies the glamour of Hollywood, the faded and unevenly printed qualities of the print give Presley a ghostly air. The emphasis on the imperfections and slippages in the mechanically reproduced photograph prompt the viewer to take a closer look at a familiar figure. The decision to double Presley's image reminds viewers that their idea of Presley's persona has been created through the consistent dissemination of the musician's image, just as people become familiar with commodities through repeated images in advertising. The haunting feel of the work creates a distance between the viewer's idea of Presley and his actual self, which is something that cannot be accessed in the images. Young artists working in California, including Ed Ruscha (b.1937), saw Warhol's *Double Elvis* displayed at the Ferus Gallery in Los Angeles in 1963. Such exhibitions had an important influence on the development of Pop art in the city.

In other parts of the world, artists likewise employed photography as a means of picturing the objects of everyday life. German artist Sigmar Polke (1941–2010) took banal black-and-white photographs of common items for his piece *Bamboo Pole Loves Folding Ruler Star* (1968–69). Comprising fifteen photographs, the work shows an absurdist parade of articles, including a spoon suspended on a string between two glasses, a pickle stuck through a piece of paper and a tube standing upright in a bowl of lettuce. *Bamboo Poles* echoes French artist Marcel Duchamp's 'ready-mades', ordinary consumer commodities that he declared to be works of art, as well as the Surrealist photographs of Man Ray (1890–1976). Polke's black-and-white photographs, awkwardly cropped and often out of focus, point to a distinctly new idiom in artistic practice: a studied indifference that made the resulting photographs as banal as the objects they pictured.

This intentional banalization of photography links Polke to Conceptual art, a loose set of practices pursued by artists around the globe. Conceptual art, so named because artists associated with it emphasized the concept over the actual object of art, emerged in the 1960s alongside, and in response to, the developments in Pop art, Neo-Dada and Fluxus. Photography assumed a central role in these practices, many of which were ephemeral and used

1 *Interior* (1964)
Richard Hamilton • screenprint
19 ¼ x 25 ¼ in. | 49 x 64 cm
Museum of Modern Art, New York, USA

2 *Double Elvis* (1963)
Andy Warhol • silkscreen ink on synthetic polymer paint on canvas
83 x 53 in. | 211 x 134.5 cm
Museum of Modern Art, New York, USA

1967	1968	1968	1970	1972	1972
Martha Rosler begins her series of photomontages *Bringing the War Home: House Beautiful*.	Warhol survives a near-fatal shooting by Valerie Solanas, a feminist extremist whom he had offended.	Robert Smithson publishes the essay 'A Sedimentation of the Mind: Earth Projects' in *Artforum*. It promotes the work of the first Land art artists.	The first dedicated Conceptual art exhibition, 'Conceptual Art and Conceptual Aspects', opens at the New York Cultural Center.	Smithson transforms an industrial wasteland into Land art with *Spiral Jetty*, a long, spiral-shaped jetty extending into Utah's Great Salt Lake.	The number of colour television sets sold in the United States exceeds that of black-and-white sets for the first time.

photography as a means of documentation. In some cases, photographic documents became the work of art, as seen in the series of documentary images *Homes for America* (above) by US artist Dan Graham (b.1942). Using a Kodak Instamatic camera, Graham took photographs on train rides home through the tract housing of suburban New Jersey, capturing images of houses and diners. First presented as a slideshow at a group exhibition—'Projected Art' at New York's Finch College Museum of Art in 1966—later that year he paired his photographs with text for an article published in *Arts Magazine*. Graham's laconic style of photography, a parody of photojournalism and tourist photography, embodies the endless sameness of post-war US suburban housing. The article, which drily dissects the bland style of suburban homes, pokes fun at journalistic stories about post-war housing and US lifestyles. The series also nods to photography's longer history of documenting US architecture and living, exemplified in the work of Walker Evans (1903–75), and picked up in the 1960s and 1970s by photographers such as William Eggleston (b.1939) and Stephen Shore (b.1947).

Graham's engagement with post-war architecture and suburbia parallels that of many of his contemporaries, including Ruscha with his *Every Building on the Sunset Strip* (1966; see p.408). Ruscha mounted a Nikon camera on the back of a pick-up truck and photographed every building on the Sunset Strip, Los Angeles—historically a centre of popular culture and a consummate Pop art subject. He pasted his images together to create a continuous accordion-fold strip of photographs and a literal survey of the area's vernacular architecture.

US artist Martha Rosler (b.1943) uses photography as a means to address contemporary issues and political positions. Engaging with Pop art's interest in consumer commodities and Conceptual strategies of distribution, Rosler's photomontage series *Bringing the War Home: House Beautiful* (1967–72) creates a collision between domestic life—embodied in images taken from contemporary interior design magazines—and war, with photojournalists' images from news magazines. In *Cleaning the Drapes* (opposite) Rosler portrays a housewife wearing a portable vacuum cleaner. Taken from a magazine illustration, the woman cleans the curtains around a window that frames

3 *Homes for America*, detail (1966–67)
Dan Graham • 35mm slide
dimensions variable
Whitney Museum of Art, New York, USA

4 *Untitled (Facial Cosmetic Variations)* (1972)
Ana Mendieta • four (of nine)
chromogenic colour prints
19 ¼ x 12 ¾ in. | 49 x 32.5 cm each
Museum of Modern Art, New York, USA

5 *Cleaning the Drapes* (1967–72)
Martha Rosler • photomontage
20 x 24 in. | 51 x 61 cm
Art Institute of Chicago, Illinois, USA

an image of soldiers holding guns and waiting behind rocks, yet she appears oblivious to them. The photograph implies that death and violence reside just outside the domestic interior. Originally Rosler distributed her photomontages on flyers and in underground newspapers, using them as an agitational tool to point out that domestic life and the Vietnam War were closely linked—and mutually implicated. She reprised the series in 2004 in relation to the Iraq War. In *Bringing the War Home*, Rosler reinforces the cultural construction of domestic space, gender and labour. Rosler's emphasis on the spectator and her exploration of forms of power reflect her interest in French theorists such as Roland Barthes and Michel Foucault, whose work, along with that of other European Structuralist and Post-structuralist theorists, was crucial to the formation and theorization of Conceptual practices.

Like Rosler, a number of female artists of the period used photography to argue that gender roles, attributes and desires are not grounded in biology but are cultural constructs. In the headshots (right) that comprise the series *Untitled (Facial Cosmetic Variations)*, Cuban-born artist Ana Mendieta (1948–85) used her body as a medium to explore the effects of make-up, wigs and other props. Each photograph constitutes a performance rather than a self-portrait and Mendieta's grotesque bodily transformations are preserved in the form of nine 35mm colour slides. The series highlights photography's power of illusion and transformation, as well as its role conveying ideals of beauty.

When US artist Robert Smithson (1938–73) travelled to the Yucatán peninsula in Mexico in 1969 he installed mirrors on dispersed sites to create a series of nine colour photographs *Yucatán Mirror Displacements* (see p.410). The mirrors reflected and refracted the surrounding environment, so that the solid landscape appears shattered. He used photography not merely as an instrument of detached documentation, but also as a tool that provides a model for his understanding of nature, history and culture. Part Earthworks and part photographs, Smithson's images encourage the viewer to contemplate temporality. They also question whether the resulting documentation of ephemeral art becomes the artwork. **JQ**

Every Building on the Sunset Strip 1966

ED RUSCHA b. 1937

8358

84

8351 8355 8363 8371 8373 8383

Every Building on the Sunset Strip
(detail)
Offset lithograph on paper
Los Angeles County Museum
of Art, USA

NAVIGATOR

To photograph *Every Building on the Sunset Strip* Ed Ruscha loaded a continuous strip of black-and-white 35mm film into his motor-driven Nikon F2 and mounted it on a tripod in the bed of a pick-up truck. He then snapped photographs at regular intervals as he drove down Sunset Strip, a mile-and-a-half (2.4 km) stretch of Sunset Boulevard in Los Angeles. In the 1960s, critics began to conceive of Los Angeles as a possible prototype for a new form of urban space. Architect Robert Venturi, in particular, responded to the ways in which Ruscha's book pictured urban sprawl and car culture.

The idea of using photography in a 'deadpan' manner, a term that critics often use to describe Ruscha's work, is a key quality of Conceptual art, as is Ruscha's use of technology to produce an inexpensive commodity rather than a work of 'fine art'. Ruscha has emphasized the informational quality of his images and eschews the notion that his work has subjective and artistic elements; he prefers the low-resolution quality of this reproduction. A close reading of his book, however, leaves the viewer wondering as to the factual content of this extraordinary collection of photographic information. **JQ**

FOCAL POINTS

1 TREES
Ruscha captures the vegetation between buildings. These trees, which seem lost within the busy urban landscape, are like aberrations within a productive urban landscape. While necessary for air and light, such spaces suggest that waste is an inevitable by-product of consumer economies.

2 SEAMS
Visible seams mark the places where Ruscha stitched together separate images. In this way, his work resembles a film strip in production; as with film, his photographs are produced by joining together discrete images. The seams also disrupt the viewer's scanning of the long strip of photographs.

3 ARCHITECTURE
Buildings such as this high-rise structure were common on Sunset Strip in the 1960s. A prime piece of real estate in West Hollywood, the Strip was the site of frequent building and rebuilding. The architecture in the area, in the 1960s as well as today, is an eclectic mixture of styles.

4 AUTOMOBILES
Ruscha's focus on the boulevard dotted with traffic underscores Los Angeles's status as a city of the car. Contemporary commentary stressed the city's sprawling nature and the prominence of its freeways. Yet, Ruscha's photographs were taken on a quiet morning and are not overpopulated by cars.

5 BLACK AND WHITE
The use of black-and-white film reinforces Ruscha's claim that his images are factual documents. The Strip appears as a monotonous architectural facade, a common metaphor for the area. The deadpan approach links his project to earlier documentary work such as that of Walker Evans (1903–75).

▲ The book opens into an accordion-fold page printed with two strips of black-and-white images, one of which is upside down.

Yucatán Mirror Displacements 1969

ROBERT SMITHSON 1938 – 73

Yucatán Mirror Displacement (9) (above)
Yucatán Mirror Displacements (2) (6) (7) (8) (opposite)
Reproduced from an original 126 format,
chromogenic-development transparency
24 x 24 in. | 61 x 61 cm each
Solomon R. Guggenheim Museum, New York, USA

I n 1969 Robert Smithson embarked on a trip to the Yucatán peninsula in Mexico. There he created a variety of outdoor sculptural installations, including the mirror 'displacements', as he called them, pictured here. He arranged the same group of square mirrors in gridlike configurations, placed them in sand, soil and foliage, and then documented the results. Smithson published photographs made from his 35mm slides in an essay titled 'Incidents of Mirror-Travel in the Yucatán' in the September 1969 issue of the journal *Artforum*. Smithson's work intersects with Earthworks, or Land art, and Conceptual art, in which photographic documentation plays a key role. Smithson also engaged with the legacy of 19th-century archaeological expeditions to the Yucatán by drawing upon John Lloyd Stephens's multi-volume archaeological work on Mayan civilization, *Incidents of Travel in Central America, Chiapas and Yucatán* (1843). In Smithson's work, an anti-archaeological foil to Stephens's project, the distortions of mirrors obfuscate the Yucatán landscape and neglect to show its famed Mayan ruins. The photographs themselves, offering only narrow slices of the historically rich Yucatán, reinforce this stifling of vision. As with contemporaries such as Ed Ruscha and Dan Graham, Smithson's seeming indifference to the photographic medium may have been a strategic attempt to privilege the concept at the heart of the work. **JQ**

👁 OTHER MIRROR DISPLACEMENTS

MIRROR DISPLACEMENT (2)
Smithson piled reddish-brown soil on the mirrors in this displacement. Appearing like artefacts of the present, the half-buried mirrors suggest a correspondence between his interventions and the Mayan objects unearthed by archaeologists in the region.

MIRROR DISPLACEMENT (8)
For this photograph, in contrast to others in the series, Smithson has pulled back from his mirror displacements to show a broader view of the landscape. The image emphasizes the remoteness of the Yucatán as well as the inaccessibility and ephemeral nature of his project.

MIRROR DISPLACEMENT (6)
Smithson shows mirrors on a sandy beach. His series reflects contemporary interest in siting works of art outdoors. On the one hand an effort to circumvent the commodification of the art market, this interest in the environment coincided with an awareness of ecology and preservation.

🕐 PHOTOGRAPHER PROFILE

1938–62
Robert Smithson was born in Passaic, New Jersey. He attended the Art Students League in New York and Brooklyn Museum School, and became interested in Abstract Expressionism. From 1956 to 1957 Smithson served in the United States Army Reserves. After his army service he moved to New York.

1963–68
Smithson began to work with sculpture and developed an interest in Minimalism. By the mid 1960s, he became interested in Conceptual art and began producing Land art. In 1968 German photographers Bernd (1931–2007) and Hilla Becher (b.1934) accompanied Smithson through the Ruhr Valley, where they photographed industrial sites.

1969–73
He continued to develop his interest in industry, ecology and science, and to create sculptural, land-based and photographic works. Smithson died in a plane crash on 20 July 1973, while surveying sites for his Earthwork *Amarillo Ramp* in Texas, which was completed after his death by his wife, artist Nancy Holt, along with Richard Serra and Tony Shafrazi.

MIRROR DISPLACEMENT (7)
In this image the mirrors reflect the sunlight and the foliage. Mirrors serve to fragment the physical world; with their incomplete views, they interrupt any illusion of continuous space or wholeness, indicating Smithson's interest in the concepts of perspective, illusion and decay.

CONCEPTUAL PHOTOGRAPHY

1 *Following Piece*, detail (1969)
Vito Acconci • silver print
3 ⅛ x 3 ⅛ in. | 8 x 8 cm
Metropolitan Museum of Art,
New York, USA

2 *Wrong* (1966–68)
John Baldessari • photoemulsion
with acrylic on canvas
59 x 45 in. | 150 x 114.5 cm
Los Angeles County Museum of Art,
California, USA

3 *Variable Piece #101* (1973)
Douglas Huebler • silver prints

Writing in 1967, the US artist Sol LeWitt described Conceptual art as a form of production in which 'the idea becomes a machine that makes the art'. Conceptual art refers to a widely divergent set of practices in which the concept, not the art object itself, is the most important aspect of the work. For Conceptual artists, the mechanized medium of photography was an effective way of emphasizing detached decision-making as well as the conceptual and linguistic aspects of art. Photography took on a conflicted role in Conceptual art, and the practices that emerged from it, because artists were eager to critique and revise photography's traditional role in art. In her essay 'The Anti-Photographers' (1976), published in the journal *Artforum*, critic Nancy Foote noted that Conceptual artists defined themselves as artists 'using' photography. Such a moniker indicated that the artists did not conceive of photography as a way to point out beauty in the banalities of daily life nor as a tool for documentation. Instead, they critically examined photography's social meanings, aesthetic codes, structural qualities and varied histories.

In his works of the late 1960s, Vito Acconci (b.1940) examined photography's role as a medium of surveillance and social control. In *Following Piece* (above), a work performed daily over the course of a month, Acconci followed a randomly

KEY EVENTS

1968	1969	1969	1970	1970	1970
Mass student-led protests take place in Paris in May. Protests erupt in other cities, such as West Berlin, Belgrade and Prague.	'Konzeption— Conception: Documentation of Today's Art Tendencies' opens at the Städtisches Museum in Leverkusen, Germany.	Vito Acconci's *Toe-Touch* records his performative body movements in photographs.	'Information' opens at the Museum of Modern Art, New York. The show catalogue mimics the documentary forms of Conceptual practices.	John Baldessari burns almost all of his previous work for his *Cremation Project*.	Huebler begins *Variable Piece #70 (In Process) Global*, intending to 'photographically document the existence of everyone alive'.

412 POST-WAR TO THE PERMISSIVE SOCIETY 1946–76

chosen stranger through New York until that person entered a private space. The resulting photographs, not taken by Acconci himself, document a performance driven by an unwitting participant. By showing Acconci's back, the photographs immerse the viewer in the artist's movement through public spaces. The voyeuristic nature of the work raises questions regarding the limits of artistic practice and the violation of ethical boundaries.

Humour is a decisive, although often overlooked, aspect of Conceptual art. US artist John Baldessari (b.1931), who began to work with photography in the 1960s, humorously explores the codes of art in his work *Wrong* (above right). A professional sign-painter, not Baldessari himself, painted the laconic caption. Baldessari made *Wrong* after looking at an art instruction book: 'The person that did the book had sketches of the scene, of let's say a landscape—but there would be two. And one would be right, according to him, and one would be wrong. And I loved the idea that somebody would just say that this is right and this is wrong.' The resulting work, characterized by a deadpan style of photography, withdraws art from the realm of artistic authority.

Like Baldessari's work, *Variable Piece #101* (below right) by US artist Douglas Huebler (1924–97) is a decidedly humorous piece. In this image, Huebler explores the nature of the photographic archive. Huebler took ten portraits of the German photographer Bernd Becher (1931–2007), requesting that Becher pose as specific types, including a priest, a criminal and a nice guy. Two months later Huebler sent the photographs to Becher and asked him to label them correctly. Becher's list is displayed in the work along with the original list Huebler gave him when the work was made. Huebler's choice of sitter is significant, given that Bernd and his wife Hilla Becher (b.1934) were key figures in the formulation of Conceptual art. Their black-and-white photographs of industrial structures (see p.402) appealed to artists of Huebler's generation, who seized upon their cool, detached objectivity and representation of cultural structures as natural, given forms. In contrast to the legibility of the Bechers' work, however, Huebler's absurdist piece deliberately confounds. As Huebler does not make clear which list corresponds with the images, viewers are left guessing as to which character types Bernd Becher acts out in each photograph. In *Variable Piece #101*, visual and verbal information exist in irresolvable dissonance.

The work of John Hilliard (b.1945), like that of many Conceptual artists, problematizes photography's relationship to fact. Hilliard's photographs, such as *Cause of Death?* (1974; see p.414), point towards a future that has become a reality in which digitally altered imagery is the dominant mode. Such projects were timely, given that the 1960s and 1970s saw the rapid growth of information theory, nuclear experimentation, Cold War escalation and a military industrial complex. In the face of such shifting historical currents, Conceptual artists questioned what it meant to collect, compile and accumulate endless masses of information. **JQ**

WRONG

Cause of Death? 1974

JOHN HILLIARD b. 1945

Silver prints and text on museum board
20 x 20 in. | 50.5 x 50.5 cm each
Private collection

John Hilliard's *Cause of Death?* is composed of four rather blurry black-and-white photographs arranged in a grid. It is the third version Hilliard made of the work. At first glance, the white shape, repeated in each photograph, appears ambiguous. The title of Hilliard's work, along with the captions—'crushed', 'drowned', 'burned' and 'fell'—give clues as to what the viewer is seeing in the photographs. The white shape is a shrouded body, its corporeality outlined by the folds of fabric. The soles of the feet face outwards towards the viewer. Hilliard's work draws upon a history of documentary photography and on police or photojournalistic photography in privileging the truth value of the photograph. Yet *Cause of Death?* is far from an unambiguous document. While the photographs present a straightforward cause and effect narrative of death, the same body is shown in each image—only the framing is different. The viewer is presented with new visual information as to the different scenarios that may have led to the victim's death. The work's title queries the use of photographic documents as objective documentation. Hilliard was interested in examining the, often hidden, codes of photographic image-making and in interrogating its association with truth. Hilliard suggests that reading photographs, even those presented in factual publications, depends not on any inherent verisimilitude but upon the accompanying texts, the cropping of the images and preconceived notions. **JQ**

✴ NAVIGATOR

👁 FOCAL POINTS

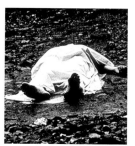

1 SHROUDED BODY
The shroud gives the body a ghostly appearance. It evokes body covers used in morgues as well as the shroud used to clothe Christ's dead body. The shroud adds a veil of mystery to the photographs because it prevents the viewer from seeing the body in its postmortem state.

2 CAPTIONS
The four verbs printed above and below the photographs—'crushed', 'drowned', 'burned', 'fell'—direct interpretations of each scene and the collective group of images. They compel the viewer to construct a narrative involving the violent death of the body hidden beneath the shroud.

DROWNED

3 FIRE
In the 'burned' photograph, the body lies on the ground near an open fire. Although the caption, written in the past tense, intimates that the shrouded person has died from burning, the shroud that obscures the body prevents the viewer from knowing if this is indeed the case.

4 FRAME
Although bounded within a frame, each photograph depends upon what is external to it, from the captions to the viewer's perspective. Hilliard draws attention to the word 'frame' meaning a physical boundary and the conceptual apparatus that shapes interpretation of photographs.

⏱ PHOTOGRAPHER PROFILE

1945–68
John Hilliard was born in 1945 in Lancaster, England. He studied at the local art school before enrolling in the sculpture school at St Martin's School of Art in London. In 1965 he won a travel scholarship to the United States.

1969–71
He had his first solo exhibition of photographic work deriving from a sculpture practice at Camden Arts Centre, London. In 1970 Hilliard started a series of works concerned with the mechanics of photography, concentrating on the attributes and capabilities of the camera itself.

1972–85
Hilliard began to examine photography as a representational device, exploring how cropping, focusing and captions direct interpretation. He moved outside the studio to investigate how photography depicts social narrative and landscape.

1986–PRESENT
The Society of German Photographers awarded Hilliard the David Octavius Hill Memorial Award in 1986. In 2010 he became Emeritus Professor in fine art at the Slade School, London.

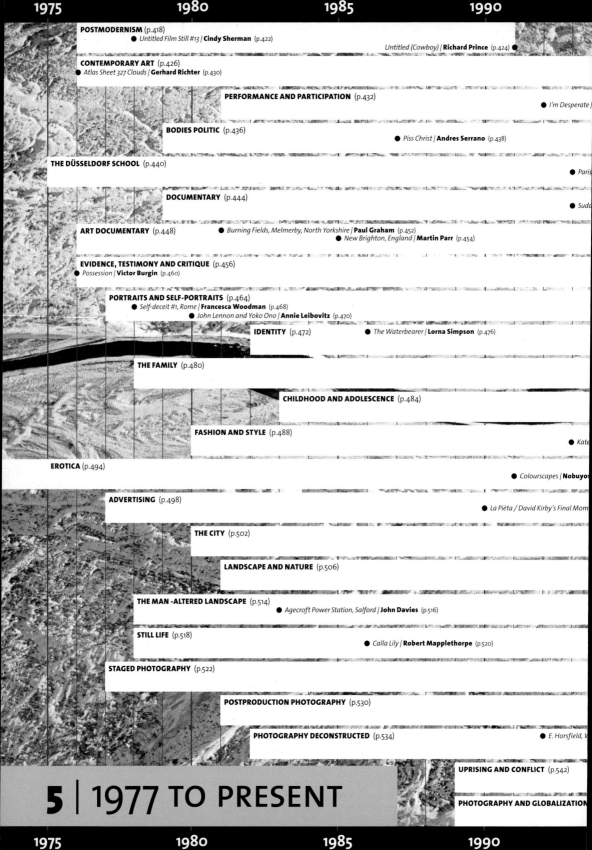

5 | 1977 TO PRESENT

POSTMODERNISM

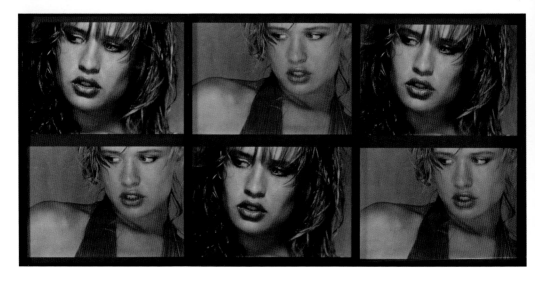

The changed social, political and economic conditions in Western societies during the 1970s, namely more flexible labour markets, new sectors of production, commercial and technological developments and global consumerism, led to a shift in the terms of cultural production. What became widely known as 'postmodernism'—whether premised on the assumption that modernism was dead, understood as a chance to revisit modernism or seen as an uneven development of modernism—became key to rethinking the nature of representation in theoretical circles of the period. In the visual arts, postmodernism often embraced a wide variety of styles, media and practices, within which photography played a leading role.

A new generation of established artists working predominantly in the United States, including Barbara Kruger (b.1945), Sherrie Levine (b.1947), Laurie Simmons (b.1949), Richard Prince (b.1949), Barbara Bloom (b.1951), Silvia Kolbowski (b.1953), Cindy Sherman (b.1954) and Vikky Alexander (b.1959)—who all had no former allegiance to the medium—used photography to demystify codes and systems of representation. Through appropriation and quotation these artists challenged the dominant modernist notions of originality, subjectivity, authenticity and authorship. Shifting the focus from modernist 'production' to postmodernist 'reproduction', the autonomous unique art object gradually gave way to the appropriated image, usually taken from mass visual culture. The autonomous work of art vanished along with the autonomous subject, as predicted by French literary critic Roland Barthes in his seminal essay 'The Death of the Author', published in 1967.

1 *Numéro Deux* (1982)
Vikky Alexander • chromogenic colour print
36 ⅜ x 120 in. | 91.5 x 305 cm
Trépanier Baer Gallery, Calgary,
Alberta, Canada

2 *Untitled (We Won't Play Nature to Your Culture)* (1983)
Barbara Kruger • silver print
73 x 49 in. | 185.5 x 124.5 cm
Mary Boone Gallery, New York, USA

KEY EVENTS

1976	1977	1977	1977	1979	1980
The journal *October* is established in New York and plays a pivotal role in introducing French theory to academic debates on postmodernism.	The 'Pictures' exhibition at Artists Space, New York brings together Troy Brauntuch, Robert Longo, Jack Goldstein, Sherrie Levine and Philip Smith.	Cindy Sherman begins her *Untitled Film Stills* series in which she is both the photographer and the photographed.	Susan Sontag publishes the influential *On Photography*, a series of essays that offers a reading of photography in terms of its privileged relationship to the real.	Laurie Simmons has her first solo show, 'Early Colour Interiors', at Artists Space in New York.	Sherrie Levine exhibits her series *After Walker Evans* in a solo exhibition at Metro Pictures Gallery, New York.

The title of the first show in which some of this new generation of artists exhibited—'Pictures'—is telling. It was curated by critic Douglas Crimp and took place in the Artists Space—an alternative arts venue in New York—in 1977. The exhibition brought together five artists relatively new to New York: Troy Brauntuch (b.1954), Jack Goldstein (1945–2003), Sherrie Levine, Robert Longo (b.1953) and Philip Smith (b.1952). These artists were not linked by a particular medium but rather by a common perception that our understanding of 'pictures' is mediated by other images, and they were among the first to challenge the notions of originality and uniqueness that dominated modernist aesthetics. They also questioned the idea that there was a single, authoritative interpretation of a work of art, suggesting instead that meaning was multivalent, with different readings being appropriate depending on where, when and by whom the artwork was seen. The works shown at this exhibition were not fine art objects but reworked images from the mass media, advertising and cinema.

Another artist who drew upon popular consumer imagery in their photography was Canadian-born Vikky Alexander. Through cropping, rephotographing, repositioning and reorganizing appropriated fashion images, Alexander produced works such as *Numéro Deux* (opposite). By repeating two images of a generically beautiful model within the formal convention of a rigid, minimalist grid, Alexander challenged not only the commodification of female imagery in the mass media and the artifice involved in the world of fashion, but also questioned the true meaning of beauty, originality, uniqueness and individuality.

Meanwhile, Barbara Kruger, who had moved into the art world after a career in graphic art, chose to appropriate the rhetoric of advertising. She combined photographs from magazines and other mass media sources with her own direct and challenging text, such as 'I shop therefore I am' and 'My body is a battleground'. The fact that these verbal messages were so resonant of advertising slogans in tone, yet so aggressively thought-provoking in content (disrupting the very ideas that the advertising images were selling), allowed her photographs to address large issues such as consumerism and, like Alexander, the stereotypical representations of women in a male-dominated media. In *Untitled (We Won't Play Nature to Your Culture)* (right), for example, the gentle photograph of a young woman sunbathing is transformed into a feminist statement by the text running across it. The linguistic shift from 'we' to 'your' within this slogan is used to refer to the binaries of feminine and masculine, nature and culture. In the original advertisement, the woman was evidently meant to play 'nature', suggested by the fact that she is lying on the grass, with her eyes covered by leaves, rendering her an object to be viewed by a male-dominated society (or 'culture'). Through the slogan, however, Kruger challenges this stereotypically passive feminine role.

1981	1981	1982	1982	1984	1985
Roland Barthes's *Camera Lucida* is translated into English.	Douglas Crimp writes in *October*: 'If photography was invented in 1839, it was only discovered in the 1960s and 1970s.'	Laurie Simmons begins her series *Ballet*, superimposing porcelain dolls in dancing postures on existing images of real-life ballerinas.	British artist Victor Burgin (b.1941) publishes *Thinking Photography*, applying both Marxism and psychoanalysis to photographic theory.	US literary critic Fredric Jameson publishes his influential account of postmodernism in *Postmodernism, or the Cultural Logic of Late Capitalism*.	The exhibition 'Representation and Sexuality' opens at the New Museum of Contemporary Art, New York.

Panama-born artist Richard Prince has also focused on cropping and rephotographing advertising images. He collected a vast number of advertisements for commercial products, such as furniture, jewellery, clothing, cars and tobacco, which he later enlarged and removed from their advertising context to give them artistic status; one example is *Untitled (Cowboy)* (1991; see p.426). Prince's use of found commercial imagery changed the unwritten rules of art creation, pushing the Duchampian appropriation to the limits. While Marcel Duchamp's concept of the ready-made was based on attributing artistic value to everyday objects, Prince's reuse of images that were copyright protected was considered by many a legal infringement. As recently as 2011, Prince lost a copyright lawsuit filed against him by photographer Patrick Cariou for the reappropriation of a number of images from Cariou's book *Yes Rasta* without obtaining his consent.

In the United States artist Laurie Simmons's postmodernist approach took on a slightly different form: she focused on portraying dolls, puppets and costumed dancers as living objects in her photographs and films. In *Walking Camera I (Jimmy the Camera/Colour)* (left), a figure inside a massive box camera is portrayed in dance tights and shoes. The work was perceived as a commentary on the camera's omnipresence in our society and its defining role in surveillance and control.

Another protagonist in the photo-based practice that flourished in the late 1970s and 1980s was Sherrie Levine. She rephotographed canonical 20th-century photographs taken by male photographers, such as Edward Weston (1886–1958), Alexander Rodchenko (1891–1956), Eliot Porter (1901–90) and Walker Evans (1903–75)—creator of *Alabama Tenant Farmer Wife* (1936; see p.308). Levine's series *After Walker Evans* (1981) comprises rephotographs of Evans's quintessential photographs of 1930s rural America. Her images— at first glance direct copies of the originals—are, in fact, reproductions of Evans's photographs from an exhibition catalogue. In this way Levine questioned photography's claim upon the modernist's precepts of originality and subjectivity, at the same time querying the revered status of the male modernist photographer. Levine's practice coincided with a period when photography was gaining ground in the marketplace, academia and the art institution on the basis of the modernist principles of authorship and individual style. In theoretical circles therefore the disappearance of the individual subject and of personal style in her photographs was interpreted as a deliberate critical stance. However, Evans's estate claimed that *After Walker Evans* was an infringement of copyright and sought to prevent the sale of Levine's prints.

The artist as a source of originality and singularity was also challenged by US photographer Cindy Sherman. Sherman, like many artists of her generation, employed the medium of photography to explore the complex possibilities of the single image. In her various series of untitled photographs—of which *Untitled Film Stills* (1978; see p.422) is one of the best known—she performed a broad range of female roles for the camera in a set of poses drawn from television soap operas, glossy advertisements and Hollywood films. Using make-up, wigs and costumes, she experimented with stereotypical female roles constructed by the mass media: 'girl next door', secretary, housewife, domestic goddess or glamorous socialite. Many feminist theorists perceived her work not only as a parody of mass culture, but also as a critical commentary on femininity as a cultural construct. Sherman's dual role as the photographer and the subject fitted perfectly into feminist debates about how images of women were constructed in the public sphere, by whom and for whom. This conflation of roles dispensed with the idea of authorship and projected a conscious refusal of the artist's subjectivity.

3 *Walking Camera I*
 (Jimmy the Camera/Colour) (1987)
 Laurie Simmons • Cibachrome print,
 edition of ten
 64 x 46 in. | 162.5 x 117 cm

4 *Made in Heaven* (1989)
 Jeff Koons • lithograph billboard
 125 x 272 in. | 317.5 x 691 cm
 Private collection

The corpus of postmodernist photographic work from the late 1970s to the late 1980s was largely identified with appropriation and pastiche; the blurring of boundaries between high art and low culture; and the continuous challenge of dominant modernist myths including autonomy, originality and authorship. The displacement of the 'aura' of the unique work of art, to use German critic Walter Benjamin's term, and the celebration of the 'copy' became the defining characteristics of the 'photographic activity of postmodernism' as it was described by Douglas Crimp. He, along with other US theorists involved with the journal *October*—namely Rosalind Krauss, Craig Owens and Hal Foster—theorized postmodernist photographic work, drawing on French theory that had been recently introduced to the English-speaking world, in particular both Roland Barthes's and Jacques Derrida's analyses of representation and Michel Foucault's theories on power and knowledge. The work of photographers such as Levine, Sherman and Kruger also opened up new channels of sophisticated theoretical writings on feminist aesthetics. Some commentators, such as Owens, interpreted the refusal of authorship in Levine's appropriated images as an attempt to deconstruct 'paternal authority', while many theorists, including Laura Mulvey, suggested that Sherman's *Untitled Film Stills* drew on psychoanalytical theories of voyeurism, fetishism and the construction of femininity for the male 'other'.

In this respect, translations of the writing of French theorists into English, and the re-readings of psychoanalytical texts by Sigmund Freud, Jacques Lacan and Melanie Klein, exerted a great influence on the practice and theory of photography in this period. Also of paramount importance for the postmodern analysis of photography were the circulation of the journals *Screen Education* and *October*, the publication of Susan Sontag's *On Photography* in 1977 and the translation into English of Barthes's *Camera Lucida* in 1981. As a result, practices such as appropriation, pastiche and irony had been assimilated by the artistic establishment by the mid 1980s and came to dominate photographic practice.

Works such as *Made in Heaven* (below) by Jeff Koons (b.1955), featuring himself and his then wife—Hungarian-born, Italian politician and porn star Ilona Staller—seemingly celebrated rather than critiqued the tropes of popular imagery, such as the sexualization of the female form. Many commentators noted that such works appeared to uphold rather than subvert the formerly dominant structures of cultural production. The defining elements of postmodernism (irony, quotation, pastiche) had lost their critical edge and were being employed for their own sake. **AM**

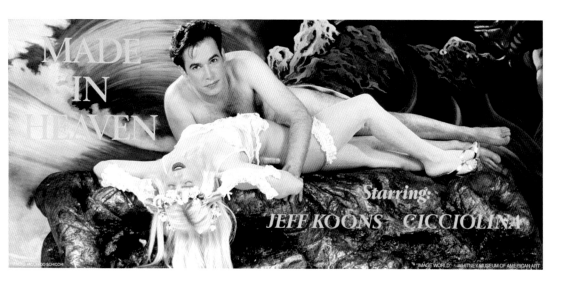

Untitled Film Still #13 1978

CINDY SHERMAN b. 1954

Silver print
10 x 8 in. | 25.5 x 20 cm
Metropolitan Museum of Art,
New York, USA

Cindy Sherman produced a series of sixty-nine modestly sized, black-and-white photographs between 1977 and 1980. Each image in the series portrays the artist in an enigmatic scene seemingly taken from films of the late 1950s and early 1960s. Sherman's role as both the observer and the observed is indicative of her self-conscious postmodern artistic practice. Her ability to disguise herself as a recognizable type—but not an actual character—from a non-existent story invites the viewer to wander within the frame and reconstruct the narratives that are implied by the photographs.

In *Untitled Film Still #13* she represents herself as an ordinary young woman with a Brigitte Bardot–inspired look. Set within an interior space, a library, and shot from a low angle, the subject is pushed to the edge of the frame. The female figure in the picture does not engage with the viewer, implying that the camera is freezing a moment of her everyday reality. This is then offered to the viewer, whose voyeurism becomes paradoxical with the realization that the character and scene never actually existed: they were only constructed for this image. This photograph is therefore a copy without an original. The multiple roles that Sherman adopts for this series suggest that femininity is a construction of cultural codes built upon representation. **AM**

👁 OTHER STILLS FROM THE SERIES

UNTITLED FILM STILL #32 (1979)
Sherman is a seductive, noirish figure in this picture. She stands mysteriously alone lighting her cigarette, dressed all in black against a black curtain. Where is she? And what is she doing here?

UNTITLED FILM STILL #50 (1979)
The sophisticated protagonist in this image appears to be waiting for an absent 'other' to join her in the stylish mid-20th-century lounge, leaving viewers to guess what might happen next.

🕐 PHOTOGRAPHER PROFILE

1954–76
Born in New Jersey and raised in Long Island, Cindy Sherman studied painting at State University College, Buffalo, New York, in 1972, but soon turned her attention to photography.

1977–80
After graduation, she moved to New York, where she started taking photographs of herself playing the stereotypical roles of B-film actresses. This became her *Untitled Film Stills* series.

1981–88
In 1981, she created *Centerfolds*, images of herself in roles inspired by glossy magazine shots. In 1985 she started to explore the grotesque in fairy tales, resulting in *Fairy Tales and Disasters*.

1989–91
At the end of the 1980s she began *History Portraits* in which she played roles from famous paintings.

1992–2005
In 1992, she created the *Sex Pictures* series, in which she was absent from her images for the first time. They featured dolls and prosthetic body parts in explicit poses.

2006–PRESENT
In 2006 Sherman created a series of advertisements for fashion designer Marc Jacobs. In May 2011 a print of her *Untitled #96* (1981) was sold for a record-breaking US$3.89 million at an auction by Christie's in New York.

Untitled (Cowboy) 1991
RICHARD PRINCE b. 1949

1 SKY

By setting his cowboy against a lightly clouded sky, Prince transforms the cowboy from an all-American symbol of freedom and adventure into a universal one. This is in contrast to his other *Cowboy* images, which are set in recognizable US desert landscapes.

2 LONE COWBOY

With his yellow coat flapping behind him in the wind, the cowboy is captured in the dramatic moment of attempting to lasso an animal. He is depicted as a lonesome hero—an image reinforced by popular Hollywood Westerns—a US symbol of individualism and free will.

This photograph of a cowboy riding under blue skies through a wide open terrain with a lariat in one hand is part of Richard Prince's *Cowboy* series, which he started in 1980 and carried on into the next decade. Like the others in the series, the image is a rephotograph of the Marlboro Man, the cowboy used in the Philip Morris cigarette advertising campaigns from the mid 1950s onwards. The figure of the cowboy had originally been chosen in order to raise the popularity of the filter brand for the male consumer market in light of previous feminine associations and the first reports linking smoking with lung cancer. Prince cropped the figure from its initial context, then rearranged and rephotographed it.

Devoid of its commercial text, blown up and seen in the context of a gallery, the image of the lonesome cowboy became symbolic of US masculinity, solitude and freedom. Taken during the early years of President Reagan's administration, the romanticized image of the cowboy also pointed to the president's public persona: he had worn a Stetson for his official campaign photograph of 1980 and was also known for his heroic acting roles in Westerns and war movies in his former career. Prince's appropriation of 'found imagery' implied a rejection of any notion of authorship on behalf of the artist. The rephotograph is almost identical to the original advertising image, except for a heightened colour and a loss of sharpness. Nevertheless, the rephotograph, when framed and hung on a gallery wall, obtained an art status denied to the original image and its maker. **AM**

Ektacolor photograph
50 x 70 in. | 127 x 178 cm

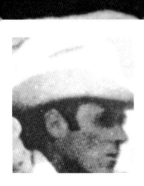

3 COWBOY HAT
The top central position of the white Stetson against the sky reaffirms the power of the traditionally masculine Wild West iconography used in the original advertisement. The Stetson is instantly recognizable as a stereotypical accessory of the macho, free-spirited cowboy.

4 USE OF YELLOW
Prince's rephotographs of magazine advertisements are characterized by heightened colours, which have a striking effect. Here, the vivid yellow of the cowboy's chaps and coat remind the viewer that the image is derived from an advertisement rather than a realistic depiction of a cowboy.

CONTEMPORARY ART

1 *Japanese Sky I* (1988)
Robert Rauschenberg · four bleached
Polaroid Polapan prints
20 x 24 in. | 51 x 61 cm (each)

2 *Quiet Afternoon* (1984–85)
Peter Fischli and David Weiss
chromogenic colour print
16 x 11 ¾ in. | 41 x 30 cm
Sprüth Magers, Berlin, Germany

The monumental work *Atlas* (1961–; see p.430) by Gerhard Richter (b.1932) exemplifies the role of photography in contemporary art. Photography has been an integral part of Richter's practice from the start of his career and it occupies both a central and a subsidiary role in his oeuvre. His early works, referred to as 'photo-paintings', are paintings from photographs of a heterogeneous body of commonplace, unsettling and abstract subjects such as clouds, doors and skulls, set out in alphabetical visual groups to evade any subjective organization. *Atlas* is an epic compendium of his source material, which began as a small collection of mainly black-and-white photographs arranged on sheets orthogonally. When *Atlas* is hung as an exhibition, Richter divides the images into visual groups. With more than 5,000 photographs, drawings and diagrams in *Atlas*, the range of reference is vast, and includes images from archives and the media, as well as images made by Richter including his own drawings of clouds, water and other rural scenes.

KEY EVENTS

1977	1977	1984	1985	1988	1988
Dieter Appelt begins his series *Memories Trace*.	Gilbert & George create their provocative series of photomontages *The Dirty Words Pictures*.	The Turner Prize is established in the United Kingdom to celebrate the best in contemporary art.	Fischli and Weiss exhibit their series *Equilibrium / Quiet Afternoon* at Galerie Monika Sprüth, in Cologne, Germany.	Gerhard Richter begins painting over the top of photographs and goes on to create more than 700 overpainted photographs.	The YBAs hold their first exhibition, 'Freeze', at an empty London Port Authority building at Surrey Docks in London's Docklands.

Of the same generation as Richter, German photographer and video and performance artist Dieter Appelt (b.1935) is concerned with memory, time and transcendence in his work. After being evacuated from their home south-west of Berlin in World War II, Appelt and his family returned in 1945 to find the bodies of deceased soldiers decomposing in the surrounding fields. Appelt was affected deeply by the experience, and it significantly informs his series *Memories Trace* (1977–79). In the series he explores themes of duration and decay as he seeks to purge himself of his childhood memories. Heavily influenced by the German performance artist Joseph Beuys, Appelt performs 'actions' that are recorded with a camera. Appelt has said of his practice: 'I see my work, as photography with sculpture. . .I photograph form as sculpture, which means that if I photograph myself, it becomes a sculpture. And it is more important that I photograph myself, rather than someone else, because I use myself as a medium.'

American artist Robert Rauschenberg (1925–2008), who is best known as a painter and sculptor, provided an important bridge between Abstract Expressionism and Pop art in the 1950s. In the 'combines' of his early career, he integrated found objects into his work, seeking to close the gap between art and life by fusing Abstract Expressionism with the materials of an unequivocal reality. By the early 1960s, Rauschenberg had moved away from 'combines' and began transferring photographs to canvas through the silkscreen process. In the late 1980s he began to make his own photographs. *Japanese Sky I* (opposite) is from his *Bleacher Series*, which shows a highly innovative use of photographic technology. Working with a Polaroid camera, he applied bleach unevenly to large sheets of Polapan film, preventing some of the photographed scene from registering on the film. The series further explores the tension between realism and abstraction that was central to his artistic concerns.

The work of Swiss artists Peter Fischli (b.1952) and David Weiss (1946–2012) establishes photography as a medium through which the artist is able to represent the commonplace, but in this case as skewed, contingent and precarious. For their series of eighty-two photographs, *Equilibrium / Quiet Afternoon* (1984–85), Fischli and Weiss took everyday objects such as kitchen utensils, vegetables and bottles and balanced them in unstable constructions, so that the uncanny sculptures teeter on the brink of collapse. The gravity-defying sculptures possess a poignant fragility and ephemerality made permanent by the camera. *Quiet Afternoon* (right) shows a cheese grater balanced at an improbable angle; a carrot lodged on the top protrudes at a near right angle and a courgette sits on the carrot. Everyday objects acquire an animism and energy through their architectural and spatial relation to other such objects. With these witty images Fischli and Weiss make the mundane appear unfamiliar and charged with a bizarre potential, as they transform arrangements of domestic items into acrobatic acts.

1993	1993	1994	1997	2011	2011
Jay Joplin opens the gallery space White Cube in Duke Street, St James's, London and exhibits the work of the YBAs.	Tracey Emin's solo show 'My Major Retrospective 1963–1993' at London's White Cube includes tiny photographs of her art school paintings.	Roni Horn creates her first photographic installation, *You are the Weather*.	Emin's photographic series *Trying On Clothes From My Friends (She Took The Shirt Off His Back)* shows her trying on friends' clothes as she explores identity.	London's Tate Modern holds a retrospective of Gabriel Orozco's work; it includes his photographic series *Until You Find Another Yellow Schwalbe* (1995).	New York's Museum of Modern Art stages 'New Photography 2011', part of an annual exhibition series showing works by artists who use photography.

```
3          4

5

```

3 *Cat in the Jungle* (1992)
 Gabriel Orozco • silver dye bleach print
 16 x 20 in. | 40.5 x 51 cm
 Kunstmuseum, St Gallen, Switzerland

4 *I've Got It All* (2000)
 Tracey Emin • ink-jet print
 48 ⅛ x 42 ⅞ in. | 124 x 109 cm
 Saatchi Gallery, London, UK

5 *You are the Weather*, detail
 (1994–96)
 Roni Horn • eight chromogenic
 colour prints
 10 ⅜ x 8 ⅜ in. | 26.5 x 21.5 cm each
 Hauser & Wirth, Zurich, Switzerland

Gilbert & George (b.1943 and b.1942) place themselves at the centre of their art, adopting an identity as 'living sculptures'. They began to create films and pictures to extend this concept without their having to be present physically. They have become known for their series of carefully juxtaposed photographic panels laid out in grids, which are highly graphic in design, such as *The Dirty Words Pictures* series created in 1977 that shows images of graffiti alongside images of London. Many of the pictures have titles taken from the graffiti of 'dirty words' such as *Lick*, *Queer* and *Fuck*. Made at a time when the punk movement had become a phenomenon, the images reflect its brashness.

Mexican artist Gabriel Orozco (b.1962) creates works that are designed to enhance viewers' perception of the world around them using photography, installation, video, drawing and sculpture. *Cat in the Jungle* (above) is an assemblage of eighteen cans of tinned green beans. A can of cat food is inserted in the middle of the display so that a cat's face peeks out among a saturation of green. The association transfigures the cans of green beans into a garden or jungle, and the cat's face is animated accordingly. Subverting the concept of supermarket displays in which order and repetition are used to attract the eye, the gentle humour of the work suggests that viewers seek out the surreal juxtapositions in the everyday.

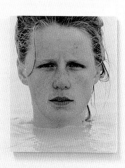 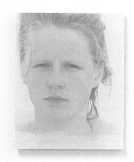 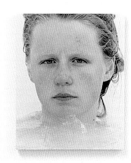 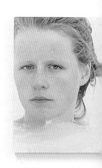

US artist Roni Horn (b.1955) uses sculpture, drawing, photography and site-specific installation to explore intimate inner geographies. *You are the Weather* (below) is a series of one hundred photographic portraits of the artist Margrét Haraldsdóttir Blöndal. Horn travelled with Blöndal through Iceland, visiting naturally heated pools of varying temperatures, caused by the island's fluctuating climate. The resulting portraits show Blöndal's head and bare shoulders; she is submerged in water, which is just visible at the bottom of the frame. Usually the portraits are hung in a single line, the changing weather reflected in the model's face, which itself changes in expression from frame to frame. The series serves to critique the portrait tradition in which a single portrait is claimed to capture the complexities of its sitter. Yet Horn's intentions are more conceptual. The model becomes the weather in its fluctuation. Strangely confrontational, Blöndal's expression calls into question the subject of the title: 'You' refers to the model, yet it can also mean the viewer, who is called to play an active role as their experience of the work unfolds.

The late 1980s saw the rise of a group of artists who became known as the 'Young British Artists'. Considered brash and vapid by the art establishment, the leading lights of the movement, notably Tracey Emin (b.1963) and Damien Hirst, found an avid supporter in art collector Charles Saatchi, whose largesse filled the void left by a decline in government arts subsidies. Emin's piece *I've Got It All* (right) is exemplary of the artist's practice as cultural commentary. There is a dualism in the image between a narcissistic self-congratulating tone—'I've got it all'—and regression. In one of eight photographs in the series, Emin sits on a red floor in a Vivienne Westwood dress with her legs spread in what is an appropriation of fashion photography. What can be seen of the room is minimal and an overstuffed plastic bag leans against the wall behind her. She is gathering money towards her vagina, an onanistic and extrovert gesture that suggests a sexual relation with money. Read in reverse, Emin is giving birth to money. In this version, the artist's gaze is pensive, her eyes are downcast, introverted and evade the camera. In other versions, her mood is more jubilant. The association of money with the vagina can be seen as an updating of the feminist art of the 1970s, critiquing the modes of behaviour ascribed to women in general, and to female artists in particular, within contemporary culture. In suggesting that the idea of riches is spiritually empty, the work critiques the suggestion, in consumer and celebrity culture, that a woman's sexuality is the woman. Emin's photographic performance simultaneously reflects and critiques the society—and the art world—of which she is a part. **GC**

Atlas Sheet 327 Clouds 1976

GERHARD RICHTER b. 1932

1 GRID

Richter uses *Atlas* as a visual diary to keep track of sketches and photographs, but by organizing his photographs into gridlike structures he creates artworks themselves. Viewers see the multiplicity of the world in the different cloud shapes as an apparent order is applied to randomness.

2 TEMPORALITY

The images suggest an evening glow. There is a change in the middle of the sequence to a stormy mood that retreats towards the images on the right-hand panel. Read vertically, the final image suggests a clearing. A sense of temporality is at work but one that has no actual chronology.

I n 1961 German artist Gerhard Richter started *Atlas*, an archive of photographs and other materials from 1945 to the present. Sheet 327 of the series, *Clouds* (1976), appears in the series directly after four sheets of *Seascapes*, taken in 1975. Their juxtaposition dissolves the seascapes into the cloud formations. Sheets 327 and 328 are each comprised of sixteen images of clouds. The grids, which echo the colour charts also found in *Atlas*, can be viewed horizontally or vertically. The clouds and their dominant colours of white, brown and blue have strong associative values. The cloud formations are tinged with orange and brown in the first sheet whereas orange is the dominant hue in the following sheet. The orange tinge in sheet 327 serves to create definition for the bright blues and whites of the cumulus fluffy clouds; as the dominant hue in the second sheet, it lends a Romantic aesthetic to the cloud formations. The unmanipulated photographs of clouds seen in *Atlas* invoke the varied associations inspired by colour in nature and symbolize the idea of nature in constant motion. They also remind the viewer of the abstractions to be found within nature.

The small photographs in *Atlas* are arranged systematically on white cardboard to a standard measurement. The images speak of a desire to turn a subjective aide-memoire into something more objective and universalizing. As repetitive grids, the sheets of *Atlas* reference Conceptual art practice; here the viewer is presented with typologies of cloud formation, akin to the typologies of industrial structures created by Bernd (1931–2007) and Hilla Becher (b.1934) between 1959 and 1973 (see p.402). Clouds appear elsewhere in *Atlas*, invoking Richter's idea of clouds as abstract paintings. The intangibility of clouds symbolizes the problems of representation. **GC**

Colour prints
20 ⅜ x 28 ¼ in. | 51.5 x 66.5 cm each
Städtische Galerie im Lenbachhaus,
Munich, Germany

3 COLOUR AND SHAPE
The delicate colours and billowing shapes recall those seen in paintings by Romantic artists such as Caspar David Friedrich. A collection of apparently haphazard images has been chosen carefully for their soft-focus shapes, which can be transformed by painterly gesture.

PERFORMANCE AND PARTICIPATION

F or Chinese artists working in the 1980s and 1990s, performance was
a politicized practice. Operating under a regime that prohibited freedom
of expression, both political and aesthetic, performance art became
identified with political and cultural transgression. For Chinese-born artist
Zhang Huan (b.1965), 'The body is language.' He has produced a prolific series
of works that speak to the restraints of human and political freedoms in China.
In his most renowned performance, *To Raise the Water Level in a Fishpond*
(above), he paid a group of forty unemployed peasants, who had gone to
Beijing to find work, to stand in a pond in order to, so it was said, raise the
water level. Their solemn faces capture what Zhang sees as the 'self-torture' of
their lives. This absurdist act and the photographs that document it highlight
the exploitation and the hardship of emigrant workers. It is, however, an
oblique critique designed to evade censorship.

The Austrian artist Erwin Wurm (b.1954) began his series titled *One-Minute
Sculptures* in 1988. In the photographs, Wurm creates a sculpture out of
situating himself, a model or models in a bizarre relationship with an everyday
object. Wurm's image *Freudian Rectification* (opposite above), from his
Philosophy-digestion series (2004), shows a young woman balanced
precariously on a stick that appears to disappear inside her. Wurm here
plays with the psychoanalytic notion of the uncanny while commenting
on the representation of women in psychoanalytic theory. His odd blend of

1 Zhang Huan's *To Raise the Water Level
in a Fishpond* performed in Beijing,
China in 1997.

2 Erwin Wurm's *Freudian Rectification*
performed in 2004.

3 Sophie Calle's *The Hotel, Room 44* (detail)
performed in Venice, Italy in 1981.

KEY EVENTS

1981	1988	1990	1992	1993	1998
Sophie Calle starts work as a temporary chambermaid in a Venetian hotel for her series of diptychs, *The Hotel*.	Erwin Wurm begins his series, *One-Minute Sculptures*, of people in humorous, temporal situations.	Philip-Lorca diCorcia (b.1951) begins *Hustlers*, a series of images of male prostitutes in Los Angeles whom he pays to photograph.	Gillian Wearing begins her first significant collaboration with members of the public and photographs people holding signs (see p.434).	In Beijing Zhang Huan is photographed performing his first piece, *The Third Leg*, for which he uses his own body and a mannequin leg.	Japanese artist Shizuku Yokomizo (b.1966) begins her series *Dear Stranger*. She sends people an anonymous letter asking them to pose in their windows.

formalism and humour works to unsettle the viewer and question the nature of sculpture and the assumptions of psychoanalytic discourse.

French Conceptual artist Sophie Calle (b.1953) realizes her art through a voyeuristic participation in everyday life. In 1981 she worked as a chambermaid in Venice and photographed items that she found in the hotel rooms she had to clean. The images were then used alongside text to create a series of diptychs titled *The Hotel*. In *The Hotel, Room 44*, the upper frame of the diptych shows adjacent twin beds in the hotel room. Printed underneath the image are journal entries detailing what she found in the room during her visits between 17 February and 1 March. From her entries viewers learn that a woman stayed in the room and a man joined her for part of her visit. Also in the upper part of the frame Calle detailed her findings after the room was vacated: a stethoscope, a sphygmomanometer, an electric blanket, a Venetian mask, biscuits, clothing, a red wig, bandages and syringes. These items are illustrated in the photographs displayed in the lower frame of the diptych (below).

The integration of art into social life has been shown recently in the choreographed work of Kateřina Šedá. For her project *There is Nothing There* (2003), the artist persuaded the entire village of Ponìtovice in the Czech Republic to take part in daily activities en masse. The 300 villagers performed regular activities such as shopping, returning home, eating and switching off their lights. However, the simultaneity of their actions transformed what they did into a ritualized social performance. The events were both filmed and photographed and exhibited at the Museum of Modern Art, Warsaw. **GC**

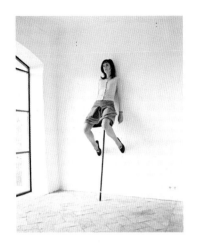

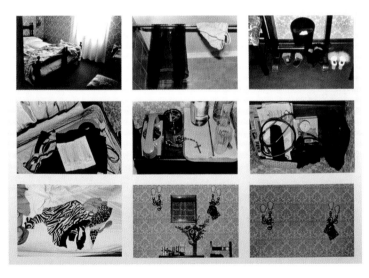

I'm Desperate 1992–93
GILLIAN WEARING b. 1963

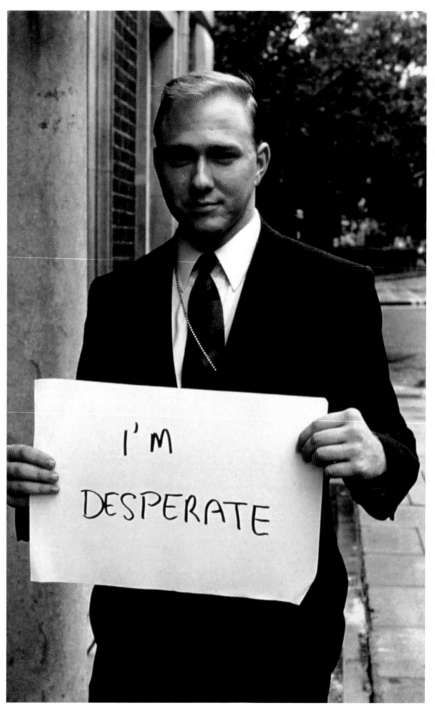

From *Signs that Say What You Want Them to Say and Not Signs that Say What Someone Else Wants You to Say*
Colour print
46 ⅞ x 31 ⅛ in. | 119 x 79 cm
Tate Liverpool, UK

English photographer and video artist Gillian Wearing is best known for her participatory practices involving the public. *Signs that Say What You Want Them to Say and Not Signs that Say What Someone Else Wants You to Say* is a series of more than fifty colour photographs of city dwellers. Wearing approached people in the street and asked them to write down what was in their heads on a piece of paper, hold up the paper and have their portrait taken. The scope and uniformity of the series, together with its social sweep from those who are homeless to city workers, are suggestive of a work of social documentary, but Wearing's series subverts the genre by giving the subjects a degree of control over their self-representation. The text functions as the voice of the mute subject, so the work resists becoming social commentary and has an egalitarian element. In one of the images a tattooed man is standing on the corner of a shopping precinct holding a sign saying: 'I have been certified as mildly insane!' In such images, Wearing plays with the assumptions that society makes about people's appearance and the stereotypes that evolve from the assumptions. The signs make private inner thoughts public; the words are humorous, touching and unsettling. Contrary to the tropes of advertising, also seen on the street, that show attractive, healthy figures whose external appearance is designed to signify happiness, the portraits suggest that appearances are deceptive and that human subjects are fragile and complex. **GC**

⬤ NAVIGATOR

◉ FOCAL POINTS

1 IDENTITY

The subject's identity remains anonymous even though the sign reveals the man's innermost thoughts and questions the viewer's presumptions about the identity of strangers. The words on the sign disrupt cultural stereotypes, but this relies on a belief that he has written the sign that he is holding.

2 BACKGROUND

It was important to Wearing that the background to her photographs was non-specific and an invocation of the everyday. The diversity of the people in the series represents the collective population. The intimate signs map interiority and obscure the boundaries between private and public.

3 SIGN

The sign is A3, the same size as Wearing's original prints. Wearing creates an affinity between the sign and her artwork: the photograph effectively becomes the sign held up by the photographer. Thus the distinction between the photographer and her subjects becomes blurred.

4 COLLAR AND TIE

The young man is wearing a business suit and tie, which is suggestive of his position in the social hierarchy. The poignancy of his message on the sign—'I'm desperate'—jars with his well-dressed, self-assured appearance, revealing the limits of documentary photography.

⏱ PHOTOGRAPHER PROFILE

1963–92

Gillian Wearing was born in Birmingham. She studied art at Chelsea School of Art and then Goldsmiths College, London.

1993–96

Wearing exhibited *Signs that Say What You Want Them to Say and Not Signs that Say What Someone Else Wants You to Say* at London's City Racing gallery. In 1994 she made *Dancing in Peckham*, a video of herself dancing in a shopping centre.

1997–2005

In 1997 Wearing made *2 into 1* for which she recorded a mother and her two sons talking about the issues they had with one another, and then switched their voices, so that the mother adopts the sons' voices and vice versa. The same year she won the Turner Prize. In 2003 she posed as members of her family as part of her ongoing photographic series *Album*, which she began in 1993 based on family snapshots.

2006–PRESENT

Wearing's installation *Family History* toured the United Kingdom. The show also incorporated self-portraits of Wearing as her maternal grandparents from her *Album* series.

BODIES POLITIC

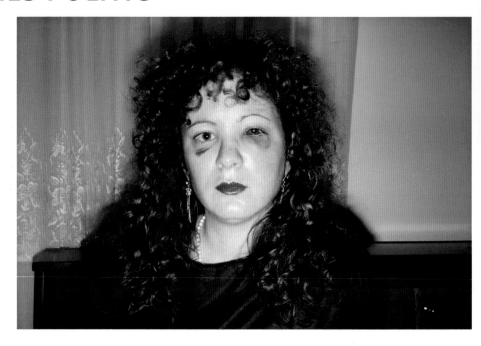

Images of the body—sensual, brutal, anatomical, erotic—have featured in works of art for centuries and reflect the cultural, religious and political environment in which they were created. In the late 1980s, in the United States, a group of Republican politicians fought to cut the funding of art that portrayed homosexuality, feminism, racism and other contentious issues. The 'Culture Wars'—as the controversy came to be known—was in part triggered by the homoerotic imagery of photographers such as Robert Mapplethorpe (1946–89) but the work that sparked most of the initial controversy was a photograph by the artist Andres Serrano (b.1950) titled *Piss Christ* (1987; see p.438), which depicts a crucifix submerged in the artist's urine. The outcry generated by this image ostensibly stemmed from the fusion of what culturally is considered sacred—the crucifix—with what is considered profane, bodily fluids. Republicans claimed the image to be sacrilegious and an affront to the morals they upheld. They argued that taxpayers' money was being used to subsidize art that was in opposition to the government, the family and religion. The debates in Congress invoked the question of censorship and the First Amendment rights of artists: in short, the freedom of expression.

The growing intolerance of public expressions of 'deviance' from cultural norms was countered by an increase in photographic representations of

KEY EVENTS

1979	1979	1985	1987	1987	1989
Graciela Iturbide (b.1942) produces her iconic image *Our Lady of the Iguanas*. It celebrates the Zapotec woman's power and freedom.	Nan Goldin begins her intimate visual diary, *The Ballad of Sexual Dependency*.	In the series *The Picture of Health?* British photographer Jo Spence (1934–92) documents her body during treatment for breast cancer.	Rotimi Fani-Kayode (1955–81) produces a series of photographs exploring race and sexuality. His image *Sonponnoi* celebrates the black male body.	Andres Serrano's *Piss Christ* (see p.438) wins an award from the Southeastern Centre for Contemporary Arts. The image is a catalyst for the Culture Wars.	'Robert Mapplethorpe: The Perfect Moment' tours successfully despite cancellation at one venue—the Corcoran Gallery, Washington, DC.

lesbian, gay and transgender bodies. Much of the work produced was a response to the silence of the government over the AIDS crisis. The arts in general, and photography in particular, played a crucial role in putting AIDS on the social and political agenda. In a show organized by Nan Goldin (b.1953) in November 1989 at the Artists Space in New York, 'Witnesses: Against Our Vanishing', many of the photographs focused on the impact that AIDS has on the human body. Some images were sexually explicit, celebrating the body and sexuality. As a result, many critics saw the exhibition as another example of deviance and 'perversion'. The artists' intention was to alert others to the devastation of their community and to offer a space of support for those who were dying of AIDS. *Post-Cards From America: X-Rays From Hell* by David Wojnarowicz (1954–92) was perhaps the most political exhibit, attacking public figures such as Jesse Helms whom he felt had played a part in preventing safer sex education and thus contributing to the spread of AIDS.

Nan Goldin's series *The Ballad of Sexual Dependency* (1979–2004) deals with gender politics and reveals the lives and loves of a marginal, urban community on the Lower East Side, New York. A collection of 700 slides set to music, it is an intimate visual diary. Images such as *Nan One Month After Being Battered* (opposite) record the abusive relationship between Nan and her boyfriend, Brian. Goldin looks directly into the camera in a close-up portrait, one eye severely bloodshot and bruised. Over the years Goldin has edited the show repeatedly; many friends disappear, often because of AIDS.

Robert Mapplethorpe died in 1989 as a result of complications caused by AIDS and he became a posthumous figurehead of the Culture Wars. A touring exhibition organized in the year before his death, titled 'Robert Mapplethorpe: The Perfect Moment', was intended as a celebration of his oeuvre, above all the precision and deliberation seen in his remarkable portraits of people and flower studies. However, the Corcoran Gallery in Washington cancelled its leg of the show in response to the Republican outcry over the photographer's representation of sadomasochistic practices and homoerotica. One of the most notorious photographs from his sadomasochism period is *Self Portrait* (above right), in which Mapplethorpe leers back at the viewer in a devil-like pose while a bull whip protrudes from his anus and snakes out of the frame.

There have also been calls for government censorship of the work of Chinese painter and performance artist Ma Liuming (b.1969). In China, much performance art centres on the body. This is partly because of the legacy of 1960s conceptualism and partly because nudity in public is an act of defiance of the state. Ma Liuming collaborated with Zhang Huan and Zhu Ming to produce *Fen-Ma Liuming's Lunch 1*. In this performance piece the androgynous-looking artist sat naked at a table in front of a plate of chicken sucking a plastic tube that was attached to his penis. Ma Liuming was arrested and jailed for two months in 1994 by the Beijing police. **GC**

1 | 2

1 *Nan One Month After Being Battered* (1984)
Nan Goldin • silver dye bleach print
15 ½ x 23 ⅛ in | 39 x 59 cm
Museum of Modern Art, New York, USA

2 *Self Portrait* (1978)
Robert Mapplethorpe • silver print
20 x 16 in. | 50.5 x 40.5 cm
Mapplethorpe Foundation,
New York, USA

1989	1990	1990	1993	1994	2008
In November, Nan Goldin curates the show 'Witnesses Against Our Vanishing' at the Artists Space, New York.	Performance artists Karen Finlay, Tim Miller, John Fleck and Holly Hughes have their grants vetoed by the National Endowment for the Arts chairman.	*Tokyo Lucky Hole* by Nobuyoshi Araki (b.1940) is published. It documents lesser known aspects of Tokyo's red light district between 1983 and 1985.	US artist Catherine Opie (b.1961) takes a series of self-portraits representing the struggle of queer subcultures.	Ma Liuming performs *Fen-Ma Liuming's Lunch 1*. The artist is arrested by Beijing police.	The Gao brothers use nudity to demonstrate the importance of the body in political collectivity, for their *Sense of Space* series.

Piss Christ 1987

ANDRES SERRANO b. 1950

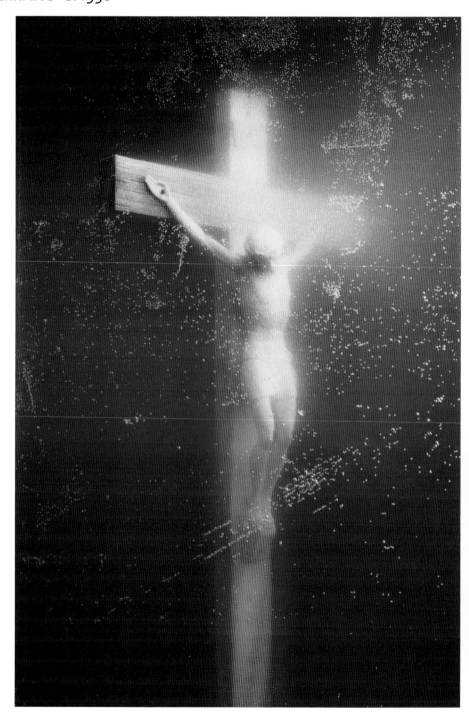

Cibachrome colour print
23 ½ x 16 in. | 60 x 40.5 cm
Walter Otero Gallery, San Juan,
Puerto Rico

Andres Serrano's image of a small crucifix submerged in his own urine is the ultimate piece of shock art. Yet without its provocative title there would be little visual cause for offence. The viewer sees a large glossy print of rich, glowing colours punctuated by small bubbles, as if the crucifix is floating in a distant, harmonious cosmos. Nonetheless, *Piss Christ* has repeatedly been at the centre of controversy.

The image was first shown at the Stux Gallery in New York without criticism in 1989, and was selected to appear in the travelling exhibition 'Awards in the Visual Arts 7'. However, when it was discovered that Serrano had received US$15,000 from the National Endowment for the Arts, a crisis arose that culminated in US Senator Alfonse D'Amato tearing up a copy of the image in the chamber of the US Senate. The picture was then vandalized in Australia in 1997, a copy was destroyed by Neo-Nazis in Sweden in 2007, and it was slashed by Catholic protesters in France in 2011. Ironically, Serrano has claimed that his aim was not to denigrate religion but to highlight the cheapening of religious icons and illustrate the true value of faith at a time of darkness, when the fear of AIDS was at its height. Like the Spanish Old Master Francisco de Goya, Serrano presents an image that is disturbing in the face of death, and by creating a transgressive image he prompts viewers to think more about the true meaning of the crucifixion scene. **CK**

✴ NAVIGATOR

👁 FOCAL POINTS

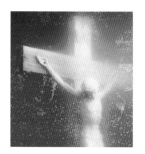

1 CRUCIFIX

By submerging a model of the crucifix in urine, Serrano both softens detail and diffuses light, simultaneously obscuring and drawing attention to the scene. In this way he is suggesting that traditional religious iconography has become trivialized by its commercialization for profit.

2 YELLOW COLOUR

The image glows with a yellow light as though the crucifix is surrounded by a golden halo. In Christian iconography a halo symbolizes the light of divine grace suffusing the soul. Serrano is suggesting that even drenched in urine the crucifix represents the 'light of the world'.

3 BUBBLES
The bubbles in the urine make it look as though the crucifix scene is encased in amber, like an ancient, resin-preserved fossil. Serrano created this image when bodily fluids were also being used by photographer Robert Mapplethorpe and sculptor Marc Quinn.

4 RED AND ORANGE COLOURS
The red and orange colours are reminiscent of blood and fire. Within religious painting traditions, blood references the blood of the Passion of Christ—the biblical account of Jesus's arrest, trial and suffering to redeem humanity from sin—while fire represents the Holy Spirit and rebirth.

🕐 PHOTOGRAPHER PROFILE

1950–66
Born in Brooklyn, New York, Andres Serrano was raised as a strict Catholic. He developed an interest in Renaissance painting and religious iconography as a child.

1967–86
Serrano studied at the Brooklyn Museum Art School from 1967 to 1969. He went on to work as an assistant art director at an advertising firm, where he became interested in photography.

1987–91
From 1987 to 1990, Serrano created the *Bodily Fluids* series using blood, urine, milk and semen; its best-known image is *Piss Christ*. He then created *Nomads*, which portrays homeless people photographed in an improvised studio in the New York subway.

1992–PRESENT
Serrano chose to court rather than eschew controversy. His *Morgue* series (1992) shows dead bodies mutilated or in decay; his *Shit* pictures (2008) are large-scale abstractions of mainly animal faeces; and his exhibition 'Holy Works' (2011) reinterprets medieval and Renaissance religious paintings.

THE DÜSSELDORF SCHOOL

In the 1980s a group of German photographers appeared on the international art scene. They had all learnt their craft at the Kunstakademie (arts academy) in Düsseldorf and were students of Bernd Becher (1931–2007). Together with his wife, Hilla (b.1934), Bernd established a highly sophisticated and recognizable photographic language. In 1959 the artist couple started to photograph the industrial architecture of their immediate environment (see p.402). With a large-format camera, they pictured structures such as water towers in a standardized mode of their own devising in front of a plain grey sky and almost invariably in full frontality. The label 'Düsseldorf School' is usually attributed to five of their earliest students: Candida Höfer (b.1944), Axel Hütte (b.1951), Thomas Struth (b.1954), Andreas Gursky (b.1955) and Thomas Ruff (b.1958). Although all of them have developed their own distinctive artistic language, they share a preference for colour prints, large-format cameras and objective points of view.

Like his fellow students, Struth is interested in photography as an original artistic medium. In his series *Museum Photographs*, taken in some of the most renowned art institutions around the globe, he puts his own work in the context of pictorial tradition. The series focuses on the dialogue between artwork and

KEY EVENTS

1975	1976	1981	1986	1986	1988
Bernd and Hilla Becher take part in 'New Topographics' at the International Museum of Photography at George Eastman House in Rochester, New York.	Bernd Becher is appointed a professor of the photography department at the Kunstakademie in Düsseldorf.	Andreas Gursky, Axel Hütte and Thomas Ruff set up a colour laboratory in a disused power station in Düsseldorf.	Ruff enlarges his portraits to more than life size for the first time, setting the mode for the rest of the Düsseldorf School.	The meltdown of the nuclear reactor in Chernobyl, Ukraine triggers one of the first global environmental catastrophes.	Candida Höfer, Gursky, Hütte, Ruff and Struth appear in the exhibition 'Klasse Bernd Becher' at the Galerie Johnen & Schöttle, Cologne.

440 POSTMODERNISM TO GLOBALIZATION 1977–PRESENT

spectator, reflecting on perception and the museum as a space of social and cultural interaction. In *National Gallery I, London* (opposite) Struth extends the composition of Cima's altarpiece *The Incredulity of Saint Thomas* (c. 1502–04) into the gallery space. The girl in the blue jacket, who leans over the cordon to examine the painting more closely, bridges the gap between painted and photographic reality, and the colours of the visitors' clothes echo the robes of the disciples.

In turn, the photographs produced by Gursky, such as *Paris, Montparnasse* (1993; see p.442), have frequently provoked comparisons to painting because of their enormous size, complex compositions and use of colour. Gursky abandoned the seriality of his teachers early in his career and focused on the single work, which he approaches with equal thoroughness. His recurring topics are the emblems of a globalized Western culture. The human element in Gursky's photographs is usually reduced to a tiny figure, dwarfed by a sublime landscape, huge architectural structure or a vast, anonymous crowd of people.

The work of Höfer deals with public space. Since her student years, she has photographed the interiors of cultural and educational institutions such as museums, libraries and theatres. *Trinity College Library Dublin I 2004* (below) exemplifies her interest in the architectural structuring of knowledge and the way it is displayed. In her dedication to a single topic, Höfer follows in the footsteps of her teachers, although she does not limit herself to a predetermined perspective but rather reacts to the particularities of the individual space. **FK**

1 *National Gallery I, London* (1989)
Thomas Struth • chromogenic colour print
72 ¼ x 78 ½ in. | 183.5 x 199.5 cm
Tate Collection, London, UK

2 *Trinity College Library Dublin I 2004* (2004)
Candida Höfer • chromogenic colour print
59 ⅞ x 70 ⅛ in. | 152 x 178 cm

1989	1996	2000	2000	2001	2007
The fall of the Berlin Wall leads to the reunification of the two German states in 1990 after more than forty-one years of separation.	Bernd Becher retires from his position as a professor at the Kunstakademie in Düsseldorf.	Ruff succeeds Bernd Becher and begins to teach photography classes at Düsseldorf's Kunstakademie.	The New Economy crashes when the dot-com bubble bursts, pushing the world's financial markets into crisis.	New York's Museum of Modern Art holds a solo show of Gursky's work, 'Andreas Gursky'.	Bernd Becher dies in Rostock, Mecklenburg-Vorpommern, Germany.

Paris, Montparnasse 1993

ANDREAS GURSKY b. 1955

Chromogenic colour print
on paper on perspex
52 ⅛ x 125 ⅝ in. | 134 x 319 cm
Tate Collection, London, UK

NAVIGATOR

This image offers an overwhelming view of a large housing block in the 14th *arrondissement* (administrative district) of Paris, designed in the spirit of Le Corbusier by French architect Jean Dubuisson. Completed in 1964, it was part of the urban renovation campaign 'Maine-Montparnasse', which aimed to catapult the old quarter into modernity. *Paris, Montparnasse* was Gursky's largest print at the time. It is also the first picture that he exhibited in which he used digital montage to implement his artistic vision, a technique that has been a pivotal means in his work ever since. Because the building was too big to fit into one frame without major contortions, Gursky took two shots from different points of view and digitally merged the images into a panoramic facade. As a side effect of this process, the picture gains sharpness in the details. Another effect of the montage technique is that the undistorted, wide-angled picture lacks any indication of the camera's standpoint. The unusual perspective contributes to the impression of detached, almost clinical objectivity that the picture evokes. *Paris, Montparnasse* comprises several of the main topics that Gursky has used throughout his career: the relationship of mass and the individual, the aesthetic contrast between an almost painterly all-over composition and the minute details afforded by his photographic method, as well as the interest in the manifestations of a globalized culture, embodied here in the international style of a mass housing unit. **FK**

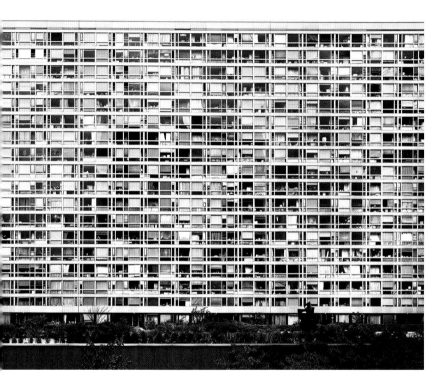

🕐 PHOTOGRAPHER PROFILE

1955–77
Andreas Gursky was born in the East German town of Leipzig but grew up in Düsseldorf. His father, Willy Gursky, worked as a commercial photographer.

1978–87
Gursky took up photographic studies at the Folkwangschule, Essen, a leading photography school influenced by the aesthetic of Otto Steinert (1915–78), the doyen of subjective photography. Gursky tried to start a career in photojournalism but was unsuccessful. He was admitted to join the class of Bernd Becher at the Kunstakademie in Düsseldorf in 1981 and he studied there until 1987.

1988–PRESENT
After finishing his studies, Gursky continued to develop a highly independent photographic language that brought him critical acclaim. In the late 1980s he started enlarging his photographs to the mural-size formats for which he is best known. In 1992 he began to discover the possibilities that digital technology offers for his photographic compositions and has worked with it ever since.

1 ABSTRACTION
Seen from a distance the image dissolves into abstraction. The grid of apartments with their coloured curtains and blinds forms a patchwork pattern. Seen close-up the furniture and fixtures add to this impression: the book shelves in the middle-left section repeat the pattern on a smaller scale.

2 CROP
Despite the huge format of the print, Gursky cropped the edges of the building, making it appear even larger. The architecture could go on beyond the frame of the photograph. In this regard the image owes something to both Abstract Expressionism and Minimalist painting.

DOCUMENTARY

The notion of photographic truth is a rhetorical one. However convincing an image may be, it only communicates a message that is substantiated by a social, political, economic, cultural and editorial context. The growing scepticism in the late 20th century regarding the objectivity of photographic evidence allowed for the acknowledgement of the tension between the camera's neutral recording and the photographer's engagement. In other words, the power held in a photographic representation of reality is inherently dependent upon the strategic visual control that the photographer exerts in encoding the truth into his or her visual message.

Nicaragua, Managua (above) by US photographer Susan Meiselas (b.1948) was taken during a trip in which she documented human rights violations carried out against Sandinista revolutionaries by Anastasio Somoza's dictatorship. The camera's medium to long shot draws the viewer into the heart of a beautiful landscape, where luscious green vegetation, a seductive blue sky and a tranquil sea—framed by soft hills on the horizon—could indicate a glamorous holiday destination. Yet this pleasure is interrupted when, in the lower section of the picture, a decomposing body—half eaten by vultures with scattered limbs next to it—is thrust into view. The sight of the mutilated corpse leads the viewer to seek out the caption that explains the reality beyond the frame: 'Cuesta del Plomo, hillside outside Managua, a well-known site of many assassinations carried out by the National Guard.'

1 *Nicaragua, Managua* (1978)
Susan Meiselas • chromogenic colour print
Magnum Photos

2 *Gold Mine, Serra Pelada, Brazil* (1986)
Sebastião Salgado • silver print

3 *Iran, Tabriz* (1980)
Gilles Peress • silver print
Magnum Photos

KEY EVENTS

1979	1981	1984	1989	1990	1990
Gilles Peress goes to Iran where he focuses on the seizure of the US embassy in Tehran by student proxy groups of the new Iranian regime.	Susan Meiselas's photographs of the revolution in Nicaragua are published in the photobook *Nicaragua 1978–1979*.	Sebastião Salgado spends fifteen months photographing the drought-stricken Sahel region of Africa.	In China the massacre of students advocating for democracy in Tiananmen Square, Beijing is broadcast live on television.	Photojournalism and the media become tightly controlled by the US government during the Gulf War.	Kevin Carter joins forces with three other photojournalists (The Bang Bang Club) to document the violence in South African townships.

Brazilian photographer Sebastião Salgado (b.1944) had been an economist for the International Coffee Organization making field visits to Africa before he switched to becoming a photojournalist and documentarian of the human condition. His *Gold Mine, Serra Pelada, Brazil* (right) is taken from a grand overview vantage point that offsets a densely packed mass of swarming bodies against the depth of an endless pit. Salgado uses black and white in a way that is closer to fine art photography than it is to photojournalism. The contrast between light and darkness, delicately enhanced by a perfectly crafted print, emphasizes the connotations of Serra Pelada with the underworld and the afterlife. Salgado's subjective recording of an almost biblical vision of the exploitation of man by man demonstrates that aesthetics and political issues can coexist.

During a five-week period from December 1979 to January 1980, French war photographer Gilles Peress (b.1946) recorded the events that unfolded during the Iranian Revolution. He published his visual accounts in a photobook, *Telex: Iran* (1984). *Iran, Tabriz* (below), which shows a demonstration in favour of the leading opposition figure, Ayatollah Kazem Shariatmadari, was chosen for the book's cover. Shot on a grainy black-and-white film, in accordance with photojournalist practice, Peress's exacting geometric composition produces an image that verges on the cinematic. His choice of landscape format, rigorously divided into four planes with the close-ups and longer shots positioned directly diagonally to one another, defies the conventions of photojournalistic reporting. In the internal space and time of the frame, he projects a filmic scene where everything is in tension. **CF**

1994	1994	2001	2003	2010	2011
Apartheid is abolished in South Africa and Nelson Mandela becomes president of South Africa on 10 May.	Carter collects the Pulitzer Prize for Feature Photography for *Sudan* (1993; see p.446) on 23 May. He commits suicide two months later.	The September 11 attacks take place in the United States. A handful of iconic pictures come to symbolize the tragedy.	The term 'embedded journalism' comes into use as reporters and photographers agree not to report compromising information during the US invasion of Iraq.	Reporters Without Borders reports that the second US war with Iraq has been the most lethal for media professionals since World War II.	Civilians in Tunisia, Egypt and Libya document their rebellion using mobile phones during the Arab Spring.

Sudan 1993
KEVIN CARTER 1960 – 94

1 VULTURE
Looming over the crouched figure, a vulture observes its prey in a sinister pause. The bird's full and heavy coat and erect posture are juxtaposed with the abandoned, malnourished infant only a few feet away. The presence of the vulture acts as a shadow of death in the chilling scenario.

2 ARID FIELD
The scene shows an arid field with primitive straw buildings in southern Sudan. Carter went to the famine-stricken country to photograph the rebels in the civil war, which had begun in 1983. Approximately two million people died as a result of war, famine and disease caused by the conflict.

In an arid landscape devastated by drought, a small malnourished infant—seemingly hunched up in agony and too weak to walk—drags itself across an unforgiving and hardened soil. Nearby, a menacing vulture stands ready and waiting. In Kevin Carter's exacting and lucid composition, the focus is equally divided between the vulture and the child. This sets up the contrast between a predator and its potential victim. The palpable tension that emanates from the photograph is the anticipation of what will happen next.

Sudan epitomizes the struggle for survival of destitute human beings on the brink of death, in a country torn apart by political chaos and assailed by natural disasters. Taken on 1 March 1993 and then published in *The New York Times* on 26 March, it earned Carter a Pulitzer Prize for Feature Photography in 1994. A shocking photograph that came to embody death by starvation in African countries plagued by famine, *Sudan* also became the focus of virulent criticism regarding the ethics of photojournalism after Carter admitted that he did not know what happened to the child. Photographer João Silva (b.1966), who accompanied Carter to Sudan in 1993, claimed later that the child did not fall victim to the vulture. According to his account, the women of the hamlet were nearby receiving food from the United Nations' Operation Lifeline Sudan and Carter chased the bird away. **CF**

Colour print

3 CHILD
The child's head, too big and heavy for its frail body, touches the ground. The small bent leg and abdomen swollen by starvation suggest that it is a life-sapping effort to move. The child's arm barely supports its upper body; it is the last anchor to prevent a total collapse with disastrous consequences.

ART DOCUMENTARY

A rt and documentary may appear to be oppositional terms, but the late 1970s saw radical shifts in the perception and consumption of photography. Coupled with new ways of thinking about visual language, this meant that distinctions between modes of photographic practice were eroded. Changes in film and cameras—from 35mm to medium and large format—and the use of colour introduced alternative ways of looking at the world. Documentary photographers adopted art photography methods of working and contemporary artists began to exploit documentary modes.

In the 1980s British photographer Paul Graham (b.1956) produced inventive work that typifies the fusion of art and documentary that flourished throughout this period. His photobooks *A1—The Great North Road* (1983; see p.452), *Beyond Caring* (1986) and *Troubled Land* (1987) all played a part in reviving documentary photography and interest in the cultures of photography in the United Kingdom and Europe. Graham was working in colour, which at the time was largely rejected by art photographers as brash, unreliable and lacking in subjectivity. However, he harnessed colour to make powerful photographs that work on aesthetic and social documentary levels.

KEY EVENTS

1976	1981	1981	1982	1985	1986
William Eggleston (b.1939) has the first solo show of colour photography at New York's Museum of Modern Art.	*The New Color Photography* by critic Sally Eauclaire is published.	An edited version of the hugely influential exhibition 'New Topographics' opens at the Arnolfini gallery in Bristol, England.	*Uncommon Places* by Stephen Shore (b.1947) is published. It proves as influential as *William Eggleston's Guide* (1976) on art documentary photography.	'Another Country', a joint exhibition by Chris Killip and Graham Smith, opens at the Serpentine Gallery in London and then tours.	*The Last Resort* by Martin Parr is published and an exhibition of the same name opens at the Serpentine Gallery.

British photographer Chris Killip (b.1946) used a large-format camera when he began to photograph the people and landscapes of his homeland, the Isle of Man in 1969, documenting the disappearing traditional lifestyles of the islanders. In 1975 he moved to live in Newcastle-upon-Tyne on a two-year fellowship from Northern Arts. There he began to photograph the north-east of England, producing photographs such as *Alice and Her Dog* (opposite) that are motivated by deep personal and political conviction. He continued the project into the early 1980s. It documents the effects of declining traditional industries on communities that were bound together by them, and movingly conveys the consequent loss of hope and purpose.

Killip and his friend Graham Smith (b.1947), who also used a large-format camera, were associated with founding Newcastle-upon-Tyne's Side Gallery. Smith photographed working-class communities and heavy industry around his home town of Middlesbrough on England's north-east coast. *Thirty Eight Bastard Years on the Furnace Front* (below) portrays a man who is wondering where the years have gone. Often Smith's photographs were an intimate response to particular public houses he used over many years which, for some, functioned as community centres or places of refuge from desperate situations. Killip and Smith showed their work in a joint exhibition 'Another Country' at London's Serpentine Gallery in 1985. It was well received but had detractors; this was

1 *Alice and Her Dog* (1982)
Chris Killip • silver print
16 x 19 ⅜ in. | 40.5 x 49 cm
Eric Franck Fine Art, London, UK

2 *Thirty Eight Bastard Years on the Furnace Front. Furnace Keeper. Mess Room for Number 5 Furnace, Clay Lane, South Bank, Middlesbrough* (1983)
Graham Smith • silver print
16 x 19 ⅞ in. | 40.5 x 50.5 cm
Eric Franck Fine Art, London, UK

1988	1988	1994	1997	2004	2004
Killip publishes *In Flagrante*. The book's release is accompanied by an exhibition of his work at the Victoria and Albert Museum in London.	The Victoria and Albert Museum's 'Towards a Bigger Picture: Contemporary British Photography' presents documentary works in a fine art context.	French photographer Luc Delahaye joins Magnum Photos as a nominee and *Newsweek* magazine as a contract photographer.	Boris Mikhailov begins photographing Ukraine's homeless for his series *Case History*.	Alec Soth publishes his monograph *Sleeping by the Mississippi* to critical acclaim. It is based on a 'road trip' along the famous river.	Curator Charlotte Cotton's book *The Photograph as Contemporary Art* maps out new territories for photography.

3 From *Workstations* (1988)
Anna Fox • matt light jet archival print
21 ½ x 24 in. | 54.5 x 70 cm
James Hyman Gallery, London, UK

4 *Untitled* from *Case History* (1997–98)
Boris Mikhailov • chromogenic
colour print
58 ½ x 39 ⅛ in. | 148.5 x 99.5 cm
Museum of Modern Art, New York, USA

5 *Taliban* (2001)
Luc Delahaye • chromogenic colour print
45 ¾ x 95 ⅜ in. | 116 x 242 cm
Los Angeles County Museum of Art,
California, USA

partly because the rapid emergence of colour meant that their black-and-white photographs appeared dated, and partly because their work was perceived as exploiting its subjects, despite the opposite being the case. However, Killip recognized the opportunities that might exist to realize a wider audience for his photographs. Much of his work that appeared in 'Another Country' was published as *In Flagrante* in 1988, which has become one of the most important photobooks of the 1980s. Concerned about an unspoken trust from those he portrayed and relentless press abuse of his more intimate pictures, Smith stopped taking photographs in 1990 and rarely exhibits or publishes his work.

It was the use of colour that marked a real turning point in documentary photography. The publication in 1986 of *The Last Resort* (see p.454) by British photographer Martin Parr (b.1952) and an exhibition held in the same year of the series of photographs featured in it saw a seismic shift in the perceptions of documentary. Before *The Last Resort*, Parr had been working in black and white, in a broadly humanist and humorous way that drew heavily on the work of British photographer Tony Ray-Jones (1941–72). He had also worked as a Butlin's holiday camp photographer, taking pictures in colour. His experience influenced the photographs he took for *The Last Resort*, which document daytrippers at the run-down seaside resort of New Brighton on the Wirral Peninsula, near Liverpool. Where Graham's colour is subtle, Parr's fizzes and burns under harsh flash and overexposure, recreating the heat and energy of an English day out in the sun. Suddenly, despite the controversy of using colour photography in this way, black and white seemed passé.

Influenced by the British documentary tradition, Anna Fox (b.1961) produced *Workstations* (1987–88), a series of colour photographs that offers a critical view of the highly competitive world of London office life in Thatcherite Britain. Her photographs are accompanied by wry captions such as 'Fortunes are being made that are in line with the dreams of avarice' (above). Harsh and unforgiving in the gaze of full flash, her photographs reflect the way that the government was restructuring the United Kingdom. Published and exhibited by the magazine *Camerawork* in London in 1988, the series makes an important contribution to understanding changes in documentary photography, as well as political engagement and critical resistance through arts practice.

By the 1990s the artificial distinctions that had defined much of photography until the late 1970s were beginning to relax. Work was seen and considered for what it was. Curators and publishers embraced documentary modes and collectors were actively acquiring new art documentary photography. Nevertheless, work was still emerging that challenged perceptions about the way photographs were made and the audiences for which they were intended. The practice of Ukrainian photographer Boris Mikhailov (b.1938) is astonishingly diverse and includes hand-coloured and tinted photographs. He is best known for his series *Case History* (1997–98), which depicts the social disintegration after the break-up of the Soviet Union. It constitutes a distressing portrayal of homeless people in the Ukraine in the 1990s (right). Moved by the abject conditions in which they were living, and with an unflinching eye, he collaborated with his subjects to recreate scenes from their own histories or Christian iconography. Mikhailov sometimes paid his subjects to undress in order to photograph the effects of poverty on their bodies. A collection of 400 photographs, the series is compelling in its grim portrayal of a disenfranchised people. The tensions between Mikhailov's emotional detachment and his declared closeness to his subjects are difficult to reconcile, and have led to accusations of the work being voyeuristic. The series is, however, an embodiment of Mikhailov's own horror at his subjects' plight and a highly original addition to the photography canon. Despite Mikhailov's interventions, *Case History* is close to many documentary traditions.

Since 2000 the specificities of photography have become increasingly blurred. The work of US photographer Alec Soth (b.1969) straddles genres and references the use of colour and composition. *History* (2001–) by French photographer Luc Delahaye (b.1962) is, like his other works, massive both in scale and ambition, showing architecture, landscape and people. To describe such works as belonging to one specific genre rather than another does a disservice to both the photographer and photography. Delahaye's work presents global events, including political demonstrations, natural disasters and evidence of war and genocides as painterly panoramas, as seen in *Taliban* (below). As histories of photography are thoroughly investigated, genres redefined and overlooked works brought to the fore, the hugely significant contribution of the various documentary traditions to creative contemporary art photography will be rightfully acknowledged. **GH**

Burning Fields, Melmerby, North Yorkshire 1981
PAUL GRAHAM b. 1956

1 HOTEL SIGN

The hotel sign is enigmatic, and despite the picture's lack of information, it offers layers of possible narratives. Does the hotel itself still exist or is the sign all that is left from a demolished building? The sign adds tension, destabilizing the aesthetics created by the balanced composition.

2 FIRE

The orange of the fire divides the frame and enlivens the photograph. It also adds a layer of narrative. The destructive power of fire is understood; that it appears unattended makes it seem potentially threatening, or even a portent that something more unpleasant awaits.

Chromogenic colour print
7 ⅞ x 9 ⅝ in. | 19.5 x 24.3 cm
Museum of Modern Art, New York, USA

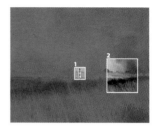

Paul Graham was one of the first British documentary photographers to make a considered and deliberate decision to work in colour with large- and medium-format cameras. His landmark works of the 1980s had a transformative effect on the black-and-white tradition that had dominated photography practice in the United Kingdom, and were influential on a new generation of photographers.

The photobook *A1—The Great North Road* (1983), in which *Burning Fields, Melmerby, North Yorkshire* appears, was the first of three major works that Graham produced during the 1980s. It resulted from various trips made along the length of Britain's longest numbered road, and is remarkable in its intelligence and breadth of vision. Graham combines landscapes and portraits to create a melancholic view of a country poised on the brink of the divisive social change resulting from Margaret Thatcher's period as prime minister. The photographs are typically restrained and have a real sense of Graham having had a preconceived vision of the way he wanted the images to look. They have an air of coolness about them that is reminiscent of the work of US photographer Robert Adams (b.1937) in the early 1970s. In *Burning Fields, Melmerby, North Yorkshire* the palette is muted and painterly. A bleak landscape is rendered sublime by the subtle gradations of colour and tone. Like Adams, Graham makes a visually arresting photograph from an apparently banal event.

The *A1* series was envisaged as a book and this can be seen in the consistency of the images. They function both individually and as a coherent whole: a position that went on to define new approaches in documentary photography. The use of landscape in a project described as documentary was an astute device used by Graham to elevate the work beyond straight social documentary traditions. Graham makes a survey of a place in which the politics of a country are undergoing change; without becoming shackled to a narrative format, the photo-document is carried off with great sensitivity and understanding. **GH**

⏱ PHOTOGRAPHER PROFILE

1956–80
Born in Stafford, England, Paul Graham graduated from Bristol University in 1978. He had his first solo exhibition, 'House Portraits', in 1980, which featured modern, detached suburban houses.

1981–85
He worked on *A1—The Great North Road* between 1981 and 1982. Graham self-published the series as a limited edition hardback and paperback in 1983, breaking new ground in British photography.

1986–91
In 1986 Graham published *Beyond Caring*, a response to the effects of unemployment in Britain. He then visited Northern Ireland to investigate the manifestations of political tension in the landscape and published *Troubled Land* (1987).

1992–2002
Graham's work took on an international perspective and became more experimental. *New Europe* (1992) looks at Europe in the aftermath of the fall of the Berlin Wall. *Empty Heaven* (1995) considers the dichotomies between history, tradition and fantasy in Japan.

2003–08
His *American Night* (2003) is a view of social division in US society and *A Shimmer of Possibility* (2007) plays with photography's ability to reflect the passing of time.

2009–PRESENT
In 2009 Graham won the Deutsche Börse Photography Prize. He was the first British winner of the Hasselblad Award in 2012.

New Brighton, England 1985

MARTIN PARR b. 1952

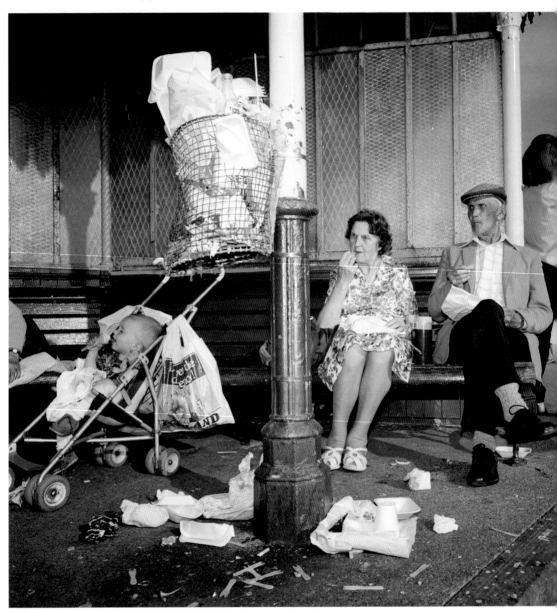

1 LITTER BIN
An overflowing litter bin dominates the composition. Although this draws attention to the shabby condition of the declining coastal resort of New Brighton, Parr's image—with people seen enjoying their day out—also demonstrates that it remains vibrant and popular with the masses.

2 WOMAN POINTING
A woman standing on the right of the photograph is pointing to something beyond the frame. This is an example of Parr's fascination with unconnected narratives. His image is like a 19th-century diorama, brimming with small dramas that invite the viewer to speculate on their outcomes.

Chromogenic colour print
Magnum Photos

✦ NAVIGATOR

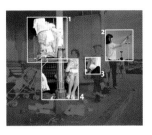

I n 1982 English photographer Martin Parr began photographing in colour and working with a medium-format camera. A shrewd observer, he turned his camera towards the declining coastal resort of New Brighton in Merseyside. His work was published in 1986 in the photobook *The Last Resort*. It marks a shift in British documentary photography and its acceptance as a fine art practice. Parr's use of flash on bright summer days, wide-angle lenses and depth of field lead to a vividly coloured, somewhat harsh picturing of his subject matter. Families playing, eating and sunbathing among their own detritus are depicted in garish detail. His use of colour was controversial because it was regarded as the preserve of editorial and fashion photographers. Parr's depiction of New Brighton holidaymakers was viewed by some as a grotesque and cold satire that ridiculed the working class. However, what might be seen on the one hand as overt snobbery and disdain for the working class could also be read as a genuinely affectionate interest in people, their lives and the unconscious, unpretentious ways those lives are played out in the public view. In this respect, Parr's *The Last Resort*, while not necessarily sensitive, is sincere both in its representation of its subjects and in its exploration of the possibilities of photography. **GH**

⏲ PHOTOGRAPHER PROFILE

1952–73
Martin Parr was born in Epsom, Surrey. He studied photography at Manchester Polytechnic. While a student he spent a summer working as a photographer at Butlin's holiday camp in Filey, North Yorkshire, where he developed an interest in the postcard photography of John Hynde (1916–98).

1974–85
Parr lived in Hebden Bridge in West Yorkshire. His work took on a more narrative edge and his wry social observations became more apparent. In 1982 he moved to Wallasey in Merseyside and began to work in colour.

1986–87
He published *The Last Resort* in 1986 and the same year exhibited at London's Serpentine Gallery.

1988–2003
Parr joined the Magnum Photos photographic agency in 1988 and became a full member in 1994. In 2002 he published his monograph, *Martin Parr*; the same year a retrospective of his work opened at the Barbican Art Gallery in London and then toured Europe for the next five years.

2004–07
In 2004 Parr was appointed professor of photography at the University of Wales. The same year he was guest artistic director for the 'Rencontres de la Photographie' photography festival in Arles, France. In 2006 Parr won the Erich Salomon Prize.

2008–PRESENT
The exhibition 'Parrworld' opened at Haus der Kunst, Munich in 2008; it toured Europe for two years.

3 FISH AND CHIPS
For Parr, the consumption of fish and chips outdoors is an identifiable northern, working-class pastime. Fish and chips, the resulting litter and the shops where they are sold serve both as an affectionate tribute to his early memories and as recurring signifiers for greed and a lack of concern for social graces.

4 RED
Parr pushes colour photography to its limit in *The Last Resort*. Red features often, as seen in the iron post in the foreground and the seating in the background. It feels almost hot in the pictures, as if Parr is using it as a metaphor for the sunburnt skin of the New Brighton daytrippers.

EVIDENCE, TESTIMONY AND CRITIQUE

As an instrument of investigation and exposure, photography has long tackled subjects of conflict, poverty and oppression. Although the claim that the photographic document provides a straight and objective record of reality had been challenged for many decades, during the postmodern era it was subjected to sustained interrogation. The impossibility of truth has been examined by artists such as Victor Burgin (b.1941), with pieces such as *Possession* (1976; see p.460) that combine image and text to illustrate how meaning is constructed. However, given the central position of documentary modes in art and visual culture since the 1970s it seems that such tensions have served to increase the attraction of the medium to artists. The camera's capacity to critique social realities is as strong as ever.

Since 1979 Chilean artist Lotty Rosenfeld (b.1943) has staged disruptive interventions into public spaces. In *A Mile of Crosses on the Pavement* (above) she glued white cloth bandages across the road markings on a major traffic artery in Santiago de Chile, altering the lane dividers to create a series of positive plus signs. Although Rosenfeld has since repeated this action in cities across the globe, it held particular significance when first performed under General Augusto Pinochet's military dictatorship. Interfering with symbols that regulate movement, her street works were an attempt to create a rupture in

the illusion of a rational social order that was in reality founded on violence. In this work, photography plays a secondary, functional role as a means by which to document fleeting gestures of resistance. Like many other artists who produce ephemeral or site-specific works, she orientates the viewer towards the action depicted rather than the image as object. Yet Rosenfeld's photodocuments play a paradoxical role, communicating her critical urban interventions to a wider audience while undermining her attempt to evade the commodifying structures of the art world by reclaiming them for the gallery space.

Picturing trauma raises many issues regarding the truth value of photography. The Photo Archive Group was founded in 1994 by two US photojournalists, Chris Riley (b.1966) and Doug Niven (b.1962), as a response to the collection of identification photographs they encountered in a filing cabinet in Cambodia's Tuol Sleng Museum of Genocide. Under the regime of Saloth Sar (aka Pol Pot), the museum building had operated as 'S-21', a brutal secret prison where thousands of men, women and children were incarcerated, tortured and executed between 1975 and 1979. Each prisoner was photographed upon arrival (below).

1 *A Mile of Crosses on the Pavement* performed by Lotty Rosenfeld in front of the Presidential Palace, La Moneda, Santiago de Chile in 1985.

2 *Unknown Inmate at S-21 Prison in Phnom Penh, Cambodia* (1975–79)
Photographer unknown • silver print
10 x 10 in. | 25.5 x 25.5 cm
Tuol Sleng Museum of Genocide, Phnom Penh, Cambodia / Photo Archive Group

Set up to fund and coordinate the cleaning, developing and cataloguing of the 6,000 negatives that survived, the Photo Archive Group selected one hundred prints to print, publish and exhibit. The exhibition of the enlarged and framed photographs raises questions regarding authorship and the ethics of display. Originally taken by members of the Khmer Rouge authorities to provide evidence that 'traitors' were being eradicated successfully, their recovery and dissemination has transformed them into a mute testimony to the catalogue of horrors that lies beneath the surface of the images.

The Atlas Group adopts a different approach to the authority of the archive, playing upon the viewer's desire to invest the photograph with evidential value by creating false images and documents. Its website claims that the project was established in 1999 'to research and document the contemporary history of Lebanon', particularly focusing on the period of the Lebanese Civil War that began in 1975 and consumed the country for fifteen years. The group's archives are said to contain an immense collection of documentary items, ranging from photography and video recordings to audio files, notebooks and literary materials.

The Atlas Group, however, is an imaginary foundation invented by Lebanese-born Walid Raad (b.1967). Although the rhetoric of the archive is adopted, its purported holdings are caught in a strange limbo between fact and fiction. Strange slippages in dates and attribution occur frequently; some of the written statements that accompany the series of photographs *We Decided To Let Them Say 'We Are Convinced' Twice. It Was More Convincing This Way* (2002–06) attribute them to a man named Marwan Hanna when he was thirteen years old; others state that they were produced by Raad during an excursion with his mother when he was fifteen. *Beirut '82, City V* (opposite) is said to depict the skyline of the west of the city under Israeli attack. While the overexposure and scratches on the surface of the image add to the sense of authenticity, the accompanying captions insist that the works are fabrications. By approaching Lebanese contemporary history through absurdist fable and fake accounts, Raad seeks to move beyond the rational surface to excavate the psychological effects of war. In this performative archive the imaginative and the irrational are presented as equally constitutive of a history that is under development as he prompts the viewer to question memory, news coverage and historic accounts.

3 *Real Pictures* (1995)
Alfredo Jaar • archival photographic boxes with silkscreen text, each containing Cibachrome photographs
Dimensions variable • Installation view
Museum of Contemporary Photography, Chicago, USA

4 *Joseline Ingabire with her daughter Leah Batamuliza, Rwanda* (2007)
Jonathan Torgovnik • colour print

5 *Beirut '82, City V* (2005)
Walid Raad • digital print
43 ¼ x 67 ⅜ in. | 110 x 171 cm
Sfeir-Semier Gallery, Beirut, Lebanon

These two projects braid together photographs with narrative to engage with the legacy of trauma. The mediating structure of the archive encourages a reflective, exploratory approach to the material and the documents picture atrocity and conflict at a distance, relying on the accompanying story to sharpen the viewer's awareness and understanding. Such an aversion to graphic imagery is common to many art projects that bear witness to disturbing historical events. The photobook *Intended Consequences: Rwandan Children Born of Rape* (2009), produced by Israeli photojournalist Jonathan Torgovnik (b.1969), deals with the aftermath of the Rwandan genocide in 1994. It presents a series of carefully composed portraits depicting Tutsi women with their children who were born as a consequence of rape by Hutu militiamen (right). Each image is presented together with a transcribed interview with the mother: a survivor testimony. The project was used both to raise awareness of the issues involved and secure funds for the education of the children affected.

In contrast to Torgovnik's deferred strategy, Chilean artist Alfredo Jaar (b.1956) travelled to Rwanda in the weeks immediately after the end of the genocide to gather evidence and to counter the Western media's lack of coverage. His installation *Real Pictures* (opposite) is one of a number of works forming the six-year *Rwanda Project* (1994–2000), which attempts to make sense of 'the massacre of one million people in the face of the world's indifference'. In this piece, photographs of corpses, refugee camps and destroyed cities have been sealed into one hundred black archival boxes, each of which is embossed with a descriptive commentary on the image together with the location, time and date it was shot printed on the lid. Set out in grids and stacks on the gallery floor, *Real Pictures* underlines not only the limits of representation but also the fundamental distrust of the image as testimony.

Argentinian photographer Marcelo Brodsky (b.1954) chose to explore the effects of dictatorship on his native country through his own family album. In the process he created highly personal memory works such as *Good Memory, The Classmates* (1996; see p.462), in which he examines the fate of pupils in his high-school class of 1967. **KL**

Possession 1976

VICTOR BURGIN b. 1941

Duotone lithograph
46 ¼ x 33 ⅛ in. | 119 x 84 cm
British Council Collection,
London, UK

A pioneer of Conceptual art, English artist Victor Burgin has engaged with photography through his artistic practice and theoretical writings. Rejecting the idea that art should be kept separate from the everyday social world, he sees photography as the means to conduct critical interventions effectively. Using strategies of appropriation and provocative interruption reminiscent of photomontage techniques, Burgin exposes the gap between the glamorous world presented in the advert and the social realities of capitalism. Burgin's practice engages directly with the politics of representation. He argues that if advertising and photography play a central role in the maintenance and reproduction of the dominant ideology, they must be analysed and deconstructed: whether verbal or visual, no representation is neutral. In *Possession* Burgin adopted the style and techniques of advertising. First commissioned as a poster for an exhibition at the Fruitmarket Gallery in Edinburgh, 500 copies of *Possession* were later fly-posted around the city centre of Newcastle-upon-Tyne in 1976. As it was intended for display on the street, Burgin made the poster eye-catching, using a familiar type of advertising image and mode of address so that passers-by could read it quickly. Using the image Burgin directs attention to the processes of seeing and interpretation, encouraging viewers to examine how meaning is constructed. **KL**

◈ NAVIGATOR

◉ FOCAL POINTS

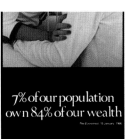

1 QUESTION

The question is directed to the 'consumer' of the image. Burgin emphasizes the role of the viewer, explicitly placing him or her at the centre of the production of meaning. He believes art is an area of social activity where the attitude of critical engagement should be encouraged.

2 COUPLE

Burgin places a glossy photograph of an affluent, attractive man and woman locked in an embrace beneath the question: 'What does possession mean to you?' The image leads the viewer to associate the word 'possession' with romantic desire and sexual domination.

3 STATEMENT

The statement '7% of our population own 84% of our wealth' is placed beneath the photograph. This statistic is taken from *The Economist* magazine. It directs the viewer to the alternative monetary meaning of the word 'possession'—to the 'haves' and 'have nots'.

◷ PHOTOGRAPHER PROFILE

1941–67

Victor Burgin was born in Sheffield, England. He studied painting at London's Royal College of Art from 1961 to 1965. He then travelled to the United States to continue his studies at Yale University, where he was taught by Donald Judd, Robert Morris, Frank Stella and Ad Reinhard. In 1967 Burgin began teaching at Trent Polytechnic in Nottingham.

1968–79

Burgin came to prominence as a Conceptual artist in the late 1960s and combined documentary-style imagery with texts in the manner of advertisements from magazines. In 1969 he exhibited *Photopath* (1967), a photograph of a floor printed to its actual size and stapled to the floor, in the groundbreaking exhibition 'When Attitudes Become Form' at the Institute of Contemporary Arts in London.

1980–85

From the early 1980s Burgin's work explored the Freudian themes of coincidence, doubling, loss and desire, with references to fetishism and voyeurism. In 1982 he published *Thinking Photography*, a collection of essays by writers including himself, Walter Benjamin, Umberto Eco, Allan Sekula and John Tagg. In the book he sought to make a distinction between photography criticism and theory.

1986–2001

In 1986 Burgin made a series of photographic works based on Edward Hopper's painting *Office at Night* (1940), featuring a female secretary and male boss. The same year he was nominated for the Turner Prize. In the 1990s he began working with digital video.

2002–PRESENT

In 2002 Burgin had a solo show at the Arnolfini gallery in Bristol. It included his video installation, *Listen to Britain*, named after a Humphrey Jennings wartime propaganda film of 1942, which blends film clips, music, news footage and text.

Good Memory, The Classmates 1996
MARCELO BRODSKY b. 1954

1 COLOUR ANNOTATIONS
The use of bold and bright colours for the handwritten annotations triggers associations with children's games and colouring books rather than official record-keeping. The effect is that the viewer conflates youthful innocence with adult futures sadly unrealized.

2 MARTÍN BERCOVICH
Brodsky's notes are highly personal reflections that make the classmates shown into real, accessible people. The artist sits next to a friend; here the text reads: 'Martín was the first one to be taken away. He didn't get to know his son, Pablo who is twenty-years-old now. He was my friend. The best.'

Marcelo Brodsky's 'Good Memory' project centres on Argentina's Dirty War during which the state systematically tortured and executed thousands of its citizens, who became known as the *desaparecidos* (disappeared). Led by General Jorge Rafael Videla, a military dictatorship took power in 1976 and maintained its oppressive rule until 1983. Returning from exile in Spain to his homeland at the age of forty, Brodsky used his family photographs as a starting point for a body of work that seeks to communicate the trauma of the experience and create a 'memory bridge' for new generations. This work is a large-scale reproduction of his class photograph taken at the Colegio Nacional de Buenos Aires in 1967. On to the surface Brodsky has inscribed marks and notes in bright colours detailing the fate of his classmates; while some had married or emigrated, a number were 'disappeared'. The wider project of which this work is a part continues this process of reframing existing material. Other works in the series use snapshots from the artist's family album to focus on his 'disappeared' younger brother, Fernando, who was taken from his home in 1979 at the age of twenty-two. By pressing the past against the present these works force the 'ghostly' figures pictured to anticipate their own futures. Brodsky's project offers a subjective narrative in which the photograph acts as a memorial. By transposing familiar vernacular materials and personal testimony into the public sphere he provides an opportunity for others to identify with and understand distant events. He explores the capacity of photography to provide a site of mediation between collective histories and private memory. **KL**

Digital print/Altered gigantograph
68 ⅛ x 45 ⅝ in. | 175 x 116 cm
Museo Nacional de Bellas Artes, Buenos Aires, Argentina

3 SIGN
The sign identifies this as a typical class photograph. It is a found image taken from the artist's archive. By using a vernacular image with such a commonplace reference, Brodsky makes it easier for the viewer to identify with the post-traumatic narrative he builds around the image.

PORTRAITS AND SELF-PORTRAITS

1 **9 Part Self-portrait** (1987)
Chuck Close · collage of large-format
Polapan prints

2 **Porträt (I. Graw)** (1988)
Thomas Ruff · chromogenic colour print
82 ¾ x 65 in. | 210 x 165 cm
Courtesy David Zwirner, New York, USA

elebrity portraits, such as those by Annie Leibovitz (b.1949), who was named the most influential living photographer by *American Photo* magazine in 2005, rely on the idea that they reveal the real person behind the facade. Images such as Leibovitz's candid shots of The Rolling Stones during their tour in 1975 and the photograph *John Lennon and Yoko Ono* (1980; see p.470)—which, in 2005, was named the best magazine cover from the last forty years by the American Society of Magazine Editors—are revered mostly for how much they disclose about their subjects. Likewise, paparazzi

photographs, such as those of a newly bald Britney Spears attacking the press in 2007, rely for their effectiveness on the idea of access to the 'real' self behind the public persona. However, scholars have been challenging the notion of a stable selfhood since the early 20th century and, by the end of that century, the idea of an authentic, unified self was under full-scale attack—denounced as an ideological construct and replaced by the idea of multiple, shifting, fictionalized selves. Contemporary portraiture and self-portraiture, as found in photography destined for the gallery wall, tend to oscillate between these two standpoints.

Traditional self-portraits often reinscribe the salutary fiction of a coherent ego. However, in the work of photographer Francesca Woodman (1958–81), who committed suicide aged only twenty-two, the viewer is presented with a form of theatre in which selves constantly fracture and shift as the subject is shown reflected in mirrors, out of focus and partially concealed, such as in her *Self-deceit #1, Rome* (1978; see p.468). It is hard to resist searching for evidence of a troubled mind and clues to her untimely death in her ethereal photographs.

The limits beyond which a face no longer looks like a face—what novelist J. G. Ballard described as the 'tolerances of the human face'—are challenged by the artist Chuck Close (b.1940). Since *Big Self-portrait* (1967–68), Close has used his own image more than any other subject matter. As seen in *9 Part Self-portrait* (opposite), he generally shows his face at rest, deadpan, cropped and decontextualized, but uses different vehicles to do so each time. For example, *9 Part Self-portrait* is a collage made from black-and-white Polaroids, whereas *Big Self-portrait* is acrylic on canvas. In the last forty years, Close has appeared as a sketch made with fingerprints, a pixelated painting, an acrylic grid, a grisaille mosaic of paper pulp, a shimmering daguerreotype and much more. He states, 'The object. . .is not just to make a picture, but to lay bare what a picture is made of.' He also experiments with size: displaying himself both in monumental proportions and in miniature. In *9 Part Self-portrait* he uses Polaroid's large-format 20 x 24-inch (51 x 61-cm) camera and builds a super-sized collage at 70 x 61 inches (178 x 155 cm). Where the Polaroids line up and overlap, they create fissures that rupture and realign the surface. Yet despite Close's attempts to attenuate his faciality, his self-portraits still read as faces: 'The thing that interests me,' he says, 'is. . .how I can present so much flat information and still have it become worked into something which has life experience in it.' Although postmodernist (and modernist) critiques have exposed the notions of photographic reality and physiognomy as highly suspect, Close's work reveals just how impossible it is to shake our human faith in securing meaning and depth from surface.

By contrast, the faces that stare out of the *Portraits* series by Thomas Ruff (b.1958), such as *Porträt (I. Graw)* (right), seem mute, empty, purely

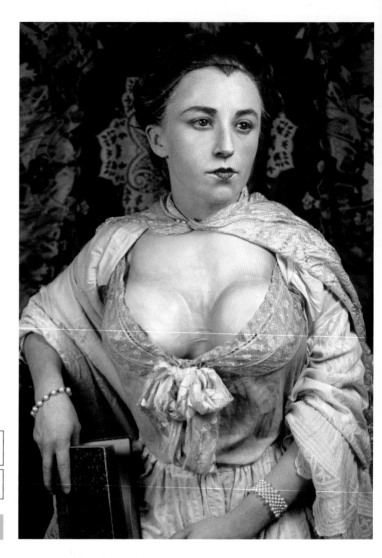

3 *Untitled #183* from *History Portraits*
(1988)
Cindy Sherman • colour print
42 ½ x 28 ½ in. | 108 x 72.5 cm

4 *Autoportait (Benidorm, Spain)* (1997)
Martin Parr • colour print
Magnum Photos

5 *Untitled* from *Citizens* (2001)
Albrecht Tübke • chromogenic
colour print

surface. Ruff says, 'I don't believe in the psychologizing portrait photography that my colleagues do, trying to capture the character with a lot of light and shade. That's absolutely suspect to me.' When Ruff began making the portraits they were only 9 ½ x 7 ⅛ inches (24 x 18 cm), with plain but often coloured backgrounds, showing sitters in various profiles. In 1986, he standardized the series, neutralizing the background to an off-white and making all his sitters sit square on, eyes facing the camera, face in repose. This means that the only differences between the portraits are in the facial detail, yet they do not read like the frank, open faces seen in the work of photographers such as Richard Avedon (1923–2004), who believed in creating 'as truthful and as deep a portrait as is possible to make'. Ruff made monumental prints, with the largest photographic paper he could find: 82 ¾ x 65 inches (210 x 165 cm). Oversizing the images made them appear less like portraits, more like topography—surfaces that refuse physiognomic readings. *Portraits* recalls the words of the surrealist playwright, Antonin Artaud, who in 1925 said, 'Reality is not under the surface.'

Rather than using models to play the many varied protagonists in her images, US photographer Cindy Sherman (b.1954) often staged herself in

them; in fact, few, if any, artists have tried on more faces and personas. She has masqueraded as everything from housewives to Hollywood starlets in her *Untitled Film Stills* series (1977–80)—one example of which is her role as a girl in a library in *Untitled Film Still #13* (1978; see p.422). She has also posed as models from men's magazines in *Centerfolds* (1981); as macabre monsters in *Fairy Tales* (1985); and as the subject of various historical artworks, such as in *Untitled #183* (opposite) from her *History Portraits* series (1989–90). Some photographs within this series directly restage masterpieces such as Raphael's *La Fornarina* (1518–20) or Caravaggio's *Young Sick Bacchus* (1593–94). Most, however, including *Untitled #183*, leave even the cultural cognoscenti guessing. Indeed, when a group of Munich art historians were asked about this particular image they attributed it to four possible great masters. *Untitled #183* shows Sherman awkwardly posed, with conspicuously fake breasts and an exaggerated costume. By exposing the conventions, which were the artifice of these Old Masters, Sherman drained them of their power.

Although Sherman is the subject of her work, it is futile to search for her 'self' within it. Moreover, the notion of self is utterly abandoned in her photography. As feminist critic Judith Butler says, 'The more she pictures herself, the more the idea of the "real" Cindy Sherman recedes like a mirage.' When Sherman modelled for Chuck Close he complained that he could not get a good shot of her until he asked her to perform. He said, 'I realized that's how Cindy always works. She always has to have a role. . . .There is no "real" Cindy in any of that work. She's perhaps the art world's greatest actress.'

British photographer Martin Parr (b.1952) also takes on roles within his own photographs, such as in his *Autoportraits* series (1996–2000). While working on assignments in far-flung places, Parr became intrigued by the images he saw displayed in local photographic studios and decided to put aside being the photographer and become the subject. In *Autoportrait (Benidorm, Spain)* (right), he is captured between the toothy grin of a cardboard shark; in *Autoportrait (Blackpool, England)* (1999) he is encircled by an oversized snake; and in *Autoportrait (Lyons, France)* (1996) he peers out from a fish-bowl astronaut helmet. The only constant is Parr's resolutely deadpan expression. Mouth closed, without a hint of a smile, he appears as the same inscrutable avatar throughout, thereby spotlighting the differences between the ever-more lavish stagings and ever more bizarre props. The series acts as a social study of the artifice of studio portraiture around the world. It mocks the idea of a 'telling' portrait while at the same time exposing our vanity, revealing just how invaluable photography has become in our poignant desire for self-definition.

German photographer Albrecht Tübke (b.1971) explored the notion of self-definition through portraits. In his *Citizens* series (2000–02), in which he photographed strangers whom he encountered on the streets of various cities (right), he explored what he described as 'the boundary between self-portrayal and real identity'. Although fascinated by personal style choices and their impact on the viewer, he withheld any subjective judgement, treating each character equally by using an urban wall as the backdrop and shooting the portrait front-on. Nonetheless, the viewer is left with a strong sense of each person's character, or at least how they choose to portray themselves.

Whether it is Woodman's elusive self-depictions, Sherman's fictitious characters, the myriad facets of Close's countenance Ruff's repetitious typologies, Avedon's individualized portraits, Parr's playfully staged scenes or Tübke's carefully choreographed street shots, each of these practices addresses the idea that the photographic portrait offers more than a mechanical rendering of the exterior self. **JMH**

Self-deceit #1, Rome 1978
FRANCESCA WOODMAN 1958 – 81

Silver print, printed posthumously
10 x 8 in. | 25.5 x 20 cm
The Estate of Francesca Woodman,
George and Betty Woodman and
Victoria Miro, London, UK

This photograph, titled *Self-deceit #1, Rome*, is part of a series of self-portraits titled *Self-deceit* that Woodman made while on a Rhode Island School of Design honours programme in Rome. The title questions the notion of authenticity in the practice of self-portraiture. Indeed much of Woodman's work examines the idea of the self as something performed, rather than revealed. Each image in this series depicts her enacting explorations of a mirror: alone and naked in the same crumbling-walled room, creeping around, standing on or hiding behind the mirror's polished surface. *Self-deceit #1, Rome* is the only image in the series in which she shows her face, yet she only reveals a glimpse of it as a reflection. The way in which she portrays her body is, likewise, ambiguous. Naked but cropped by both the wall and the mirror, its movement means that the camera translates it as a spectral flicker caught between space and time.

We are told that Woodman read Proust. His words from *The Prisoner*, the fifth volume of *In Search of Lost Time* (1923), aptly describe how she appears in the *Self-deceit* series: 'A person, scattered in space and time. . .no longer a woman but a series of events on which we can throw no light, a series of insoluble problems.' Despite the vast number of images of herself that Woodman created (at least 500), she remained unreadable and unknown throughout her short life, more a ghostly apparition than someone real. **JMH**

FOCAL POINTS

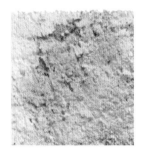

1 DECAYING WALL
The wall, mottled by age, creates an atmosphere of neglect and decay but also a sense of timelessness. Woodman shot the image in the basement of the 15th-century Palazzo Cenci, where the Rhode Island School of Design housed its Rome exchange students.

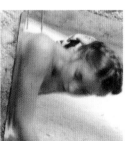

2 REFLECTED FACE
Woodman shows the back of her head and a reflection of her angled face in the mirror. She also moves just as she takes the shot, rendering her face a smudged shadow. This contrasts with traditional self-portraits that show the face to urge the viewer to consider the subject's state of mind.

3 MIRROR
The way in which Woodman carefully crawls around the mirror, not looking directly into it, gives the impression that she is encountering a stranger in her own reflection. This ties in with the psychoanalytical notion of looking in the mirror as the advent of the self as other.

4 HANDS
Woodman's hands are the only part of her body in focus in this image. Consequently the rest of her body appears insubstantial, as if melting into the background. The wall and mirror further fragment this ephemeral apparition. The whole composition conspires to erase her.

PHOTOGRAPHER PROFILE

1958–76
Francesca Woodman was born in Denver, Colorado to Betty and George Woodman, the ceramic artist and painter. At the Rhode Island School of Design in Providence, one of her professors was photographer Aaron Siskind (1903–91).

1977–78
While studying in Rome on a European exchange programme, she discovered the work of André Breton, the Surrealists and the Futurists, and her photography flourished. In March 1978 she was given her first solo exhibition at a small bookshop, Libreria Maldoror.

1979–81
In 1979, she moved to New York. Work was difficult to come by, but she exhibited at the Alternative Museum of New York, was artist-in-residence at the MacDowell Colony in New Hampshire and published *Some Disordered Interior Geometries* (1981). On 19 January 1981, at just twenty-two years old, she committed suicide by jumping from a window on the Lower East Side of Manhattan. Her work has since been exhibited worldwide.

John Lennon and Yoko Ono 1980

ANNIE LEIBOVITZ b. 1949

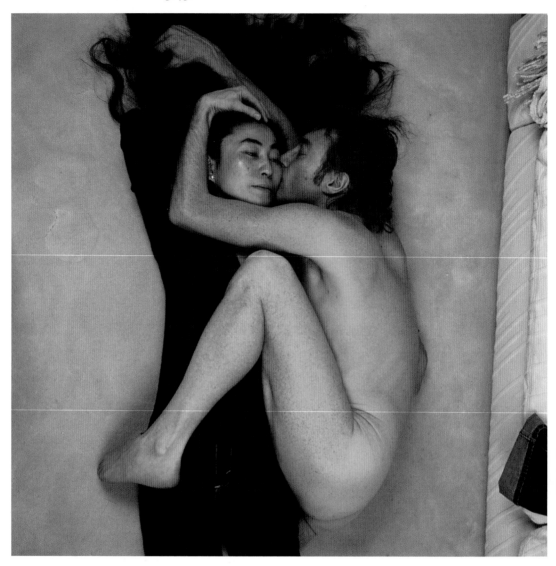

John Lennon and Yoko Ono, 8 December 1980,
New York City

The celebrity portrait tantalizes the viewer with the notion that it might reveal the real person behind the facade of fame. The power of this promise is amplified in Annie Leibovitz's *John Lennon and Yoko Ono* because it was the last time that Lennon was ever photographed. Five hours later, he was shot five times at point-blank range and killed. The story of the making of this photograph fuels the myth of the 'telling' celebrity portrait. On the afternoon of 8 December 1980, Leibovitz was doing a photoshoot with John Lennon and Yoko Ono at their apartment in the Dakota building for *Rolling Stone* magazine. *Rolling Stone* had asked Leibovitz to get a picture of Lennon alone, but he was determined to include Ono. Consequently, *John Lennon and Yoko Ono* became not only the last photograph of Lennon, but also a tribute to one of the best-known relationships of the period. Indeed, later, when discussing it, Ono asked, 'Why wasn't I told that John would be taken away? That's what I think when I see it.' However, that morning the mood was playful. As they looked over the Polaroids, Leibovitz remembers that Lennon immediately picked this image out of the pile and said, 'You've captured our relationship exactly. Promise me it will be on the cover.' The photograph did indeed make the cover of *Rolling Stone*, although in a way that none of them could have anticipated. It graced the memorial issue to Lennon on 22 January 1981. **JMH**

◉ FOCAL POINTS

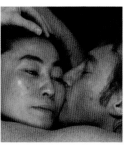

1 ONO'S HAIR
Ono's long black hair, fanned out against the blank canvas of the light carpet, looks as if it is flying upwards, which makes her look like she is plummeting. Her vertical position within the composition accentuates this sense of freefall. Lennon's right fist grabs on to her hair, as if refusing to let her slip away.

2 EYES
The difference in their gazes sets up an intriguing dialogue. Lennon's eyes, closed as he kisses her with affection, are the iconic image of devotion. Ono's eyes, open and looking into the distance, read as a refusal to acknowledge that she is being kissed. It is as if Lennon is already not there.

3 SOFA EDGE
Leibovitz has framed the image to include what looks like the edge of a sofa and the turned-up hem of Lennon's jeans. This hint of the real world grounds the image. What could have read as an abstraction now appears to take place on their living room floor in the Dakota building.

4 CLOTHED ONO
Ono being fully clothed in this image provides a stark contrast to Lennon's nakedness, making him seem emotionally as well as physically exposed. However, his position, curled and cleaved to her body, underscores this vulnerability. Leibovitz recalls that, after Lennon had got undressed, Ono wanted to take off her top. But Leibovitz told her to leave everything on, not really preconceiving the picture. Then he instinctively curled up next to Ono, providing Leibovitz with the now-seminal shot.

◷ PHOTOGRAPHER PROFILE

1949–69
Born in Waterbury, Connecticut, Leibovitz went on to study painting at the San Francisco Art Institute, taking night classes in photography.

1970–97
Leibovitz started her career as a photographer for the newly launched *Rolling Stone* magazine, through which she met and became tour photographer for the Rolling Stones in 1975. Some 142 covers later, in 1983, she moved to *Vanity Fair*.

1998–PRESENT
In 1998, she began working for *Vogue*, but also continued her high-profile independent projects. In 2006, she published *Annie Leibovitz: A Photographer's Life: 1990–2005*, and a retrospective of her work opened at the Brooklyn Museum, New York.

IDENTITY

1 *Untitled, Self-portrait* (1977)
Samuel Fosso • silver print
19 ⅝ x 19 ⅝ in. | 50 x 50 cm
Moderna Museet, Stockholm, Sweden

2 From *I Wanna Kill Sam 'Cause He Ain't
My Motherfuckin' Uncle* (1993)
Faisal Abdu'allah • acrylic on aluminium
78 x 39 in. | 198 x 99 cm
Autograph ABP, London, UK

ince the 1980s, there has been increased interest within photographic
practice in the issue of identity, both individual and collective, which
has been explored through portraits and self-portaits. As early as the
mid 1970s, before the postmodernist work of photographers such as Cindy
Sherman (b.1954) had become well known, Cameroon-born photographer
Samuel Fosso (b.1962) started what would become an enormous body of
masquerade self-portraits. In 1975, at the age of only thirteen, Fosso opened his
own studio in Bangui, Central African Republic, with his brother's financial help.
At the end of each day, after his clients had left the studio, he constructed sets
and took extrovert self-portraits, in which he recreated cool, cosmopolitan,
often camp styles featuring outfits from high-waisted flares and wide-collar
shirts (above) to hotpants and gloves. In this way Fosso unconsciously
undermined traditional notions of African identity. Nigerian-born curator and
critic Okwui Enwezor has commented on how forward-thinking this was: 'In an
uncanny anticipation of postmodern photographic conventions. . .he remade

KEY EVENTS

1982	1983	1987	1988	1989	1993
The Black Audio Film Collective is set up and makes award-winning films, such as *Handsworth Songs* (1987), as well as photography.	A book of images by Christer Strömholm (1918–2002) titled *Friends from Place Blanche* is published. It portrays a community of Parisian transsexuals.	The international scholarly journal *Third Text* is established. It publishes the work of often marginalized artists who confront diversity issues.	In London Rotimi Fani-Kayode (1955–89) and others form the Autograph Association of Black Photographers.	Chinese students descend on Tiananmen square in Beijing appealing for greater freedom. They are brutally oppressed by the People's Army.	Shirin Neshat begins the *Women of Allah* series to cope with the discrepancy between her past and present experience of her native country.

his studio. . .into a space of self-mimicry, idealization and theatricalization.' Fosso never intended to publish these images; it was only in 1994, when French photographer Bernard Deschamps came across his work when passing through Bangui that they came to the attention of the international art world. Although Fosso maintained that the images were simply a means of individual self-expression, it is difficult, because of the flamboyant use of Western fashion and poses, not to view them simultaneously as a representation of the emerging African youth culture at a time of increased international dialogue. Fosso has continued to create self-portraits, but his more recent images tend to be both more elaborately composed and more deliberately conscious in their exploration of African identity. For example, in the series *African Spirits* (2008) Fosso poses as historical African American characters, such as Malcolm X and political activist Angela Davis.

British photographer Faisal Abdu'allah (born Paul Duffus, 1969) explores the collective identity of black youth culture in his work. In his series of monumentally sized portraits titled *I Wanna Kill Sam 'Cause He Ain't My Motherfuckin' Uncle* (1993), he presents young Londoners provocatively looming over the viewer with weapons, such as the photograph of a man holding out a gun (right). Abdu'allah took his series title from the US rap song 'I Wanna Kill Sam' from Ice Cube's *Death Certificate* (1991). The Uncle Sam character in Ice Cube's song is symbolic of the United States, which the singer believed had let down young African American men. Abdu'allah's photographs show the large extent to which certain British youths were being influenced by the violent US rap culture at the time. Although criticized by some for perpetuating the stereotypical image of 'violent black males', it can be argued that Abdu'allah was, in fact, challenging this notion by asking British people whom he knew to take on self-consciously the roles of threatening, US-style gangsters. In this way he was challenging viewers to question their own attitudes towards contemporary black youth culture.

During the same period, Iranian artist Shirin Neshat (b.1957) — who had fled to the United States during the mass exodus from her country in the wake of the revolution in 1979 — was also challenging stereotypes, in particular Western views of Middle Eastern women. At this time, the Middle East as a whole, and the Muslim faith in particular, was being presented as the 'other' to Western society, a role previously ascribed to the Soviet Union during the years of the Cold War. In 1993 Neshat returned to Iran. The visit had a profound emotional impact on her after such a long time away from her native country, and she made the *Women of Allah* series (1993–97) in an attempt to gain a better understanding of the 'new' Iran, reclaim her cultural and religious identity as a displaced Iranian woman and suggest more positive ways for Middle Eastern 'otherness' to be understood. Four symbolic elements recur in these photographs: the veil, the gun, the text and the gaze, as is evident in

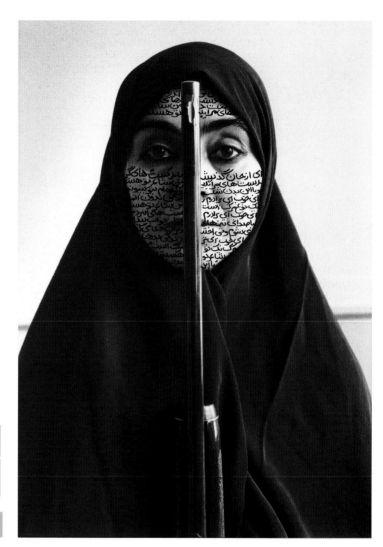

3 *Rebellious Silence* (1994)
Shirin Neshat • resin-coated print
and ink
11 x 14 in. | 28 x 35.5 cm
Gladstone Gallery, New York, USA

4 *Untitled* from *Effnik* (1997)
Yinka Shonibare • chromogenic
colour print
48 x 36 in. | 122 x 91.5 cm
Stephen Friedman Gallery, London, UK

5 *The First Intellectual* (2000)
Yang Fudong • chromogenic colour print
76 x 50 in. | 193 x 127 cm
Museum Madre, Naples, Italy

Rebellious Silence (above). In the image the woman gazes with dignity past
the barrel of the gun that she is holding, proud to be wearing her veil as a sign
of her religious and cultural identity and willing to protect that identity at all
costs, although potentially melancholic about the need to do so. Neshat says:
'Despite the Western representation of the veil as a symbol of Muslim
women's oppression, the subjects of these images look strong and imposing.
In fact, the use of the black veil as a uniform has transformed the feminine
body into that of a warrior, determined and even heroic.' Like many artists
investigating the issue of identity from the late 1980s onwards, including Lorna
Simpson (b.1960)—creator of *The Waterbearer* (1986; see p.476)—Neshat chose
to incorporate text into her photography because of what she saw as the
limitations of a purely visual language. In the image above, as in much of the
Women of Allah series, she includes Farsi text, taken from prose and poems
written by contemporary Iranian women. Her placing of this on the woman's
face—the only part of her that is visible—acts as a reminder of the intertwined
and indivisible nature of individual and cultural identity. Meanwhile, Neshat's
use of a script that is indecipherable to most people in the West has the
effect of placing Westerners as the 'other'.

British artist Yinka Shonibare (b.1962) is known for his exploration of the 'us' and 'them' roles that can arise out of collective identity. In his *Effnik* series, created with collaborating artist Joy Gregory (b.1959), he wittily plays with traditional Western portraiture to great effect. One work from the series depicts a colonial portrait scene that is reminiscent of the painted portraits of Gainsborough and Reynolds (above right). The composition features the familar signifiers of wealth and power: a writing desk complete with quills, a backdrop of luxurious red fabric and a grand white column. However, Shonibare subverts the tradition of the genre by inserting himself, a Nigerian-born black man, to play the part of the 18th-century grandee. In this role, he looks out at the viewer with a haughty expression, unsettling the racial dynamics of Britain's past and encouraging viewers to consider their own position.

The complex, shifting nature of identity resonates not only for those typecast as a result of their race or nationality. It is also of considerable significance to any group that finds itself marginalized by the establishment or under-represented in mainstream society. US photographer Catherine Opie (b.1961) initially gained attention in the early 1990s with her assertive portraits of the gay community in San Francisco, many members of which were also involved in a sadomasochistic subculture. Showing their often semi-naked, pierced, tattooed bodies against brightly coloured studio backdrops, she presents as 'normal' what she knows some are likely to view as shocking and 'abnormal'. It is at times hard to tell the gender of her subjects, thus undermining the significance of gender types at the same time as challenging societal expectations of who and what we 'should be'. For her *Being and Having* series in 1991, she had her lesbian sitters wear fake moustaches to further blur the boundaries of identity.

The tactic of using disguise to explore identity is taken a step further by Korean-born artist Nikki S. Lee (b.1970) in photographs such as *Hip Hop Project (1)* (2001; see p.478) from her *Projects* series (1997–2001). In these she effaces not only herself but also her Korean ethnicity by adopting a new style, look and attitude to fit into whichever social or cultural group she is working with at the time—whether punks, lesbians or Latinos—thereby questioning the role of individual identity within diverse groups.

The First Intellectual

The work of Chinese artist Yang Fudong (b.1971) similarly interrogates the constantly shifting nature of identity. In 2000, he made a powerful triptych of photographs titled *The First Intellectual* (below right), in which a young professional Chinese man stands, in his suit and tie, in the middle of a major road, with the Shanghai skyline in the background. With a brick in his hand and blood on his shirt and face, it appears as though he has been attacked by an unseen assailant and is at a loss as to how to react. Why has he been attacked and by whom? And where does he go from here? His bewilderment and frustration at being assaulted by an unknown figure, and his solitary position in the middle of the road, symbolize how difficult it is to retain a sense of integrated self and stable values in a society undergoing rapid social, political and economic change. Instead, the individual is in danger of feeling a sense of isolation, fragmentation and being torn between two worlds—the traditional one of his parents' generation and the modern one in which 'the first intellectual' now lives.

Although photographers often comment on cultural differences and change, much of their work concerning issues of identity ultimately encapsulates common psychological needs—to have a strong sense of individual self and to belong to a group. Fudong comments: 'Like all of us, I'm a bit like that "first intellectual": one wants to accomplish big things, but...there are obstacles coming either from society or from inside oneself. [The first intellectual] doesn't know if the problem stems from him or society.' **CB**

The Waterbearer 1986

LORNA SIMPSON b. 1960

SHE SAW HIM DISAPPEAR BY THE R
THEY ASKED HER TO TELL WHA
ONLY TO DISCOUNT HER M

1 WOMAN'S HAIR

A recurrent theme in Simpson's work is hair as a marker of selfhood and pride in African American culture. She often shows how black women have attempted to conform to white notions of beauty with their hair by dyeing and processing it. Here, however, the woman's hair is natural and dishevelled.

2 PLASTIC CONTAINER

The fact that the vessel in the woman's right hand is made of plastic places the image in the 20th or 21st century. The shapely jug in her other hand reminds viewers of the past, as does the black-and-white nature of the image. The central figure is therefore suspended between past and present.

⚙ NAVIGATOR

SHE SAW HIM DISAPPEAR BY THE RIVER, THEY ASKED HER TO TELL WHAT HAPPENED, ONLY TO DISCOUNT HER MEMORY.

Portraying predominantly African American women and combining both imagery and text in her photographs, Lorna Simpson is renowned for challenging perceptions of identity—in terms of gender, race, culture and identity. In *The Waterbearer* she found a format and approach that has almost become her template and influenced much of her future work. The loose-fitting, white fabric shift dress that the woman is wearing does not reveal her figure, thus denying the stereotypical picturing of women as a sexualized object. She carries two quite different water containers: one is made of contemporary white plastic; the other seems more historic and is made of some type of reflective metal. The outstretched nature of the character's arms as she carries the two vessels calls to mind the scales of justice. Their imbalanced position suggests an underlying social inequality—a sense that is arguably heightened by the fact that the viewer cannot see the woman's face.

The words beneath the figure strengthen this notion of inequality by revealing that the woman's voice has also been denied. Simpson presents an interesting interplay between text, image and potential readings of the work. The text is open-ended without revealing a coherent story; the viewer is left wondering what actually did happen 'by the river' and why the woman's version of events was dismissed. However, despite the unsettling nature of the text, the woman's self-assured stance and the act of her pouring out the water suggest that her sense of self has not been undone by society's refusal to recognize her. Cultural critic bell hooks (née Gloria Watkins) proposes that by turning the woman's back to the viewer—and, by association, to the 'they' who discounted her memory—Simpson allows her to 'create by her own gaze an alternative space where she is both self-defining and self-determining'. She is therefore free to establish her own unique identity, separate from that which society may try to impose upon her. **CB**

Silver print with vinyl lettering
55 x 77 in. | 140 x 195.5 cm
Collection Sean and Mary Kelly, New York, USA

3 SHIFT DRESS
The simplicity of the white dress gives no clues as to the wearer's character or identity, and the contrasting plain black background refuses to locate her within any particular time or place. This allows the woman to become representative of all women—specifically black women—throughout time.

SHE SAW HIM
THEY ASK
ONLY

4 TEXT
The text at the base of the composition adds a sense of menace to the image, leaving the viewer to question what might have happened outside the frame—an escape or a lynching? Whatever the answer, why has the woman's memory of events been discounted and by whom?

'
PPENED,
RY.

Hip Hop Project (1) 2001

NIKKI S. LEE b. 1970

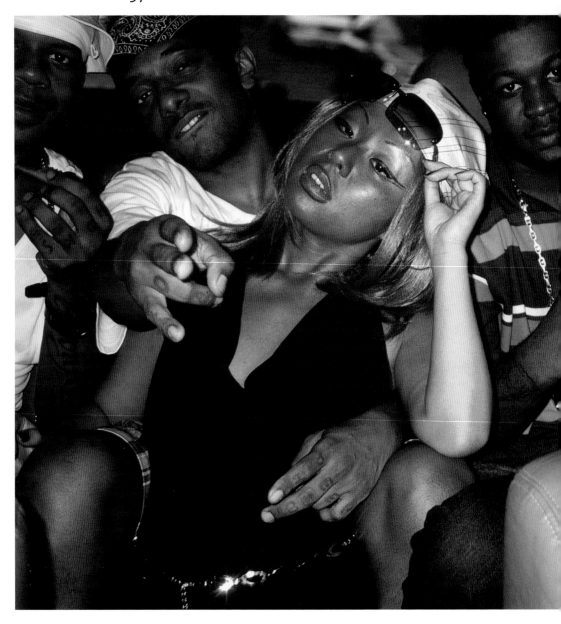

Chromogenic colour print
21 ¼ x 28 in. | 54 x 71 cm
Albright-Knox Art Gallery, Buffalo,
New York, USA

In 1997 Nikki S. Lee embarked on a series titled *Projects*, in which she infiltrated a broad range of groups of people over a four-year period—from schoolgirls, yuppies and senior citizens to punks, swingers and, as seen in this example, the hip hop subculture. For each individual project Lee would introduce herself as an artist; spend several weeks hanging out with the people and adopting their style and mannerisms; then, at the right point, ask a friend or someone from the group to take a contextual photograph with her in it. Her chameleonlike role in the vastly varying images questions preconceptions about race and identity, and provides visual proof of how fluid these notions can be. **CB**

◉ FOCAL POINTS

1 BODY LANGUAGE

Lee looks completely at ease sitting beween the legs of her male companion and he, in turn, is at ease with her, with one hand on her torso and the other gesturing towards the camera. Her ability to look natural despite essentially being the artistic director of each image is key to the success of her work.

2 LEE'S 'LOOK'

Lee darkened her skin colour during the 'hip hop project' in order to fit better into the predominantly black hip hop scene. Effective manipulation of her look, through the use of make-up, wigs, clothes and accessories was central to her credibility in each group with whom she worked.

3 DIRECTION OF GAZE

Some of the group, such as the man in the striped T-shirt, who has a soft, unguarded gaze, is looking straight at the camera. Others, however, such as the girl on the right, are looking elsewhere, as if unaware of the shot being taken. This implies that this is an impromptu shot taken among friends.

4 GREY LEATHER SEAT

The grey leather seat on the right locates the image within a luxurious car, a recognizable prop from many hip hop music videos. The seat's dominance, which causes the near-exclusion of the male figure on the left, also adds further to the happenstance look of the photograph.

5 DATE DISPLAY

The inclusion of the digital date display in the bottom right corner of each image reinforces its status as a candid 'snapshot'. The apparent authenticity of the work and its appearance as an everyday vernacular photograph is key to Lee's aesthetic and the work's reception.

✦ NAVIGATOR

THE FAMILY

Picturing the family in photographs is both an everyday activity and a subject that fascinates fine art photographers. For some, the intersection between amateur and professional photography is what makes the subject interesting. Nicholas Nixon (b.1947) has photographed his wife and her sisters, using a large-format camera and black-and-white film, annually since 1975 (see p.482). Nixon's work taps into the visual language associated with both fine art photography and snapshots taken for a family album.

Larry Sultan (1946–2009) photographed his elderly parents for a series *Pictures from Home* (1982–92), which was published as a book in 1992. An archivist as well as a photographer, Sultan used found photographs in his practice. In his book he combined family snapshots, text and memorabilia to create an intimate record of everyday events and rituals in the home; it tells a story of relationships in a US family. Sultan began the project when his father was forced into early retirement and his photographs reveal the effect this had on the family. *My Mother Posing* (above) shows his mother standing, her hands behind her back, while his father sits with his back to the camera watching sports. An unconventional family portrait, it exudes a sense of melancholy and

KEY EVENTS

1978	1982	1982	1991	1992	1994
Philip-Lorca diCorcia (b.1951) uses his family for staged shots such as *Mario* (1978), showing his brother standing in front of a fridge.	German artist Joachim Schmid (b.1955) starts his ongoing series *Archive* using family photographs found on the street.	Larry Sultan begins his series *Pictures from Home*, which portrays his parents' daily domestic life.	*Living Room* by Nick Waplington (b.1970), which chronicles the lives of two working-class British families, is published as a photobook.	Sally Mann (b.1951) exhibits images of her three children—naked and partially clothed—from the series *Immediate Family*; it causes controversy.	The 'Who's Looking at the Family?' exhibition at the Barbican Art Gallery in London shows snapshots and a foetal scan alongside artworks.

loss, combined with humour and tenderness that pervades the series. Sultan depicted his father as a man who had left behind a successful working life and occasionally seemed unsure of what to do with his time. Sultan worked with his parents setting up scenes and getting them to pose but he also captured them when they were not expecting the shutter to click, causing his father to state that he could not recognize himself in his son's photographs. This lack of recognition suggested to Sultan that he had achieved his aim, which was to show his father how he saw him as a son, rather than how his father wanted the world to see him. As such, the book becomes a tender and moving tribute of son to father, as well as a comment on the myths and clichés surrounding the family album.

Elinor Carucci (b.1971) has been taking startlingly intimate shots of her family since she was fifteen years old. Over time she has photographed four generations—her grandparents, parents, brother, cousins, husband and children—often in states of undress and at private moments. Carucci has said: 'I found myself and my family discovering more about ourselves, or at least, discovering nuances we couldn't otherwise see.' No area appears off limits to Carucci's camera: her photographs are like stills from an ongoing fly-on-the-wall documentary about her life and relationships. Carucci was twenty-two years old when she made the earliest photographs in her book *Closer* (2002), which depicts family life without spin or veneer. She appears in many of the photographs nude or partially dressed. Her photographs of her mother and father picture the ageing process in a way that is tender and yet clear-eyed, as seen in *Mother's Head in Sink* (below). **CB**

1 *My Mother Posing* (1984)
Larry Sultan • chromogenic colour print

2 *Mother's Head in Sink* (1999)
Elinor Carucci • chromogenic colour print

1996	1997	1997	2002	2003	2009
Richard Billingham (b.1970) publishes *Ray's a Laugh*, an unsentimental portrayal of his alcoholic father and obese mother.	'Sensation' is shown in London, Berlin and New York. The works are from Charles Saatchi's collection and include Richard Billingham's photographs.	Swiss artist Annelies Štrba (b.1947) publishes *Shades of Time*, which documents four generations of her family.	*The Family Album of Lucybelle Crater* (1974) by Ralph Eugene Meatyard (1925–72), showing friends and family in masks, is revised and reprinted.	*Family Business* by Mitch Epstein (b.1952) is published. It is a book about his father and the demise of the family furniture store.	*All the Days and Nights* by Doug DuBois (b.1960) is published. It is a moving portrayal of his family life from 1984.

The Brown Sisters 1999

NICHOLAS NIXON b. 1947

Silver print
7 ⅝ x 9 ⅝ in. | 19.5 x 24.6 cm
Museum of Modern Art, New York, USA

NAVIGATOR

Nicholas Nixon met Beverly 'Bebe' Brown in 1970 and they married the following year. Bebe is the eldest of four sisters, including Heather, Laurie and Mimi. The girls' parents, Sally and Fred Brown, had taken an annual Christmas photograph of their children from the year of Bebe's arrival; these were on display in the family home. Being an only child with parents who were only children, Nixon was fascinated by Bebe's family and its rituals.

In July 1975 Nixon took a group portrait of the sisters at a family gathering. Happy with the results he agreed with the sisters to photograph them every year. This ongoing project, known as *The Brown Sisters*, has become the defining work of his career. Nixon set himself some formal guidelines in order to ensure a visual continuity across the series and he always positions his camera at eye level. The sisters always appear left to right, Heather, Mimi, Bebe and Laurie. The setting is usually outdoors in natural light, on a lawn or a beach. Sometimes Nixon appears as a shadow cast across the group of women. No matter how many exposures he takes in a sitting, Nixon selects only one to represent the women each year. When the photographs are seen together, the viewer is struck by the passage of time as it is evoked by the women's changing faces, bodies, hairstyles and clothes. The different postures they adopt, and how they look at the camera, suggests the shifting ebb and flow of their relationship to each other—and to the photographer. **CB**

👁 FOCAL POINTS

1 MIMI

Mimi Brown is the youngest of the sisters; she was just fifteen when the project began. She appears the most guarded and perhaps self-conscious of the subjects. Looking at each of the sisters across Nixon's series is revealing. Mimi's appearance and demeanour change significantly over time.

2 BEBE

The women are close together in a group but only one is shown fully. She is the eldest and Nixon's wife, Bebe. The longevity of the series speaks of the strength of the couple's marriage and of Bebe's relationship with her siblings. She had been married four years when the series began.

3 LAURIE'S EYES

It is possible to see Nixon and his camera reflected in Laurie's eyes. Nixon uses a large-format view camera mounted on a tripod for maximum clarity and detail. The resulting negatives mean that his prints capture the essential textures, tonalities and expressions of the subjects he photographs.

4 BLACK AND WHITE

Nixon uses black and white exclusively. He has spoken of his preference for black and white rather than colour as being almost emotional: 'Colour prints don't keep me awake at night the way exciting black-and-white prints do. It's just a physical love of the final product.'

5 HANDS

Bebe's sister, Laurie, places her hands protectively around her older sister. One hand rests on her shoulder; the other touches her upper arm in a warm display of affection and filial love. This pose is echoed in other photographs in the series, in 2006 and 2007 for example.

▲ Nixon took his first portrait of the Brown sisters in 1975. It was only when he took the second photograph, in the following year, that he decided to photograph the women posing in the same order.

🕐 PHOTOGRAPHER PROFILE

1947–73

Born in Detroit, Michigan, Nicholas Nixon studied American literature at the University of Michigan, Ann Arbor and then gained a Masters in Fine Arts in photography at the University of New Mexico, Albuquerque. He met his future wife, Beverly Brown, in June 1970.

1974–87

In 1974 Nixon moved to Boston. He made a series of photographs of the city taken from high viewpoints that were included in the influential exhibition 'New Topographics: Photographs of a Man-altered Landscape' at the International Museum of Photography at George Eastman House in Rochester, New York in 1975. The same year he began *The Brown Sisters* series and joined the staff of the Massachusetts College of Art and Design in Boston. John Szarkowski (1925–2007) curated Nixon's first solo exhibition at the Museum of Modern Art, New York in 1976.

1988–91

Nixon released his photobook *Pictures of People* (1988), which explores people's physical and emotional relationships via views of their torsos, arms, hands, legs and feet. He published the book *People with AIDS* (1991), which portrays AIDS patients in their final months.

1992–PRESENT

Nixon published *School: Photographs from Three Schools* (1998), featuring Boston schoolchildren. In 1999 the Museum of Modern Art in New York displayed *The Brown Sisters* series when it reached its twenty-fifth anniversary. In 2003 he published a collection of his photography under the title *Nicholas Nixon*. He is a professor of photography at the Massachusetts College of Art in Boston. His work is included in the collections of the Metropolitan Museum, New York, the Los Angeles County Museum of Art and the Museum of Fine Arts in Boston, among many others.

CHILDHOOD AND ADOLESCENCE

1 *Untitled—May 1997* (1997)
Hannah Starkey • chromogenic
colour print
48 x 59 ⅞ in. | 122 x 152 cm
Saatchi Gallery, London, UK

2 *Hilton Head Island, SC, USA
June 24, 1992* (1992)
Rineke Dijkstra • chromogenic
colour print
16 x 12 in. | 40.5 x 30.5 cm
San Francisco Museum of
Modern Art, USA

3 *Tiny in her Halloween Costume* (1983)
Mary Ellen Mark • silver print

Childhood and adolescence have long been subjects of fascination for photographers (see p.108). Young children at play is a recurrent motif of 20th-century street photography, particularly in the work of Henri Cartier-Bresson (1908–2004), Helen Levitt (1913–2009) and Roger Mayne (b.1929). In recent years there has been a shift away from photographing children in public spaces. This is possibly because fewer children play outside on city streets, but it also reflects the increasing suspicion in Western societies about the motives of those taking pictures of children. US photographers Sally Mann (b.1951) and Tierney Gearon (b.1963) attracted controversy, in 1992 and 2001 respectively, over photographs that each took of her own children. The images show their children, then aged under ten, naked or partially dressed (see p.486).

Photographers have often found the transition from childhood to adulthood a rich topic for the camera. The teenage subject inhabits a psychological terrain that is lost to the adult viewer. Within this genre girls on the cusp of womanhood are often favoured as subject matter by female photographers. Mary Ellen Mark (b.1940) is a US documentary photographer who first gained international acclaim for her photographs of prostitutes in Bombay, India, which were published in 1981 as *Falkland Road*. In April 1983 she went to Seattle, Washington for a *Life* magazine assignment about runaway children living on the streets. There she met a fourteen-year-old girl with the street name 'Tiny'. She later returned with her husband, Martin Bell, to make a documentary

KEY EVENTS

1983	1992	1994	1995	1997	1997
Richard Prince (b.1949) reproduces a controversial nude photograph of actress Brooke Shields aged ten for his image *Spiritual America*.	Director Steven Cantor releases his short documentary film *Blood Ties: The Life and Work of Sally Mann*. It looks at the reception of *Immediate Family*.	Judith Joy Ross (b.1946) completes her series of portraits of students at public schools in Hazleton, Pennsylvania.	Bill Henson (b.1955) begins *Untitled*, his series of sensual photographs of older teenagers photographed as if at twilight.	Hannah Starkey completes her MA at the Royal College of Art, London. Fellow students include Ori Gersht (b.1967) and Anne Hardy (b.1970).	Anna Gaskell (b.1969) has her first show of colour photographs, 'Wonder', depicting scenarios inspired by *Alice in Wonderland* (1865).

film about the children, *Streetwise*, and in 1988 a book with the same name was published. The photograph of *Tiny in her Halloween Costume* (below right) appeared on the book's cover. The success of Mark's work lies in her ability to show great empathy with, rather than sympathy for, subjects who are often on the periphery of society. She does not judge them or their lifestyles, but seeks to present their daily reality truthfully. The position of Tiny's hands and arms wrapped close against her slight body points to her vulnerability, although her downturned mouth and slightly fierce expression suggest the hardened outlook of a much older individual.

Dutch photographer Rineke Dijkstra (b.1959) produces series of portraits with either a plain background or minimal props. Using a 4 x 5-inch field camera and tripod, her exposures are not instantaneous and the sitter must stay still. She says that she is interested in photographing children 'because they don't have the feeling of self-consciousness yet and teenagers don't know how to hide yet so it's very much on the surface. . .I try to look for an uninhibited moment, where people forget about trying to control the image of themselves'. Her photograph of a girl in an apricot-coloured bikini, from the series taken at Hilton Head Island, South Carolina (above right), captures the innocence and awkwardness of adolescence. The image is often compared to Sandro Botticelli's *The Birth of Venus*, painted in *c.* 1485. Indeed, the long exposures, scale of the prints and muted palette lend a sense of monumentality to her work that is similar to painting. Producing picture postcard-sized negatives, Dijkstra can print her work large in scale with immaculate detail, creating powerful and real-life tableaux.

Although there is an interplay between artistic intention and chance in Dijkstra's oeuvre, the working process of Belfast-born Hannah Starkey (b.1971) is more highly controlled. Starkey casts actors as her sitters and, although the images are set in ordinary urban spaces, they are carefully choreographed. She has said of her practice: 'By carefully constructing my photographs and controlling all elements within the image, I can express to others how I view the world around me. Also by collaborating with the people that I cast for my characters and working with them I find out how others view the world.' *Untitled—May 1997* (opposite) is an example of the narrative photography that came to prominence in the 1990s. The scene appears loaded with meaning, although the narrative itself remains unclear. Viewers are unsure whether to describe the main character who is gazing at a moth on the mirror as a girl or a woman. What is clear, however, is that her moment of private reverie is the focal point of the scene and activates the narrative element of the composition. Starkey contrasts her youthfulness with the older woman, who wears curlers in her hair and gazes at the young girl's reflection in the mirror. The young girl holds all the power in this tableau, which points to the supremacy of youth and beauty in many societies today. **CB**

1998	1999	2001	2001	2001	2003
Juergen Teller (b.1964) photographs teenage wannabe models sent to him by fashion casting agents for his series *Go-sees*.	New York exhibition 'Another Girl, Another Planet' brings together the work of a group of female photographers, and features mainly adolescent girls.	Tierney Gearon exhibits images of her children at the 'I Am a Camera' exhibition at the Saatchi Gallery, London. It attracts a warning for indecency.	Mary Ellen Mark is awarded the Cornell Capa Award by the International Center of Photography.	Hellen van Meene (b.1972) exhibits work made in Japan featuring adolescent girls in her first solo show in New York.	Rineke Dijkstra exhibits at Tate Modern's first group photography show—'Cruel and Tender: The Real in the Twentieth-Century Photograph'.

Untitled 2000
TIERNEY GEARON b. 1963

1 MASKS
The children wear masks, an element that might strike the viewer as disturbing. Gearon said of her pictures: 'I don't crop them, I don't retouch and the shots are never staged. I might introduce an element, like a mask, to a given situation, but I would never insist that the child put it on.'

2 VIVID COLOURS
The harsh lighting and bright, vivid colours in the photograph suggest the glare of a hot, sunny day. The garish yellow masks and the lurid blues of the sky and sea create the impression that the image is a family snapshot of children playing while on a day out at the seaside.

Chromogenic colour print
48 x 72 in. | 122 x 183 cm
Saatchi Gallery, London, UK

✪ NAVIGATOR

This photograph is one of two that catapulted US photographer Tierney Gearon to fame and notoriety in 2001 when it appeared in the 'I Am a Camera' exhibition at the Saatchi Gallery in London. The photographs were part of a collection of fifteen snapshot-style images that document Gearon's family life, and portray her daughter and son aged six and four.

Eight weeks after the show opened, the gallery was visited by officers from Scotland Yard's Obscene Publications Unit after receiving complaints from the press and members of the public. The police claimed the images could be in contravention of the Protection of Children Act of 1978, which aimed 'to prevent the exploitation of children by making indecent photographs of them; and to penalise the distribution, showing and advertisement of such indecent photographs'. The police warned that they would return to seize this, and another image showing Gearon's son urinating in the snow, unless they were removed before the gallery reopened. The Saatchi Gallery refused to withdraw the photographs, however, neither Gearon nor the gallery were prosecuted for exhibiting the pictures. The outcry led to a debate about censorship. **CK**

⏱ PHOTOGRAPHER PROFILE

1963–83
Tierney Gearon was born in Atlanta, Georgia and studied ballet at the University of Utah. She was spotted by a European modelling agency and went on to become a fashion model, modelling bridalwear and lingerie.

1984–88
While working as a model, Gearon kept a scrapbook of Polaroids she took of other models as a personal record. When they came to the attention of a Parisian agent, he was sufficiently impressed that he sent her out with a camera to see what she could do. Soon after, she gave up modelling to become a fashion photographer working for fashion houses and publications such as *i-D*.

1989–2007
Gearon began a personal project documenting her extended family. In 2001 she participated in the 'I Am a Camera' exhibition at the Saatchi Gallery in London. In 2006 she showed her series *The Mother Project* (2006) at the Yossi Milo Gallery in New York. The series became the subject of a documentary film and a book for the exhibition titled *Daddy, Where Are You?*, which was published later that year.

2008–PRESENT
Gearon's series *Explosure* (2008), in which she used double exposure to superimpose two unrelated images into one, was shown at the Ace Gallery in Beverly Hills, California and at Phillips de Pury & Company in London.

3 NUDITY
Gearon took the photograph while on a trip. She has said it was not posed and her children liked to run around nude in the heat. Yet their nudity revealing their genitalia has caused offence, prompting questions regarding the children's privacy and accusations that they were being exploited.

4 POSES
The boy Michael points a toy gun at the viewer. Next to him his sister Emilee stands— almost provocatively—with a hand on her hip. The fact that both children are wearing female masks is a playful subversion of the conventional gender roles suggested by their poses.

FASHION AND STYLE

1 *Stephanie, Cindy, Christy, Tatjana, Naomi, Hollywood* (1989)
 Herb Ritts • silver print

2 *Suzanne & Lutz, White Dress, Army Skirt*
 (1993)
 Wolfgang Tillmans • chromogenic
 colour print • dimensions variable
 Courtesy Maureen Paley, London, UK

At the end of the 1970s *Vogue*'s editorial director, Alexander Liberman, described fashion photography as 'a subtle and complex operation that involved art, talent, technique, psychology and salesmanship'. He wrote of 'the emerging power of the new woman, the unexpectedly all-pervading power of worldwide fashion and the all-encompassing power of photography'. Liberman's vision of the mighty 'new woman' was embodied by models such as Jerry Hall and Lauren Hutton, and the luxurious world that these sirens inhabited was exalted in the work of leading fashion photographers, including Helmut Newton (1920–2004), Guy Bourdin (1928–91), Gian Paolo Barbieri (b.1938) and Chris von Wangenheim (1942–81).

Fashion photographs of the late 1970s and 1980s frequently portrayed fantasies of lust and consumption, and the most contentious of these images were published in European magazines. Newton—creator of controversial, erotic works such as *Sie Kommen (Naked and Dressed)* (1981)—was partly influenced by images of Paris taken in the 1930s by Hungarian photographer Brassaï (born Gyula Halász; 1899–1984), who wandered the streets at night photographing the city's underworld (see p.230). Newton was fascinated by the idea of voyeurism and even employed night-vision telescopes and binoculars in his exploration of paparazzo techniques. The work of US photographer Arthur

KEY EVENTS

1980	1986	1987	1988	1990	1990
British magazines *i-D* and *The Face* are launched, providing an antidote to mainstream glossy fashion magazines.	*Arena* magazine, aimed at male consumers, is founded by Nick Logan, who had started *The Face* six years earlier.	Designer Karl Lagerfeld selects seventeen-year-old Claudia Schiffer to be the face of Chanel, launching her career as one of the first supermodels.	Anna Wintour is appointed editor-in-chief of US *Vogue* and is highly influential in establishing the global phenomenon of the supermodels.	Corinne Day takes images of Kate Moss for *The Face*, in a feature titled 'The Third Summer of Love', marking the start of Moss's stellar career.	Version 1.0 of Adobe Photoshop is launched by Thomas and John Knoll, enabling groundbreaking manipulation of digital images.

Elgort (b.1940) was less provocative, but his images were likewise staged to resemble spontaneous shots of beautiful women going about their everyday lives. By the 1980s, top models were better paid than ever before and the phenomenon of the 'supermodel' began to take hold. Photographer and former designer Steven Meisel (b.1954) was instrumental in shaping the stellar careers of many celebrated models. From choreographing their poses to advising them on hair colour, Meisel was a key player in the creation of the model as an international brand. The original group of 1980s supermodels (a term that was probably first used in the 1940s by model agent Clyde Dessner) comprised Christy Turlington, Cindy Crawford, Claudia Schiffer, Linda Evangelista, Naomi Campbell, Stephanie Seymour and Tatjana Patitz. Various combinations of these elite few were often photographed, most notably by Peter Lindbergh (b.1944), Herb Ritts (1952–2002) and Meisel.

In 1989, five of these supermodels posed nude together on a studio floor for Herb Ritts, their slender limbs languorously intertwined and their hair artfully tousled (opposite). The photograph was produced as a poster and distributed globally. More group portrait or pin-up shot than fashion image, the photograph does not present any garments or accessories for sale, rather it celebrates the body beautiful and is typical of Ritts's style: sensual, bold and uncluttered. His portraits and editorial fashion shoots appeared in glossy magazines such as *Vogue* and *Vanity Fair* and he produced advertising campaigns for major fashion houses—Armani, Calvin Klein and Chanel—as well as for high street retailers Gap and Levi's. The 1980s also witnessed a greater interest in men's fashion and the muscular male physique, as depicted in the work of Bruce Weber (b.1946), whose predominantly black-and-white images of toned bodies reference classical figures and youthful athletes captured in earlier decades by the German photographers Herbert List (1903–75) and Leni Riefenstahl (1902–2003).

Style publications that were aimed at both sexes, such as *i-D* and *The Face*, provided a counterpoint to the airbrushed perfection of the major glossy magazines. Both these titles centred on youth culture, contemporary music and emerging trends, and their pages were populated with images depicting alternative types of beauty, taken by photographers including Ellen von Unwerth (b.1954), Nick Knight (b.1958), Terry Richardson (b.1965), Juergen Teller (b.1964) and Wolfgang Tillmans (b.1968). The latter first came to public attention when his powerful snapshot-like portraits of his friends, such as *Suzanne & Lutz, White Dress, Army Skirt* (right), were published in *i-D*. Like the work of earlier photographers such as Elgort and contemporaries such as Teller, Tillmans's photographs appeared improvisatory but were, in fact, carefully staged. Tillmans went on to become one of the most influential photographers of the 1990s, and in 2000 he became the first non-English artist and the first photographer to be awarded the prestigious Turner Prize.

1992	1992	1997	2000	2003	2009
Alexandra Schulman becomes editor of British *Vogue* and starts to incorporate the grunge imagery previously associated with *i-D* and *The Face*.	*Dazed and Confused* magazine launches in London and goes on to commission shoots by Nick Knight, Rankin and Terry Richardson.	The death of fashion photographer Davide Sorrenti, caused by a heroin overdose, sparks criticism of 'heroin chic' photography.	The Victoria and Albert Museum, London stages the exhibition 'Imperfect Beauty: The Making of Contemporary Fashion Photographs'.	Tate Britain, London presents a mid-career retrospective of Tillmans's work, the first exhibition there devoted to the work of a single photographer.	The International Center of Photography, New York stages 'Weird Beauty: Fashion Photography Now'.

Founder of *i-D* Terry Jones and photographer Steve Johnson also made important photographic documents during the 1990s. They pioneered a documentary style of street portraiture for the magazine that was known as 'straight up'. Punks, New Wave youth and other style-conscious passers-by were stopped on the street and photographed against a wall from head to toe wearing their own clothes. More recently, this method of capturing street style has been imitated all over the world by internet bloggers, such as Scott Schuman, Garance Doré and Yvan Rodic, and by South African photographer Nontsikelelo 'Lolo' Veleko (b.1977). Her bold series of urban fashion portraits, *Beauty is in the Eye of the Beholder* (2003–06), portrays the youth of Johannesburg and explores the subjects of inventive dress and identity among the country's 'born free' generation that has grown up after the end of apartheid.

In the early 1990s waiflike, androgynous models featured in the images of Corinne Day (1965–2010) and Craig McDean (b.1964), who were emerging talents commissioned by Phil Bicker, art director of *The Face*. They collaborated with stylists such as Melanie Ward, creating images that were dubbed neo-realist, anti-fashion or grunge, as seen in Day's *Kate Moss, Under Exposure* (1993; see p.492). At the heart of her work lay an interest in everyday life and real people, celebrated for all the flaws that make them individual, as she explained: 'Fashion magazines had been selling sex and glamour for far too long. I wanted to instil some reality.' Day frequently incorporated her own clothes and accessories into her candid fashion shoots and is credited with shaping the early career of the model Kate Moss. By the mid 1990s, however, the supermodel phenomenon was beginning to wane, and stars from other spheres—film, music and sport—were seen more frequently in advertising campaigns and fashion magazines.

New magazines continued to be launched throughout the 1990s, most notably *Dazed & Confused*, which was first published by Jefferson Hack together with the photographer Rankin (born John Rankin Waddell, 1966) in 1992 as a fold-out poster. The title showcased contemporary designers, artists, musicians and filmmakers and featured photography by practitioners such as Nick Knight and Terry Richardson. The strongly sexual themes in Richardson's work have led some critics to accuse him of exploiting models. The title of his *Three Graces* (above left) refers to mythological goddesses of beauty, and the graphic close-up shot of three women sharing a kiss is typical of Richardson's irreverent attitude.

When Alexandra Schulman became editor of British *Vogue* in 1992, the magazine began to assimilate a neo-realist style of photography. However, images of pale and extremely slender models in grimy settings sparked criticism that came to a head in 1997, when the twenty-year-old photographer Davide Sorrenti (1976–97) died after a heroin overdose. In a speech at the US Conference of Mayors in May 1997, President Bill Clinton decried 'heroin chic' fashion photography for promoting drug abuse as glamorous and sexy. However, fashion image-makers have continued to challenge and provoke. The subversive work of Steven Klein (b.1965), for example, confronts themes such as masochism, decadence and decay in the United States.

Since the late 1990s, digital manipulation has become central to the work of photographers such as Nick Knight, and the internet is an ever-growing forum for fashion image makers. In 2000, Knight launched SHOWstudio.com, a fashion broadcasting company dedicated to sharing live fashion media online. Furthermore, in recent years museums and art galleries have embraced fashion photography like never before. The medium has become increasingly collectable and photographers such as Sarah Moon (b. 1941), a former model who began her photographic career in 1970, have successfully made the

3 *Three Graces* (2002)
Terry Richardson • colour coupler print
24 x 20 in. | 61 x 51 cm

4 *Christina* (2008)
Sarah Moon • toned silver print
23 ⅝ x 19 ⅝ in. | 60 x 50 cm
Michael Hoppen Gallery, London, UK

5 *Dinner Party #5* (2009)
Miles Aldridge • Lambda print

transition from magazine commissions to the fine art market with bewitching images such as *Christina* (right). As curator and writer Susan Bright explains, 'Some of the very best art photographers are being seduced by the money, glamour and structure of fashion photography.' Bright cites Nan Goldin (b.1953), Philip-Lorca diCorcia (b.1953) and Nikki S. Lee (b.1970) among those who have worked for *Vogue* or *W* magazines.

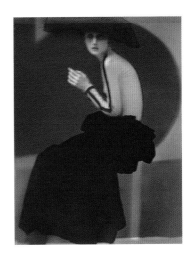

Today's most dazzling fashion images are rich with colourful and poetic narratives. Just as fashion designers recycle and reinterpret the trends of decades past, contemporary photographers often look to their forebears for inspiration, melding influences from past eras. For example, Tim Walker (b.1970) conjures a whimsical, technicoloured England, referencing the opulence of the early work of Cecil Beaton (1904–80; see p.264) and classic fairy tales. He has collaborated with art director and set designer Simon Costin for a decade, and Costin's oversized props feature in many of Walker's sparkling, magical scenes. The luscious hues that characterize the images of Miles Aldridge (b.1964), as in *Dinner Party #5* (below)—photographed for *Vogue Italia* in 2009—are reminiscent of photographic work in the 1930s by Madame Yevonde (1893–1975). Yevonde specialized in the Vivex process, which produced rich, jewel-like colours, for her *Goddesses* series, including the portrait of Lady Bridgett Poulett (1935; see p.278).

Several leading fashion designers have used photographs in their clothing ranges. In her Autumn/Winter 92/93 collection, 'Always on Camera', Vivienne Westwood printed Beaton's portraits of Marlene Dietrich on to denim. Alexander McQueen's Autumn/Winter 96/97 collection, titled 'Dante', reflected the suffering of religious conflict by fusing the shocking images of war taken by Don McCullin (b.1935) with luxurious fabrics, and Dries van Noten transformed nightscapes by photographer James Reeve (b.1974) into printed fabrics for his Spring/Summer 12 collection. These collections exemplify a further role that photography plays within the fashion industry. **SB**

Kate Moss, Under Exposure 1993
CORINNE DAY 1965 – 2010

Chromogenic colour print
9 ⅜ x 12 in. (24 x 30.5 cm)
Victoria and Albert Museum,
London, UK

R aw, uncompromising and peculiarly British, Corinne Day's fashion photographs were entirely at odds with the glamorous aesthetic of mainstream magazines of the early 1990s and helped to usher in the style that came to be known as 'grunge'. Day did not attempt to sell an overtly sexy or sophisticated ideal of feminine beauty; instead her work was rooted in reality, shaped by her free-spirited and fearless approach to living. This image of nineteen-year-old, waiflike Kate Moss in her own flat, part of a series published in British *Vogue* for an underwear feature in June 1993, sparked controversy and accusations from some critics of promoting eating disorders, drug use and even paedophilia. As Day recalled: 'It was said at the time that the shock these photographs caused was like that of a cider-obliterated punk wandering into a coming-out ball.'

Day's earlier photographs of Moss for a feature titled 'The Third Summer of Love' in *The Face*, July 1990 had helped to launch the career of the then little-known model, and Moss and Day had become close friends and collaborators. However, by the time of the *Vogue* shoot in 1993, Day realized: 'It wasn't fun for [Kate] any more, and she was no longer my best friend but had become a "model".' Favouring unconventional-looking, often androgynous, young models, Day's intimate, documentary-style approach went on to influence fashion photography worldwide. **SB**

FOCAL POINTS

1 BLANK GAZE
Moss's famously wide-set hazel eyes stare out of the picture. Her expression is ambiguous: is she relaxed, confrontational, vulnerable or melancholy? The photographer later remarked that she took the photograph on a day when the model had been crying, following a fight with her boyfriend.

2 GOLD CRUCIFIX
The delicate, glinting gold cross at the centre of the composition is the only accessory the model wears, and her pose loosely echoes its shape. Such is its size that it would be barely noticeable on the magazine page, but it brings an element of innocence and purity to an image of adolescent sexuality.

3 UNDERWEAR
The focus of the shoot was underwear, and the text read: 'What to wear beneath effort-free clothes? Barely-there underwear, naturally.' As is typical of Day's anti-fashion approach, the garments became incidental to the mood of the image and the personality of the model.

4 DOMESTIC INTERIOR
This shoot took place in Moss's London flat. The coloured fairy lights, crudely fixed to the wall with strips of masking tape, are arranged to outline Moss's figure, and there is a glimpse of a piece of blue furniture in the bottom left corner. Day frequently photographed models in their own homes.

PHOTOGRAPHER PROFILE

1965–80
Born in London, Corinne Day had little interest in school and left aged sixteen. At eighteen she began modelling.

1981–89
Modelling work took her to Japan where, in 1985, she met her partner Mark Szaszy. He taught her how to use a camera and she began photographing her fellow models 'off-duty'.

1990–95
Day started taking on commissions for *The Face*, and work for other magazines, including *Vogue*, followed. Her confessional approach helped to usher in the 'grunge' style.

1996–2000
Day was diagnosed with a brain tumour in November 1996. In 2000, she published her first book, *Diary*; an exhibition of the same name was held at The Photographers' Gallery, London.

2001–10
Day continued to take on high-profile assignments for fashion magazines despite her illness. In 2007, she married Mark Szaszy. On 27 August 2010 she died at home.

EROTICA

By the 1980s erotica had become a legitimate photographic genre in its own right and postmodernist scholars began to critique the highly sexualized imagery for the iniquitous power relationships it promoted. Feminist theory was dominant in this regard—claiming the female subject as the object of an implicit male gaze in film, photography and advertising—and the most influential postmodern feminist film theorist was Laura Mulvey, whose pioneering study 'Visual Pleasure and Narrative Cinema' (1975) interrogated this claim. It was during this period of growing political correctness that photographers such as Helmut Newton (1920–2004) and Nobuyoshi Araki (b.1940) made sexualized images of women their art form, as seen in Araki's *Colourscapes* (1991; see p.496).

From the late 1970s to 1980s, Newton's work gained acclaim in England and the United States, with photographs such as *Sie Kommen (Naked and Dressed)* (1981). However, the images that attracted most attention from feminist critics were those in which Newton was in the frame, fully clothed, photographing the naked model. Newton's most renowned series is *Big Nudes*, which he began in 1975. It comprises a number of oversized black-and-white prints of naked models. In *Big Nude III: Henrietta* (1980), the model is fully exposed apart from her hands folded over her crotch. Newton's title seemingly

KEY EVENTS

1978	1978	1979	1979	1981	1983
British photographer John Swannell (b.1946) begins taking erotic photographs of the female body.	Chris von Wangenheim (1942–81), a German photographer working in New York, produces erotic images of US model Gia Carangi.	Bob Carlos Clarke takes a series of photographs to illustrate Anaïs Nin's erotic novel *Delta of Venus* (1979).	US art photographer Ralph Gibson (b.1939) produces nudes that possess a modernist aesthetic reminiscent of Edward Weston (1886–1958).	Helmut Newton takes *Self-portrait with Wife June and Models*. In the image there is a clear triangulation of voyeurism.	*The World of Jan Saudek* is published. His work fuses erotic imagery and themes of political suppression with the aesthetic of 19th-century pornography.

divests the woman of her subjectivity; she is one in a series of 'big nudes'. However, the more than life-size scale of this nude series makes the models, not the viewer, appear powerful. Whether made for fashion, advertising or art, Newton's nudes are Amazonian and predatory, his monochrome works executed in a graphic style that has little in common with the self-conscious artiness found in erotic images by French photographer Jeanloup Sieff (1933–2000), for example.

The photographic repertoire of Sieff is extensive. His works range from iconic Parisian scenes and images of aspiring French actors in the 1950s and 1960s to landscapes of Scotland and Death Valley, which in their scale and precision are reminiscent of the US modernist photographer Ansel Adams (1902–84). However, it is for his stylized erotic images that Sieff is best remembered. *Suspenders* (right) is characteristic of his black-and-white modernist-derived style, which plays with shadows and light. He approached his work with a degree of humour, and of this image he wrote: 'Feminine seduction needs this fetishistic fussiness as cardinals do their birettas.'

Irish-born photographer Bob Carlos Clarke (1950–2006) began work in the late 1970s with a series of photographs taken to illustrate Anaïs Nin's erotic novel *Delta of Venus*, published in 1979. These illustrations feature the female nude bending over the armrest of a vintage chaise longue wearing only stockings, her behind visible in provocative and sexually passive poses. His subsequent series of photographs, *Obsession* (1981) and *The Dark Summer* (1985), earned Carlos Clarke a reputation as a highly stylized photographer of erotic images, whose aesthetic precision has been compared to that of Robert Mapplethorpe (1946–89), who was working in New York during the same period.

Carlos Clarke is often regarded as Helmut Newton's successor, and the criticism of Carlos Clarke, like Newton, is divided between those who hailed his work as celebrating women's power and sexuality, and those who understood it as reducing women to objects. In one of his images, the model is posed on her hands and knees wearing black PVC gloves and boots. An aerial is attached to her back and in the left-hand part of the frame is a radio. Read across the photographic space, the woman's body mimics and becomes the object. The female model is again objectified in *Keeping Up with the Joneses* (opposite), which features a model on all fours, dressed in black stilettos, a PVC thong and long black gloves, with a sheet of clear glass covering her back. Here the actual sexualized woman becomes the table in a photographic reworking of the artwork *Table* (featuring a mannequin) by Allen Jones from 1969. For his final monograph, *Shooting Sex* (2003), Carlos Clarke photographed strangers taking part in sexual acts. His other work, which includes dramatic still lifes of everyday objects—knives, forks and spoons—has been overshadowed by the provocative eroticism of his advertising and fashion photography. **GC**

1 *Keeping Up with the Joneses* (1985)
Bob Carlos Clarke • silver print

2 *Suspenders* (1985)
Jeanloup Sieff • silver print

1989	1991	1997	1998	2005	2005
Ellen von Unwerth (b.1954) creates images of erotic femininity for advertising campaigns, including some of Claudia Schiffer for Guess Jeans.	Bettina Rheims (b.1952) collaborates with Serge Bramly to produce the series *Chambre Close*, a collection of erotic photographs of women in bedrooms.	Araki's controversial work, *Tokyo: Lucky Hole*, is published. It documents his pornographic encounters at Japanese strip clubs.	Helmut Newton collects the Polaroids he has taken throughout his career and publishes them in the volume *Pola Women*.	The Erotic Museum in Los Angeles exhibits *A History of Sex* by Andres Serrano (b.1950).	The Kunsthaus Zürich exhibits erotic images of women in public places taken by Czech photographer Miroslav Tichý (1926–2011) using a home-made camera.

Colourscapes 1991
NOBUYOSHI ARAKI b. 1940

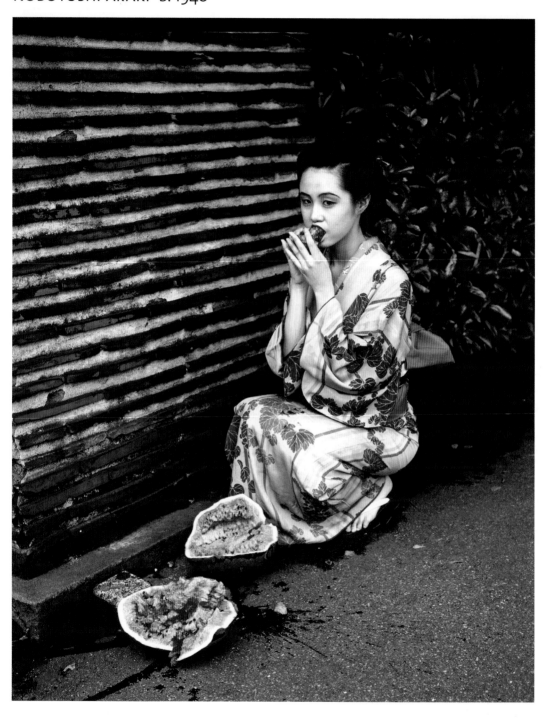

RP direct print
Taka Ishii Gallery, Tokyo, Japan

Nobuyoshi Araki has made sexualized images of women his art form throughout his career, viewing the bond between photographer and sitter as a sexual relation and commenting in interview that his work is analogous with foreplay. His images have been considered pornographic in content, featuring naked women, often tied in bondage. These women are sometimes accompanied by Araki's collection of dinosaur and reptile miniatures, such as a snake on the inner thigh seemingly moving up to the model's crotch. Art critics including Adrian Searle see more to Araki's photographs than the objectification of his female subjects, understanding his work to manifest eroticism, intimacy and aesthetics in such a way that none of these elements can be strictly divided from the others.

Although not explicit, *Colourscapes* is characteristic of the photographer's style. Dressed in a kimono, the model is shown crouching in an urban alley and sucking on a piece of watermelon, which is a clear reference to fellatio. Her pose also resembles praying. Although the geisha is fully clothed, her body is eroticized by the textures and colours of the fruit. The passiveness of the female, while simulating a sexually submissive act, is called into question by the violence of the smashed watermelon, its juices splattered bloodlike on the pavement. This ambiguity is heightened by the equivocal gaze of the woman: is it erotic, or fearful, or aggressive? **GC**

NAVIGATOR

FOCAL POINTS

1 TOKYO LOCATION
The scene is heavily urban, with the model crouched in front of a metal grid in an alleyway in Tokyo. Even the leaves suggest an urban jungle. Araki's work embodies a keen nostalgia of place and he has stated that he cannot take photographs of anywhere except Tokyo.

2 ANGLE
The camera angle gives the lens a predatory feel. It approaches the model from above, as if hunting her. This sense is heightened by the model's ambiguous look. The manner in which she eats the fruit with both her hands and her stooping pose also suggest a frightened animal.

3 KIMONO
The kimono is the traditional garment of Japanese women, and the term translates literally as 'the thing worn'. Here Araki subverts the tradition of the kimono as a luxury garment (only the elite wore silk kimonos) by having his model crouch barefoot in the dirty street.

4 COLOUR
The pink flesh of the watermelon has an affinity with the model's sash (*obi*), her lips and the ornament in her hair. The vibrant colour of her clothing contrasts with the grunge of the urban street. The colours suggest a sensuousness and eroticism despite the model being fully clothed.

PHOTOGRAPHER PROFILE

1940–69
Nobuyoshi Araki was born in 1940 in Tokyo. He began working in the 1960s, photographing the urban underside of Tokyo: its streets, nightlife and strip bars. In 1963 he joined Dentsu Advertising, where he took commercial photographs but also used the company's facilities for his own work.

1970–98
Araki called 1970 'the first year of Araki' and began to publish an extensive body of work. In 1984 he privately published *Nostalgic Nights* as a wedding anniversary gift to his wife, Yoko. She died in 1990 and Araki published photographs of his wife before her death in the volume *Winter Journey* (1991).

1999–PRESENT
In 1999 Araki began his most extensive work, the series *Tokyo Nostalgy*, which documents the variable nature of the Japanese city over almost four decades. In the same year the Tokyo Metropolitan Museum of Art held a major retrospective of his work. Araki gained international acclaim in 2005 for his first London show at the Barbican Art Gallery, which displayed more than 4,000 photographs.

ADVERTISING

Although it is widely believed that commissioned photography compromises the photographer's creativity, many of the most celebrated photographers in the history of art, including Edward Steichen (1879–1973) and Edward Weston (1886–1958), produced work for advertising. The financial benefits of such work should not be underestimated. In 1946, Weston worked for the first time in colour for a series commissioned by Kodak. He earned US$250 per image, thought to be the highest fee he ever received for his work. Steichen was criticized by Alfred Stieglitz (1864–1946) when he joined *Vanity Fair* as chief photographer in 1923. Sixty years later, the US photographer Annie Leibovitz (b.1949) was similarly accused of 'selling out' when she took the same post at the relaunched *Vanity Fair*.

The 1980s saw an increasing blurring of the boundaries between advertising photography—most notably for fashion—and visual art. This hybridization was particularly prominent in the work of French fashion photographer Guy Bourdin (1928–91). The revolutionary images that he took for luxury shoe brand Charles Jourdan in 1967 witnessed a new era of advertising in which the photographer produced advertising imagery, designed for the magazine page, that privileged aesthetic innovation over the product. Bourdin's avant-garde aesthetic can be seen in the images that he produced for the Pentax calendar in 1980. Taken from the calendar, the picture of a naked model lying on a white floor with red paint flowing from her mouth (above) is at once erotic, disturbing and surreal.

KEY EVENTS

1977	1983	1986	1991	1991	1992
Sarah Moon shoots Cacharel's advertising campaign for its perfume Anaïs Anaïs, producing an iconic, vintage style.	Annie Leibovitz leaves *Rolling Stone* and joins *Vanity Fair*.	Juergen Teller carries out his first shoots for youth magazine *i-D*, attracting attention for his grainy, realist aesthetic.	Bruce Weber creates a series of monochrome adverts for Calvin Klein of male models in underwear, forging an enduring advertising identity for the brand.	Herb Ritts (1952–2002) shoots the Calvin Klein 'Escape' campaign. The edgy images reference homoeroticism and challenge racial and sexual conventions.	Led by Oliviero Toscani, Benetton begins an advertising campaign that uses images associated with social and environmental issues.

Like Bourdin, US photographer David LaChapelle (b.1963) often combines the surreal with the erotic. Other significant campaigns include those by Cédric Buchet (b.1974) for Prada in 2001 and Juergen Teller (b.1964) for Marc Jacobs in 2008. In a playful image Teller shot for the latter campaign (below) the legs of Victoria Beckham, clad in Marc Jacobs shoes, can be seen emerging feet first out of a shopping bag. Notable for their retro, rather than contemporary, aesthetic are the photographs of Sarah Moon (b.1940) for L'Oréal in 1978. Often in sepia, Moon's impressionistic photographs capture a grainy, childlike, fantastic world, crossing the aesthetic borders between advertising and visual art practice.

In the United States, Irving Penn (1917–2009) and Bruce Weber (b.1946) were at the forefront of advertising photography. Penn's campaigns for L'Oréal brought his signature minimalist style to cosmetics. Weber's is a very different aesthetic. In 1982 his billboard of Tom Hintnaus dressed in only a pair of white Calvin Klein underpants, his tanned, athletic body leaning against a white column on the Greek island of Santorini, was a catalyst for the later eroticization of the male body in advertising.

The question of how far a company can go in the attempt to court controversy became clear in 1992, with advertising campaigns conducted for the clothing company Benetton. Creative director Oliviero Toscani (b.1942) was at the helm of a campaign that featured a series of real-life situations, such as a man dying of AIDS in hospital (1990; see p.500). Toscani resigned in 2000 after the 'We, On Death Row' campaign, featuring inmates on death row with the slogan 'Sentenced to Death' across their portraits. Criticized by victims' rights groups and the US government, Benetton was forced to issue an apology and to make a US$340,000 charitable donation. **GC**

1 *Pentax Calendar* (1980)
Guy Bourdin • Fujicolor crystal archive chromogenic colour print
20 x 24 in. | 50.5 x 61 cm
Michael Hoppen Gallery, London, UK

2 Marc Jacobs Spring/Summer Campaign 2008 (2007)
Juergen Teller • dye transfer print

1994	2000	2001	2002	2004	2011
US photographer Steven Meisel (b.1954) shoots Prada's Autumn campaign. Meisel has shot every cover of *Vogue Italia* since 1988.	Olivieri Toscani resigns following the outcry in the United States over Benetton's 'We, On Death Row' advertising campaign.	*Exhibit A*, a posthumous collection of the work of Guy Bourdin, features the Pentax calendar image on its cover.	David LaChapelle comes to prominence with his advertising images for Lavazza.	US photographer Richard Avedon (1923–2004) shoots the Spring/Summer campaign for Christian Dior.	Cédric Buchet creates Luis Vuitton's Spring campaign featuring the model Doug Pickett on safari.

La Pietà 1992 | David Kirby's Final Moments 1990
BENETTON | THERESE FRARE b. 1958

UNITED COLORS
OF BENETTON.

Colour photograph

In November 1990, Therese Frare's photograph *David Kirby's Final Moments* appeared in *Life* magazine, printed in black and white (opposite below). It depicted AIDS victim David Kirby on the point of death. A powerful work of social documentary, the photograph won the Budapest Award in the World Press Photo Contest in 1991. The different ways in which the image appeared in the public domain, however, highlights the importance of context in terms of responses to photographic imagery.

When Benetton used a colourized version for a 'consciousness-raising' advertising campaign in 1992, it was highly controversial. Some commentators felt that it helped to promote understanding of AIDS; others argued that it promoted homophobia. Many of Benetton's critics questioned the ethics of using images that were not interpreted for the viewer and the company faced allegations of exploiting such images for their shock value. Benetton had contributed to an AIDS foundation when it secured the rights to use the image, but leading AIDS charity The Terence Higgins Trust claimed that the photograph's use in this context was offensive to those suffering from the disease. Benetton refused to financially support a campaign led by the Trust that focused on AIDS and the family.

The campaign, designed by Tibor Kalman, working with Oliviero Toscani, was certainly a groundbreaking moment for the industry: not only did the series feature no Benetton products, but it also presented negative imagery in connection with the brand. Toscani himself has said: 'I called the picture of David Kirby and his family "La Pietà" because it is a pietà which is real. The Michelangelo's *Pietà* during the Renaissance might be fake, Jesus Christ may never have existed. But we know this death happened. This is the real thing.' **GC**

✪ NAVIGATOR

FOCAL POINTS

1 KIRBY'S FACE

Many commentators have remarked on the dying man's Christlike face. Moreover, his family's poses are strongly reminiscent of figures from a 'pietà', a traditional scene in Christian art depicting the Virgin Mary and mourners with Christ's dead body after the crucifixion. The family had asked Frare to photograph their final moments with Kirby. At the time, Frare was doing voluntary work at Pater Noster House, a home for people with AIDS in Columbus, Ohio.

2 COMPASSIONATE HANDS

One of the most undeniably moving aspects of the photograph is the recurrence of hands reaching out to offer comfort. David Kirby's hands are fragile and thin, dwarfed by those of his carer (to the far left) and his father, which reach around his head to touch his face. His sister's arms encircle her daughter and her hands cup around her protectively. A religious print on the wall behind Kirby's head depicts Christ's outstretched hands.

3 COLOURIZATION

Benetton colourized the image to make it look more like an advertisement. However, this has resulted in a more painterly effect—the image is less like a photograph and more like a hand-tinted religious print. Details become less sharp and the individual personalities in the black-and-white image appear more like illustrated figures. The manipulation of the image in this way is somewhat problematic: it could be seen as an exploitation of the image for dramatic effect.

4 BENETTON LOGO

Much of the controversy sparked by Benetton's use of controversial images in its advertising campaigns stemmed from the fact that the only reference to its product was the green Benetton logo in the right-hand corner of each image. With no other reference to the company included in the photograph, and no context given, it seemed to effectively 'brand' a social issue rather than a product. Many critics found this distasteful.

▲ Frare's black-and-white photograph of AIDS activist David Kirby was taken at Pater Noster House, Columbus, Ohio in May 1990.

THE CITY

The city—the locus for ideas about the nature of modernity—remains an enduring subject of fascination for contemporary photographers. Over the course of the last century, the modernist celebration of the city, in terms of its pace of life, size, transport networks, architecture and levels of social tolerance, has given way to a more ambivalent postmodern response that recognizes the city as an agent of globalization. The wealth-generating capabilities of a global city are often underpinned by the destruction of traditional modes of work and architecture, and the waste that is generated by a city can be toxic for the environment. The strictures of family life are replaced by the alienation of a socially atomized existence.

Philip-Lorca diCorcia (b.1953) conveys his interest in the city through its inhabitants. He has photographed people at random in cities around the world, from New York to Tokyo. He documents the moments of encounter between city dwellers and turns them into glossy, large-format portraits that are displayed in galleries and museums. He often uses a tripod and, although his subjects are usually aware that he is taking a photograph, diCorcia does not speak to them. His photograph of people walking along a street (above) is one of a series taken in New York. They are shown below advertising hoardings and tall buildings that recede into the distance. One man jostles his way through the crowd, as if in a hurry, and he sports headphones that help him avoid the noise of the city around him. He appears oblivious to the man in crutches staring into the

KEY EVENTS

1980	1991	2001	2002	2005	2006
Shenzhen becomes China's first Special Economic Zone. This allows it to conduct business in a way that is not possible in the rest of mainland China.	Dutch sociologist Saskia Sassen popularizes the term 'global city' to describe a city that has become a command centre for the global economy.	The travelling exhibition 'Open City: Street Photographs since 1950' opens at the Museum of Modern Art in Oxford, England.	Japanese photographer Naoya Hatakeyama (b.1958) begins his *River Series* (2002–04; see p.504), focusing on the Shibuya river in Tokyo.	Al-Azhar Park opens in Cairo, Egypt. It uses one of the city's poorest and most populous areas to create green space.	A judge dismisses a lawsuit against diCorcia in which one of his subjects claimed that his privacy rights were violated by the publishing of an image.

502 FROM POSTMODERNISM TO GLOBALIZATION 1977–PRESENT

distance, who seems immobile and lost in his own thoughts. Such ephemeral moments do not generally feature in museum art and yet, when they are captured and put on display in the exhibition or art book, they preserve those details of a particular historical epoch that would otherwise be lost to history.

By contrast Zoe Leonard (b.1961) documents life in Manhattan's Lower East Side and Brooklyn by reference to the inanimate objects she encounters. She photographs shop fronts, signage and mundane objects in an attempt to create a portrait of contemporary society. For the series *Analogue* (1998–2007) she combed city streets with an archaeologist's eye, cataloguing the structures and detritus that give clues to what matters to people and what does not.

Chinese artist and photographer Weng Fen (b.1961), also known as Weng Peijun, travelled through the coastal cities of Haikou, Shanghai and Shenzhen to examine the rapid urban development and shift to capitalism in parts of his homeland. In the series *Sitting on a Wall*, or *On the Wall* (1998–2003), many of the images show schoolgirls with their backs to the camera, looking out across the landscape. *Sitting on the Wall—Shenzhen 1* (below) is typical of the series in that the stark realism of an unkempt foreground is balanced against the romanticism of a bright blue skyscraper flanked by glistening modern structures. The adolescent girl stares out at her future and at the country that China is becoming as she herself is becoming a woman. Weng conflates the past and the present in his exploration of the concept of an urban Utopia, and its dystopian connotations, in an age of globalization. **CK**

1 *New York* (1998)
Philip-Lorca diCorcia • Ektacolour print
25 x 36 ⅜ in. | 63.5 x 93 cm

2 *Sitting on the Wall—Shenzhen 1* (2002)
Weng Fen • chromogenic colour print
19 ⅝ x 25 ⅞ in. | 50 x 65.5 cm

2007	2007	2007	2007	2008	2011
'Global Cities' at London's Tate Modern looks at the changing faces of ten cities, including Istanbul and Tokyo, through photography and film.	Zoe Leonard's photobook *Analogue*, which documents the changing face of 20th-century urban life, is published.	Work begins on the first global financial and IT services hub in India—the Gujarat International Finance Tec-City.	The United Nations forecasts that by 2030 three out of five people will live in cities. The world's urban population will rise to nearly five billion.	Naoya Hatakeyama begins his series *Tracing Lines / Yamate-Dori*, which documents one of Tokyo's major highways.	The world has more than twenty-one mega-cities, each with populations of more than ten million people.

Shadow (# 002) from *River Series* 2002 – 04
NAOYA HATAKEYAMA b. 1958

Light jet print
21 ¼ x 19 ¼ in. | 54 x 49 cm
Museum de Pont,
Tilburg, Netherlands

N aoya Hatakeyama explores the relationship between nature, the city and photography. His images rarely feature people yet human traces are evident as he examines the impact of humanity's intervention on the landscape. He often takes the photographs from unusual perspectives that prompt the viewer to see beauty in the most surprising locations. *Shadow (# 002)* is one of a series focusing on the Shibuya river, which runs in a concrete culvert through south-east Tokyo. The title refers to the reflections on the water's surface: in the photographs he transforms an unsightly, man-made landscape into what appears to be an image of an organic form or abstract artificial environment. The title invokes the phrase used by William Henry Fox Talbot (1800–77) — 'the art of fixing a shadow' — to describe his invention of the negative/positive photographic process. This reference indicates that Hatakeyama's work is also a meditation on photography itself; he takes a picture that delineates nature, although the resulting image appears unreal. The philosophical nature of the relation between a given subject and its representation (or reflection) is emphasized by the decision to invert the image. The viewer questions the nature of the image presented, which is more akin to a painting, in particular the *Water Lilies* series (1899–1926) by Impressionist Claude Monet. Hatakeyama challenges ideas of what constitutes the real in photography. **CK**

✦ NAVIGATOR

◉ FOCAL POINTS

1 HORIZONTAL LINE
A line bisects the image. Formed by a ripple of water, its inclusion and position interrupts the picture as if it has been slashed by a knife, disrupting its visual harmony. It makes it very difficult for the viewer to ascertain where the water level is. In this way Hatakeyama disturbs notions of what is real.

2 DISTORTED REFLECTIONS
Vertical dashes of golden yellow punctuate the image and appear like splashes of paint on a canvas. They are distorted reflections of the city lights above, which lie beyond the edge of the photograph. Hatakeyama makes the ordinary and ugly appear extraordinary and attractive.

3 DIAGONAL LINE
A diagonal line sweeps across the image at the bottom right, adding dynamism and dividing the blue-grey rectangles in the picture. The line is made by the water level and is a repetition of the line between the canal and the buildings. Hatakeyama creates movement through pattern and repetition.

4 RUNGS
The three metal rungs at the bottom left corner provide a visual clue that the picture is not what it first appears to be. They allow descent into the water. Hatakeyama waded knee-deep in the dirty water of the Shibuya river, which is used as a drainage conduit, to take his photographs.

🕐 PHOTOGRAPHER PROFILE

1958–85
Naoya Hatakeyama was born in Iwate Prefecture, Japan. He studied at the University of Tsukuba and graduated in 1984.

1986–99
His first major series, *Lime Hills (Quarry Series)* (1986–91), comprised colour photographs of the workings of lime quarries. Hatakeyama began his ongoing *Blast* series in 1995, for which he uses remote-control cameras to capture the flying debris in limestone blasting operations.

2000–PRESENT
In 2000 Hatakeyama published the photobook *Underground*, showing the underground tunnels and rivers in Tokyo. In 2001 he represented Japan at the Venice Biennale. The same year he made his series *Slow Glass* in Milton Keynes, England. Inspired by science fiction novel *Other Days, Other Eyes* (1972) by Bob Shaw, it depicts city views seen through the rain on a car windscreen. He received the Photographer of the Year award from the Photographic Society of Japan in 2003. His series *Tracing Lines / Yamate-Dori* (2008–10) documents one of Tokyo's major highways.

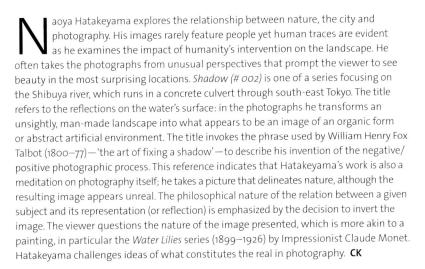

LANDSCAPE AND NATURE

Much landscape photography of the 20th century was dominated by romantic notions of the sublime, typified by the elevated, idealized vistas of the United States produced by Ansel Adams (1902–84). In 1975 the exhibition 'New Topographics: Photographs of a Man-altered Landscape' punctured the myth of the pristine panorama. Instead it fostered a postmodern aesthetic with a deadpan gaze depicting scenes littered with traces of humanity. Contemporary artists alternate between an aesthetic and a documentary mode, often combining the conceptual and the traditional in their framing of the landscape, linking it to ideas of time, memory and history.

US photographer Thomas Joshua Cooper (b.1946) situates landscape within the passage of time but with particular reference to human history. In 1968 he made a monkish vow that he has adhered to ever since, swearing to 'make art only with my 1898 Agfa camera, to only make images outdoors and to only ever make one image in any one place'. He travels the world to map photographically the extremities of the lands and islands of the five continents that surround the Atlantic Ocean. He gives this epic endeavour, which lends his work a performative aspect, an epic title, *The World's Edge—The Atlantic Basin Project* (1990–). Cooper starts by selecting specific locations on a map. Then he devises highly logistical expeditions by air, sea and land to some of the

KEY EVENTS

1981	1985	1986	1990	1995	1997
Jem Southam and Paul Graham (b.1956) bring the 'New Topographics' exhibition to the Arnolfini gallery in Bristol, England.	Andy Goldsworthy (b.1956) holds a touring exhibition of images taken of his ephemeral sculpture, *Rain, Sun, Snow, Hail, Mist, Calm*.	Richard Billingham (b.1970) premieres his *Zoo* series of video installations at the Compton Verney gallery in Warwickshire, England.	Thomas Joshua Cooper takes the first photograph for his ongoing series *The World's Edge—The Atlantic Basin Project*.	Olafur Eliasson establishes Studio Olafur Eliasson, a laboratory for spatial research in Berlin, Germany.	Abbas Kiarostami's film *Ta'm e guilass* (*Taste of Cherry*, 1997) wins the Palme d'Or at the Cannes Film Festival.

remotest places on Earth. Indeed after sailing for fifty days to reach Prime Head, the most northern point of the Antarctic Peninsula, he was told that fewer people had stood there than on the moon. However, the places that Cooper selects are not defined simply by their geographical extremity but also by their historical significance. *At the World's Edge—South-west most—Looking Towards The New World—The North Atlantic Ocean, Cabo São Vicente, Portugal* (opposite) depicts a site off the coast of Cabo São Vicente where the Portuguese explorer Ferdinand Magellan spent twenty-four hours praying before embarking on his fatal voyage to circumnavigate the globe. In memory of Magellan, Cooper performed a twenty-four-hour vigil and took this image on the twenty-fourth hour at 6 a.m. Like the rest of Cooper's seascapes, it is free from human form. It is composed entirely of ocean, exquisitely rendered. Indeed, Cooper's highly aesthetic images often seem redolent of historical notions of the sublime.

British photographer Jem Southam (b.1950) is drawn only to landscapes that change. For his series *The Shape of Time: Rockfalls, Rivermouths and Ponds* (1994–2000) he scoured his native coastline in search of rockfalls. *Seaford Head, November 1999* (below), from the series, depicts the chalk cliffs outside the town of Seaford, East Sussex. Southam is attracted by 'the idea of the Earth in a permanently fluid state, as the forces of erosion—gravity, rain, wind

1 *At the World's Edge—South-west most—Looking Towards The New World—The North Atlantic Ocean, Cabo São Vicente, Portugal* (1994)
Thomas Joshua Cooper • silver print
Haunch of Venison, London, UK

2 *Seaford Head, November 1999* (1999)
Jem Southam • chromogenic dye coupler print
36 x 45 in. | 91.5 x 114.5 cm
Robert Mann Gallery, New York, USA

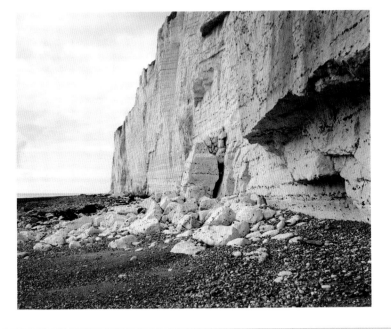

2001	2001	2001	2003	2004	2005
Southam publishes his photobook *The Shape of Time: Rockfalls, Rivermouths and Ponds*.	Tate Britain in London shows Darren Almond's *Night as Day*. It revisits the locations of paintings by J. M. W. Turner during full moon.	Hiroshi Sugimoto wins the prestigious Hasselblad Foundation International Award in Photography.	Eliasson represents Denmark at the fiftieth Venice Biennale. His installation *The Weather Project* opens at Tate Modern in London.	Southam's landscape photographs of Cornish Clay Country mines commissioned by the Tate are shown at Tate St Ives in Cornwall, England.	Kiarostami has his first UK photography exhibition. It is held at the Victoria and Albert Museum in London.

and wave—shape the land through time'. He has talked about the gradual, day-to-day changes that geologists describe as 'creep', such as breaking waves dragging shingle down a beach or the slippage of a tiny stone from a rock face, and contrasts this with notions of deep time: the almost incomprehensible vastness of the geologic timescale. Southam's work attempts to draw the two temporal scales together. In *Seaford Head* the layers visible in the rock face are more than eighty million years old, from the Late Cretaceous period. The rockfall appears tamed by weathering and erosion but the boulders hint at the cataclysmic event that once brought them crashing down. People's perception of time tends to be gauged by the span of their lives. Southam adds: 'This was a particular reflection making the "Rockfalls" pictures through the 1990s when my children were born and began their lives, while their grandparents entered into the final stages of theirs.' The series is a reminder that experiences of time different to the viewer's are recorded in the landscapes that surround him or her.

Japanese photographer Hiroshi Sugimoto (b.1948) also measures the landscape through time. He arrived at his series *Seascapes* (1980–2002), which includes *North Atlantic Ocean, Cape Breton Island* (1996; see p.510), during a quest to find a scene that has remained the same since the dawn of humankind. The work of British photographer Darren Almond (b.1971) explores the effects of time on the individual. He started practising night photography for his *Fullmoon* series in 1998, using moonlight and an extremely long exposure. The result is an ongoing series of landscapes bathed in an eerie brightness, in which night appears transformed into day, as seen in *Fullmoon @Yesnaby* (2007; see p.512).

Olafur Eliasson (b.1967) spends several months a year in Iceland making a near-encyclopaedic photographic inventory of its geological formations: from caves to glaciers, islands to rivers. Nearly all his subjects are fixed with crystalline clarity, often composed frontally and uncropped. Anything picturesque is avoided. His seemingly straightforward presentation invokes the language of documentary where the subjective is suppressed in favour of purported objectivity. It is an approach that finds clear precedents in the New Topographics

movement where a lack of style became the style. Eliasson's *Jokla Series* (opposite) follows the Jokla river across vast tracts of land from its source in Iceland's biggest glacier, Vatnajokull. Eliasson resorted to aerial photography, much as a scientific surveyor might map the topography of the land, creating forty-eight images. The bird's-eye perspective confuses the viewer's sense of scale; the large geological valleys and rifts visible at ground level appear like stark graphics. Eliasson heightens this sense of abstraction by arranging the images in a grid, just as Bernd (1931–2007) and Hilla Becher (b.1934) did with their industrial structure typologies. The grid encourages the formal aspects of each image to come to the fore; the Jokla river snakes through each picture like a black line punctuated into a series of semaphores. Eliasson rejects a traditional portrayal of a landscape; *Jokla Series* is simultaneously abstract sculpture and aerial survey, vacillating between expressive subjectivity and scientific objectivity. He states: 'Our ability to re-evaluate existing structures and systems, such as the still prevalent modernistic ideas about space and their value systems, requires a critical engagement with the world...what we must do is challenge the ways in which we engage with our surroundings.' The series does this; it frames the landscape as a spatial experience that morphs according to one's perspective.

The landscapes of Abbas Kiarostami (b.1940) relate to the everyday. His series *Rain* (2005) depicts rain-splattered car windows. The Iranian filmmaker is less well known as a photographer even though he has used the medium since the 1970s. His photography tends towards the cinematic, using *mise en scène* to create meaning: carefully composing, even constructing, landscape. For the image below he turned off his car windscreen wipers: 'I wanted the raindrops to remain on the glass. Everything we can see in the photographs—the yellow-brown, the green, the black—we owe to the light. It's the reflection of the light on the raindrops that gives the pictures these subtleties and nuances.' The rain emphasizes the car window by tracing patterns across its surface, breaking down the view of the world beyond. A fleeting, seemingly insignificant moment becomes a beautiful meditative space; an element of the sublime is frozen within the everyday. **JMH**

3 *Jokla Series* (2004)
Olafur Eliasson • forty-eight
chromogenic colour prints
14 ¾ x 22 in. | 37.5 x 56 cm each
103 ⅛ x 186 ¾ in. | 262 x 474.5 cm series
Museum of Modern Art, New York, USA

4 From *Rain* (2005)
Abbas Kiarostami • chromogenic
colour print
18 ½ x 27 ½ in. | 47 x 70 cm
Pari Nadimi Gallery, Toronto, Canada

North Atlantic Ocean, Cape Breton Island 1996
HIROSHI SUGIMOTO b. 1948

Silver print
46 ⅞ x 58 ¾ in. | 119 x 149 cm
Hirshhorn Museum, Smithsonian
Institution, Washington, DC, USA

 NAVIGATOR

Hiroshi Sugimoto's *North Atlantic Ocean, Cape Breton Island* is from his third series, *Seascapes* (1980–2002). The inspiration for the series came to him on a night in New York in 1980. He pictured the great volcanoes of Mount Fuji and Mount Hakone, and realized that their topography had altered over the years. Then he understood: 'Although the land is forever changing its form, the sea, I thought, is immutable. Thus began my travels back through time to the ancient seas of the world.' His twenty-two-year odyssey took him to every continent in the world.

Like landscapes, seascapes often prompt metaphysical musings and in particular the seemingly infinite stretch of a marine horizon. The 19th-century French writer and naval officer Pierre Loti, in his novel *Pêcheur d'Islande* (*An Iceland Fisherman*, 1886), has been quoted with reference to Sugimoto's seascapes. The novel's hero reflects: 'This horizon, which indicated no recognizable region of the Earth, or even any geological age, must have looked so many times the same since the origin of time, that, gazing upon it, one saw nothing save the eternity of things that exist and cannot help existing.' Not only have marine horizons remain unchanged since humans first walked the Earth, but they also depict any period in the Earth's history since the oceans formed, and indeed any point going forward. Sugimoto's description of his seascapes as 'immutable' suggests that they stand outside time. **JMH**

👁 FOCAL POINTS

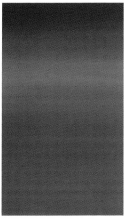

1 AIR

The seascapes vary in exposure times. A daytime exposure takes between 1/30th and 1/60th of a second, but a night exposure takes longer. Although this particular seascape is a long exposure—it took one and half hours to burn itself on to the film—it is unusual among the night seascapes. Most of the night seascapes in the series have similar exposure times to the day seascapes; fewer than ten per cent of the night examples are long exposures.

2 MOON ON SEA

Sugimoto said: 'I don't want to photograph the moon itself, but its passage over the water and the light it throws.' He had to calculate the line the moon would track through the night sky before taking the exposure. He elaborated: 'It has to be south or south-east of the position of the camera.'

3 SEA

To obtain the powdery sea effect, Sugimoto used an 8 x 10-inch sheet of Kodak Plus-X 125 ASA film in his Deardorff camera mounted on a tripod. He then put a 16x neutral-density filter on the camera lens. It reduced the film's sensitivity to well below one ASA, enabling him to make such a long exposure. Sugimoto has commented, 'That's like the speed of 19th-century film, when photography was invented.'

4 HORIZON

Sugimoto took this image from a high vantage point on land, which enabled him a clear view of the marine horizon. The horizon cuts like a knife across the frame, bisecting the composition into two optically equal but not identical halves. It runs at the same position throughout the whole series.

▲ *Black Sea, Ozulice* (1991). Sugimoto has said of his *Seascapes*: 'Water and air. So very commonplace are these substances, they hardly attract attention—and yet they vouchsafe our very existence'.

🕐 PHOTOGRAPHER PROFILE

1948–70

Hiroshi Sugimoto was born into a family of merchants in Tokyo, Japan. He was given his first camera at the age of twelve. Sugimoto graduated in politics and sociology from Rikkyo University, Tokyo after which he travelled to the Soviet Union.

1971–75

Sugimoto moved to the United States, settling in California. He retrained as an artist, enrolling at the Art Center College of Design in Los Angeles. After graduating in 1974, Sugimoto moved to New York, where he worked as a photographer and antique dealer.

1976–79

Inspired by the displays in New York's American Museum of Natural History, Sugimoto began work on his series *Dioramas* featuring natural history displays. Two years later he produced the series *Theatres*, which depicts the screens and architecture of cinemas.

1980–99

Sugimoto started to photograph the first of his many seascapes in 1980. He produced the *Sea of Buddhas* series in 1995. For his series *Portraits*, begun in 1999, Sugimoto photographed wax models based on historical figures from the 16th century up to prominent figures of the present day. He attempted to recreate the lighting that the original painters would have used.

2000–PRESENT

The *Architecture* series (2000–03) features blurred photographs of famous examples of modernist architecture. Sugimoto is also an architect and restored the Go-oh Shrine at Naoshima in Japan. In 2009 he used a 400,000-volt Van der Graaff generator to apply an electrical charge directly on to film for his series *Lightning Fields*. In 2010 he set up the Odawara Art Foundation.

Fullmoon@Yesnaby 2007
DARREN ALMOND b. 1971

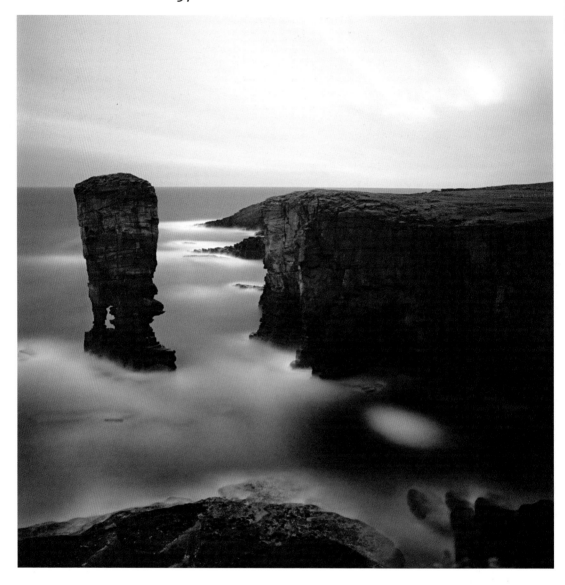

Chromogenic colour print mounted
on to aluminium
50 ¼ x 50 ¼ in. | 127.5 x 127.5 cm
White Cube, London, UK

D arren Almond has said of his *Fullmoon* (1998–) series: 'There's something about the light in these photographs that isn't daylight. You're not quite sure whether this landscape actually exists—it looks fictitious or overly ideal. There's a strange kind of depth of field and the quality of light that keeps you trapped in.' Moreover, because the images are of remote locations at night, they are always free of people, indeed any trace of humanity. The ethereal light bathes the vast and empty vistas, conjuring up eerie otherworlds that exist within and yet apart from the Earth.

The series also interrogates the experience of time. The photograph is usually associated with the snapshot: capturing and stilling a moment. Yet here, Almond left the shutter open for tens of minutes. This enabled the light in the nocturnal landscape to score the surface of the film gradually. During the camera's patient vigil, an image emerged out of darkness. Almond also situated the series in a different time frame. The book that features *Fullmoon@Yesnaby* is called *Moons of the Iapetus Ocean* (2008), named after a sea that existed some 400 to 600 million years ago between England and Scotland, near where Almond took his photographs. Just as Hiroshi Sugimoto's *Seascapes* (1980–2002; see p.510) can be situated within deep time, so too can Almond's moonscapes. They reveal a world within the Earth from aeons past. **JMH**

◉ FOCAL POINTS

1 MOON'S RAYS
The shafts of light from the bank of cloud look like rays of sunshine, yet they emanate from the moon. Almond is drawn to moonlight: 'When I moved to London I really started to miss the moonlight and my relationship with the moon. . .I wanted to go back and find it again.'

2 CIRCULAR PATCH OF LIGHT
The moonlight seems to travel strangely. The bright circular patch of light where the sea lies darkest beneath the black cliff face appears from nowhere; there is no other illumination nearby and the source of light is perplexing. The light appears to flow like liquid across the landscape.

3 INDIGO-COLOURED SEA
The moonscape reveals a world that the human eye cannot see. Almond's long exposures wait for colours to appear: colours that are almost true of daylight. Here the sea takes on dark shades of indigo while the sky appears in tonal striations of aqua blue, the cliff-top vegetation as grey-green.

4 APPEARANCE OF FOG
Motion is blurred. In particular, the pounding of the waves on the stack has imprinted itself on the negative and morphed into something that looks more like a dense, creeping fog. Almond would have left the shutter of his medium-format camera open for between fifteen and forty-five minutes.

◷ PHOTOGRAPHER PROFILE

1971–94
Darren Almond was born in Appley Bridge, near Wigan, in Lancashire, England. He graduated in fine arts from Winchester School of Arts, then moved to London.

1995–97
Almond had his first solo exhibition at Great Western Studios in London, where he showed *A Real Time Piece* (1995), a live video link that showed his empty studio with an industrial flip-clock. Three years later he was selected to exhibit in Charles Saatchi's 'Sensation' touring exhibition, which opened at the Royal Academy in London in 1997. He was the youngest artist to have work in the show.

1998–2004
In 1998, as an experiment, he made a long exposure of a moonlit landscape; it became the first image in the *Fullmoon* series. In 2003 he was selected for the Venice Biennale.

2005–PRESENT
Almond was shortlisted for the Turner Prize in 2005. In 2008 his show 'Moons of the Iapetus Ocean' opened at the White Cube, London and his book of the same name was published.

THE MAN-ALTERED LANDSCAPE

During the last thirty years, photographers have sought to document the impact of industry on the land. John Davies (b.1949) photographed areas of the British landscape, such as *Agecroft Power Station, Salford* (1983; see p.516), that were powerhouses during the Industrial Revolution but that have since experienced the devastating effects of economic decline.

Canadian photographer Edward Burtynsky (b.1955) has also made the man-altered landscape a key feature of his oeuvre. His large-scale prints, often taken from aerial or elevated angles, reveal the horror and beauty of industrial scenes. After hearing a radio broadcast about the Valdez oil spill and the decommissioning of single-hull tankers, Burtynsky decided to go to Bangladesh. He investigated where the tankers were being taken apart and there discovered a recycling industry employing a vast swathe of people, often working in appalling conditions. He said of his trip to Bangladesh in 2000: 'I felt . . .as though I was stepping back a hundred years. There are undoubtedly a lot of parallels one could draw between what I encountered and what Dickens witnessed during the Industrial Revolution in England—young people working,

no rules or regulations, people getting hurt. The marine paint being cut was probably enough to make one ill, not to mention the toxic substances inside the hulls.' Yet there is a stark beauty to his images, such as *Shipbreaking #11, Chittagong, Bangladesh* (opposite). The strong colours and colossal scale of the ship's hull rising from what appears to be an almost post-apocalyptic landscape have an uplifting effect on the viewer despite the evident decay.

Few artists who feature man-altered landscapes in their work make direct comment on the subject; viewers are offered both industrial splendour and the tragedy of the environmental cost. However, US photographer Joel Sternfeld (b.1944) recognized the opportunity to promote one environmental project: to open a disused railway line in New York to the public as an urban walkway. The West Side Line elevated freight railroad spur running through western Manhattan lay abandoned and closed off. Sternfeld took a series of photographs at various locations throughout the landscape, charting seasonal changes and revealing an undiscovered natural paradise that runs like a vein through an urban environment. The images were reproduced in a book, *Walking the High Line* (2002), and were a revelation to many people. The railway tracks serve to anchor the skyline of New York, creating a newly seen topography for the city. However, the true revelation is the reclamation of the train tracks by nature as seen in images such as *A Railroad Artifact, 30th Street, May 2000* (below). The area is now open to the public and is known as the High Line linear park. **CB**

1 *Shipbreaking #11, Chittagong, Bangladesh* (2000)
Edward Burtynsky • chromogenic colour print

2 *A Railroad Artifact, 30th Street, May 2000* (2000)
Joel Sternfeld • digital chromogenic colour print
39 ½ x 50 in. | 100.5 x 127 cm
Collection of Luhring Augustine, New York, USA

1990	1992	2006	2006	2009	2010
Bernd (1931–2007) and Hilla Becher (b.1934) win the Golden Lion at the Venice Biennale for their photographs of industrial structures.	Wout Berger (b.1941) publishes his photobook *Poisoned Landscape*. It records 170 chemical waste dump sites in the Netherlands.	Edward Burtynsky's documentary film about China, *Manufactured Landscapes*, features sites such as the Three Gorges Dam.	John Davies publishes his photobook *The British Landscape*, a survey of his British landscape work from 1979 to 2004.	Burtynsky's five-year international touring exhibition, 'Oil', opens at the Corcoran Gallery of Art in Washington, DC.	'Permanent Error' by Pieter Hugo (b.1976) opens in Cape Town, South Africa. It depicts people living on a vast dump of obsolete technology in Ghana.

Agecroft Power Station, Salford 1983

JOHN DAVIES b. 1949

1 COOLING TOWERS
The four cooling towers dominate the landscape. Davies places them at the centre of his picture, showing them receding into the distance. His composition and use of perspective highlight the towers' monumentality and their repetitive, curvaceous, geometrical forms.

2 FOOTBALL MATCH
The football match being played near to the power station reflects on the connection between work and leisure in England that dates to the Victorian era. The players and their area of recreation appear tiny in comparison to the architectural structures that loom behind them.

NAVIGATOR

In 1981 John Davies began a series of photographs documenting Britain's changing industrial and post-industrial landscape. The images were later published in the book *A Green & Pleasant Land* (1987). The title is taken from the hymn 'Jerusalem' (1916), written by Sir Hubert Parry and based on a poem by William Blake that refers nostalgically to a landscape disappearing in the wake of industrial development. Davies photographed areas of northern England and south Wales that were powerhouses of the Industrial Revolution in the 19th century in order to reveal how they had shaped the urban environment. *Agecroft Power Station, Salford* was taken near Manchester, using a large-format camera, from a vantage point that ensures that the figures in the landscape are dwarfed by the cooling towers behind. He photographed the scene in black and white, and the dark tones emphasize the stark landscape. The cooling towers are impressive structures that possess a formal and functional beauty, similar to the industrial structures seen in the work of German photographers Bernd and Hilla Becher. Unlike the Bechers' typological approach that isolated their subjects, Davies situates his cooling towers in the landscape: his image of the man-altered landscape is more romantic than conceptual in style. *Agecroft Power Station, Salford* reminds the viewer of the demise of the coal-mining industry on which this coal-fired power station depended. At the time the photograph was taken the power station was functioning: the water vapour coming out of the tall, hyperbolic-shaped cooling towers is visible. Davies's work has been described as 'narrative landscape' and this image tells a story of industrial decline. It has since acquired a certain poignancy because it depicts a vista that no longer exists—in 1994 the cooling towers were demolished. **CB**

Silver print
15 ⅛ x 22 in. | 38 x 56 cm
San Francisco Museum of Modern Art, USA

3 TREES
Trees fringe the lower part of the photograph and the outline of a hilltop is visible in the centre right. Davies does not show an idealized countryside, rather a semi-rural landscape that coexists with one altered by man in what is part of a complex, 20th-century environment.

4 CARS AND RUBBISH
Davies's photograph is filled with layers of detail that are revealing about contemporary society's uneasy relationship with the environment. A line of cars is parked next to a pile of rubbish, underlining how humanity's interaction with nature can be chaotic, with grave consequences for nature.

STILL LIFE

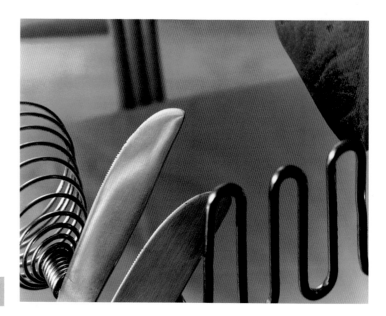

1 *Untitled* (1978)
Jan Groover • chromogenic colour print
14 ⅞ x 19 ⅛ in. | 37.5 x 48.5 cm
Museum of Modern Art, New York, USA
Reproduced courtesy of Janet Borden, Inc.

2 *Ancien réchauffoir du capitaine des
gardes, Corps Central—R.d.C., Versailles,
France* (1986)
Robert Polidori • chromogenic
colour print
40 x 50 in. | 101.5 x 127 cm
Flowers East, London, UK

The notion of a conceptual approach in photography—which has been
prevalent in art since the 1960s—may, at first, seem to marginalize the
traditional genre of still life and its complementary subject, the interior
view. However, in the hands of some notable artists, both subjects have been
reinvigorated. Jan Groover (1943–2012) is best known for her still lifes of kitchen
utensils, in which her gaze transforms everyday items, such as spatulas, spoons,
knives and egg cups, into artful compositions (above). Created predominantly in
1978 and 1979, the series garnered critical acclaim. John Szarkowski (1925–2007),
the former director of photography at the Museum of Modern Art in New York,
hailed her alongside great names from photography's past, saying, 'In the next
generation I can think of only one whose work—for fecundity of invention and
quality—invites comparison with that of Edward Weston (1886–1958) and that
one is Jan Groover.' The comparison is apt because Groover, like Weston, often
favours form over content, but goes as far as to almost erase the subject in her
work. Her compositions juxtapose different items, featuring only their edges
and often foreshortening them beyond recognition. Surface is as important
as shape, whether it is the reflection of a knife or the transparency of a mixing
bowl. Equally as important as the objects themselves are the spaces between
them. The photographs in Groover's series therefore become less images of
kitchen utensils and more complex, sometimes abstract, spatial arrangements
of shapes, colours and textures.

KEY EVENTS

1978	1979	1982	1985	1987	1993
Jan Groover turns her attention from outdoor shots of cars and highways to the still life imagery of kitchen objects for which she is best known.	Thomas Ruff (b.1958) begins his *Interiors* series. It shows single elements within rooms simply, while still capturing the essence of the space.	Uta Barth exhibits for the first time in a group exhibition at the Joseph Dee Museum of Photography, San Francisco.	Robert Polidori wins a commission to document the restoration of the Château de Versailles —a project that lasts over twenty-five years.	Groover has a solo exhibition at the Museum of Modern Art, New York, which then goes on tour until 1989.	Spanish photographer Miguel Rio Branco (b.1946) includes a mix of atmospheric still lifes, interior shots and portraits in his *Santa Rosa Boxing Club* series.

By contrast, Canadian photographer Robert Polidori (b.1951) privileges form and aesthetics in his imagery not to eradicate but to emphasize its subject. He began the *Versailles* series in 1985, and it documents a near-encyclopaedic experience of the refurbishment at the Château de Versailles, Paris, comprising meticulously observed, seductively toned photographs. The images are so large that viewers feel as though they could walk into them. *Ancien réchauffoir du capitaine des gardes, Corps Central—R.d.C., Versailles, France* (below) shows a room with its walls stripped and furniture covered in dust sheets. Polidori took a second image of this room in 2005, capturing it in all its restored glory—its walls adorned with gilt-framed oil paintings, marble busts and grand lanterns.

US photographer Robert Mapplethorpe (1946–89) created works, such as *Calla Lily* (1986; see p.520), that placed the emphasis firmly on the subject. Whether photographing a female bodybuilder, marble statue or flower, he aimed to transform each one into the apogee of classical beauty. Berlin-born artist Uta Barth (b.1958) takes a very different approach. She explains that while most artists tend to focus either on the subject shown (as with Polidori and Mapplethorpe) or on formal ways of depicting a subject (as with Groover), she focuses on 'everything that is peripheral rather than central'. As a result, her work becomes an investigation of the act of taking a photograph and a meditation upon the pleasures of everyday observation. **JMH**

1997	1997	2001	2005	2007	2009
Inspired by a Paul Auster novel, Sophie Calle (b.1953) creates and photographs seven colour-coordinated meals, which she calls *The Chromatic Diet*.	Polidori travels to Cuba to begin the series *Havana*, which he continues in 2000 and completes in 2002.	Polidori visits the Ukraine to document the aftermath of the Chernobyl nuclear disaster from inside the exclusion zones.	Polidori photographs New Orleans in the wake of Hurricane Katrina. His images of the damaged homes bear testimony to the chaos left behind.	Barth exhibits her *Sundial* series at the Tanya Bonakdar Gallery, New York. In it, she tracks the sunlight as it filters through the windows of her home.	Wolfgang Tillmans (b.1968) creates *Faltenwurf (Morgen) II*, continuing the series of discarded clothes still lifes that he has developed since 1989.

Calla Lily 1986
ROBERT MAPPLETHORPE 1946 – 89

Silver print
36 ½ x 36 ½ in. | 93 x 93 cm
Solomon R. Guggenheim
Museum, New York, USA

Robert Mapplethorpe took a wide range of flower still lifes from the late 1970s until just months before his death in 1989. Tulips, orchids, irises, poppies and lilies were eternalized in his depiction of them. He nearly always divorced his flower subjects from nature by isolating them against the black backdrop of his studio. Although he often photographed flowers at the peak of their bloom, without the slightest blemish, this version of *Calla Lily*, which was created the same year that he was diagnosed with AIDS, shows the elegant flower in decay. Over the next few years, he returned to the lily as his subject again and again. His photographs alluded to the 17th-century tradition of vanitas paintings in which fruits and flowers—including the lily—symbolized life's impermanence. However, in this image, Mapplethorpe has halted the process of decay, preserving the inflorescence in glorious perfection for eternity. Just as he was confronted with his own inevitable decline and death, he used photographs such as this one to offer immortality to the subjects in front of his lens.

Calla Lily adorned the cover of the book of the last exhibition curated while Mapplethorpe was still alive—'Robert Mapplethorpe: The Perfect Moment.' Janet Kardon, the curator of the exhibition, noted how 'a flower—poised, open, awaiting the bee—is an analogue of sexual readiness'. Arguably *Calla Lily* exudes less seduction than danger. It emerges from darkness to occupy the frame aggressively, and the tip of its petal seems to curl into a talon, or even a poisonous sting. **JMH**

◷ PHOTOGRAPHER PROFILE

1946–62
Robert Mapplethorpe was born in Long Island, New York, the third of six children in a middle-class family. When he was sixteen years old he moved to Brooklyn.

1963–72
He enrolled to study drawing, painting and sculpture at the Pratt Institute, Brooklyn. In 1967, he met Patti Smith and three years later they moved into the Chelsea Hotel, Manhattan together. The same year, he acquired a Polaroid camera and began producing his own photographs.

1973–76
In 1973 Mapplethorpe exhibited his Polaroids with Andy Warhol (1928–87) and Brigid Polk (b.1939) above the Gotham Book Mart, New York. In 1973 he exhibited his Polaroids, displayed in Plexiglass boxes, in a solo show at New York's Light Gallery. In 1975 he acquired a Hasselblad camera to work with negative film and light. This was also the period in which he began photographing flowers.

1977–87
Mapplethorpe produced a prolific body of work, from sadomasochistic photographs through images of flowers, the naked human form and sculptures to portraits of artists and celebrities. In 1977 he participated in Documenta 6 in Kassel, Germany. This was followed by shows at the Robert Miller Gallery, New York, the Frankfurter Kunstverein, Frankfurt and the Institute of Contemporary Arts, London, to name but a few. In 1986, he was diagnosed with AIDS.

1988–89
In 1988 the first retrospective of his work took place at the Whitney Museum of American Art, New York. Mapplethorpe died from an AIDS-related illness on 9 March 1989.

THE PERFECT MOMENT

'The Perfect Moment' opened in December 1988 and featured more than 150 works, including nudes and still lifes such as *Calla Lily* (1988; below). The show ran successfully at most venues but was cancelled before opening at Washington's Corcoran Gallery of Art in 1990. At the time a debate on arts funding and censorship was raging after the furore over Andres Serrano's *Piss Christ* (1987; see p.438). When the show reached Cincinatti's Contemporary Arts Center in April 1990, police seized seven 'sexually explicit' works and arrested the director. The works were later returned and the director acquitted.

STAGED PHOTOGRAPHY

S taged photography comprises work in which events or images are staged for the camera. The construction of the photographic image challenges the notion of photography as a medium that records the real. There are two distinct but overlapping approaches. Firstly, there are photographers whose work is cinematographic in inspiration and method, as seen in images by Gregory Crewdson (b.1962), who is known for elaborately staged tableaux such as *Untitled (Ophelia)* (2001; see p.528). Secondly, there are photographers who produce an image or model for the camera. For example, in *Action Photo, after Hans Namuth* (1997; see p.526), Vik Muniz (b.1961) recreates a photograph of artist Jackson Pollock creating *Autumn Rhythm, Number 30* (1950) but using chocolate syrup. The two approaches have much in common: a tendency for large-format, colour tableaux similar to history paintings and a narrative element that is especially evident in the cinematographic type of staged photography. The genre is often discussed in terms of contemporary work, but can be traced back to the medium's origin. *Self-portrait as a Drowned Man* (1840) by Hippolyte Bayard (1807–87) is perhaps the earliest image showing photography's potential to subvert the documentary role so often ascribed to it.

KEY EVENTS

1977	1981	1985	1987	1988	1993
Douglas Crimp publishes his 'Pictures' essay in the journal *October*; it highlights the staged photography of US artist Cindy Sherman.	Sandy Skoglund's work is included in the exhibition 'Staged Shots' at the Delahunty Gallery in Dallas, Texas.	Sherman, James Casebere and Joel-Peter Witkin are featured at the Whitney Museum of American Art Biennial in New York.	Art historian and curator Anne H. Hoy publishes her book *Fabrications: Staged, Altered, and Appropriated Photographs.*	Sherman dons make-up, prosthetics and costumes for her *History Portraits* (1988–90) series, which references painters and their masterpieces.	Jeff Wall completes *A Sudden Gust of Wind (After Hokusai)*, which combines staged photography with digital-imaging techniques.

Canadian artist Jeff Wall (b.1946) is the most celebrated practitioner of staged photography, although Wall himself rejects this description, emphasizing that there are degrees of stagedness in much photography. He concedes that his sitters are directed but argues that their behaviour is equally real. Preparation and collaboration are crucial to Wall's work. He is an art historian and critic as well as an artist, and his work often references the history of painting. *Double Self-portrait* (opposite) is a transparency presented as a lightbox that confronts the viewer with two Jeff Walls posing for the camera. Whereas the one on the left appears stand-offish, the one on the right is more open and welcoming—he even seems to be offering the viewer the chair in the foreground. On closer inspection the viewer becomes aware of a photograph that seeks to undermine its illusion: the apparent domestic space is unconvincing and, in large versions of the image, the seam between the two transparencies is visible.

US artist Sandy Skoglund (b.1946) uses animals in her staged photography, albeit ones that she has formed in clay and cast in resin. She creates installations for the camera featuring tableaux in which seemingly ordinary houses and landscapes are subjected to bizarre invasions, as in *Revenge of the Goldfish* (below). Although the photograph looks like it has been digitally manipulated, it depicts an actual interior in which Skoglund suspended handmade, terracotta, bright orange fish. Like Wall, Skoglund constructs staged tableaux for the camera but, in contrast to Wall, there is some ambiguity with

1 *Double Self-portrait* (1979)
Jeff Wall • Cibachrome silver dye bleach transparency, aluminium light box
67 ¾ x 90 ⅛ in. | 172 x 229 cm
Art Gallery of Ontario, Canada

2 *Revenge of the Goldfish* (1981)
Sandy Skoglund • Cibachrome print
25 ⅝ x 32 ⅝ in. | 65 x 83 cm
Collection Frac Lorraine, Metz, France
Revenge of the Goldfish © 1981
Sandy Skoglund

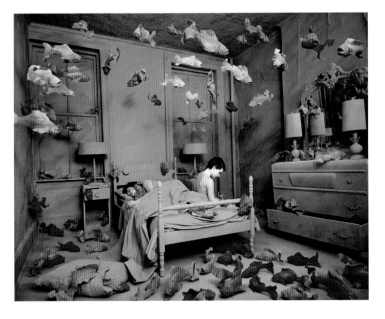

1995	1998	1999	2004	2006	2009
Wall publishes his influential essay '"Marks of Indifference": Aspects of Photography in, or as, Conceptual Art'.	Gregory Crewdson begins his *Twilight* series. By working with a large production crew, he takes staged photography to a new level.	Vik Muniz creates *Double Mona Lisa, After Warhol* using peanut butter and jam.	The large-scale tableaux of Crewdson's series *Beneath the Roses* evoke eerie scenes of small-town life in the United States.	'Acting the Part: Photography as Theatre' opens at the National Gallery of Canada. It includes work by Sherman, Wall and Morimura.	'Theatres of the Real' opens at the Fotomuseum Antwerp, Belgium featuring the work of eight photographers working in the United Kingdom.

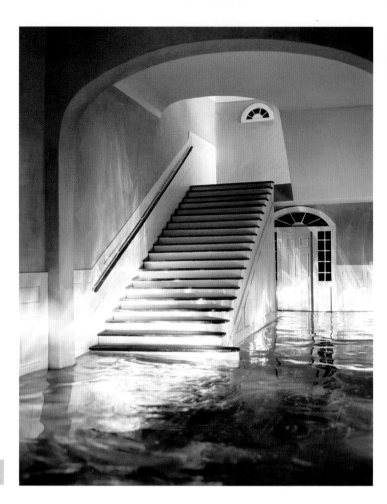

3 *Green Staircase #1* (2002)
James Casebere · digital chromogenic
colour print mounted to Plexiglas
60 x 48 in. | 152.5 x 122 cm
Sean Kelly Gallery, New York, USA

4 *Woman in the Blue Hat, New York* (1985)
Joel-Peter Witkin · toned silver print
16 x 20 in. | 40.5 x 51 cm
University of Virginia Art Museum,
Charlottesville, USA

regard to the final work that results from the staging. In 1981 *Revenge of the Goldfish* appeared as an art installation at the Castelli Graphics gallery in New York. The installation showed the interior as a type of stage set minus the actors shown in the photograph, again deconstructing the final seamless image seen in the photograph. Although Skoglund's installations are staged, they can also be seen to exist as independent works of art.

US artist James Casebere (b.1953) produces miniature installations for the purpose of photographing them. He constructs three-dimensional architectural spaces using materials such as museum board, Styrofoam and plaster. Often these table-top models imitate institutional or domestic spaces and the resulting large photographs, with their moody lighting, have a disquieting effect. The viewer is unsure whether what they are seeing is real and this unease is compounded by the fact that Casebere depicts buildings that appear both familiar and yet strange. *Green Staircase #1* (above) is a photograph of a model of the entrance hall of a US colonial home. Looking closer the viewer can see the level of attention to detail in the rendering of the Neoclassical features, but also notices that the building is flooded. According to the artist, the flooding is a metaphor for the passage of time, as well as fullness and an excess of emotion.

German artist Thomas Demand (b.1964) is also known for his photographs of constructed three-dimensional spaces. In contrast to Casebere, many of Demand's models are inspired by stories and photographs from the media.

He recreates the original spaces and scenes, usually life size, in materials such as paper and cardboard. His models are based on photographs of actual buildings and are destroyed once they have been photographed. The tableaux depict banal interiors, yet their apparent banality can belie the disturbing events that took place in their space. *Corridor* (1995) recreates the hallway leading to serial killer Jeffrey Dahmer's Milwaukee apartment, while the series *Tavern* (2006) depicts an inn in Burbach, Germany where a child was kidnapped and murdered.

US artist Joel-Peter Witkin (b.1939) produces staged tableaux that are highly distinctive in terms of their subject matter, sitters, props and theatrical staging. His choice of subjects, notably his erotic representations of people who are intersex or have physical abnormalities, has caused controversy but his work sets out not to shock so much as to challenge assumptions of gender and normality. *Woman in the Blue Hat* (below) exemplifies his theatrical approach to staging. Wearing a blindfold, a hat and her underwear, the woman appears to be seated on a stage complete with a painted backdrop and ornate curtain, and the focus is on her gestures and unusual proportions. The woman in the picture, theatrical agent and actress Jackie Tellafian, uses a wheelchair but has rejected criticism that the picture exploits her or sensationalizes her disability. The toning of the silver gelatin print gives an intensity to the image that speaks more of artistic fiction than photographic reality.

Photography lends itself to appropriation and re-enacting or remaking is a common trope in staged photography. US artist Cindy Sherman (b.1954) has restaged Old Master paintings, with herself in the place of Michelangelo Merisi da Carravagio's *Young Sick Bacchus* (c. 1593–94). The Japanese artist Yasumasa Morimura (b.1951) has not only restaged French painter Edouard Manet's *Olympia* (1863) but re-enacted staged photography too; *To My Little Sister: For Cindy Sherman* (1998) restages Sherman's *Untitled #96* (1981) with Morimura playing the role of Sherman. **SP**

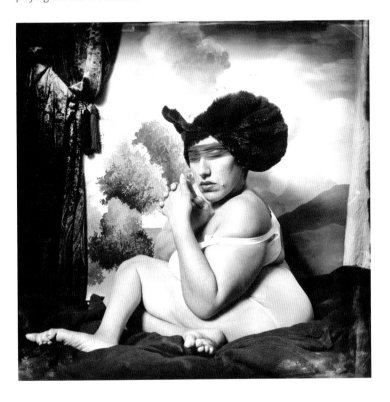

Action Photo, after Hans Namuth 1997

VIK MUNIZ b. 1961

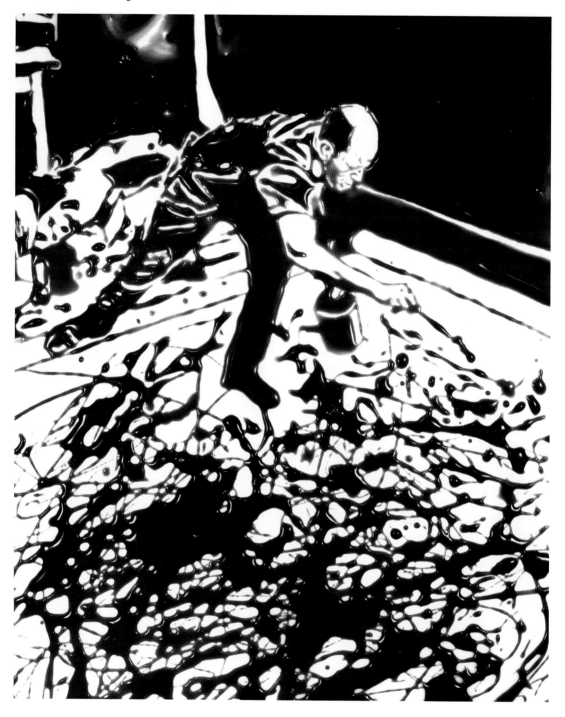

Chromogenic colour print
Museum of Modern Art,
New York, USA

V ik Muniz is a Brazilian artist based in New York. His art consists of photographs, but he is not a conventional photographer. He creates images to be photographed, which survive only as photographic imagery. Often remaking famous artworks or iconic photographs, he presents viewers not with this re-creation but with its photographic reproduction. Muniz's subject matter sometimes resonates with his choice of material, as is exemplified by the series *The Sugar Children* (1996) in which portraits of the children of sugar cane plantation workers are rendered in sugar. Muniz's *Pictures of Chocolate* series (1997) consists of photographs of drawings made in Bosco chocolate syrup. *Action Photo, after Hans Namuth* is a copy in chocolate of one of the photographs German photographer Hans Namuth (1915–90) took of the artist Jackson Pollock at work on an action painting—*Autumn Rhythm (Number 30)*—in 1950.

Muniz's selection of source material is significant because he returns the photographic image to its painterly origin. The entire image is rendered in chocolate, including Pollock, his paintbrush and paint pot. The mess on the floor looks like a painting by Pollock, but it is also a pool of chocolate. Pollock himself is swallowed up by the material that renders him visible. The chocolate has many connotations, from luxury and desire to the scatological. The reduction of everything to the materiality of chocolate is a playful response to the reification of Jackson Pollock. **SP**

✪ NAVIGATOR

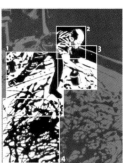

◉ FOCAL POINTS

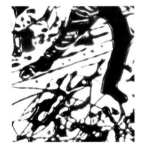

1 FEET AND CANVAS
Pollock stands with one foot on the canvas and the other beyond its edge. Placing the canvas on the floor was important to Pollock's drip painting technique. Muniz's transformation of the photograph into chocolate serves to restage painting as an event.

2 MONOCHROME
The monochrome image is rendered entirely consistently throughout. Pollock and his surroundings are all chocolate. Muniz's 'painting' method recalls fresco painting and the 'wet into wet' technique of painting directly on to a newly plastered wall rather than by building up layers.

3 POLLOCK'S ARM
Pollock's right arm is outstretched in the Namuth photograph and the brush that he holds is blurred because of the speed of his movement. Muniz recreates the dynamic thrust of his arm, emphasizing it by the exaggerated creases in his clothing to highlight the painter's action and vitality.

4 PAINT
The chocolate syrup paint is aptly splashed around yet Muniz's skill at recreating the photograph is evident. The syrup is a good painting medium but Muniz had to complete and photograph the painting within an hour before the chocolate started to dry and lose its gloss.

⏱ PHOTOGRAPHER PROFILE

1961–82
Vicente 'Vik' José de Oliveira Muniz was born in São Paulo, Brazil. As a child he drew compulsively; he was awarded a scholarship at an academic studio for drawing and sculpture.

1983–88
Muniz moved to the United States, first to Chicago and then New York, where he took courses in theatre direction and set design at New York University and The New School. He began making sculpture but then became interested in photography. In 1988 he exhibited at the Stux gallery in New York.

1989–PRESENT
He began his series *The Best of Life* in 1989, featuring photographs of drawings from memory from iconic photographs that appeared in *Life* magazine. In 1996 Muniz started to make works using materials such as sugar and dust. His work featured in group shows, including 'Recent Acquisitions' at the Metropolitan Museum of Art (1996) and the 'New Photography' exhibition at the Museum of Modern Art in New York (1997). In 1998 he had a solo show at the International Center of Photography, New York. In 2006 his show 'Reflex' began touring.

Untitled (Ophelia) 2001

GREGORY CREWDSON b. 1962

1 CONSTRUCTED SET
The interior is a set constructed in a studio on top of a raised soundstage. There is painstaking attention to detail in the creation of a small-town suburban house, from the typical staircase and furniture to the portrait photographs on the wall sourced from a wedding photographer.

2 FLOATING WOMAN
Ophelia is often depicted in art bedecked with wild flowers and floating in a river with flowing hair, as in John Everett Millais's painting of 1851–52. Here, she appears completely still and calm, as if resigned to her fate. It is unclear whether she is alive; her eyes are wide open and stare into space.

⬡ NAVIGATOR

In 1998 Gregory Crewdson began working with a large crew to construct life-size sets for the *Twilight* series (1998–2002). His directorial role is emphasized by the realization of the work occurring in collaboration with a director of photography, camera operator, actors, casting director and location manager. The series references cinema not only in its method of construction, high production values and dramatic lighting, but also in terms of its narrative. The series specifically references science fiction films, such as *Close Encounters of the Third Kind* (1977): figures are drawn out of their houses towards unidentified mysterious light sources, while others are placed in bizarre domestic environments. This photograph from the series, *Untitled (Ophelia)*, depicts a woman floating on the surface of the water in a flooded domestic interior. The woman's pale skin and white dress create a stark contrast with the darkness of the murky water. The light streaming through the windows and the electric lighting eerily illuminate an otherworldly scene. The photograph alludes to the tragic fate of the character Ophelia from William Shakespeare's play *Hamlet* (*c.* 1599–1601) in which, after being spurned by her beloved prince and grieving for her father, Ophelia is found drowned. **SP**

⏱ PHOTOGRAPHER PROFILE

1962–82
Gregory Crewdson was born in Brooklyn, New York. His father was a Freudian psychoanalyst, and as a child Crewdson eavesdropped on his father's consultation sessions with patients.

1983–91
Crewdson studied at the State University of New York at Purchase in New York and then gained a Master of Fine Arts in photography from Yale University in 1988. In 1991 he exhibited in 'Pleasures and Terrors of Domestic Comfort' at the Museum of Modern Art in New York.

1992–2003
He had a solo exhibition at the Houston Center for Photography in Texas in 1992, and the following year was appointed to the Yale faculty.

2004–PRESENT
Crewdson was awarded the Skowhegan Medal for Photography. In 2005 his exhibition 'Beneath the Roses' began touring galleries in New York, London, Athens and Paris. Hatje Cantz published a major catalogue of Crewdson's work following his first European retrospective exhibition titled *Gregory Crewdson 1985–2005*.

Laser chromogenic colour print
47 ½ x 59 ½ in. | 120.5 x 151 cm
The Rose Art Museum, Waltham, USA

3 WATER
Because of concerns over the weight of water on top of the raised soundstage, Crewdson adjusted the stair rails and furniture to make the depth of the water appear greater than it is. The floor of the stage was lined with black fabric to make the surface of the water opaque and reflective.

4 TABLE
The items on the table are clues to the woman's emotional state. As well as an ashtray and books there is an open bottle of pills and a glass of water. The paperback is *Inner Harbor* (1999) by Nora Roberts, a romantic novel featuring a mysterious woman who arrives in a small town.

POSTPRODUCTION PHOTOGRAPHY

The combining, rather than layering, of more than one negative has its roots in the 19th century and specifically in the 'combination printing' associated with O. G. Rejlander (1813–75) in works such as *Two Ways of Life* (1857; see p.116). The era of digital postproduction has led to a dramatic increase in photographic manipulation in the form of simple editing acts, such as enhancing or cleaning up a photograph, or the deliberate creative process that occurs after an image is taken and before it is printed.

Dutch artists Inez van Lamsweerde (b.1963) and Vinoodh Matadin (b.1961) pioneered photographic manipulation techniques in the early 1990s, sometimes working with a Quantel Paintbox operator. They employed photo editing to digitally graft the skin of their subjects, raising issues regarding gender, sexuality and the relationship between the body and technology. In the series *Final Fantasy* of 1993, the Dutch pair produced provocative portraits of young children that challenge notions of childhood innocence. *Final Fantasy, Wendy* (above) shows a girl of less than three years of age posed in what appears to be a pink leotard. The subject grins at the camera while one strap of her outfit slips off her shoulder. Her grin, with its unfeasible amount of teeth, is central to the work's conception: the child's mouth has been digitally replaced by that of a man.

US artist Anthony Aziz (b.1961) and Peruvian artist Sammy Cucher (b.1958) have been working in collaboration since 1990 when they also became pioneers in the use of digital imaging. Drawn to the possibility of producing images that challenged photography's relation to truth, their series *Dystopia*

KEY EVENTS

1981	1982	1982	1990	1991	1992
The Quantel Paintbox computer graphics workstation is launched. It enables digital retouching from scanned images.	Nancy Burson (b.1948) works with engineers at Massachusetts Institute of Technology to produce computer-generated portraits, such as *Warhead*.	*National Geographic* causes controversy after manipulating a photograph of the pyramids of Giza to fit the format of the magazine's cover.	The graphics editing program Adobe Photoshop 1.0 is released exclusively for the Apple Macintosh computer.	Kodak launches the DCS-100, the first commercial digital single-lens reflex camera. It combines a Nikon F3 body with a Kodak digital sensor.	Anthony Aziz and Sammy Cucher create their series of digitally manipulated portraits with genitalia and nipples removed, *Faith, Honor and Beauty*.

(1994–95) consists of disturbing portraits where the eyes, noses and mouths of their subjects are covered by skin. Aziz and Cucher's work references contemporary fears around genetic engineering and mutation: with his shaved head, *Chris* (opposite below) enacts an erasure of individuality. Although the work's digital manipulation is central to the conception of this series, it is the effect of reality in the photographic representation that makes the fantastical elements both credible and disturbing.

Digital skin grafting is also seen in the work of South Korean artist Kim Joon (b.1966). He creates photographs such as *Bird Land-Batman* (below) using 3D animation software. Joon creates three-dimensional models that he can graft with a variety of types of skin on to which he digitally paints tattoolike patterns to reveal how brands penetrate the individual in a consumer society.

Canadian artist Jeff Wall (b.1946) uses digital manipulation to produce fantastical images that have a basis in reality. His digital montage *The Flooded Grave* (1998–2000; see p.532) was photographed at two different cemeteries in Vancouver and on a set in his studio. **SP**

1 *Final Fantasy, Wendy* (1993)
Inez van Lamsweerde and Vinoodh Matadin• chromogenic colour print mounted on Plexiglas
38 ¼ x 59 in. | 97 x 150 cm
Museum Boijmans Van Beuningen, Rotterdam, Netherlands

2 *Bird Land-Batman* (2008)
Kim Joon • digital print
47 ¼ x 47 ¼ in. | 120 x 120 cm
Sundaram Tagore Gallery, New York, USA

3 *Chris* (1994)
Anthony Aziz and Sammy Cucher
chromogenic colour print
50 x 40 in. | 127 x 101.5 cm

1993	1996	1999	2000	2007	2010
Inez van Lamsweerde and Vinoodh Matadin produce their *Final Fantasy* series with the aid of a Quantel Paintbox operator.	Nikon releases the Coolpix 100 digital camera with a PCMCIA card that can be plugged into a laptop.	Nikon launches its D1, the first fully digital single-lens reflex camera for consumers. It has a resolution of 2.7 megapixels.	Jeff Wall completes *The Flooded Grave* after two years' work combining numerous photographs digitally.	Andreas Gursky (b.1955) sells *99 Cent II Diptychon* (2001) for US$3.34 million, making it the most expensive photograph sold at auction.	The Fujifilm FinePix Real 3D W3 is released. It is the first consumer digital camera that can shoot 3D photographs and video.

The Flooded Grave 1998 – 2000

JEFF WALL b. 1946

1 CROWS
Crows are scavengers known for feeding on carrion, contributing to their association with death. Wall has said: 'That's what it looks like at the Mountain View Cemetery; the crows are always hanging around there. Nothing is invented; that's what you would see on a rainy day.'

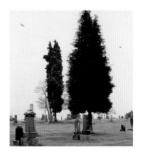

2 TREES AND SKYLINE
The skyline is bisected by a tree that stretches beyond the upper edge of the image. The high horizon line suggests that the photograph is shot from a low angle but the perspective, when combined with the angle of the grave, appears odd and this may be a result of the digital composite.

Silver dye bleach transparency,
aluminium light box
90 x 111 in. | 228.5 x 282 cm
Friedrich Christian Flick Collection,
Hamburger Bahnhof, Berlin, Germany

Jeff Wall is one of the most successful contemporary art photographers. He is best known for his large-scale photographic tableaux that are often presented as large-format transparencies in light boxes. *The Flooded Grave* was completed over a two-year period, highlighting the complexity of its construction. It consists of approximately seventy-five separate images merged together in postproduction. The grave is in the immediate foreground and its edge is cut off by the frame of the picture. The photograph depicts a rainy day in a cemetery in Vancouver, Canada. At first glance the photograph appears to be a cemetery scene dominated by a freshly dug, empty grave that awaits its occupant. However, the grave is not empty but flooded following the rainfall; moreover, it is full of marine life. With *The Flooded Grave* Wall attempts to stage a brief instant in which a passer-by momentarily imagines the bottom of the ocean inside a flooded grave. Wall has spoken about the impossibility of photographing such an imaginary vision; however, by combining a number of location shots in postproduction with a set constructed in the studio he was able to transform this daydream into a photographic image. **SP**

◷ PHOTOGRAPHER PROFILE

1946–69
Jeffrey Wall was born in Vancouver, Canada. He studied art history at the University of British Columbia, where he taught himself photography.

1970–76
In 1970 his work was included in a group show, 'Information,' at the Museum of Modern Art in New York. He lived in England from 1970 to 1973 while undertaking doctoral research at the Courtauld Institute of Art in London.

1977–83
In 1977 Wall began making carefully composed, backlit Cibachrome transparencies in an attempt to find a new way of representing everyday life pictorially. A year later he had his first solo show at the Nova Gallery in Vancouver.

1984–90
His solo show 'Jeff Wall: Transparencies' was exhibited at the Institute of Contemporary Arts in London and at the Kunsthalle Basel in Switzerland.

1991–2001
Wall began to use digital technology to produce photographic tableaux, which often reference well-known works of art, such as *A Sudden Gust of Wind (after Hokusai)* in 1993.

2002–PRESENT
In 2002 he won the Hasselblad Award. Wall was the subject of retrospectives including 'Photographs 1978–2004' at Tate Modern in London in 2005, 'Jeff Wall' at the Museum of Modern Art, New York in 2007 and 'The Crooked Path' at the Palais des Beaux-Arts in Brussels in 2011.

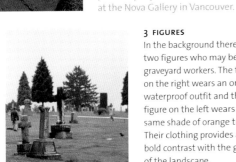

3 FIGURES
In the background there are two figures who may be graveyard workers. The figure on the right wears an orange waterproof outfit and the figure on the left wears the same shade of orange trousers. Their clothing provides a bold contrast with the green of the landscape.

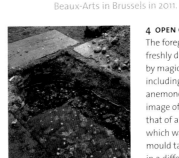

4 OPEN GRAVE
The foreground depicts a freshly dug grave filled as if by magic with sea creatures, including starfish, red sea anemones and sea urchins. The image of the grave is actually that of a tank in Wall's studio, which was created from a mould taken from a hole dug in a different cemetery.

PHOTOGRAPHY DECONSTRUCTED

Postmodernism brought photography to the forefront of contemporary art practice. However, few artists using photography wanted to be known as photographers. Many contemporary artists have rejected the aesthetic, technical and subjective emphasis of fine art photography in favour of an examination of how photographs are used by popular culture and advertising and how this shapes and disseminates social meaning. Fine art photography, as opposed to contemporary art photography, which has its roots in modernism, is generally monochrome and small scale. However, Craigie Horsfield (b.1949) made large prints, such as *E. Horsfield, Well Street, East London, March 1986* (1992; see p.538), before Thomas Ruff (b.1958) and others had made monumental colour prints fashionable. Ruff and the other artists of the Düsseldorf School (see p.440), particularly Andreas Gursky (b.1955), as well as Jeff Wall (b.1946) and Gregory Crewdson (b.1962), made the monumental colour print the dominant format for serious contemporary photography.

As the idea that photography's new-found high-art status depended upon a renunciation of its past became ubiquitous, it also became clear that there was a growing number of practitioners who were interested in the conceptual

KEY EVENTS

1982	1984	1986	1991	1992	1995
Pierre Cordier (b.1933) recasts Paul Klee's painting *Ad Marginem* (1930) in *Chemigram 7/5/82 II* using the 'chemigram' process he created in 1956.	Adam Fuss creates a series of pinhole camera images. This leads to his first photogram two years later.	James Welling explores the photogram process, producing a series of colour photograms made with shadows, titled *Degradés*.	In his darkened living room, Morell makes his first camera obscura photograph.	Garry Fabian Miller makes entirely abstract images using glass vessels filled with liquids or cut-paper forms to cast shadows and filter light.	Welling becomes head of the photography department at the University of California, Los Angeles.

possibilities not of subject matter, but of photographic chemistry. These artists, who are not part of a school and do not share a common credo, use the most basic principles of photographic chemistry and/or antiquarian photographic technology and print processes to deconstruct what constitutes the photographic. Their works challenge the orthodoxy that presents the medium as transparent, and meaning as residing only in content rather than technique.

In addition to collodion photography and daguerreotypy, contemporary artists have revived the print processes of Woodburytype, cyanotype, tintype and ambrotype, reminding viewers of the profusion of 19th-century processes that led one exasperated critic in 1856 to call them 'humbugotypes'. Others have gone even further back in time. Abelardo Morell (b.1948) has used the camera obscura, the device that photographic cameras were based upon, to create striking modern compositions. The principles of the camera obscura (meaning 'dark room') pre-date photography by centuries. Aristotle recognized them but he was not the first; that accolade goes to a Chinese philosopher, Mozi, from the 5th century BC. If one takes a darkened room or box and creates a sufficient small aperture or opening in that camera obscura, an inverted image of the scene outside will be projected on to the walls of that chamber. The camera obscura in box form was popularized at the start of the 18th century by painters such as Canaletto and Paul Sandby, who used it as a mechanical aid to drawing. Morell employs the camera obscura in its literal sense, as a darkened room. He has described his process: 'I cover all windows with black plastic in order to achieve total darkness. Then, I cut a small hole in the material I use to cover the windows.' Light travels into Morell's camera obscura through this hole and in a wondrous feat of physics projects a dim hovering inverted view of the world outside on the wall inside. The resulting exposures, including *Camera Obscura Image of Boston's Old Customs House in Hotel Room* (opposite), taken over at least eight hours, create a complex jigsaw in which the viewer is left trying to tease apart the geographies of the room from that of the projected view. Morell has travelled the world, collapsing exterior and interior views, from New York to Paris and Florence.

Adam Fuss (b.1961) says: 'It's only when I make a picture that I have to keep looking at that I feel I've succeeded. . .like the sensation of looking into the face of someone very beautiful.' His work revels in the seductive power of the photographic surface; he has experimented with such diverse processes as monochrome gelatin silver and colour saturated dye destruction prints. For *Butterfly Daguerreotype* (right) he resurrected one of the earliest photographic processes, the daguerreotype. *Butterfly Daguerreotype* is part of the series *My Ghost* (1995–2001) in which Fuss investigates themes of love and loss. The butterfly symbolizes the fragility and brevity of life; picturing it on the metal surface of a daguerreotype calls to mind 19th-century post-mortem photographs that were almost exclusively made by this process. When looking

1 *Camera Obscura Image of Boston's Old Customs House in Hotel Room* (1999)
Abelardo Morell • silver print
20 x 24 in. | 51 x 61 cm
Bonni Benrubi Gallery, New York, USA

2 *Butterfly Daguerreotype* (2001)
Adam Fuss • daguerreotype
24 x 20 in. | 61 x 51 cm
Victoria and Albert Museum, London, UK

1998	2000	2004	2006	2010	2011
Sally Mann (b.1951) experiments with the wet-plate collodion process for her *Deep South* series, to reflect the timelessness of the Mississippi landscape.	Susan Derges begins a residency at the Museum of the History of Science in Oxford, England resulting in her series *Natural Magic* (2001).	Chuck Close (b.1940) publishes a limited edition portfolio of twenty daguerreotype portraits, *A Couple of Ways of Doing Something*.	Craigie Horsfield has a solo show at the Jeu de Paume in Paris.	The exhibition 'Shadow Catchers: Camera-less Photography' opens at the Victoria and Albert Museum in London.	A retrospective exhibition of Adam Fuss's work is held at the Huis Marseille museum in Amsterdam.

directly at *Butterfly Daguerreotype*, its polished surface, like its 19th-century precursors, reflects back the viewer's countenance. Unlike early daguerreotypes, however, it offers more than a glimpse of one's self; its dimensions are as large as a mirror and act as a powerful memento mori.

In his attempt to create a means to fix the image of nature in permanent form, William Henry Fox Talbot (1800–77) achieved his first success with the photogram. By placing objects directly on to light-sensitive paper and exposing both to direct sunlight, he created what he called 'photogenic drawings'. Anna Atkins (1799–1871) made botanical prints in much the same way, although she used the cyanotype print process rather than Talbot's calotype (see p.42). Contemporary artist James Welling (b.1951) references Talbot and Atkins in his series *Flowers* (2004–). Like them he chose to focus on botanical specimens, picking plumbago blossoms from his garden to create photograms, although his method differs. In his darkroom, he arranged the plants on pieces of black-and-white film and made an exposure. This created a negative in which plant specimens rendered white were silhouetted against dark backgrounds, much like Talbot's and Atkins's contact photograms. However, Welling then employed a colour mural enlarger and colour filters to shine coloured light through the black-and-white negatives in order to create a series of positive images. In *021* (above) the plant appears as a spectral apparition on a bleached backdrop. The word 'photography' means 'drawing with light', but in this case Talbot's early term for his experiments 'sciagraphy', meaning 'shadow drawing', is more apt.

The photogram is only one way in which Welling locates the conceptual in the processes upon which photography is based; for Garry Fabian Miller (b.1957), however, it is his principal means of artistic expression. Fabian Miller has pushed the photogram into the realms of pure abstraction, as in his pair of works *Quenching the Red & Blue Gazing* (September 2008). Because his work is not about objects, such as Welling's flowers, shadows recede in importance. Instead light and its chromatic lexicon of colour are the focus. He has explained: 'I'm interested in that moment of peace which descends when someone is reading a book, or observes flowers in a vase, and a certain quality of light comes into the room, some transcendent instant — and then it passes. I want to preserve a space for those special moments — the pictures are embodiments of them.' Fabian Miller's explorations of light are done in his darkroom where he often works in near-total darkness for hours. Using the highly light-sensitive Cibachrome printing paper, he pins it to a wall and then exposes it to light that has passed through variously filled glass vessels. The reds and blues of his abstract palette, seen in *Quenching the Red* (below), come from shining light through water in coloured glass containers, whereas vibrant yellows and oranges are created with a clear glass container of engine oil. Reproductions rarely do justice to the luminosity of Fabian Miller's images and in galleries the pieces glow as if lit from behind. His works are sometimes called 'luminograms', a term used to describe a variation of the photogram in which the objects obstructing the light to form an image are not in direct contact with the photographic paper.

British photographer Susan Derges (b.1955) also produces photograms; she is fascinated by water in its myriad natural forms and this is illustrated in various series of her work: waterfalls and breaking waves as in *Shoreline* (1997–99), its various states from liquid to solid to vapour as in *Ice* (1997), and its patterns of ebb and flow as in *River Taw* (1997–98; see p.540) for which she worked outdoors rather than in a studio. Like many contemporary artists, she finds the description 'photographer' a misnomer: 'I am reluctant to think of myself as a photographer because so much of my work feels as if it has been to do with working with light in terms of drawing with light and dealing in a very tactile way with paper and surfaces with different kinds of emulsions. . . I certainly see myself as a maker.' **JMH**

3 *021* (2006)
James Welling • chromogenic colour print
46 x 37 in. | 117 x 94 cm
Courtesy David Zwirner, New York, USA

4 *Quenching the Red & Blue Gazing*, detail (September 2008)
Garry Fabian Miller • water, light unique dye destruction prints
20 x 24 in. | 51 x 61 cm each
Private collection

E. Horsfield, Well Street, East London, March 1986 1992

CRAIGIE HORSFIELD b. 1949

Photographic paper
on aluminium
83 ⅛ x 51 ⅛ in.
213 x 132 cm
Tate Collection,
London, UK

T he photographic works of Craigie Horsfield serve to deconstruct the medium not through antiquarian or previously obsolete processes but by reconceptualizing the medium's temporal aspect. For his nude study *E. Horsfield, Well Street, East London, March 1986*, Horsfield staged the scene and took the negative in 1986 but waited six years to print it. This deliberate time lag is a feature of his practice: sometimes he waits months to print a negative, sometimes more than a decade. As such, Horsfield's photographic work is the antithesis of the documentary tradition encapsulated in Henri Cartier-Bresson's (1908–2004) formulation of 'the decisive moment' (see p.366). The idea of photography as a window on to the world and an art of the instantaneous, with the speed of its execution mirrored in its casual cropping and inadvertent background detail, is inverted by a technique and subject matter that makes photography, for Horsfield, a medium of 'slow time'. Horsfield's notion of slow time is inspired by the French historian Fernand Braudel and his writings on 'slow history'. Living in Krakow, Poland, he was confronted daily by its 18th- and 19th-century architecture and realized that his existence in the present was part of the fabric of the city's history. By creating a temporal split between negative and print, Horsfield's photographs are art objects that exist in the present and that depict subjects that are inflected by the past. **JMH**

⬡ NAVIGATOR

👁 FOCAL POINTS

1 SUBJECT
The subject is Horsfield's wife, Ewa. Nearly all of his photographic portraits are of family or friends. He said: 'When I made the photographs they seemed wholly insubstantial, untrue. They were unbearable to look at when confronted with the presence of the person, the place.' Yet, over time, many of the people and places are lost giving his photographs new meaning. As Horsfield himself explains: 'With time it is all that remains, the only trace.'

2 THE APEX
The apex where the walls and floors meet has no sense of depth. The three surfaces of the room appear as three planes of grey, pressed forward into a graphic jigsaw. The model seems to hover in the flattened space. This refusal of perspective serves as a reminder that 'the picture itself, of course, is two dimensions; it is merely paper and chemical emulsion.' A print of this subject is likely to be unglazed to reveal the matt texture of its photographic surface.

⏱ PHOTOGRAPHER PROFILE

1949–67
Craigie Horsfield was born in Cambridge, England. In 1967, at the age of eighteen, he travelled to Germany. His first-hand experience of the unrest and upheaval of that time left a lasting impression.

1968–71
He studied painting at St Martins School of Art in London from 1968 to 1971. Encouraged by his tutor, Dermot Goulding, Horsfield's focus switched to photography and film.

1972–90
Horsfield moved to Krakow, Poland. There he studied graphics at the Academy of Arts for two years and became interested in theories of 'slow history' or 'slow time'. He returned to England in 1979 with his wife, Ewa. They lived on the streets, then in a hotel for the destitute. Eventually they moved into a high-rise housing block in London's East End.

1991–95
Horsfield gained international recognition when a London Institute of Contemporary Arts show of his work toured Europe. In 1994 he stopped taking part in exhibitions and moved almost exclusively into collaborative projects. In the mid 1990s he worked on a photographic project in Barcelona that described the experiences and identities of individuals living in various communities.

1996–PRESENT
From 1996 his range of media broadened to include film, architecture, theatre and music. The same year he was nominated for the Turner Prize. In 2000 he was the artistic director of the Monts des Arts project in Brussels. He participated in Documenta XI in Kassel, Germany, in 2002 and in the Whitney Biennial in New York in 2004. In 2011 he published his photobook *Confluence and Consequence*, which reproduces a series of large jacquard tapestries based on his photographs.

River Taw (Ivy) 1998
SUSAN DERGES b. 1955

Photogram, dye destruction print
Victoria and Albert Museum, London, UK

✦ NAVIGATOR

The photogram has been Susan Derges's medium of choice since 1983 and she uses it to render her dominant subject: water. She says: 'Water has been the focus of my photographic work for the past twenty-seven years. I first became aware of the fragility and preciousness of this element when I lived in Japan in the early 1980s.' However, it was in the 1990s that Derges found her main outlet for this fascination and what would become her most photographed subject: the River Taw, which rises near the village in Dartmoor, Devon, where she has a studio. The *River Taw* (1997–98) series, to which *River Taw (Ivy)* belongs, signalled a change in Derges's working practice. Having previously made her photograms in the studio, she began to make them outdoors at night, seeking 'a more direct and tactile relationship to water by using the landscape as a large darkroom'.

Derges would have made this image on a moonlit night. Kneeling beside the river, she submerged beneath its surface an aluminium slide holding a sheet of photographic paper. By releasing a flashgun, she would have illuminated the scene for a millisecond, capturing the flow of the river directly on to the paper. Each ripple and leaf on the actual print is life size. The vertical format and delicate patterning are suggestive of a Japanese scroll. Derges became interested in oriental philosophy and aesthetics while training at the Slade School of Fine Art in London. Later, while living in Japan, she was inspired by Japanese minimalism. This inflects much of her work, exemplified here in the simplicity of the colours and shapes, and the pared-down composition. **JMH**

👁 FOCAL POINTS

1 TRAIL OF IVY
The dark silhouette of the trailing ivy foliage guides the eye down the frame, encouraging the viewer to scan the image in the direction that the water flows. This has the effect of reanimating the stilled surface of the paper, recreating the sense of the ebbs and eddies of the river. By capturing the movement of the water through the environment, the image also serves as a visual narrative and a metaphor for the cycles of life, death and renewal.

2 BLUE
Although Derges takes her images at night with a flashgun, nuances in the ambient light create different colour casts. The deep, indigo blues here occur when there is a full moon. New moons generate dark green hues. Peaty waters tend to result in golden-brown colours.

⏱ PHOTOGRAPHER PROFILE

1955–80
Born in London, England, Susan Derges trained as a painter at the Chelsea School of Art from 1973 to 1976 and at the Slade School of Fine Art from 1977 to 1979.

1981–85
Derges moved to Japan for five years where she studied at the University of Tsukuba. During her stay her focus moved from painting to photography. She produced her first major photogram works, the *Chladni Figure* series, in 1985. The ghostly black-and-white images in the series were produced by sprinkling carborundum powder directly on to photographic emulsion where it was exposed to sound waves at different frequencies.

1986–99
She returned to London and made various further photogram series that examine the life cycles of frogspawn and toadspawn. In 1991 she produced the series *The Observer and the Observed*. In 1992 Derges moved to Dartmoor, Devon and, inspired by its wilderness, started making imagery outdoors such as the *River Taw* series, which involved working at night. She published *Woman Thinking River* in 1999.

2000–PRESENT
Derges embarked on a residency at the Museum of the History of Science in Oxford, resulting in the series *Natural Magic* (2001). She published the book *Kingswood* in 2002. In 2004 she produced the *Eden* series as part of a residency at the Eden Project in Cornwall. The work is etched on to the glass panels of the Solar Terrace.

UPRISING AND CONFLICT

After the defeat of Iraq by a US-led coalition in the first Gulf War, French intellectual Jean Baudrillard imperturbably announced that the war had not taken place. He did not intend to deny that thousands of people had been killed, but to suggest a reality deficit in a war conducted as a news spectacle and experienced by the public solely through visual images. The proliferation of imagery in the contemporary world has not only created Baudrillard's illusory world of spectacle, but also opened up opportunities to subvert accepted versions of events and promote alternative visions.

Since the 1990s, the role of photojournalists has been diluted by the ubiquity of digital and phone cameras and the instant circulation of images on the internet. These technological advances have given amateur photographers potential access to a global audience and political activists the chance to create alternative visual stories, which they distribute on websites and photoblogs as a strategy of resistance to mass media coverage of their actions.

Participants in the protest movement against neoliberal globalization, who appeared on city streets from the late 1990s, also use digital and phone cameras to capture and share their political actions. There are a small number of artistic projects that engage with the anti-globalization movement: these also stand in opposition to the photojournalistic images of violence favoured in mainstream representations of the movement. Allan Sekula (b.1951) photographed the

KEY EVENTS

1989	1991	1991	1994	1999	2001
Chinese citizens— mostly students— calling for political reform are massacred after protests in Tiananmen Square.	The Gulf War starts, waged between Iraq and a coalition of thirty-four nations led by the United States.	A civil war begins in former Yugoslavia; infamous for war crimes, including ethnic cleansing, it continues until 1995.	The massacre of hundreds of thousands of Rwandans in one hundred days goes almost unreported by Western mass media.	The first mass anti-globalization protests confront the World Trade Organization summit in Seattle.	The 9/11 terrorist attacks on the World Trade Center in New York shock the world and mark a new era in world politics.

five days of protest against the World Trade Organization summit in Seattle in 1999, capturing the protesters, who come from all sectors of society. Although Sekula photographed the evolution of the demonstrations, as did many photojournalists, his practice can be defined as anti-photojournalistic. Politically committed, Sekula went with the flow of the demonstration without flash, telephoto lens or press pass, moving as an integral part of the crowd and being subjected to police action. This experience produced the sequence of colour slides titled *Waiting for Tear Gas (White Globe to Black),* including the untitled image of a masked demonstrator dressed in a red devil suit and wielding a pretend chainsaw (opposite). Sekula's 35mm camera, the street lighting and the absence of digital manipulation of colours resulted in images of low technical quality—an effect central to his goal of a critical realism.

Other practices opposing the shock value of photojournalistic photography belong to the upcoming genre of 'aftermath photography'. Photographers such as Simon Norfolk (b.1963), Paul Seawright (b.1965) and Joel Meyerowitz (b.1938) took photographs of scenes in the aftermath of conflict. Their large-scale images of ruins, devastated land and deserted landscapes were destined for the gallery wall. Their artistic status stemmed from the aestheticization of the subject matter, high printing quality and careful composition. Norfolk made explicit reference to traditional landscape art in *The North Gate of Baghdad (after Corot)* (2004; see p.548). Seawright's *Valley* (below) pictured the detritus of war in an Afghan

1 From *Waiting for Tear Gas (White Globe to Black)* (2000)
Allan Sekula • colour slide

2 *Valley* (2002)
Paul Seawright • Cibachrome print

2001	2003	2004	2004	2005	2008
As a response to 9/11, the armed forces of the United States and its allies intervene in Afghanistan in order to dismantle terrorist organization al-Qaeda.	On 20 March, US and British armed forces invade Iraq, accusing Iraq of holding weapons of mass destruction.	The destruction of the Iraqi city of Fallujah is followed by the global circulation of shocking images of mutilated bodies of Iraqi civilians.	Photographs of Iraqi prisoners tortured and sexually abused by US soldiers in Abu Ghraib prison surface on the internet.	Dutch photojournalist Geert van Kesteren publishes *Why Mister Why?* It shows photographs of refugees in Iraq.	The Brighton Photo Biennial exhibition examines the intersection of warfare and photography.

3 From *Aftermath: World Trade Center Archive* (2001)
Joel Meyerowitz • chromogenic colour print

4 *Iraqi Refugees, Turkey*
from *Baghdad Calling* (2007)
Geert van Kesteren • ink-jet print
23 ⅝ x 15 ¾ in. | 60 x 40 cm

valley. As part of their longstanding series of war art commissions, the Imperial War Museum in London commissioned Seawright to go to Afghanistan in 2002. Seawright's image is often compared to the well-known Crimean War photograph, *Valley of the Shadow of Death* (1855; see p.52), by Roger Fenton (1819–69), in which cannonballs take the place of bodies on a battlefield. As in Fenton's photograph, there is no human presence, yet the artillery shells lying in the arid landscape of Seawright's *Valley* manage to create a poetic image of suffering, pain and war. Meyerowitz documented the destruction caused by the terrorist attacks on New York City in September 2001 and the recovery efforts at Manhattan's Ground Zero. His dystopic cityscapes (above), published in his book *Aftermath: World Trade Center Archive* (2006), remind viewers of the encounter of photography with aesthetics, ethics and politics.

One of the most intensively reported events in history—the invasion of Iraq in March 2003 and the subsequent occupation—signalled a changing culture in the coverage of war. The extensive use of mobile phones enabled photojournalists to report quickly from war zones. Many photographs that appeared on television, in newspapers and magazines, on websites and photoblogs were in fact reproduced from cheap phone cameras. At the same time, most of the photojournalists had to be 'embedded' with a particular military unit. Sharing the war experience with the troops not only gave access to military operations and war scenes from close proximity, but also allowed the photojournalists to develop close relationships with the soldiers.

Embedding successfully fed the mass media's lust for spectacle, but offered a rather blinkered view of the war. Independent photojournalists, such as Iraqi Ghaith Abdul-Ahad (b.1975), positioned themselves as 'unembedded' in what they saw as a more honest approach to documenting the conflict with images such as *Baghdad, April 4, 2004* (2004; see p.546). Most of their images were distributed as photobooks, but they were also publicized in the mass media.

New technology allowed amateur photographers to take many of the most potent images of the Iraq War. The publication *Baghdad Calling* (2008) by Dutch photojournalist Geert van Kesteren (b.1966) revealed how ordinary Iraqis were living under occupation or as refugees in Jordan, Syria and Turkey (below). Van Kesteren assembled images taken on mobile phones by Iraqi citizens, gathered from social networking websites. These snapshots of parts of Iraq that were unreachable to Western photojournalists provided an unsentimentalized picture of everyday life. Other amateur snapshots were taken by US soldiers guarding Iraqi prisoners in Abu Ghraib. Surfacing in the world's media and on the internet, the images shocked the public with their violence, suffering and sexual content. Coming swiftly to the centre of public debate, they also brought to the fore the old but still relevant question of photography's reliability as testimony. One of the most circulated images — the 'Hooded Man' — shows a prisoner in a black cloak and hood, standing in a cruciform posture on a box of C-rations, with hands and genitals wired. The simplicity of the composition and its resemblance to Christian images of crucifixion lent the photograph a kind of inverse iconicity: it has been reproduced in many forms around the world, from the mass media to graffiti.

In 2011, the social uprisings in Egypt, Libya and Syria and the protest movements against austerity cuts in Spain and Greece opened up discussion about the role of photography in shaping democratic debate. The presence of photographs of these moments in the media raises questions about photography's ability to shape public opinion about social unrest. More importantly, their often contradictory character takes the conflict from an economic, social and political level to the level of representation, on which the formation, sustainability, reception and outcome of these movements are reliant. **AM**

Baghdad, April 4, 2004 2004

GHAITH ABDUL-AHAD b. 1975

1 MEN IN THE BACKGROUND
The two men walking behind the burning vehicle are participants in the daily life of the city that has been disturbed by the conflict. Their presence gives the image a spontaneous air, and the photographer had been pounding the Baghdad streets in search of such a moment.

2 BOY
The boy, who raises his arm in a victorious gesture, is a symbol of Iraqi resistance. Abdul-Ahad's image challenges the Western stereotype of the opponent of the occupying forces as an Islamic terrorist. Instead, it portrays resistance to the occupation as the action of an ordinary Iraqi civilian.

Baghdad, Iraq: An Iraqi boy celebrates after setting fire to an American army vehicle that was attacked earlier by insurgents on 4 April, 2004 in Baghdad, Iraq

⊙ NAVIGATOR

G haith Abdul-Ahad is an independent Iraqi photojournalist. He was taking snapshots on the streets of Baghdad at the time of the invasion and occupation in 2003. Unlike the Western journalists who were mostly 'embedded' with a US troop unit, Abdul-Ahad remained among the Iraqi people, exposed without protection to the vicissitudes of war but able to capture the response of Iraqi civilians to the occupation.

This photograph depicts a boy celebrating the destruction of a US military vehicle. The snapshot captures the moment that the boy runs away after having set fire to it. His clenched fist and his facial expression indicate feelings of victory over the enemy. The image is similar to a number of other photographs by independent photographers portraying boys and young men rejoicing at the site of attacks by insurgents. Abdul-Ahad risked his life reporting from the front line of the anti-US insurgency. He was one of the last journalists to work in Fallujah before the US military assault on the insurgent-held city in April 2004. He was wounded in Baghdad in September 2004, taking photographs when US helicopters opened fire on crowds celebrating around a burning armoured personnel carrier. His Iraqi occupation photographs, including this one, appear in the book *Unembedded: Four Independent Photojournalists on the War in Iraq*, published in 2005. Abdul-Ahad's photojournalism shed light on a side of the war that had been largely unknown to the Western mass media up to that time. **AM**

⊙ PHOTOGRAPHER PROFILE

1975–2000

Ghaith Abdul-Ahad grew up in Baghdad. As a young man he lived an underground existence to evade service in Saddam Hussein's army.

2001–04

He started taking photographs on the streets of Baghdad. After the invasion of Iraq in 2003, he documented the conflict as a photographer and journalist, narrowly escaping death by US fire in September 2004.

2005–10

Abdul-Ahad's photographs were published in the book *Unembedded* in 2005. He became a correspondent for the British daily newspaper the *Guardian*, reporting from a number of conflict zones across the Muslim world, including Somalia, Iraq, Sudan and Afghanistan.

2011–PRESENT

On 2 March 2011, Abdul-Ahad was detained while covering the social unrest in Libya. Amnesty International called for his release and the Libyan government released him after a fortnight.

The North Gate of Baghdad (after Corot) 2004

SIMON NORFOLK b. 1963

1 GREEN

The green grass attracts the viewer's eye, leading up to the distant wrecked tank. The monumental scale allows the viewer to savour the colour and rich detail of the highly aestheticized composition—an aesthetic experience that may or may not ask for an ethical or political response.

2 AVENUE OF TREES

The avenue of trees at the centre of the composition emphasizes the resemblance of the photograph to 18th-century European landscape painting. Norfolk has said of this work: 'It looks like a painting—but this is a place in Iraq where people were slaughtered.'

✪ NAVIGATOR

S imon Norfolk took *The North Gate of Baghdad (after Corot)* while in Iraq as an embedded photographer. Although 19th-century French painter Jean-Baptiste-Camille Corot is referenced in the title, no specific painting provided the model for the work. The photograph shows the arched entrance to the city alongside swaying trees under a blue sky and puffy white clouds. The lyrical beauty of the landscape is intensified by the absence of people and the detailed visual field. However, the pleasure invoked by the landscape scene is jarred by the incongruous presence of destroyed military vehicles and water-logged tracks. These traces of the war remind the viewer of the horrors that have taken place within this landscape. For works such as this, Norfolk uses a large-format, wooden field camera on a tripod and photographs his subjects from a distance. All his works are saturated in colour and are printed large format, on a scale intended for the gallery wall. Norfolk's highly aesthetic landscapes open up a space of contemplation that transcends the easily digestible everyday news, saturated by shocking images of death and violence. **AM**

🕐 PHOTOGRAPHER PROFILE

1963–88
Born in Lagos, Nigeria, Simon Norfolk studied documentary photography at the University of Newport, South Wales.

1989–93
He covered post-Communist Eastern Europe and the 1991 Gulf War as a photojournalist.

1994–98
Norfolk abandoned photojournalism to focus on landscape photography, creating images of sites of genocide. He published *For Most of It I Have No Words: Genocide, Landscape, Memory* in 1998.

1999–2002
Photographing the aftermath of decades of conflict in Afghanistan, in 2002 he published *Afghanistan: Chronotopia*, winning the European Publishers' Award for Photography.

2003–05
Norfolk worked in post-invasion Iraq and in war-torn Bosnia, publishing his Bosnia aftermath images in book form as *Bleed* in 2005.

2006–PRESENT
Norfolk's more recent work includes a series on US military missile and rocket launches.

Fujicolor crystal print

3 BUILDING
Iraqi dictator Saddam Hussein built fake Babylonian buildings on roads into Baghdad in an effort to connect his regime with Iraq's ancient heritage. Tiles have fallen off, revealing bare concrete. The gate refers to the romantic ruins that feature in traditional European landscape painting.

4 TRUCK
The idyllic landscape image is disrupted by the presence of military vehicles destroyed in the Iraq War. The combination of these traces of a preceding battle with the unpopulated, tranquil scene creates a composition that has been described by Norfolk himself as possessing 'strange beauty'.

PHOTOGRAPHY AND GLOBALIZATION

1 *Siemens, Karlsruhe, Germany* (1991)
Andreas Gursky • mixed media
78 ¾ x 66 ⅞ in. | 200 x 170 cm

2 *Middle Passage* from *Fish Story* (1993)
Allan Sekula • chromogenic colour print

The years after the collapse of the Soviet Union signalled the start of a new political era largely identified with neoliberal globalization. 'Globalization' was characterized by the integration of China and the former Soviet bloc into the global economy, the development of communication technologies, the rise of multinational companies and the international circulation of goods. Since the 1990s, the anti-globalization movement has strongly challenged the dominant economic and political establishment.

The encounter between art and globalization resulted in the global spread of art exhibitions, bazaars and biennials, and the growing network of nomadic curators and artists moving between countries. The photographic image proliferates in these mega exhibitions and sells at high prices in the global market. In contemporary art shows, fashion, advertising and war reportage coexist beside photography that directly addresses issues of migration, environmentalism, diaspora and economic inequality, whether they oppose or celebrate globalization. At the same time, the internet has opened up new possibilities for photography's dissemination, exchange and manipulation, creating a space for reflection on the role of photography in a globalized world.

Growing numbers of photographers from different cultural backgrounds have explored globalization. German photographer Andreas Gursky (b.1955) largely focuses on its technological and industrial potential. He manipulates

KEY EVENTS

1989	1990	1992	1995	1997	1999
The collapse of the Berlin Wall separating East and West Germany signals the end of the Cold War and the beginning of a new era.	The dissolution of the Soviet Union inaugurates the predominance of liberal capitalism in most countries of the world.	Political scientist Francis Fukuyama proclaims 'the end of history' and ideologies due to the triumph of political and economic liberalism.	Allan Sekula publishes *Fish Story*, a photography project documenting the world's maritime space accompanied by critical text.	Kyoto protocol establishes an international agreement proposing ways to minimize global climate change.	Andreas Gursky produces *Chicago, Board of Trade II*, a digitally manipulated photograph addressing the issues surrounding globalization.

his prints digitally to create a flat surface, as in *Siemens, Karlsruhe, Germany* (opposite), a large-format photograph of the Siemens industrial park. Gursky gained access to the factory's grounds and, using excesses of light and colour, produced an idealized image of industrial reality.

A more critical standpoint was adopted by US artist and writer Allan Sekula (b.1951) in his photobook *Fish Story* published in 1995. Sekula combines images and text to tell a different story about globalization—one that has evolved around the world's harbours, coastlines and ports that are central to the traffic of world trade. Travelling from the old industrial Western docklands to the new harbours of the developing world, Sekula spent several years documenting the world's docklands in a globalized economy. His panoramic image of a container ship loaded with cargo in the middle of the Atlantic Ocean (below), which provided the cover image for *Fish Story*, shows the view out to open sea from one of the containerized vessels responsible for the global circulation of goods.

The rise of globalization was also aligned with the movement of economic migrants across Western borders in search of a better life. Yto Barrada (b.1971), a French and Moroccan citizen based in Tangier, photographed people and places around the border city from 1998 to 2004 for *A Life Full of Holes: The Strait Project*. Barrada's project included photographs of frustrated and frightened people trying to cross the border from Morocco into Spain illegally. Her images portray the drama of displacement and illegal migration that large numbers of refugees experience in the globalized world. **AM**

2001	2001	2003	2004	2008–09	2010
A young anti-globalist protester, Carlo Giuliani, is shot dead by police during the protests against the G8 meeting in Genoa, Italy.	Photography features prominently at art show 'Documenta XI'. Curated by Okwui Enwezor, it focuses on the encounter of globalization and art.	Wang Qingsong (b.1966) produces the staged photograph *Follow Me* (see p.552). It takes a critical look at the contradictions in contemporary China.	The social networking service Facebook is launched. It impacts on how users communicate and exchange photographs.	The economies of the United States and a number of other countries are led into recession in late 2008 and early 2009.	'Uneven Geographies', shown at Nottingham Contemporary, England, examines how art responds to globalization.

Follow Me 2003
WANG QINGSONG b. 1966

Chromogenic colour print
47 ¼ x 118 ⅛ in. | 120 x 300 cm
Wang Qingsong Studio

NAVIGATOR

A rtist Wang Qingsong employs various media, including photography and computer-generated images, to examine the contradictions existing in contemporary China. *Follow Me* is a staged photograph named after an English-language programme, co-produced by BBC TV and China Central Television, that ran for twelve years from 1982. Designed for high schools, its popularity was unprecedented and the programme opened a window on to Western life and culture for millions of Chinese people, including Wang.

The image depicts a huge blackboard covered in handwritten symbols, acronyms, drawings and phrases in English and Mandarin, in front of which the artist, in the guise of a teacher, is seated at a desk and pointing to the blackboard with a stick. The monumental format of the computer-manipulated print allows a hyper-detailed depiction. From everyday phrases (often ungrammatical) in both languages to direct comments on Beijing's preparation for the Olympic Games, the viewer encounters an almost incomprehensible composition. The logos of multinationals, such as McDonald's, Nike and Coca-Cola, symbolize the dominance of Western consumer culture in the post-Mao era, which is often said to have eroded China's cultural heritage. Wang's seemingly playful tableau, representing the mutual fascination of China and the West, invokes the wider shift in the balance of global economic and political power that has led some to suggest that this millennium will be known as 'The Chinese Century'. **AM**

1 SLOGAN
The ungrammatical paraphrasing of the slogan 'China Walks Towards the World, and World Learns About China' suggests the artist is commenting ironically on China's efforts to be integrated into the global capitalist system and the dilemmas posed by that integration.

2 GREAT WALL OF CHINA
The outline of the Great Wall of China is at the centre of the blackboard. The gigantic monument, a widely recognized symbol of China, refers to the great cultural and historical heritage of the nation. Its inclusion suggests a resistance to foreign imports, whether cultural or consumerist.

3 OLYMPIC RINGS
The hosting of the Olympic Games by Beijing in 2008 is referenced by the emblem of the five interlocking rings and by phrases such as 'Good Luck Beijing! Good Luck China!' China regarded the games as an opportunity to promote Chinese culture and tourism in the West.

4 COCA-COLA
The Coca-Cola bottle is a symbol of US consumer culture. The brand is often used by Wang in his practice. In *Requesting Buddha No. 1* (1999) the artist depicted himself as a multi-armed Buddha seated on a Coca-Cola throne, grasping money and well-known consumer products.

GLOSSARY

35mm
Introduced originally for motion picture use, 35mm film's format, frame and sprockets were standardized in 1909. It was adopted for still picture use and became the most popular film format producing a standard negative or transparency of 24 x 36 mm. The format and size has been retained in 'full frame' digital cameras.

albumen print
The use of albumen derived from egg whites was first used in 1848 for dry plates, before being superseded by the wet-collodion process from 1851. Albumen had far greater success for coating on to paper where it provided a smooth surface for the photographic emulsion. This was described by Louis Désiré Blanquart-Evrard in 1850 and albumen paper remained popular until the 1890s.

aperture
The opening through which light passes to expose sensitized material or a sensor. It is usually located behind or within a lens mount, originally as removable 'stops' and later as an iris diaphragm. The size of the aperture is defined in f-numbers.

Autochrome
Patented in 1904 by Auguste and Louis Lumière and manufactured from 1907, the Autochrome process was the first practical system of colour photography using dyed starch grains and a panchromatic emulsion to produce colour transparencies with a distinctive colour palette. Production ceased in the 1930s.

backlighting
Describes lighting from a source behind the subject. It is usually used in conjunction with other lights, but by itself it can separate the subject from a dark background or create a halo effect around it.

calotype
A photographic process patented by William Henry Fox Talbot in England and Wales on 8 February 1841, also known as Talbotype. The process was a significant enhancement of Talbot's photogenic drawing process and used silver iodide combined with gallic acid to enhance its sensitivity. After exposure the paper was developed to produce a negative and then chemically fixed to make it permanent. The calotype was the first negative/positive process and it provided the basis of modern photography.

camera angle
Describes the position of the camera relative to the subject. Where the camera is placed and the type of lens being used will determine how the viewer perceives the subject.

camera lucida
An optical device used by artists that employs a prism to superimpose a virtual scene or subject image onto a drawing board so that an outline can be traced on to paper. It was invented by William Hyde Wollaston in 1807.

camera obscura
An optical device that came into use during the Renaissance. It consists of a box or a darkened room with an opening on one side projecting an image on to the facing side. It was used by artists as a drawing aid because it preserved perspective. By the 18th century the use of lenses and a mirror set at 45 degrees made for smaller, portable camera obscurae.

candid photographs
Unposed images often taken without the knowledge of the subject. They were made possible by small hand cameras; the first was reputedly taken in 1892. The term was first used in 1930 by the *Weekly Graphic*.

carbon print
A number of carbon processes were described before Sir Joseph Swan patented a process in 1864. Swan's was introduced the following year and found commercial success by providing the photographer with ready-made materials. His patents were bought out by the Autotype Company. The process produced a print using carbon, which made it permanent and not susceptible to fading. Carbon prints typically have a matt finish from black, grey to sepia and other tones.

chromogenic print
A print made by the chromogenic development process and also known as dye-coupler print. The process was developed in the mid 1930s and is the basis of the majority of modern colour silver-based photographic materials, such as Kodachrome, Ektachrome, Kodacolor and Agfacolor producing both negatives and direct positives. The prints are often incorrectly referred to as C-[Type] prints, which refers, precisely, to a negative-positive chromogenic paper called Kodak Color Print Material Type C available from 1955 to c. 1959.

chronophotography
A method of analysing movement by taking a series of still pictures at regular intervals. It was pioneered separately by Étienne-Jules Marey and Eadweard Muybridge among others from the early 1870s. In 1877 Muybridge was able to confirm by chronophotography Marey's assertion that a horse lifted all four hooves off the ground at once when trotting.

close-up lens
A supplementary lens fitted to a camera lens that changes the focal length. For close-up work, a positive lens effectively shortens the focal length so that with a given lens-to-subject distance the near focusing limit is reduced.

collodion process
A dry—or more commonly—a wet process using collodion as a medium to support a light sensitive emulsion. The wet-collodion process was described by Frederick Scott Archer in 1851 and, after refinement, came in to widespread use from c. 1854. It remained dominant until the mid 1870s. Collodion was also used to produce direct positives on glass (ambrotypes) and tin (tintypes).

collotype
A screenless printing process invented by Alphonse Poitevin in 1856 and commercially popular from the 1870s to 1920s.

combination printing
A technique using two or more photographic negatives or prints to make a single image. It was suggested by Hippolyte Bayard in 1852 for improving the appearance of skies. It was first shown by William Lake Price in 1855. O. G. Rejlander's *Two Ways of Life* (see p.116) of 1857 and Henry Peach Robinson's *Fading Away* of 1858 are the best-known examples. The technique was revived in the 1920s and 1930s often to produce surreal work. Digital techniques have made it obsolete.

compound lens
A lens combining two or more individual elements, usually cemented together.

copper plate
A printing plate used by any method of intaglio printing, etched or engraved to take ink for transferring on to paper. Although the term 'copper plate' is widely used, plates are commonly made from copper or zinc.

cropping
Altering the boundaries of a photograph, negative or digital image to improve the composition, remove unwanted elements, or to fit a method of display.

cyanotype
A process invented by Sir John Herschel and reported in 1842. The prints are also known as blue-prints. The process is simple and produces a characteristic blue image on paper or cloth. It was popular in the 1840s and the 1880s. Its main use has been for the reproduction of architectural or technical drawings.

daguerreotype
Announced on 7 January 1839 and presented to the world in August 1839 (except in England and Wales where it was patented), the daguerreotype produced a unique image on a silver-coated copper plate. The process was popular until the mid 1850s, although for longer in the United States, until it was superseded by the more sensitive wet-collodion process.

darkroom
A space in which there is total darkness or limited illumination by red or orange safelights so that light-sensitive materials such as film or paper can be handled, processed or printed without being affected by unwanted light.

depth of field
The zone of sharp focus seen in the camera. Manipulation of this zone by extending or reducing it can be an important aspect of creative control and view cameras have evolved to facilitate this.

digital print
In photography this refers to a photograph produced from either a conventional negative or a digital file by a digital printer. This includes various fine art digital printing techniques, inkjet and laser printing.

documentary photography
A photographic depiction of the real world intended to show the subject in a literal and objective way. Early examples include the work of Maxime du Camp in recording the Near East, Roger Fenton in the Crimea and Mathew Brady in the American Civil War. An important sub-genre is social documentary photography, which records the human condition within a wider context. Examples range from Thomas Annan in 1860s Glasgow to Jacob Riis in 1890s America and the Farm Security Administration photographers of the 1930s.

double-exposure
The recording of two superimposed images on the same piece of photo-sensitive material. This may be through error or as part of the creative process.

dry plate negative
Although produced from the late 1850s, they were more successfully introduced from the early 1870s and quickly supplanted wet-collodion plates. Dry plates matched and surpassed the sensitivity of wet-plates and were more convenient to use.

Düsseldorf School
A group of students who studied at the Kunstakademie Düsseldorf in the mid 1970s under the influential photographers Bernd and Hilla Becher, producing clear, objective, black-and-white images of industrial structures. Among its best-known students are Thomas Struth and Andreas Gursky.

dye transfer print
This is a subtractive process for making colour prints from colour positives or negatives. There were processes from 1875 but Eastman Kodak's wash-off relief process of 1935, which was improved and reintroduced in 1946 as the dye transfer process, was the most successful. Although complex it produced attractive permanent prints with strong colours.

emulsion
A light sensitive colloid usually of silver halide grains in a thin gelatin layer, and coated on to glass, film or paper base.

exposure
The process of allowing light to act on a sensitive material. Within the camera this is controlled by the shutter and aperture.

field camera
Usually refers to a large-format camera that can be folded to reduce its size making it easier to transport.

filter
An optical coloured or neutral glass or plastic usually mounted in front of the camera lens. Most remove or reduce particular parts of the light spectrum; others such as neutral density or polarizing filters affect light absorption in other ways.

fine art photography
Photographs that are made by a photographer as art work and usually intended to be offered for sale.

frame
A term that has a number of meanings within photography. It can refer to a single image within a series on a length of film or a single digital image; a border made from one of a number of materials to enclose and protect a photograph; or the boundaries of a subject seen through a camera viewfinder.

humanist photography
A photographic approach that places the human subject within his or her everyday life. It uses photography's descriptive power and emotional immediacy to inform the viewer. It was particularly popular among French photographers between the 1930s and 1960s, although it arguably informs many styles of photography.

ink-jet print
A print made up from tiny droplets of ink being expelled on to paper using electromagnetic fields to guide charged ink streams. The technology was developed commercially from the 1950s and for digital photographic printing from the 1970s.

Kodachrome
A colour transparency film invented in 1933 by Leopold Mannes and Leopold Godowsky, Jr and introduced by Eastman Kodak in 1935 in 35mm, sheet and motion picture film formats. For many photographers it was the standard by which all other films were judged. Manufacture ceased in 2009.

mammoth plate
An outsize plate format approximately 18 x 21 inches and used by some 19th-century outdoor photographers, notably Carleton E. Watkins and William Henry Jackson working in the American West. Some contemporary photographers continue to use very large formats.

over exposure
The exposure of light sensitive material with too much light. With negative film this has the effect of increasing shadow contrast and the total density range. They require longer printing times and appear grainier.

photobook
Traditionally referred to as photographically illustrated books and then illustrated books, the term photobook has become popular since the 1980s to refer to a book in which the photographs make a significant contribution to the content. Important examples include Henri Cartier-Bresson's *The Decisive Moment* (1952; see p.366) and Martin Parr's *The Last Resort* (1986; see p.454). The term is also a commercial one applied to single or very short run digitally printed books.

photogram
An image produced without a camera or lens by placing an opaque, translucent or transparent object between, often directly on, a piece of photographic paper or film and a light source. These were among the earliest photographic images from Thomas Wedgwood and Humphry Davy, and William Henry Fox Talbot, who called them photogenic drawings. Photograms had renewed popularity as a creative technique in the 1920s with Man Ray, who called them Rayographs.

photogravure
A photomechanical intaglio ink printing process capable of rapid, high-quality reproduction of photographs preserving detail and tone on paper.

photojournalism
The term was coined in 1924 to designate a sequence of photographs that emphasized photographic reportage, requiring the skills of both photographer and journalist. This distinguishes it from press or news photography. It thrived with the rise of illustrated news magazines, such as *Picture Post* and *Life* from the 1920s to 1960s, and is now best seen in newspaper colour supplements.

photomontage
An image created by assembling several different images, sometimes in other media, by cutting and pasting, projection or digital techniques.

Pictorialism
A term that was used generally by photographers from the late 19th century and was popular until World War I to define an artistic approach to photography. Pictorialism was part of a larger debate around art and photography that had preoccupied photographers since the 1850s and it was, in part, a reaction against the ease of taking photographs from the mid 1880s. In the 1920s Pictorialism gave way to realism and objectivity in photography, although it never quite disappeared and interest in it continues today.

Polaroid
The Polaroid Corporation was founded by Edwin Land in 1937 to produce polarizing glasses for three-dimensional applications. In 1948 Land launched the Polaroid Model 95 camera, which offered almost instant photography. In 1963 instant colour film was introduced and in 1972 the iconic Polaroid SX70 camera was introduced, which gave true instant photographs that developed without the need for peeling or the subsequent coating of the photograph. The 1978 launch of Polavision instant movies system failed as video proved more attractive to consumers. In 2001 the company filed for Chapter 11 bankruptcy protection as digital photography eroded its traditional markets.

Post-processing
A term that refers to the work traditionally done on a negative or print after the normal process has been completed. With the digital era the term is more usually associated with adjustments made to the raw image file using software such as Photoshop.

Resin-coated (RC) paper
A paper that has been sealed on both sides with a pigmented polyethylene resin and has the light sensitive emulsion coated on to one side. RC paper does not absorb water or chemicals making it quick to process and dry. It was widely introduced from c. 1968. With traditional fibre-based papers the emulsion is absorbed into the paper, which gives more depth to the image. It is considered more archivally stable than RC paper. Fibre papers are generally preferred by photographic artists.

retouching
With film and paper this referred to work done with a brush or knife to the emulsion of a negative or print to remove parts or add to it. The advent of digital working has added these and other tools via software of which Photoshop is the best known. Photoshop has become a verb in its own right.

roll film
A length of light sensitive film rolled on a spool usually with a backing paper and able to be loaded into a camera in daylight. Cellulose nitrate roll film was commercially introduced in 1889, daylight loading film cartridges in 1891 and paper-backed film, which remains in production today, in 1892. A large number of roll film formats and lengths have appeared since 1889 with the most common being 120, 620 and 127 sizes. The safer film base cellulose acetate was increasingly used from 1934; in the late 1940s, cellulose triacetate was introduced, and in the 1980s polyester bases became the norm.

salted paper print
The earliest form of silver halide printing paper developed by William Henry Fox Talbot around 1834. Talbot used paper soaked in salt; this was dried and then brushed with silver nitrate before being exposed and subsequently fixed with a concentrated salt solution or, later, sodium thiosulphate ('hypo').

saturation
A setting on a digital camera or in image editing software that adjusts the intensity of colour relative to its own brightness. A desaturated image will appear with grey tones.

silver print
Also known as gelatin silver print, this refers to photographs mainly produced since the early 1870s using gelatin as a colloid. More recently the term has been applied within the photographic art market to differentiate photographs produced using traditional silver-based techniques from digital printing.

solarization
A photographic effect achieved in the darkroom or digitally where an image on a negative or photographic print is wholly or partially reversed in tone. Dark areas appear light or light areas appear dark. It can be created in error but is also used for creative effect.

staged photography
A posed scene or performance enacted before the camera similar to *tableaux vivants* (living pictures). It can include studio portraiture and scenarios involving people that are directed or manipulated by the photographer.

stereograph
A pair of photographs mounted together that are designed to be viewed with a stereoscope. The term applies to any medium used to create the pair of images, but can be refined to be process specific, for example, stereo-daguerreotype.

stereoscope
An optical instrument with two viewing lenses that fuses two images so that a single three-dimensional image is perceived. The three principal designs have been the Wheatstone (1838); the Brewster lenticular (1838, but popular from c. 1849) and the Holmes-pattern (c. 1895).

straight photography
Photography that attempts to depict a scene or object as realistically and objectively as possible. Straight photography rejects the use of manipulation; the term first emerged in the 1880s as a reaction to manipulated photography. In 1932 Group f/64 defined it as: 'possessing no qualities of technique, composition or idea, derivative of any other art form'.

street photography
A style of documentary photography that features subjects in public spaces. Street photography became popular from the 1890s with the introduction of hand cameras. The genre has attracted renewed interest since the early 2000s.

under exposed
The exposure of light sensitive materials with too little light. In negative film this reduces density with a resultant loss of contrast and detail in the darker subject areas. In transparency film it results in an increase in density.

vernacular photography
Refers to images usually created by amateur or 'unknown' photographers and often depicts family or people in everyday and domestic situations. Their frequent banality, humour or photographic errors and occasionally artistic merit can give them an unintentional artistic quality or charm. They have attracted increasing interest from collectors and galleries.

view camera
Also known as a technical camera. The term refers to a large-format camera usually with lateral and vertical movements plus swing or tilt adjustment on the camera back and/or front lens standard. Traditionally the image was viewed on a ground glass screen on the camera back. Increasingly this has been replaced with a digital back with the subject viewed on a monitor.

waxed-paper negative
The waxing—usually with beeswax—or oiling of negatives that was undertaken by William Henry Fox Talbot to calotype negatives aimed to improve their translucency and minimize a lack of sharpness. In 1851 Gustave Le Gray's waxed paper process proposed waxing the paper base of the negative before it was sensitized. The finished negatives secured better detail and tonal range comparable with the wet-collodion negative, which used glass as its base.

wide-angle lens
A lens of shorter than normal focal length to give a larger angle of view.

Woodburytype
Refers to both the process and print. The process is a photomechanical intaglio ink process. It was developed by Walter B. Woodbury in 1864 and was used for book illustration from 1866 until around 1900. It was commercially successful and capable of reproducing detail and the tonal range in a photograph.

Zone System
A system designed to bridge the gap between sensitometry and creative photography. It was developed by Ansel Adams and Fred Archer in 1939–40. It relied on empirical testing by the photographer of film and paper to provide information about the characteristics of the materials to support the photographer in defining the relationship between the way a subject was visualized and the end result.

CONTRIBUTORS

Anne Bracegirdle (AB) is a Russian art specialist at an auction house in New York City. She has an MA in the history of photography from Sotheby's Institute of Art, London, UK.

Camilla E. Brown (CB) works as a writer, curator and lecturer. She was previously senior curator at the Photographers' Gallery, London and exhibitions curator at Tate Liverpool, UK.

Susanna Brown (SB) is curator of photographs at the Victoria and Albert Museum, London, UK. She writes and lectures on photography and has curated exhibitions including 'Selling Dreams: One Hundred Years of Fashion Photography', 'The Other Britain Revisited' and 'Queen Elizabeth II by Cecil Beaton'.

Martina Caruso (MC) lives between Rome and London, where she teaches art history and is completing her PhD on Italian humanist photography. Her publications include 'Counter-regime Photography Under Fascism' in *Visual Conflicts*, edited by Paul Fox and Gil Pasternak (Cambridge Scholars, 2011).

Patrizia Di Bello (PDB) is a writer and lecturer in the history and theory of photography at Birkbeck, University of London, UK. Her publications include *Women's Albums and Photography in Victorian England: Ladies, Mothers and Flirts* (Ashgate, 2007).

Chantal Fabres (CF) has an MA from Sotheby's Institute of Art, London and has worked at HackelBury Fine Art, London, UK. She works with Toluca Editions, Paris, on Latin American photography projects. Her publications include *Trauma, Absence, and Memory:The Pinochet Legacy on Contemporary Chilean Art Photography* (Ocho Libros Editores, 2012).

Dr Ashley Givens (AG) is assistant curator of photographs at the Victoria and Albert Museum, London. She has curated various exhibitions, including 'A History of Photography: Highlights from the Collection from the 1970s to Now'.

Pamela Glasson Roberts (PGR) is a writer and former curator of the Royal Photographic Society. Her publications include *A Century of Colour Photography* (Andre Deutsch, 2007) and *Camera Work* (Alinari, 2008). She is currently working on an exhibition and catalogue about Alvin Langdon Coburn.

R. G. Grant (RG) is a historian and freelance writer. He has published more than fifty books on cultural and historical subjects. He also contributed to *Art: The Definitive Visual Guide* (Dorling Kindersley, 2008).

Juliet Hacking (JH) is programme director of the MA in photography (history and theory) at Sotheby's Institute of Art, London. A specialist in 19th-century photography, she is the author of *Princes of Victorian Bohemia: Photographs by David Wilkie Wynfield* (Prestel, 2000).

Karen Haas (KH) is the Lane Collection Curator of Photographs at the Museum of Fine Arts, Boston. Her publications include *Charles Sheeler: American Modernist* (Bulfinch Press, 2002), *Ansel Adams* (MFA, 2006) and *An Enduring Vision: Photographs from the Lane Collection* (MFA, 2011).

Colin Harding (CH) is curator of photographic technology at the National Media Museum, Bradford, UK. His publications include *Classic Cameras* (Photographers' Institute Press, 2009).

Jackie Higgins (JMH) is a writer, journalist and documentary director. She has produced films for the BBC, National Geographic and the Discovery Channel. Her publications include *Look: David Bailey* (Phaidon, 2010).

Greg Hobson (GH) is curator of photographs at the National Media Museum, Bradford, UK. He regularly curates exhibitions, writes for photography publications and sits on photography selection panels. He is currently programming the National Media Museum's new exhibition space, which is due to open in London in 2013.

Sabina Jaskot-Gill (SJG) is an AHRC-sponsored PhD student at the University of Essex, UK, in collaboration with Tate Research. Her thesis explores how post-war Polish photography challenges the histories and critical frameworks that govern Western European and Anglo-American practice and theory.

Carol King (CK) is a writer based in London and Italy. She studied fine art at Central St Martin's, London and English literature at Sussex University, UK.

Fabian Knierim (FK) is an art historian and curator, who specializes in photography. His recent exhibition projects include displays on David Goldblatt (Victoria and Albert Museum, 2011), abstract photography (Museum Folkwang, 2011) and Floris Neusüss (Munich City Museum, 2012).

Erika Lederman (EL) is a writer and photography historian who works in the Word and Image Department of the Victoria and Albert Museum, London, UK. She has published articles in *Art Monthly*, *The New York Times*, *Bloomberg News* and *The Art Newspaper*.

Jacob W. Lewis (JWL) is a historian of 19th-century art and photography, and a former fellow at the Metropolitan Museum of Art, New York and the National Gallery of Canada. He is currently finishing his PhD in art history at Northwestern University, Illinois, USA.

Kirsten Lloyd (KL) is associate curator at Stills, Edinburgh. Her curatorial projects include 'Social Documents', a three-year programme examining artists' mediation of social, political and economic realities.

Russell Lord (RL) is the Freeman Family Curator of Photographs at the New Orleans Museum of Art, USA. Before that he worked

in the department of photographs at the Metropolitan Museum of Art, New York and Yale University Art Gallery, Connecticut, USA. He has organized several exhibitions and published articles on 19th-, 20th-century and contemporary photographers.

Joanne Lukitsh (JL) is a professor of art history at the Massachusetts College of Art and Design, USA. She has published on historical and contemporary photography, most recently an essay for *The Pre-Raphaelite Lens: Photography and Painting, 1848–1875* (National Gallery of Art, Washington DC, 2011).

Kathleen Madden (KM) is a former commissioning art editor at Phaidon Press. She teaches at Sotheby's Institute in New York and writes regularly for *Artforum*.

Dr Antigoni Memou (AM) lectures at the University of East London and Sotheby's Institute of Art. Her book *Photography and Social Movements: From the Globalisation of the Movement (1968) to the Movement Against Globalisation (2001)* is to be published by Manchester University Press in 2013.

Dr Sandra Plummer (SP) is an artist, writer and lecturer on photography at Sotheby's Institute of Art, London. Her publications include 'String, Space and Surface in the Photography of Vik Muniz' (2007) in *Textile*.

Jennifer Quick (JQ) is a PhD candidate in the department of history of art and architecture at Harvard University, Boston, USA. She holds an MA in contemporary art and theory from the University of Maryland, Baltimore.

Emma Sandon (ES) is a lecturer on film and television at Birkbeck, University of London. She publishes on colonial and ethnographic film and photography. She is an honorary research associate at the Archive and Public Culture Initiative at the University of Cape Town, and a project management team member of www.colonialfilm.org.uk.

David Secombe (DS) is a freelance photographer and writer. He is also the editor of The London Column (thelondoncolumn. com), an online magazine showcasing 'pictorial reports from the life of a city'.

Pepper Stetler (PS) is assistant professor of art history at Miami University, Oxford, Ohio, USA. She is currently writing a book about photographic books published during Germany's Weimar Republic.

Dr Bernard Vere (BV) is lecturer in modern art at Sotheby's Institute of Art, London, UK, where he also teaches on the MA in Photography: Contemporary and Historical.

Dr Marta Weiss (MW) is a curator of photographs at the Victoria and Albert Museum, London, UK. She has published articles and essays on topics ranging from Victorian photocollage to contemporary Middle Eastern photography.

SOURCES OF QUOTATIONS

p.9 'simply documents I make'
'Interview: Man Ray', *Camera*, Vol. 54,
February 1975

p.11 'facts' Elizabeth Eastlake, 'Photography',
The Quarterly Review, April 1857, extract
reprinted in *Art in Theory, 1815–1900: An
anthology of changing ideas*, Blackwell, 1998

p.11 'most mortal enemy' 'The modern public
and photography' from 'The Salon of 1859'
reprinted in *Art in Paris, 1845–1862: Salons
and other exhibitions reviewed by Charles
Baudelaire*, Phaidon, 1965

p.11 'has nothing to do...never supersede it'
'The Art of Engraving', quoted by Michael
Harvey in 'Ruskin and Photography', *Oxford
Art Journal*, Vol. 7, No. 2, 1984

p.14 'if photography was invented...
photography itself'
Douglas Crimp, 'The Museum's Old, the
Library's New Subject' in *On the Museum's
Ruins*, MIT Press, 1993

p.19 'Nothing but a method...is elegant'
'Tom Wedgwood, Journals of the Royal
Institution' in *The First Photographer*, Richard
Buckley Litchfield, Duckworth, 1903

p.22 'The exquisite minuteness...approached it'
Samuel Morse, letter to his brother, the editor
of the *New York Observer*, who re-published it
in the newspaper on 19 April 1839

p.25 'enable us to introduce...from nature'
The Pencil of Nature, William Henry Fox Talbot,
Longman, Brown, Green & Longmans, Part 2,
January 1845

p.25 'us to hand down...sunshine of yesterday'
The Athenaeum, No. 904, 22 February 1845

p.26 'After having iodized...frame was perfect!'
Quoted in translation from *The Daguerreotype
in America*, Beaumont Newhall, New York
Graphic Society, 1961

p.28 'I have been lucky...glorious things'
Ruskin in Italy. Letters to his Parents, 1845,
Harold I. Shapiro, Clarendon Press, 1972

p.33 'The instrument chronicles...Apollo
of Belvedere'
The Pencil of Nature, William Henry Fox
Talbot, Longman, Brown, Green & Longmans,
Part 1, 1844

p.34 'could never be used to make portraits'
*Comptes rendus des séances de l'Académie
des sciences*, Vol. 9, No. 8, 19 August 1839

p.34–5 'to make a portrait...white draperies'
The History of Photography, Helmut
Gernsheim, McGraw-Hill, 1969

p.35 'by far the most...I have yet seen'
Letter, Herschel to Draper, 8 October 1840,
Draper Collection, Library of Congress,
Washington D.C., USA

p.37 'such a record of their ancestors' and 'how
small a portion...rely with confidence'
The Pencil of Nature, William Henry Fox Talbot,
Longman, Brown, Green & Longmans,
Part 3, 1845

p.45 'the wax process...prepared paper'
'Photography in France,' Roger Fenton, *The
Chemist*, New Series Vol. 3, No. 29, February 1852

p.45 'the rough surface...lights of themselves'
Letter, D. O. Hill to Henry Sanford Bicknell, 17
January 1849 (erroneously dated 1848 by Hill),
George Eastman House, Rochester, New York

p.49 'astonishment' and 'the satisfaction to
the eye...to be imagined'
'On a Binocular Camera', Richard Calvert Jones,
Journal of the Photographic Society of London,
Vol. 1, No. 5, 21 May 1853

p.53 'the sight...treading upon them'
Letter, Roger Fenton to Grace Fenton,
4–5 April 1855, quoted from letter No. 7,
Roger Fenton's Letters from the Crimea
http://www.rogerfenton.org.uk

p.53 'returning back...our trophies'
Letter, Roger Fenton to Grace Fenton,
24 April 1855, quoted from letter No. 10,
Roger Fenton's Letters from the Crimea
http://www.rogerfenton.org.uk.

p.53 'here is the Valley...unholy place'
'Fine Arts. Photographs from the Crimea',
The Athenaeum, No. 1457, 29 September 1855

p.53 'as soon as the door...every pore'
'Narrative of a Photographic Trip to the Seat
of War in the Crimea,' Roger Fenton, *Journal
of the Photographic Society*, Vol. 2, No. 38,
21 January 1856

p.53 'This is the studio of battle'
'Mr. Fenton's Crimean Photographs,' *Illustrated
London News*, Vol. 27, No. 769, 10 November 1855

p.55 'destined to make...in the world'
'Daguerrotyping', John H. Fitzgibbon in
*Western Journal of Agriculture, Manufactures,
Mechanic Arts, Internal Improvements, Commerce
and General Literature*, 6:3, June 1851

p.57 'The rough surface...of God'
*Facing the Light: The Photography of Hill and
Adamson*, Sara Stevenson, National Galleries
of Scotland, 2006

p.57 'to apply the calotype...classes of
individuals'
Letter, Sir David Brewster to William Henry
Fox Talbot, 3 July 1843, National Media
Museum, Bradford, UK

p.58 'an unreasoning machine...of facts'
London Quarterly Review, April 1857

p.58 'Your duty...beautiful cases'
*Sleeping Beauty: Memorial Photography in
America*, Stanley B. Burns, Twelvetrees/Twin
Palms Press, 1990

p.59 'people went masked through the streets'
*Physiognomy and the Meaning of Expression
in Nineteenth Century Culture*, Lucy Hartley,
Cambridge University Press, 2006

p.59 'recognized by this accusatory image'
'Esquisses photographiques a propos de
l'exposition universelle et de la guerre d'orient',
Ernest Lacan (1856) in *Ghost in the Shell:
Photography and the Human Soul 1850–2000*,
Robert A. Sobieszek, MIT Press, 1999

p.61 'as if the patient...some enemies';
'she gained a small...but poorly' and
'To be well...food every day' *The Physiognomy
of Insanity*, John Conolly, reproduced in *The
Medical Times and Gazette*, Vol. 16, 1858

p.71 'We can hardly...an imagination'
Cosmos, 14 July 1854, quoted from André
Jammes and Eugenia Parry Janis, *The Art
of French Calotype*, Princeton University
Press, 1983

p.71 'Gutenberg of photography'
'Publications héliographiques', Francis Wey,
La Lumière, Vol. 1, No. 25, 27 July 1854

p.97 'views in distant...streets and squares'
Manual of Photographic Manipulation,
William Lake Price, J. Churchill, 1858

p.103 'the greatness of the inner...outer man'
Annals of My Glass House, Julia Margaret
Cameron, University of Washington Press, 1997

p.127 'Who has the right...Beauty & poetry'
and 'When focusing...insist upon'
'Annals of My Glass House', Julia Margaret
Cameron (1874) in 'Mrs Cameron's
Photographs', *Camera Gallery*, 1889

p.130 'Killed in the frantic...and kindred';
'Slowly over the misty...harvest of death' and
'Such a picture...its pageantry'
*Gardner's Photographic Sketch Book of the
Civil War*, Alexander Gardner, Dover
Publications, 1959

p.139 'My house is inundated...paid us a visit'
Illustrated London News, 26 September 1863

p.143 'These photographic methods...integral
part'
Photography and Science, Kelley Wilder,
Reaktion Books, 2009

p.144 'But by intensifying...was obtained'
'Helios: Eadweard Muybridge in a Time
of Change', Philip Brookman in *Eadweard
Muybridge*, Tate Publishing, 2010

p.148 'an unreasoning...evidence of facts'
Journal of the Photographic Society,
15 March 1864

p.149 'the father of art photography' and
'The urchins...object of charity'
'O. G. Rejlander's Photographs of Street
Urchins', S. Spencer, *Oxford Art Journal*,
Vol. 7, No. 2, 1984

p.149 'the culmination. . .nineteenth century'
Masterpieces of Photography from the George Eastman House Collections, Robert Sobieszek, Abbeville Press, 1985

p.149 'Atget considered . view of the city'
'My Memories of E. Atget, P. H. Emerson and Alfred Stieglitz', Brassaï, *Camera*, Vol. 48, January 1969

p.151 'the earliest comprehensive. . .Great Britain'
'Introduction', Anita Ventura Mozley, *Photographs of the Old Closes and Streets of Glasgow*, Thomas Annan, Dover, 1977

p.153 'The camera should be. . .instruction of the age' Quoted in *John Thomson: Life and Photographs*, Stephen White, Thames & Hudson, 1985

p.153 'They have been reduced. . .energy to beg'
Street Life in London, John Thomson and Adolphe Smith, 1877

p.155 'Where Mulberry Street. . it is enough' and 'From midnight. . .in the picture'
How the Other Half Lives, Jacob Riis, C. Scribners, 1890

p.158 'It was the first time. . .take pictures himself'
Letter, George Eastman to W. J. Stillman, 6 August 1888, quoted in *George Eastman: A Biography*, Elizabeth Brayer, Johns Hopkins University Press, 1996

p.159 'The letter "K". . .ending with "K"'
George Eastman: A Biography, Elizabeth Brayer, Johns Hopkins University Press, 1996

p.159 'This is not a foreign name. . .in the art'
George Eastman, Carl W. Ackerman, Constable, 1930

p.160 'However much a man. . .was beautiful'; 'Art rules. . .in the artist' and 'Any dodge. . .in a picture'
Pictorial Effect in Photography, Henry Peach Robinson, Nabu Press, 2010

p.163 'From 1893. . .steaming car horses'
Alfred Stieglitz: An American Seer, Dorothy Norman, Aperture, 1973

p.176 'American photography. . .fixed purpose'
Amateur Photographer, 2 June, 1904

p.183 'The scene fascinated. . .ship, ocean, sky' and 'If all my photographs. . .quite all right'
Alfred Stieglitz: An American Seer, Dorothy Norman, Aperture, 1973

p.189 'Events of. . .something to happen'
Central State Film, Photo and Audio Archives, St Petersburg, Russia
http://4w.danganj.net/Article/Print.asp?ArticleID=2469

p.197 'If it was possible. . .literal photographs'
Edward Steichen: A Life in Photography, Edward Steichen, Doubleday, 1963

p.201 'A record of emotion. . .topography'
'Frederick H. Evans', Beaumont Newhall, *Aperture Monograph*, Vol. 18, No. 1, 1973

p.210 'identical workers. . .and sickles' and 'revolutionary photography. . .Communist culture'
The Soviet Photograph, 1924–1937, Margarita Tupitsyn, Yale University Press, 1996

p.210 'stop colour patching. . .of the bourgeoisie'
Lef Manifesto, Lef 2 (1923) in *Modernism: An Anthology of Sources and Documents*, Vasiliki Kolocotroni, Jane Goldman and Olga Taxidou (eds), Edinburgh University Press, 1998

p.210 'a biased routine. . .visual thought'
'The Paths of Contemporary Photography' in *Aleksandr Rodchenko, Experiments for the Future: Diaries, Essays, Letters and Other Writings*, Alexander N. Lavrentiev (ed.), Museum of Modern Art, New York, 2005

p.226 'the eye of Paris'
'The Eye of Paris', Henry Miller, *Globe Magazines*, 1937

p.229 'I said to her. . .into something else'
Kertész on Kertész: A Self-Portrait, Abbeville Press, 1985

p.232 'psychic automatism. . .pure state'
Surrealist Manifesto, André Breton, 1924

p.235 'The surrealism. . .is more surreal'
Brassaï: The Monograph, Brassaï, Alain Sayag et al (eds), Bulfinch Press, 2000

p.244 'Thanks to the photograph. . .new eyes'
'A New Instrument of Vision', László Moholy-Nagy in *The Photography Reader*, Liz Wells (ed.), Routledge, 2002

p.245 'To be photographed. . .subjective intention'
'Painting Photography Film', László Moholy-Nagy (1925) in *Ghost in the Shell: Photography and the Human Soul 1850–2000*, Robert A. Sobieszek, MIT Press, 1999

p.245 'recording faithfully. . .the outer man'
Annals of My Glass House, Julia Margaret Cameron, University of Washington Press, 1997

p.247 'unconsciously divided into two'
Anton Giulio Bragaglia quoted in *Photographie futuriste italienne: 1911–1939*, Giovanni Lista, Musée d'art moderne de la ville de Paris, 1981

p.252–3 'I am inspired. . .settings and lights'
Eyes Wide Open, František Dritkol, Svět, 2002

p.255 'Sometimes just by a half. . .body shapes'
In Focus: André Kertész, Getty Publications, 1994

p.257 'It is as if. . .lived many lives'
Georgia O'Keeffe: A Portrait by Alfred Stieglitz, Metropolitan Museum of Art, 1997

p.261 'the first serious. . .ever made'
High Fashion: The Condé Nast Years 1923–1937,

William A. Ewing, Todd Brandow, W. W. Norton & Company, 2008

p.262 'original pictures. . .portraiture as well'
Man Ray: Bazaar Years, John Esten, International Center of Photography, 1988

p.263 'the most beautiful women in Paris' and 'Man was to take. . .props and backgrounds'
The Photographic Art of Hoyningen-Huene, William A. Ewing and George Hoyningen-Huene, Thames & Hudson, 1998

p.263 'the erotic president of the Dada movement'
Erwin Blumenfeld: I was Nothing but a Berliner, Dada montages 1916–1933, Erwin Blumenfeld and Helen Adkins, Hatje Cantz, 2008

p.267 'my best pictures. . .dirty ashtray, something'
Cathy Horyn, *New York Times*, 19 November 1999

p.275 'mad dogs' LIFE, 27 January 1941

p.275 'a stubborn surly snarling animal'
Weegee's World, Miles Barth (ed.), Little, Brown, 1997

p.280–1 'truthfully represent or subterfuge'
'Statement', Edward Weston in John Wallace Gillies, *Principles of Pictorial Photography*, Falk Publishing Co., 1923

p.283 'completely. . .more than a pepper'
Edward Weston, 8 August 1930, in *The Daybooks of Edward Weston, Volumes 1 and 2*, Nancy Newhall (ed.), Aperture, 1981

p.288 'these are simply. . .that I make'
Atget quoted by Man Ray in *Interview: Man Ray, Camera*, Vol. 54, No. 2, February 1975

p.289 'scenes of crime'
'The Work of Art in the Age of Mechanical Reproduction' in *Illuminations*, Walter Benjamin, Pimlico, 1999

p.290 'I don't like. . .into our memory'
Photography in Print: Writings from 1816 to the Present, Vicki Goldberg, Simon and Schuster, 1981

p.314 'The dead were lying. . .was the end'
Magnum: Fifty Years at the Front Line of History, Russell Miller, Pimlico, 1999

p.315 'I could never. . .of my nostrils'
'Miller's Tale', *V&A Magazine*, Winter 2007

p.316 'The war correspondent. . .the first wave'
Slightly Out of Focus, Robert Capa, Henry Holt, 1947

p.317 'The bullets. . .water around me'
Slightly Out of Focus, Robert Capa, Henry Holt, 1947

p.329 'Although there was. . .at your snaps'
Magnum: Fifty Years at the Front Line of History, Russell Miller, Pimlico, 1999

p.330 'a new photographic style' and 'the demands of our time'
Preface to *Subjektive Fotografie I*, Otto Steinert, Bruder Auer Verlag, 1952

p.333 'sleeping giants'
Creative Camera, No. 190, April 1980

p.335 'what the world...world to mean'
'Photography as an Art Form', Aaron Siskind, unpublished lecture, Art Institute of Chicago, 7 November 1958 in *Photographers on Photography*, Nathan Lyons, Prentice-Hall, 1966

p.338 'A superficial glance...its contents'
'Frederick Sommer: Collages of Found Objects', Minor White *et al*, *Aperture*, Vol. 4, No. 3, 1956

p.339 'a prisoner of external perception'
Surrealism and Painting, André Breton, MFA Publications, 2002

p.339 'Max Ernst...Pentelic marble'
www.getty.edu.art/exhibitions/sommer

p.341 'I am a reflection...a reflection'
http://artistresearcher.wordpress.com/2009/12/13/duane-michals-a-letter-from-my-father-1960-75/

p.344 'You are not here...buttons and bows'
The Golden Age of Couture: Paris and London 1947–57, Claire Wilcox, V&A Publications, 2007

p.347 'a kind of dream image'
Avedon Fashion 1944–2000, Philippe Garner, Carol Squires and Vince Aletti, Abrams, 2009

p.347 'the most remarkable...of her time'
New York Times, 5 May 1990

p.347 'I don't know why...of the picture'
American Masters: Richard Avedon: Darkness and Light, TV documentary directed by Helen Whitney, WNET, 1996

p.349 'My aim was to take...still camera'
Norman Parkinson: 50 years of Portraits and Fashion, Robin Muir, National Portrait Gallery, 1981

p.351 'Perhaps if I ever...in the sand'
Angus McBean: Portraits, Terence Pepper (ed.), National Portrait Gallery, 2006

p.351 'grubbiness of the times'
On the Edge: Images from 100 Years of Vogue, Random House, 1992

p.352 'the best since Nadar...Cameron'
John Deakin: Photographs, Schirmer/Mosel, 1996

p.354 'In the future...fifteen minutes'
Andy Warhol's Exposures, Andy Warhol and Bob Bolacello, Hutchinson, 1979

p.354 'A photographic portrait...he looks'
www.richardavedon.com/data/web/richard_avedon_kissinger.pdf

p.355 'If we start...let us in' and 'I think Andy...show a photographer'
Andy Warhol's Exposures, Andy Warhol and Bob Bolacello, Hutchinson, 1979

p.356 'the projection upon...own rights'
Public Opinion, Walter Lippmann (1922) quoted in *Ghost in the Shell: Photography and the Human Soul 1850–2000*, MIT Press, 1999

p.356 'remarkable strangers...the earth';
Almost no one...few archaeologists';
'The look of the inhabitants...the Inca cities'
Worlds in a Small Room, Irving Penn, Studio, 1980

p.357 'A brother...to Cuzco'; 'I found pictures... and adornments'; 'something of their tiny size'
Worlds in a Small Room, Irving Penn, Studio, 1980

p.357 'as impersonally...still lives' and 'observes them...know them'
'Some Early Portraits by Irving Penn' in *Irving Penn: A Career in Photography*, ed. Colin Westerbeck, Little, Brown & Co., 1997

p.359 'Again and again...no babies';
'You're going to see...damn show'; 'I'm going to strip...It's a tough life'
Carnival Strippers, Susan Meiselas, Steidl, 2003

p.361 'I felt that...filled with grace'
Focus: Fine Art Photography, February 2007

p.363 'When I began...never observed'
Camera in London, Bill Brandt, Focal Press, 1948
http://www.vam.ac.uk/content/articles/b/bill-brandt-biography/

p.365 'Photography is...the exterior'
Masterpieces of Photography from the George Eastman House Collections, Robert A. Sobieszek, Abbeville Press, 1985

p.368 'In the past decade...to know it'
'New Documents' press release, Museum of Modern Art, New York, 1967

p.368–9 'Taking my cue...intuition directed me'
Tod Papageorge quoted in 'Senior Moment', *New York Times Magazine*, 30 March 2007

p.369 'to even loosely...what I photographed'
Passing Through Eden, Photographs of Central Park, Tod Papageorge, Steidl, 2007

p.370 'camera like a knife...the city'
Eyes of an Island: Japanese Photography 1945–2007, Michael Hoppen and Marc Feustel, Studio Equis, 2007

p.371 'I feel...get it approach' 'The Realist Position', Roger Mayne, Upper Case, 1961

p.371 'to communicate...do things' and 'Photography can be a mirror...with the camera'
A Day Off: An English Journal, Tony Ray-Jones, Thames & Hudson, 1974

p.372 'photographic problem it states';
'contest between content and form' and 'if you run into a monkey...in the photograph'

'Monkeys Make the Problem More Difficult: A Collective Interview with Garry Winogrand, New York (1970) first published in *Image Magazine*, Vol. 15, No. 2, July 1972

p.373 'I'm sure that photo...war movies'
San Francisco Chronicle, 19 October 2003

p.382 'I wasn't thinking about...more dignified'
Documentary Photography, Robert Frank, Time-Life Books, 1972

p.385 'We all had a dream...or dead'
Bruce Davidson, Photofile series, Thames & Hudson, 1990

p.389 'Its personality...finally finished'
Goodbye Baby and Amen: a Saraband for the Sixties, David Bailey and Peter Evans, Coward, McCann, 1969

p.390 'You don't...with gore'
http://www.musarium.com/stories/vietaminc/interview.html

p.391 'Ultimately...becomes anti-war'
http://www.blinqphotography.com/people/good-war-photography-is-anti-war-tim-page/

p.395 'It was night-time...magic moment'
The Moon Landing: 20 July 1969, Paul Mason, Hodders Wayland, 2002

p.395 'The surface...my boot'
Appointment on the Moon: The Inside Story of America's Space Venture, Richard Lewis, Viking Press, 1969

p.397 'of a surrealist nature'
'Work by American photographers new to the museum to be shown', Press Release, Museum of Modern Art, New York, 26 February 1953

p.399 'snapshot chic'
'Art Focus on Photo Shows', Hilton Kramer, *New York Times*, 28 May 1976

p.399 'It is an insect's view...child's view'
William Eggleston's Guide, John Szarkowski, Museum of Modern Art, New York, 2002

p.401 'pretense to truthfulness'
New Topographics: Photographs of a Man-Altered Landscape, William Jenkins, George Eastman House, 1975

p.404 'liking things' Andy Warhol interview by Gene Swenson, *Art News*, November 1963

p.412 'The idea becomes...makes the art'
'Paragraphs on Conceptual Art,' Sol LeWitt, *Artforum*, summer issue, 1967

p.413 'The person that did...this is wrong'
http://collectionsonline.lacma.org/mwebcgi/mweb.exe?request=record;id=31081;type=101

p.427 'I see my work...myself as a medium'
'Dieter Appelt: L'Hypothese du Chamanisme, A Conversation with Dieter Appelt', Peter Hay Halpert, *Art Press International*, March 1996

p.432 'the body is language'
http://www.zhanghuan.com/ShowText.
asp?id=30&sClassID=1

p.444 'Cuesta del Plomo. . .National Guard'
http://www.magnumphotos.com/C.
aspx?VP3=ViewBox_VPage&VBID=2K1HZOFLG
FQ2V&IT=ZoomImage01_VForm&IID=2K7O3R
WW994&PN=5&CT=Search

p.458 'to research. . .history of Lebanon'
http://www.theatlasgroup.org

p.459 'the massacre. . .world's indifference'
Frieze, November-December 2011

p.465 'tolerance of the human face'
The Atrocity Exhibition, J. G. Ballard,
Jonathan Cape, 1969

p.465 'The object. . .picture is made of' and
'The thing that interests me. . .experience in it'
Chuck Close: Self portraits, 1967–2005, Siri
Engberg and Madeleine Grynsztejn (eds),
Walker Art Center/SFMoMA, 2005

p.465 'I don't believe. . .suspect to me'
'Thomas Ruff: Reality So Real its
Unrecognisable', interview with Thomas
Wulffen, *Flash Art International*, No. 168,
January/February 1993

p.466 'as truthful. . .possible to make'
'The Interview: Richard Avedon', D. C. Denison,
Sunday Boston Globe Magazine, 5 April, 1987

p.466 'reality is not under the surface'
'Dinner is Served', Antonin Artaud (1925) in
Selected Writings, Susan Sontag (ed.), Farrar,
Straus & Giroux, 1976

p.467 'The more she pictures. . .like a mirage'
'So How Do I Look? Women Before and
Behind the Camera', Susan Butler in
*Staging the Self: Self-Portrait Photography
1840s–1980s*, James Lingwood (ed.), National
Portrait Gallery, 1987

p.467 'I realized. . .world's greatest actress'
*Close Reading: Chuck Close and the art of the
self portrait*, Martin Friedman, Abrams, 2005

p.467 'the boundary between. . .real identity'
http://www.tuebke.info/text.php?g_ti=5

p.471 'Why wasn't I told. . .when I see it' and
'You've captured. . .on the cover'
*Rolling Stone: 1000 covers: A History of the
Most Influential Magazine in Pop Culture*,
Jan S. Wenner, Abrams, 2006

p.472–3 'In an uncanny. . .and theatricalization'
Samuel Fosso, Francesca Bonetti and Guido
Schlinkert, 5 Continents Editions, 2006

p.474 'Despite the Western. . .even heroic'
Shirin Neshat, Arthur C. Danto, Rizzoli, 2010

p.475 'Like all of us. . .him or society'
Yang Fudong, Yang Fudong and Marcella
Beccaria, Thames & Hudson, 2006

p.477 'create by her own. . .self-determining'
http://findarticles.com/p/articles/mi_m0268/
is_n1_v32/ai_14580117/

p.481 'I found myself. . .otherwise see'
http://www.elinorcarucci.com/personal/
closer/closercopy.htm

p.483 'Colour prints. . .final product'
Family Pictures, Nicholas Nixon, Smithsonian
Institution Press, 1991

p.485 'because they don't. . .image of themselves'
*Image Makers, Image Taker: The Essential Guide
to Photography by Those in the Know*, Anne-
Celine Jaeger, Thames & Hudson, 2007

p.485 'By carefully constructing. . .the world'
Art Photography Now, Susan Bright, Thames
& Hudson, 2005

p.486 'I don't crop. . .put it on'
'Where is the Sex', *Guardian*, 13 March 2001

p.487 'to prevent. . .indecent photographs'
http://www.legislation.gov.uk/ukgpa/1978/37

p.490 'Fashion magazines. . .some reality'
Imperfect Beauty, Charlotte Cotton, Victoria
and Albert Museum, 2000

p.491 'Some of the very best. . .fashion
photography' *Face of Fashion*, Susan Bright,
National Portrait Gallery, 2007

p.493 'it wasn't fun. . .become a "model"'
Telegraph, Lucy Davies, 2 September 2010

p.495 'Feminine seduction. . .do their birettas'
Jeanloup Sieff, Taschen, 2010

p.500 'I called the picture. . .the real thing'
http://theinspirationroom.com/daily/2007/
benetton-pieta-in-aids-campaign/

p.503 'it's axiomatic. . .are deceitful'
http://www.lacan.com/frameXIV9.htm

p.505 'the art of fixing a shadow'
What Do Pictures Want? , William J. Thomas
Mitchell, University of Chicago Press, 2005

p.506 'make art only. . .any one place'
http://www.prixpictet.com/artists/statement/96

p.507–8 'the idea of the Earth. . .through time'
Landscape Stories, Jem Southam, Princeton
Architectural Press, 2005

p.508 'this was a particular. . .stages of theirs'
Change: Land/Water and the Visual Arts, Jem
Southam, Paul Honeywill, 2009

p.509 'Our ability. . .with our surroundings'
Experiment Marathon, Serpentine Gallery,
Reykjavik Art Museum, 2009

p.509 'I wanted the rain. . .and nuances'
http://www.guardian.co.uk/
artanddesign/2009/jul/29/photography-
abbas-kiarostami-best-shot

p.510 'Although the land. . .seas of the world'
Hiroshi Sugimoto: Time Exposed, Thomas
Kellein, Thames & Hudson, 1995

p.511 'I don't want to photograph. . .light
it throws' and 'It has to be south. . .of
the camera'
Hiroshi Sugimoto: Time Exposed, Thomas
Kellein, Thames & Hudson, 1995

p.511 'water and air. . .our very existence'
www.sugimotohiroshi.com/seascape.html

p.513 'There's something about. . .trapped in'
and 'When I moved to London. . .find it again'
'Captain Moonlight: A New Exhibition
of Darren Almond's Ethereal, Nocturnal
Images is About to Open at the White Cube',
Independent, 17 January 2008

p.514–15 'I felt. . .inside the hulls'
*Manufactured Landscapes: The Photographs of
Edward Burtynsky*, National Gallery of Canada
in association with Yale University Press, 2003

p.518 'In the next generation. . .is Jan Groover'
Jan Groover: Photographs, Little Brown, 1993

p.519 'everything that is. . .rather than central'
Utha Barth, Pamela M. Lee, Phaidon, 2004

p.521 'a flower. . .sexual readiness'
Robert Mapplethorpe: The Perfect Moment,
Janet Kardon, Institute of Contemporary Art,
University of Pennsylvania, 1989

p.532 'That's what it looks. . .a rainy day'
http://www.tate.org.uk/modern/exhibitions/
jeffwall/infocus/section5/detail2-2.shtm

p.535 'humbugotypes'
'OTypes', *Humphrey's Journal*, No. 13, 1856

p.535 'I cover all windows. . .the windows'
http://abelardomorell.net/photography/
cameraobsc_01/cameraobsc_01.html

p.535 'It's only when. . .someone very beautiful'
http://www.mfa.org/exhibitions/adam-fuss

p.537 'I'm interested in that moment. . .
embodiments of them'
http://iam-hiuandawake.blogspot.com/2011/
03/garry-fabian-miller-color-of-time.html

p.537. 'I am reluctant. . .myself as a maker'
http://www.vam.ac.uk/vastatic/microsites/
photography/story

p.539 'When I made the photographs. . .the
place';
'With time. . .only trace' and 'the picture. . .
chemical emulsion'
Craigie Horsfield, Institute of Contemporary
Arts, 1991

p.541
'Water has been. . .early 1980s' and 'a more
direct. . .a large darkroom'
http://www.prixpictet.com/artists/
statement/252

PICTURE CREDITS

2 Photograph by Hoyningen-Huene. © R.J. Horst **8** Popperfoto/Getty Images **9** Roger-Viollet/TopFoto **10** © 2012. Image copyright The Metropolitan Museum of Art/Art Resource/Scala, Florence **11** © 2012. Image copyright The Metropolitan Museum of Art/Art Resource/Scala, Florence **12** © 2012. Digital image, The Museum of Modern Art, New York/Scala, Florence **13** Telimage, Paris 2012. © Man Ray Trust/ADAGP, Paris and DACS, London 2012. **15** Andreas Gursky/Courtesy Sprüth Magers Berlin London/© DACS, London 2012. **16-17** fotoLibra **18** Getty Images **19** Getty Images/SSPL **20** Getty Images **21** t © The British Library Board **21** b La Société française de photographie **22** FotoLibra **24** Getty Images/SSPL **26** © National Media Museum/ Science & Society Picture Library **27** Courtesy of Jenny Jacobson **28** Bibliothèque nationale de France **29** t Getty Images/SSPL **29** b Courtesy of George Eastman House, International Museum of Photography and Film **30** The J. Paul Getty Museum, Los Angeles **32** Courtesy of George Eastman House, International Museum of Photography and Film **34** Getty Images/SSPL **35** Courtesy of George Eastman House, International Museum of Photography and Film **36** Louis Dodier en prisonnier/Humbert de Molard Louis Adolphe/© RMN-GP/Hervé Lewandowski/Musée d'Orsay **37** © The British Library Board **38** Museum fur Kunst und Gewerbe Hamburg **40** P1999.13, Amon Carter Museum of American Art, Fort Worth, Texas **42** Getty Images/SSPL **43** Scottish National Portrait Gallery **44** © Victoria and Albert Museum, London/V&A Images -- All rights reserved. **45** © 2012 Image copyright The Metropolitan Museum of Art/Art Resource/Scala, Florence **46** © 2012 Image copyright The Metropolitan Museum of Art/Art Resource/Scala, Florence **48** © 2012 Image copyright The Metropolitan Museum of Art/Art Resource/Scala, Florence **50** The J. Paul Getty Museum, Los Angeles **51** The Royal Collection © 2011 Her Majesty Queen Elizabeth II/ The Bridgeman Art Library International **52** The J. Paul Getty Museum, Los Angeles **54** t Roger-Viollet/TopFoto **54** b © 2012 Image copyright The Metropolitan Museum of Art/Art Resource/Scala, Florence **55** Musee du quai Branly/Scala, Florence **56** Scottish National Portrait Gallery **58** © 2012 Image copyright The Metropolitan Museum of Art/Art Resource/Scala, Florence **59** © 2012 Image copyright The Metropolitan Museum of Art/Art Resource/Scala, Florence **60** Getty Images/SSPL **62** © Victoria and Albert Museum, London/V&A Images -- All rights reserved. **63** Getty Images **64** Getty Images/SSPL **66** t © Victoria and Albert Museum, London/V&A Images -- All rights reserved. **66** b © Victoria and Albert Museum, London/V&A Images -- All rights reserved. **67** © Victoria and Albert Museum, London/V&A Images -- All rights reserved. **68** © Rheinisches Bildarchiv Koln, rba_c012098, rba_c020927 **70** Courtesy of The Art Institute of Chicago. **71** Getty Images/SSPL **72** © 2012 Image copyright The Metropolitan Museum of Art/Art Resource/Scala, Florence **74** Bibliothèque des arts decoratifs, Paris **75** Le Stryge/Nègre Charles/© RMN-GP/Hervé Lewandowski/Musée d'Orsay **76** Paysage à Rome/Le Dien Firmin Eugène/© RMN-GP/Patrice Schmidt/Musée d'Orsay **77** © 2012 Image copyright The Metropolitan Museum of Art/Art Resource/Scala, Florence **78** The Royal Society, London **80** Yale University Art Gallery/ Art Resource/Scala, Florence **82** Nu féminin allongé/Moulin Félix Jacques Antoine/© RMN-GP/Hervé Lewandowski/Musée d'Orsay **83** Courtesy Collection Dietmar Siegert **84** Bibliothèque nationale de France **86-87** © Victoria and Albert Museum, London/V&A Images -- All rights reserved. **88** © 2012 Digital image, The Museum of Modern Art, New York/Scala, Florence. **89** t © Victoria and Albert Museum, London/V&A Images -- All rights reserved. **89** b Scottish National Portrait Gallery **90** © Victoria and Albert Museum, London/V&A Images -- All rights reserved. **92** Getty Images/SSPL **93** Bibliothèque nationale de France **94** Courtesy of the Peabody Essex Museum, Salem, Massachusetts **96** © Victoria and Albert Museum, London/V&A Images -- All rights reserved. **97** © 2012 Image copyright The Metropolitan Museum of Art/Art Resource/Scala, Florence **97** b The Metropolitan Museum of Art/Art Resource/Scala, Florence **98** Getty Images **100** © Victoria and Albert Museum, London/V&A Images -- All rights reserved. **101** © 2012 Image copyright The Metropolitan Museum of Art/Art Resource/Scala, Florence **102** © 2012 Image copyright The Metropolitan Museum of Art/Art Resource/Scala, Florence **102** t © 2012 Digital image, The Museum of Modern Art, New York/Scala, Florence. **103** b Paris, Musee d'Orsay. © 2012. Photo Scala, Florence **104** © National Portrait Gallery, London **106** Bibliothèque nationale de France **108** t Gernsheim Collection, Harry Ransom Humanities Research Center, The University of Texas at Austin **108** b © Victoria and Albert Museum, London/V&A Images -- All rights reserved. **109** © Victoria and Albert Museum, London/V&A Images -- All rights reserved. **110** © 2012 Image copyright The Metropolitan Museum of Art/Art Resource/Scala, Florence **112** Royal Photographic Society/National Media Museum/Science & Society Picture Library -- All rights reserved. **113** The J. Paul Getty Museum, Los Angeles **114** Bibliothèque nationale de France **115** t © Royal Academy of Arts, London; photographer J. Hammond **115** b The J. Paul Getty Museum, Los Angeles **116** © NMPFT/Royal Photographic Society/Science & Society Picture Library -- All rights reserved. **118** © Victoria and Albert Museum, London/V&A Images -- All rights reserved. **120** Courtesy of George Eastman House, International Museum of Photography and Film **121** The J. Paul Getty Museum, Los Angeles **122** Getty Images/SSPL **124** Image courtesy of the Art Institute of Chicago. Permission granted by Mr Paul F Walter. **125** t © 2012 Image copyright The Metropolitan Museum of Art/Art Resource/Scala, Florence **125** b Library of Congress, Prints & Photographs Division, (LC-USZ62-64301) **126** The J. Paul Getty Museum, Los Angeles **128** The J. Paul Getty Museum, Los Angeles **129** t National Army Museum, London/The Bridgeman Art Library **129** b Gernsheim Collection, Harry Ransom Humanities Research Center, The University of Texas at Austin **130** Courtesy of George Eastman House, International Museum of Photography and Film **132** © 2012 Image copyright The Metropolitan Museum of Art/Art Resource/Scala, Florence **133** t Musee du Quai Branly/Scala, Florence **133** b The J. Paul Getty Museum, Los Angeles **135** p © 2012 Image copyright The Metropolitan Museum of Art/Art Resource/Scala, Florence **136** © 2012 Image copyright The Metropolitan Museum of Art/Art Resource/Scala, Florence **137** Scottish National Portrait Gallery **138** ullstein bild/akg-images **140** Petrie Museum/ University College London **141** © 2012 Digital image, The Museum of Modern Art, New York/Scala, Florence. **142** Courtesy of George Eastman House, International Museum of Photography and Film **143** b Getty Images **143** t © The British Library Board **144** Kingston Museum & Heritage Service **146** Wellcome Collection **148** IMAGNO/Austrian Archives/akg-images **149** Getty Images **150** © 2012 Digital image, The Museum of Modern Art, New York/Scala, Florence. **151** Library of Congress, Prints and Photographs Division, LC-USZ62-76959 **152** © John Thomson/ the Museum of London **154** © 2012 Digital image, The Museum of Modern Art, New York/Scala, Florence. **156** © Victoria and Albert Museum, London/V&A Images -- All rights reserved. **157** Courtesy of George Eastman House, International Museum of Photography and Film **158** Courtesy of George Eastman House, International Museum of Photography and Film **159** p Getty Images/SSPL **160** Getty Images/SSPL **161** Scottish National Portrait Gallery **162** t Getty Images. © Georgia O'Keeffe Museum/DACS, 2012 **162** b Getty Images/SSPL **163** © 2012 Digital image, The Museum of Modern Art, New York/Scala, Florence. Permission of the Estate of Edward Steichen **164** Getty Images/SSPL **166** La Société française de photographie **168-169** © 2012. Digital image, The Museum of Modern Art, New York/Scala, Florence. © DACS 2012. **170** La Grande Roue des Tuileries/Dubreuil Pierre/© RMN-GP/Jean-Jacques Sauciat/Musée d'Orsay **171** © 2012. Digital image, The Museum of Modern Art, New York/Scala, Florence. © Georgia O'Keeffe Museum/DACS, 2012 **172** Getty Images/SSPL **174** Getty Images/SSPL **176** Getty Images/SSPL **177** © 2012. Digital image, The Museum of Modern Art, New York/Scala, Florence **178** 'The White Trees' CW no.29, 1910. Lee Gallery, Winchester, USA **179** b The Philadelphia Museum of Art/Art Resource/Scala, Florence **179** t © 2012. Digital image, The Museum of Modern Art, New York/Scala, Florence **180** © 2012 Image copyright The Metropolitan Museum of Art/Art Resource/ Scala, Florence/Permission of the Estate of Edward Steichen **182** Getty Images/SSPL. © Georgia O'Keeffe Museum/DACS, 2012 **184** Photograph by Jacques Henri Lartigue © Ministere de la Culture - France/AAJHL **185** Getty Images/NY Daily News **186** Scott Polar Research Institute, University of Cambridge **188** Getty Images **189** The Art Archive **190** Robert Capa © International Center of Photography/Magnum Photos **192** © 2012. Digital image, The Museum of Modern Art, New York/Scala, Florence. © Christian Schad Stiftung Aschaffenburg/VG Bild-Kunst, Bonn and DACS, London 2012. **193** © 2012. Photo Scala, Florence/BPK, Bildagentur fuer Kunst, Kultur und Geschichte, Berlin. © The Heartfield Community of Heirs/VG Bild-Kunst, Bonn and DACS, London 2012. **194** © 2012. Photo Scala, Florence/BPK, Bildagentur fuer Kunst, Kultur und Geschichte, Berlin. © DACS 2012. **196** © 2012.

Quintessence would also like to warmly thank: Alison Hau for her design work, Philip Contos and Kelly Thompson for their editorial work, and Dr Michael Pritchard FRPS, who compiled the Glossary.